L.A. Rebellion

L.A. Rebellion

Creating a New Black Cinema

EDITED BY

Allyson Nadia Field,
Jan-Christopher Horak,
and Jacqueline Najuma Stewart

UNIVERSITY OF CALIFORNIA PRESS

University of California Press, one of the most
distinguished university presses in the United States,
enriches lives around the world by advancing scholarship
in the humanities, social sciences, and natural sciences.
Its activities are supported by the UC Press Foundation
and by philanthropic contributions from individuals
and institutions. For more information, visit www
.ucpress.edu.

University of California Press
Oakland, California

Library of Congress Cataloging-in-Publication Data

L.A. Rebellion : creating a new black cinema/edited by
Allyson Nadia Field, Jan-Christopher Horak, and
Jacqueline Najuma Stewart.
 pages cm
 Includes bibliographical references and index.
 ISBN 978-0-520-28467-8 (cloth : alk. paper)
 ISBN 978-0-520-28468-5 (pbl. : alk. paper)
 ISBN 978-0-520-96043-5 (ebook)
 1. African American motion picture producers and
directors—California—Los Angeles—History—20th
century. 2. Independent filmmakers—California—Los
Angeles—History—20th century. 3. Independent
films—California—Los Angeles—History—20th
century. 4. Experimental films—California—Los
Angeles—History—20th century. I. Field, Allyson
Nadia, 1976–editor. II. Horak, Jan-Christopher,
editor. III. Stewart, Jacqueline Najuma, 1970–editor.
 PN1995.9.N4L24 2015
 791.43089'96073—dc23
 2015016337

Manufactured in the United States of America

24 23 22 21 20 19 18 17 16 15
10 9 8 7 6 5 4 3 2 1

The paper used in this publication meets the minimum
requirements of ANSI/NISO Z39.48–1992 (R 2002)
(*Permanence of Paper*).

For Elyseo Taylor and Teshome Gabriel

Contents

Once upon a Time in the West . . . L.A. Rebellion

CLYDE TAYLOR

I'm not a fan of the Big Bang theory where, in one version, the universe explodes from a subatomic particle, much smaller than a pinpoint. But the image of the Big Bang in reverse does capture me, with Total Everything spinning in a whirlwind back to this one infinitesimal spark. In this memory capsule, I want to follow some threads in rewind to capture partial, personal glimpses of the L.A. Rebellion, hoping to focus some particulars of the cultural scenes it swam in and also highlight some threads that its energy small-banged into the cultural firmament.

A good place to start is the African Film Society. One day in the mid-1970s, VèVè Clark, my brilliant friend and colleague in UC Berkeley's Black Studies Department, called me (and eighty others, she said) and said don't miss the film playing that night at the Pacific Film Archive, UC Berkeley's articulate cinematheque. The film was Haile Gerima's *Harvest: 3,000 Years* (1976), a world-class masterpiece easily placed between Chaplin and Kurosawa. I was blown away, as any great film can do to you. But who made this film? Out of what matrix? An Ethiopian? Before I reached the aisle to exit, I was plotting to know more. Each step down the stadium staircase brought another thought. There must be an association that promotes such films. At the time, I didn't know three African films, but if more existed, I was going to find and support them. There must be some African film society somewhere. By the third step, my conclusion was fixed: if there isn't, I'm going to start one.

FIGURE P.1. *Harvest: 3,000 Years,* (Dir. Haile Gerima, 1976).

The African Film Society (AFS) began in 1976 as a small group of Bay Area media- and PR-savvy cultural activists and artists. The original core included my wife, Marti Wilson-Taylor, and Valerie Jo Bradley, Edsel Matthews, Iris Harvey, and Sandra and Fasil Demissie, with other generous spirits like Juma Santos and Ed Guerrero pitching in. We planned and organized film screenings based on improvised research into African filmmaking. We focused on African film from the jump, thinking it the newest and neediest scene then commanding attention. But we always included Black independent cinema and diaspora films in our brief, even though we hadn't fully grasped the ferment taking place on the Westwood campus. Still, the trail was due to lead back to Los Angeles.

(For your Butchered History file, from the Wikipedia entry for "Film Society": "In 2005 the Musée Dapper in Paris founded the first film society entirely concentrating on the cinema of Africa, the Caribbean and the African-American diaspora—the occasion being the celebration of 50 years of African Cinema.")

Our crusade had a limited reach, with audiences sometimes as small as forty people. But it also stretched to different ends. We learned a good deal more about Africa, which we put to use in our individual

ways, I in classrooms and writing. We dug into a crash course on film language and history. And just as one reminder that it was not all about Los Angeles, one of our principle advisors, mentor, really, was our friend, New York documentary master St. Clair Bourne, during one of his many sojourns in California, at one stretch teaching film techniques to the "rebels" at UCLA. Another friend was blossoming actor Danny Glover, who says that his interest in African films began at AFS screenings. Glover has had more impact on home-based African movies than any other American, through his acting, producing, and bringing African films to U.S. television. (He also acted in Charles Burnett's *To Sleep with Anger* [1990] and *Namibia: The Struggle for Liberation* [2007].)

We soon discovered companion drives advancing the new screen imagery, like Oliver Franklin's film series at the African American Museum in Philadelphia and Tony Gittens's Black Film Institute in Washington, DC, which he later massaged into the Washington, DC, International Film Festival. Pearl Bowser was a one-person film institute in herself, programming film series around the country and in Europe. Her dedicated revival of interest in Oscar Micheaux and early "race" movies helped the independent scene recognize that the trail had been blazed before.

I'll never forget a postscreening dialogue after the first AFS screening, between one of our collective and a member of the audience. The viewer said, "Oh, I get it, it is not a *professional* film." And my film society colleague said, "No, you don't understand: it *is* a professional film, it is just not a commercial film." I smiled, thinking I had seen the manure pile of US cultural ignorance blush just a bit.

In the AFS we knew we were among the first doing something that seriously needed to be done. We mounted what was one of the first Black women's film series. But we were impatient to make this gripping expression go "viral" within the bloodstream of our times. As one move to reach a wider audience for African and Black independent films, I took to writing about them. And that brought me back to UCLA.

"Back to UCLA" cues another rewind. One of Teshome Gabriel's early essays became a tattered reference for us in the society. "Images of Black People in Cinema" looks like a draft for a book I wish Teshome had gone on to write, and was surely a sketch for a path I would trample for decades to come, including the first comments on the upheaval at UCLA.[1] But I remembered Teshome only slightly from my days as a visiting professor in the UCLA English Department from 1969 to 1972. I needed to get to know him better.

FIGURE P.2. Charles Burnett and Jamaa Fanaka. Collection of Jamaa Fanaka, courtesy Twyla Gordon-Louis, Trustee, Gordon Family Trust.

I have a clearer memory of an afternoon around 1971 when I ran into Elyseo Taylor on campus.[2] A well-rounded intellectual, Elyseo only occasionally mentioned his work on film production in theater arts. Naturally we stopped to chat about the issues and crises facing Black faculty in those days, like supporting Angela Davis, under fire from the UC Regents or sooner or later menaced by a national witch hunt. Behind Elyseo, as we stood on the walkway close to Bunche Hall, was a group of young men who looked more like construction workers than students, except that the gear they carried was film-production hardware. My side glance caught their bored impatience. But as I re-memory them and put faces onto those figures in the background, I think I see Larry Clark, Haile Gerima, Charles Burnett, and Majid Mahdi—a crossing of paths that would make more sense later.

It was probably Elyseo who insisted that I come to a hall on UCLA's campus one afternoon to watch African films and meet African film-makers. My sharpest impression was Paulin Vierya's short film *Afrique sur Seine* (1955), basically showing African students strolling about Paris as if their very existence there was remarkable: *which it was!* No doubt I also saw Ousmane Sembène's short film *Borom Sarret* (1963) that afternoon but had no idea what he and that film would mean to me, nor know how much I would have to learn to see in that film some of the dense cinematic and cultural meaning that Manthia Diawara draws out in his book *African Film: New Forms of Aesthetics and Politics*.[3] Need I say that I came to recognize Sembène as one of the greatest film artists of all time?

A few years later, at a panel in New York, Paulin Vierya, who was also a critic and theorist as well as a filmmaker, remarked that African films should be shown on international airliners like the one that brought him to the United States. At the time I thought this was utopian, which it was. But more precisely, it was visionary. These snippets and glimpses from the time when a group of UCLA film students were plotting to reframe the image of Black people in the world anticipated a future when the unthinkable could become thinkable. And while many projections and goals are far from met, these glimpses catch sight of cultural activists who were growing in the health of their visionary creativity. They understood the warning James Baldwin sent in a letter to his nephew: "You were born into a society which spelled out with brutal clarity [. . .] that you were a worthless human being. [. . .] You were not expected to aspire to excellence. You were expected to make peace with mediocrity."[4] What was afoot at UCLA, and not only among the film students, and not only at UCLA, was a visionary determination to smash those expectations.

So I had many prompts that something special was happening at UCLA and I better get into its wind. Just one more prompt demands mention. Months before I saw *Harvest* for the first time, Roy Thomas, another provocative colleague in Black studies at UC Berkeley, arranged a screening of Gerima's *Child of Resistance* (1972), which parabolically examines the frame-up of Angela Davis. This was another breakthrough moment for me, a bit like hearing Coltrane the first time, except that I was familiar with the roots of Coltrane in Lester Young and Charlie Parker. Heavily symbolic to the point of surrealism, parodic, caricatural, poetic—akin in its way to Edvard Munch's *The Scream*—the film made me wonder if cinema could load the kind of impact that had fired

FIGURE P.3. *Child of Resistance* (Dir. Haile Gerima, 1972).

off in Baraka's *Black Magic* poems or would later terrorize audiences like Melvin Van Peebles's play *Ain't Supposed to Die a Natural Death* (1971).[5]

We pressed on with screenings in the African Film Society. But I also began writing about what I was seeing and learning. After all these nudges from the grass fires around me—I was a lit-crit professor and a part-time art film buff—I headed down to UCLA to get the story straight before I wrote about it. I went again to L.A. to see films by Charles Burnett, Julie Dash, Barbara McCullough, Ben Caldwell, Alile Sharon Larkin, Larry Clark, Barbara O. Jones, Billy Woodberry—the most vital and accomplished screen representation of Black Americans ever: years later I still stand ready to back up this argument.

It turns out that I caught up with this blast of talent when its fuse was still sizzling. Julie Dash's promise was clear from her *Diary of an African Nun* (1977), well before *Illusions* (1982) and *Daughters of the Dust* (1991); and I followed Alile Sharon Larkin's steep ascent from *Your Children Come Back to You* (1979) to *A Different Image* (1982). When Larry Clark defended *Passing Through* (1977) at his UCLA master's project screening, I sat in the auditorium among a stunned audience.

Your Children Come Back To You

Sharon Larkin's half-hour dramatic film YOUR CHILDREN COME BACK TO YOU, in my opinion, is one of the most ambitious, challenging works of its kind made by a black woman.

Clyde Taylor
THE BLACK COLLEGIAN

FIGURE P.4. *Your Children Come Back to You* (Dir. Alile Sharon Larkin, 1979).

FIGURE P.5. Promo card for *Your Children Come Back to You.* Collection of Alile Sharon Larkin.

I got to know the filmmakers, heard their problems and dreams, looked over their shoulders at work on the editing table.

I witnessed a movement giving birth to itself—that stage of collective creativity and awakening when everything needed to be done for the first time. Each film or discovered filmmaker added a stroke to the developing self-portrait of once-invisible people. Every new film from

Sembène or from Cuba, Brazil, or the Philippines, old movies from China, became building blocks of self-knowledge.

The scene was a laboratory for film insurrection. One of the student provocateurs, John Rier, advanced a quest I never forgot: films in which Black people banded together in a common cause and prevailed at the end, something you can see in any *Toy Story* (Dir. John Lasseter, 1995) but remains *verboten* for Black characters even to this day in the post-Apartheid American movie industry. It was on the job postdoctoral education. Naturally, I consulted Teshome Gabriel's generous, nuanced thinking.

At an outdoor lunch on campus, Teshome scratched out three notions on a paper napkin that I modified in the essay "New U.S. Black Cinema" about Black independent filmmaking.[6] In rewind, I think the combative style of interaction in those days and on campus did the gentlemanly humanist personage of Teshome a disservice. He never claimed or got his "props" as a contributor to the Rebellion. The hyperauteurist mentality on that scene, on that scrimmage field of exploration and resistance, clouded the impact of a nonfilmmaker like the scholar-theorist-teacher Teshome or an essential performer like Barbara O.

Teshome and I silently carried one bond. He more than I shied away from the risk of being labeled a cultural outsider as critic-scholar—he in the context of an Ethiopian discussing African American representation and I in writing about African film. So I feel a twinge that at that brown-bag lunch that day, he was handing me his notes on Black independent films and moving on. It was an unnecessary and unwanted gallant gesture.

The UCLA film engine got me running, but it wasn't the only game in town. There was also Bill Greaves and the important episode of *Black Journal,* the Public Broadcasting television series that premiered in 1968, perhaps the only group action comparable (and preceding) the UCLA movement in the collective training and development of many pioneering film producers. For a while the cliché ran that New York, where *Black Journal* was based, dominated Black documentaries, while L.A., meaning UCLA, shone among Black independents in fiction and feature films. But that was an oversimplification. Carroll Parrott Blue was outstanding as a UCLA documentarian. And in New York Kathleen Collins, Ronald Gray, Bill Gunn, Charles Lane, Woodie King Jr., Jimmy Mannas, Al Santana, and others, including Bill Greaves himself, made fictional or auteurist documentary films.

I didn't mind thinking of what I wrote as film journalism. I can look at it as a first draft of a new history of Black image projection. Kalamu

ya Salaam agreed to have me write a column about Black film in the *Black Collegian,* where I hoped to attract Black colleagues to this new historical source of original, independent thinking. I feel no pain revisiting what I wrote in those days. In the 1970s, 1980s, and some of the 1990s it's possible that I wrote more stuff about Black independents than anybody else. This is less a celebration than a lament.

We had a flash of recognition around 1980 when the African Film Society hosted a reception for Ousmane Sembène in the Bay Area. We had the satisfaction of watching the mutual admiration between Sembène, widely recognized as a great international film director, and Angela Davis, free and no longer hunted, both in full stride as two of the brilliant rebels of the twentieth century, both connected in different ways to the filmmaking insurgence at UCLA.

This rewind projection from Big Bang back to small acts catches moments where we can see a matrix, a film culture, taking shape in the 1970s and growing stronger in the 1980s. By then the Atlanta African Film Society had launched, spearheaded by Ed Spriggs, with Cheryl Chisolm and others. A surprising sister movement sprang up in Britain out of radical and innovative workshops—Ceddo, Sankofa, and Black Audio—producing strong films with the fingerprints of work coming out of UCLA all over them. In the 1980s, Black independents were welcomed and celebrated in the Festival of Pan African Cinema (FESPACO) in Burkina Faso, West Africa. They became invitees to film series in Europe. Solid academic work began to appear, like Ntongela Masilela's "The Los Angeles School of Black Filmmakers."[7] Some of this burgeoning activity was sparked directly or indirectly by films from the L.A. Rebellion. And in the roil and mix of the action around this growing film culture, the films from UCLA were always given a special, pedigreed respect.

By the early 1990s, your mind could gather up driblets of impressions, signs of incremental momentum within the Black independent film scene—growing numbers of young women determined to become filmmakers, inspired by Julie Dash; St. Clair Bourne at the center of a network of activity; an army of novitiates entranced by the oratory of Haile Gerima. A special sign of arrival: Toni Cade Bambara, from the royalty of Black literature, had rolled up her sleeves and collaborated with Louis Massiah to make films in Philadelphia, gracing the Black independent film movement with some of its most brilliant interpretation. By then there was no doubt: Black independent film was a movement.

Once, in the mid-1980s, while I was sitting on a funding panel for the National Endowment for the Arts, an application from one of the

UCLA filmmakers came through. When I looked in the folder for critiques and reviews of previous works, I was relieved to see a review I had written, noting accurately that this applicant's film was a singular achievement in American cinema. One of a dozen monkeys jumped off my back, no longer screaming "Do something!" Relief twisted sour when I saw that sheet was the only one in the folder. Why hadn't others taken the time to write reviews? The monkey jumped back into my head, screeching "Shouldadonemoooore!"

Around the same period, one day I was haunting the cubicles at UCLA where the film students were at work, researching a piece on Black women filmmakers for the *Black Collegian*. When I got to the station where Alile Sharon Larkin was working on *A Different Image*, she checked me, saying, "I'm not ready for you yet, Clyde." Not ready for *me*? The transition slowly dawned on me. In my mind I may have still been an eye-witness sending communiqués back from the front, where we all had stakes in a war to achieve vindication through visibility. But the camaraderie born of a shared venture had slowly shifted; I was also a "critic," a term I have always ditched in favor of "cultural historian." Sharon's gentle stiff-arm, an unexpected honor perhaps, was a sign of maturing structure in a movement trying to become institutionalized. Before and after, the filmmakers always charmed me with their openness and warmth compared to the cattiness of the Black literati. Black independent film gave me some of the best friendships I ever had. And except for being threatened with an ass kicking on one occasion, or on another being urged to "commit intellectual suicide"—both from UCLA cinéastes—Black independents were remarkable for their positive, supportive style, across the board.

Seeing me as a critic might ensure a filmmaker's identity as a film director for real. It was like the passage in Jean Genet's *The Balcony* where a character role playing in a brothel says, "My being a judge is conditioned on your being a thief." "Critics" of the kind that pored over Jean Renoir or Kurosawa were rare if not nonexistent for the upsurgent Black film movement, unaware of what they were missing. But in their absence, I later recognized, some directors, Africans among them, needed imagined scenes where some visible critic woefully misunderstood or neglected their finer artistic flourishes. And if I happened to be in the area, I would do nicely as a target for their verbal lances, just like a windmill walking into a Don Quixote phantasm.

When we look at later developments like the African Film Festival in New York, based at Lincoln Center, or New York's African Diaspora

FIGURE P.6. Production photograph, *A Different Image* (Dir. Alile Sharon Larkin, 1982). collection of Alile Sharon Larkin.

Film Festival, the Pan African Film Festival in Los Angeles, and dozens of other film series sprawled about the country, we can see that much of this was bound to happen. But a couple of these outcomes came about directly or indirectly from the spark of films from the L.A. Rebellion. In Washington, DC, David Nicholson started *Black Film Review,* which under the direction of Jacquie Jones continued to assert the reality of a Black film movement. An archive came later, and academic recognition, bibliographies, filmographies. (But a curious side note: Once, on a panel in Milan when I was being scolded by an African director because "you" don't show enough African films in the United States, I said and discovered as I spoke, that "we" were giving African films more exposure at festivals than US Black independent films.)

. . .

"That's it!" John Hanhardt, the broad-visioned director of the Film and Video Program at the Whitney Museum of American Art, said to the theme and title "L.A. Rebellion." This was one of several I had scratched out as possibilities for a series I was to curate showcasing Black

independent films. I flinched a bit and started backtracking against my own suggestion. Wasn't this title too snappy, almost commercial in the way Hollywood might market a project? Too much the lingo of *Variety?* As a one-time Angelino, I understood the distaste for the slangy "el ay" shorthand for Los Angeles. I knew well the danger of catchy historical labels like "the Harlem Renaissance," which gather the focus of an attention-deficit public while sapping the nuance and variety of a whole cultural period. As my master teacher Sterling Brown famously said, "It wasn't in Harlem, and it wasn't a renaissance." "The Black Arts movement" was another shortcut description whose verve *and* imprecision I had watched close-up. Was I like a tabloid journalist betraying his "sources" and material? I sweated out my choice, leaning toward duller titles. But Oscar Wilde was probably right: "An idea that is not dangerous is unworthy of being called an idea at all." Fortunately, I never heard accusations of betrayal from the two constituencies I did not want to let down: UCLA filmmakers themselves and the many committed independent film professionals from outside that circle. So, the tag stuck, as a handy ID for films and directors and a movement that was due to get some fragments of the success and celebration it deserves.

When I tried to put a written frame around what I was learning from the UCLA film artists and others, I was pushed to new understandings. Soon after the Whitney event, I was writing that the Rebellion films, along with other Black independents, offered the truest and most valuable on-screen representations of Black people ever fashioned in the United States. But how to explain: how and why was this true, then and now?

I think the Black film movement found it challenging to put into words what success would look like on the screen. I once wrote of a "realness dimension," hoping later to find a way to pin down this abstraction. "Authentic portrayals" as an ideal also has pitfalls, since as we know, authenticity can be faked, or overrated. "Positive images" invites uncritical acceptance of mediocrity and pandering.

For me now, the description that best fits the achieved success of the movement is the realization of *humanistic* or *humanized* representations. When I say humanist, I'm remembering another outbreak against the intellectual limits of its times that rose up in Europe in the 1400s and 1500s. Thinkers and artists calling themselves humanists affirmed the primary significance of human beings compared to the medieval church's view of people as just so much vermin on God's sleeves. These European reformers tried to liberate their worlds from the religious superstitions of the Dark Ages. The L.A. Rebellion affirmed the signifi-

cant humanity of its subject against the ethnic superstitions of Americanist movies.

Like the European humanists, the UCLA directors had cosmopolitan inspirations. The earlier movement was inspired by ancient Greek and Roman models. The UCLA rebels saw models in the wave of postcolonial, international directors like Tomás Gutiérrez Alea and Sara Gomez in Cuba, Ousmane Sembène and Souleymane Cissé in West Africa, Glauber Rocha and Nelson Pereira dos Santos of Brazil, Jean-Luc Godard in France, and the Italian neorealists. With the weapons of style and methodology they grabbed from this research, the UCLA filmmakers broke out of the orbit of cultural Americanism.

But the film art movement coming out of Westwood and South Central Los Angeles was not defined by a uniform style or method, like cubism or abstract expressionism. When I think of the UCLA body of work I am reminded of a display at an exhibition of African art at the Guggenheim in New York over a decade ago. Ten Ethiopian sculptures stood together, each about five feet high, each imposing its own majesty and charisma but lending its force to an aggregation of power not possible to each alone. We know that the UCLA film artists were *engaged*, they had something to prove. And their intellectual independence was married to stylistic insurgencies that are particular and refreshingly different from each other. In fact, many of their films are declarations of creative individuality—the best known of them are nearly all manifesto films.

The revolutionary intensity of these film artists gives their images the declarative insistence of manifestos, but at the same time, this intensity often gels into scenes of choreographed ritual. Broadly, these are rituals of dedication to truths untold but inscribed in the signature style of each director. Barbara McCullough's *Water Ritual #1: An Urban Rite of Purification* (1979) embraces ritual enactment comprehensively. But it also takes flesh in *Daughters of the Dust* in the kissing of Nana Peasant's "hand," or again in the call to action by the African horn in *Passing Through,* the symbolic transformations of *I & I: An African Allegory* (Dir. Ben Caldwell, 1979), the "Bitter Earth" scene in *Killer of Sheep* (Dir. Charles Burnett, 1977), and the group sledge-hammering of a television set in Gerima's *Child of Resistance*. We should not have expected that when the shadow of obscurantism was lifted from Black humanity there would be only one size fits all.

But the most powerful gain to be drawn from this work remains the spectacle of Black people in full flight as beings-for-themselves instead of fantasy-beings for-others. The fabulous cinematic liberation, brought

off with flair, is this refusal to answer the bell of Americanist expectations, these filmmakers releasing themselves of the burden of race, of the servile duties of otherness.

It is not simply that the films are made with Black viewers in mind instead of being tailored for a White gaze. The viewer of *Killer of Sheep* is not invited to view people under the sociological lens of Blackness as lack, with condescending pity, as in *Sounder* (Dir. Martin Ritt, 1972) or *The Autobiography of Miss Jane Pittman* (Dir. John Korty, 1974), but to spend sympathetic time with Black people in a narrative where the most significant meaning lies within *them, not* within the gaze of some idealized White observer, either inside or outside the text. Instead, the films suggest humans as individuals with intrinsic worth, with spiritualized connections to each other, and with potential, aspirational roles in history in the widest sense.

Funny things happen when actual Black people show up as masquerades of their spook image, as Ralph Ellison's *Invisible Man* demonstrates. Any Hollywood movie that grants some humanistic glimpse of Black Americans is, predictably, grossly misunderstood and usually dismissed. *Beloved* (Dir. Jonathan Demme, 1998) and *The Cotton Club* (Dir. Francis Ford Coppola, 1984) are two instances that come to mind. Hollywood producers routinely reject many Black-authored scripts because "there is no story," because the humanity of Black people expressing itself could not possibly be "story," or only weak story at best.

When humanized images are presented by Black *independents* in fuller, more concentrated doses, the disconnect becomes absurd. While making *Losing Ground* (1982), Kathy Collins lost the promised use of a neighbor's mansion who, after she read the script, refused cooperation, because "these are not anything like the Black people that I know." When Julie Dash took *Daughters of the Dust* to theater distributors, some rejected it as "a foreign movie." It took the high-art section of American film culture three decades to recognize *Killer of Sheep* not as a low-budget home movie but as a national heirloom. Only when you can accept the truth of this hidden humanity can you also see the beauty of the works. Quoting Oscar Wilde again: "When they say a work is grossly unintelligible, they mean that the artist has said or made a beautiful thing that is new."[8]

This wonderful project to celebrate, preserve, and archive this extraordinary cultural manifestation at UCLA, for which we owe gratitude to its dedicated organizers, is an atypical and rare event in our era

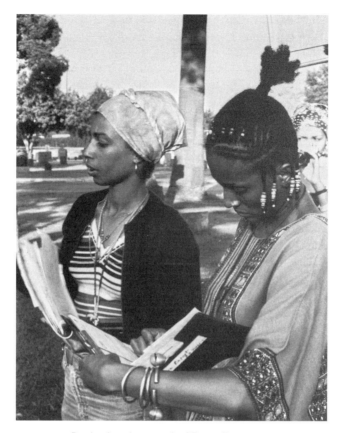

FIGURE P.7. Production photograph of Penny Bannerman (continuity) and Barbara O. Jones (assistant camera) on the set of *Passing Through* (Dir Larry Clark, 1977). Collection of Larry Clark.

of gilded banalities. More than allowing me to pay some dues, this rewind calls to mind some corrections to the Up from the Ghetto self-congratulation the US explanation industry bestows on "minority" cultural accomplishments. It was never ordained that these talented young people, and only they, could and would make the creative leaps that they did. For each of them, there were always handfuls of other young kids harboring sparks of genius that got ground down before they could even make it to a newly more open UCLA. And it is too easy to acknowledge the brilliance of the survivors and push aside the sodden, degraded national mental culture they had to slog through while growing their art, or to dismiss the lingering resistance to their gifts today, as well as to young people who come after them.

Those who might dismiss the preservation of these films as something like storing a time capsule are mistaken. These films are still radioactive in the present cultural landscape. It only took one black swan to disprove the myth that all swans were white. It only took one Black presidency to help us see that all the others were White presidencies. And it only takes one L.A. Rebellion to . . . I leave it to you to fill out the rest.

Yes, it was in Los Angeles. And, yes, it was a rebellion. May it never end.

NOTES

1. Teshome Gabriel, "Images of Black People in Cinema: A Historical Over-View," *Ufahamu: A Journal of African Studies* 6, no. 2 (1976): 133–67.

2. See the editors' introduction to the present volume for a full discussion of Elyseo Taylor.

3. Manthia Diawara, *African Cinema: New Forms of Aesthetics and Politics* (New York: Prestel, 2010).

4. Quoted in ibid. Regarding suspension points in this volume, bracketed ellipses in quoted material indicate omissions; those without brackets represent pauses in speech.

5. Amiri Baraka (as LeRoi Jones), *Black Magic: Sabotage, Target Study, Black Art; Collected Poetry, 1961–1967* (Indianapolis: Bobbs-Merrill, 1969). Unpublished, Van Peebles's play opened at Sacramento State College in 1970, then moved to Off-Broadway, and in October 1971 opened on Broadway (Ethel Barrymore Theatre).

6. Clyde Taylor, "New U.S. Black Cinema," *Jump Cut* 28 (April 1983): 41, 46–48, www.ejumpcut.org/archive/onlinessays/JC28folder/NewBlackCinema.html.

7. Ntongela Masilela, "The Los Angeles School of Black Filmmakers," in *Black American Cinema*, ed. Manthia Diawara (New York: Routledge, 1993), 107–17.

8. Oscar Wilde, *The Soul of Man*, in *The Complete Works of Oscar Wilde*, vol. 4, *Criticism: "Historical Criticism," "Intentions," "The Soul of Man"* (London: Oxford University Press, 2007), 251.

Acknowledgements

The L.A. Rebellion Project took shape in 2009 as a UCLA Film & Television Archive endeavor to find, recover, restore, preserve and catalog the films of the group of filmmakers who have come to be known as the L.A. Rebellion, funded by the Getty Foundation in connection with their *Pacific Standard Time: Art in L.A. 1945–1980* initiative. At first, we thought that the L.A. Rebellion comprised the work of about ten to twelve filmmakers. As our research progressed, however, we discovered over fifty filmmakers who were involved to various degrees with L.A. Rebellion filmmaking, along with over one hundred film titles. As the scope grew, the project expanded to cover five main components. First, we sought to locate both films and papers for collection and preservation at UCLA. Many of the films turned out to have been lost, suffered damage, faded, or survived only as video copies, so the preservation of any original material by making new negatives, digital files and prints was an immediate priority. Another priority was collecting the papers and surviving documents of Larry Clark, Julie Dash, Jamaa Fanaka, Alile Sharon Larkin, Barbara McCullough, and others, which are now housed at UCLA Library Special Collections. This was one of the first projects in the history of the UCLA Film & Television Archive to involve every staff member, and we thank each of them for their enthusiastic and exceptional work throughout this massive undertaking. In addition to striking new prints for circulation, the UCLA Film & Television Archive launched a comprehensive website for broader community

access and for students, researchers, and enthusiasts (www.cinema. ucla.edu/la-rebellion). The website has dedicated pages to the filmmakers, full filmographies, an interactive timeline, and information about accessing archival materials. It also has a section for the Project One films (the first films made by students at UCLA); these can be streamed in their entirety directly from the website. The website was created by Kelly Graml, Kevin Crust, and Jennifer Rhee, and content was provided by the curators and students in Allyson Nadia Field's graduate seminar on the L.A. Rebellion in the fall of 2011.

The second component was the recording of oral histories with filmmakers and "fellow travelers," people who were at UCLA at the same time and taught or worked with the L.A. Rebellion filmmakers. These oral histories, selections from which are included in this volume, have provided invaluable background for thinking about the social, political and personal factors that shaped these artists and their work. The oral histories were conducted by the curators and videotaped by Robyn Charles, and are archived in their entirety at UCLA. A number of graduate students provided invaluable research assistance, credit transcription, oral history transcription, and the inventory of papers. We are grateful to Tony Best, Michael Bright, Yasmin Damshenas, Michelle Geary, Jane'a Johnson, Michael Kmet, Kelly Lake, Nina Lavelanet, Kevin McMahon, Diamond McNeil, Samuel Prime, Samantha Sheppard, and Maya Smukler.

The third part of the L.A. Rebellion Project was a three-month long film exhibition "L.A. Rebellion. Creating a New Black Cinema" held at UCLA's Billy Wilder Theater (and which has subsequently traveled nationally and internationally). Curated by the editors of this volume and Shannon Kelley, Head of Public Programs for the UCLA Film & Television Archive, the series consisted of approximately 40 titles in 20 public programs that ran from October to December 2011. Screenings were accompanied by panel discussions featuring many filmmakers in person. The series was part of the Getty Foundation-funded exhibition *Pacific Standard Time: Art in L.A. 1945–1980*, and was co-funded by the Andy Warhol Foundation for the Visual Arts, the National Endowment for the Arts, the Academy of Motion Picture Arts and Sciences, and the California Council for the Humanities. Support for the series was provided by UCLA staffers Paul Malcolm, Nina Rao, Tamara Keough, Adam Ginsburg, Todd Weiner, Steven Hill, Rosa Gaiarsa, and Bryce Lowe. Preservation work at the Archive was handle by Ross Lipman, Jere Guldin, the late Nancy Meisel, and Randy Yantek. Abridged

versions of this L.A. Rebellion program have since toured the U.S. and have begun to be screened internationally, and we are deeply grateful to the curators, institutions and audiences that are keeping this important work alive by sponsoring and attending screenings.

The fourth component was an academic conference. On November 12, 2011, UCLA held a one-day symposium on the L.A. Rebellion, organized by Allyson Nadia Field and Jacqueline Najuma Stewart. As the scholarly corollary to the film series, the symposium gathered film-makers, pioneer critics, and emerging scholars to contextualize, assess, and reflect on the rich and diverse work of the L.A. Rebellion. The symposium was organized into two panels—Black Film and Social Change: Representing Black Culture, Politics, and Labor Before and During the L.A. Rebellion; and Creating Black Film Style: Black Arts, Music, and L.A. Rebellion Aesthetics—and a roundtable on The L.A. Rebellion: Then and Now. Much of the work that appears in this book emerged from the symposium. We thank the participants for their engagement: Keynote speaker Clyde Taylor (NYU Emeritus, who coined the name "L.A. Rebellion"), Jan-Christopher Horak (UCLA Film & Television Archive), Ed Guerrero (NYU), David James (USC), Chuck Kleinhans (Northwestern University Emeritus /*Jump Cut*), Michael T. Martin (Indiana University), Samantha Sheppard (UCLA), Cauleen Smith (film-maker, UCLA alum), Monona Wali (filmmaker, UCLA alum), Daniel Widener (UCSD), Morgan Woolsey (UCLA). The symposium was sponsored by Dean Teri Schwartz of UCLA's School of Theater, Film and Television, Dean Barbara O'Keefe of Northwestern University's School of Communication, and the UCLA Film & Television Archive. Additional support at UCLA was provided by the Department of Film, Television & Digital Media; Moving Image Archive Studies; the Center for the Study of Women; Elevate; and the Ralph J. Bunche Center for African American Studies. Samantha Sheppard was a masterful symposium coordinator.

This scholarly volume is the capstone of the multi-year L.A. Rebellion Project. It is intended to be the sourcebook on the films and film-makers of the L.A. Rebellion, available for use by teachers, filmmakers, researchers, and enthusiasts alike. In addition to the contributors, we wish to thank the following students who worked on the filmography, compiling information from often-scant sources: Meenasarani Linde Murugan, Leigh Goldstein, Mikki Kresbach, and Sabrina Negri. Mark Quigley provided immeasurable research support for the book and the project as a whole. We are grateful to the following individuals for

granting permission to reproduce images: Ben Caldwell, Larry Clark, Julie Dash, Zeinabu irene Davis, Preston J. Edwards, Sr., Barend van Herpe, Alile Sharon Larkin, Twyla Gordon-Louis, Joey Molina, Renate Taylor, Cauleen Smith, Third World Newsreel, and the Charles E. Young Research Library, UCLA. The publication of a book is invariably aided by many individuals. We thank Dean Martha Roth, Division of the Humanities, University of Chicago, for generous support towards the illustrations. Daniel Langford provided exceptional assistance in the preparation of the manuscript. From very early on, Mary Francis at the University of California Press was enthusiastic and supportive of this project; we are most grateful to her. We also want to thank Kim Hogeland, Bradley Depew, and Rachel Berchten at the Press for their patience and attention to detail in dealing with the book's many moving parts.

In conjunction with this book, UCLA Film & Television Archive will release a DVD teaching set of the L.A. Rebellion within months of the publication of this volume. Funded by the National Endowment for the Arts, the L.A. Rebellion DVD will be distributed free of charge to teaching institutions only.

Finally, this project would never have been possible without the support of the filmmakers and their families. We have been awed by their talent, inspired by their passion, moved by their resilience, and humbled by their generosity. We cannot thank them enough. We also wish to remember the filmmakers who are no longer with us, and we hope this book serves as a testament to their legacy: Anita Addison, Melvonna Ballenger, Jamaa Fanaka, Akintunde Ogunleye.

This book is dedicated to Elyseo Talyor and Teshome Gabriel, teachers and mentors whose impact on the filmmakers of the L.A. Rebellion lives in their films and throughout these pages.

Emancipating the Image

The L.A. Rebellion of Black Filmmakers

ALLYSON NADIA FIELD, JAN-CHRISTOPHER HORAK, AND JACQUELINE NAJUMA STEWART

What was interesting to me were the subliminal aspects
of cinema; I started getting interested in the whole idea of
how film was really a ritual and a spell. I've noticed that a lot
of subliminal images were threaded throughout films in the
history of filmmaking and all those things were to the demise
of my culture. So I felt we had to work against that kind
of symbology and we had to change the ritual. So that's why
I ended up on that road of really seeing filmmaking as a way
of emancipating the image.

—Ben Caldwell

The group of Black filmmakers that have come to be known as the L.A.
Rebellion created a watershed body of work that strives to perform the
revolutionary act of humanizing Black people on screen. The filmmakers
in this group met as students in film school at the University of California,
Los Angeles, between the late 1960s and the mid-1980s. Many members
are still active as media makers, teachers, and activists. This first group of
film school–trained Black filmmakers shared a desire to create an alterna-
tive—in narrative, style, and practice—to the dominant American mode of
cinema, an unwelcoming and virtually impenetrable space for minority
filmmakers that routinely displayed insensitivity, ignorance, and defama-
tion in its onscreen depictions of people of color. Ben Caldwell's descrip-
tion of the group's efforts to "emancipate the image" in the epigraph
above places these artists firmly within Black radical traditions dating

back to resistance against slavery. At the same time, Caldwell's phrase captures the vanguard status of these artists, whose experimentations with film form broke from earlier generations of Black filmmaking to interrogate on deeper levels how moving images construct notions of race, class, and gender, particularly for Black viewers.

The L.A. Rebellion filmmakers worked with a common purpose to create a new Black cinema characterized by innovative, meaningful reflection on past and present lives and the concerns of Black communities in the United States and across the African diaspora. But the artists pursued this goal in substantially different ways. As with many artistic movements named by critics and historians, "L.A. Rebellion" was not coined by members of this group, nor has it been used and embraced by all of them. Individually, the artists represent widely diverse origins, experiences, and points of view. Caldwell's movements between "I" and "we" in his articulation of his/their artistic goals reflects the productive tension we see in the L.A. Rebellion group: they evince individual (we might even say auteurist) artistic visions, while together they make gestures toward developing a collective creative "movement" that charts a different course in Black cinematic expression.

It is in this spirit of creative friction that we have chosen to use the term Clyde Taylor devised, "L.A. Rebellion," in the title of this book. The group has been called by other names: Ntongela Masilela refers to them as the "Los Angeles School of Black Filmmakers"[1]; Toni Cade Bambara describes them as "the Black insurgents at UCLA"; and in this volume, Michael T. Martin explains his preference for "L.A. Collective." For us, the label "L.A. Rebellion" reflects the assemblage of these artists at a particular, politically charged place and time in which they attempted to speak truth to power—to address institutional racism as manifested at UCLA and in the dominant film industry headquartered in Los Angeles. We use "L.A. Rebellion" not as a simple descriptor but as a problematic that points to many complex factors shaping Black filmmaking and historiography: tensions between individual and collective goals and actions; between claiming a defiant racial specificity and acknowledging the many influences that inform the creation of "Black" cinema; and, as Clyde Taylor discusses in the preface, between the nuances lost in superficial branding and the overdue attention that a "handy ID" can bring to marginalized cultural practices.

"L.A. Rebellion" signals that the filmmakers were working *against* something. But we might also ask what were they rebelling *for?* Most obviously, many in the group saw Hollywood's representational

hegemony as mass entertainment as a dangerous culprit in perpetuating cultural misunderstandings and, as Barbara McCullough states, the group was interested in "having another image out there" besides the one produced by Hollywood.[2] To create "another image" they developed unconventional formal and thematic strategies to perform implicit critiques of Hollywood, and some took up Hollywood's racism directly as subject matter (e.g., Julie Dash's *Illusions* [1982] and Ben Caldwell's *For Whose Entertainment* [1979]). In this project of resistance and self-determination, their filmmaking practices were inspired by Third Cinema practitioners in Latin America and Africa. As elaborated later in this introduction, Third Cinema provided a model of activist filmmaking that posited film as a medium that can bring about meaningful change in the minds and lives of its audiences. To varying degrees, the L.A. Rebellion artists identified as Third World filmmakers, rebelling for their right to an expanded identity as politicized artists of color with affinities beyond U.S. borders, and interests beyond mere entertainment, with its dangerous capacity to place "a spell" over viewers (as Ben Caldwell puts it), blocking spiritual, intellectual, and political progress.[3]

The L.A. Rebellion was in dialogue with "new" cinemas that emerged not just in the Third World (e.g., Brazil's Cinema Novo) but also in the United States and Europe during the 1960s and 1970s. They developed their craft as the "classical Hollywood cinema" was facing multiple challenges as the dominant industrial model (with the breakup of vertically integrated studios) and the primary entertainment medium (with the rise of television), opening up spaces for protest from emerging filmmakers around the world who were radicalized to varying degrees by the activist and liberation movements of the period. Like the New American Cinema of Jonas Mekas, John Cassavetes, and Shirley Clarke; the New Hollywood Cinema of Francis Ford Coppola, Robert Altman, and Martin Scorsese; the French New Wave; and the New German Cinema, the L.A. Rebellion was rebelling for ways to make and circulate films free of the restrictions that the filmmakers believed made commercial, "official" cinemas corrupt and conservative in style and politics, such as manipulative narrative conventions, high budgets, censorship, and prohibitive distribution and exhibition systems.[4]

The creation of a "new" Black cinema also involved remaking previous conceptions of "Black cinema." As Jan-Christopher Horak outlines in his contribution to this volume, the L.A. Rebellion filmmakers sought to create alternatives to the lucrative "Blaxploitation" films released during the early 1970s, with their lurid emphases on sex and violence.

The L.A. Rebellion was also breaking from earlier generations of Black filmmaking. The filmmakers were exposed to the works of Black filmmaker Oscar Micheaux, the leading figure of the "race film" movement of the 1910s–1940s, a period in which Jim Crow segregation created the conditions for a separate sphere of Black-cast films serving Black audiences. While the extremely low budgets of race movies generated some striking deviations from Hollywood fare, generally they followed the generic and stylistic models of mainstream movies, employing familiar conventions from melodramas, westerns, musicals, gangster films, and so on. The L.A. Rebellion filmmakers were (and are) far more experimental in their approaches to plot, setting, and character construction, drawing not just on a wider range of cinematic models (prominently including Third Cinema, British documentary, and Italian neorealism) but also on a range of Black diasporic aesthetic models (such as jazz, blues, griot storytelling, and Black literature). The new Black cinema they envisioned was shaped by the new Black identities forged in the wake of the civil rights movement. Developing their craft contemporaneously with the Black Arts movement, the L.A. Rebellion artists moved away from aesthetic strategies that they felt reflected assimilationism and aspirations to enter the middle class (as we might argue of many race movies). They instead spent time elaborating distinct elements of Black culture and exploring the lifeworlds of Black working-class and poor people. L.A. Rebellion films present the economic status of their subjects as the result of structural oppression, not simply something to overcome and not as a cultural deficit.

The L.A. Rebellion was rebelling for a Black-oriented cinema more firmly grounded in Black aesthetic traditions and less dependent on white models. The mentorship that the filmmakers received from an older generation of Black artists who had worked in Hollywood—including Ivan Dixon, Clarence Muse, Carlton Moss, and Frances Williams—suggests that they did not simply reject their Black cinematic predecessors, but learned from their achievements and obstacles as they crafted new ways to use the medium to express Black identity.

Despite the many key connections and interventions that we find in the L.A. Rebellion's history and works, scholarly attention to this turning point in American cinema culture has been surprisingly and unduly slight. This is in large measure because only a fraction of L.A. Rebellion films have been available for viewing. In 2009, the UCLA Film & Television Archive began a major collection, preservation, and exhibition endeavor to expand our understanding and appreciation of these films

and filmmakers. As part of the Pacific Standard Time project of the Getty Foundation, the archive's work to document the L.A. Rebellion places the movement within the flowering of innovative postwar art-making in Southern California.[5] The UCLA Film & Television Archive now houses a substantial collection of L.A. Rebellion films, and UCLA Library's Performing Arts Special Collections holds related archival materials (filmmakers' personal papers, posters, festival catalogs, production stills). These materials, including a DVD box set to be released in 2015, as well as oral histories conducted by the editors of this volume, make possible new and deeper scholarship on the L.A. Rebellion.

This volume is the first extended, book-length study of the L.A. Rebellion and constitutes a comprehensive and inclusive account of the films and filmmakers that comprise this cinema "movement." The essays offer new critical frameworks for understanding the significance of the films and filmmakers of the L.A. Rebellion, contextualize their work in relation to contemporary filmmaking, and historicize their endeavors. In this introduction, we outline the conditions by which these filmmakers came to UCLA, the kinds of filmmaking they produced, the circulation of their work, and our recent preservation efforts to ensure that their films remain available for future scholars and enthusiasts as well as new generations of audiences to come.

That this project began at UCLA is a fitting homecoming for the filmmakers associated with the L.A. Rebellion—not all of whom received the recognition they deserved from the school at the time. Their student filmmaking is a product of their environment at UCLA and the ways in which the campus focalized the broader cultural and political climate of the time. The reforms and investments of the mid- to late 1960s created opportunities for increasing numbers of Black students to attend elite institutions like UCLA while also providing a critical framework for social critique and the role of media in engaged civic discourse. Understanding the conditions that were in place at UCLA—as a highly selective and a public university—provides the necessary context for understanding how a movement like the L.A. Rebellion could have been possible. It also demonstrates the creative possibilities that can be achieved through a commitment to greater diversity in student bodies. In an era of increasing cuts to public education and the decreasing accessibility of higher education for the poor and working class, the L.A. Rebellion stands as a reminder of the tremendous possibilities that can occur with greater access to public higher education and of the importance of students taking an active role in shaping their own education.

UCLA AS TRAINING GROUND

When Clyde Taylor dubbed this group the "L.A. Rebellion," he surely had the Watts Rebellion of 1965 in mind.[6] It was the frustration and devastation signaled by the five days of violence and destruction in Watts that called Elyseo Taylor to the area when he moved to Los Angeles upon returning to the United States from Europe. Taylor's community work in the wake of the violence eventually led him to UCLA, where he coordinated the early initiatives to recruit and train students of color in media production that led to the extraordinary body of work to which this volume is dedicated.

The first Black faculty member in UCLA's film school, Elyseo Taylor had been a major in the U.S. Army and served in an antitank battalion during World War II. He returned home to Chicago after the war and later returned to Europe, where he studied economics, philosophy, German, French, and Italian at the Universities of Heidelberg, Grenoble, and elsewhere and married Renate Drescher, a German professional photographer, in Geneva. Taylor had a strong amateur interest in photography. A voracious reader with broad intellectual interests across the humanities and social sciences, his background in economics (which he had studied briefly as an undergraduate in his home town at the University of Chicago) and an interest in international affairs, particularly African culture and politics, landed Taylor a position with the Switzerland-based Basel Center for Economic and Financial Questions, under whose auspices he made his first visit to Africa in the late 1950s. Upon settling in L.A. in the fall of 1965, where he began working as a freelance photojournalist and cameraman, Taylor visited Watts frequently, taking his still camera and his Bolex film camera to teach neighborhood youth how to document their own communities.

Taylor worked with artists and activists affiliated with the Mafundi Institute and Watts Happening Café, two key centers of creative expression among many that were operating in the wake of the Watts Rebellion. In these contexts, Taylor's filmmaking workshops were conducted alongside programs seeking to cultivate other Black Arts—including writing, music, dance, and theater—efforts explicitly tied to goals of using art as a tool for raising political consciousness and affecting social change.[7] Taylor wrote, "When I began teaching filmmaking in Watts shortly after the insurrection [. . .] my idea was that art, including film, was a means by which a people could engage in a dialogue with itself. Up until then, and especially with regards to motion picture and tele-

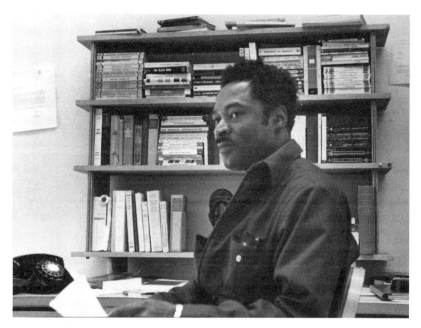

FIGURE I.1. Elyseo Taylor in his UCLA office. Collection of Elseo Taylor, courtesy of Renate Taylor.

vision, the minority groups had been ease-dropping [sic] in on the dialogue of the white community. [. . .] In making their own films, the people would [. . .] be able to become acquainted with themselves as a community. They could look into all of its parts, learn the needs, discover the dreams, search for solutions to common problems."[8]

Taylor's media education efforts with young people in Watts came to the attention of Colin Young, chair of the Department of Theater Arts at UCLA. Young recruited Taylor to teach at UCLA and they worked together on a committee appointed by Vice Chancellor Paul O. Proehl to "consider the role of UCLA in translating its interest, knowledge, and activities relating to the urban crisis and the special needs of ethnic minorities into radio and television programming, particularly for educational purposes on a mass basis."[9] This committee came to be known as the Media Urban Crisis Committee (MUCC). Various UCLA faculty and administrators had been developing strategies to address inequalities in higher education at least since the early 1960s, creating programs to cultivate talented minority high school students and help them succeed at UCLA. After the conflagrations in Watts in summer 1965, there was a sense of increased urgency to bring the resources of the university

to bear on what was happening in the ethnic neighborhoods of Los Angeles, to better fulfill its mandate to serve the city's population with equity and as an engaged citizen.

A university-wide committee was formed in 1968, chaired by an African American administrator, Assistant Vice Chancellor Charles Z. Wilson, to consider issues of "Student Entry, Curricular Development, and Urban Involvement," and several initiatives (High Potential Students, Upward Bound, Educational Opportunity Program) were placed under a "Special Educational Programs" umbrella. UCLA chancellor Charles E. Young described to the Academic Senate his "efforts to identify and recruit faculty from minority groups" at a moment when, as Wilson recalls, "UCLA had fewer than 10 tenured black faculty members on the entire campus."[10] But Wilson also recalls that efforts toward "expediting creative responses to legitimate issues that poor and disadvantaged minority students had raised" faced major opposition from "conservative" forces—some administrators, regents, Governor Ronald Reagan—such that "funding for the urban crisis agenda of the president never fully got off the ground."[11]

Like many units at UCLA, the film school was a target of student protest for its lack of diversity. UCLA was a hotbed of student activism of all sorts and was a particularly charged environment for students of color, especially during the years just after Taylor's arrival. In January 1969, conflicts between students affiliated with the Black Panthers and the US Organization resulted in the fatal shooting of Alprentice "Bunchy" Carter and John J. Huggins Jr. during a Black Student Union meeting in Campbell Hall. Later that year, philosophy assistant professor Angela Davis was fired from the university on the grounds that she was a member of the Communist Party; after regaining her position, the next year she was fired again for engaging in "inflammatory" speech (e.g., calling police "pigs"). She and her supporters maintained that her dismissal was based on objections to her work in the Black liberation struggle.

It was in this heightened political climate that Elyseo Taylor became founding director of a program called Media Urban Crisis (MUC), which grew out of the ad hoc Media Urban Crisis Committee mentioned above. Prior to the MUC Program, UCLA instructor Peter A. Schnitzler had been teaching filmmaking to Black and Chicano high school and junior college students in Venice, Pacoima, and the San Fernando Valley through the University Extension Media Center, with minority graduate students in theater arts serving as teaching assist-

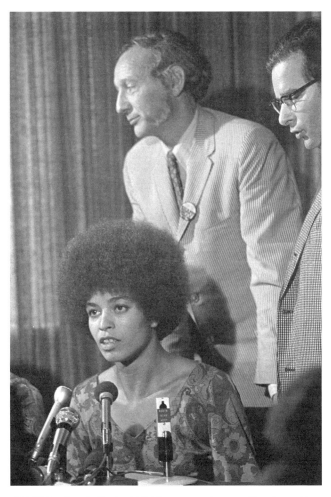

FIGURE I.2. Angela Davis at UCLA press conference. Courtesy of Los Angeles Times Photographic Archive, Library Special Collections, Charles E. Young Research Library, UCLA.

ants.[12] The MUC Program, which won a $17,200 grant from the Ford Foundation, was designed to train Black, Chicano, Asian, and Native American students at UCLA to use mass communication technologies to document their own communities and thereby increase understanding of and a sense of cultural participation for marginalized groups.[13] Recruitment of these students into the department's MP/TV (motion picture/television) division dramatically increased its minority population. Taylor reports that "until then, of the some 400 registered

students in the MP/TV Div. of the Dept. of Theater Arts, there were only two from the ethnic minority, one Mexican-American and one Afro-American."[14]

Students and faculty involved in developing the MUC Program were very enthusiastic about the possibilities for recruiting students of color, creating educational programming for minority audiences, and enhancing UCLA's curricula in communications. A story in the *Los Angeles Times* celebrated the program's first semester in January 1970, in which "UCLA graduate and undergraduate students will be taking part in a project aimed at throwing light on life in the ghetto and perhaps broadcasting that light to others."[15] But the program also faced challenges, particularly when its work began to extend beyond the committee's primary charge of developing ideas about educational programming (as UCLA administrators considered the purchase of land and equipment to activate two television channels) and toward a very expansive interpretation of the charge to review the university's "needs in terms of research and development aspects of communications as they relate to present curricula and departments."[16]

Colin Young and Elyseo Taylor not only developed an intensive media production curriculum oriented to students of color but also attempted to enroll and fund students to levels beyond those initially approved by administrators.[17] The two men seem to have taken the MUC Committee charge as an opportunity to support and expand the production "training program" they had already started developing in theater arts for "the Ethnic Minorities."[18] In response to a Theater Arts Department proposal to form an "ethno-communications" program (apparently a reformulation of the MUC Program), Charles Z. Wilson wrote a letter to Vice Chancellor David S. Saxton outlining a litany of irregularities and objections. In the letter, Wilson questions how the program will secure resources for supplying underresourced students with film supplies and equipment, and he rejects the department's plans to "initiate appointments of faculty on a temporary basis without the chairman of the department and the dean of the college stating very clearly how they intend to come up with permanent FTE's." Regarding student recruitment, he writes, "There appears to be a preoccupation with ethnic participation; some students do not want white students to be a part of the program at all. I indicated to Colin [Young] that under no circumstances could we allow deliberate exclusion of white students."[19] At the same time, students and faculty representing UCLA's ethnic centers (Afro-American Center, Asian-American Center, Ameri-

can Indian Project, Mexican-American Cultural Center) complained that the Media/Urban Crisis Committee was not doing enough, and that the "curriculum [had] become a step-child within the Theatre Arts Department—unwanted, neglected, and exploited."[20]

Taylor worked to develop a program of study in which students of color were trained "to utilize film as a tool in community development" and to "conduct studies into the type of films these communities wanted and into how these films would have to be made."[21] This was a challenging enterprise, for predictable reasons. This early group of students of color were not fully "integrated" into the film school—they stood apart as a separate group. They had a separate stream of funding (Ford Foundation) and set of equipment purchased for their use (which some other students perceived as superior to the department's regular equipment). Like so many others on the front lines of desegregation, the sheer presence of these students created discomfort for white students and faculty. And many of these students were not simply silent symbols of change—they voiced their concerns in person, and in their work.

As the faculty member "responsible" for recruiting and mentoring students from underrepresented groups, Taylor was in an embattled position. Yet he used this position to educate students, and the department as a whole, about what he believed were the political possibilities of cinema, in keeping with the Black Arts philosophies and practices found in the Watts creative organizations. Charles Burnett, who was Taylor's TA, has recalled in several interviews that he brought African filmmakers to the UCLA campus, hosting screenings and discussions that enabled students to connect this emerging cinema with their own struggles as U.S. "minorities." Taylor also created the course "Film and Social Change" in which he screened works by emerging African and Latin American filmmakers.

Students remember Taylor's presence as a tough and commanding one, what we might expect of an army major. Billy Woodberry recalls being questioned rather harshly by Taylor when inquiring about admission to the program; Larry Clark recalls students referring to him as "Papa Doc."[22] While Taylor's presence was critical for many of the Black students he recruited, his position was not stable within the department. Not long after Colin Young's chairmanship ended, Taylor's case for tenure was denied, and he left both the university and Los Angeles. Ben Caldwell memorializes the angry student response to Taylor's firing, "for racist reasons," in the closing credit of his thesis film *I & I: An African Allegory* (1979).

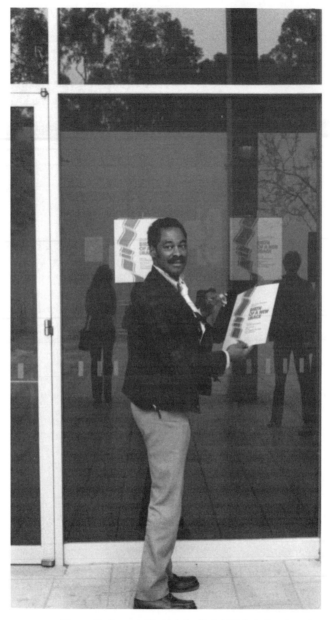

FIGURE I.3. Elyseo Taylor outside Melnitz Hall, UCLA. Collection of Elseo Taylor, courtesy of Renate Taylor.

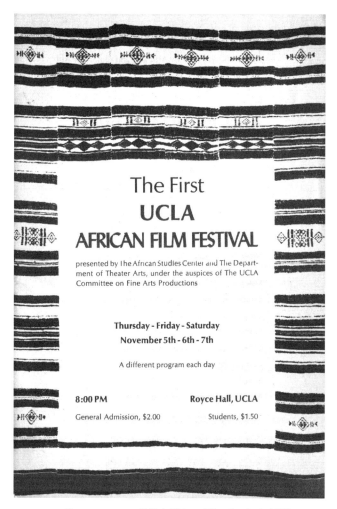

FIGURE I.4. Program cover, UCLA African Film Festival, 1970.

Taylor's presence in UCLA's film school lives on in the continuation of the "Film and Social Change" course he created, which was taught by his successor, renowned Third World film theorist Teshome Gabriel, who had been a graduate student at UCLA and was hired to replace Taylor. Gabriel taught "Film and Social Change" until his untimely death in June 2010, and the course continues to be an important part of the department's curriculum. Despite their striking methodological and pedagogical differences (the gracious, understated Gabriel would never be compared to Papa Doc Duvalier), Gabriel picked up Taylor's mantle

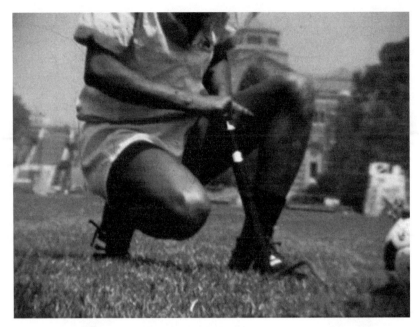

FIGURE I.5. *Analogy* (Dir. Teshome Gabriel, 1972).

by recruiting and mentoring students of color at UCLA, teaching and debating issues of film history and theory, and inspiring them in an ongoing exploration of the relationships between cinema, identity, history, and politics.

Taylor and Gabriel brought international films to UCLA, and "Film and Social Change" taught students to think of filmmaking as a social practice. The presence of Taylor and then Gabriel on the faculty significantly contributed to an environment in which students of color felt they could find a place for themselves. While the concentration of talented students of color at UCLA in the 1970s and early 1980s was due in part to several educational opportunity programs that targeted minority applicants (e.g., the MUC Ethno-Communications Program), not all Black students were admitted under such aegises. They came from all across the country and from different socioeconomic backgrounds, with varied educational and life experiences prior to enrolling at UCLA. Though students, most of them were adults and many were parents. Nearly all had worked before coming (back) to school. This made them a more mature group than we might imagine when we say "film school student," and their commitment to filmmaking was bol-

stered by and weighted against family concerns, economic pressures, and their experiences in the "real world" prior to entering UCLA.

L.A. REBELLION: THE FILMMAKERS

The backgrounds and stories of the individuals who collectively comprise the L.A. Rebellion demonstrate the synergy of creative voices that we now recognize as a "movement" catalyzed by the opportunities afforded by UCLA at a particular moment. The early cohort of Black students achieved a critical mass in the film school in the early 1970s. Considered the first L.A. Rebellion filmmaker to arrive at UCLA, Charles Burnett came to the film program from L.A. Community College in 1967 and eventually became a TA for the Ethno-Communications Program. Burnett was born in Vicksburg, Mississippi, but moved to Los Angeles as a toddler, first living in East Los Angeles before settling in South Central.[23] Larry Clark arrived at UCLA in 1970. Born in Cleveland, Ohio, Clark moved to Los Angeles as an adolescent. After graduating from Miami University of Ohio, where he had been president of the Black Student Union, Clark visited UCLA thinking he would enter the Afro-American Studies Program but was encouraged to apply to the new Ethno-Communications Program after meeting Elyseo Taylor. One of a handful of Africans associated with the L.A. Rebellion,[24] Haile Gerima was born in Gondar, Ethiopia, to a storytelling family (his father was a well-known historian and playwright). He arrived in Chicago in 1967 to attend drama school and then met Teshome Gabriel in Maine while teaching Amharic to Peace Corps volunteers. He was inspired to move to UCLA's Theater Department, where he won the prestigious Hugh O'Brian Acting Award. The following year, in 1971, he transferred to the Film Department with the encouragement of Larry Clark.[25] In turn, Gerima convinced fellow Ethiopian Abdosh Abdulhafiz to apply to the film program. Abdulhafiz spent three years in Berkeley studying with Albert Johnson before returning to UCLA. After graduation he was hired in the school's tech office, where he still works.[26]

Also part of this early cohort, Jamaa Fanaka was born Walter Gordon in Jackson, Mississippi, and moved with his family to Compton at age twelve. Fanaka served in the Air Force and then came to UCLA's film school in 1971 after taking the necessary prerequisites at Compton Community College.[27] The year after Fanaka arrived, Texan Billy Woodberry came to UCLA via Cal State L.A. at the encouragement of Mario DeSilva, a Brazilian graduate student who worked closely with

Burnett and Gerima; the latter introduced Woodberry to Taylor.[28] Originally from New Mexico, Ben Caldwell entered UCLA after the first affirmative action initiative as part of the "regular" program, though he recalls that "it was still very Ethno" working with Elyseo Taylor and with Haile Gerima, who was the TA for Caldwell's "Project One," the program's first production exercise.[29] (Allyson Nadia Field discusses the Project One films in her essay in this collection.)

Other students came to UCLA as undergraduates before entering the film school. Bernard Nicolas was born in Haiti and moved to San Pedro, California, at age eleven. As an undergraduate, he was involved in the Black Student Union and the organization of a national Black student group. Nicolas dropped out to become a "full-time revolutionary" and visited China with the National Association of Black Students. He returned to Los Angeles, finished a degree in economics, and then started graduate school in Latin American studies. He had taken Taylor's "Film and Social Change" course in his last quarter as an undergraduate and got to know the Black students in the film program. With the encouragement of Barbara McCullough in particular, he eventually shifted from Latin American studies to the film program, after taking a yearlong "Ethnographic Film" course.[30] Don Amis came to UCLA as part of the High Potential Program in 1969 and took a cinematography class in his second year, which inspired him to apply to the film program. Born in Philadelphia, Amis dropped out of high school to join the air force. He then completed his GED before moving to Los Angeles to work with a nonprofit called Operation Bootstrap, designed to help people develop work-related skills.[31] Robert Wheaton also came to UCLA as an undergraduate, entering directly into the film program from L.A. Community College in 1981. He was the only African American in his cohort but made friends with the graduate students who came the same year, including S. Torriano Berry and Ruby Bell-Gam.[32] Originally from Meridian, Mississippi, Wheaton moved to Los Angeles with his family when he was two. His father was a doctor, his mother a teacher, and he attended Palisades High School in the affluent neighborhood of Pacific Palisades. At the same time there were a few students of color in the graduate animation program, including Valencia Sinclair and Carlos Spivey.

After a first wave of predominantly male students, more African American women were admitted to the MFA program. Some of these women have speculated that the Black men of the first wave were quite intimidating to the predominantly white faculty. Whatever the case, the work these women created at UCLA continued with formal and political

FIGURE I.6. Alile Sharon Larkin, Stormé Bright Sweet, Melvonna Ballenger, Julie Dash, c. 1973. Collection of Julie Dash.

radicalism and experimentation. Originally from Chicago, O.Funmilayo Makarah moved to Los Angeles in 1974 and began working in UCLA's Graduate Advancement Program (GAP) office, covering for someone on maternity leave.[33] Through the GAP office, she met Woodberry, Caldwell, and other film students who encouraged her to apply to the graduate program, where she was in the same Project One class with Alile Sharon Larkin and Julie Dash in 1975.

Larkin was born in Chicago but moved to Pasadena before she was two years old. She graduated from the University of Southern California, where she studied journalism, photojournalism, and creative writing, and then she came to UCLA for a master's in film.[34] Dash grew up in the Queensbridge Housing Projects in Long Island with her South Carolinian parents. In high school she participated in a College Discovery Program and did an afterschool cinematography workshop at the Studio Museum of Harlem. While studying at City College she saw a flyer at the Studio Museum about Black filmmakers at UCLA: Larry Clark, Haile Gerima, and Charles Burnett. She applied to UCLA but did not have her paperwork in order to be admitted that year, so she went to the American Film Institute (AFI), graduating in 1974, after which she was admitted to UCLA's master's program.[35] Makarah herself

moved to Europe in 1979 before returning to UCLA in 1989 to complete her MFA. The gap in her time at UCLA meant that she became a part of two different cohorts, overlapping with the earlier group as well as later filmmakers like Zeinabu irene Davis.[36] Encouraged to apply by Yreina Cervantez, Makarah received a grant from the Women's Building, given to a woman artist to do a project on another woman artist. Makarah's project was on her classmate, *Creating a Different Image: Portrait of Alile Sharon Larkin* (1989). Makarah shot on video, a medium she and other students began exploring in the 1980s, connecting them with women's videomaking taking place across the country.

Barbara McCullough was born in New Orleans and moved to Los Angeles when she was eleven. Because her father was a blind veteran, scholarship opportunities enabled her to attend private school. Then, after taking courses at Cal State L.A. and L.A. Community College, she came to UCLA through an undergraduate affirmative action program.[37] Carroll Parrott Blue, from Houston, received her undergraduate degree from Boston University and moved to Los Angeles in May 1965, where she began doing photography. She got to know the Asian American film students who were a part of the Visual Communications Program (Robert Nakamura, Alan Kondo, Alan Ohashi, Eddie Wong) and entered UCLA the same year as McCullough. Nakamura introduced Blue to film school professor Richard Hawkins, and he encouraged her to apply; she began the master's program in 1976.[38] McCullough and Blue were also classmates with Melvonna Ballenger. From St. Louis, Missouri, Ballenger graduated from Howard University with a bachelor's in communications and entered UCLA's master's program in film in 1978.

Less well-known women filmmakers at UCLA at this time include Stormé Bright Sweet, Jacqueline Frazier, and Gay Abel-Bey. Born outside Cincinnati, Ohio, Sweet arrived at UCLA in 1975 after graduating from Temple University. The first person she met was Larry Clark, who mentored her through the film program, and she became close friends with Dash, Ballenger, Larkin, Makarah, Blue, and McCullough.[39] Frazier was born in San Francisco and arrived at UCLA in 1977, having graduated from UC Irvine with degrees in drama and comparative cultures and having studied for a year at the University of Ghana.[40] Abel-Bey graduated from Mount Holyoke College before earning her MFA from UCLA.

In the early 1980s, Shirikiana Aina enrolled in a joint master's program of African studies and film. A Detroit native, Aina attended Howard University, where she studied film and worked with Haile

Gerima, who had arrived at Howard as a teacher the same year that Aina enrolled. They were married during her time at UCLA.[41] Also at UCLA in the early 1980s was the "baby" of the group, Zeinabu irene Davis, born in Philadelphia to working-class parents with strong artistic sensibilities and interest in theater and education. A product of Catholic school, Davis attended Brown University, spent time in Kenya, and then entered the master's program in African studies at UCLA in 1983; she began the film program in 1985.[42] While Clyde Taylor has called Davis the "last flame" of the L.A. Rebellion, we suggest in the conclusion to this introduction that there are strong continuities with ensuing generations of film students.

These are only some of the filmmakers of African descent associated with the L.A. Rebellion. This overview indicates the diverse paths that led these filmmakers to UCLA and the diverse experiences and sensibilities that shaped their work. The filmography at the end of this volume includes a broad range of filmmakers who were at UCLA during this period (1967–90) and who worked with and among the filmmakers featured here. Additionally, the oral histories in the L.A. Rebellion Oral History Project are repositories for names of many fellow students from all backgrounds who were integral to the L.A. Rebellion. Our hope is that this volume serves as a springboard for further research on these filmmakers and their films, especially less well-known figures. In particular, one goal of the L.A. Rebellion Preservation Project is to lay the groundwork for more research on the other students of color and progressive white students who worked with the Black filmmakers and were important participants in creating the distinctive creative culture at UCLA. While a singular definition of the L.A. Rebellion has been contested and challenged by the filmmakers, one consistent assertion is the importance of multi-ethnic collaboration and discussion among students at UCLA. In addition to the well-known influence of Robert Nakamura, Shirley Clarke, John Boehm, and other non-Black faculty members, students such as Moctesuma Esparza, Monona Wali, Francisco Martinez, Mario DeSilva, Ahmed El Maanouni, Todd Darling, among many others, deserve further discussion.

"BLACK CINEMA SPOKEN HERE!": SUBJECTS AND STRATEGIES OF L.A. REBELLION FILMS

With several notable exceptions, L.A. Rebellion films are, in the aggregate, concerned with the lives and struggles, individual and systemic, of

their working-class Black subjects.⁴³ Often directly derived from the personal experiences of the filmmakers, these films thematically address a wide variety of social, political, and economic issues directly relevant to the Black urban poor and working class, including the following:

- urban redevelopment and disenfranchisement: *Brick by Brick* (Dir. Shirikiana Aina, 1982), *L.A. in My Mind* (Dir. O.Funmilayo Makarah, 2006);
- drugs: *A Day in the Life of Willie Faust, or Death on the Installment Plan* (Dir. Jamaa Fanaka, 1972);
- incarceration and joblessness: *Welcome Home, Brother Charles* (Dir. Jamaa Fanaka, 1975), *Grey Area* (Dir. Monona Wali, 1982);
- youth community organizing: *Emma Mae* (Dir. Jamaa Fanaka, 1976);
- class exploitation: *Daydream Therapy* (Dir. Bernard Nicolas, 1977), *Rich* (Dir. S. Torriano Berry, 1982);
- education: *Shipley Street* (Dir. Jacqueline Frazier, 1981), *Ujamii Uhuru Schule Community Freedom School* (Dir. Don Amis, 1974);
- unemployment and underemployment: *Bless Their Little Hearts* (Dir. Billy Woodberry, 1984);
- African American participation in the U.S. military: *Fragrance* (Dir. Gay Abel-Bey, 1991), *Ashes & Embers* (Dir. Haile Gerima, 1982);
- lynching and northern migration: *Dark Exodus* (Dir. Iverson White, 1985), *Daughters of the Dust* (Dir. Julie Dash, 1991);
- intraracial class differences and AIDS: *Compensation* (Dir. Zeinabu irene Davis, 1999);
- gender and sexual violence: *A Different Image* (Dir. Alile Sharon Larkin, 1982);
- sexual orientation: *HappyValentine's Day* (Dir. Gay Abel-Bey, 1980);⁴⁴
- cultural imperialism: *The Diary of an African Nun* (Dir. Julie Dash, 1977);
- family, class, urban poverty, welfare, assimilation: *Your Children Come Back to You* (Dir. Alile Sharon Larkin, 1979);
- generational wisdom: *Ashes & Embers, I & I* (Dir. Ben Caldwell, 1979);

- child abuse and neglect: *Tommy* (Dir. Gay Abel-Bey, 1978), *The Kitchen* (Dir. Alile Sharon Larkin, 1975);
- mental health, hair, domestic work: *The Kitchen;*
- unplanned pregnancy and abortion: *Hidden Memories* (Dir. Jacqueline Frazier, 1977), *Bush Mama* (Dir. Haile Gerima, 1975);
- single parenthood: *Your Children Come Back to You, The Snake in My Bed* (Dir. Omah Diegu [Ijeoma Iloputaife], 1995);
- misjustice and police brutality: *Kinky Babylon* (Dir. Grayling Williams, 1979), *Bush Mama, Gidget Meets Hondo* (Dir. Bernard Nicolas, 1980), *Ashes & Embers.*

Within the body of work that comprises L.A. Rebellion filmmaking, a subset of films thematically deal with domestic liberation, radical politics, armed resistance, and facets of Black Power (*Rain (Nyesha)* [Dir. Melvonna Ballenger, 1978], *Fragrance, Tamu* [Dir. Larry Clark, 1970], *As Above, So Below* [Dir. Larry Clark, 1973], *Hour Glass* [Dir. Haile Gerima, 1971], *Bush Mama, Gidget Meets Hondo*). Several films overtly reference global liberation movements (*Passing Through* [Dir. Larry Clark, 1977], *Boat People* [Dir. Bernard Nicolas, 1982], *Bush Mama, Your Children Come Back to You*), while others focus on the cultural hegemony of Hollywood and use experimental forms (*I & I, Medea* [Dir. Ben Caldwell, 1973], *Water Ritual #1* [Dir. Barbara McCullough, 1979]). While not all of the films function in a realist mode, they reflect the group's commitment to revealing the real-world material, psychological, and spiritual challenges that Black people face in a racist society.

To this end, all these films reflect a commitment to telling their stories in a way that rejects mainstream methods of representing African Americans and their communities. The concurrent proliferation of "Blaxploitation" films, while different in style, representational veracity, political commitment, and audience impact, offered the L.A. Rebellion filmmakers another bad object, this one a countermodel of representing Black urbanity. Still, while this trajectory of Blaxploitation films was clear by the mid-1970s, it had not been clearly delineated in the early years that comprised the first cohort of L.A. Rebellion filmmakers at UCLA (late 1960s to early 1970s), and the radical impulse of an independent film such as *Sweet Sweetback's Baadasssss Song* (Dir. Melvin Van Peebles, 1971) had not yet been neutered by Hollywood's stylistic appropriation.

FIGURE I.7. *Dark Exodus* (Dir. Iverson White, 1985).

FIGURE I.8. *Grey Area* (Dir. Monona Wali, 1982).

As discussed previously, many of the L.A. Rebellion artists identified as Third World filmmakers. This identification followed two strands—modes of production and narrative and formal investments. L.A. Rebellion filmmakers employed guerilla production practices, emphasized collaboration, and worked collectively. Crewing on one another's films created a sense of camaraderie among the Black filmmakers and their friends who shared their perspectives and sensibilities. This created strange bedfellows; even filmmakers whose respective creative ethos seemed to conflict (such as the spiritual experimentation of Ben Caldwell and the exploitation narrative conventions of Jamaa Fanaka) worked together in realizing one another's vision. These filmmakers translated Third Cinema's emphasis on film as social practice to the social practice of filmmaking—collaborating on shooting, editing, and exhibition.

As noted, many L.A. Rebellion filmmakers also shared narrative and formal affinities with Third Cinema. In *Third Cinema in the Third World: The Aesthetics of Liberation,* published in 1979, Teshome Gabriel emphasizes a "new cinematic language" of this "cinema of decolonization and for liberation." Gabriel posits four main purposes of an aesthetics of liberation: to decolonize minds, to contribute to the development of a radical consciousness, to lead to a revolutionary transformation of society, and to develop new film language with which to accomplish these tasks. Translated to the context of L.A. Rebellion filmmaking, these goals take on new valences and investments.

Furthermore, Gabriel traces a film practice that aligns with the plight and struggle of a Third World people against imperialism and class oppression, even if from the relatively privileged position of the filmmaker. For Gabriel, a key concern of Third Cinema practitioners is not in "aestheticizing ideology" but in "politicizing cinema." As Gabriel states, "The principal characteristic of Third Cinema is really not so much where it is made, or even who makes it, but, rather, the ideology it espouses and the consciousness it displays." As Cynthia Young has argued, the struggle against imperialism and class oppression was no less important in the United States, even if it was not immediately recognized as such, and the L.A. Rebellion filmmakers sought to align their work with global anti-imperialist fights.[45]

The alignment with international liberation struggles is a thread that runs through many L.A. Rebellion films, but it also informs an approach to domestic concerns. In this way, local issues are presented as part of a larger international struggle against systemic oppression. The role of

filmmaking, then, is to visualize these concerns and put them in terms that are relatable and transformative for Black audiences. In his essay in this volume, Chuck Kleinhans argues that that Third Cinema as it was conceived by Latin American filmmakers, "presumed both a specific political movement and a coherent community that the makers and films are speaking from and to," conditions that did not exist in the same way for Black filmmakers in the United States. There was therefore a limit to how far the L.A. Rebellion artists could apply the Third Cinema model, given the fracturing of Black communities in the wake of the civil rights movement (particularly along class and political lines). But even if Third World affinities were conceived within the "utopian optimism" found among art-student communities of all sorts, we think it useful to trace how the L.A. Rebellion artists understood and attempted to apply Third Cinema principles. These efforts are central to the ways in which the L.A. Rebellion group developed their cinematic styles and performed the radical work of imagining themselves as Black filmmakers, even with so few accessible models to follow.

While not a direct application, Gabriel's fourfold model of Third Cinema shaped many of the L.A. Rebellion filmmakers as they applied the concerns of global liberation struggles to the situation faced by many African Americans across the country, primarily in urban environments. In terms of the project of the decolonization of minds, this follows two tracks in L.A. Rebellion films: first, to align the diaspora with struggles in Africa (and other peoples engaged in anti-imperialist fights); and second, to call attention to the cultural impoverishment generated by assimilation. These same concerns are shared across a number of films and find an acute critique in those centered on the lives of the underemployed residents of Watts in South Central Los Angeles.

Perhaps the most famous example of this in L.A. Rebellion filmmaking is Haile Gerima's *Bush Mama,* in which the protagonist, Dorothy, a pregnant welfare recipient being harassed by the government to get an abortion, comes to an awakened political consciousness, understanding her situation in relation to broader global, systemic oppressive mechanisms. Gerima directly aligns Dorothy's plight with anti-imperialist struggles in places like Angola. As Dorothy is politicized, she removes her wig—a symbol of assimilation—and announces: "the wig is off." Her coming to political consciousness is treated as a success even while the conditions of her environment remain unchanged, and it is presumed she will face imprisonment. Cynthia Young notes that while

Dorothy "has arrived at a radical subjectivity," "it is one contained by state forces." For Young, the film is characteristically pessimistic because "liberation is delayed."[46] However, other L.A. Rebellion films posit the trajectory of politicization and radicalization *as* liberation, such as the fashion model's journey back in time in *Sankofa* (Dir. Haile Gerima, 1993) and the student's political awakening in *Hour Glass*. Decolonizing the mind is not just the first step in an anti-imperialist struggle, but in the case of the "internal colony" inhabited by a non-white underclass, it is perhaps the most radical gesture.

Politicization is dramatized in several L.A. Rebellion films, framed as a generative, optimistic first step in fighting against systemic disenfranchisement. For example, Alile Sharon Larkin focuses on the consciousness of a child to suggest that the success of a Pan-African struggle hinges on investment in the next generation. *Your Children Come Back to You* is about the conflict between resistance and assimilation, broadly understood. Tovi (played by Charles Burnett's niece Angela, who also acted in *Killer of Sheep* [Dir. Charles Burnett, 1977] and *Bless Their Little Hearts*) lives with her father's partner, Lani, while he is in Africa fighting in an unnamed liberation movement. (We get flashbacks of the father helping Tovi spell "MPLA," implying that he has joined the People's Movement for the Liberation of Angola). The father's sister, Chris, is a middle-class woman who continually reminds Lani that she has "more than enough" and can take care of Tovi in ways that Lani cannot. Struck by the differences between her immediate family (Lani emphasizes pride and heritage) and Chris (who brags about traveling to Europe and being the "only Negro in the group"), Tovi asks Chris if she is "adopted"—a perspective explained by Tovi's recounting of a story told at her progressive, Afrocentric school (similar to the Community Freedom School captured in Don Amis's *Ujamii Uhuru Schule*) that posits a collective consciousness of nonwhite people against white hegemonic oppression (economic, political, and cultural).

From the perspective of a child, the assimilated Black woman has been "adopted" by the white "strangers." At the end of the film, Tovi rejects the idea of moving in with Chris and confronts her, saying, "You're adopted. You're like the strangers. We'll never get home with you." Larkin posits the child's growing cultural and political consciousness—a specifically Pan-African consciousness—as the solution to the damage perpetuated by generations of increasing alienation from an African heritage. The film is both confrontational to those who might not share these affinities as well as optimistic about the future for children with Tovi's

perspective. As a child, Tovi represents the fantasy of a blank slate, the untaught mind, who because of age or lack of experience can erase all previous assumptions, permitting the inscription of a new, revolutionary consciousness.

Gabriel's second definition of "a film in a Third World context" is one that seeks to contribute to the development of a radical consciousness. Haile Gerima's films—like *Bush Mama* and *Sankofa*—aim to take their audiences on a journey along with the protagonists so that the characters' coming into awakened consciousness is a motivating model for the possible spectator. As a student at UCLA, Bernard Nicolas set out to learn Hollywood techniques in order to use them to convey a counternarrative, a strategy that rejects a prescriptive aesthetics of countercinema practice whereby aspects of the dominant cinema's formal language are inverted. Instead, Nicolas squarely apprenticed himself in the use of the master's tools. Motivated to learn the methods by which Hollywood films captivated people, Nicolas explains, "I wanted to learn how they do it and then reverse the message and just capture the Hollywood techniques, but then have a revolutionary message that would not be the same message as Hollywood."[47] The concept for Nicolas's Project Two film, *Gidget Meets Hondo,* is that "Gidget," a self-absorbed young white woman living in Marina del Rey, an affluent coastal community in Los Angeles, is oblivious to the outside world and the violence erupting around her. She becomes an accidental victim of police brutality when a SWAT team mistakes her home for a terrorist haven. The film opens with still photography taken by Nicolas of a demonstration in downtown Los Angeles against the LAPD's murder of Eula Love in 1979.[48] As a critique of white complacency toward the LAPD's treatment of African Americans, the film asks whether such police brutality would be tolerated if the victim were a middle-class white woman.

The narrative of *Gidget Meets Hondo* pivots on multiple misunderstandings. Gidget mistakenly assumes she is safe in her own home, mistakenly assumes that the news on her television does not relate to her, mistakenly assumes that the police will come to her rescue. The SWAT commander is wrong in thinking Gidget's home harbors terrorists, and after gunning down Gidget the police open fire on an empty room, shooting directly at the camera. In this sense, the audience is implicated in the deadly police error; no longer a witness to these multiple misunderstandings, the spectator becomes a symbolic victim as well. By narrativizing these deadly misunderstandings, Nicolas demonstrates that

no one is safe from police misconduct in a society where the police wage violence on the poor and those who seek to champion their rights.

The critiques articulated in L.A. Rebellion films are designed to shift perspectives and challenge received narratives. In this sense, they correspond to Gabriel's third definition of Third Cinema, one whose purpose in filmmaking is to catalyze a revolutionary transformation of society. From the desire to develop a radical consciousness in spectators, these films seek to participate in social transformation. In the L.A. Rebellion this happens on two fronts. First, these films proffer a shift in representational paradigms (related to the last component of Third Cinema about the development of new film language). Most simply, this is the centering of Black subjects and subjectivities (already a radical gesture in American cinema). Second, this means a kind of modeling of strategies of resistance.

Larry Clark's *As Above, So Below* puts forth a powerful political and social critique in its portrayal of Black insurgency. The film opens in 1945 with a young boy playing in his Chicago neighborhood and then follows the adult Jita-Hadi as a returning Marine with heightened political consciousness. Like *The Spook Who Sat by the Door* (Dir. Ivan Dixon) and *Gordon's War* (Dir. Ossie Davis), both also released in 1973, *As Above, So Below* imagines a post–Watts Rebellion state of siege and an organized Black underground plotting revolution. With sound excerpts read from the 1968 report of the House Un-American Activities Committee, *Guerrilla Warfare Advocates in the United States*, Clark's *As Above, So Below* is one of the more politically radical films of the L.A. Rebellion. Like Haile Gerima, whose work is concerned with decolonizing the mind ("The wig is off!") as well as condemning Black complicity in social inequities, Clark extends this critique and imagines an organized, armed insurgency. Clark destabilizes expectations, revealing that the characters coded as compromised might in fact be insurgents and those who are not will get their comeuppance. For example, the character Pee Wee, presented as the epitome of a "colonized mind"— someone who blames social inequities on the disenfranchised—is shot by the police when attempting to flag them down to turn in the guerillas. Bee, presented early in the film as a numbers-playing devout church lady, is in fact one of the leaders of the insurgency. Gerima plays a guerilla fighter, and the leader of their unit is played by the same actor (Johnny Withers) who would go on to play T. C., Dorothy's politically aware partner in *Bush Mama*.

As countercinema movements asserted from the start, transformative film practices must be coupled with transformative film language. In

FIGURE I.9. Myko Clark on the set of *As Above, So Below* (Dir. Larry Clark, 1973).
Collection of Larry clark.

Gabriel's schema, the fourth purpose of Third Cinema is to develop a new film language. As mentioned above, the centering of Black subjects and subjectivities is part of a new film language. Or, rather, it is recuperated from earlier Black filmmaking practices (such as "race" films produced explicitly for Black audiences). However, this also applies to experimentation with film form. L.A. Rebellion filmmakers followed countercinema practitioners in their efforts to break from the formal hegemony of classical Hollywood cinema. To varying degrees, these filmmakers challenged representational norms and sought a storytelling form that would be more "authentic" to their subject, breaking from the ideological implications of traditional Western film. Ben Caldwell describes how he and his cohort sought to challenge accepted formal paradigms of cinema: "Once you start studying film, you not only feel that you have to emancipate the story, but you have to emancipate the structure of the story."[49] Taking this familiar construction from countercinema discourses, Caldwell applies it to the positive generation of a Black film aesthetic.

Caldwell's thesis film, *I & I: An African Allegory,* experiments with form, genre, and narrative as Caldwell engages with three distinct modes of filmmaking: experimental, documentary, and fiction. In many respects, we can see these three modes operating concurrently in a number of L.A. Rebellion films, from the aestheticized lens of Charles Burnett's *Killer of Sheep* on its nonprofessional actors in their own environment to Jamaa Fanaka's *Emma Mae* with its unstaged opening in a park and ensuing highly stylized fight scenes and narrative drama. However, Caldwell breaks these forms down in *I & I;* the film's three sections each feature a different mode, the film overall a résumé piece to showcase his skills. The experimental section that begins the film features the awakening of Alefi (Pamela Jones), the wind messenger of Oyá in Yoruba mythology. The film begins with her appearance "to show us America through her I's." The camera lens, Alefi's perspective, and the concept of "I & I" merge in this section in which Caldwell centers the wind goddess's perspective and estranges the realm of white, capitalist "America" via a slow downward tilt that reveals Alefi walking through an impersonal corridor of downtown Los Angeles office buildings. But how effective could this kind of experimentation with film form be with audiences accustomed to the conventional cinematic language of commercial narratives?

REACHING AN AUDIENCE: EXHIBITION AND DISTRIBUTION OF L.A. REBELLION FILMS

Most of the L.A. Rebellion filmmakers actively sought Black audiences for their films and showed their work at community-based screenings in Los Angeles and elsewhere, as well as in programs they curated on campus. But it is not surprising that their work could not reach mass Black audiences, given that so few titles received theatrical distribution and so little of the work fit the generic and stylistic parameters that were familiar to viewers, or marketable to them via the attention of major media outlets. Indeed, it is not clear that all of the filmmakers wanted to reach Black audiences on the same scale as "Blaxploitation" films. Instead, because these artists also crafted individual voices in auteurist terms, their films received the most initial critical attention outside the orbit of the Los Angeles–based film industry, from academics and the film community at large in Europe and other places far from L.A. At the same time that the films were often met with stunned silence when presented to the filmmakers' white peers and professors at UCLA, they were being

celebrated as signs of a new Black American cinema in international film festivals in Cannes, Paris, Berlin, and Amsterdam.

At first, it was individual filmmakers who broke into the festival circuit. Clark's *As Above, So Below* was presented at the Philadelphia Black Film Festival in 1974. The films of Fanaka, on the other hand—*Welcome Home, Brother Charles, Emma Mae,* and *Penitentiary* (1979)—were released commercially and somewhat mistakenly perceived as Blaxploitation titles, although *Emma Mae* also made an appearance at the Deauville Film Festival (France). By the time *Penitentiary* screened in Cannes in 1980, several of Fanaka's colleagues had already journeyed across the Atlantic, most prominently Haile Gerima, whose *Harvest: 3,000 Years* (1976) was shown at Cannes, Filmex (Los Angeles), the Figueira da Foz International Film Festival (Portugal), London, and the Jamaica Film Festival (Montego Bay) and won the Silver Leopard at Locarno. A year later, Clark's *Passing Through* (1977) won a special jury prize at Locarno and then screened at festivals in the Virgin Islands, Deauville, Edinburgh, Montreal, Carthage (Tunisia), Auckland, Moscow, and Perth (Australia) and at the the the Pan African Film Festival in Ouagadougou, Filmex in Los Angeles, and the Art Institute of Chicago. Burnett's short, *The Horse* (1973), opened at the Oberhausen Short Film Festival in Germany, and his *Killer of Sheep* won the FIRESCI prize in Berlin (1979). Carroll Parrott Blue's *Two Women* (1977) was chosen for the Chicago Film Festival and Filmex, and her *Varnette's World* (1979) also played Chicago, winning the festival's highest award, the Golden Hugo. Despite these screenings on the international festival circuit, as well as the many undocumented domestic screenings, the idea that these filmmakers constituted a movement or were even related had not yet crystallized.[50]

That began to change in 1980 with two seminal events in France. The first was organized by French film curators Catherine Arnaud and Catherine Ruelle: the Festival de cinéma des noirs américains, 1920–1980, sponsored by the Fnac (department store) and Nouvelles littéraires and staged at the Fnac Forum in the Forum des Halles in Paris. That retrospective focused specifically on independent Black filmmakers and included Gerima's *Child of Resistance* (1977), Dash's *The Diary of an African Nun* and *Four Women* (1975), Nicolas's *Gidget Meets Hondo,* Burnett's *Killer of Sheep* and *The Horse,* Caldwell's *I & I* and *For Whose Entertainment,* Pamela Jones's *One* (1980), Clark's *Passing Through,* Woodberry's *The Pocketbook* (1980), Ballenger's *Rain/(Nyesha),* Larkin's *Your Children Come Back to You,* and McCullough's *Shopping Bag Spirits and Freeway Fetishes: Reflections on Ritual Space*

FIGURE I.10. Program cover, Festival de cinéma des noirs américains, 1920–1980, Paris, 1980. From the collection of Julie Dash.

(1981). These were screened along with early films of Oscar Micheaux and Richard Maurice and the works of East Coast filmmakers like William Greaves (*Ali, the Fighter,* 1971; *Symbiopsychotaxiplasm: Take One,* 1968; *Still a Brother,* 1968; *Just Doin' It,* 1976; and *From These Roots,* 1974), Ronald K. Gray (*Transmagnifican Dambamuality,* 1976), Madeline Anderson (*I Am Somebody,* 1970), Kathleen Collins (*The Cruz Brothers and Miss Malloy,* 1980), Warrington Hudlin (*Black at Yale,* 1974), and Bill Gunn (*Ganja & Hess,* 1973), among others. This important gathering put L.A. Rebellion filmmakers in dialogue with Black independent filmmakers in other parts of the country, and

FIGURE I.11. Independent Black American Cinema program, 1981. From the collection of Julie Dash. Courtesy of Third World Newsreel.

the L.A. films would continue to be connected as critics and scholars discussed the new ground being broken by Black film artists.

The second seminal event of 1980 occurred at the International Film Festival in Cannes. Many of the shorts that appeared at the Fnac Forum, plus *Varnette's World* and *Water Ritual #1*, were also featured in Cannes (and then in Paris) in an important program that Barbara McCullough and Julie Dash curated. They brought their own works and films by their peers in their suitcases and rented screening space for a program titled "Nouveaux courts métrages noirs Américains," exposing their work to journalists from around the world.[51] After these programs, Amsterdam organized the Independent Black Cinema Festival in 1981. Also in 1981, the Fnac program traveled to New York State under the auspices of the Theater Program of Third World Newsreel, programmed by Pearl Bowser and sponsored by the New York State Council on the Arts, Film News Now Foundation, and Avis Inc. In 1982 the Fnac program played in London at the British Film Institute's National Film Theatre. The same year, the Black Filmmaker Foundation, founded in 1978 in New York by Warrington Hudlin, published its first catalog and

NOUVEAUX COURTS METRAGES NOIRS AMERICAINS
NEW BLACK AMERICAN SHORTS

Projections privées au Festival de Cannes présentées par Julie Dash de "Shameless Hussy Films" et Barbara Mc Cullough de "The Opened I. inc." Los Angeles	*Private screening at Cannes Film Festival with the directors : Julie Dash and Barbara Mc Cullough*
Mardi 13 mai à 13 heures Salle C, Palais des Festivals	*Tuesday May 13 1:00 pm at Salle C, Palais des Festivals*

FIGURE I.12. Program Cover, New Black American Shorts, Cannes, 1980. Collection of Julie Dash. Photo courtesy of Preston J. Edwards, Sr., *The Black Collegian*.

began distributing the work of John Rier (*Black Images from the Screen*, 1978), Larkin (*A Different Image*), Dash (*Illusions*), Burnett, Clark, Frazier (*Shipley Street*), and Blue, facilitating both domestic and international screenings, including programs in twelve African nations.[52]

Distribution, on the other hand, remained difficult. Ben Caldwell reports that he was approached by the American Library Association to distribute his *I & I* as an accompaniment to screenings of episodes of the miniseries based on Alex Haley's *Roots* (1977); he turned them down because they wanted his film virtually for free, while he was making relatively good money showing it himself three to four times a

FIGURE I.13. Kathleen Collins and Larry Clark, Black American Film Festival, Amsterdam, 1981. Collection of Larry Clark. Courtesy Barend van Herpe, Dutchphotography.nl

month.[53] While the Black Filmmaker Foundation, as a nonprofit collective, distributed prints to noncommercial venues, almost no titles were picked up by commercial distributors or played theatrically. Indeed, other than Jamaa Fanaka, only Charles Burnett (*To Sleep with Anger* [1990]), Julie Dash (*Daughters of the Dust*), and Carroll Parrott Blue (*Conversations with Roy DeCarava* [1983]) received theatrical distribution (from the Sam Goldwyn Company, Kino International, and First Run Features, respectively).[54] Third World Newsreel and Women Make Movies picked up individual titles, but again distributed to the nontheatrical market. To ameliorate this situation, Bernard Nicolas, himself an L.A. Rebellion filmmaker, founded a distribution company in the early 1990s, Inter Image Video. However, he soon realized that he could not generate enough income to cover his own expenses, much less pay his colleagues: "We figured we needed at least a half a million dollars, but that was not to be found. I was able to raise money from friends and family—$35,000. So I said, 'That's what I'm starting with.' Later, of course, that would be the clear downfall of the effort because how can you have a budget of half a million, but you're gonna do it on $35,000? But it was that old determination from the old film school days where you just do it."[55]

Our preliminary research indicated that less than 39 percent of our initial list of L.A. Rebellion titles received distribution of any kind, other than when venues directly approached the filmmakers with invitations to screen their work or borrow prints.[56] It was Gerima who established the most successful self-distribution model, when he four-walled *Sankofa*, taking it from theater to theater, prompting even the industry trade magazine *Variety* to take notice:

> When filmmaker Haile Gerima had no takers to distribute his feature "Sankofa," he decided to carve a niche for his film himself. Along with his wife and co-producer, Shirikiana Aina, the Ethiopian-born, Howard U. professor booked his film—about a Ghanaian model transported back to the days of slavery—for its U.S. debut at a Washington, D.C., cinema in October 1993. The film played for 11 weeks, making enough of a profit to enable Gerima to make copies of his print and release it to a second city. And thus, the filmmakers' grassroots distrib, Mypheduh Films, was created. "Sankofa," which cost less than $ 1 million to produce, opened at Boston's Museum of Fine Arts in January 1994. Gerima and Aina have now criss-crossed the country with their film, four-walling it in over 15 cities, including Baltimore, Chicago, Detroit and Los Angeles. [. . .]To date, the film has grossed more than $ 2.2 million.[57]

While Gerima's *Ashes & Embers* took festival prizes in Berlin and London in 1983—the same year that several films by women in the group, including Dash's *Illusions*, were screened at the International Women's Film Festival in New York—it was not until February 1984 that Black filmmakers were acknowledged on their own home turf, when UCLA hosted the Black American Independent Cinema conference and film series. On the heels of that program, the first iteration of L.A.'s Pan African Film Festival in August, held at the Fox in Venice, reprised much of that program for the community. While L.A. Rebellion films continued to be shown at European and African festivals in 1984–85, it was not until January 1986 that the movement received its name, with the premiere of Clyde Taylor's series at the Whitney Museum in New York: "The L.A. Rebellion: A Turning Point in Black Cinema." That seminal film program showed no fewer than fifteen features and shorts.

Just as film festivals in the 1970s and early 1980s focused on individual filmmakers or saw these filmmakers within the context of a new Black American cinema, so too did the press make few distinctions between L.A. Rebellion filmmakers and other Black American independents. Taylor himself had published two essays in 1980 and 1985, respectively, which discussed Black women filmmakers and Black independents, before he coined the L.A. Rebellion moniker.[58] In the same

1986 issue of *Black Film Review* in which Taylor defined the L.A. Rebellion, Monona Wali discussed the L.A. movement without adopting Taylor's term.[59]

Indeed, no sooner had Taylor named the movement than it began to lose critical attention to its size and diversity. From the 1980s into the current century, the L.A. Rebellion was discussed in a handful of academic articles and books on Black American cinema, contributions that performed sensitive close readings but usually only mentioned the most prominent filmmakers of the group (especially Burnett, Dash, and Gerima) and focused on single films. Ed Guerrero writes in *Framing Blackness: The African American Image* (1993), "The films of university-trained black filmmakers in the 1970s laid a clear political, philosophical, and aesthetic foundation for an ongoing cinematic practice that challenges Hollywood's hegemony over the black image. Charles Burnett, Julie Dash, Billy Woodberry, and Haile Gerima have contributed to creating an emergent, decolonizing, antiracist cinema that in its images, sounds, aesthetics, and modes of production has attempted to reconstruct the world on the screen from black points of view cast in liberating images and new paradigms."[60]

Guerrero then goes on to discuss Burnett's *To Sleep with Anger* and Dash's *Daughters of the Dust,* foregoing further comment on the varied works of the larger group. Similarly, Paula J. Massood's *Black City Cinema: African American Urban Experiences in Film* (2003) analyzes Gerima's *Bush Mama,* mentioning simply that "Gerima was part of a group of African and African-American film students, enrolled in the Theatre Arts and Film Departments at UCLA, who are referred to as alternately the 'L.A. Rebellion.'"[61]

It was David James in *The Most Typical Avant-Garde: History and Geography of Minor Cinemas in Los Angeles* (2005) who refocused academic attention on the L.A. Rebellion as a movement, even if he, too, vacillated on whether to call it the Los Angeles School or the terminology adapted here. James begins with close readings of Van Peebles's *Sweet Sweetback's Baadasssss Song* and Clark's *Passing Through,* which both "vividly allegorize the contradictions in their respective conditions of production."[62] James goes on to read the work of mainly Gerima, but also of Burnett, Caldwell, and McCullough, against the backdrop of the Third World liberation aesthetics that Teshome Gabriel had formulated in his UCLA classes. James concludes somewhat pessimistically that "rather than inaugurate a popular community cinema, the films of the L.A. Rebellion survived mostly in the academy, with occasional appearance on public television."[63]

James's assertion downplays the level of attention that the works of individual filmmakers garnered in the 1990s and the new century. After the back-to-back commercial release of Burnett's *To Sleep with Anger,* Dash's *Daughters of the Dust,* Fanaka's *Street Wars,* and Gerima's *Sankofa,* another major retrospective series followed in 1993 at the Brooklyn Museum, "African-American Independent Cinema: The L.A. Rebellion," again curated by Clyde Taylor. Meanwhile other retrospectives were organized in honor of Fanaka (1991, AFI), Gerima (1995, Dallas), and Burnett (1997, New York). The latter two filmmakers, along with Dash, also continued to produce and distribute new works, but it was the belated theatrical and DVD release of Burnett's *Killer of Sheep,* after a major restoration by the UCLA Film & Television Archive in 2006, that signaled new interest in the work of the L.A. Rebellion, culminating in the archive's massive 2011 film program, "The L.A. Rebellion: Creating a New Black Cinema," and subsequent tour to over ten major media markets around the country and internationally. Even before then, *Killer of Sheep* had been added to the National Film Registry (in 1990), as had Dash's *Daughters of the Dust* (in 2004), while Woodberry's *Bless Their Little Hearts* was named to the registry in 2013. In April 2015, a slightly modified version of the L.A. Rebellion tour opened in London at the Tate Modern, followed in May by screenings at the Courtisane Film Festival in Belgium.

PRESERVING THE L.A. REBELLION

The naming of *Bless Their Little Hearts* to the National Film Registry, an annual list of twenty-five films chosen by the Librarian of Congress as "culturally, historically or aesthetically significant," is an important milestone in the history of the L.A. Rebellion. Unlike the relatively early naming of *Killer of Sheep* (in the second round of selections) and the selection of Dash's *Daughters of the Dust,* which has the distinction of being the first film by an African American woman director to be placed in theatrical distribution, Woodberry's *Bless Their Little Hearts* was recognized after being preserved by the UCLA Film & Television Archive. This preservation project (which included blowing up some films, including *Bless,* from 16mm to 35mm), has given new visibility to the group as a whole and raised instructive questions about how preservation work participates in the construction of film histories and canons.

Materially, the archive's preservation of L.A. Rebellion works has included collecting the material, stabilizing it physically, and making

viewable copies that approximate the quality of the original versions. Though such work is often invisible to scholars and other audiences, Caroline Frick reminds us of the influential role that that archivists play: "just as students in film history classes study aspects of film production, distribution, and exhibition, so too should they be aware of the film archiving community's participation in the industry and in global cultural discourse throughout the last one hundred years."[64] As Alessandra Raengo's essay in this volume demonstrates, when films are framed and re-presented as archival objects, a range of new interpretive possibilities and debates open up. In the case of the L.A. Rebellion, the films reenter film history on a platform that allows for freshly surveying the work and for considering that the struggles faced by marginalized filmmakers extend far beyond making and showing their work to include limitations on the very survival of their work absent archival intervention.

Even for those members of the L.A. Rebellion who enjoyed a degree of critical success, most of their work has remained at the fringes of the film and media industry, in economic terms. As students, they funded production budgets from their own pockets, sometimes supplementing with small grants. Thesis films and later works often took many years to produce due to financing hurdles. As a result, many of the films were produced with very low budgets, filmmakers cutting costs by using materials deemed substandard compared to commercial filmmaking; for example, some shot their films on pieced-together 16mm short ends, some shot on video, and some copied music tracks without legal clearance. Furthermore, due to financial constraints, the filmmakers have stored their negative materials at best in the laboratories that struck their release prints, at worst in garages and closets, where they have been subject to intense vinegar syndrome and other forms of decomposition.

As discussed above, while a number of the L.A. Rebellion films have been in distribution, the reality is that most were unavailable from commercial distributors, and virtually none had been preserved archivally prior to the current project. This means that few if any preprint materials (visual and sound elements that are married in the creation of projection or release prints) were stored under archivally sound conditions. For example, Fanaka's most successful film commercially, *Penitentiary,* was available in theatrical distribution at the time of its release but is presently only distributed in DVD formats. A somewhat smaller number of films are in distribution through small nonprofit distributors, such as the Black Filmmakers Foundation, Third World Newsreel, and Women Make

Movies. However, the projection prints from these sources were usually produced in the year of original release, meaning that many prints are in extremely poor condition, showing signs of wear and tear from decades of projection, such as jumps in the action, streaks and scratch lines, dirt, color fading, and whole scenes removed.

Of the first seventy-three films and videos identified as L.A. Rebellion titles during the course of our research, only twenty-eight (39 percent) have ever been in distribution, and we found that even distributors hold substandard preprint materials. Meanwhile, many other materials have remained in the possession of the filmmakers. These filmmakers never had enough funding to finance new prints after the generation of the original release print, which is the print they have often been running for years. Moreover, it is often the case that filmmakers lose track of their original negatives and fine grains because a laboratory has closed while holding their film elements. For example, Larry Clark's *As Above, So Below* had not been located since the mid-1970s, only to be found by UCLA Film & Television Archive preservationist Ross Lipman, just as S. Torriano Berry's *Rich* was rediscovered in a lab.

During the first research phase of the L.A. Rebellion project, funded by the Getty Foundation, while looking at publically available sources and conducting oral histories with the participants, we realized that any film program would have to rely on a massive effort by all departments of the UCLA Film & Television Archive to identify, find, recover, restore or reconstitute, catalog, preserve, and protect the films of these filmmakers. Indeed, the L.A. Rebellion became the first project in the archive's history to engage every member of the archive team. The project was conceived of as a true archeological project, whereby every surviving element, no matter how distressed, was potentially the only element available for preservation. For example, *Rain/(Nyesha)*, the late Melvonna Ballenger's beautiful short film, survived in a single 3/4-inch tape that had been made from an untimed 16mm work print transfer, which had to be literally baked before a signal could be digitized. As the archive has gathered all surviving preprint and print material from the filmmakers, an ongoing search that continues to this day, it has become evident that most materials have been stored extremely poorly, without the benefit of climate control and therefore subject to extreme acetate decomposition. Magnetic tapes and 16mm prints striped with magnetic soundtracks are particularly vulnerable to vinegar syndrome. All the films could benefit from digital sound restoration. Another problem is that a number of the titles only survive on obsolete film formats, such as

Super 8 film or U-Matic tape, which must now be preserved through optical blowups or as digital files.

Filmmakers who agreed to place their work at the UCLA Film & Television Archive had their films inventoried, recanned in archival housing, and placed in humidity- and temperature-controlled vaults. Proper storage is the first level of conservation and preservation. The immediate concern was then to generate acceptable projection materials for the retrospective program slated for fall 2011, as well as to identify stable preservation materials for long-term protection. We employed two strategies, one analog and one digital. Given the stability of analog film, the archive team decided to produce new 16mm or 35mm materials from existing films, either by blowing up 16mm preprint materials to 35mm negatives or making new 16mm prints from existing 16mm negatives. In the case of Super 8, 8mm, and video materials, we decided to digitize for access as well as long-term preservation, although preservation in the digital realm is still fraught with uncertainty, given that ongoing migration of digital files is at present the only acceptable form of digital preservation.

The archive completed full preservation on a number of titles, making decisions based on available resources and the time constraints of preparing for the 2011 retrospective. Full preservation is defined as generating new picture and track negatives on 16mm or 35mm film for long-term preservation, creating fine-grain masters, and creating projection prints. For *Killer of Sheep, Bless Their Little Hearts, Water Ritual #1*, and *The Pocketbook*, new 35mm negatives were generated from the 16mm a and b rolls, as well as new projection prints. Producing 35mm materials ensures that these films may be seen in an analog format, since 16mm projection is dying out in the United States. For *Several Friends* (Dir. Charles Burnett 1969), *As Above, So Below, The Horse, Rich, I & I, Your Children Come Back to You, Dark Exodus*, and *Passing Through*, new 16mm projection prints were produced from 16mm negatives and/ or a and b rolls for the L.A. rebellion exhibition and tour. With *Illusions*, whose preservation was completed in 2014, a digital intermediary was produced before generating a new 16mm print, because the sound work in the original had always been problematic. *Daughters of the Dust* required corrected timing for a second 35mm answer print, since all previously available prints had not been timed correctly. As Julie Dash confirmed at the premiere screening, the new print revealed layers of visual information that had never been visible in previous versions. Producing

FIGURE I.14. *The Pocketbook* (Dir. Billy Woodberry, 1980).

new, clean prints for the exhibition and tour, rather than relying on worn and ragged used prints from the 1970s and 1980s, has allowed audiences to rediscover the aesthetic qualities of many of the L.A. Rebellion films.

Due to budget constraints as well as the changing preservation environment, which is now rapidly moving toward 100 percent digital workflows, the archive preservation team decided to digitize in standard and high definition all of the "Project Ones" (the first production assignment, usually on small-gauge 8mm or Super 8 stock, as discussed in Allyson Nadia Field's contribution in this volume), as well as all the material originating in analog video. Thus, Jamaa Fanaka's *A Day in the Life of Willie Faust, or Death on Installment Plan* (1972) was digitized and digitally cleaned up, because only a single high-contrast 16mm print had survived and it was found lying in the dirt in the bottom of a storage shed. With Julie Dash's *The Diary of an African Nun,* on the other hand, a new 16mm print was first generated from the 16mm a and b rolls, themselves blown up from the 8mm original, and then digitized and cleaned up to produce a new 35mm negative with laser technology. In other cases, such as Carroll Parrot Blue's *Varnette's World,* Don Amis's *Festival of Mask* (1982), and Elyseo Taylor's *Black Art,*

Black Artists (1971), a single surviving 16mm print was digitized for access and exhibition, until funds can be secured for full preservation. Obviously, video titles such as *Dreadlocks and the Three Bears* (Dir. Alile Sharon Larkin 1991), *Rain (Nyesha), Define* (Dir. O. Funmilayo Makarah, 1988), and *Fragrance* had to be transferred to digital, because analog video is now considered an obsolete format.

Indeed, for access and distribution, the UCLA Film & Television Archive is continuing to digitize materials. A DCP (Digital Cinema Package) was recently produced for *Bless Their Little Hearts,* while *Harvest: 3,000 Years* experienced a 2K digitization for DVD release. The archive's L.A. Rebellion website has posted many of the Project Ones for streaming and will continue expanding those offerings. Meanwhile, new digital files of Julie Dash's short films were made accessible to Women Make Movies for DVD and streaming access, and the National Endowment for the Arts is presently funding a DVD box set, which will be distributed by UCLA Film & Television Archive to teaching institutions. In other words, preservation and access work on L.A. Rebellion titles will continue for the foreseeable future, given that materials are still trickling in from L.A. Rebellion filmmakers, for example, from Jacqueline Frazier, Stormé Bright Sweet, and Imelda Sheen (formerly Mildred Richards). Their films were digitized and shown at the 2015 UCLA Festival of Preservation.

CONTENTS OF THE BOOK

This book is an important feature of the effort to preserve and provide greater access to the L.A. Rebellion. It includes nine new critical essays, most of which (along with Clyde Taylor's preface) are based on presentations made at the symposium "L.A. Rebellion: Creating a New Black Cinema" in November 2011 during the archive's retrospective at UCLA's Billy Wilder Theater. This important gathering featured presentations by a diverse group of scholars, including those who had written in-depth about the L.A. Rebellion in the past (Taylor, Chuck Kleinhans, David James, Michael T. Martin); the editors who, along with Shannon Kelley (the archive's head of public programs), are co-curators of the 2011 exhibition; and UCLA graduate students close to the project (Morgan Woolsey, Samantha N. Sheppard).[65] Many of the filmmakers were in attendance as well. The symposium was a significant moment of dialogue between the artists, scholars, and audience members about particular works and the L.A. Rebellion movement/group as a whole, which has informed our ongoing archival and interpretive work.

FIGURE I.15. L.A. Rebellion Symposium, UCLA, November 12, 2011.

The essays featured here cover a broader range of L.A. Rebellion works than have ever been treated before, now that more films and videos have been located and titles are easier to access.[66] The authors were encouraged to move beyond the tendency in L.A. Rebellion scholarship to treat a handful of better-known filmmakers and films and instead to look from a higher vantage point, to consider a wider and more diverse range of works and discuss issues and themes that deepen our understanding of the group's objectives, output, and significance. Chuck Kleinhans provides a sobering macro view of the movement in his essay "Threads and Nets: The L.A. Rebellion in Retrospect and in Motion." Kleinhans looks back at the aesthetic and political aspirations of the group to argue that social and economic forces framing their optimistic labors, prominently including the business realities of making and distributing films with Black audiences foremost in mind, forestalled the fulfillment of the "dream of an autonomous African American cinema." In the interest of offering "some lessons" for future socially engaged film practice, Kleinhans deromanticizes the L.A. Rebellion by historicizing it within, among other things, the material conditions of U.S. independent filmmaking. And he calls for a reframing of the group within more nuanced understandings of the evolving desires of Black audiences, the cultural value of neorealist aesthetics, and the applicability of Third World/Third Cinema models in a U.S. context.

Kleinhans calls our attention to three filmmakers—Don Amis, Carroll Parrott Blue, and Ben Caldwell—whose documentary and experimental works have not received much critical attention due to their

deviation from the model of the arthouse narrative feature. These film-makers' film-school training enabled them to craft long careers in community-oriented creative practices that are less visible, perhaps, than auteurist filmmaking but offer a more realistic life trajectory for using media education to affect social change. While Kleinhans points out the unsustainability of the utopian radicalism facilitated by film school, Allyson Nadia Field takes us back to the quixotic days when the L.A. Rebellion makers were just starting out as students, and she describes in detail how they expressed their raw radicalism in their first filmmaking efforts. In "Rebellious Unlearning: UCLA Project One Films (1967–1978)," Field charts how the L.A. Rebellion artists used this first "initiation" exercise (nonsynchronous sound shorts) to smash the conventions of classical cinema and broach a range of Black topics and traditions they felt were ignored by the dominant media and by their white film-school peers and professors. Field's detailed survey of Project One films, both extant and nonextant, provides a compelling picture of the artists' initial attempts to translate their political and artistic ideas into cinematic form, a process that required an "*un*learning" of mainstream representational and production conventions.

Echoing Kleinhans's observation that the L.A. Rebellion should be read within more detailed consideration of contemporaneous Black popular culture, essays by Jan-Christopher Horak and David James explore the movement's relationships with "Blaxploitation" films and Black music. In "Tough Enough: Blaxploitation and the L.A. Rebellion," Horak describes the ways in which L.A. Rebellion filmmakers critique Blaxploitation—the most visible mode of Black cinematic representation of the 1970s—not by ignoring or opposing it wholesale, but in part by referencing its themes and conventions. Horak considers how films by Ben Caldwell, Haile Gerima, Larry Clark, and especially Jamaa Fanaka tell stories set in the same types of distressed urban settings presented in Blaxploitation films, treating many of the same issues, such as police brutality, white corruption, drug selling/use, the sexual exploitation of Black women, and Black-on-Black violence. But, in different ways, these filmmakers devise strategies to present these issues as symptoms of larger structural problems of racism, sexism, and class oppression. In his essay "Anticipations of the Rebellion: Black Music and Politics in Some Earlier Cinemas," David James places the L.A. Rebellion's extensive tapping of Black musical traditions in dialogue with several largely white-produced "proto-Black" cinemas: Blaxploitation, underground film, concert documentaries, and films by the Newsreel

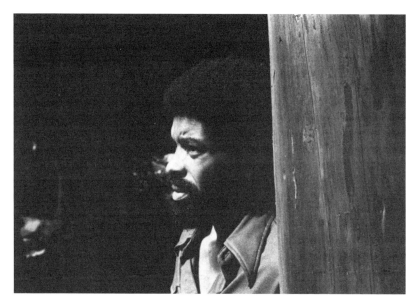

FIGURE I.16. Behind-the-scene production photograph of Larry Clark on the set of *Passing Through*, 1976.

cooperative. James argues for the importance of recognizing the "plurality" of Black musics in the 1960s and 1970s, and the many cinematic uses to which they were put, in order to understand how the L.A. Rebellion artists attempted to mobilize their expressive power. James finds that while Black musical forms (primarily R&B, soul, and free jazz) could signal aesthetic freedom or Black nationalism, they could also point to tensions surfaced by gender and class differences in efforts to address racial inequality, complicating the work music does in L.A. Rebellion films as an "intertextual medium."

Like James, Morgan Woolsey discusses the uses of music in L.A. Rebellion works. But her essay, along with that by Michael T. Martin, takes up the L.A. Rebellion's relationship to Third Cinema politics and aesthetics, a relationship that, as Kleinhans's essay indicates, requires further unpacking. In her essay, "Re/soundings: Music and the Political Goals of the L.A. Rebellion," Woolsey notes that the founding theorists of Third Cinema focused on the regime of the visual, leaving the work that sound performs in films not only undertheorized but underappreciated. Suspicion about the emotionally manipulative capacity of film music has precluded careful consideration of how music could be used to further the political agendas of radical filmmaking. She surveys the wide

range of Black musical forms used by L.A. Rebellion filmmakers to show how they are employed to celebrate the diversity of African diasporic musics across history, to displace European romantic-era music as the standard for underscoring, and "to expand understandings of what 'Black' music could sound like." Woolsey argues that music is a key pedagogical tool for the L.A. Rebellion artists, mobilized to raise political consciousness and to teach their audiences alternative ways of engaging with films by highlighting that they are both viewers and listeners.

In "Struggles for the *Sign* in the Black Atlantic," Michael T. Martin traces the development of Third Cinema to show how it, along with the documentary work by Black directors on the East Coast (William Greaves, Madeline Anderson, St. Clair Bourne) and the Black radical tradition of fighting for freedom more generally, shaped the films and practices of the group. Preferring the term *Los Angeles Collective,* Martin emphasizes that the group did not have a shared, concrete political program, formalized like those of Third Cinema practitioners. But he shows that while the group's styles diverged, they were collectively committed to exploring an overlapping set of themes that acknowledge Black history, lived experience, and agency. Focusing on the early works of Julie Dash, Charles Burnett, and Haile Gerima, Martin argues that the group's ongoing struggles for "the sign," or control over representation, have important temporal trajectories that mark them as part of a "radical-militant film practice" influenced in part by Third Cinema. In different ways, they deploy what he calls "cine-memory," a strategy of animating history and inspiring activism that works as "the means to recuperate the past, mobilize in the present, and gesture futurity," radically asserting Black subjects across historical time despite hegemonic efforts to circumscribe or erase them.

The next two essays in the book take up how L.A. Rebellion filmmakers made the important contribution of devising ways to represent Black interiority—to render Black screen subjects as thinking, feeling people. Samantha N. Sheppard's essay, "Bruising Moments: Affect and the L.A. Rebellion," considers how L.A. Rebellion works evince what she calls Black affective labor. Sheppard describes how L.A. Rebellion films represent the plight of Black bodies defined by work in ways that are intended to move audiences emotionally and politically. She argues that what Greg Tate calls "bruising moments" of Black emotional pain in L.A. Rebellion films work to bind viewers (particularly Black ones) to shared historical experiences of exploitation and oppression. Sheppard's close analyses of films through the lens of affect—including Billy Wood-

berry's *Bless Their Little Hearts,* Julie Dash's *Daughters of the Dust,* Bernard Nicolas's *Daydream Therapy,* and Zeinabu irene Davis's *Cycles* (1989)—constitute a compelling new model for understanding the dynamics of Black spectatorship, stemming from the ways in which these artists' efforts connect viewers with the interior lives of Black characters.

Jacqueline Najuma Stewart explores a related dimension of Black interiority, namely how the L.A. Rebellion artists represent their own subjectivities in their work. In "The L.A. Rebellion Plays Itself," Stewart traces self-representations across L.A. Rebellion works, a relatively minor strategy as a whole, and argues that these moments importantly but counterintuitively subvert expectations of authenticity and transparency in these and other Black cultural productions. Instead, the brief, partial, and oblique qualities of their self-representations highlight the tensions that wielding the camera can create for "minority" artists seeking to represent their own "minority" group. Stewart likens the L.A. Rebellion artists to Trinh T. Minh-ha's figure of the "insider/outsider," aka the "Inappropriate Other," as they negotiate the challenges of playing the role of Black filmmaker, an identity they largely had to craft for themselves.

The final essay, by Alessandra Raengo, can be read as an evocative response to Chuck Kleinhans's call for a more nuanced consideration of how meaning is produced, not by the content of films alone, but in the interplay between films and their audiences. Raengo's essay, "Encountering the Rebellion: *liquid blackness* Reflects on the Expansive Possibilities of the L.A. Rebellion Films," gives innovative readings of a wide range of L.A. Rebellion works made possible by the concentrated viewing offered by the touring program of films that traveled to over ten cities in the United States and Canada in 2012–13. In anticipation of the tour's run in Atlanta (at Georgia State and Emory Universities), a collective called *liquid blackness* formed to host the visiting filmmakers at sites across the city and to facilitate communal dialogue. "Encountering the Rebellion" is both an account of the formation and work of this group (consisting of scholars and "students, within and without Georgia State, as well as interested curators, local artists and intellectuals") and a report on the collective insights they have reached thus far. Raengo provides a deeply thoughtful survey of works that demonstrates how the L.A. Rebellion evinces "the expansiveness of Blackness" in its transnational and transhistorical interests and its opening up of the representational boundaries typically placed on Black bodies and Black minds. The essay offers some provisional thoughts about "aesthetic liquidity" in L.A. Rebellion works—their formal, stylistic, and narrative experimentations—suggesting a wealth of

new lines of inquiry to follow now that these films are available for close analysis.

Raengo's essay and several others draw on oral histories we conducted as part of the L.A. Rebellion exhibition project, valuable sources of information and insight shared by members of this pioneering group of film-makers.[67] We include excerpts from the oral histories on a variety of topics to give readers a sense of the diversity of the filmmakers' experiences and voices. The book also features the most comprehensive filmography and bibliography on the L.A. Rebellion published to date.[68] The bibliography includes scholarly works as well as key writings about the group in nonscholarly sources (trade publications and journalistic sources). We have also included a large number of illustrations—including frame enlargements, production stills, publicity materials, and other primary documents—most published here for the first time. Our hope is that the contents of this book will inspire ongoing viewing and reflection, not only by presenting new facts and flagging research resources about the L.A. Rebellion, but also by suggesting new frameworks for understanding the lives and times, the work and legacy of this pioneering group of Black artists.

. . .

A recent article in the *Washington Post* profiling the breakout Black cinematographer Bradford Young notes that he was a student of Haile Gerima's at Howard University and has deeply internalized the lessons Gerima imparted about the politics and aesthetics of Black filmmaking. Linking Young to other celebrated cinematographers who studied at Howard during Gerima's tenure there as a professor—Arthur Jafa and Ernest Dickerson—the *Post* writer calls this group "the Howard Continuum," a "bona fide successor to the L.A. Rebellion."[69] This recognition of the L.A. Rebellion as a coherent and generative force by the mainstream press is instructive. It indicates the mainstream appeal of "catchy historical labels" that worried Clyde Taylor. At the same time, it suggests how we might chart what Taylor calls in his preface the "radioactive" quality of the L.A. Rebellion, its ongoing capacity to inspire new cinematic thinking and practices far beyond the UCLA campus.

It is also important to remember that the L.A. Rebellion, as we discuss it here, has a significant legacy at UCLA itself. Teshome Gabriel continued teaching until his death in 2010 and mentored many students of color in the PhD and MFA programs. Many of the figures who were

prominent in the 1970s and 1980s are still involved in the life of the department, including long-term faculty and former students who became staff members. Some Black filmmakers, like Cauleen Smith, chose to study at UCLA because of the rich legacy of the L.A. Rebellion. Yet, we should be cautious in presuming continuity in the styles and politics of Black students across cohorts. Many students that entered the film school in the 1990s and beyond were not aware of the previous generation of UCLA Black film students or of the pioneering work of Elyseo Taylor and others. Whether UCLA-trained Black filmmakers like Dawn Suggs, Nicole Jefferson, Désha Duncan, Brian Gibson, and Gina Prince-Bythewood should be considered in relation to the L.A. Rebellion is an open question.

The "radioactive" quality that Taylor identifies in the L.A. Rebellion could also be ascribed to the intersections of filmmaking and education. Consider how many of the L.A. Rebellion artists have taught film and media as university faculty (Haile Gerima, Ben Caldwell, and S. Torriano Berry at Howard; Billy Woodberry and Ben Caldwell at CalArts; Zeinabu irene Davis at UC San Diego; Larry Clark at San Francisco State; Carroll Parrott Blue at San Diego State and the University of Houston; Iverson White at the University of Wisconsin–Milwaukee; Gay Abel-Bey at NYU; Barbara McCullough at the Savannah College of Art and Design), as visiting artists (Julie Dash and Charles Burnett teach workshops at universities around the country), and in K-12 institutions (Alile Sharon Larkin and Melvonna Ballenger at 32nd St/USC Visual and Performing Arts Magnet School; O.Funmilayo Makarah in the Humanitas Program serving Los Angeles public schools). The transmission of knowledge taking place through these formal educational channels has as much, if not more, potential to generate ongoing critical and imaginative work with regard to the racial politics of cinema than the increased circulation of L.A. Rebellion works.

In their rethinking of what "collectivity" means for contemporary Black artists, Huey Copeland and Naomi Beckwith observe that it is instructive to understand "how collectives come together and fall apart politically and affectively."[70] This book seeks such an understanding of the origins, activities, and dispersion of the L.A. Rebellion group, of the relationships between "I" and "we" that have shaped their experiences and work as socially conscious Black film and video artists. As the following pages demonstrate, the L.A. Rebellion is a film movement that still carries potent political and affective charges long after its participants convened on the UCLA campus.

NOTES

Epigraph: Ben Caldwell, oral history interview by Allyson Field and Jacqueline Stewart, June 14, 2010, L.A. Rebellion Oral History Project, UCLA Film & Television Archive (hereafter LAROH).

1. Ntongela Masilela, "The Los Angeles School of Black Filmmakers," in *Black American Cinema,* ed. Manthia Diawara (London: Routledge, 1993), 107–17. See also Ntongela Masilela, "Women Directors of the Los Angeles School," in *Black Women Film and Video Artists,* ed. Jacqueline Bobo (London: Routledge, 1998), 21–41; and Ntongela Masilela, "The Los Angeles School," *IJELE: Art eJournal of the African World* 5 (2002), www .africaknowledgeproject.org/index.php/ijele/article/view/784.

2. Barbara McCullough, oral history interview by Jacqueline Stewart and Jan-Christopher Horak, June 8, 2010, LAROH.

3. Barbara McCullough and Julie Dash explicitly articulated this allegiance in an interview for the UCLA TV show *Convergence.*

4. Ultimately, the L.A. Rebellion artists did not form lasting collective mechanisms for funding and showing their work; though they worked as crew on each others' films, they largely shepherded the financing and distribution of their own projects individually. Bernard Nicolas and Haile Gerima spearheaded distribution initiatives.

5. Pacific Standard Time project, www.pacificstandardtime.org.

6. Clyde Taylor, "The L.A. Rebellion: A Turning Point in Black Cinema," in *Whitney Museum of American Art: The New American Filmmakers Series 26* (New York: Whitney Museum of Art, 1986), 1–2.

7. See Daniel Widener, *Black Arts West: Culture and Struggle in Postwar Los Angeles* (Durham, NC: Duke University Press, 2010).

8. Elyseo Jose Taylor, "Mass Media and the Social Dialogue, One Experience," paper presented at The Role of the Mass Media in Enlisting Public Support for Marginal Groups conference, European Centre for Social Training and Research, sponsored by the United Nations, at the Rockefeller Foundation Study and Conference Centre, Bellagio, Italy, September 20, 1976, p. 4. Many thanks to Renate Taylor for sharing a print copy of this paper, a revised draft dated May 3, 1977.

9. Paul O. Proehl to Professor Colin Young, Chairman, April 23, 1969, UCLA University Archives, Young Research Library.

10. [Steering Committee on urban and minority problems] to Chancellor Charles E. Young, "Preliminary Report on Summer Activities," September 30, 1968, 1; Minutes of the President's Council of Chancellors, January 7, 1969, both in UCLA University Archives, Young Research Library; Charles Z. Wilson, *Crossing Learning Boundaries by Choice: Black People Must Save Themselves, a Memoir* (Bloomington, IN: Authorhouse, 2008), 300.

11. Wilson, *Crossing Learning Boundaries by Choice,* 302–3.

12. Elyseo J. Taylor, "Appendix C, Media Urban Crisis Staff Report," December 2, 1969, UCLA University Archives, Young Research Library; "UCLA Students Will Film Aspects of Ghetto Life as Means to Dialog," *Los Angeles Times,* January 4, 1970, W10.

13. "Summary of Projects by Campus," *University Bulletin: A Weekly Bulletin for the Staff of the University of California* 18 (July 1969—June 1970): 85. The first students accepted into the program were "AFRO-AMERICAN; James Johnson, Rufus Howard, Wendel Handy, [Clifford] Stewart and [Richard] Wells; AMERICAN INDIAN; Tom Nelford, Sandy Johnson, Ted Hollappa, Lorene Bennett, Arch Henry White; ASIAN AMERICAN; Yasu Osawa, Danny Quan, Ernest Harada, Daniel Norbori, Peter Takeushi; MEXICAN AMERICAN; Moctezuma Esparza, Xavier Reyes, Francisco Martinez, Gloria Gutierrez, David Lazarin." Elyseo J. Taylor, "Appendix B, Media Urban Crisis Staff Report," December 2, 1969, UCLA University Archives, Young Research Library.

14. Elyseo J. Taylor, "Media Urban Crisis Staff Report," p. 8, December 2, 1969, UCLA University Archives, Young Research Library.

15. "UCLA Students Will Film Aspects of Ghetto Life as Means to Dialog," *Los Angeles Times*.

16. Paul O. Proehl to Henry W. McGee Jr., Emmett S. Oliver, Yuji Ichioka, Gilbert P. Garcia, March 18, 1970, UCLA University Archives, Young Research Library.

17. David S. Saxon, Vice Chancellor, to J.W. Robson, Administrative Officer, Admissions Office, January 12, 1970; Charles Z. Wilson to Dean H. Carroll Parish and Assistant Dean Martha E. Johnson, April 20, 1970, both in UCLA University Archives, Young Research Library.

18. Taylor, "Media Urban Crisis Staff Report."

19. Charles Z. Wilson to David S. Saxton, June 10, 1970, UCLA University Archives, Young Research Library.

20. Henry W. McGee Jr., Emmett S. Oliver, Yuji Ichioka, Gilbert P. Garcia to Paul O. Proehl, Vice Chancellor, March 16, 1970, UCLA University Archives, Young Research Library.

21. Taylor, "Appendix C, Media Urban Crisis Staff Report."

22. Larry Clark, oral history interview by Jan-Christopher Horak and Jacqueline Stewart, June 2, 2010, LAROH. The nickname equated Clark with the brutal dictator of Haiti, François "Papa Doc" Duvalier.

23. Charles Burnett, oral history interview by Allyson Field and Jacqueline Stewart, June 7, 2010, LAROH; and Clark, oral history.

24. The African students included Teshome Gabriel, Omah Diegu (Ijeoma Iloputaife), Ruby Bell-Gam, Karen Guyot, Akintunde Oguleye, and Bethelehem Teshayu.

25. Haile Gerima, oral history interview by Jacqueline Stewart, Allyson Field, Jan-Christopher Horak, and Zeinabu irene Davis, September 13, 2010, LAROH.

26. Abdosh Abdulhafiz, oral history interview by Allyson Field, October 15, 2010, LAROH.

27. Jamaa Fanaka, oral history interview by Allyson Field, Jan-Christopher Horak, and Jacqueline Stewart, June 16, 2010, LAROH.

28. Billy Woodberry, oral history interview by Jacqueline Stewart, June 24, 2010, LAROH.

29. Caldwell, oral history.

30. Bernard Nicolas, oral history interview by Allyson Nadia Field, Jan-Christopher Horak, and Jacqueline Stewart, January 23, 2010, LAROH.

31. Don Amis, oral history interview by Jacqueline Stewart, November 2, 2010, LAROH.

32. Robert Wheaton, oral history interview by Jacqueline Stewart, August 30, 2011, LAROH.

33. O.Funmilayo Makarah, oral history interview by Jacqueline Stewart, May 29, 2011, LAROH.

34. Alile Sharon Larkin, oral history interview by Jan-Christopher Horak and Shannon Kelley, June 13, 2011, LAROH.

35. Julie Dash, oral history interview by Allyson Field, Jan-Christopher Horak, and Jacqueline Stewart, June 8, 2010, LAROH.

36. Makarah, oral history.

37. McCullough, oral history.

38. Carroll Parrot Blue, oral history interview by Allyson Field and Jacqueline Stewart, June 23, 2010, LAROH.

39. Stormé Bright Sweet, oral history interview by Jacqueline Stewart and Jan-Christopher Horak, August 23, 2011, LAROH.

40. Jacqueline Frazier, oral history interview by Jacqueline Stewart and Jan-Christopher Horak, August 29, 2011, LAROH.

41. Shirikiana Aina, oral history interview by Jacqueline Stewart, May 27, 2011, LAROH.

42. Zeinabu irene Davis, oral history interview by Jacqueline Stewart and Allyson Field, June 24, 2010, LAROH.

43. The quotation in the section title is from Taylor, "The L.A. Rebellion: A Turning Point in Black Cinema." In his published gallery talk, Taylor wrote, "To this day, among the films of the black independent movement, those coming out of the Los Angeles Rebellion stand out for the assurance with which they say 'black cinema spoken here!'"

44. While gay characters are seen at the margins of Fanaka's *Penitentiary* films, the L.A. Rebellion filmmakers almost never explored lesbian, gay, bisexual, transgender (LGBT) issues, a glaring omission that deserves further consideration.

45. Cynthia Young, *Soul Power: Culture, Radicalism, and the Making of a U.S. Third World Left* (Durham, NC: Duke University Press, 2006).

46. Ibid., 239.

47. Nicolas, oral history.

48. Eula Love, a thirty-nine-year-old widow and mother of three with a delinquent gas bill, was shot eight times in her front yard by the LAPD for brandishing a knife. The actions of the police were deemed appropriate and the officers were not indicted, despite public outcry and mass protests.

49. Caldwell, oral history.

50. Much of the basic research for this section is indebted to Moving Image Archive Studies graduate student Kevin McMahon, who compiled a 1975–96 exhibition chronology for Allyson Nadia Field's seminar (FTV 221) in spring quarter 2011.

51. Barbara McCullough, oral history; Julie Dash, oral history. Also see the festival program.

52. See the Black Filmmaker Foundation (BFF) website, accessed January 17, 2014, at www.dvrepublic.com/about.php.

53. Caldwell, oral history.

54. In the 1990s and the decade after 2000, both Burnett and Dash worked sporadically for public and commercial television. For example, Burnett's *Nightjohn* (1996) and Dash's *Funny Valentines* (1999) were produced by the Disney Channel and BET, respectively.

55. Nicolas, oral history.

56. "UCLA Film & Television Archive—L.A. REBELLION," implementation grant application, Pacific Standard Time program, Getty Foundation, 2010.

57. Rex Weiner, "Straight as an Arrow," *Daily Variety,* July 25, 1995.

58. Clyde Taylor, "The Next Wave: Women Film Artists at UCLA," *Black Collegian* (1980): 12; Clyde Taylor, "Decolonizing the Image: New U.S. Black Cinema," in *Jump Cut, Hollywood, Politics and Counter-Cinema,* ed. Peter Steven (Toronto: Between the Lines, 1985), 166–78.

59. Clyde Taylor, "The L.A. Rebellion: New Spirit in American Film," *Black Film Review* 2, no. 2 (1986): 11, 29; Monona Wali, "LA Black Filmmakers Thrive Despite Hollywood's Monopoly," *Black Film Review* 2, no. 2 (1986): 10.

60. Ed Guerrero, *Framing Blackness: The African American Image* (Philadelphia: Temple University Press, 1993), 137.

61. Paula J. Massood, *Black City Cinema: African American Urban Experiences in Film* (Philadelphia: Temple University Press, 2003), 107.

62. David James, *The Most Typical Avant-Garde: History and Geography of Minor Cinemas in Los Angeles* (Berkeley: University of California Press, 2005), 326.

63. Ibid., 335.

64. Caroline Frick, *Saving Cinema: The Politics of Preservation* (New York: Oxford University Press, 2011), 6.

65. Also presenting at the symposium were UCLA film school alumni Monona Wali (an L.A. Rebellion classmate), filmmaker and visual artist Cauleen Smith (who completed her MFA at UCLA in 1998), and historian Daniel Widener.

66. Most titles can be viewed at the UCLA Film & Television Archive.

67. The full oral histories are available at the Getty Research Institute as well as the UCLA Film & Television Archive.

68. The L.A. Rebellion website also has filmography information and other resources: www.cinema.ucla.edu/la-rebellion/story-la-rebellion.

69. Ann Hornaday, "Howard University Has Become Incubator for Cinematographers," *Washington Post,* January 28, 2014.

70. Huey Copeland and Naomi Beckwith, "Black Collectivities: An Introduction," *Nka: Journal of Contemporary African Art* 34, no. 2 (2014): 6.

Critical Essays

Threads and Nets

The L.A. Rebellion in Retrospect and in Motion

CHUCK KLEINHANS

We're looking at a dynamic network that changed over time. Some of the threads have been severed and some of the nodes forgotten. To get a full, rich picture, we need to see as much as possible. I'm guided here by several questions. What produced the L.A. Rebellion? What has happened since the zenith of the Rebellion? What have we learned that we didn't know then? And how can we come to a better understanding of a specific political media movement to in turn better understand how to use art and culture activism in the future?

We can start by asking, what were the reasons for creating a new Black cinema? The answer seems fairly clear. Hollywood film did present African Americans, but largely as stereotypes, and despite the efforts of talented actors, creative sensibility seemed to stay within a white liberal orbit at best and always within a commercial entertainment imperative. Some arthouse films and the social documentary tradition provided a more serious perspective, but Blacks seldom had full creative control of such projects. Against this backdrop, it seemed that an alternative cinema with African American creative control could serve the Black community's rising expectations unleashed by the civil rights movement.

At the time, the 1970s and early 1980s, there was an expectation, a hope, a utopian desire, a pragmatic assessment that together advanced the idea of a distinct African American filmmaking, grounded in the maker's vision and integrity and speaking to a self-conscious and aware

social and political movement for Black liberation. By and large this would be a realist cinema, a continuation of neorealism, independent of the Hollywood studio system and the demands of entertainment media. The L.A. Rebellion films seemed to fit that hope, which was really an aspiration of young filmmakers and filmmakers-in-training. Following their work were some critics and intellectuals: Some of them journalists, some academics, some programmers and festival organizers or curators. And on the edge, some publicists, distributors, and exhibitors. And a few, very few, funders.

That model or hope fell apart in history and the encounter with the real world. In part this occurred because of a flawed analysis of actual conditions. In part it happened because other forces were in operation, still emerging at that point, that could not be easily foreseen. And in part this occurred because although hopes and dreams are necessary to take on the difficult task of making films and building a distinct film culture, they are not enough to sail against the storms of history. It pays to look at the past and what happened, not to rewrite heroes and villains to our liking, and not to assign blame, but to better understand what can be accomplished in terms of building a vibrant media counterculture the next time. So: some lessons.

THE DREAM OF AN AUTONOMOUS AFRICAN AMERICAN FILM CULTURE

Understanding the complexities of an essentially industrial art takes time and experience. As students and young adults, the L.A. Rebellion participants were in process, and part of that process included a heavy dose of utopian optimism. That is normal and a basic element of any arts education. Using delayed gratification to accept postponed goals, developing artists have high hopes and a few blind spots. For the student filmmakers, some economic realities were bracketed: equipment and facilities were provided at school; cast and crew lived at home or in low-rent student situations and they would crew for each other for free; and by not promptly finishing your degree or continuing on as an adjunct teacher or staff person, you could maintain access to equipment, facilities, and other campus amenities for years. All of which gained synergy by student artists romanticizing the possibilities, especially if writing and directing dramatic feature films was the goal. But there were alternate ways. Some aspired to working in documentary modes where a fairly stable set of diffusion institutions existed: television, the educational market, established and new startup distributors

and exhibitors, and so forth. And there was a small but established space for artisanal artistic experimentation media.[1]

The dream of an autonomous African American cinema was not just a matter of pragmatics. It also involved positive projection into the future. The major energies unleashed by the civil rights movement invigorated Black arts, in turn inspiring a new generation to cultural production. We now have a better assessment of how the post–civil rights activities turned out, which will be detailed later in this essay, but we can note here that the general harmony and unity of struggle for civil equality helped feed an optimistic view of the future. And new laws, policies, and initiatives for affirmative action opened doors. Given previous exclusion, younger artists pushed for new efforts. They aimed at independent achievement, autonomy rather than simple integration. And critical intellectuals shared and promoted this viewpoint. The default perspective took for granted that there was a coherent community that wanted and would support an alternative to mass consumer culture. And while there were differing degrees of emphasis on nationalism, Pan-Africanism, and other issues, the idea of a core community still held.

BLACK CINEMA: THE CONCEPT

Thinking about Black cinema by the major stakeholders (aspiring makers and culture activists) was framed by established ways of thinking at a time when underlying conditions were rapidly changing. There's no blame here; it is a condition of many social situations. But in the L.A. case, it was also colored by the influence of Third World students being present and by the interests of critical thinkers who shaped disparate people, objects, and events into a synthetic whole for persuasive purposes.

Throughout this period, by and large the critical thinkers of the L.A. Rebellion (both makers and critics) did not deal realistically with the nature of film viewing in the African American community. While dismissing Hollywood film as ideologically corrupt, they did not account for the mass audience's actual cinematic experience, which was primarily using cinema for entertainment in available leisure time. Jamaa Fanaka provides the exception to the rule, and his pursuit of action genres was cleverly attentive to community habits (and markets). But it is notable that much of the L.A. Rebellion corpus conspicuously avoids the three most common paths for Black performers to gain an audience:

sports, music, and comedy. The 1970s witnessed an expansion of celebrated African Americans in college and professional sports, while the rising visual presence of Black music, in particular in music videos once Michael Jackson broke the color barrier on MTV in 1983, and of Black comedy, both acerbic stand-up (Richard Pryor) and mild middlebrow (Bill Cosby), found a welcome home in the times.

While it is easy to understand the aspiration for university-educated young artists to produce work that is serious and social in intent, often this work fails in the mass media marketplace. Where the educational and communication function can successfully fuse is in a different sector, one aimed at education and community. But this has remained an undervalued, understudied, and undertheorized part of African American media activity.[2] Actually, by going outside of the Rebellion moment, one can find a range of successful Black professionals working in the range of journalism, television, and the educational film market.[3]

THIRD CINEMA AND INDEPENDENT BLACK FILM

The L.A. Rebellion has come to be seen as a highpoint of the U.S. Black film movement, but that special attention has oversimplified the history, the context, and the development of critical thinking about African American cinema in general and the L.A. Rebellion in particular. The Rebellion's foundational theoretical perspective was embodied in the idea of Third Cinema, thanks largely to the central position of the faculty member Teshome Gabriel as a teacher of film history and criticism at UCLA in those years. Born in Ethiopia, he maintained strong ties with African filmmakers in particular, while being especially critical of Hollywood cinema. Gabriel's own book, his classes on cinema and social/political change, his connections with international filmmakers, and his screenings of Third World film provided a rich basis for developing a political aesthetics.[4] But it must be understood that Third Cinema as originally conceived in Latin America was a militant and oppositional cinema, a revolutionary one. And that presumed both a specific political movement and a coherent community that the makers and films were speaking from and to.[5] First, these conditions were not really in place in the United States in the 1970s. The unity of the civil rights movement had fractured into the Black Power era with different and often competing organizations and agendas.[6] The Black Arts movement of the 1960s also faded. Of course examples from abroad, especially Africa and Latin America and the Caribbean, were inspirational. But they were not

FIGURE 1.1. *To Sleep with Anger* (Dir. Charles Burnett, 1990).

always useable models for new work by U.S. filmmakers and taken together did not form a coherent whole.[7] And the original center of Third Cinema was documentary film, militant and oppositional, in the United States probably best embodied in the Newsreel groups.[8] In an expanded view, Third Cinema could encompass a wider range of politically progressive film, but the films then did not fit a formula.

In the process of branding the phenomenon the "L.A. Rebellion," a residual nationalist identity politics pushed to frame the body of work in terms of the maker's race and ostensible intentions. Yet this abstracted the films from a broader history of progressive political films dealing with race. A polemical stance for independence and against Hollywood (especially the Blaxploitation cycle) left hanging any accommodation with entertainment and the urban mass audience.

With the archival process underway, we can see the Rebellion as including a broad cluster of works, often short documentary, experimental, poetic, and essayistic films that show considerable diversity in themes and modes.[9] But in critical discourse, the L.A. Rebellion is best known for developing an auteurist dramatic-feature Second Cinema for the arthouse and niche market. Charles Burnett's *Killer of Sheep* (1977)

and *To Sleep with Anger* (1990), Julie Dash's *Illusions* (1982) and *Daughters of the Dust* (1991), and Haile Gerima's *Bush Mama* (1975), *Ashes & Embers* (1982), and *Sankofa* (1993) have been esteemed, taught, programmed, and written about as artistic independent achievements by makers who are singular writer-director creative artists.

IN ITS OWN TIME

It is useful to consider the L.A. Rebellion in terms of the larger national context of African American filmmaking at the time and also in relation to parallel or connected attempts to build distinct independent cinema sectors such as Latino, Asian American/Pacific, feminist, gay and lesbian, and experimental. In the late 1960s there was a national push for admission of minorities into public higher education, with its own particular character in L.A. and at UCLA. There was a group of eager future filmmaker students, who were highly motivated. And all this formed a distinctive local history in what is, after all, an entertainment industry town.

In June 1982, John Hess and I interviewed several key people for research on Los Angeles Black, Chicano, and Asian alternative filmmaking since the 1960s. As two of the *Jump Cut* co-editors we'd been following this development in articles and reviews we'd published. By meeting with people involved with the emergence of a new political film culture, such as at the Alternative Cinema Conference in 1979, we were eager to learn more about what was going on, and it was clear that L.A. was a very active area.[10]

We interviewed Teshome Gabriel, who had been teaching Third World cinema at UCLA since the mid-1970s and whose dissertation on Third Cinema in the Third World was about to be published as a book. Partway through the interview, we were joined by Dick Hawkins, a UCLA faculty member who was familiar with the earlier and later history. We also had the opportunity to interview filmmaker Charles Burnett, who was in production of his second feature-length film, *My Brother's Wedding* (1983), and Jesus Trevino, filmmaker and organizer of the Chicano Cinema Coalition. More views were added by Jason Johansen, a former UCLA student in the 1970s who at the time was an active critic and writer on Chicano film. Robert Nakamura, a UCLA film-production faculty member, co-founder of Visual Communications and co-director of the feature *Hito Hata: Raise the Banner* (1980), had been present at the beginnings of the movement for Third World independent film in Los Angeles. Nancy Araki, director of Visual Com-

munications, discussed the history and activities of the Asian Pacific visual media center that she led. In addition, Claudia Springer and I interviewed filmmaker and former UCLA student Melvonna Ballenger.[11]

Our interviewees concentrated on telling the history of each separate group. John and I saw many parallels and similarities among the stories, certain things that were mentioned that resonated with the concerns of others we interviewed. We could also draw on our knowledge of other independent filmmaking groups around the country.

Most importantly, we found a pattern of development among politically oriented media groups. In the context of a larger social and political movement for change, some experienced activist media people were joined by other new folks with politically engaged backgrounds. And new energy appeared in the form of students just beginning their studies. Together, they saw a common purpose. By and large, they were already closely related to the community and active in a period of intense effort. In Los Angeles this was specifically the demand for increased minority enrollment at UCLA, which was related to other areas of struggle within higher education institutions such as establishing African American studies and Chicano studies.[12] These folks came together to get some access to (a) training, gaining skills in media work; (b) equipment and facilities; and (c) in some cases money for production (but this varied a lot). At the same time, these people were exposed to other kinds of films than the commercial or mainstream norm, in particular to the new wave of Third World films connected to post–Word War II national liberation struggles.

The participants made films, typically short documentaries that were closely related to what was happening in the communities they came from. In the process the whole group learned a lot, typically working together in a variety of ways to give each other support. At a certain point of development, there was often a desire to form a "collective" organizational form, although the exact meaning of this and participation in it varied substantially and evolved over time.[13] This formal or informal collective had problems and eventually fell apart or drastically changed.

The evolution or devolution had different aspects. Often there were different levels of skills and experience within the group. There were often different political or ideological positions: at the time, feminism and gay issues challenged some old-guard attitudes. And there were changes in individuals. As the first group of activists matured professionally, members had other obligations and wanted to do other projects.

Yet newcomers to the group still needed be taught so they could participate. The result was a cycle that some individuals found hindered their own professional development, while others were comfortable with always teaching newbies. Other significant changes occurred as economic and family life changed. As people established financial and personal relations, such as having children or taking on other responsibilities, they found they could not easily continue to live in the student or bohemian lifestyle they had when starting out. Within the group, some people advanced professionally and some didn't. Those who remained static sometimes seemed jealous of those who moved on. Those who succeeded could be seen as too ambitious, overly competitive, or separating from the group's original goals. Class, race, and gender privilege was often involved as well. People with an advantaged background may have had more resources to fall back on, or someone may have been supported by a successful partner who cushioned the hard times.

Of course, over time, one is in a different historical moment, a different set of circumstances created by matters beyond one's own control. The histories of almost all social-political projects in modern societies show similar patterns of initial growth and change, withering into decay or transforming into institutionalized and far less radical stability. For minority media groups, the initial organizing involved optimistic struggle that exhibited incredible amounts of human energy. In her retrospective look at the UCLA Ethno-Communications Program, Renee Tajima found that the 1968–74 years produced a profound change, but with uneven results.[14] Chicano and Asian American veterans of the early years were able to establish continuing organizations; Blacks were not as well organized.

Since the 1970s another development has affected the terrain for understanding Black cinema. Critical thought has expanded and gives the audience a much greater range of understanding and engagement with film. The call for a totally independent Black cinema assumed, at heart, that cinema simply delivered a message. At its crudest this was a variant of the "hypodermic needle" model of how film affects audiences: directly injecting ideology into viewers unable to resist. The basis of most censorship activities in film history, this indoctrination assumption used the "image of" model in which negative images were condemned and positive images celebrated: the sort of thing that was popularized by Donald Bogle's widely read study of Hollywood racism, *Toms, Coons, Mulattoes, Mammies, and Bucks* (1973). Those calling for an independent Black cinema counterposed their ideal to the domi-

FIGURE 1.2. Production photograph, *As Above, So Below* (Dir. Larry Clark, 1973). Collection of Larry Clark.

nant Hollywood model. Even in its most sophisticated forms, the advocacy for an alternative was based in suspicion of the emotional effects of the studios' dramatic fiction features.[15]

Two different aspects are at work here. One, some of the L.A. Rebellion filmmakers did aspire to making dramatic features, and while they were "different" than the studio norm at the time, in retrospect they are clearly examples of arthouse auteurist Second Cinema. Gerima's *Ashes & Embers* follows a well-known subgenre: the life of a traumatized returned veteran. Dash's *Illusions*, intended as a critique of Hollywood's racism, though short, works formally and narratively within the common standards of a Hollywood picture.[16] Their later features, *Sankofa* and *Daughters of the Dust*, respectively, fall well within the by then familiar arthouse/Sundance indie market sector, and Burnett's *To Sleep with Anger* is a low-budget Hollywood feature. While these films mark a maturing of the L.A. Rebellion, around the same time the commercial sector saw the increasing presence of Black-directed features aimed primarily at an African American audience, though with crossover in mind: Reginald Hudlin, *House Party* (1990); Mario Van Peebles, *New Jack City* (1991); John Singleton, *Boyz n the Hood* (1991); Bill Duke, *A Rage in Harlem* (1991); Spike Lee, *Jungle Fever* (1991); Carl Franklin, *One False Move* (1992) and *Laurel Avenue* (1993); the Hughes brothers, *Menace II Society*

(1993).[17] These films' and filmmakers' presence knocked one leg off the argument that Blacks were excluded from directing mainstream commercial films.

The second factor was an increasing awareness in the 1970s and 1980s among critical thinkers that the "meaning" of a film was not simply a given thing contained by an aesthetic package, but rather meaning was generated by a dynamic process of the audience reading a film. Audiences didn't simply consume messages; they interpreted what was at hand and often subverted or reframed what might appear to be dominant. The field of cultural studies developed and flourished within this new understanding. In particular, key feminist and gay analysts showed how audiences can produce new meanings. And these ideas also opened up new ways of thinking about how African American viewers responded to films. It is worth thinking this through more rigorously, and a younger generation of critics have begun with a much greater awareness, using insights from cultural studies analyses and audience studies.[18] A good reference point for this situation was the controversy surrounding Steven Spielberg's film version of Alice Walker's novel *The Color Purple* (1985). Predictably, the film was heavily criticized by some Black male writers in particular for presenting images of Black misogyny as well as for being directed by a white man.[19] Yet the film was generally well received in the Black community and both defended and criticized by African American feminists. Jacqueline Bobo's "Black Women's Responses to *The Color Purple*," discusses the film in terms of reader-response analysis to show how and why the film provoked a community response.[20]

COMPLEX NETWORK

In revisiting the past, we should also be alert to seeing a much more complex network and web of relations vis-à-vis other cinemas in considering the L.A. Rebellion. A useful conceptual grid would include the fact of a diverse range of political and socially progressive cinema arising in the 1960s. In the United States this would have to include the social documentary tradition, the realist and neorealist drama, the post–World War II social problem film, countercinema, and the political thriller. And it would have to note some remarkable independent films dealing with race: Lionel Rogosin's *Come Back, Africa* (1959); John Cassavetes's *Shadows* (1959); Shirley Clarke's *The Connection* (1961), *The Cool World* (1963), and *Portrait of Jason* (1967); and Michael Roemer and Robert M. Young's *Nothing but a Man* (1964).[21]

In addition, it would recognize the interweaving of progressive politics of the era: anti–Vietnam War, civil rights, antinuclear and peace, anti-imperialist, the student movement, and the counterculture. A steadily increasing access to films from and about the developing world provides another strand, especially in the frame of national liberation, decolonization, and democracy.

Another important critical adjustment has to involve seriously reconsidering the critical and theoretical issues pursued at the time.[22] For example, the exchange by Julianne Burton and Gabriel on critical theory in relation to Third World film and a later exchange on presumed limits to or flaws within U.S. Black filmmaking by Clyde Taylor, David Nicholson, and Zeinabu irene Davis were somewhat careless and over-heated, but the central issues can still face useful reconsideration.[23] Revisiting some other past matters could also be productive, such as the original focus on theatrical film while disregarding the medium of video and the fact of television production as an important place for Black expression. And no one seems to have noticed that the L.A. school never produced a comedy: why?[24]

BLACK FILM AUDIENCE AND THE AUDIENCE FOR BLACK FILMS

We now have a much better perspective on the nature of the Black film audience. For several understandable reasons, during the L.A. Rebellion members of the group and proponents of their work tended to simplify the notion of "the Black audience." This assumed that everyone in the audience was essentially the same and had the same interests: thus filmmakers went about making "our films," about "our lives," for "our audience."

However, that analysis was flawed, in its own time and as social and economic changes continued. As Ed Guerrero has pointed out in his crucial essay "A Circus of Dreams and Lies: The Black Film Wave at Middle Age," the African American audience has changed and evolved since the early 1970s Blaxploitation era.[25] The theatrical audience has shifted to a younger crowd, and the rise of the indie film sector, and the vast expansion of home viewing through VCRs/DVDs/cable TV/streaming creates a vastly different situation. Even more crucially, the Black community once conveniently thought of as a singular unity now appears diversified (and sometimes antagonistic) around class, gender, education, historical experience, and generational lines.

One positive and productive way of thinking and using the concept of the "L.A. Rebellion" rests in the knowledge that for the immediate

participants, those present at the formation and continuation, it made sense as a lived concept, a perceived bond, a common experience in a shared historical moment. If we add to this considerable changes in film economics and distribution, we can get a better purchase on the question. While the breakdown of the old studio system in the 1960s created a newer space for Hollywood mavericks in the 1970s, the industry recouped itself with the blockbuster formula High Concept film and increased its base in television. In the 1980s, money was increasingly made downstream rather than in theatrical release.[26] By the early 1990s, Hollywood earned over half of its theatrical receipts overseas. The conventional thinking in the business was that Black actors and Black-themed narratives were seldom viable in overseas markets, thus limiting financing for such projects.[27]

As I've argued here, the current commonplace understanding of the L.A. Rebellion centers on a few very talented directors best known for their feature films. And those films tend to be ones that can be readily identified with established and consecrated cultural concerns: the idea of Third Cinema, the world of indie features, the expressions of Black feminism, the continuing validation of neorealist aesthetics, the mythic resonances of Africa's global diaspora. What I've tried to explain is that we are better served by a richer and more extensive way of thinking about both makers and films. I'll extend that by discussing three different and distinct figures who participated in the UCLA moment but whose subsequent careers were distinctly framed within communities: Don Amis, Carroll Parrott Blue, and Ben Caldwell.

DON AMIS

Don Amis was born and raised in Philadelphia, coming to UCLA in 1970 as part of a program to enroll talented minority students. In 1974, as an undergraduate, he directed *Ujamii Uhuru Schule Community Freedom School,* a short documentary about an Afrocentric inner-city primary school. His MFA film, another documentary, depicts an annual parade and celebration of community-based artists who make masks. Amis returned to Philadelphia and worked on educational programs, public-service projects, and documentaries for the Commonwealth Media Service and with WHYY, the Philadelphia PBS station. Thus his creative work during the Rebellion period and his subsequent career were grounded in community concerns and values.

Festival of Mask (1982) depicts an annual community arts parade and celebration that takes place every late October at Hancock Park in

FIGURE 1.3. *Festival of Mask* (Dir. Don Amis, 1982).

L.A. Shot and edited in a fairly conventional style, the film begins with mask-making activities in different places, such as Day of the Dead preparations at an East L.A. center, and then moves on to a parade populated by people from local community art centers, children from different schools, clowns and professional or semiprofessional performers, all enjoying the chance to show off their creations. A female voice-over provides basic background information. When we arrive at the fair we find a variety of activities and a lot of cross-cultural exchange. There are food stands with items such as Thai barbeque and Ethiopian stew, and the customers seem to be sampling a foreign cuisine. Many different mask types and techniques are shown, usually with a synchronous sound presentation by the maker: carving from wood, making from steel, face painting and makeup, leather, papier-mâché, gourds. Various performance activities are shown: an actor training program, commedia dell'arte, Ghana drummers, Japanese dance, Chinese Dragon dance, and a mix of traditional forms such as Korean and Thai theatrical dance and hybrid forms of theater and dance borrowing from tradition. The overall mood of the film is genial fun, and the repeated depiction of a cultural combination across ethnic/racial/cultural lines reinforces the sense of a diverse and interactive community.

The film continues the founding mood of the UCLA Ethno-Communications Program, the forerunner of the L.A. Rebellion era, in stressing the mixed diversity of the community, and the film functions as an endorsement of the festival's sponsor, the L.A. Craft and Folk Art Museum. In its own time, *Festival of Mask* celebrates different ethnic and national traditions, shows cultural mixing; it stands at a different point than Don Amis's earlier undergraduate film, *Ujamii Uhuru Schule,* which presented an Afrocentric alternative school, cutting images of student activities against an extremely didactic voice-over by the school's director. In the earlier film, boys are shown in martial arts training. Without synch sound footage of classroom activity, the film (perhaps inadvertently) seems to show the students simply affirming Afrocentric slogans and motifs rather than developing an understanding. To a skeptical viewer, the images can be taken to show indoctrination rather than learning. The film presents a strong case for separation and nationalism (in the form of a rather vague and eclectic Pan-Africanism) that articulates a somewhat dogmatic and exclusionary view.[28] The later film avoids sloganeering and highlights cross-cultural encounter as a positive thing. But both films serve well as basic off-site public relations introductions to the institutions they represent: an inner-city school with a specific cultural orientation; a museum with a notable annual public event. Just the sort of thing that can be used by an official spokesperson in informing or fund-raising: pragmatic, useful, serviceable, and something that can be seen again and again. It's sometimes forgotten in the rush to affirm Art that media arts are always defined as well by Communication.

Taking the long view of Amis's UCLA films we can see them as rather typical student projects: undergrad and MFA. They set him up to have a career in media production aimed at education, media service, and public-sector communication: backstage, out of the spotlight. And thus Amis is not a suitable subject for grandstanding proclamations about revolutionary Third Cinema, but a productive and responsible craftsperson serving the public good.

CARROLL PARROTT BLUE

Carroll Parrott Blue's work is also closely tied to community, but in a different way. Arriving at the UCLA program in 1976, Blue was already an accomplished photographer whose photojournalism covered the Black Panthers and other Black Power events on the West Coast and the

arrival of Vietnam refugees at Camp Pendleton in 1975. She was a skilled film lab technician and had years of experience as a probation officer and working in youth services in Los Angeles. In the MFA program she made a significant documentary, *Varnette's World: A Study of a Young Artist* (1979), and then went on to direct a well-regarded film about African American photographer Roy DeCarava. Her career continued with two films on art in Nigeria and work on Robert Nakamura's feature *Hito Hata*, the PBS television series *Eyes on the Prize* (1987–90), and Marlon Riggs's *Black is . . . Black Ain't* (1994).

Varnette's World provides a portrait of a visual artist living in Los Angeles, positioning the painter between her local community and her accomplished artworks. Thus an opening panning shot shows parts of a gathering of people going to church, with voices of people meeting and greeting, and then continuing into church services with enthusiastic gospel singing. We also see Varnette Honeywood present in colorful kente cloth. The film continues with the artist explaining that she draws on subjects from her community. As viewers we witness this repeatedly as the film cuts from one of the artist's distinct images of a face or person to a film image of a person and then to the artist herself at work. In one scene Honeywood is working on a large outdoor mural and a woman passing by stops and talks with her, showing the connection between not only subject matter (the Black community) and artist but also the community audience and someone who is likely to view the completed work. At another point we find an enthusiastic group of girls painting and preparing for a mural, and it is gradually revealed that Honeywood is their teacher and supervisor.

The painter articulates her desire to produce predominantly positive images for Black children, an official part of her role in an administrative post of developing art curricula for eight Los Angeles schools in coordination with a local university (University of Southern California). Though her greatest recognition for this kind of art practice came later in her career, the goal of presenting affirmative images is clearly present in this early stage of her work. The images are graphically strong and colorful, and they mark distinctive features, such as African American hairstyles, broad noses, brown eyes, and prominent lips. When Honeywood discusses her own history, the details connect to themes in her art: going to college at Spelman College in the Deep South and changing from an education major to art; attending an international art festival in Lagos, Nigeria, and meeting Black artists from around the world. The connections are repeated in the present, with her teaching children

FIGURE 1.4. *Varnette's World: A Study of a Young Artist* (Dir. Carroll Parrott Blue, 1979).

in the community and attending a local Afrocentric arts festival, with music and dancing as well as visual arts and crafts. Again, a rapid montage cuts between active performers dancing and drumming and her paintings, allowing the still art to become dynamic while underpinned by rhythmic music.

The film addresses topical political issues in a very indirect way. At a small meeting of community artists, participants gather around a table to discuss the difficulties of having a career in the arts. Some problems are vaguely laid out, but the context or the issues are not detailed. Actually, at the time there was national and local attention to the federal Comprehensive Employment and Training Act (CETA) begun in 1974. Designed to subsidize beginning employment in the public sector, with an aim to give people usable skills and experience that they could then use to get a regular job, CETA was widely used by community organizations to advance programs. The catch was that the enrollees had to move on after eighteen to twenty-four months, and the program was endlessly embroiled in conservative attempts to cut funding (it was phased out nine years later by the Reagan administration). While arts organizations were early adopters, setting up CETA training programs, because the

funds were awarded by geography, local politicians eventually caught on and competed by pushing civic programs that they could shape and with which they could claim credit and reward constituents. Artists did indeed experience the end of CETA and other programs, and the limited window of funding. The point being that *Varnette's World* can allusively reference such larger matters but that it would be inappropriate to actually explore such matters in a twenty-six-minute piece aimed at providing a portrait of the artist. The film touches on similar matters that could raise larger questions, including Afrocentricity, community art festivals, arts education in the public school curriculum, and so forth.

By presenting a positive image of an artist who works in the vein of presenting grassroots-based positive images, *Varnette's World* functions in an obviously instructive way. The length is just right for viewing in a classroom or meeting presentation, to be followed by a discussion. A wide audience ranging from children to elders, ordinary folks to professionals, African Americans of course, but with no barriers to others, serves to make the film widely accessible. The subject is "uplifting," inspiring positive and optimistic feelings about this artist and her activities. These very qualities in Honeywood's art were subsequently validated when actor and comedian Bill Cosby decided to use Honeywood's art in every room of the set for his immensely successful TV sitcom *The Cosby Show* (1984–92), depicting a successful professional-class African American nuclear family. With his long-standing personal emphasis on "positive image" entertainment, Cosby's endorsement boosted Honeywood's recognition.

Much of Blue's subsequent career was spent teaching media production at San Diego State. During this time she produced a major documentary work published as a book and accompanied by an interactive DVD-ROM: *The Dawn at My Back: Memoir of a Black Texas Upbringing.*[29] *Dawn* combines a personal autobiography and a family history with reflections on the history of African Americans in twentieth-century Houston, Texas, and the dominant mass culture represented in photography and commercial cinema. While working with L.A.'s Asian American media arts center, Visual Communications, Blue appreciated the center's collections of family archival materials, especially photos. Her family's photos and letters are woven together with the troubled history of her parents' marriage and her own difficult relation with her mother. This most personal level of history is cast in a larger sense of her childhood community, a pioneering Black neighborhood framed within deadly racist violence against the residents, fiercely maintained

segregation, and a description of how the community coped and responded. In a much larger frame, Blue reflects on photojournalism, such as images in *Life* magazine; and the movies, ranging from Douglas Sirk's glossy melodrama of passing, *Imitation of Life* (1959), to a teen infatuation with the star image of Harry Belafonte and reflections on the star's experience with the Hollywood blacklist. Using the metaphor of the quilt, a patterned piece made of disparate scraps, and a notable and increasingly recognized form of African American women's art, Blue moves through different times and forms in an associative rather than linear and chronological way, perfectly suited to the accessible style of a DVD-ROM presentation.[30] The result is a powerful experience that allows movement from the most intimate, particular, and painful moments of a mother-daughter quarrel to the pair sharing the opportunity to see *The Graduate* (Dir. Mike Nichols, 1967) in Houston's downtown movie palace theater, formerly open only to white audiences, thus marking Black community progress.

Blue returned to Houston in the millennium years as a research professor at the University of Houston. Using her art experience as a base, and leveraging her administrative skills, she embarked on public art, architecture, and environmental projects to improve the Third Ward, her childhood neighborhood.[31]

BEN CALDWELL

Another L.A. Rebellion artist with close ties to the community, Ben Caldwell has been an anchor in the Leimert Park neighborhood of Los Angeles.[32] Running a storefront art space since his return to L.A. after teaching at Howard University from 1981 to 1984, Caldwell has taught youth a variety of media production skills, including working with sound recording, and he has developed a community of aspiring media makers and hip-hop and rap musicians.

Caldwell's *I & I: An African Allegory* (1979), his MFA film, stands as an anomalous case in the flow of L.A. Rebellion cinema. From the most experimental and avant-garde maker in the group, the film is a striking mix of different modes: fictional drama, documentary, and formal abstraction. David James provides an excellent summary of the film.

> Prefixed by titles asserting that it takes its inspiration from the sweep of African history and that its style is rooted in the virtuosity of Africa's religion and lyric arts and African American music, *I & I* uses an African legend to teach Americans how to transcend the opposition between I and You

introduced, the film argues, by the Devil and to return to the undifferentiated African commonality of I and I. Composed of more or less discrete sections, each filmed in a different style, it is unified by the figure of a beautiful, blue-robed woman who becomes its protagonist in the manner of the trance film: scenes of women dancing through nighttime forests transformed with abstract visuals come to rest on a vision of her nestling in the roots of a tree. She then appears wandering in alienation through the high-rise buildings of the Los Angeles financial district. Subsequent sections feature extended montages of still photos of black people that come to focus on civil resistance, a dramatic section in which a black man performs a soliloquy over the body of his dead white father, and an oral history section in which an old lady tells a young girl tales of her ancestors' struggles under slavery. The woman's visionary re-experiencing of the fall, historical recovery, and finally the regeneration of African people concludes as, to the sounds of African music and the reading of a poem by Amiri Baraka, birds fly across the sky in a red sunrise that dissolves into a pan down the regal figure of the blue-robed woman.[33]

The filmmaker has said that he intended to make a film that would demonstrate his ability to work in all three forms. In that sense the film functions as a "calling card" to showcase technical prowess or ambition rather than as a way to develop a consistent, controlled narrative and style. This is a common characteristic of some student and young artist media making, particularly common in animation work, where early career efforts often exhibit a "sampler" aesthetic as the maker progresses through successive and more complex mastery of various skill levels and technologies.[34] But *I & I* also highlights problems characteristic of student films concerning other issues such as recycling and piracy. Without the capital to clear music rights or pay for original music, students often borrow existing music but are then blocked from ever circulating the films beyond the festival and classroom circuit.[35] Most acutely, the montage of photographs is drawn from mostly well-known and widely republished photos, including some famous Diane Arbus images apparently meant to imply that white people are grotesques. The result is, regrettably, a certain trite discourse. The documentary interview section suffers from the elder's sometimes absent delivery; a docudrama reenactment would have been more effective. And the dramatic soliloquy (a demanding moment for any actor) suffers from the performer's limited range and the passage's unexplained motivation.

Despite these problems of ambition overreaching practical matters, *I & I* stands as an intriguing example of an often overlooked creative energy in formal flexibility and imaginative style in the L.A. Rebellion.[36] It also marks a high point for the use of allegorical visual association to

invoke Afrocentricity. The movement from Africa to the United States is imaginative rather than spatial, declarative rather than historical, spectacular rather than narrative.

One of the early participants in the Ethno-Communications Program, Caldwell includes as a final title to *I & I* the notice that the film is dedicated to Elyseo Taylor, who was "fired for racist reasons." After finishing his degree, Caldwell tried to set up a production center for Black filmmakers in Los Angeles, refurbishing a house with a screening room, writers space, and editing space. But the project couldn't be carried on, in contrast to the more effective institutions of Asian Americans and Chicanos in L.A. On his return to L.A. in 1984 he established a new center, aimed at young people in the neighborhood. In contrast to the metaphorical Pan-African community of *I & I*, Caldwell's KAOS Network is completely grounded in the Leimert Park neighborhood. As a teaching and performance space, the storefront draws neighborhood youth to engage with a variety of media and expressive forms: poetry, hip-hop, film and video, sound recording and mixing, and music performance. KAOS Network functions as an exhibition space and also a classroom for digital media training and through video conferencing puts local kids in touch with their counterparts in other locations, cities, and countries.

A MOMENT IN MOVEMENT

An imperfect storm created conditions for several decades of independent Black filmmaking in Los Angeles. With the passage of the federal Civil Rights Act in 1964, a new phase in African American progress began. In Southern California, the Watts Rebellion of 1965 created a shock wave for change accelerating minority admissions that enabled some access, some professional training, some opportunities. Actual participants used the possibilities in different ways: for Jamaa Fanaka it meant an opening to make exploitation films; for others it led to working in the industry; for yet others it was a path to being semiautonomous creative artists with the burden of patching together funding for this most expensive of arts. For politically directed intellectuals such as Gerima, Gabriel, and Clyde Taylor, the moment of change seemed to open a new opportunity, one they read through their understanding of the Black Arts movement of 1960s America and the international frame of Third World film activity in Latin America and Africa. The original imperative of Third Cinema was to create a radical alternative art: in

form, in content, in mode of address, in audience, and in effect. Activist, interventionist, collective and communal, and existing outside of commercial film and established institutions, Third Cinema inspired the goal of a new Black cinema. That radical aspiration could push student artists through their twentysomething years, but it doesn't suffice for the pragmatics of having a career, supporting a family, keeping one's skills honed, and continuing to create.[37]

Earlier I remarked that African American artists and intellectuals have often called for both integration and separation. Thinking of the L.A. Rebellion in this frame, we can witness African Americans such as Amis, Blue, and Caldwell mastering the dominant culture's technologies and institutions while validating the strengths of their communities. With its historical importance now clear, the L.A. Rebellion's continuing significance grows as it becomes woven into a new generation's imagining of the community's past and projection of a better future.[38]

NOTES

This essay was written with the help of many people to whom I owe thanks: the L.A. Rebellion organizers, Allyson Nadia Field, Jan-Christopher Horak, and Jacqueline Stewart, who led the project, involving archival preservation, a three-month film program, a landmark conference, and outstanding editing advice. The conference participants inspired many new ideas about my essay. My research partner and *Jump Cut* co-editor John Hess shaped the questions, research, and writing decades ago. As always, Julia Lesage gave intellectual and practical support. For their own enthusiasm for African American media and makers, and for answering questions and providing key ideas, I want to thank Zeinabu irene Davis, Martha Biondi, Elizabeth K. Jackson, Shannon Gore, and Claudia Springer. Ben Caldwell generously showed me *I & I* and some of his other creative work, and he answered many questions one afternoon in the early 1990s at KAOS, his Leimert Park art center; Jamaa Fanaka stopped by, enthusing about his upcoming exploitation film, *Street Wars* (1992), and I suddenly saw what some might think were two extremes—fast and dirty commercial entertainment and meditative personal artisan work grounded in the local community—conversing and occupying the same space and moment. Crossed threads revealed an unexpected node in the net; beyond theoretical constructs, the human face of supportive colleagues. Later in the decade, the late Edward Bland told me of his enthusiasm for working with the kids at KAOS when I interviewed him. I want to dedicate this essay to the memory of two warm and talented Black filmmakers who always thought of their art as part of a community: Elspeth kydd and Bill Gunn.

1. UCLA, a part of the state university system, was the main institutional anchor of the L.A. Rebellion, training students in both fiction drama and

documentary modes. The University of Southern California, a private, elite, expensive school centered its filmmaking program on training for fictional features in the existing industry. Starting in 1969, the American Film Institute's Conservatory Program also offered postgrad training in dramatic film, which Julie Dash attended before going to UCLA. Another area hub was CalArts, which offered extensive concentration in animated film, and from the late 1960s on, in artist and experimental film. In addition, Los Angeles has always drawn international people hoping to learn film by apprenticeship in the industry or arriving with previous training abroad that they hoped to turn into an industry career.

2. Actually, just the opposite often reigns, with standard complaints that Hollywood does not satisfactorily fund or promote socially and artistically serious films, or claims that a film that earned more than its production budget was "successful." Such arguments are based in a naïve and uninformed understanding of the Hollywood system. I discuss Hollywood and indie economics at length in Chuck Kleinhans, "Independent Features: Hopes and Dreams," in *New American Cinema,* ed. Jon Lewis (Durham, NC: Duke University Press, 1998), 307–27; and in Chuck Kleinhans, "1993: Movies and the New Economics of Blockbusters and Indies," in *American Cinema of the 1990s: Themes and Variations,* ed. Christine Holmlund (New Brunswick, NJ: Rutgers University Press, 2008), 91–114.

3. Notable in this area are New York–based William Greaves (producer of the key TV series *Black Journal* [1968–70]) and St. Clair Bourne. Documentary media, particularly about ongoing issues rather than unique events, tend to have long legs, being profitable and widely available in distribution for many years. Sales and rentals to schools, libraries, and targeted audiences makes the work viable. Well-established documentary-short distributors such as Newsreel and California Newsreel (both leftist), Women Make Movies, and Frameline (LGBT) and distribution co-ops such as New Day actively sought works about race issues. Thus a Black feminist documentary maker had a better chance for long-term distribution stability than a Black male feature maker. An acute study of public-service broadcasting produced by and for African Americans from 1968 to 1974 is Devorah Heitner, *Black Power TV* (Durham, NC: Duke University Press, 2013). For an excellent overview of Black documentary, see Phyllis R. Klotman and Janet K. Cutler, *Struggles for Representation: African American Documentary Film and Video* (Bloomington: Indiana University Press, 1999).

4. Teshome Gabriel's own book is *Third Cinema in the Third World: The Aesthetics of Liberation* (Ann Arbor: UMI Research Press, 1982).

5. The concept of Third Cinema, first articulated in a 1969 manifesto by Argentine filmmakers Fernando Solanas and Octavio Getino, described First Cinema as Hollywood-centered dominant commercial entertainment media with imperialist stretch. Second Cinema was occupied by European and Eurocentric auteurist and arthouse work. Third Cinema was an oppositional alternative to both, militant and confrontational. The key founding documents can be found in Michael T. Martin, ed., *New Latin American Cinema,* vol. 1, *Theory, Practices, and Transcontinental Articulations* (Detroit: Wayne State University Press, 1997). A particularly acute reassessment is Anthony R. Guneratne

and Wimal Dissanayake, eds., *Rethinking Third Cinema* (New York: Routledge, 2003).

6. This was particularly the case in Los Angeles with a shoot-out on the UCLA campus between the Black Panthers and the US Organization in 1969. Various and conflicting reports make clear that the shadow of this event shaded subsequent campus political activity, including filmmaking.

7. Cuban film, for example, often held up as the standard of Third Cinema, ranges from newsreels and party-policy propaganda through challenging new forms of documentary and satire to neorealist narratives and operatic epics, including turns to popular genres and European co-productions heavy on tropical exoticism. Advocates for "Third Cinema" tend to pick and choose from the variety rather than account for the complex whole, Gabriel included.

8. By the late 1970s there were two: the New York–based Third World Newsreel and the San Francisco–based California Newsreel. Both were strongly leftist, anti-imperialist, and antiracist. For an extremely detailed discussion, see Cynthia A. Young, *Soul Power: Culture, Radicalism, and the Making of a U.S. Third World Left* (Durham, NC: Duke University Press, 2006).

9. The UCLA Film & Television Archive retrospective "L.A. Rebellion: Creating a New Black Cinema" shows such diversity and balance.

10. An overview report on the event is Chuck Kleinhans, Ellen Seiter, and Peter Steven, "Alternative Cinema Conference: Struggling for Unity," *Jump Cut* 21, (November 1979): 35–37, www.ejumpcut.org/archive/onlinessays/JC21folder/ReportACC.html. See also the individual reports by various editors in the same issue as well as reprinted conference documents.

11. Claudia Springer continued to interview L.A. film women, publishing her findings in the article "Black Women Filmmakers," *Jump Cut* 29 (February 1984):34–37, www.ejumpcut.org/archive/onlinessays/JC29folder/BlackWomenFilmkrs.html. Discussing fifteen different filmmakers, including three from Africa, Springer gives crucial social and historical context for the women and the issues they faced as well as detailing their artistic work.

12. At the time, California had the most extensive system of public higher education in the United States. The colleges and universities had extremely low tuition rates.

13. Around the same time, our publication, *Jump Cut,* had editing collectives in Chicago and Berkeley.

14. Renee Tajima, "Lights, Camera . . . Affirmative Action," *The Independent* (March 1984): 16–18.

15. Bogle is a good example, though in the later expanded and updated version of his book he more clearly discusses the issues, referencing newer films made for a primarily African American market. Speaking from a strong advocacy stance, Clyde Taylor's writings push anti-Hollywood independence as a prime concern, as in "New U.S. Black Cinema," *Jump Cut* 28 (April 1983): 41, 46–48, www.ejumpcut.org/archive/onlinessays/JC28folder/NewBlackCinema.html. From a scholarly viewpoint, Mark A. Reid tends to work within the same model of the film directly delivering a meaning in his *Redefining Black Film* (Berkeley: University of California Press, 1993). Reid's later follow-up, *Black Lenses, Black Voices: African American Film Now* (Lanham, MD: Rowman

and Littlefield, 2005), moves to a wider recognition of meaning being shaped by the interaction of film and viewer, thus showing a range of responses.

16. This is not so surprising when you are aware that Dash completed the well-regarded American Film Institute's director's program, aimed at preparing students for roles in the industry, before entering the MFA program in film at UCLA.

17. Nelson George provides an entire chapter highlighting just the 1991 production of Black-directed features, in his book *Blackface: Reflections on African-Americans and the Movies* (New York: HarperCollins, 1994), 107–29.

18. For example, Stephane Dunn, *"Baad Bitches" and Sassy Supermamas: Black Power Action Films* (Chicago: University of Illinois Press, 2008); Todd Boyd, *The Notorious Ph.D.'s Guide to the Super Fly '70s: A Connoisseur's Journey through the Fabulous Flix, Hip Sounds, and Cool Vibes That Defined a Decade* (New York: Broadway Books, 2007); Yvonne D. Sims, *Women of Blaxploitation: How the Black Action Film Heroine Changed American Popular Culture* (Jefferson, NC: McFarland, 2006); Paula J. Massood, *Black City Cinema: African American Urban Experiences in Film* (Philadelphia: Temple University Press, 2003); and Novotny Lawrence, *Blaxploitation Films of the 1970s: Blackness and Genre* (New York: Routledge, 2007).

19. Hostility to Black feminism was an ongoing issue in the 1970s and 1980s, circulating around key texts such as Ntozake Shange's play *For Colored Girls Who Have Considered Suicide When the Rainbow Is Enuf* (San Lorenzo, CA: Shameless Hussy Press, 1975), and Michelle Wallace's book *Black Macho and the Myth of the Superwoman* (New York: Dial Press, 1979)

20. Jacqueline Bobo, "Black Women's Responses to *The Color Purple*," *Jump Cut* 33 (February 1988): 43–51. www.ejumpcut.org/archive/onlinessays /JC33folder/ClPurpleBobo.html. Bobo extends the argument in her book *Black Women as Cultural Readers* (New York: Columbia University Press, 1995), which includes an analysis of *Daughters of the Dust*.

21. David E. James, *Allegories of Cinema: American Film in the Sixties* (Princeton, NJ: Princeton University Press, 1989), provides a good introduction. Given her several Black-themed features, it is curious that Shirley Clarke is almost never mentioned in relation to the L.A. Rebellion, although she taught at UCLA from 1975 to 1985.

22. Michael T. Martin's three anthologies provide a foundation: Martin, *New Latin American Cinema*, vol. 1, *Theory, Practices, and Transcontinental Articulations;* Michael T. Martin, ed., *New Latin American Cinema*, vol. 2, *Studies of National Cinemas* (Detroit: Wayne State University Press, 1997). Michael T. Martin, ed., *Cinemas of the Black Diaspora: Diversity, Dependence, and Oppositionality* (Detroit: Wayne State University Press, 1995).

23. Julianne Burton, "Marginal Cinemas and Mainstream Critical Theory," *Screen* 26, nos. 3/4 (May–August 1985): 2–21; Teshome Gabriel, "Colonialism and 'Law and Order' Criticism," *Screen* 27, nos. 3/4 (May–August 1986): 140–47. The Taylor/Nicholson/Davis exchange is reprinted in Martin, *Cinemas of the Black Diaspora*.

24. This is especially odd, given that the Rebellion era could be seen as framed by two terrific comedies set in Los Angeles: Michael Schultz's *Car Wash*

(1976) and Robert Townsend's *Hollywood Shuffle* (1987). Nor did the Rebellion represent, much less address, African American gay issues and individuals. Clarke's *Portrait of Jason* (1967), made when she was in New York, marks a notable start, but it was not until Berkeley-based Marlon Riggs made *Tongues Untied* (1989) that the subject was really explored.

25. Ed Guerrero, "A Circus of Dreams and Lies: The Black Film Wave at Middle Age," in *The New American Cinema,* ed. Jon Lewis (Durham, NC: Duke University Press, 1998), 328–52.

26. In the 1990s it was common for commercial films to make only half of their gross in theatrical release. Today many theatrical premieres are seen in the industry as simply commercials for later platform revenues.

27. A default Hollywood compromise was the buddy/sidekick figure pairing a Black actor with a white one, as discussed by Ed Guerrero in "The Black Image in Protective Custody: Hollywood's Biracial Buddy Films of the Eighties," in Manthia Diawara, ed., *Black American Cinema* (New York: Routledge, 1993), 237–46. But even the screen presence of a relatively high-profile figure such as Eddie Murphy tends to be marked by comic roles that fall into stereotypes.

28. Black nationalists were not the only people in the 1960s–70s era who established alternative schools on untested premises. Various counterculture and religious sects and fundamentalist groups initiated day-care, elementary, home-schooling, and after-school programs based on strong sectarian perspectives. Relatively few thrived and few survived.

29. Carroll Parrott Blue, *The Dawn at My Back: Memoir of a Black Texas Upbringing* (Austin: University of Texas Press, 2003).

30. Unfortunately, the 2003 publication leaves the DVD-ROM in a now-archaic computer operating system platform. I am still able to view it on my third-oldest laptop, but on none of the others or my desktop machine.

31. Lisa Gray, "Woman's Goal: Transformation of Southeast Houston," *Houston Chronicle,* February 13, 2013, www.houstonchronicle.com/life/gray/article/Woman-s-goal-transformation-of-southeast-Houston-4282520.php#/0.

32. Leimert Park became an arts hub in the 1980s, drawing on various institutions earlier located in other Black neighborhoods, particularly Central Avenue. Eric Gordon provides an excellent survey in "Fortifying Community: African American History and Culture in Leimert Park," in *The Sons and Daughters of Los: Culture and Community in L.A.,* ed. David E. James (Philadelphia: Temple University Press, 2003), 63–84.

33. David E. James, *The Most Typical Avant-Garde: History and Geography of Minor Cinemas in Los Angeles* (Berkeley: University of California Press, 2005), 334.

34. The film's ambitious optical effects were done by distinguished filmmaker Pat O'Neill, with a bit more imagination than perfected craft at this point in his career.

35. This problem applied to numerous L.A. Rebellion films, including *Killer of Sheep*. Music rights are particularly closely policed, and clearance typically involves working through expensive, experienced law firms that manage such matters. Few students or young artists could ever overcome the copyright management fees and barriers.

36. Other notable examples include Barbara McCullough's *Water Ritual #1* (1979) (photographed by Caldwell) and Zeinabu irene Davis's *Cycles* (1989), *Trumpetistically, Clora Bryant* (1989), and *A Period Piece* (1991).

37. I address some of these issues in Chuck Kleinhans, "Charles Burnett," in *Fifty Contemporary Filmmakers,* 2nd ed., ed. Yvonne Tasker (London: Routledge, 2010), 60–69.

38. Examples include Daniel Widener, *Black Arts West: Culture and Struggle in Postwar Los Angeles* (Durham, NC: Duke University Press, 2010); Monique Guillory and Richard C. Greene, eds., *Soul: Black Power, Politics, and Pleasure* (New York University Press, 1998); and the brilliant study by Richard Iton, *In Search of the Black Fantastic: Politics and Popular Culture in the Post–Civil Rights Era* (New York: Oxford University Press, 2008).

2

Rebellious Unlearning

UCLA Project One Films (1967–1978)

ALLYSON NADIA FIELD

At its best, the university can be a generative nexus where creative minds collaborate and facilitate each other's expression, where differences are catalyzed into productive synergy. The Black filmmakers who came together at UCLA starting in the late 1960s, a group that Clyde Taylor retrospectively designated as the "L.A. Rebellion," were from a variety of places, including southern towns and cities, New Mexico, Texas, New York City, various neighborhoods in Los Angeles, and even Haiti and Ethiopia.[1] The shared experience of being film students at UCLA, specifically film students of color, fostered a bond between them in spite of their diverse backgrounds and life trajectories to that point. As much as the process of studying film in a university consisted of learning the necessary skills, techniques, and history of filmmaking, working with a medium that had historically been mobilized in the persistent marginalizing and dehumanizing of people of color necessitated approaching filmmaking with circumspection. It required a radical *un*learning. In these students' work, as Taylor observed, "Every code of classical cinema was rudely smashed—conventions of editing, framing, storytelling, time, and space."[2] They were likewise committed to questioning cultural assumptions about representation, as well as challenging institutional practices and many aspects of the film school curriculum.

Of the many meanings of "rebellion" that Taylor's appellation invokes, the act of unlearning is the most foundational to the collectivization of these student filmmakers. This was initially practiced in the

Project One assignment, the first film made by each student after arriving at UCLA. The Project One process established a spirit of collectivity among the Black filmmakers and other student filmmakers of color, allowing open exploration of the medium of film. From an initial dismantling of formal conventions, the student filmmakers experimented with different strategies for articulating notions of Black "authenticity." Such a totalizing goal was of necessity complicated, and the ambition of the filmmakers' projects, coupled with the fact that these are *student* films, means that we are dealing with a body of work that is at once uneven and difficult to categorize. Yet with the unruliness of the Project One films comes incredible energy, vibrancy, and a rawness that reflect the cultural environment in which they were made and its affiliated political movements, social concerns, and problematic gender expectations. The films assert the claim, as Taylor put it, "Black cinema spoken here!"[3]

For something described as a group, the L.A. Rebellion is unusual in that it was not a collective of filmmakers with a shared background or a common political or aesthetic agenda. Rather, it was defined by a network of relationships woven through the experience of making films as students at UCLA. The L.A. Rebellion filmmakers were shaped across decades by a shared collaborative process that impacted not only how they made films but what was in them. Because of this, a straightforward typology of the Project One films would suggest a coherent and deliberate project incongruous with the more open association of the Black students, other filmmakers of color, and like-minded "fellow travelers." Even so, there are a number of themes and formal aspects that characterize this body of work to the extent that certain tendencies emerge and common concerns can be traced across the films. Taken as a whole, these films reflect a general and not necessarily linear trajectory from pessimism and near nihilism to an optimistic belief in the capacity of film to catalyze social change. The Project One films also laid the foundation for the subsequent works produced by these filmmakers at UCLA and beyond.

While the film school at UCLA had a few notable Black alumni by 1968, such as Ike Jones and William Crain, it was the multiethnic student-led Media Urban Crisis Committee (MUCC, cheekily dubbed the "Mother Muccers") that resulted in the establishment of the Ethno-Communications Program the following year, enabling more Black students to enroll in significant numbers.[4] While students came into the film school through a variety of channels, the Ethno-Communications Program was the primary catalyst for collaboration among filmmakers

of color. Students formed multiethnic crews on one another's shoots, but they were especially encouraged to work within their minority groups and to produce films that reflected the communities from which they came. There was certainly a naïve assumption operating here about community, one that elides differences of gender, class, and geographic origin and segments students along the reductive category of ethnic identity. Thus, this emphasis created conflicts for some students, such as the women who often had to contend with male colleagues who were arguably enacting internalized patriarchal hierarchies through their work and their collaborative styles. Indeed, the gender dynamics that emerge from the film school's pedagogical model merit further exploration, especially the ways in which the "assertive nationalism," as David James has characterized these early works, was manifested through gender.[5] Nonetheless, the Ethno-Communications Program offered students access to dedicated equipment and encouraged them to tell stories that reflected their experiences (rather than those that conformed to industry expectations). The collaborative pedagogical model served the purpose of the students' socially conscious goals.

This essay surveys a series of extant and nonextant Project One films made by sixteen of the African American students in the film school at UCLA between 1967 and 1978. This is the group retrospectively recognized by Taylor as the L.A. Rebellion and by Ntongela Masilela as the first and second "waves" of the Los Angeles School of Black Filmmakers: Charles Burnett, Larry Clark, Thomas Penick, Haile Gerima, Billy Woodberry, Jamaa Fanaka, Ben Caldwell, Don Amis, O.Funmilayo Makarah, Alile Sharon Larkin, Bernard Nicolas, Jacqueline Frazier, Carroll Parrott Blue, Barbara McCullough, Julie Dash, and Melvonna Ballenger.[6] In looking at the first student films of these filmmakers, I will trace several overarching themes and formal strategies that account for the changing dynamics, interests, and foci across the decade following the establishment of the Ethno-Communications Program.

The Project One assignment was a standard part of the MFA curriculum that was then applied to the undergraduate program in Ethno-Communications, so both the undergraduate and graduate students who would later be termed the "L.A. Rebellion" typically made a Project One film. "Like an initiation" into film school, it set technical parameters for student work while allowing aspiring filmmakers to explore a subject of their choosing.[7] The minimal constraints were that films had to be shot in 8mm nonsynchronous sound, with the option of a 16mm mag soundtrack mixed by the student. Added in the editing

process, sound was a crucial element in L.A. Rebellion Project One films: both sound and image were subjected to critical rethinking as the filmmakers experimented with creative combinations of film elements. In particular, the sonic structure of the L.A. Rebellion Project One films demonstrates an investment in representing the multilayered textures of the filmmakers' experiences, not just complementing the films' visual elements but serving key narrative and formal functions.

Project One functioned like a laboratory for experimenting with the medium of film as a means of expression, and the films demonstrate this sense of formal experimentation that would be foundational for the filmmakers' later work. Each student wrote, produced, directed, and edited his or her own Project One film, which was then screened and critiqued by faculty and fellow students.[8] The faculty stipulated that Project One films should be around three minutes, but the films made by the students of color tended to be significantly longer. As Larry Clark recollects, "Well you've kept us quiet all these years, and you give us a chance to speak and you can't tell us it's got to be three minutes, it's whatever you want it to be!"[9] Giving the students ample leeway to design the projects on their own, the faculty emphasized the individuality of each student's voice, stressing that they did not want all films coming out of UCLA to look the same.[10]

In general, the Project One films of Black students centered on issues of race, class, and community, though the films covered a range of topics affecting African American people and their communities: rising political consciousness (*Tamu* [Dir. Larry Clark, 1970], *Hour Glass* [Dir. Haile Gerima, 1971], *Rain/(Nyesha)* [Dir. Melvonna Ballenger, 1978], *Daydream Therapy* [Dir. Bernard Nicolas, 1977]); notions of patriotism and cultural belonging (*Apple Pie* [Dir. O.Funmilayo Makarah, 1975]); drug abuse (*Tamu, A Day in the Life of Willie Faust* [Dir. Jamaa Fanaka, 1972]); domestic labor (*The Kitchen* [Dir. Alile Sharon Larkin, 1975], *Daydream Therapy*); social oppression and mental health (Charles Burnett's untitled Project One [1968], *The Kitchen*); representational disenfranchisement (*Medea* [Dir. Ben Caldwell, 1973]); identity, self-determination, and cultural pride (*Hour Glass, Ujamii Uhuru Schule* [Dir. Don Amis, 1974], *The Diary of an African Nun* [Dir. Julie Dash, 1977]); family (*Chephren-Khafra: Two Years of a Dynasty* [Dir. Barbara McCullough, 1977], *Hidden Memories* [Dir. Jacqueline Frazier, 1977]); cross-generational dialogue (*Two Women* [Dir. Carroll Parrott Blue, 1977]); unplanned pregnancy and abortion *(Hidden Memories)*; sexual assault (Billy Woodberry's untitled Project

One [1973], *Willie Faust, 69 Pickup* [Dir. Thomas Penick, 1969], *Daydream Therapy*); and interracial sex (Charles Burnett's untitled Project One, *69 Pickup*). While sharing a commitment to social relevance, the films employed a variety of formal strategies from narrative to the avant-garde, fiction to documentary. Many of the films are replete with references, allusions, slogans, and symbols of political commitment (*Tamu, Hour Glass, Daydream Therapy*). Others are more formally restrained but no less critically invested (*Ujamii, The Diary of an African Nun*). Through the Project One films, the Black student filmmakers demonstrated an eagerness to rethink cinema as a medium of communication, critique, persuasion, and activism.

Film students were encouraged to work on one another's shoots, ostensibly to gain valuable experience in production.[11] Designed to model the collaborative aspect of industrial filmmaking, the group-project aspect of the Project One process also reflected the collective nature of contemporary social movements with which most students closely identified. The camaraderie that emerged in the Project One process, fostered through shared experience and "sweat," united students from different backgrounds and life experiences to create lasting respect among them.[12] Filmmakers who would later be seen as diametrically opposite in style and purpose (such as Ben Caldwell and Jamaa Fanaka) collaborated on early films.[13] The students also bonded in the "bull pen," the nickname for the Project One editing room. Often staying consecutive nights in the editing room where they were practically living, the sleep-deprived students edited and synched their films by hand. As Julie Dash described the atmosphere in the editing room, "Everyone's complaining, miserable—it was great."[14] It is this act of collaboration, perhaps even more than political commitments, resistance to Hollywood aesthetics, and shared experience, that characterizes the L.A. Rebellion as a collective group, however informal or loosely defined.

In an educational environment, part of the students' unlearning had to do with determining from whom to learn. With the faculty taking a hands-off approach to the Project One process, the mentorship of the older students, particularly Burnett, Gerima, and Clark, was especially significant to the younger students of color. In the mid-1970s, Charles Burnett served as a TA for the Project One class and was an unofficial mentor to many more, to the extent that he earned the nickname "the Professor." This kind of internal mentorship was necessary because the filmmakers of color felt they received little support from others. The atmosphere, as one filmmaker recalls, was like "the inmates running the

asylum."[15] Yet the inmates did not always get along. While the atmosphere was "creatively chaotic," Burnett recalls the combination of personalities that comprised the UCLA film school as "explosive."[16] Alongside the filmmakers of color were many students from privileged backgrounds who had not been exposed to the kinds of issues explored in the films of minority filmmakers. When the students would screen the films for the faculty and fellow students, the films made by the African and African American students were often met with stunned silence, what Alile Sharon Larkin characterizes as the recognition that "this is something new and different."[17] At the same time, many narratives were met with skepticism from an audience so culturally removed from the subject. Critical comments often centered on the veracity of a story, dismissing troubling subject matter (such as police brutality) with, "Oh, that couldn't happen."[18] Gerima became so frustrated with the disbelief of his fellow students over issues such as police brutality that he wrote a monologue called "The Bunch of Mr. Convince Me" to motivate himself to continue doing the kind of work that he found significant.[19]

The skepticism and general disconnect from inner-city realities prevalent on the Westwood campus should certainly be considered contributing factors to both the relentlessness of some of the works (the unflinching camera of Bush Mama [Dir. Haile Gerima, 1975], the prolonged church sequences in As Above, So Below [Dir. Larry Clark, 1973]) and the documentary impulse behind many of them (the use of photographs of a demonstration against Eula Love's killing by the LAPD in Gidget Meets Hondo [Dir. Bernard Nicolas, 1980], the systematic documentation of Medea and I & I [Dir. Ben Caldwell, 1979], the location shooting in Watts and use of non-professional actors from the community in Killer of Sheep [Dir. Charles Burnett, 1977]). This same skepticism and general disconnect also explain, in part, the assertive tendency of the early Project One films; their shocking content can be read as a manifestation of aggression born out of frustration on the part of students who, at least in the early years, were seen by some white faculty, administrators, and students as out of place in the film department. Frustrations with the curriculum, though, sometimes erupted in creative ways, such as in Haile Gerima's "The Death of Tarzan," made for a design course and lauded by one of the Chicano students in the class for killing "that diaper-wearing imperialist," and in the critical reimaginings of Gunsmoke (1955–75), a television series used so frequently for the basic editing course that the class was commonly referred to just by the title of the show.[20]

Charles Burnett entered UCLA in 1967, a year prior to the organization of MUCC. As UCLA did not have an enforced policy of archiving student films, Burnett's untitled first film is believed to be no longer extant.[21] He shot it on a Bolex with a Switar lens, borrowed from his TA, using regular 8mm Kodak color film.[22] Burnett had gone to school with the artist Michael Cummings and featured him as a Black artist who chokes his white nude model after making love to her.[23] Shortly after Burnett arrived, Thomas Penick came to UCLA and made his first film, with Burnett as director of photography. *69 Pickup* is about two Black men who pick up a white woman and then rob, sexually assault, and beat her.[24] Penick made the film shortly after breaking up with a girlfriend and was admittedly angry. The woman, played by a UCLA theater student, stood on Western and Adams, an unusual spot for a white woman to be hitchhiking at the time, which led to numerous cars pulling over and interrupting the shoot.[25]

The Project One films of Burnett and Penick, who perceived themselves to be outsiders in the insular world of UCLA, demonstrate an assertive resistance to white middle-class sensibilities. Their presentation of interracial taboos around sex evokes contemporary revolutionary discourses. While neither of these films is overtly political (in the sense of Eldridge Cleaver's assertion that raping white women was "an insurrectionary act"),[26] they inherently reference the disturbing sexual politics of certain aspects of the Black Power and Black Arts movements, such as that conveyed in sections of Cleaver's 1968 *Soul on Ice* and the work of Amiri Baraka, where the idea of poetry as a weapon of action extends to imagined physical violence. While Burnett and Penick challenge white patriarchal norms, their acts of resistance actually serve to reinforce those same norms through a form of racialized misogyny. Thus, although Jamaa Fanaka is often singled out as embracing aspects of exploitation cinema that put him at odds with many of his classmates, Burnett's and Penick's Project One films show that he was not alone in portraying women as sexualized objects of male fantasy. (In fact, while Fanaka's later work arguably draws from sexually exploitative elements of popular "Blaxploitation" cinema, his second feature film made at UCLA, *Emma Mae* [1976], centers on an active and strong woman protagonist who is neither a victim nor subordinate to any man.) The otherwise progressive films of some of the male filmmakers arguably perpetuate the fetishization of figures such as Angela Davis or fall back on stereotypes or voyeuristic filmmaking, something that several of the filmmakers themselves acknowledged was a concern.[27] The

filmmaker also rehearse patriarchal and nationalist notions of gender roles in these early films and in this respect reflect contemporary debates about the role of women in revolutionary struggle.

The machismo evident in some of these early films extended to the classroom, where professors reportedly felt intimidated by the perceived aggression of the male students of color. Larry Clark recalls one instance of a run-in with the faculty:

> They would show *Birth of a Nation* [Dir. D. W. Griffith, 1915], and it was always prefaced, "Well, we're not going to talk about the sociological parts, we will talk about the film itself as cinema." Now how can you not with *Birth of a Nation*? And so one year this professor was going to show *Birth of a Nation* and Haile Gerima and Francisco Martinez walk to the front of the room and one grabbed one arm and the other grabbed the other arm, they lifted him up and carried him out of Melnitz Hall and went back and taught the class.[28]

Incidents like this arguably prompted the faculty to admit more women in subsequent admissions cycles in an attempt to neutralize the aggression of the male students of color.[29]

Other student filmmakers of color aimed to present positive images of their respective cultural experiences that would correct the misrepresentation prevalent in mainstream culture. As with Third Cinema practitioners, they were concerned with modeling resistance through narrative choices and cinematic language. Inspired by Glauber Rocha, Larry Clark recalled, "We were thinking more, really truly more of cinema as a gun."[30] Like many of his colleagues, Clark came to UCLA with a strong social mission that seemed well suited to the film school's collaborative emphasis and multicultural orientation. Clark had been president of the Black Students Union in college in Ohio, and when he first came to UCLA he first went to the Afro-American Studies Program, which pointed him to Elyseo Taylor and the new Ethno-Communications Program in the film school. At the same time, Clark was determined to get involved in the cultural community off campus: "I made myself a promise that I would have one foot in UCLA and another foot in the community."[31] To this end, he became involved with PASLA (Performing Arts Society of Los Angeles), an all-Black theater company founded by Vantile Whitfield in 1964 to train inner-city youth in the performing arts.[32] Clark started a film workshop with the support of Whitfield and met both Nathaniel Taylor and Ted Lange at PASLA, as well as most of his crew for *As Above, So Below* and *Passing Through* (1977).

With *Tamu,* his Project One film (shot on Super 8), Clark set out to counter Hollywood's negative stereotyping. "I wanted to do something positive," he explained. The desire to produce positive images proved to be more complex than he initially expected. He describes the process as an "Aha! Eureka!" moment:

> I am editing the film and I get a rough cut and I say "Jesus Christ!" and I saw this film is just as negative and stereotypical as anything coming out of Hollywood. And that's when I really realized how deep this stuff is—people say, "Oh, I'm not influenced by Hollywood," even if you are a person of color you pick up on these same negative things. So then you realize "I have some work to do"; you can't just say, "I'm going to do something that's not negative." Those are good intentions, but how do you get there? You have to unlearn a lot of stuff.[33]

He ended up recutting the whole film "to salvage it."[34] The Project One experience made Clark realize that film could be a powerful medium for him to convey his message through writing and directing.[35] In the final edit, *Tamu* was twelve minutes long and imagines the thought processes of two figures, based on Eldridge Cleaver and Angela Davis, as they develop their consciousness against the realities of drug infiltration and other systemic means of perpetuating a Black urban underclass. Concurrently, the film imagines a relationship between the two figures who are represented as both specific Black leaders through references to Cleaver and Davis and relatable everymen through the generality of their portrayal.

Clark's films are generally notable for the way they mobilize politically progressive contemporary jazz and spoken word artists to proffer a critique of Black disenfranchisement and political apathy. In *Tamu,* the soundtrack indicates political commitment and demonstrates the cultural fluency with music that Clark and many of his colleagues had while they were learning the technical skills of filmmaking. The musical samples, in fact, express the thematic concerns of the film in a more coherent critical perspective than the narrative diegesis, opening up a rich terrain to comprehend the film's loose narrative structure. The film begins with Pharoah Sanders's "Hum-Allah-Hum-Allah-Hum-Allah" from the 1969 album *Jewels of Thought,* as the Eldridge Cleaver figure sits in his car in the rain watching a junkie across the street, wondering in an internal monologue if the problems of the day are any different than before. After a rapid montage of images representing historical oppressions of Black people, the man concludes that the issues are the same: "the only difference is that there are bigger and better forms of

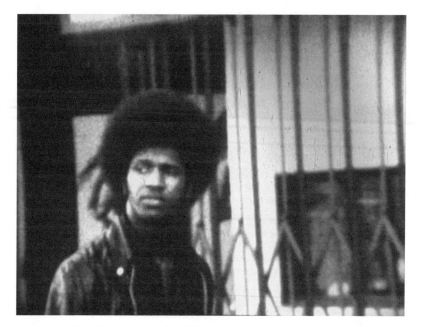

FIGURE 2.1. *Tamu* (Dir. Larry Clark, 1970).

control and repression." He then goes on to connect the struggles in the United States to international liberation movements as he drives through a neighborhood replete with wig shops and other visual markers of broad disenfranchisement of the Black urban underclass. Later, The Last Poets' "Two Little Boys" is heard over a scene in which the man witnesses two boys stealing a purse from an elderly woman, followed by an excerpt from Malcolm X's "Message to the Grass Roots" on the necessity of overcoming differences between Black people. This excerpt motivates the man to think about Black-on-Black violence, referencing Frantz Fanon's characterization of the internalized violence of the oppressed. At the end of an impassioned internal monologue, he asserts that "what we need is a revolution," motivating a cut to a wanted poster for "Eldridge Brown," who is listed as "Interstate Flight Revolutionary" (a subversion and reimagining of the FBI's poster for Cleaver that announced assault with the intent to commit murder).

The next section of the film follows the Angela Davis character, introduced in her apartment making coffee, a Patrice Lumumba poster hanging in her kitchen and Miles Davis's "Sanctuary" from the 1970 album *Bitches Brew* playing extradiegetically. The Davis figure reflects

on the image of the Soledad Brothers in chains and cites Fanon, "the oppressor always overreacts to the actions of the oppressed," concluding, like the Cleaver figure, that "what we need is a revolution." The two characters then meet as he climbs the stairs to her apartment as the opening theme from Pharoah Sanders replays. Reaching her, he draws her close to him and tells her, "Hey baby, you're the one. The true Black gold. The real Black gold. Ain't going to ever miss the joy of calling *you* sister." The two figures then go outside, where the man observes the junkie urinating against a wall with a PASLA tag. As if channeling the intersection of the junkie's subjectivity and that of Cleaver, the soundtrack samples The Last Poets' "Jones Comin' Down," with Martin Luther King Jr. saying "suddenly a great revolution is going on in our world today, sweeping away an old order." The Cleaver figure sees the junkie standing under a stop sign and shakes his head in disapproval, followed by Malcolm X proclaiming "revolution is in Asia, revolution is in Africa." Here, the situation of the disaffected urban poor is juxtaposed against global liberation movements.

The film concludes with the junkie staggering off as Cleaver's voice declares the organization of the Black Panther Party: "We're going to develop a coalition all the way across this country and we're going to organize. Black Panther Party all across this country." In this sense, the organization of the Panthers is posited as an act of resistance to the disenfranchisement of the poor, yet the optimism of the call to organize is tempered by the sustained image of the junkie. *Tamu* portrays progressive Black political activism as emerging from the actual conditions of urban poverty and vying against counterforces detrimental to collective action for the consciousness of the community within a patriarchal framework. The film then ends with a reimagined wanted poster for "Tamu Davis," who, like "Eldridge Brown," is listed as "Interstate Flight Revolutionary." Although the film is named *Tamu* and ends with the wanted poster for Davis—Tamu was Davis's African name—the film centers on the Cleaver figure. Davis's revolutionary potential is circumscribed by the implicit gender expectations of Black revolution: the Cleaver figure is portrayed as active as well as reflective, while the Davis figure is passive and reflective, associated with domestic space and delighting in the validation given to her by her male counterpart.

Like *Tamu*, Jamaa Fanaka's 1972 Project One film, *A Day in the Life of Willie Faust*, highlights the abuse of drugs in the Black urban environment. While *Tamu* grounds its social critique in the intellectual history of anti-imperialist struggles, *Willie Faust* allegorizes systemic

oppression through the figure of an interracial corporate board overseeing the "payment in full" of a junkie who has, in effect, sold his soul for drugs. Where *Tamu*'s central protagonist observes the junkie from a detached standpoint, Fanaka makes him the central figure, chronicling a day in his life—a day predetermined by the plotting devil figure as his last. Fanaka had read Goethe's *Faust* while a student at Compton Community College, and with *Willie Faust* he contemporizes the Faust legend by transposing the story to South Central Los Angeles. Like Clark, in *Willie Faust* Fanaka mobilizes popular, politically engaged, and socially conscious contemporary music to articulate the critique and provide commentary on the narrative action. The film's episodic structure is punctuated by musical samples, as Fanaka draws from the recently released soundtracks of *Shaft* (Dir. Gordon Parks, 1971) and *Super Fly* (Dir. Gordon Parks Jr., 1972) as well as The Beatles' "Come Together" and the music of Pharoah Sanders.

The film opens with Isaac Hayes's "Walk from Regio's" from the soundtrack to *Shaft,* which serves as the entrance theme for the devil. The devil is imagined as the president of an interracial corporation, named Universal, whose board is meeting on the final day of an executive seminar. While acknowledging the efforts of Universal's "archrival Gabriel & Associates," who endeavors to convince its clients to renege on their agreements, the president tells the board that they will observe one of the president's own clients on the day in which his account is to be "paid in full." The scene then cuts to Willie, played by Fanaka himself, in bed with his wife, who sleeps as he tries to steal the cash she has tucked in her bosom. Unsuccessful, he leaves the house as his wife tries to quiet their crying baby. Willie breaks into a house, and after being caught in the act of robbery and attempted rape, he escapes, shoplifts from a supermarket, sells what he stole to a pool hall, and buys drugs on a street corner. Against Curtis Mayfield's theme from *Super Fly,* the drug dealing scene is shot from across the street as if from a surveillance camera or the perspective of a removed observer, like the evil corporate board or even that of an audience titillated by the spectacle of an urban underworld in films such as *Shaft* and *Super Fly.* As the film is structured with a framing device so that the entire unfolding occurs through the lens of the board members, the audience shares their privileged perspective and the spectator's view is thereby complicit with Willie's downfall.

Yet, if Fanaka denies the spectator the salaciousness of the drug deal, keeping his camera at a distance, he unflinchingly presents the overdose in an extended shoot-up sequence. After buying drugs, Willie returns

FIGURE 2.2. *A Day in the Life of Willie Faust, or Death on the Installment Plan* (Dir. Jamaa Fanaka, 1972).

home to his baby crying, goes into the bathroom and shoots up to Isaac Hayes's rendition of Charles Chalmers's "One Big Unhappy Family." Then, when the heroin is injected, Pharoah Sanders's "Black Unity" comes on, musically expressing the effects of heroin on Willie; it obliterates the "unhappy family" with Sanders's free jazz. Yet the Black unity imagined by the music is rendered ironic through Willie's self-imposed isolation and self-destruction. In the absence of true Black unity, drug abuse is able to infest. As Sanders's saxophone punctuates Willie's deadly high, Fanaka intercuts close-up shots of the corporate board members laughing directly at the camera, watching Willie as we do. As Willie slowly overdoses, the laughter of the board members becomes increasingly grotesque, merging with the shrill saxophone. While at first "Black Unity" signaled a release from the demands of his crying baby and pleading wife, as Willie dies the saxophone becomes like an alarm crying for help while the board members laugh in sadistic delight. When Willie collapses to the floor, the board members collectively rise in a standing ovation, celebrating the conquest of another soul.

The film ends with Willie's wife discovering his overdose as the board members look on in amusement. Following an intertitle "paid in full,"

Willie's wife tries to revive him as their baby cries. The film concludes with the first verse of "The Creator Has a Master Plan (Peace)," sung by Leon Thomas and recorded in 1969 with Pharoah Sanders. The final song is thematically circular in that it conjures a pre-Fall idyll "when peace was on the earth, and joy and happiness did reign, and each man knew his worth." The nostalgic optimism of the lyrics is subverted by the cynicism of the board's ruthless "cashing in" of Willie's debt. As a social critique, *Willie Faust* draws from *Super Fly*'s and *Shaft*'s recognition of economic and racialized inequities—captured through the street scenes that, like *Bush Mama,* reveal the commercial reinforcement of the disenfranchisement of the urban underclass (such as wig stores and pawn shops)—while complicating these two films' voyeuristic aesthetic.

In the initial course screening, *Willie Faust* was reportedly well received, which Fanaka found invigorating—"I loved it! That's when the directing bug bit me."[36] Fanaka went on to make an unprecedented three feature films while a student at UCLA. While these films were critiqued by some fellow filmmakers for their commercialism, with charges of replicating stereotypes rather than exploding them (especially the *Penitentiary* [1979, 1982, 1987] series), the message, execution, and narrative of *Willie Faust* are consistent with the formal and thematic concerns of the other Black filmmakers at UCLA at the time, and the work exhibits characteristics that would later be identified as representing a film movement.

Fanaka's use of allegory is also present in Haile Gerima's Project One film, *Hour Glass,* made in 1971. Where Fanaka imagines the devil made flesh as a CEO, overseeing a corporate board of evil executives who plot to win souls through drug addiction, Gerima imagines college basketball culture as a contemporary iteration of the brutality of ancient Roman gladiator matches. *Hour Glass* serves as a kind of bridge between the more narrative projects of filmmakers such as Fanaka and the experimental works of filmmakers such as Ben Caldwell and Barbara McCullough, as it embeds formally experimental sequences within a larger narrative trajectory centered on a single protagonist. *Hour Glass* is a fourteen-minute film shot by Gerima and Larry Clark, made with Clark's leftover Super 8 film that he gave to support Gerima (who had just entered the film school from the Theater Department).[37] Such sharing of unused film was a common practice among the L.A. Rebellion filmmakers and supportive African American filmmakers working in Hollywood (such as Carlton Moss, who gave Clark a box of short ends that contributed to *Passing Through*).[38] *Hour Glass* was edited after Gerima dreamt

the film rolling through his mind, and he edited it the way he had dreamt it. Dreams became a significant part of Gerima's filmmaking process; his Project Two film, *Child of Resistance* (1972), came out of a dream he had after seeing the image of Angela Davis in handcuffs.[39]

Like Gerima's later features *Bush Mama, Ashes & Embers,* and *Sankofa* (1993), *Hour Glass* chronicles a protagonist's coming into political consciousness, assuming a sense of identity and self-worth. In *Hour Glass,* a Black college athlete becomes politicized, rejects the role assigned to him on campus, and moves to a Black community. Even more directly than *Child of Resistance, Hour Glass* is a laboratory of ideas for *Bush Mama.* Most notably, it shares with the later feature an interest in capturing on film the vibrancy of the Black community, contrasted with the hostility of the university and the imagined fickle tolerance of white students for the Black student athlete. Gerima's critique of the way Black student athletes provide entertainment for white spectators certainly echoes the tensions he must have observed between the campus politics of that era and the championship years of UCLA's men's basketball team under celebrated coach John Wooden. *Hour Glass* captures the spirit of players such as Kareem Abdul-Jabbar (Lew Alcindor), a Bruin who boycotted the 1968 Olympics in protest against America's treatments of its Black citizens. Abdul-Jabbar was inspired by sociologist Harry Edwards, who encouraged the boycott, proclaiming, "It's time for the black people to stand up as men and women and refuse to be utilized as performing animals for a little extra dog food."[40]

Still, despite its resonance with actual events, the film is highly symbolic and weaves narrative diegesis and dreamscape, color and black and white (a strategy Gerima will employ in his next film, *Child of Resistance*). As with Gerima's later work, the soundscape is key for understanding the film. Just like the bureaucratic voices that occupy Dorothy's mind in *Bush Mama,* the soundtrack of *Hour Glass* functions as the externalization of the mental subjectivity of the student athlete. The subjective soundscape also triggers the visual projection of the athlete's fantasies. As Larry Clark did in *Tamu,* Gerima samples the socially conscious spoken word poetry of The Last Poets and the speeches of Malcolm X, Martin Luther King Jr., and Angela Davis.

Hour Glass opens in black and white with a striking extreme low-angle shot of a young Black man with a noose around his neck, the sound of a clock ticking. This leads to an extended basketball sequence in which the player imagines the white spectators as modern-day Roman emperors, deriving sadistic pleasure from the physical battles of combatting

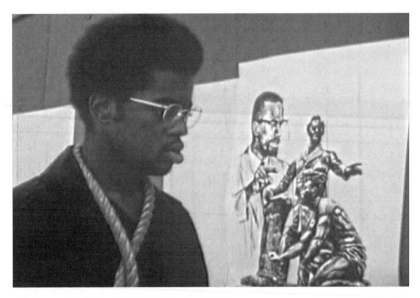

FIGURE 2.3. *Hour Glass* (Dir. Haile Gerima, 1971).

slaves. Later in his dorm room, the student athlete reads postcolonial theory and Black liberation literature, and he imagines a nightmarish scene of a naked Black boy trapped in a prison cell full of liquor bottles and a frightening elderly white woman who snatches the sheets away from him to reveal they are in fact portraits of civil rights leaders. She hangs the sheet portraits of Malcolm X and Martin Luther King Jr. on the wall, only to have them immediately crossed out by shadows and the sounds of bullets and screaming. As she tries to take the sheet bearing Angela Davis's image, the boy resists and holds on to the portrait. This gendered fantasy scene of successful defiance is followed by the student athlete intervening between the camera and Davis's poster, packing his bags, leaving the dorm, and moving to a Black community as Elaine Brown's "Seize the Time" plays on the soundtrack. In addition to commenting on the political issues concerning Black student athletes, the story draws from Gerima's own experiences as a student at UCLA. *Hour Glass* exhibits the frustration and alienation that Gerima felt at UCLA while also reflecting the growing political consciousness of the Black student body in the wake of the 1969 Campbell Hall shootings, the firing of Angela Davis, and the founding of the ethnic studies centers. Most of the filmmakers strongly identified with the Black Panthers and their critique of American imperialism at home and abroad. The male fantasy of pro-

tecting Angela Davis that is evident in *Tamu* and *Hour Glass* reflects the gendered politics of the Black Panthers but also springs from the general outrage against the pervasive mistreatment of Black women.

For his Project One film, Billy Woodberry drew from an actual incident that took place in Chicago yet represented widespread police misconduct toward African Americans and the historical sexual abuse of Black women by white men. The story centers on a young girl who was sexually assaulted by the police; initially ignored, when the incident was reported to the Panthers they pursued the officer and demanded justice. Woodberry took the story from the Black Panther Party newspaper and used it as voice-over narration for his film.[41] Another story Woodberry wove through the film centers on the attractive girlfriend of a member of his Marxist study group. In retrospect, Woodberry realized he had shot the woman voyeuristically and that as a result the film was unsuccessful and "a mess because of two conflicting impulses or ideas."[42] The instance where the girl is captured by the police in their car is shown abstractly—"the only thing you really see is shadow and light"—relying on narration to convey the full significance of the incident. Woodberry recollects the response Gerima had to the use of the newspaper story as narration: "Haile told me, wonderfully, you don't talk a film, you show a film."[43] (Gerima would show a similar atrocity in the climactic scene of *Bush Mama*.)

Woodberry praised the relative freedom of the Project One experience, in which the filmmakers were free to explore images that intrigued them: "I do this thing at the end of the film, just a car driving on a wet street. Why? Because I liked shooting a car driving on a wet street."[44] Like a number of other Project One films, Woodberry featured traveling shots of people on the street to create a sense of urban ambiance, in this case filming skid row as a stand-in for Chicago. Though grappling with how to avoid a voyeuristic gaze, and how to best structure a narrative, Woodberry's film demonstrates a commitment to bringing to light racist atrocities and to recentering cinematic language to focus on the neglected stories of the urban African American underclass. The narrative of the film is an evident precedent for Woodberry's later works, *The Pocketbook* (1980) and *Bless Their Little Hearts* (begun in 1978 and completed in 1984).

The critical focus of Project One films was not simply on the present, as Black student filmmakers also evinced an interest in exploring the damaging historical trajectory of racist imagery that had gained such a stronghold in the visual representation of African Americans, particularly

in Hollywood and popular culture. O.Funmilayo Makarah's 1975 Project One, *Apple Pie,* is a reflection on the bicentennial in which she asked different people what they thought about America. Choosing an all-male multiracial group of more advanced students, she asked her subjects to sing "The Star Spangled Banner." She reflects, "No one could do it, and at the very end I had a group of people singing it and it was so out of tune and so wrong that it was a good comment on America about everybody."[45] With *Apple Pie,* Makarah offered a critical perspective on the dissonance between the official national discourse of the bicentennial celebrations and the "true reality" of inequality and racism.[46]

The work of Ben Caldwell similarly reflects on questions of representation and the role of visual culture in systemic racism. Engaging with a different project than many of his classmates, who saw him as "off into the cultural part," Caldwell privileged cultural questions over a specific political project conveyed through narrative storytelling.[47] Still, Caldwell's work exhibits fluency with the same set of intellectual references as his classmates, drawing from contemporary Black Arts writings and a selectively curated visual arsenal. These differences and similarities sparked intense dialogues and led to decades-long conversations about the nature of film and art, most notably in his collaborations with Charles Burnett. As Caldwell remembers, "It helped make really engaging discussions because we were all very different and we were all from different places. So all of that difference was really engaging, even though that same difference made it impossible for us to organize a name for the organization, but part of it had a lot to do with the reason we were together was to be different. We were trying to make Western thinking concepts out of something that was very antithetical to it."[48] It was in such ways that the process of filmmaking could unify the students of color far more than a single style or voice. The questions that the minority students brought to their work demonstrated a shared consciousness, however elastic, that informed their work and their collaboration.

The six-and-a-half-minute long *Medea* was submitted as Caldwell's Project One, under the supervision of Haile Gerima, the TA for the course. Caldwell describes the collage film as being about "all of the information that comes into a child before it's born."[49] The title *Medea* for a film concerned with the preexisting world into which a child is born references the immediate threat that will confront the child as well as the history of infanticide as a gesture of resistance. In Euripides's version, Medea is a scorned barbarian woman who kills her children to exact vengeance for her husband's betrayal. Caldwell has a different account,

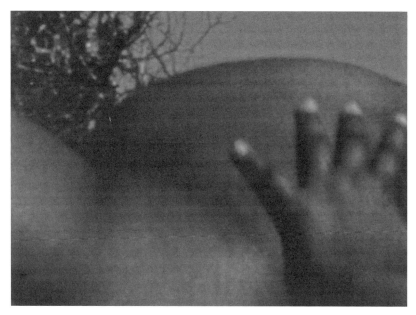

FIGURE 2.4. *Medea* (Dir. Ben Caldwell, 1973).

one based on the view of Margaret Garner as a modern Medea, a posi-
tion that took imaginative hold in antislavery discourse, most notably in
Thomas Satterwhite Noble's 1867 painting *The Modern Medea.* Subse-
quent invocations of Medea in an African American context have carried
a tone of gravitas, cognizant of the complexities and ambivalences of
bringing children into a world of such totalizing inequity.[50]

Using an animation crane, Caldwell linked static images "kind of like
the history of art in ten seconds," conveying "the history of the birth of
this young man in those few minutes."[51] Editing in the camera, that is,
shooting sequentially and precisely so that there is minimal postproduc-
tion editing necessary, Caldwell worked on the interplay between stasis
and motion in a single image: "Within each picture is also an innate
movement even though it is a static picture."[52] Accompanying these
images, a woman's voice recites Amiri Baraka's poem "Part of the Doc-
trine" from *Black Magic: Collected Poetry, 1961–1967.* The amalgama-
tion of still images comprises a collected history of representations of
culture, mainly African and African American, chronicling early cultural
encounters through the history of segregation and civil rights struggles.
Caldwell uses a myriad array of examples, ranging from white ethno-
graphic images to contemporary photojournalistic representations to a

history of Black self-representation. In the film, these images function like flashes of memory, the collected mental subjectivity of a people's history, the history that the unborn child will inherit.

Caldwell's collected images counter the persistent dehumanizing images perpetuated in Western visual culture. But, as his initial invocation suggests, they are also a kind of "comeback" whereby the ethnographic images give way to twentieth-century moments of empowerment, resistance, and affirmation. Caldwell, in fact, came to the idea for the film as he was becoming interested in the ways in which film could function as "ritual and spell":

> I've noticed that a lot of those subliminal images were threaded throughout films in the history of filmmaking and all those things were to the demise of my culture. It was like jigaboos and funny things and subtle implications of who we are and that's because we were conquered and the conqueror was the one that was showing these films. You could see with *Birth of a Nation,* no subtleties there but they played like it was subtle and I had to fight for imagery. [. . .] I felt we had to work against that kind of symbology and we had to change the ritual.[53]

To change the ritual, he cites the tradition of "making the tools work towards our story":

> That's why I ended up on that road of really seeing it as a way of emancipating the image. So that's the reason I got involved with the first frame. With each frame I wonder, how does it look, how was it operated, and we as humans see each frame. It changes your view, and so how are they related to each other almost like poems? Each was created within the poem, there is no word stronger than the word before it or the word that it's about to follow; it's the same thing with pictures.[54]

By editing in the camera, Caldwell creates a kind of visual poetry akin to jazz or spoken word, where the impact is affected by the real-time experimentation with visual collage. The live-action sequences feature cloud patterns in the sky, a pregnant Black woman, and a young child holding a balloon that bursts at the end as Caldwell cites a passage from Ayi Kwei Armah's *Two Thousand Seasons*: "A culture provides identity, purpose and direction. If you know who you are, you'll know who your enemy is. You'll also know what to do, what is your purpose." Caldwell uses an experimental form to articulate a gendered nationalism predicated on a practice of othering.

As in *Medea,* Don Amis's nine-minute Project One film, *Ujamii Uhuru Schule Community Freedom School,* uses documentary tech-

niques to understand the process of transmitting knowledge to future generations. One of the few Project One films entirely documentary in approach, *Ujamii* is a portrait of an Afrocentric elementary school a few blocks west of Crenshaw on West Adams in Los Angeles. Perhaps because of this documentary impulse, *Ujamii* moves away from the pessimism of the previous Project One films to present a more positive celebration of Black cultural practice and cross-generational affirmation. Amis came to UCLA through the High Potential Program and saw himself as coming to the university from "a community perspective"; he made his Project One to take back to the community, ultimately giving the school the original negative. He described his decision to film at the school: "I visited the school and checked it out. And I thought it was a good visual. It was a lot of activity, a lot of kids, adults, a lot of cultural history going on, a lot of self-awareness, a lot of self-respect, a lot of teaching about things that weren't being taught any place else at the time."[55] He filmed on three occasions, and by the end of his filming the students were used to the camera and he was able to get a number of cutaway shots. Amis recalls, "Being part of the community, being in that environment, knowing what was going on, looking and dressing like everyone else, it made the actual filming of that project easy."[56]

Ujamii is shot in an observational mode, showing a day in the life that captures the artwork, slogans, images, and sounds that comprise the Community Freedom School. Against these images and the sound of drums and students repeating slogans, a teacher explains in voice-over the educational philosophy of the school and the commitment to correcting the misperception of Black inferiority perpetuated by the public school system. With an emphasis on pride and heritage, the school exemplifies the educational mission of the Black Power movement. (It is the kind of school that the fictional Tovi attends in Alile Sharon Larkin's *Your Children Come Back to You* [1979].) When *Ujamii* was screened for the UCLA faculty and students, Amis recalls that they were shocked and surprised because the majority of films made by Black students were fiction narratives. Apart from Chicano and Asian American students who were making community-based documentaries, the film school was largely sequestered from the diverse ethnic communities of greater Los Angeles. Amis recalls, "Nobody was bringing what was going on in the community or outside of UCLA—what was going on in the real world into the campus or onto the screen. [. . .] Nobody was doing what was going on around them. And there was everything— there was so much going on at that time."[57] With *Ujamii,* Amis presents

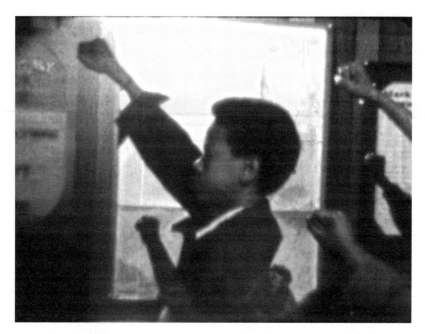

FIGURE 2.5. *Ujamii Uhuru Schule Community Freedom School* (Dir. Don Amis, 1974).

a celebratory portrait of the transformative power of early education, an optimism markedly resilient in the context of repeated attacks on Black Power, civil rights, and progressive politics that were coming to dominate the tenor of the era. By focusing on the positive message of self-respect and self-determination, Amis provides a stark contrast to the Project One films that turned a lens on the damage of such extreme social inequity, to both the individual psyche and the collective consciousness.

Made the following year, Alile Sharon Larkin's first film demonstrates the power of the message of "Black Is Beautiful" championed by the Community Freedom School and how harmful the absence of positive images could be. Made in 1975 as her Project One and shot in Pasadena, *The Kitchen* is a six-minute narrative film about the psychological damage caused by a beauty culture that values straight hair over "natural" African American hair. The film lays bare the psychological damage caused by Eurocentric beauty culture, a theme taken up by other Black student filmmakers who critiqued the proliferation of wigs and wig shops in urban Black communities (e.g., in *Tamu, Willie Faust,* and *Bush Mama,* among others). The surviving copy does not

have synch sound, though the original soundtrack consisted of a woman's stream of consciousness narration that expressed her wish to look like her white employer, with long, straight hair.[58] Like several other Project One films, *The Kitchen* has a nonlinear structure and the plot unfolds through the protagonist's flashbacks.

The Kitchen begins with a straitjacketed young woman in a near-catatonic state being led down an institutional hallway into a cell. She repeatedly strokes a wig she wears and does not allow the nurse to remove it. The cause of her breakdown is made evident through a series of flashbacks intercut with her institutionalization. These flashbacks show her working as a domestic in the home of a white woman, roughly brushing her daughter's coarse hair, and then primping her daughter's hair as they wait for a bus. The concerns of the flashbacks—her place of employment and her relationship with her daughter—become linked as the film unfolds, as she turns out to be obsessed with the quest for straight hair. While ironing in the background, she watches mesmerized as her employer brushes her own daughter's long, straight hair. Distracted, she burns the ironing and the smell of burning interrupts the employer: in the foreground of the frame, she and her daughter rapidly turn around to face the burning ironing and whip their long, straight hair, as if to punctuate the cause of distraction. The employer rushes to the maid and angrily points to the ruined ironing, trying to shake her out of the reverie, but the maid just reaches for the employer's straight hair, running it through her fingers.

The most haunting sequence is the subsequent flashback, where we see the maid's daughter running toward her, smiling and excited. The reverse shot shows the mother smiling at her daughter, but when the shot returns to the daughter we see that the mother does not see her daughter as she is but as she wishes her to be: in a dress with perfectly coiffed hair, twirling around and enacting a classical type of prettiness. The idealized daughter is intercut with the real daughter wearing a T-shirt, pants, and sweater tied around her waist and less styled hair. Her mother's hand enters the frame and yanks the daughter by the hair, and the film cuts to the two of them in the kitchen as the mother roughly combs the daughter's hair with a straightening comb, causing the young girl pain. The mother heats up the comb on the stove so that it is smoking and holds it on her daughter's head. The daughter struggles, but the mother keeps her grip. Larkin allows the camera to linger on the torture of the young girl to register the horror of the damage, physical and psychological, caused by an impossible ideal. After

FIGURE 2.6. *The Kitchen* (Dir. Alile Sharon Larkin, 1975).

the mother's psychosis has resulted in the maiming of her daughter, the scene cuts back to the mother in the institution, shaken from her comatose state by the memory and subdued by the nurses in a straitjacket.

The Kitchen is a thematic corollary to Haile Gerima's *Bush Mama*, made the same year. Like the young mother in *The Kitchen*, through much of *Bush Mama* Dorothy has a glazed, detached stare. Gerima chronicles her awakening political consciousness and her assumption of her own self-worth, culminating when she declares that "the wig is off," both a literal statement—she removes her wig—and a figurative marker of resistance to hegemonic disenfranchisement. But where Dorothy is motivated to action to protect her daughter, whom she discovers being raped by a policeman, the mother in *The Kitchen* is awakened from her comatose state only after she realizes the horror that she has inflicted on her daughter due to her own internalization of her distorted self-image. Both films depict the political and social disenfranchisement of poor African Americans as violently played out on the bodies of the young daughters.

While *The Kitchen* depicts the displaced frustrations of a working-class mother, Jacqueline Frazier's Project One film, *Hidden Memories*,

focuses on a middle-class notion of family in tension with the professional ambitions of a Black woman. Made in 1977 and set in Los Angeles, *Hidden Memories* is a ten-minute narrative film featuring Mary Porterfield as a college student who gets pregnant and chooses an abortion in order to attend graduate school. Frazier was invested in narrative storytelling, "When I came to UCLA and was seeing all these other peoples' films . . . it was all this abstract stuff, and I'm like, 'What the hell is that? I want a story. I want to tell a story. That's what I'm here to do.' So that's what I did."[59]

With The Supremes' "Reflections" as the main theme, *Hidden Memories* presents its action through a flashback within a presumably contemporary frame. The film opens in color with an elated couple holding a newborn baby. The camera tracks in on the baby, motivating a flashback shot in black and white that depicts the mother as a student. She approaches her boyfriend, who is flirting with another woman, and despite misgivings she goes home with him. After he leaves, she realizes she has missed her period and goes to the clinic for a test. At the clinic, the nurse tells her that her pregnancy test is positive and the word "positive" echoes repeatedly. She is distraught but, watching kids play, saves a young boy from running in the street and being hit by a car, as if to suggest that her maternal instincts are in place despite the pregnancy being a surprise. She finds her boyfriend, who is again flirting with other women, and her confession "I am pregnant" again echoes. At home, she opens a letter announcing her acceptance to the Stanford School of Journalism for fall quarter 1967, indicating that the flashback likely takes place a decade earlier. Embracing her mother, she hears on the radio an announcement for an abortion clinic.

The abortion sequence is the most striking part of the short film, as the doctor and nurse are shot through a distorted lens and their reassuring banter seems grotesque against the woman's screams and moans. (The scene recalls Dorothy's abortion nightmare in *Bush Mama*.) The film then returns to the present day, in color, and the woman looks out as if reflecting on the past. She walks past her husband picking flowers, and as he offers her one she smiles and embraces him. She is then shown inside, cooking, an activity intercut with shots of her holding the newborn with her husband—the same shot that opened the film—and shots of her next to her sleeping husband, holding his head adoringly. These juxtapositions reframe the initial shots with the newborn as if to situate the birth of their baby as a corrective to the flashback of the past, itself represented in black and white. The hidden memories of the abortion

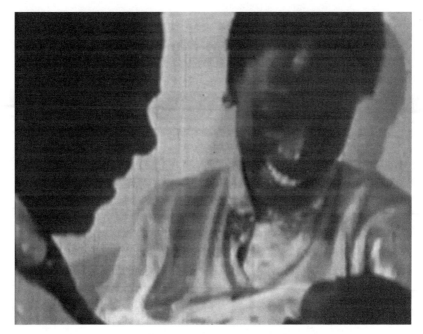

FIGURE 2.7. *Hidden Memories* (Dir. Jacqueline Frazier, 1977).

are thereby supplanted by the joyful memories of marriage and mother-hood. Despite the use of such contrasts, *Hidden Memories* does not judge the protagonist's actions but rather presents her choices as legiti-mate, her "proper" marriage functioning as a redemptive ending to the traumatic experience of choosing abortion a decade earlier. Yet, with this narrative resolution, the film curiously validates a middle-class ideal of family as compatible with the woman's professional ambition. Marriage and education may not be presented as in conflict, but the film's social vision is dependent on the woman's choosing an appropri-ate partner and her pregnancy's occurring within the stability of a mid-dle-class marriage.

The Project One films of Carroll Parrott Blue and Barbara McCul-lough, both made in 1977, also center on issues of the family and deal with cross-generational dialogue.[60] *Two Women* centers around Blue's aunt, who was in her eighties, and a teenage girl. Blue explains, "I was making comparisons about what it meant to be an older Black woman and young Black woman and how their philosophies about life were dif-ferent."[61] McCullough's *Chephren-Khafra: Two Years of a Dynasty* fea-tures the filmmaker's two-year-old son and weaves together moving

images and still photography in a personal portrait. As the title suggests, the interest in Egyptian and other African histories, as well as the relationship between the Black diaspora and Africa, was an important theme in the film. *Chephren-Khafra* also prefigures films such as *I & I, Your Children Come Back to You, Water Ritual #1: An Urban Rite of Purification* (Dir. Barbara McCullough, 1979), *Cycles* (Dir. Zeinabu irene Davis, 1989), *Daughters of the Dust* (Dir. Julie Dash, 1991), and *Sankofa.*

An interest in Africa is likewise present in Julie Dash's *The Diary of an African Nun,* a film that reflects on the tenuous and often damaging relationships that result from cultural dissonance. Made in 1977, Dash's Project One is an adaptation of an Alice Walker short story, featuring the magnetic Barbara O. Jones as a nun in Uganda questioning her faith and cultural belonging.[62] Dash matriculated at UCLA after attending the American Film Institute, where she had already written *Four Women* (1975) and *Illusions* (1982) (she would direct *Four Women* for her Project Two and *Illusions* for her thesis film). As Dash had more experience than most of her classmates, *The Diary of an African Nun* demonstrates a polish and professionalism rarely found in their first (or even second) films. Dash was inspired to adapt Walker's story because of the striking image of the nun's habit and a photograph that she encountered, which appears in the film and was used for its publicity, of several white nuns surrounded by a group of Black children. The contrast of the habit with the environment, along with the inner turmoil expressed by Walker's protagonist, led Dash to want to see that woman come to life and to visualize her conflict.[63] She also saw the story as relevant to contemporary Black life, to issues of assimilation, class mobility, cultural authenticity, and individual aspirations. Moreover, she was struck by Walker's way of describing the nun's conflict, the nun's knowing that she was bringing "death to an imaginative people" yet at the same time believing that she was ultimately working in their best interest.[64] Though set in Uganda, *Diary* thematically resonates with the Project One films set in Los Angeles through its concern with women's choices and with telling stories about women's lives that are "personal and different" from what is typically shown on screen.[65]

One of the strongest feminist films made as a Project One is Bernard Nicolas's *Daydream Therapy.* In it, Nicolas subverts the Hollywood representation of the figure of the Black maid, who labors in the margins of the narrative and the frame, by centering both on the daily chores of such a worker and on her interior and intellectual space. While *Bush Mama* would later imagine a voice for the systemically silenced, *Daydream*

FIGURE 2.8. Production photograph, *The Diary of an African Nun* (Dir. Julie Dash, 1977). Collection of Julie Dash.

Therapy already treats that voice as resistant, militant, and self-possessed, envisioning the fantasy life of a hotel worker whose daydreams provide an escape from workplace indignities. Made in 1977 under the supervision of Robert Nakamura, who was teaching the Project One course at the time, *Daydream Therapy* is set to Nina Simone's haunting rendition of "Pirate Jenny" (from Kurt Weill and Bertolt Brecht's *The Threepenny Opera*) and concludes with Archie Shepp's "Things Have Got to Change." As in *Bush Mama*, which opens with documentary footage of the LAPD harassing Gerima and his crew, the shoot of *Daydream Ther-*

FIGURE 2.9. Handwritten insert, *The Diary of an African Nun* (Dir. Julie Dash, 1977). Collection of Julie Dash.

apy was interrupted by the local sheriff who was alarmed at the sight of, in Nicolas's words, a "bizarre assemblage" of a dozen Black people with strange costumes surrounding a white man apparently bleeding on the ground in Burton Chace Park in Marina del Rey.[66] Of course Nicolas was shooting guerilla-style, without the necessary permits, but the white actor who played the hotel manager had gone to school with the sheriff and was able to explain that it was a student film and thus diffused the situation. The film was well received and Nicolas subsequently entered it in a number of festivals, winning several awards—including first place in its category at the Philadelphia International Film Festival.

Like Gerima's *Hour Glass*, Nicolas alternates between black-and-white and color images to express the increasing indignation and

political consciousness of the protagonist as she resists sexual exploitation by her boss. As Jacqueline Stewart has pointed out, Nicolas draws from Third Cinema and avant-garde precursors—such as Ousmane Sembène's *La Noire de . . .* (1966) and Maya Deren and Alexander Hammid's *Meshes of the Afternoon* (1943)—but reimagines their endings to replace impasse with resilience.[67] With precision, Nicolas frames his protagonist with the sharp diagonals of the furniture and architecture that make up her work environment, from the wooden table she lifts as she vacuums to the railings of the steps in front of an office building where she sits to have her lunch. Spatially confined, she finds liberation through her imagination. Looking out beyond the immediate concrete surroundings, she fantasizes about an insurrection of which she is the leader. With creative geography that connects downtown Los Angeles's banking center to the shore at Marina del Rey, the film depicts Black pirates who abduct the hotel manager and look to the domestic worker for instruction for whether to kill the captive "now or later." Dressed in her regular clothes (rather than her maid's uniform) and holding a child, she opens her eyes wide as Nina Simone whispers "right now," silently conveying the death sentence. A sword is raised over the victimizer turned victim, and the film cuts back to the woman distractedly eating chips while staring out to the distance, daydreaming as the music shifts to Archie Shepp's "Things Have Got to Change." The woman gets up and leaves. No longer statically framed, she now moves through the urbanscape, the camera barely keeping pace as it films her rapidly moving legs and body, intercut with matching shots in color of her briskly walking in red pants as she caries a copy of Kwame Nkrumah's *Class Struggle in Africa* (1970).

As the film toggles between the maid in black and white and her politically conscious self in color, we see her carrying a sign announcing "don't just dream, FIGHT for what you want." The color image of her marching with the sign cuts to a black-and-white shot of her holding a camera, leading to a color image of her marching with the camera and finally a shot of her marching with a rifle. The trajectory from thought to action—book to camera to gun—is literalized through montage. When she returns to work, walking through the sliding-glass doors of the hotel, she is armed with the militant consciousness that serves as her "therapy." The film ends with the optimistic intertitle "the beginning . . . " and identifies Nicolas not as director but as "Answerable," just as Gerima identifies himself in the opening titles of *Bush Mama*.

A self-styled revolutionary, Nicolas was foremost an activist who turned to filmmaking as a tool of activism. It is fitting, then, that he

portrayed a young revolutionary in Melvonna Ballenger's Project One film, *Rain/(Nyesha)*, made in 1978. Like *Daydream Therapy*, the sixteen-minute narrative of *Rain* is concerned with political consciousness, in this case of a young typist played by Evlynne Braithwaite. Ballenger chronicles the woman's increasing political awareness at the encouragement of an activist, played by Nicolas, whom she meets as he is handing out flyers on the street. The soundtrack of the film poetically brings together voice-over reflections of the two protagonists with John Coltrane's "After the Rain," celebrating the will to personal transformation and demonstrating how personal changes are reflections of broader political transformations. Rain is figured as a metaphor for revolution—cleansing "the atmosphere of elements detrimental to the human mind and to all of nature"—and the film concludes with the optimistic refrain, "Storm winds are blowing."

Though concerned with political consciousness, the film is equally invested in depicting the quotidian routine of its protagonist. As Zeinabu irene Davis, in *Cycles*, would later explore the personal space of a young African American woman living alone, Ballenger here gives attention to the small gestures that comprise her protagonist's daily routine, including showering and dressing.[68] This attention is lovingly presented even while Ballenger's subject speaks of her "dreary routine." By starting the film with the character in her own home, Ballenger simply yet radically positions the Black female body within its own context, not as defined in relation to others—whether men, white people, strangers, or employers. Ballenger thus radically defines the locus of identity and self-respect as something innate rather than externally catalyzed. The typist may have been encouraged by the radical's outreach efforts, but, as the character explains in voice-over, change comes from within, and by changing yourself you change those around you. Unusually for Project One films, as the protagonist becomes increasingly politically aware, the gender roles correspondingly change: she shifts the typing to the activist, making him type up his manifesto in a feminist gesture that belies the machismo of much contemporary revolutionary rhetoric.[69] The film thus reflects the mission of its fictional activist, who types the manifesto for a filmmaking collective: "The film co-op is a progressive group of filmmakers dedicated to developing strong and positive images of the minority peoples in their respective communities."

This fictional collective is likely an echo of the collaborative emphasis of Ethno-Communications, as well as the work of other groups coming out of UCLA (such as Visual Communications). The collective also

FIGURE 2.10. *Rain/(Nyesha)* (Dir. Melvonna Ballenger, 1978).

presents an ideal image of what organized collaboration would look like had the Black filmmakers of the L.A. Rebellion formalized their collectivity. With "the film co-op," Ballenger echoes the commitment of Ethno-Communications to presenting positive images of people of color that would serve as a corrective to the myriad misrepresentations prevalent in mainstream culture. Like *Hour Glass, Ujamii,* and *Daydream Therapy, Rain* is optimistic about the possibility of personal and political change.

What the vast and varied Project One films show is that, as much as the filmmakers were rooted in their communities, UCLA was a tremendous influence on their work, fostering an environment where creative experimentation through rebellious unlearning was possible. UCLA not only gave access to equipment and facilities; it also provided exposure to world cinema (thanks to Elyseo Taylor and Teshome Gabriel) and offered camaraderie and collaboration among the students of color and their "fellow travelers," other progressive and politically engaged student filmmakers from a broad range of backgrounds. Through the Project One films, we can see the nascent coming together of ideas, styles, themes, and goals that would become emblematic of this Los Angeles–based Black independent film movement.

The Project One films are the least known of each filmmaker's creative oeuvre, as many have not been seen since their initial showing in UCLA's Melnitz Hall screening room and a few subsequent festival appearances. However, thanks to the efforts of the UCLA Film & Television Archive and the tenacity of the filmmakers who saved their work in whatever format possible, we are now able to revisit these early works. Doing so gives us a fuller appreciation of the creative trajectories of the Black filmmakers at UCLA during this period and an understanding of the genesis of the only Black independent film movement to come out of a university.[70] Even if the Black filmmakers "graduated into a desert" rather than a welcoming industry, as Gerima lamented, their Project One films enabled experimentation with film form and a free exploration of thematic concerns, providing the opportunity for student filmmakers to collaborate and lay the foundation for their subsequent creative work.[71] Through this process of unlearning, the L.A. Rebellion filmmakers discovered that "revolution" through film is not so simple, and their later work is marked by the rebellion born of these early experimentations with film form.

NOTES

Many thanks to Chon Noriega for his insightful comments on an earlier draft of this essay and to Daniel Morgan for his astute eye. Thanks also to Artel Great and Samantha Sheppard for their research assistance.

1. Clyde Taylor, "The L.A. Rebellion: A Turning Point in Black Cinema," in *Whitney Museum of American Art: The New American Filmmakers Series 26*, 1–2 (New York: Whitney Museum of American Art, 1986).

2. Ibid.

3. Ibid.

4. See the introduction to this volume for a more thorough discussion of MUCC and Ethno-Communications.

5. David E. James, *The Most Typical Avant-Garde: History and Geography of Minor Cinemas in Los Angeles* (Berkeley: University of California Press, 2005), 305.

6. Taylor, "Turning Point"; Ntongela Masilela, "The Los Angeles School of Black Filmmakers," in *Black American Cinema*, ed. Manthia Diawara (New York: Routledge, 1993), 107. While I focus on the key figures, there were other Black film students at UCLA at the time. The sixteen filmmakers I discuss here reflect the materials collected and oral histories conducted as part of the L.A. Rebellion Preservation Project. Hopefully, more materials will continue to become available to encourage wider consideration of even more student filmmakers of color.

7. Bernard Nicolas, oral history interview by Allyson Nadia Field, Jan-Christopher Horak, and Jacqueline Stewart, January 23, 2010, LAROH.

8. Several films had a more prolonged screening life outside of UCLA as they circulated in festivals, though these were primarily in Europe where the films' political engagement and anti-Hollywood aesthetic were met with critical approval.

9. Larry Clark, oral history interview by Jan-Christopher Horak and Jacqueline Stewart, June 2, 2010, LAROH.

10. Don Amis, oral history interview by Jacqueline Stewart, November 2, 2010, LAROH.

11. The connections between filmmakers can be traced in this volume's comprehensive filmography detailing their collaborations.

12. O.Funmilayo Makarah, e-mail correspondence with the author, April 6, 2012.

13. For example, Jamaa Fanaka performed in *I & I* (Dir. Ben Caldwell, 1979) and Ben Caldwell's still photography appears in *Welcome Home, Brother Charles* (Dir. Jamaa Fanaka, 1975).

14. Julie Dash, oral history interview by Allyson Field, Jan-Christopher Horak, and Jacqueline Stewart, June 8, 2010, LAROH.

15. Monona Wali, "Roundtable: L.A. Rebellion: Then and Now," at the symposium "L.A. Rebellion: Creating a New Black Cinema," UCLA Film & Television Archive, Billy Wilder Theater, Los Angeles, November 12, 2011.

16. Charles Burnett, oral history interview by Allyson Field and Jacqueline Stewart, June 7, 2010, LAROH; Clark, oral history.

17. Alile Sharon Larkin, oral history interview by Allyson Field, Jan-Christopher Horak and Shannon Kelley, June 13, 2011, LAROH.

18. Ibid.

19. Haile Gerima, oral history interview by Jacqueline Stewart, Allyson Field, Jan-Christopher Horak, and Zeinabu irene Davis, September 13, 2010, LAROH.

20. Ibid.

21. Charles Burnett, conversation with author, March 11, 2012.

22. Burnett, oral history.

23. Michael Cummings, e-mail correspondence with the author, January 19, 2012. Cummings went on to become a renowned painter and quilter.

24. In his oral history, Penick recounts that *69 Pickup*'s original ending had a surrealist twist, with the three figures throwing balled-up newspapers around the room, having fun. Penick states that in a fit of anger he removed the ending because the response from students and professors was that the ending was inconsistent. Thomas Penick, oral history interview by Allyson Nadia Field, LAROH.

25. Ibid. The soundtrack of the film does not survive.

26. Eldridge Cleaver, *Soul on Ice* (New York: Dell, 1968), 33.

27. See Billy Woodberry, oral history interview by Jacqueline Stewart, June 24, 2010, LAROH.

28. Clark, oral history. Notably, Clyde Taylor has written the most convincing argument against this type of pedagogy concerning *Birth of a Nation*. Clyde Taylor, "The Re-Birth of the Aesthetic in Cinema," *Wide Angle* 13, nos. 3/4 (July–October 1991): 12–30.

29. Several filmmakers have agreed with Teshome Gabriel's assessment that more women were admitted because the faculty "didn't want to deal with the

men anymore." Teshome Gabriel, conversation with the author, October 21, 2009. See also Larkin, oral history.

30. Clark, oral history.

31. Q&A at screening of *Passing Through* (Dir. Larry Clark, 1977), Billy Wilder Theater, Los Angeles, December 10, 2011.

32. Whitfield also appeared in Haile Gerima's *Ashes & Embers* (1982).

33. Clark, oral history.

34. A perfectionist, Larry Clark would not permit *Tamu* to be shown in the UCLA Film & Television Archive's series "Creating a New Black Cinema." However, the film can be viewed at UCLA's Archive Research Study Center in Powell Library, along with the other surviving films of the L.A. Rebellion that have been deposited at UCLA.

35. Clark, oral history.

36. Jamaa Fanaka, oral history interview by Allyson Field, Jan-Christopher Horak, and Jacqueline Stewart, June 16, 2010, LAROH.

37. Gerima, oral history.

38. Clark, oral history.

39. Gerima, oral history.

40. Scott Moore, "Negroes to Boycott Olympics," *San Jose Mercury News*, November 24, 1967, 1.

41. *Black Panther Newspaper* 10, no. 7 (1973): 6 and 13.

42. Woodberry, oral history.

43. Ibid.

44. Ibid.

45. O.Funmilayo Makarah, oral history interview by Jacqueline Stewart, May 29, 2011, LAROH.

46. O.Funmilayo Makarah, e-mail correspondence with the author, April 6, 2012.

47. Ben Caldwell, oral history interview by Allyson Field and Jacqueline Stewart, June 14, 2010, LAROH.

48. Ibid.

49. Ibid.

50. Tyler Perry's signature character Madea may seem to reference the classical myth, yet the character's name more closely references the truncation of "Ma'Dear," a common appellation for African American matriarchs, derived from southern Black culture.

51. Caldwell, oral history.

52. Ibid.

53. Ibid.

54. Ibid.

55. Amis, oral history.

56. Ibid.

57. Ibid.

58. Larkin, oral history.

59. Jacqueline Frazier, oral history interview by Jacqueline Stewart and Jan-Christopher Horak, August 29, 2011, LAROH.

60. Neither of these films is known to be extant.

61. Carroll Parrot Blue, oral history interview by Allyson Field and Jacqueline Stewart, June 23, 2010, LA Rebellion Oral History Project, UCLA Film & Television Archive.

62. Walker's short story was first published in *Freedomways: A Quarterly Review of the Freedom Movement* 8, no. 3 (Summer 1968), and subsequently anthologized in Alice Walker, *In Love and Trouble: Stories of Black Women* (Orlando, FL: Mariner Books, 1973), 113–18.

63. Julie Dash, interviewed by Barbara McCullough on *Convergence*, c. 1978–79, UCLA Film & Television Archive, inventory no. VA8025 M.

64. Ibid.

65. Ibid.

66. Nicolas, oral history.

67. Jacqueline Stewart, "Defending Black Imagination: The 'L.A. Rebellion' School of Black Filmmakers," in *Now Dig This!: Art and Black Los Angeles, 1960–1980*, ed. Kellie Jones (Los Angeles: Hammer Museum, University of California; New York: DelMonico Books/Prestel, 2011), 47.

68. For a thorough discussion of *Cycles*, see Kathleen Anne McHugh, "Experimental Domesticities: Patricia Gruben's *The Central Character* and Zeinabu Davis's *Cycles*," in *American Domesticity: From How-To Manual to Hollywood Melodrama* (New York: Oxford University Press, 1999), 179–94.

69. While it is not clear if Ballenger saw the film, her interest in the intersection of political and domestic revolution echoes the great blacklisted film of the 1950s, *Salt of the Earth* (Dir. Herbert Biberman, 1954).

70. Many of the Project One films are now available for streaming on the UCLA Film & Television Archive's L.A. Rebellion website, www.cinema.ucla.edu/la-rebellion.

71. Gerima, oral history.

Tough Enough

Blaxploitation and the L.A. Rebellion

JAN-CHRISTOPHER HORAK

The tidal wave of so-called Blaxploitation films that hit American screens in 1972 in the wake of the huge financial successes of Ossie Davis's *Cotton Comes to Harlem* (1970), Melvin Van Peebles's *Sweet Sweetback's Baadasssss Song* (1971), and Gordon Parks's *Shaft* (1971) was unprecedented in terms of both the numbers of African Americans receiving first-time screen credits and the intense debates among Black viewers and critics accompanying each film's release. While "Blaxploitation" has become a blanket term for all Black-themed films from the 1970s, here I use it in the context of the moment it was coined, to point to films that featured violent and sexualized Black images. These images were the objects of intense critique and debate precisely because of their power and proliferation. Not since the Race film era of the 1920s–1940s had so many Black-cast films been produced, and these too had been heavily critiqued (particularly in the pages of the African American press) for digressing from the uplift project of respectability and "positive images."[1] During the 1950s and 1960s, African Americans were relegated to the margins on the big and small screens, with rare star turns by performers like Sidney Poitier or Harry Belafonte. All that changed after Van Peebles's independently produced and distributed film grossed $15 million, while the MGM-financed *Shaft* took in more than $12 million.[2] Just as Rick Altman has demonstrated that *Little Caesar* (Dir. Mervyn LeRoy, 1931) gave rise to the gangster film, as producers rushed to replicate the earlier success, so too

did box office dollars inevitably breed a new Hollywood genre, Blaxploitation.[3]

Ed Guerrero has succinctly characterized the Blaxploitation era from roughly 1971 to 1976 and its demise: "When Hollywood no longer needed its cheap, black product line for its economic survival, it reverted to traditional and openly racial stereotypical modes of representation, as the industry eagerly set about unplugging this brief but creatively insurgent black movie boom."[4] Dividing the Blaxploitation era into three periods, Guerrero notes that the great wave of critically unacceptable Blaxploitation films was accompanied by the production of a handful of serious-minded films, including *Sounder* (Dir. Martin Ritt, 1972) and *Lady Sings the Blues* (Dir. Sidney J. Furie, 1972). Guerrero's critique is best expressed in his concluding characterization of Blaxploitation as "a diversionary period of violent 'superspade' caricatures masquerading as progress on the issue of black filmic representation."[5] Given his cultural critique of Blaxploitation, Guerrero plays down the fact that, if only briefly, the Blaxploitation wave admitted numerous African American producers into the entertainment industry.

As students at UCLA, the L.A. Rebellion filmmakers echoed this critique, and as filmmakers they were especially sensitive to the institutional and representational challenges of making Black films for a mass audience. But as this essay will demonstrate, the L.A. Rebellion does not merely have an oppositional relation to Blaxploitation; rather the L.A. Rebellion engaged with, responded to, and in some cases drew from Blaxploitation as the most visible mode of Black representation of the period. And without excusing the sexism and racial stereotyping that are undoubtedly part and parcel of many Blaxploitation titles, film scholars have recuperated the genre as a highly formalized and generic expression of African American culture. As such, Blaxploitation's heterogeneity exposes many of the contradictions of African American life that are also explored in the films of the Rebellion.[6] Furthermore, while the L.A. Rebellion as a group took a critical stance toward Blaxploitation, this essay discusses works by the Rebellion's first wave. This predominantly male cohort—the ones who started making work at the height of the Blaxploitation cycle—most directly took up the challenge of critiquing Blaxploitation as a genre, focusing on gendered questions of oppression and resistance.

The L.A. Rebellion's aesthetic strategies and ethics emerged as a direct reaction to Blaxploitation's amplification of particular signs and symbols of African American life (e.g., the urban, the criminal), but the Rebellion

films also referenced those "false" images in order to work toward a more nuanced and comprehensive view of Black experience. Some of the first L.A. Rebellion films to enter the marketplace (principally the work of Jamaa Fanaka) undoubtedly benefitted from Blaxploitation's economic updraft, even as they upended its conventions. Arguably, Fanaka took a more direct approach, seemingly embracing Blaxploitation while turning its stereotypes and plots upside down and consciously subverting specific generic expectations. This strategy attempted to critique the genre from within, often creating self-conscious characters and narratives that stood in contradistinction to the sexist, at times racist fantasies of most mainstream Blaxploitation films; it was a strategy also employed by some independently produced films, like *The Spook Who Sat by the Door* (Dir. Ivan Dixon, 1973) and *Gordon's War* (Dir. Ossie Davis, 1973).

As the L.A. Rebellion filmmakers were studying at UCLA, directors of color were being afforded their first opportunities to direct feature films, some with Hollywood studios. These included Ossie Davis, Parks, and Van Peebles, as well as Gordon Parks Jr. *(Super Fly)* [1972], Ivan Dixon *(Trouble Man)* [1972], Mark Warren *(Come Back, Charleston Blue)* [1972], Hugh A. Roberston *(Melinda)* [1972], Bill Gunn *(Ganja & Hess)* [1973], Sidney Poitier *(Buck and the Preacher)* [1972], William Crain *(Blacula)* [1972], and Oscar Williams *(The Final Comedown)* [1972]. New Black films stars also appeared, including Pam Grier, Tamara Dobson, Vonetta McGee, Richard Roundtree, Jim Brown, Billy Dee Williams, and Fred Williamson. Typical of other Hollywood genres, according to Altman, Blaxploitation incorporated elements of many other genres, including comedy (*Uptown Saturday Night*, Dir. Sidney Poitier, 1974), horror (*Blackenstein*, Dir. William A. Levey, 1973), westerns (*Thomasine & Bushrod,* Dir. Gordon Parks Jr., 1974), melodrama *(Sounder)*, and contemporary drama (*Claudine,* Dir. John Berry, 1974). In 1972, twenty-five African American films were released, followed in 1973 by twenty-three; in 1974, twenty-five. Not only had Hollywood discovered a niche audience in urban centers, which at that key moment saved the industry from financial ruin, but also the Black community investment in film production exploded.[7] Yet, while Black urban audiences flocked to the cinema to cheer on proud African American heroes, middle-class Black spokespeople mercilessly attacked Hollywood and their own for trafficking in images that portrayed the Black community in a negative light.

The term *Blaxploitation*, a conflation of *Blacks* and *exploitation,* was coined sometime in late 1972 by Junius Griffin, then executive

director of the Hollywood branch of the National Association for the Advancement of Colored People (NAACP), as a pejorative term, implying that such films exploited Black Americans.[8] By the time *Super Fly* had earned a fortune, grossing over $20 million in its first seven months of release, with its glamorous treatment of a high-living cocaine-pusher hero, critical protests had grown to a roar. In the December 1972 issue of *Ebony*, B. J. Mason attacked the wave of Black films as "culture or con game," without using the Blaxploitation moniker.[9] A month later, the *Los Angeles Times* reported that "the Coalition Against Blaxploitation (CAB), representing local civil rights groups—the NAACP, Southern Christian Leadership Conference and CORE has pledged to set up its own rating system for black movies."[10] As the aforementioned Junius Griffin railed, "We will not tolerate the continued warping of our black children's minds with the filth, violence and cultural lies that are all pervasive in current productions of so called black movies. The transformation from the stereotyped Stepin' Fetchit to Super Nigger on the screen is just another form of cultural genocide. The black community should deal with this problem by whatever means necessary."[11]

But this critique was not universally shared. For example, the Black Panther Party welcomed what it saw as the revolutionary potential in *Sweetback*, as evidenced by Huey P. Newton's positive film review of the film: "Through *Sweetback*, Melvin Van Peebles is righteously signifying and teaching the people what must really be done to survive. When Sweetback realizes that he cannot turn his back, he takes the handcuffs, the chains which have been used to hold him in slavery, and he starts to kick ass. Using the handcuffs as a weapon against the oppressor rather than as the tool of submission, he downs both of the policemen."[12] The Panthers also provided production help on *The Mack* (Dir. Michael Campus, 1973), shot in Oakland.[13] Some African American film workers took a more moderate view of the films, as illustrated by James Earl Jones, who noted that "even the black exploitation movie has a role to play. The groups trying to cancel these movies are fighting a losing battle. I think there is some call for such movies. The black image is in state of creation."[14]

It was within this context of open questions about the direction of Black film images that the L.A. Rebellion emerged. Indeed, the first feature films of the African American members of the UCLA film school appeared in the mid-1970s, when Blaxploitation was on the wane. Even if a retronym, the very name of the "Rebellion" signaled the revolt of student filmmakers and industry outsiders against Hollywood in gen-

eral and the Blaxploitation aesthetic in particular. L.A. Rebellion film-makers sought to produce films that consciously invoked art cinema and Third World liberation aesthetics and avoided the violence and "ghetto milieu" of Blaxploitation's most derogatory products. The Rebellion filmmakers, like many of their colleagues, focused instead on family life in the lower-middle-class and working-class Black commu-nity. Their models for an alternative to Hollywood were Italian neoreal-ism, Cinema Novo, and Third World liberation cinema, not the formu-laic conventions of Hollywood genre films. As Charles Burnett noted in an interview,

> All the people attending the course [in Ethno-Communications, taught by Elyseo Taylor] were there making films in response to false and negative images that Hollywood films were promoting. There was an anti-Hollywood attitude—but it was more than that, the focus was on telling *your* story and working out an aesthetic. [. . .] If you try to go beyond stereotypes and reflect real people who share the same concerns as everyone else, you're told that your characters aren't "black" enough, or to use more curse words because the language isn't "real" enough. You have to have drugs and gangsters.[15]

Burnett's complaint is not only against Blaxploitation per se, but against all forms of genre cinema employed by Hollywood. Haile Gerima articulates another problem with Blaxploitation, namely the penchant for sexual exploitation of women: "Especially our people who liked at that time *Shaft,* or even *Sweet Baadasssss* [*sic*], which we didn't like. We didn't like it. I had a fight, an argument with the brother, the filmmaker in Ohio, but I didn't like it, because I felt that whole sexual exploitation was against our principle."[16] Clyde Taylor put the objec-tions to *Shaft* and other Blaxploitation films most succinctly: "*Shaft* was a pre-disco movie opera in which the characters, instead of singing, spoke an oratorio of bad dude pseudo Black English."[17] Larry Clark, on the other hand, took a more moderate, albeit still negative view: "Some of those films didn't satisfy me though . . . I mean I can understand the struggles they had to make those films and how it was a victory that they could do it, but nevertheless their films and imagery left a lot to be desired. When you see them you have to read between the lines . . . there were a lot of compromises that had to be made within the subject-matter."[18]

In addition to "reading between the lines" of mainstream cinema, the L.A. Rebellion filmmakers were trying to bring their intellectual and political investments into their efforts to develop new aesthetic strate-gies. These strategies attempted to meld art cinema, Third World libera-

tion ideologies, and their understanding of African American realities in Los Angeles.

The strategies developed by L.A. Rebellion filmmakers ran the whole stylistic gamut. On the one side, a film like Haile Gerima's *Bush Mama* (1975) consciously eschewed Hollywood genre narratives, relying instead on Third World cinema–style elliptical montages, mixing documentary and fiction as well as multiple levels of audio with extremely fragmented editing. Yet, the film's title and narrative of an African American woman coming into class and race consciousness seem to have been consciously constructed as an antidote to films featuring actors like Pam Grier and Tamara Dobson in sexualized fantasy roles. At the other end of the spectrum, Jamaa Fanaka's films like *Emma Mae* (1976) and *Penitentiary* (1979) employed the tactics of mainstream cinema to produce Black films as cheaply as possible, but they also critiqued Hollywood's vision of African Americans through self-conscious irony. L.A. Rebellion films used various aesthetic strategies to produce works that self-reflexively and nonexploitively referenced and critiqued Blaxploitation films.

Jamaa Fanaka's body of work has been most closely associated with Blaxploitation, a label Fanaka explicitly rejects but his sometime distributor, Xenon, embraced. As the American Film Institute (AFI) Film Festival wrote of Fanaka retrospectively in 1991, "Pitching his films to a brew of blaxploitation and devil-may-care social observation with a fatal garnish of humanism, he soon had a grind-house hit with *Penitentiary*."[19] Most Internet sites discussing *Emma Mae, Welcome Home, Brother Charles* (1975), and the *Penitentiary* cycle (1979, 1982, 1987) reference Blaxploitation.[20] Yet a closer reading of his work reveals that while Fanaka mimics, parodies, subverts, and critiques Blaxploitation genre conventions and expectations more closely than any of his Rebellion compatriots, he also constructs an explicitly political text that deconstructs Blaxploitation cinema's male chauvinist and often racist narratives.

Another aspect that allies Fanaka ideologically to the L.A. Rebellion is his decades-long struggle for Black artistic rights and against Hollywood's racist labor practices, which have to the present day constricted African American participation in creative and economic decision making to levels far, far below African Americans in the general population. Fanaka was one of the founders of the African American Steering Committee at the Directors Guild of America in the early 1980s. He also singlehandedly and without the benefit of NAACP support took on and pursued a class-action lawsuit against the Directors Guild of America

(DGA), the Motion Picture Export Association of America (MPEAA), and almost all the major film studios for employment discrimination against African Americans.[21] That struggle more than likely destroyed his film career. Like most of his compatriots, Fanaka has remained an outsider to the established film and television industry, self-financing many of his own films.

Fanaka's method of playing off of Blaxploitation's genre conventions is already apparent in Fanaka's first student film, a required 8mm short project (*A Day in the Life of Willie Faust, or Death on the Installment Plan*, 1972). Presented in 16mm with a nonsynchronous soundtrack, *Willie Faust* is Fanaka's version of Goethe's epic *Faust*, set in a contemporary Black urban environment like that of *Super Fly*, which Fanaka explicitly references by using Curtis Mayfield's hit song during a drug-purchasing scene. Often out of focus, under- or overexposed, with an overactive camera, the film immediately exudes nervous energy.[22] The film's first two scenes are Blaxploitation-genre set pieces: the meeting of the syndicate around a table and the "hero" waking up in bed with his woman. But audience expectations and genre conventions are subverted in both scenes. In the opening narrative frame, the chairman of the board (aka the Devil) takes the film out of the surface realism of Blaxploitation and into the realm of fantasy when he promises to show the assembled drug lords a live performance of "paying in full," transitioning then to the subsequent narrative. In the second scene, the African American "hero" wakes up to a baby screaming and a modestly dressed wife, rather than the nude and willing female companions of Shaft or *Super Fly*'s Priest. Fanaka notes about the film, "Goethe's Faust sold his soul to the devil mainly for the love of a woman. But my Faust sold his soul to the devil for drugs. I played Faust and my wife played Faust's wife."[23]

Unlike many of Blaxploitation's heroes, who maintain an inner moral code even while ostensibly breaking the law, the "hero" here reveals himself to be a thief, a rapist, and a drug user. These aspects of his character are conveyed in scenes that are as graphic in their violence as the finale, when Willie dies of a heroin overdose. Unlike Priest's elegant cocaine consumption with a silver spoon, Willie's arm gushes blood from the punctured vein as he injects the heroin he has scored. He slowly nods off and then expires in a pitiful heap on the bathroom floor, thus capturing the grim reality of all junkies, regardless of race or economic status (an acquaintance of Fanaka, a real drug addict, body doubled for the injection shot). At the same time, Fanaka intercuts hysterically laughing heads, giving the scene an expressionistic edge that productively collides with the

FIGURE 3.1. *A Day in the Life of Willie Faust, or Death on the Installment Plan* (Dir. Jamaa Fanaka, 1972).

film's realism. And as if to thoroughly obliterate the Hollywood fantasy of acquiring drug wealth to escape the circumscriptions of Black life, Fanaka concludes with a shot of the wife and baby, widowed and orphaned, while a title reads, "Paid in Full." This attention to the destitute family Willie leaves behind and the film's condemnation of the central character's amoral life both mark Fanaka as a filmmaker whose concerns are much more closely allied with his fellow students than previously assumed.

In 1975, while still at UCLA film school, Fanaka completed his first feature film, *Welcome Home, Brother Charles* (1975), shot in color on weekends in seven months and later released on video/DVD as *Soul Vengeance* by Xenon. As the new title suggests, *Brother Charles* has been perceived as closer to Blaxploitation than any other L.A. Rebellion film, but here too Fanaka subverts generic expectations, producing a biting satiric narrative on Los Angeles police and judicial corruption, especially in his remixing of realistic narrative, surrealist fantasy, and generic conventions from horror, crime, and Blaxploitation features. *Brother Charles* was financed through grants from the Ford and Rockefeller Foundations and supposedly given the standard exploitation promotion, but Fanaka contends that "actually it was made for the

FIGURE 3.2. Theatrical poster for *Welcome Home, Brother Charles* (Dir. Jamaa Fanaka, 1975). Collection of Jamaa Fanaka, courtesy Twyla Gordon-Louis, Trustee, Gordon Family Trust.

thinking man."[24] The film was initially distributed by Crown International and apparently earned $1 million, but this may be apocryphal, given that no film reviews could be found in the mainstream press.[25] However, it has since become a cult classic, discussed on fan sites dedicated to Blaxploitation. William Poundstone calls *Brother Charles* "the Sistine chapel of blaxploitation high concepts: the angry black man who strangles white oppressors with his penis."[26] Another DVD reviewer writes, "On the surface, *Soul Vengeance* is your typical low-budget all-black revenge drama. But just underneath that familiar veneer is an incredibly sordid sleaze classic with one amazing scene that has gone

down in the history books of cult film viewing, and easily makes the Top 10 list of scenes you'll need to rewind almost immediately to confirm you just witnessed what you think you did!!"[27]

Like *Willie Faust*, the film opens with a frame: a Black male is trapped by police on the roof of a high building and threatens to commit suicide by throwing himself off, leading to the narrative proper as his girlfriend is brought up to talk him down. A small-time criminal, Charles Murray, is arrested, handcuffed, and beaten to a pulp by two white plain-clothes detectives, though he has committed no crime. While one of the cops looks the other way, the other one takes a knife to Charles's manhood. This is in part an allusion to routine police brutality against Black men but also can be read within the narrative as additionally motivated by the cop's wife's sexual attraction to Black men. Charles is subsequently sent to jail by a corrupt judge, seen in an earlier scene accosting a Black prostitute, and by an equally corrupt prosecutor, both of whom treat Charles like a misbehaving child.

After three years in prison (represented in black-and-white stills shot by Ben Caldwell in the same Lincoln Heights jail that would become the primary location for Fanaka's later film *Penitentiary*), Charles is released to find his girlfriend involved with threatening criminals and his younger brother involved in drug dealing. He is also unable to find a job, and he suffers from an unknown affliction, the result of scar tissue and second-hand exposure to a radioactive nuclear device (the knife with which he was mutilated had previously been used by the cop to deactivate a nuclear bomb). One day, on television, Charles sees the cop who wrongly arrested and maimed him and decides to take his revenge on all of those responsible for his plight. He goes to the officer's home and hypnotizes his wife with the shocking result of his physical affliction: a penis that grows to anaconda-like lengths. Just how Charles dispatches the cop is not revealed until a subsequent night, when he seeks revenge against the prosecutor: he strangles him with his snaking, enlarging penis, after turning the man's wife into a similarly transfixed zombie. When Charles's white psychiatrist reveals to the police his "dreams of strangulating victims with his penis," Charles is stopped from killing the corrupt judge, after again seducing the wife. Returning to the opening framing scene on the rooftop, the film ends with a freeze-frame on Charles's new girlfriend after she shouts "Jump!"

Brother Charles opens with images of an African statue, a fertility god with a giant penis, while an African-sounding musical instrument (actually a distorted saxophone) plays, indicating that the narrative that follows originates in both African mythology and a white racist subjec-

FIGURE 3.3. *Welcome Home, Brother Charles* (Dir. Jamaa Fanaka, 1975).

tivity that has demonized African American males for their perceived threatening sexuality. While the white women Charles confronts lose all self-control in the face of his powerful manhood, thus substantiating subjective white male fears of losing patriarchal and political control, the brutal cop who nearly castrates Charles also suffers from emasculation at the hands of his wife, who vocally complains about his inability to satisfy her. Significantly, the psychiatrist who betrays Charles displays an African fertility statue on his desk, as if to state that he too has bought into the myth. Fanaka is clearly playing with long-standing racial stereotypes about the mythological endowment of Black males, exaggerating the organ's power to ridiculous extremes to expose the white myth. In a sustained close-up on Charles's face as he enacts his revenge, Charles's strained expression implies that it is not primarily a moment of sexual ecstasy but rather one of unleashed rage. And yet, as the film's end demonstrates, Charles's victory is circumscribed, and he is yet again a victim of the dehumanizing white power system.

White men (and women) as agents of an oppressive political system activate his transformation. His sexual relations with his African American girlfriend are not affected. And he does not seek revenge against the

FIGURE 3.4. Photograph by Ben Caldwell, *Welcome Home, Brother Charles* (Dir. Jamaa Fanaka, 1975).

gangster who steals his first girlfriend and likely framed him. He returns from prison, committed to going straight. The street scenes of him walking to his mother's house present the Black community as tight knit and intergenerational rather than riddled with drugs and prostitution as seen at the film's beginning. Like other L.A. Rebellion filmmakers, Fanaka decries the lack of legitimate employment opportunities for Black men who have been incarcerated, demonstrating that their attempts to establish a sustainable existence are doomed, given the economic and racial barriers of white society. The film imagines Charles as a reluctant superhero, with powers drawn from horror, atomic-age science fiction, and Blaxploitation films. In this way, the film uses the tools of Blaxploitation (i.e., hypermasculinity) to put a new twist on the genre's critique of white power structures as inherently racist and corrupt.

The sadistic manifestations of white male power presented in Fanaka's film are a function of racist and patriarchal structures. These structures are also examined in Ben Caldwell's *I & I: An African Allegory* (1979), which features a scene that can be interpreted as referencing Blaxploitation's interest in critiquing "the Man." In the "wake" scene,

a well-dressed, young African American man sits in a dark room, addressing an unseen body in a coffin as "Dad." When the off-camera corpse remains silent, despite the son's plea to "talk to me," the young man walks up to the body, expresses his hatred, and spits on its cheek. A subsequent close-up of the corpse reveals it to be an older white man with slicked-back black hair. An extreme close up of his cheek, with the spit running down, emphasizes every imperfection of the man's skin, an ugly landscape of white flesh. Is the corpse an allegory for the white men who brought African peoples to the New World, as visualized in a previous scene? Is he "the Man" who inflicts daily injustices on African Americans through the police and the courts, as visualized in later montages of police riots? Or is he a Mafia don who engages in illegal activities in Black communities, thereby referencing Blaxploitation gangster narratives? The fact that the young man can only express his anger at a harmless corpse may signify his emasculation, his inability to confront living white power. Or, can we read this as a stinging confrontation of the legacy of the white father, a refusal to maintain the sanctity of the laid-out body? Interestingly, in the film's subsequent section, the filmmaker interviews an elderly Black woman, shifting the narrative back again to the African matriarchy, signaled by characters played by Pamela Jones before and after this scene. Caldwell's nonlinear and ambiguous film construction thus suggests multiple levels of interpretation of the historical African American experience.

Jamaa Fanaka's next feature film, again made while he was a student at UCLA, likewise shifts emphasis to African American women: *Emma Mae* (1976) was released subsequently by its distributor as *Black Sister's Revenge* to exploit its connections to Blaxploitation. In point of fact, while the film focuses on a strong African American woman as its central character, one who takes violent action and thus references characters popularized by Pam Grier and Tamara Dobson, Fanaka undercuts generic expectations by focusing much more on family drama (and ultimately comedy) than on genre conventions of Blaxploitation.

Financing the film through his parents, as well as through a distribution deal with Crown International, Fanaka hired nonunion actors, paying them cash rather than deferred salaries. Production began on June 20, 1976, and was completed in six weeks. The film's initial budget was $81,400, with some of financing supplied by two producers, Peer Oppenheimer and William Silberkleit (S&K Films),[28] eventually expanding to $240,000.[29] Furthermore, like *Brother Charles*, the film was partially financed with public grants, this time from the American Film

Institute and from the UCLA Black Studies Center.[30] Interviewed by *Variety's* Joseph McBride, Fanaka noted that UCLA film school professors discouraged him from making another feature as his master's thesis. He contended that the film school was "geared toward mediocrity," that teachers didn't have adequate production backgrounds, and that students were urged "to take a safe approach."[31]

Emma Mae opens with the arrival to Los Angeles (Compton) of a country cousin from rural Mississippi, whom the family initially embraces somewhat tepidly, given her unsophisticated clothing and speech. Her female cousins take Emma Mae to a party at the student union of their college, where she is introduced to Jesse Amos, a sometime drug dealer and full-time drug user. She then impresses the group by beating up Jesse's friend, Zeke, who calls her cousins "bitches." Later, the very tall Jesse comes calling to take Emma Mae to another party and she insists on waiting for him when his crew gets into a rumble. Emma Mae repeatedly tells her cousins she thinks Jesse is cute, although they consider him a loser. Jesse displays poor judgment when he and Zeke attack two Black cops who have pulled them over for apparently no reason, and Emma Mae saves the day by kicking a gun from the cop's hands. Escaping the cops, the couple hole up with a Black revolutionary, "Big Daddy" Johnson, but the police find and surround them and demand that Jesse release his "hostage," forcing them to surrender. Emma Mae decides to organize the community to raise bail money for Jesse by setting up a car wash, but the police force the landlord to close down their operation. Emma Mae suggests robbing a bank to make Jesse's bail and she proceeds to pull off the heist. At the subsequent welcome home party, Jesse fails to show up. The next morning, Emma Mae finds him in bed with another woman, telling her he never loved but only used her. She then proceeds to give him such a public beating that even his own crew doesn't want to deal with him anymore. The film ends with Emma Mae walking away from the humiliated Jesse with her cousins supporting her.

Far from being a Blaxploitation film that glorifies drug dealers and gangs, *Emma Mae* advocates an antigang, profamily ideology that is evident from the film's very beginning. As in *Brother Charles*, the Black community is visualized as a giant family. The opening credits, for example, are presented over scenes in a Compton park where families gather to make music. Emma Mae's Aunt Dara runs a beauty salon out of her home, with neighbors arriving to gossip about families. When Emma Mae meets Jesse, she says to him, "Back home, we got one rule,

FIGURES 3.5. & 3.6. *Emma Mae* (Dir. Jamaa Fanaka, 1976).

families have to stick together." And indeed, this film is about the family, whether an extended nuclear family or the community as family.

Emma Mae, as played by Jerri Hayes, is far from being the oversexed mannequin that other Blaxploitation actresses, like Pam Grier or Vonetta McGee, were limited to playing, Based on Fanaka's own cousin, Daisy Lee, "who at 11 could kick a 16-year-old boy's ass," Emma Mae functions as a nurturer and protector in the community.[32] Dark-skinned, with unprocessed hair and a petite yet strong body, Emma Mae is a real human being rather than a figure of male fantasy. She comforts her younger cousin, who is worried about the size of her breasts, and later beats up another woman who refuses to join the community in collective action. Even her willingness to commit a crime is motivated by her falling in love. The final image of Emma Mae being embraced and comforted by her three female cousins communicates a strong sense of both family and female empowerment. Indeed, Fanaka has stated that Emma Mae is an homage to his strong-willed aunt, who like so many women in urban African American communities struggling with underemployment, have had to carry the burden of keeping families together.

Jesse, however, has no intention of following in that path, as evidenced in an early scene in which he uncomfortably sits with Emma Mae's family while she dresses for their date. Jesse represents the braggart, the self-absorbed and vain illusions of African American youth gangs who convince themselves that their macho posturing is cool. Despite her cousins' warning her against Jesse, and the fact that she sees him repeatedly swallowing "reds," Emma Mae believes that he can be saved. She gives herself to him, before he is arrested, and will do seemingly anything to protect him. When she visits Jesse in jail, though, he demands that she bring him more money and then screams at her when she asks whether he can get drugs in jail. In the scene, Fanaka returns once more to the Lincoln Heights jail in East Los Angeles. The final beating that Emma Mae gives to Jesse, repeatedly smashing her fist into his groin, illustrates his emasculation, thus demonstrating that men involved in dealing drugs and gang warring are essentially cowards who should be shunned by the community if they fail to reform or mature. Fanaka's concern here is for the family and the community, both of which are threatened as much by enemies from within as by the white power structure; indeed, gang violence is an indirect effect of white oppression.

The film's antigang ideology is communicated through a variety of scenes and characters. When the first evening's party is broken up by

FIGURE 3.7. *Emma Mae* (Dir. Jamaa Fanaka, 1976).

gang warfare, Fanaka demonstrates that the tussle between rivals has no rational origin. Big Daddy, who represents the militant, Black nationalist, and revolutionary elements in the community, likewise blasts young Black toughs who think that with a gun in their pocket they own the world. Dressed in an African caftan, he tells them that gang warfare is completely counterproductive and they would be better served taking their community back from the white man. Big Daddy's words are echoed by Emma Mae, when the police close down her car wash: "They always talking about how we young people are always using dope and kill each other in the street. Then when we try to do what they say how it should be done, they mess with us and shut us down."

Contemporary reviews did take notice of Fanaka's tribute to the strength and resiliency of African American womanhood, noting that it was "one of the most positive female images in recent American pix."[33] Seen as character driven rather than action oriented, the film received numerous positive reviews, including one by critic Arthur Knight: "'Emma Mae' explores aspects of black ghetto life with insight that no white filmmaker has yet provided—the reason behind the black's hatred of cops (most of whom, as shown in the film are black), the gang wars

and rip-offs of rival factions in the black community, and the film's singular lack of concern that a bank has been robbed to provide bail for a man who is worthless."[34] Writing retrospectively in the *Los Angeles Times,* when the film was revived at the L.A. Pan African Film Festival in 2005, Kevin Thomas concurred: "Awash with 70s afros and bellbottoms, *Emma Mae* has lost none of its immediacy or relevance—or its potent mix of grit and humor."[35] For latter-day Blaxploitation enthusiasts, *Emma Mae* lacks the sex and violence they associate with the genre. As one DVD reviewer put it, "OK, so this ain't *Coffy* [Dir. Jack Hill, 1973]. This black sister's revenge is nowhere near as cool as Pam Grier kicking major ass and blowing away bastards with a shotgun."[36]

Here we see expressed the desire for exploitation set pieces full of violence and sexuality that Fanaka's film consistently inverts. The gang rumble scene, which could have turned into an orgy of violence, cuts away to show the partygoers fleeing the scene, thereby focusing on the community's innocent bystanders rather than on macho posturing with chains and baseball bats. The bank robbery scene comes closest to meeting generic expectations, although its success without a shot fired or anyone hurt runs counter to Blaxploitation films' predilection for violence and blood as visual pleasure. Emma Mae is clearly the leader of the crew of robbers in the scene, screaming instructions at the mostly white bystanders and bank employees, but she takes pains to steal only the bank's money and not damage the lives of innocent bystanders. The final showdown between Emma Mae and Jesse, leading to his emasculation and unmasking as a fake and the empowerment of women as family leaders, completely undermines Blaxploitation genre conventions. Coffy and other female Blaxploitation protagonists may represent strong African American women, but they also reflect the desires of male audiences. Thus, in *Emma Mae* Fanaka interrogates and debunks two of Blaxploitation's most crass male-driven stereotypes: the sexualized Black female body subject to the male gaze and the invincible and sexually alluring male outlaw. Instead, he visualizes an empathetic African American womanhood as a nurturing and protective force in the Black community, and he critiques as irresponsible the culture of immature, macho posturing African American males, who are detrimental to the community as a whole because of their egotistical need to prioritize their own pleasures over familial commitments.

Much more radical in its critique of American society in general and Blaxploitation in particular is Haile Gerima's UCLA master's thesis film, *Bush Mama* (1975). Gerima's film performs a Marxist critique of

the capitalist power structure that subjugates the urban poor in economic, political, social, and psychological terms, as well as the Hollywood media images that perpetuate racist stereotypes. Indeed, the African American heroine of *Bush Mama* traverses a narrative trajectory from victimhood to empowerment, from passivity to action, and from ignorance to ideological awareness that parallels the action-reaction revenge narratives of films like *Coffy* and *Foxy Brown* (Dir. Jack Hill, 1974) but in much more sophisticated terms, simultaneously eschewing the genre's depiction of African American women as objects, subject to the male gaze.

Funded in part by a $40,000 grant from the National Endowment for the Arts, awarded to Gerima after a script competition within the UCLA Theater Department, the film was apparently completed in 1975–76 but was not publicly screened until 1978.[37] According to Gerima, he conceptualized the film after seeing a Black woman in Chicago evicted from her flat in the dead of winter: "I never knew how a person could be thrown out and so, I came up with the idea *Bush Mama*."[38] It was subsequently presented at the American Independents Program of the Seventeenth New York Film Festival in September 1979 and then played in numerous European venues. Its reception in the mainstream press was decidedly mixed; much attention focused on the film's perceived anti-white imagery. A white critic for the UCLA student newspaper, the *Daily Bruin,* for example, called *Bush Mama* "conspicuously anti-white and hopelessly pretentious," stating that "the film drowns in its own grisly despair."[39] The *Los Angeles Times* film critic, on the other hand, complained of the film's experimental techniques and "gratuitous and gruesome abortion fantasy."[40] Janet Maslin in the *New York Times* commented on Gerima's visual and auditory narrative construction: "[*Bush Mama*] has a visual style as jumbled as its soundtrack, though this quality of sensory overload is as dulling to the eye as it is provocative to the ear. The film's principals, all of them very strong players, emerge from a cluster of vividly sketched lesser figures. [. . .] The sense of these characters' imprisonment and frustration is the film's most vivid message, far more powerful than the angry declaration at which Dorothy finally arrives."[41] And even a critic as astute about avant-garde work as J. Hoberman in the *Village Voice* admitted that the film was "poorly constructed and wildly uneven," but he also praised its experimental energy and raw power: "Gerima's idiomatic evocation of the milieu is more developed than Dorothy's key move toward revolutionary consciousness. Still, the film has a jarring forcefulness which cannot be denied."[42]

Bush Mama utilizes the stylistic tools employed by Third World film-makers, as well as European modernists like Jean-Luc Godard, but both the film's overall narrative and individual scenes reference Blaxploitation cinema, turning perceived negative images into positive ones. As played by Barbara O. Jones, the central character of Dorothy fights a never-ending battle with the Los Angeles welfare system, whose bureaucrats are determined to enforce and maintain its dehumanizing and racist regulations, all of which have been designed to maintain existing class and racial hierarchies rather than help struggling African American people. As a "welfare mother," Dorothy is defined a priori by America's power structure as a negative stereotype, robbed of any individuality. Between forays to the welfare office, Dorothy takes care of her preteen daughter, Luann, and spends time with friends and her lover T. C., a Vietnam veteran who can't find a job and with whom she is expecting a child. T. C. is arrested and sent to prison on a trumped-up charge, while the welfare authorities demand that she abort her child. As a politically conscious friend tells her, aborting a Black child is akin to race suicide. Dorothy discovers a white policeman raping her daughter in her own home, pushing her to kill the cop. Dorothy is arrested and beaten so badly in the police station that she miscarries. She takes off her wig to reveal her natural hair, removing an iconic sign of her oppression. Dorothy thus moves from a position of complete apathy and passivity (induced in part by her resort to alcohol) to one of revolutionary action, equated with the poster image in her flat of an Angolan revolutionary "bush mama" with a baby in her arms and a rifle on her shoulder.

Allyson Nadia Field observes that the opening music and scenes of Dorothy's walking along the street in *Bush Mama* rewrite and recast the opening of *Shaft* by following the lead character who is introduced within bustling urban streets.[43] But while John Shaft is shown as exemplary, Dorothy is presented as a representative of her community. And while Blaxploitation films go on to develop linear narratives, Gerima's film creates a cacophony of sounds and images that defy easy insertion into a unified narrative, where reality and Dorothy's daydreams are inextricably intertwined. Synchronous sound scenes of Dorothy in dialogue with her friends and acquaintances are mixed with flashbacks, flash-forwards, dream sequences, and newsreel montages, as well as nonsynchronous loops of dialogue from the welfare office, police sirens, radio sermons, and political speeches, the latter functioning less as narrative content than as a never-ending soundscape of oppression. All of

FIGURE 3.8. *Bush Mama* (Dir. Haile Gerima, 1975).

these modernist devices short-circuit narrative expectations while forc-
ing the viewer to construct meaning from the juxtaposition of these
heterogeneous visual and auditory cues.

Through much of the film, Dorothy remains passive, hardly reacting
to either the demands made on her or the insults and queries hurled at
her. Only when she is pushed too far does Dorothy answer self-defen-
sively with violent action. She expresses her anger and newfound revo-
lutionary defiance in a final address, in which she faces the camera and
in voice-over addresses her partner, T. C., in the form of a letter. It is in
this final shot that she actually focuses her gaze, looking directly at the
audience rather than passively observing her environment, a world in
which she is objectified in the crosshairs of the police and other institu-
tions of white power. But Gerima's camera also shows great care and
respect for the strong, statuesque, and striking features of Barbara O.
Jones, an actress who had appeared in his previous film *Child of Resist-
ance* (1972) and Julie Dash's *The Diary of an African Nun* (1977) and
would be seen again in *Daughters of the Dust* (Dir. Julie Dash, 1991).
In constructing a narrative of endless day-to-day struggle, Gerima's
Bush Mama offers a view of African American womanhood more

directly derived from everyday experience than the Blaxploitation of a gun-toting "Black Mama" like Pam Grier.

Police violence is ubiquitous in *Bush Mama*, as it is in most Blaxploitation films. In a very early scene we see white cops harassing some African American males on the street (recalling similar scenes in *Brother Charles* and *Emma Mae*), a cinéma vérité scene that actually documents the LAPD's harassment of Gerima's film crew. Gerima also intercuts scenes of another African American man being murdered by police on the street, despite being handcuffed, as well as a scene in which an African American man with an ax is gunned down in cold blood; a poster of an African American male corpse, riddled with twenty-four police bullets, protests the act. Dorothy's beating at the hands of police as well as her daughter's rape by a white police officer escalate similar scenes of police violence against Black women seen in Blaxploitation films, especially in the officer's utilization of racial and sexual slurs. Crooked white cops are a veritable cliché of Blaxploitation films, often functioning as the ultimate drug lords and crime bosses behind Black gangsters, whether in *Super Fly* or *Coffy*. In such films, these white antagonists are anomalous rather than representative of white America's power structure. In contrast, Gerima sees police violence against African Americans as endemic to a capitalist system that keeps Black people in economic and social dependency to white power while protecting white perpetrators of crimes in the interest of social stability.

According to Gerima, the oppression of African American women is also a function of the emasculation of African American men, who are put on ice, thrown into prison at the slightest sign of resistance. Dorothy's lover, T. C., suffers from night terrors, brought on by his Vietnam War experiences. Used as a tool for a white man's war, unable to get a job, T. C. is easy prey for corrupt policemen looking for a scapegoat. In the film, Gerima cuts from T. C.'s going to a job interview to his incarceration, implying that the criminalization of Black men is just another institutional means of control. He spends most of the film's narrative in jail, where he is radicalized, as we learn in his letters to Dorothy, but he also forcibly remains passive behind bars. Like Jamaa Fanaka, who uses the location in three films, Gerima shoots T. C.'s prison scenes in the Lincoln Heights jail, but his mise-en-scène is much more formalist, emphasizing the inmates' stasis, with close-ups of T. C. behind bars or moving camera shots of the prison's security installations while T. C. rails against the system on the soundtrack. In one long moving camera shot, the viewer is shown faces, backs, and shadows of

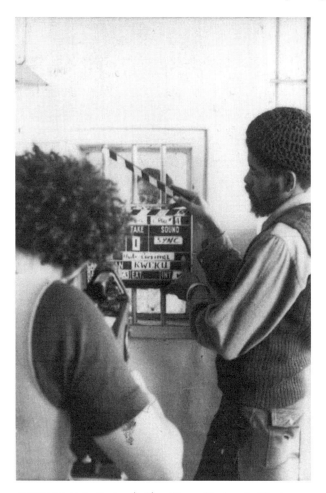

FIGURE 3.9. Haile Gerima (left) and Larry Clark, set of *Bush Mama* (Dir. Haile Gerima, 1975). Ben R. Caldwell Artist Photo.

inmates, indicating that men of flesh and blood have been turned into shadows both within prison and on the outside, made into ciphers and statistics, subject to manipulation and control.

Larry Clark also draws this equation in his UCLA master's thesis film, *Passing Through* (1977). The hero, Eddie Womack, tells his girl-friend Maya that not only is prison inhuman but its victims are then released into a new jail cell called American society. Coming after a sequence of extended tense encounters between Womack and Maya, the scene demonstrates that the experience of incarceration hinders

intimacy and the ability to connect. In an earlier flashback, Womack, a jazz musician, is seen in a jail cell, looking out through the bars, a scene shot at the same Lincoln Heights jail used by Fanaka and Gerima. Clark then cuts to documentary footage of the Attica Prison riots in New York State in September 1971, including African American leaders' reading their demands to prison officials, shots of gunfire on the soundtrack, and the infamous photograph of naked inmates being marched through the Attica Prison yard and beaten by guards. Clark intercuts these documentary images with fictional shots of Womack and fellow inmates' helping to carry wounded prisoners out of the line of fire, seeking to meld Third Cinema aesthetics and African American jazz with a narrative that, as I argue, references Blaxploitation films. Wall-to-wall jazz music led one French critic to call *Passing Through* perhaps "the only jazz film in the history of cinema."[44]

Produced after the completion of his first feature film, *As Above, So Below* (1973), Larry Clark's *Passing Through* received an initial grant of $10,000 from the American Film Institute in 1974, followed by a grant of $8,400 from the National Endowment for the Arts in 1975 and $2,000 from the Center for Afro-American Studies at UCLA in 1976.[45] Clark also participated in the fellows program at the AFI in this period and managed to complete the film in early 1977. The film's world premiere took place at Filmex (precursor to the Los Angeles Film Festival) on March 22, 1977, and subsequently toured numerous other venues, winning a special jury prize at the Locarno Film Festival (Switzerland) in August 1977 and playing at film festivals in Edinburgh (1978), Perth (1978), and Moscow (1979). Like his fellow students Gerima and Fanaka, Clark did not immediately submit the film for graduation, in order to continue to take advantage of the school's no- or minimal-cost filmmaking facilities.

The film's reception in the mainstream press was mixed. Writing immediately after the film's premiere, critic Jean Hoelscher in the *Hollywood Reporter* noted, "Director Clark is unable to gain credible dramatics either from the thin script he wrote with Ted Lange or from his loosely staged scenes. His film's saving grace resides in its strong visual images and the extremely complex soundtrack."[46] In his Locarno review for *Variety*, Gene Moskowitz complained of the film's liberation politics, stating that it "tries too hard to say too much with sideline cutting to race riots and African changes, rather than allowing his characters to flower into more potent personages rather than symbols."[47] In contrast with these mainstream critics, Clyde Taylor interviewed Clark about the

UCLA film school and analyzed *Passing Through* in the *Black Collegian*, complaining that the film used Blaxploitation aesthetics: "Where *Passing Through* loses some ground is in the script. A real weakness is in the resolution of the musician's dilemma through a gunfire wipeout of the mob, with no casualties and no repercussions—an unneeded page from blaxploitation movies. [. . .] These short cuts to self-indulgent vision of the real world impede the film's originality with Hollywoodisms from blaxploitation and mystery movies."[48] In contrast, one might look at the way *Passing Through* productively reworks themes and tropes from Blaxploitation films that in fact often reflected actual attitudes within the Black community toward existing white hierarchies and power.

In *Passing Through*, Womack is released after five years in prison for the killing of a white gangster who had attacked and blinded a fellow musician. Not willing to play for the mobsters who control the music industry, including clubs and record companies, Womack searches for his mentor and grandfather, the legendary jazz musician Poppa Harris. He tries unsuccessfully to organize his fellow musicians, leading to the murder of the blind musician, Skeeter, which is accidentally captured on camera by Womack's girlfriend, the photojournalist Maya. Womack attends Poppa Harris's funeral, where he meets his grandfather's mystical partner, Oshun. In a gangland-style ambush, Womack and his posse murder Gus, a mob boss who controls the music industry, and his two henchmen, paving the way for Womack to liberate his music.

Larry Clark theorizes in *Passing Through* that jazz is one of the purest expressions of African American culture, embodying the struggles of generations of Black people going back to slavery times but now co-opted by corporate interests that brutally exploit jazz musicians for profit. The opening seven-minute credit sequence is accordingly an homage to jazz and jazz musicians, beginning with a list of names and then featuring carefully orchestrated layers of images of musicians performing. Indeed, the notion that the jazz tradition has been disrupted is underscored by Womack's first attempt to improvise with his band, when the spiritual aftereffects of prison keep him from connecting. The film repeatedly returns to scenes of various musicians improvising jazz, as well as flashback scenes (in black and white) in which Poppa Harris teaches Womack to play saxophone. Jazz is seen as part and parcel of the cultural heritage of African Americans, yet as one musician states, "Niggers haven't controlled the music scene since the drum."

Returning from prison, Womack learns that the mobsters still control the business by paying some musicians with heroin. Like in

FIGURE 3.10. Production photograph of Adele Sebastian, *Passing Through* (Dir. Larry Clark, 1977). Collection of Larry Clark.

numerous Blaxploitation films in which white mobsters run the drug or pimp/prostitution trade, Clark constructs a narrative in which white mobsters ruthlessly exploit musicians. When Womack suggests that his band free themselves from their music industry contracts and form their own recording and distribution company, the other musicians sympathize but back out, because they fear retaliation through blacklisting. Womack also learns that his former girlfriend, Trixie, is now working in a mob-controlled strip club and has found a new boyfriend, making

FIGURE 3.11. *Passing Through* (Dir. Larry Clark, 1977).

the Mafia responsible on both the political and personal level for Womack's sense of alienation and powerlessness. While the latter plot twist is reminiscent of films like *Cool Breeze* (Dir. Barry Pollack, 1972) and *Brother Charles*, the narrative frame pitting African Americans against a white criminal conspiracy is a cliché of the Blaxploitation genre.

Unable to effect any change, Womack's anger at white corporate powers only increases after he learns that his friend and fellow musician has been murdered by the mob. When Poppa Harris, seemingly from beyond the grave, tells Womack "to slay the dragon," he springs into action. In a scene most heavily criticized by Clyde Taylor as unnecessary "blaxploitation," a female accomplice feigns a broken-down van to get the attention of the mobsters, who leer at her body. When they step out of their vehicle, they are gunned down by Womack and two colleagues who have been hiding in the van. The scene ends with a self-conscious freeze-frame of the fleeing gangster boss in the moment he is hit by bullets, thus implying that this scene may be a Hollywood fantasy, an expression of desire rather than an actual killing. Clark introduced other self-conscious filmic devices when he inserted what Clyde

Taylor characterized as the obligatory (for UCLA Black students) scenes of the African revolution.[49]

As in Blaxploitation films, Clark's construction of the gangster's demise could potentially serve as a cathartic release for African American audiences, happy to see the white mobsters get their due at the hands of Black justice. In Blaxploitation films, the vigilantism of the African American hero or heroine is legitimized through claims to higher moral values than the corrupt system around them, as if fulfilling the false promise of American justice in the Constitution. The moral righteousness of Womack's actions is legitimated through association with various African and African American liberation movements. Maya talks about her deceased husband, a photojournalist covering the war of liberation in Guinea-Bissau (1963–74), while Clark creates a montage of photographic images in sepia tones of liberation leaders in Africa. The film's apotheosis is a montage of photographs beginning with Malcolm X and continuing with Nkrumah and numerous other African independence leaders, captured in an iris, itself an archaic and self-conscious device. Clark also inserts a filmic montage of the rise of the Black Panthers out of the ashes of the 1960s urban uprisings, using various newsreel and audio documents. Finally, the struggle against the white mobsters in the music industry is connected to Third World liberation movements through the character of Poppa.

It is the Africanism of Poppa Harris, as the spiritual center of *Passing Through,* that ties together Black American jazz and the liberation movements of Africa and North America. In the early flashback sequences in sepia, Poppa Harris appears in African dress and teaches saxophone under the sky. Clark seemingly asks audiences to accept at face value Poppa's ability to mystically raise from the dead with an African horn a jazz musician who has overdosed on heroin, after showing the audience a flatliner screen behind the musician's body. Poppa's funeral ceremony includes many individuals in African dress, while after his death he sends Oshun Bey as his medium, a Jamaican woman, who tells his fortune through cards. During this encounter, Womack tells Oshun that Poppa, who is perceived as a legendary jazz performer, taught him that the music comes from the soil, from the earth, leading him to bury his saxophone to improve his playing. The film's final montage incorporates shots of African revolutionary leaders with a close-up of Poppa's eye and close-ups of Black hands holding the soil. Thus through visual symbolism the film connects jazz, Africa, and the earth in one mystical union and arguably, by extension, justifies the liberation

of oppressed lands through popular struggle, whether in Africa or Los Angeles.

If *Passing Through* and *Bush Mama* see the United States as a giant prison for African American males, then Jamaa Fanaka's *Penitentiary* depicts prison as a microcosm of America, better said, a microcosm of Black America, given that incarcerated African American men far outnumber their proportional representation in the general population. The idea for a movie mixing the prison and boxing genre came to Fanaka, remembering his time in the U.S. Air Force, when he attended an amateur boxing tournament. Obviously fascinated with the Lincoln Heights jail location that he had used in two previous films, Fanaka wrote a prison drama, showing drafts of his script to prisoners on Terminal Island.[50] Considered by audiences and critics alike to be a late example of the Blaxploitation wave, *Penitentiary* manipulates the genre's stereotypes to allegorize African American life, seeing the prison system as a continual violent struggle against both external (the prison system) and internal (fellow prisoners) forces, played out on the bodies of inmates, who are either sexual "sissies" (the exploited) or "beasts" (the exploiters). Mixing scenes of brutal violence, humor, sex, surrealism, and boxing sport, *Penitentiary* remains a hybrid, hardly encapsulated by the term "blaxploitation."

Produced for less than half a million dollars, much of it grant money, including $50,000 from the New York State Council for the Arts and loans from his parents, since Fanaka was still officially a student at UCLA, *Penitentiary* was both the most financially successful L.A. Rebellion film ever made and its least typical. Purportedly grossing over $10 million, the film earned most of its receipts in urban theaters after being picked up for distribution in March 1980 by the Jerry Gross Organization.[51] As Ntongela Masilela maintains, Fanaka was "fascinated by Hollywood and averse to the contentious ideological and artistic discussions . . . fundamental to the formation of the [Los Angeles] school."[52] However, according to Fanaka, his interest was not in Hollywood per se but rather in making films independently and as cheaply as possible, in the spirit of Oscar Micheaux or Roger Corman, as what Fanaka terms a guerrilla filmmaker.[53] In keeping with the L.A. Rebellion's commitment to empowering people of color in front of and behind the camera, Fanaka's crew was 90 percent African American, filling almost all key positions except cinematographer Marty Ollstein, but also nonunion, because so few people of color were in the craft unions.[54] Though *Penitentiary* was shot in seven weeks

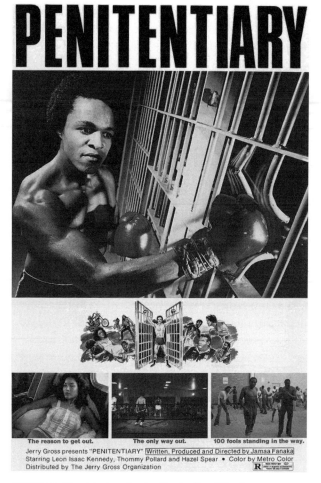

FIGURE 3.12. Theatrical poster for *Penitentiary* (Dir. Jamaa Fanaka, 1979). Collection of Jamaa Fanaka, courtesy Twyla Gordon-Louis, Trustee, Gordon Family Trust.

primarily at the Lincoln Heights jail, the film's prison yard was filmed on UCLA's back lot, behind Melnitz Hall. Leon Isaac Kennedy was first brought in as a producer, and he then took over the leading role when Glynn Turman (*Cooley High,* [Dir. Michael Schultz, 1975]) became unavailable. The film experienced a gala premiere at the Hollywood Fox Theatre, attended by Leon Isaac Kennedy and boxers Muhammad Ali, Ken Norton, Sugar Ray Robinson, and Carl Weathers (of *Rocky* [Dir. John G. Avildsen, 1976] fame).[55]

FIGURE 3.13. *Penitentiary* (Dir. Jamaa Fanaka, 1979).

In the film, Martel "Too Sweet" Gordone is incarcerated, having been framed for the murder of a white biker after Too Sweet comes to the defense of a prostitute. In the seemingly all-Black prison, Too Sweet is confronted with a gang that not only controls the prison but assigns weaker inmates ("sissies") to sexual duties. When the crazy but also physically powerful Half Dead tries to rape him, Too Sweet beats him up, much to the surprise of the other inmates. In the prison yard, Too Sweet gets into another fight with Jesse Amos, the leader of the gang, who is not happy that Too Sweet has befriended his "bitch," Eugene. The prison's head guard announces a boxing tournament (and possible parole for the winner), and Too Sweet signs up when he hears that Eugene has also joined. A series of boxing matches ensue, the first won by Eugene, who is cheered on by the "sissies." Another prize offered to the winners is a connubial visit out in a trailer. After winning his match, Too Sweet meets Linda, the prostitute he had defended, and learns that she killed the biker and left Too Sweet to take the rap. Returning to his cell, the hero is jumped by a knife-wielding Half Dead, but Eugene jumps in between and is fatally wounded. Too Sweet then insists on fighting Amos, who is behind Eugene's murder, and defeats him. With a boxing contract in hand, Too Sweet is released from prison.

Film reviewers unequivocally identified *Penitentiary* as a late entry into the Blaxploitation field, although many also noted that the film did not traffic in the white stereotypes seen in other films in the genre, for

example, by making the head prison guard "neither stereotyped brutality nor a caricatured honky."[56] Kevin Thomas, while acknowledging the film's exploitation origins, wrote positively: "Jamaa Fanaka has taken one of the movies' classic myths, the wrongly imprisoned man who fights for his freedom with his boxing gloves, and made it a fresh and exciting experience."[57] Finally, while some reviewers confessed to squirming at the film's raw sex and violence, *Penitentiary*'s high energy and story of finding inner strength won them over. Tom Allen in the *Village Voice* called the film "one of the most expressive American movies of the year and much more accomplished in its visuals than its acting."[58]

Within the conventions of exploitation cinema—whether Blaxploitation, prison, or boxing film, the latter two genres having histories that go back to the early silent period—Fanaka visualizes the physical punishment of African American male bodies and the threat of rape endemic to their existence since slavery days. Through the shorthand of genre, Fanaka zooms in on the ritualistic establishment of pecking orders among African American gang members, carved out in blood on their bodies, to which in prison is added the continual threat of sexual violence. In a prison almost exclusively filled with Black inmates, Fanaka sketches out a crisis in African American masculinity, which though the result of white racism now perpetuates itself almost exclusively through "Black on Black" crime, thus also returning to one of the themes of *Emma Mae*. And while it was not necessarily Fanaka's intention to make a political statement about the number of African American males in the American prison system, he freely acknowledges that the proportion far outstrips their representation in the general population.[59]

We are introduced to the prison in a close-up of an inmate, a lighted cigarette protruding from one of his ears and an unlighted broken cigarette from his lips, indicating the negative psychological effects of incarceration. The scene then opens up to reveal a gang ceremony in the cellblock, involving the exposing of cowering inmates as "fresh meat" and the crazed Half Dead, his face covered with shaving cream like a mad dog. The inmates speak to and handle each other and the "fresh meat" with extreme roughness. The powerlessness of the victims and the extreme arbitrary violence of the perpetrators mark both as caught in a vicious cycle of violence.

Fanaka also makes a very positive and humanistic argument: to struggle against all odds is better than to despair; each human being has inner strengths and powers to mobilize in the most hostile environment.

Eugene learns that he is not anyone's property, and though considered a "sissy," he boxes his way to victory, becoming the tragic sidekick who "takes the bullet" for the hero. Seldom Seen, the wise old trainer who has been incarcerated fifty of his sixty-five years, has a reflective political consciousness reminiscent of Poppa Harris and Big Daddy Johnson. With quiet dignity, Seldom Seen's mode of protest is his refusal to have hopes and desires that would be rendered futile by the impossibility of freedom. Then there is Sweet Pea, a cross-dresser who turns prison garb into personal expression, a stereotype of queerness to be sure, but one that the film treats with light humor rather than ridicule.

On the other hand, the strictly heterosexual sex scenes in the communal toilet (one of which features the director in a cameo) are sexist and pander to male voyeurism, as Haile Gerima would argue, although Fanaka has stated that the pent-up sexual energy of incarceration warranted the scenes. Jacqueline Stewart has interpreted the scene differently, in relation to similar moments in African American novels about slavery that illustrate the difficulties of finding moments of humanity, pleasure, and intimacy in dehumanized situations. But it can also be read, she concedes, as a rape scene, with the man descending, literally, upon an unsuspecting woman and then, troublingly, presenting her enjoyment. Thus, the scene may have be double edged, both gratuitous sexual display and an illustration of Black humanity/sexuality.[60]

I would therefore argue that *Penitentiary,* while differing from the majority of the L.A. Rebellion films, also differs from the majority of Blaxploitation films. It shares with the L.A. Rebellion a concern for visualizing African American experiences and struggles. It also shares an interest in representing the complex struggles that African American men encounter in trying to live up to dominant notions of masculinity in the face of racist and class oppression. In this way we can see *Penitentiary* resonating with the work of Ben Caldwell, Haile Gerima, and Larry Clark discussed here or with Charles Burnett's *Killer of Sheep* (1977) and Billy Woodberry's *Bless Their Little Hearts* (1984). For example, Burnett's slaughterhouse worker struggles with intimacy in a scene with his wife, due to the intense social pressures that affect his daily existence. The representation of Black masculinity through supersexed, often invincible male heroes in Blaxploitation films reflected the desires of many African American viewers seeking more assertive male images. But we find more nuanced treatment of Black masculinity in the films of the L.A. Rebellion, which explore the psychological effects of systemic oppression. Reading the various films reveals the

L.A. Rebellion's complex relationship to Blaxploitation. While clearly reacting negatively to the generic stereotypes of Blaxploitation, the Rebellion filmmakers discussed in this essay, to varying degrees, engaged the genre in their work.[61]

NOTES

1. See Charlene Regester, "The African American Press and Race Movies, 1909–1929," in *Oscar Micheaux and His Circle: African-American Filmmaking and Race Cinema of the Silent Era,* eds. Pearl Bowser, Jane Gaines, and Charles Musser (Bloomington: Indiana University Press, 2001), 34–52.

2. See "The Numbers," Nash Information Services, www.the-numbers.com /movie/Sweet-Sweetbacks-Baad-Asssss-Song#tab=box-office; and "The Numbers," Nash Information Services, www.the-numbers.com/movies/series/Shaft. php.

3. Rick Altman, *Film/Genre* (London: BFI Publishing, 1999), 25.

4. Ed Guerrero, *Framing Blackness. The African American Image in Film* (Philadelphia: Temple University Press, 1993), 70.

5. Ibid., 110.

6. See, for example, Harry M. Benshoff, "Blaxploitation Horror Films: Generic Reappropriation or Reinscription?" *Cinema Journal* 39, no. 2 (2000): 31–50; and Jon Kraszewski, "Recontextualizing the Historical Reception of Blaxploitation: Articulations of Class, Black Nationalism, and Anxiety in the Genre's Advertisements," *Velvet Light Trap* 50 (Fall 2002): 48–60.

7. Although, as Rhines notes, only a minority of the circa one hundred Black films produced between 1970 and 1974 were controlled and financed by African American interests, the starting point had been zero before the arrival of Melvin Van Peebles. See Jesse Algeron Rhines, *Black Film/White Money* (New Brunswick, NJ: Rutgers University Press, 1996), 45–46.

8. See Malcolm Boyd, "Priest Attacks Movies That Exploit Blacks," *Los Angeles Times,* October 8, 1972, 6.

9. B.J. Mason, "The New Films: Culture or Con Game," *Ebony,* December 1972, 60.

10. Hollie I. West, "Makers of Black Films Stand at the Crossroads," *Los Angeles Times,* January 28, 1973, 18.

11. Quoted in Mason, "New Films," 60.

12. Huey P. Newton, "He Won't Bleed Me: A Revolutionary Analysis of *Sweet Sweetback's Baadasssss Song,*" *Black Panther* 6, June 19, 1971.

13. Michael Campus, conversation with the author, January 15, 2004.

14. Quoted in West, "Makers of Black Films Stand at the Crossroads," 18.

15. Charles Burnett, quoted in Nelson Kim, "Charles Burnett," *Senses of Cinema,* May 2003, accessed May 4, 2005, http://sensesofcinema.com/2003 /great-directors/burnett/#1.

16. Haile Gerima, oral history interview by Jacqueline Stewart, Allyson Field, Jan-Christopher Horak, and Zeinabu irene Davis, September 13, 2010, LAROH. See also Haile Gerima, "On Independent Black Cinema," in *Black*

Cinema Aesthetics: Issues in Independent Black Filmmaking, ed. Gladstone L. Yearwood (Athens: Ohio University Press, 1982), 106–13.

17. Clyde Taylor, "*Passing Through:* An Underground Film About Black Music Underground," *Black Collegian* (February/March 1980): 20.

18. Catherine Ruelle, "Larry Clark: On My Way, the Movie," *Africains Américains, Amiens Film Festival Catalog,* 1999.

19. *American Film Institute Film Festival 1991 Catalog,* reprinted in *L.A. Weekly,* April 21, 1991.

20. See, for example, Rufus, review of *Welcome Home, Brother Charles,* in *Rufus' House of Horrors,* May 28, 2011, http://rufus-houseofhorrors.blogspot.com/2011/05/welcome-home-brother-charles.html; Casey Scott, review of *Soul Vengeance, The Black Godfather,* and *Black Sister's Revenge,* in *DVD Drive-In,* www.dvddrive-in.com/reviews/n-s/soulvengeance757476.htm; Christopher Armstead, review of *Black Sister's Revenge,* in *Film Critics United,* www.filmcriticsunited.com/bsr.html; Mike Jackson, review of *Penitentiary,* in *DVD Verdict,* August 2, 2000, www.dvdverdict.com/reviews/penitentiary.php.

21. Fanaka's multifarious legal struggles are documented in his papers, deposited in UCLA Library, Special Collections, and are a subject for further research. UCLA Cinema & Media Studies graduate student Maya Smukler has organized these files.

22. A single 16mm reversal print from the Super 8 original survives and is being preserved at the UCLA Film & Television Archive.

23. Jamaa Fanaka, oral history interview by Allyson Field, Jan-Christopher Horak, and Jacqueline Stewart, June 16, 2010, LAROH.

24. "*Emma Mae* Goes before the Cameras June 20," *Hollywood Reporter,* June 18, 1976.

25. See distribution letter, Crown International Pictures/Scott Schwimer to Jamaa Fanaka, January 31, 2001, Jamaa Fanaka Papers, UCLA Library, Special Collections. The letter mentions the original contract, signed August 11, 1975. While no reviews could be found, *Variety* does discuss the production history of the film: Joseph McBride, "Jamaa Fanaka Working on 2nd Feature as Master's Thesis," *Variety,* August 19, 1976. See also Joseph McBride, "Birth of a Black Director: Jamaa Fanaka Completes at 26; Master's Degree from UCLA," *Variety,* September 8, 1976.

26. William Poundstone, "1970s Anatomical Revenge Films," William Poundstone: Author Site, accessed November 2010, http://home.williampoundstone.net/Revenge/Revenge.html. See also PopeyePete, review of *Welcome Home, Brother Charles,* in *Grindhouse Cinema Database,* www.grindhousedatabase.com/index.php/Welcome_Home_Brother_Charles. Another website, no longer available, contained a database of hundreds of titles of exploitation films, with short descriptions (www.cinemademerde.com/Soul_Vengeance.shtml).

27. Scott, review of *Soul Vengeance, The Black Godfather,* and *Black Sister's Revenge.*

28. Loeb and Loeb to Jamaa Fanaka, December 15, 1980, UCLA Library, Special Collections, which details Fanaka's lawsuit against the producers for breach of contract.

29. Arthur Knight, review of *Emma Mae, Hollywood Reporter,* December 27, 1976, 3 and 5.

30. See Bill White, "*Soul Vengeance*: Jamaa Fanaka's War on Hollywood," Jamaa Fanaka Papers, Box Emma Mae, UCLA Library, Special Collections.

31. See McBride, "Birth of a Black Director."

32. Suzanne Donahue, "An Interview with Cult/Independent Movie Director Jamaa Fanaka," *Associated Content,* June 20, 2007, www.associatedcontent.com/user/17679/suzanne_donahue.html (website no longer available).

33. Mack, review of *Emma Mae, Variety,* December 23, 1976, reprinted in *Variety,* December 29, 1976.

34. Knight, review of *Emma Mae,* 3.

35. Kevin Thomas, "Memory and Love in the South," *Los Angeles Times,* February 10, 2005.

36. Scott, review of *Soul Vengeance, The Black Godfather,* and *Black Sister's Revenge.*

37. Gerima, oral history. The award led to friction within the department, because some of the professors were upset that the first such award should go to a film perceived as leftist and anti-American.

38. Ibid., 18.

39. Michael Auerbach, "Gerima Beats around the Bush in *Mama,*" *UCLA Daily Bruin,* April 6, 1978.

40. Linda Cross, "*Bush Mama:* A Trip to Awareness," *Los Angles Times,* April 7, 1978, 20.

41. Janet Maslin. "*Bush Mama* Tells Story of a Coast Ghetto," *New York Times,* September 25, 1979.

42. J. Hoberman, "Independents," *Village Voice,* December 24, 1979. See also more recent DVD reviews online: Cyrus Fard, "The Wig Is Off: *Bush Mama* as a Deconstructive Narrative," *PopMatters,* May 27, 2010, www.popmatters.com/pm/feature/119414-the-wig-is-off-bush-mama-as-a-deconstructive-narrative; "Flashback #79," *The Seventh Art,* June 12, 2010, http://theseventhart.info/2010/06/12/flashback-79/; Cinema of the World website, www.worldscinema.com/2010/06/haile-gerima-bush-mama-1979.html (gives brief descriptions of hundreds of films, but the page for *Bush Mama* is no longer available); Alexandra Frederickson, "Bush Mama Reveals State Tactics of 'Absorption' and 'Insulation,'" *Yahoo! Voices* (formerly at *Associated Content*), January 31, 2007, http://voices.yahoo.com/bush-mama-reveals-state-tactics-absorption-and-186330.html?cat=9.

43. Gerima, oral history.

44. The original quote reads, "*Passing Through* est peut-être le seul 'Jazz Film' de l'histoire du cinéma. Tous les matériaux utilises et malaxes pulsent au même rythme dans nos oreilles, dans nos têtes et jusqu'au creux des nos os." Raphaël Bassan, "Douarmenez tout noir," *Libération,* September 9, 1985.

45. Larry Clark papers, UCLA Library, Special Collections.

46. Jean Hoelscher, Filmex review of *Passing Through, Hollywood Reporter,* March 22, 1977, Academy of Motion Picture Arts and Sciences (AMPAS), Margaret Herrick Library, Clippings File.

47. Gene Moskowitz, *"Passing Through,"* *Variety,* August 31, 1977, AMPAS Clippings File.

48. Taylor, *"Passing Through,"* 22.

49. Ibid., 16.

50. "Myron Meisel Makes *Penitentiary* Critics Choice," *Reader* (Chicago), February 29, 1980.

51. Lane Maloney, *"Penitentiary* Taking Shot at Crossover Audiences," *Variety,* February 22, 1980, 2. Another source indicates the film earned $6.2 million on 450 screens across the country in eleven weeks. See also "Indie Distribs Hard-Pressed but *Penitentiary* Paying Off," *Hollywood Reporter,* April 1, 1980; and *Hollywood Reporter,* December 2, 1980, AMPAS Clippings File.

52. Ntongela Masilela, "The Los Angeles School of Black Filmmakers," in *Black American Cinema,* ed. Manthia Diawara (New York: Routledge, 1993), 115.

53. Donahue, "Interview with Cult/Independent Movie Director Jamaa Fanaka."

54. "Fanaka Seeks to Tap Black Market with *Penitentiary,"* *Hollywood Reporter,* July 27, 1978, AMPAS Clippings File. Little has changed in the intervening years, with Hollywood craft unions all but closed to minorities, as indicated by the NAACP's latest report on diversity in the industry. According to a news story on the report, "Specifically, the report reveals that hiring, promotion and acting opportunities for minorities are directly tied to highly subjective practices, a closed roster system and potentially discriminatory membership guild requirements." See "NAACP Report Shows Television Industry Still Falls Seriously Short in Achieving Diversity," *Wichita NAACP Blogpost,* December 18, 2008, http://wichitanaacp.blogspot.com/2008/12/naacp-report-shows-television-industry.html.

55. [Untitled], *Variety,* February 29, 1980.

56. Arthur Knight, *"Penitentiary,"* *Hollywood Reporter,* December 21, 1979. See also Peter Rainer, *"Penitentiary* Not Too Sweet," *L.A. Herald Examiner,* February 29, 1980, AMPAS Clipping File.

57. Kevin Thomas, *"Penitentiary* Freshens Myth," *Los Angeles Times,* February 29, 1979, 10. See also Vincent Canby, review of *Penitentiary, New York Times,* April 4, 1980.

58. Tom Allen, review of *Penitentiary, Village Voice,* April 21, 1980, AMPAS Clipping File.

59. Fanaka, oral history.

60. Jacqueline Stewart, e-mail correspondence with the author, April 3, 2011.

61. Jamaa Fanaka went on to make two *Penitentiary* sequels (1982, 1987) and *Street Wars* (1992), all of which referenced Blaxploitation narratives. Larry Clark's *Cutting Horse* (2002) likewise draws on tropes and plot elements from Blaxploitation within a larger contemporary narrative of Westerns, for example, its discussion of miscegenation and its stereotyped white villains. These are certainly subjects for further research.

4

Anticipations of the Rebellion

Black Music and Politics in Some Earlier Cinemas

DAVID E. JAMES

In the early 1970s, Los Angeles was the primary crucible for the new independent cinemas formed around the civil rights movements of ethnic and sexual minority groups, especially African, Asian, and Mexican American and feminist and gay. These various identity groups all developed cinematic components to represent themselves on their own terms and thus contest their prejudicial representation in the dominant industrial cinemas. All of them were shaped by the interaction of four main forces and traditions: the specific mode of self-discovery and self-realization projected by the group in question; the state or philanthropic initiatives that responded to it; the history of the group's position in industrial cinema; and the forms of precinematic cultural practices that each group had previously developed and by which it had sustained itself.

In the case of African American civil rights struggles, three primary forces came into play: (1) a phylum of student filmmaking seeded in UCLA's Ethno-Communications Program in the late 1960s and coming to maturity in the university's film program through the 1970s and 1980s, in what became known as the Los Angeles School or the L.A. Rebellion; (2) an ongoing history of derogatory representations of Black people in Hollywood films that had nevertheless been interrupted by independent Black feature-film production, especially in the 1920s in reaction against *The Birth of a Nation* (Dir. D.W. Griffith, 1915), and subsequently in all-Black industrial and para-industrial features, especially musicals; (3) the traditions of African American music. This last sustained powerful

links with African heritage as well as, in its nonmateriality, preserving traces of the traumatization of that heritage in slavery; for as Amiri Baraka, a seminal theorist of the cultural significance of Black music, argued, only the nonmaterial aspects of African culture—"music, dance, religion [that] do not have artifacts as their end product"—survived the diaspora and enslavement.[1] Like literature and other forms of African American culture, then, many of the L.A. Rebellion films found inspiration and a frame of reference of conjoined aesthetic and political significance in the historically self-aware traditions of Black music. Its disciplined spontaneity, rhythmic complexity, and textural nuance provided powerful models for expressive visual composition, while also mobilizing community identity, pride, and resistance against marginalization and oppression.

So comprehensive a role for music inevitably encountered contradictions. The opening frames of one of the Rebellion's greatest achievements, Larry Clark's feature *Passing Through* (1977), for example, dedicate the film to more than forty "Black Musicians known and unknown," including Eric Dolphy, Ornette Coleman, John Coltrane, Sun Ra, Horace Tapscott, and Arthur Blythe. Its protagonist is a saxophonist who celebrates Free Jazz as "an endless river of knowledge whose waters run on the dark soil of the brothers' souls," and the film creates its own visual, filmic correlatives to the music. However, its narrative is torn across tensions between the music's intrinsic aesthetic and spiritual significance that sustains its social role as community self-realization and its actual instrumentality within the corrupt, White-owned corporate music business—between the music itself and the controlling mode of musical production. *Passing Through*'s analysis of the tension among these negative and positive politics of music allowed the film to offer itself as a reflexive allegory of the possibilities of a free Black film and free Black cinema. But its achievement in these terms also reflected the circumstances and politics of its own mode of production, not in the community or the industry but in the UCLA film program, where the university's public funding shielded it from interference by non-Black interests and from the economic and ideological constraints of capitalist cinema. Not until its final frames does *Passing Through* acknowledge that its own production and hence its emancipatory vision of an ascendant autonomous Black culture were financed by a combination of mainstream institutions, specifically the American Film Institute in association with the National Endowment For the Arts; the Performing Arts Society of Los Angeles; a UCLA, Afro-American Studies research grant; and a Louie B. Mayer grant.

Though no other Rebellion film engages Black music with such ambitious multidimensional complexity, many do employ it as an integral component of their own expressive vocabulary or as an intertextual medium through which cinematic and social concerns may be conjured. Two other feature masterpieces, *Killer of Sheep* (Dir. Charles Burnett, 1977) and *Bush Mama* (Dir. Haile Gerima, 1975)—partially funded, respectively, by the Louie B. Mayer Foundation and the National Endowment for the Arts—primarily use nondiegetic underscore. The mostly classic jazz and blues in *Killer of Sheep* include vocal music whose lyrics comment on the unfolding action: Paul Robeson's "Ballad for Americans" as youngsters play in an abandoned lot, for example, or Dinah Washington's "This Bitter Earth" as two troubled lovers dance. And *Bush Mama*'s modern jazz underscore becomes both a musical correlate to the spontaneous improvised camera work and a figure for the liberation into cultural self-consciousness and rebellion that the film's heroine finally achieves.

Such expressive intertextual use of Black music had been anticipated in earlier, similarly utopian proto-Black cinemas that lacked the Rebellion's state and philanthropic financing and in which White people had significant involvement. Three of the most important such cinemas were underground film, concert documentaries, and the Newsreels, which respectively were amateur-aestheticist, para-industrial, and amateur-agitational projects. To varying degrees they were all indebted to Black music, but their different objectives and different modes of production allowed different modes of Black music to mobilize different meanings. Because these musics form the context in which the distinctiveness of the UCLA project may be gauged, their spectrum and the play of their various significations open up the otherwise reified concept of Black music to its plurality in the 1960s and 1970s. These musics were framed especially by the failure of new thing or Free Jazz to command a popular, let alone a revolutionary, mass Black audience and by the tensions between avant-garde jazz and more demotic modes, especially soul and gospel, which to some degree stratified the Black public sphere.[2] But any historically self-conscious consideration of these musics should be seen in light of the Rebellion's most immediate commercial context, one that also particularly pugnaciously combined music and politics: Blaxploitation.

Sweet Sweetback's Baadasssss Song (Dir. Melvin Van Peebles, 1971) and, opening two months later, *Shaft* (Dir. Gordon Parks, 1971) inaugurated the controversial genre and established its prototypical hero:

the assertive, powerful urban Black male whose physical and sexual aggressiveness was underscored by similarly assertive and innovative urban music, breaking with the filmic legacy of Sidney Poitier as decisively as that of Stepin' Fetchit. The legacy of *Sweetback* itself is complicated: On the one hand, by writing, producing, directing, starring in, and distributing the film himself, Van Peebles was a model for other independent Black filmmakers and for the efficacy of music in subtending their films' text and production. With some sources claiming returns of more than $15.2 million on the estimated $500,000 invested,[3] *Sweetback* became, according to Van Peebles himself, "the whole stencil for using the soundtrack as a marketing tool."[4] On the other hand, the pivoting of Sweetback's social significance on the power of his penis entailed what many found to be a regressive stereotype, one that objectified men as much as it did women. So while Huey Newton celebrated it as "the first truly revolutionary Black film made [. . .] presented to us by a Black man"[5] and made it required watching in the Black Panther Party (BPP), *Sweetback* was criticized by Black nationalist poet Haki R. Madhubuti (Don L. Lee),[6] by many Black social groups, and by Haile Gerima, who attacked Sweetback's "false manhood," the film's misogyny, and its failure to depict a collective resistance to systemic oppression.[7] Similar contradictions appeared in the lyrics to some of the soul music that bolstered other Blaxploitation films: in "Shaft," for example, Isaac Hayes introduced the hero as "the black private dick / That's a sex machine to all the chicks."

These contradictions reflected the tensions between sexuality and ethnicity in the identity politics of the time, specifically as they had been precipitated by the collapse in the 1950s of unified opposition to capital. Resistance to "every manner of exploitation and oppression, whether directed against a class, party, sex, or race," had been historically fundamental to socialism since being articulated in the Erfurt program in 1891.[8] Such resistance had been renewed in the 1930s by U.S. Communists' recognition of the integral importance of what were then called the "Negro Question" and the "Woman's Question" in class struggle and the struggle against fascism. The Communists' great cinematic product was, of course, *Salt of the Earth* (Dir. Herbert J. Biberman, 1954), the *only* U.S. feature film to show a strike being won by the working class themselves. Denounced by Pauline Kael as "as clear a piece of Communist propaganda as we have had in many years,"[9] it nevertheless identified the class struggle with the struggle for racial equality and identified both with the struggle for gender equality: the

final leader and best theorist of the strike turned out to be Esperanza, a working-class Mexican American woman.

The identity politics of the 1970s emerged in the context of the repression of such a unified resistance and of class consciousness generally during the (earlier) McCarthy era and the Cold War. Underway since the late 1940s, agitation for civil rights for African Americans reached a crisis point in the mid-1960s and inspired parallel movements for Hispanic Americans and, then, in what was a new conceptual formation, Asian Americans. Approximately the same period saw the emergence of identity politics around sexuality and gender, with Betty Friedan's *Feminine Mystique* (published 1963) and the Stonewall riots (June 1969) being primary historical markers. Mobilizing political action on behalf of underprivileged minority groups, these precipitated identity formations based on proposals of structural social divisions that not only reinforced the separate identities but also inevitably led to further fragmentation and/or contradictory social positions: that of Black and lesbian women in the early phases of the women's movement, for example, or that of women in the civil rights movement after Stokely Carmichael's 1964 remark that the "only position for women in SNCC is prone!" are exemplary.[10] Reinforced in both *Sweetback* and *Shaft,* different combinations of similar social tensions involving the elevation of the interests of one underprivileged group over those of the working class as a whole occurred in earlier Black cinemas and in their use of Black music.

UNDERGROUND FILM

The Communist culture that created *Salt of the Earth* was destroyed by the Hollywood blacklist, a persecution that was especially critical for progressive cinema and all forms of culture in Los Angeles. Inevitably the first resurgences of radical filmmaking occurred elsewhere, in the beat culture of San Francisco and New York, within which African Americans had a privileged position. But the beat movement typically envisioned them, not as agents of their own emancipation or of a general social transformation, but as romantically idealized outsiders to mainstream society. Their exemplary "beat" social marginality was epitomized in the figure of the jazz musician, and modern jazz was integral to the two films that announced the emergence of the New American Cinema, *Pull My Daisy* (Dir. Robert Frank and Alfred Leslie, 1959) and *Shadows* (Dir. John Cassavetes, 1959), with the latter's narrative also revolving around Black jazz musicians.

The lyrical, personally expressive film languages created by beat film-makers after the 1950s in contradistinction to classic Hollywood real-ism were derived from various sources, but especially from modern jazz and from beat literature, which had itself internalized the improvisa-tional rhythms of bebop saxophonists. Beat writer Jack Kerouac's ideal of "spontaneous prose" was an exemplary advocation of writing as an "undisturbed flow from the mind of personal secret idea-words, *blow-ing* (as per jazz musician) on subject of image."[11] In underground film, "blowing personal secret idea-words" became "blowing personal secret idea images," a fair enough description of the film style of many prom-inent underground filmmakers, including Stan Brakhage and Jonas Mekas—or Peter Mays, to take an example of an avant-garde film-maker working at and around UCLA in the late 1960s. Though Bra-khage himself was uninterested in jazz, his notion of the "untutored eye" freed filmmaking from the restrictions of all forms of correctness, allowing him to take advantage of the entire range of exposure and focal length available to the camera, to use multiple superimpositions, and even to bake or bury the film stock to increase its expressive vocab-ulary. These breakthroughs had close parallels in jazz, not only to Ker-ouac's bebop but also to the Free Jazz that emerged in reaction against the fixed, preestablished forms that remained in it. Though silent, the Brakhagian mode in underground film—with its visual parallels with Free Jazz's atonality, metrical irregularity, complete freedom of improv-isation, grounding in the body, and eagerness to use all kinds of uncon-ventional sounds—produced one of the most notable instances of the re-creation of musical forms in materiality of the film itself, the innova-tion of a specific mode of film musicality.

Such a musicality was perhaps realized most expressively in the L.A. Rebellion in Ben Caldwell's *I & I: An African Allegory* (1979). Taking, so introductory titles affirm, "its inspiration from the whole fantastic sweep of Africa's history," with its style "rooted in the virtuosity of Africa's ancient religion, lyrical arts, and African American music," the film depicts the awakening of Alefi, the wind messenger of Oyá (the goddess of the River Niger and husband of the god Ogún) in the forests of Africa; she subsequently brings the emerging future life force of the "Sun People" to the United States, where her Black people are presently subject to the depredations of the "Snow People." Large sequences in the visuals are a free collage of handheld moving-camera shots reminis-cent of Brakhage, while the accompanying music emphasizes jazz rock or fusion drumming, especially by Lenny White and Billy Cobham,

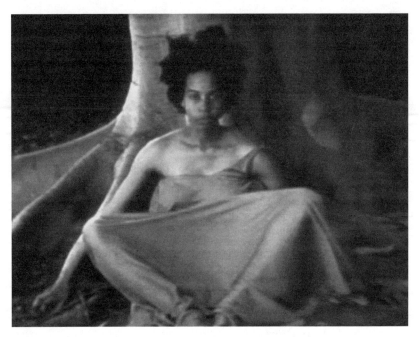

FIGURE 4.1. *I & I: An African Allegory* (Dir. Ben Caldwell, 1979).

whose resemblance to the world fusion music of Los Angeles–based Ornette Coleman alumnus, Don Cherry, also reflects the utopian globalism of the film's vision.

I & I: An African Allegory is essentially an extended trance film in the tradition inaugurated in Los Angeles by Maya Deren's *Meshes of the Afternoon* (1943) and continued in the city by several underground filmmakers, especially Kenneth Anger and Curtis Harrington, who used the trance film form to explore their own sexualities. In the genre, the surrealistic visuals are proposed as the heightened subjective experience of a protagonist displaced from mundane consciousness, a trope that structures one of the very greatest of the Rebellion short films, Barbara McCullough's *Water Ritual #1: An Urban Rite of Purification* (1979), which Caldwell photographed and which uses both African chanting and Don Cherry's music. A majestic naked African American woman walks though the burned-out shell of a house, squats on the ground, and urinates: a ritual in which the water issuing from her body redeems both herself and the place where she finds herself.

While drawing on formal innovations developed in underground film, *I & I* and *Water Ritual #1* radically transformed their social mean-

ing. Within beat culture, jazz and films that visually re-created jazz aesthetics were understood as signifiers, not so much of social contestation but of the emancipation of the individual imagination that, at best, might generate hedonistic bohemian subcultures outside square society. But the Rebellion films sustained by a jazz visuality were fundamentally a cry of outrage at the depredations of a racist society and a call for social transformation.

CONCERT DOCUMENTARIES

As the 1960s developed, the bases of White youth cultures shifted from the beats' preferred instrument—the African American saxophone—to the African American guitar: southern rural and northern urban and electronic blues became the musical basis of the late 1960s counterculture. By combining the blues heritages with contemporary rock 'n' roll and dressing it in English mod psychedelic flamboyance, Jimi Hendrix became the era's most important musician and the crucial figure in two utopian countercultural concert documentaries, *Monterey Pop* (Dir. D. A. Pennebaker, 1968) and *Woodstock* (Dir. Michael Wadleigh, 1970). The shock of his musical and actual pyrotechnics in the former and his lamentation for the costs of the nation's imperialism in his rewriting of "The Star-Spangled Banner" in the latter made him iconic for White youth, though not for Black culture generally, where ethnic rather than generational identities were paramount.

Held in commemoration of an earlier Los Angeles rebellion, the one that took place in Watts in 1965, the 1972 Wattstax music festival was often called the "Black Woodstock." *Wattstax* (1973), the film about it, was directed by a Hollywood insider, Mel Stuart, now best known for *Willy Wonka & the Chocolate Factory* made the year before. *Wattstax* is structurally similar to *Woodstock* in its dual focus on musical performance and the documentary investigation of the local community, and in its proposal that music provided the basis of an independent nation conjoining musicians and people. During the trial of the Chicago Seven (after Bobby Seale had been separated from the other defendants), when the presiding judge asked Abbie Hoffman for his place of residence, he replied, "I live in Woodstock Nation. [. . .] It is a nation of alienated young people. We carry it around with us as a state of mind in the same way as the Sioux Indians carried the Sioux nation around with them. It is a nation dedicated to cooperation versus competition."[12] A parallel notion of a Black nation was axiomatic in Black nationalism

FIGURE 4.2. *Wattstax* (Dir. Mel Stuart, 1973).

and also a central issue in *Wattstax,* collectively annunciated by the attendees in a call-and-response (a musical structure) in reply to Jesse Jackson's repeated question: "What time is it? [. . .] It's nation time." The musical bases of the two nations were integrally related, indeed the White counterculture privileged Black music more than any other form of culture, but still they contained different emphases.

Hendrix died before Wattstax, but the festival featured neither jazz nor Hendrix-inspired psychedelia (such as Funkadelic, whose *Maggot Brain,* with Eddie Hazel's ten-minute mind-shredding guitar excursus on the title track, had been released the previous year), both of which were relatively marginal tastes in the Black working-class community the festival drew together. Rather, though it included the blues performers Albert King and Little Milton, Wattstax's music was centered primarily on gospel, along with lesser or greater secularizations of it represented by two of its standout acts, the Staple Singers and Isaac Hayes. But this choice of music was prompted by economic as much as aesthetic or social considerations: all the acts recorded for Stax, the Memphis label whose vice president, Al Bell, cooperated with Jesse Jackson in organizing the event. Strongly committed to both Black civil rights and economic advancement, Bell had guided the company to its great success with Hayes's albums *Hot Buttered Soul* (1969), *Black Moses* (1971), and, of course, *Shaft.* Bell's nationalist concern ensured a remarkable degree of Black participation in the concert and in the film's production: over 90 percent of the twelve crews were Black, including

Larry Clark who worked as a cinematographer.[13] Hayes's performance assembled an especially rich and contradictory skein of both visual and musical references: dressed in gold chains and dick-displaying pink tights, he was introduced by Jesse Jackson as "a bad, bad brother," at once Black Moses and Shaft. His performance of "Shaft" and his identification of himself as its hero is *Wattstax*'s climactic scene, one that asserts vernacular Black popular music presented in a concert documentary—a genre that had been oriented to the mostly white counterculture—as the masculinist basis of Black community reconstruction.

Though none of the Rebellion filmmakers were in a position to organize an event of Wattstax's magnitude, *Passing Through* featured so much music that it almost became a concert film. So did *Trumpetistically, Clora Bryant* (Dir. Zeinabu irene Davis, 1989), a scintillating, inspiring documentary on a pioneer woman trumpeter who rose from conditions of near slavery in her north Texas childhood to celebrity in the jazz mecca on Los Angeles's Central Avenue, playing what Dizzy Gillespie, interviewed in the film, asserts is "a man's instrument, a young man's instrument." Though in more restricted contexts, musical performance in other films also registered social distinctions. *Fragrance* (Dir. Gay Abel-Bey, 1991) is a domestic melodrama evidently set in the era of the invasion of Vietnam that focuses on the conflict between two brothers, one of whom has joined the army while the other has been expelled from his home for calling his also patriotic father a "colored idiot." Containing nondiegetic period music from Nina Simone and *Hair,* the film was also framed by two performances from a third, much younger brother, Bobby. At the beginning of the film Bobby obeys his teacher who, to punish him for disobedience, forces him to sing "My Country 'Tis of Thee." But at the end of the film, having clarified for himself his distance from his father and eldest brother's patriotism, he remains silent, his refusal to perform constituting a performance of resistance.

Given its date, *Fragrance* seems like a flashback to early 1970s nationalism, especially in comparison to a film made a decade earlier, *Festival of Mask* (Dir. Don Amis, 1982), a documentary of the mask-making traditions of various ethnic groups in Los Angeles who all assemble for an annual festival that involves music and dance from Ghana, China, Korea, and Japan. While on the one hand the masks assert a specific social origin, the wearing of one also allows an identity to be assumed or concealed; as a voice-over asserts, "The charm of acquiring another face [. . .] is restricted by nothing more than one's imagination." If in

FIGURE 4.3. *Trumpetistically, Clora Bryant* (Dir. Zeinabu irene Davis, 1989).

FIGURE 4.4. *Fragrance* (Dir. Gay Abel-Bey, 1991).

this the film goes beyond the nationalism of the early 1970s toward notions of flexible and performative identity that would dominate in the next decade, it also recalls the possibility of transracial solidarity in the Communist heritage, which had been revived in the late 1960s by the Newsreels.

THE NEWSREELS

Heir to the Workers Film and Photo League of the mid-1930s, the late 1960s Newsreel collectives were formed in several cities across the country by small groups of independent documentary filmmakers to work on projects about the US invasion of Vietnam, the resistance to it, and other movement issues. One of their first productions was San Francisco Newsreel's collaboration with the Oakland branch of the Black Panther Party on *Off the Pig* (aka *Black Panther*, 1968), a film about the Ten Point Program that the Panthers used in recruiting and in combating the state's war against them. *Off the Pig* was consequential in the UCLA culture from which the Rebellion emerged. A screening of the film at a local branch of Students for a Democratic Society in October 1967 inspired a group of White, mostly ex-UCLA students, including Jonathan Arthur, Christine Hansen, Dennis Hicks, Judy Belsito, and Peter Belsito, to form the Los Angeles Newsreel. Their major project was a collaboration with the Los Angeles branch of the BPP on a film about the shooting at UCLA of students leaders, Alprentice "Bunchy" Carter and John Huggins, respectively deputy ministers of defense and of information of the L.A. BPP, by, the Panthers believed, the rival US Organization. Called *Two Revolutionary Brothers* and based on footage of Huggins's speaking and of the Breakfast Program, together with interviews of local BPP members who elaborate on the difference between the Panthers' class analysis of the Black struggle and the US Organization's Black nationalism, the film linked the Panthers' and all working-class struggles in the United States with the revolutions in Angola and Vietnam.

The sustained offensive by the Los Angeles Police Department (LAPD) against the Panthers was notoriously vicious; members of the Oakland Panthers noted that the city "had a new breed of pig, one that was trying to reestablish the old west,"[14] an analysis validated when the LAPD destroyed the Panther headquarters in L.A., effectively ending Panther leadership of the community and paving the way for the recrudescence of gang control. Reflecting these developments, the film was recut to include evidence of the destruction and new footage of the

police occupation of the community, and it was retitled *Repression* (1970). However, funds for completion could not be raised, and in 1970 the filmmakers abandoned it to mobilize factory workers; the image and audio tracks were not married till much later.[15]

Repression knits together footage of the Black community, of the invasive police presence, of the BPP Breakfast Program, of Third World armed struggle, of BPP spokespeople—including Masai Hewitt (L.A. BPP minister of education), Eldridge Cleaver, Elaine Brown—and eventually of the Newsreel members themselves. On camera or in voice-overs, they explain the economic basis of racism and slavery and argue the need for the first-world working class to unite with the global struggle against imperialism. The result was a schematic but fully articulated analysis of the situation of Black people in Los Angeles, in US capitalism and imperialism, and in the global struggles against them. Culminating in an appeal to the audience that we should become "one people, led by the working class, Black, Brown, Yellow, Red, and White, man and woman," it returned to *Salt of the Earth*'s vision of a working class united across ethnic and gender lines, more radically comprehensive than the Pan-Africanism Haile Gerima proposed in *Bush Mama*.

And again music is integral to the film's discursivity. *Repression* opens with a Free Jazz dirge, Ornette Coleman's recording of his own composition, "Sadness," that accompanies documentary footage of prisoners on a chain gang. As the remainder of the film reveals the causes of this condition and the global resistance that may relieve it, the soundtrack is taken over by Elaine Brown's performance of one of her compositions, "The End of Silence," which she recorded in 1969 with the assistance of Horace Tapscott when she was a member of the L.A. BPP, soon after the murder of Higgins and Carter.[16] Both the timbre of her voice and the urgency of her appeal recall Nina Simone, whose political music was so important to the civil rights movement and also to the Rebellion.[17] Asserting that both dignity and equality are necessary to make "a man a man," Brown's lyrics reiterate the Panthers' Fanonian espousal of violence, most bluntly in her chorus that declares the debilitating exploitation of black people will end only when we get guns "and be men." Though the film as a whole envisages a working-class political commonality beyond identity politics, its most salient woman's voice remains within patriarchal sexism, a sexism that Brown herself would confront directly when she became chairman of the BPP and that eventually would cause her to leave the organization. And

though the Los Angeles Newsreel's utopian social vision was never publically exhibited until much later, the contradictions that her song in *Repression* unconsciously articulated would mature in the 1970s as Black feminism and produce the Black women's component in the latter years of the Rebellion.

NOTES

This essay © David E. James, 2013. Parts of this essay draw on my *Allegories of Cinema: American Film in the Sixties* (Princeton, NJ: Princeton University Press, 1989) and *The Most Typical Avant-Garde: History and Geography of Minor Cinemas in Los Angeles* (Berkeley: University of California Press, 2005).

1. Amiri Baraka, "Hunting Is Not Those Heads on the Wall," in *Home: Social Essays* (New York: William Morrow, 1966), 16.

2. The most vigorous contemporary overview of proposals for the revolutionary significance of Free Jazz was Frank Kofsky, *Black Nationalism and the Revolution in Music* (New York: Pathfinder Press, 1970). More recently, the complex relations between Free Jazz, the Black Arts movement, and Black nationalism have been well treated by Iain Anderson in *This Is Our Music: Free Jazz, the Sixties, and American Culture* (Philadelphia: University of Pennsylvania Press, 2007).

3. Figures are from "The Numbers," Nash Information Services, www.the-numbers.com/movies/1971/0ASSS.php.

4. See Gerald Martinez, Diana Martinez, and Andres Chavez, "Melvin Van Peebles," in *What It Is . . . What It Was!: The Black Film Explosion of the '70s in Words and Pictures* (New York: Hyperion, 1998), 35.

5. Huey P. Newton, *To Die for the People* (New York: Random House, 1972), 139 and 113, respectively.

6. Ed Guerrero, *Framing Blackness: The African American Image in Film* (Philadelphia: Temple University Press, 1993), 86–90.

7. Gerima quoted in Gladstone L. Yearwood, "*Sweet Sweetback's Baadasssss Song* and the Development of the Contemporary Black Film Movement," in *Black Cinema Aesthetics: Issues in Independent Black Filmmaking*, ed. Gladstone L. Yearwood (Athens: Ohio University Center for Afro-American Studies, 1982), 62.

8. "Minutes of the Party Congress of the Social Democratic Party of Germany: Held in Erfurt from October 14–October 20, 1891," German History in Documents and Images, German Historical Institute, Washington, DC, accessed October 24, 2013, www.marxists.org/history/international/social-democracy/1891/erfurt-program.htm.

9. Pauline Kael, "Propaganda—*Salt of the Earth*," reprinted in *I Lost It at the Movies* (Boston: Little Brown, 1965), 131.

10. The most authoritative account of this incident and the consternation it caused is in Mary King, *Freedom Song: A Personal Story of the Civil Rights Movement* (New York: Morrow, 1987), 451–52.

11. Jack Kerouac, "Essentials of Spontaneous Prose," in *A Casebook on the Beat,* ed. Thomas Parkinson (New York: Thomas Crowell, 1961), 65 (emphasis added).

12. "The Chicago Seven Conspiracy Trial: Testimony of Abbie Hoffman, December 23 and 29, 1969," Federal Judicial Center, accessed July 18, 2011, www.fjc.gov/history/home.nsf/page/tu_chicago7_doc_1.html.

13. See "*Wattstax 72* Film Shot by 90% Black Crews: 250 G Budget for Docu," *Variety,* September 27, 1972, 1, 61.

14. Elaine Brown, *A Taste of Power: A Black Woman's Story* (New York: Pantheon, 1992), 184.

15. Along with other Newsreel films, *Repression* is available on the DVD compilation *What We Want, What We Believe: Black Panther Party Library.*

16. Of "The End of Silence," musicologist Dean Wilson writes, "Elaine Brown's gripping, unadorned voice embodies the contradictory energies of the Black Panthers, and indeed her crucial animating role in the movement, maternal, even soothing in its brightness, warmth and control. The mournful arpeggiated piano accompaniment, full chords gently pulsing only during its soul-tinged refrain, belies her lyrical and paradoxical call to 'get guns / and be men.'" (personal correspondence, October 28, 2012). Elaine Brown gives a brief account of the recording session in *A Taste of Power,* 195–96. The poem was taken as an exemplary statement of Panther militancy; see, for example, John A. Courtright, "Rhetoric of the Gun: An Analysis of the Rhetorical Modifications of the Black Panther Party," *Journal of Black Studies* 4, no. 3 (March, 1974): 249–67. White Panther John Sinclair understood the record as an instance of "self-determination music," recommending it alongside Horace Tapscott's *The Giant Is Awakened* and Stanley Crouch's poetry record, *Ain't No Ambulances for No Niggers Tonight.* See John Sinclair and Robert Levin, *Music and Politics* (New York: World Publishing, 1971), 56–57.

17. Julie Dash's film *Four Women* (1975) was based on Simone's eponymous song, and Bernard Nicolas's *Daydream Therapy* (1977) was based on Simone's "Pirate Jenny," though it concluded with Archie Shepp's Free Jazz composition "Things Have Got to Change."

Re/soundings

Music and the Political Goals of the L.A. Rebellion

MORGAN WOOLSEY

THE PLACE OF MUSIC IN CINEMAS OF DECOLONIZATION

In their 1968 call for a Third Cinema, Argentine filmmakers Fernando Solanas and Octavio Getino describe the necessity of the deconstruction of deceptive images propagated in the neocolonial world and the creation of truthful, demystified images to take their place. "The cinema of the revolution is at the same time one of *destruction and construction:* destruction of the image that neocolonialism has created of itself and of us, and construction of a throbbing, living reality which recaptures truth in any of its expressions."[1] They champion documentary filmmaking as the basis for the revolutionary cinema they describe, since in the neocolonial situation *"the image of reality* is more important than reality itself."[2] The image is therefore of utmost importance in the cinema of decolonization they describe. In their formulation, film is a tool for change, a weapon: "the camera is our rifle."[3]

Solanas and Getino's linking of camera and rifle in the revolutionary struggle finds visual representation in *Daydream Therapy*—Bernard Nicolas's Project One at UCLA in 1977—in which the protagonist is depicted marching with a series of objects, translating her daydreams into action: a copy of *Class Struggle in Africa;* a sign urging the audience/reader to "fight for what you want"; a camera; and finally a rifle. Made roughly a decade after "Towards a Third Cinema" was published, *Daydream Therapy* explores many of the same issues. Notably, however, the project is constructed around two pieces of music—Nina

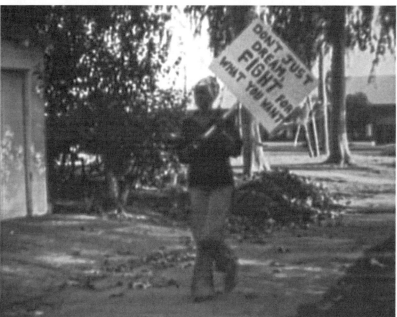

FIGURES 5.1. & 5.2. *Daydream Therapy* (Dir. Bernard Nicholas, 1977).

FIGURES 5.3. & 5.4. *Daydream Therapy* (Dir. Bernard Nicolas, 1977).

Simone's interpretation of "Pirate Jenny" and Archie Shepp's "Things Have Got to Change"—that can hardly be ignored, nor deferred to the primacy of the images. Simone's "Pirate Jenny," recorded in 1964, when she herself was in the midst of a massive political awakening,[4] is a snarling, theatrical fantasy of retribution: how can her performance of the song be discussed in the context of revolutionary filmmaking, a discussion that has tended to favor considerations of the visual and metaphors rooted in sight?

If the camera is a rifle, what of nonvisual cinematic elements and technology? What kind of a weapon would something like a microphone, for example, or "Pirate Jenny" be? While Solanas and Getino certainly use music and sound in fascinating and critical ways in their own work, their manifesto does not explicitly discuss a decolonizing program for music in the creation of a revolutionary Third Cinema, nor does it deploy auditory metaphors in its discussion of decolonization, though "voice" is used often enough elsewhere in political discourse to denote agency.[5] The image, instead, becomes for them the main figure by which to enact a number of relationships to "truth." As they say, "Every image that documents, bears witness to, refutes or deepens the truth of a situation is something more than a film image of purely artistic fact; it becomes something which the System finds indigestible."[6]

The characteristics associated with the image in "Towards a Third Cinema" all fit within the "visual" half of what Jonathan Sterne has termed "the audiovisual litany": a "set of presumed and somewhat clichéd attributes" that elevate "a set of cultural prenotions about the senses (prejudices, really) to the level of theory."[7] In this litany, seeing stands for the rational, the objective, the spatial, and the intellectual, while hearing stands for the irrational, the subjective, the temporal, and the affective or emotional. In this binary, vision takes the privileged place in relation to truth procedures, while sound occupies a much more vexed position. Music in particular—understood as operating on a level analogous to that occupied by emotion: intimate and personal, as well as unconscious, unmediated, and prone to manipulation by outside forces—occupies an especially vexed position vis-à-vis "truth."

In particular, the use of musical scoring or nondiegetic music[8] is often the recipient of harsh condemnation from filmmakers invested in the "construction of a throbbing, living reality which recaptures truth in any of its expressions," as put forward by Solanas and Getino. As such, Julie Hubbert's comments regarding cinéma vérité's struggles with defining the place of music are applicable here: "Both narration and music

destroyed the intended neutrality of the *vérité* aesthetic because they emphasized the filmmaker's interpretation or perspective over the viewer's. Both additives interpreted the subject being documented instead of letting the subject speak for itself [. . .] adding music to a documentary was especially egregious because it was one of the quickest and easiest ways of destroying the perception of uncontrolled reality."[9] But not only might a musical score added during postproduction destroy "the perception of uncontrolled reality" promoted by the image; such musical scores also represented a culturally specific mode of storytelling of which Third Cinema practitioners might be somewhat wary. This sentiment is articulated by Senegalese filmmaker Ousmane Sembène: "The whites have music for everything in their films—music for rain, music for the wind, music for tears, music for moments of emotion, but they don't know how to make these elements speak for themselves."[10]

Sembène combines the *vérité* concern of letting an image "speak for itself" with a Third Cinema dictum to discard the aesthetic strategies of the European colonizer. Nondiegetic music—the dominant model of which is firmly rooted in European practices of orchestral music and opera—is therefore doubly marked. Diegetic music, or source music, on the other hand—music that can be traced to a location within the world of the film—presents less of a problem for the filmmaker concerned with truth and decolonization, as Hubbert describes: "If nondiegetic music was unacceptable because of its unreal or mediating influence, then diegetic music was acceptable, and not necessarily because it couldn't comment on the events being filmed. Certainly, diegetic music, too, had extramusical abilities. But because its source could be visually observed within the film, those editorial capabilities could be more obviously confined to aspects of time and location instead of mood and emotion."[11]

It is unsurprising, then, that the discussion of music is not a central concern of Solanas and Getino's treatise. However, as my opening example of *Daydream Therapy* might suggest, there are many other ways to conceptualize the place of music within revolutionary film projects, especially when considering the group of Black filmmakers who have come to be known retrospectively as the L.A. Rebellion. Clyde Taylor says as much in his early article on these filmmakers, "New U.S. Black Cinema." The first sentence of this article reads, "The impact of black music on the new black cinema is clearly intentional and well documented."[12] The L.A. Rebellion, then, represents a group of filmmakers concerned with the creation of a new cinematic vocabulary capable of representing the truths of Black experience, and this is a

cinematic language that must account, explicitly, for the use of music. My own essay is an attempt to delineate some of the ways in which music can be understood in the context of revolutionary film that, in part due to its reliance on documentarian models, is reticent in its usage of music, or at least in the discussion of that usage.

The works that belong to this category—the L.A. Rebellion—are as varied in their approaches to music as they are in their styles and genres, and so a complete examination is impossible. I have, however, drawn examples from a wide range of forms—feature-length narratives, shorts, dance films, documentaries—that represent a wide range of political and representational goals in the hope that this survey might encourage future exploration into the sonic worlds of the L.A. Rebellion and the staggering array of music to be found therein.

In this essay I delineate some of the ways in which the uses of music in L.A. Rebellion work can be understood as participating in the furthering of the political goals of the filmmakers. First, I explore how filmmakers worked to depathologize the wide range of musics of the African diaspora grouped under the heading "Black music."[13] Some films sought to elevate jazz and other genres through the eschewal of romantic-era European styles of underscoring in favor of other methods. Some short films attempted to trace a genealogy of the use of Black music in film, such as *Illusions* (Dir. Julie Dash, 1982) and *A Day in the Life of Willie Faust* (Dir. Jamaa Fanaka, 1972). And some—both documentary and narrative—focused on the lives of musicians, such as *Passing Through* (Dir. Larry Clark, 1977) and *Horace Tapscott: Musical Griot* (Dir. Barbara McCullough, in production). Others featured scores or soundtracks meant to expand understandings of what "Black" music could sound like, as in *Killer of Sheep* (Dir. Charles Burnett, 1977).

I then discuss the many educational functions music could be called upon to serve in revolutionary film. Filmmakers sought to educate their audiences on a wide range of issues through music. The use of the music of well-known politically engaged musicians served as a lesson in music history and politics, as in *Bless Their Little Hearts* (Dir. Billy Woodberry, 1982) and *Rain (Nyesha)* (Dir. Melvonna Ballenger, 1978); and the narrative or documentary focus on musicians demonstrated some ways in which musical practice could be a blueprint for liberation, consciousness raising, and other revolutionary goals (e.g., in *Passing Through* and *Musical Griot*). Music also functioned more broadly to destabilize the usual hierarchy of cinematic sounds that dictates that all sonic elements assure the intelligibility of the dialogue. This destabiliza-

tion aimed to produce a more active engagement between audience and film, as in *Bush Mama* (Dir. Haile Gerima, 1975) and *Ashes & Embers* (Dir. Haile Gerima, 1982), not only to educate audiences in the particular issues of the film at hand—which *Bush Mama* and *Ashes & Embers* accomplished vis-à-vis songs with clear, didactic lyrics—but to educate them in the consumption of film and audiovisual media as well.

Finally, and most expansively, music played a vital role in the ongoing project of restoring denied humanity and interiority to Black cinematic subjects. Clearly many of the goals outlined above can be interpreted as feeding into this larger, overarching goal. However, in this essay's final section, I explore some of the most fraught moments in these films—dealing with physical violence and psychological trauma—to try to specify some qualities of the music used that make it essential in these particular cinematic projects of decolonization. From multilayered depictions of women's experiences of embodiment and violence (*African Woman, USA* [Dir. Omah Diegu (Ijeoma Iloputaife), 1980], *Hidden Memories* [Dir. Jacqueline Frazier, 1977], *Bush Mama*) to the fracturing of time during moments of trauma and change (*Welcome Home, Brother Charles* [Dir. Jamaa Fanaka, 1975], *Ashes & Embers*), I hope to demonstrate some of the ways in which music can be used—experimentally or more conventionally—to contribute to the imperative for Third Cinema with which I opened: the "destruction of the image that neocolonialism has created of itself and of us, and construction of a throbbing, living reality which recaptures truth in any of its expressions."[14]

THE RECUPERATION AND VALORIZATION OF "BLACK MUSIC"

In order to discuss how the L.A. Rebellion filmmakers sought to depathologize and expand understandings of music made by Black subjects, we must first examine some of the historical dynamics to which they were responding. From the very earliest days of the sound film, Black voices—and the music those voices produce—have occupied a highly circumscribed and fetishized position within cinema, at once revered for a perceived "warmth" and expressive quality often tied to religiosity, and denigrated for a perceived primitivity often tied to sexuality, the effect of the body from which the voice emanates.

In the early days of the talkies, as Alice Maurice demonstrates, anxieties that sound would draw too much attention to dialogue (thereby rendering action ineffective), that recorded voices sounded artificial, and that technology would inhibit the production of films, as well as their

exhibition, seemingly could be resolved through the use of African American performers, specifically, through the filming of song and dance. Early critics observed that particular qualities possessed by "the Negro voice [. . .] [made it] the ideal medium for talking pictures."[15] Maurice argues that discourses of race and synchronization "supported each other not because of the alleged suitability of 'black voices' to sound recording, but because of what they already had in common: a dependence on popular expectations regarding authenticity, the alignment of internal and external characteristics, and the evidence of the senses."[16]

The idea of the "Black voice," then, is one made possible by "synesthesia," the conflation of the audible and visible.[17] Maurice's example of synesthesia is a "presumed perceptual link between color and sound. [. . .] Color/race promises a particular kind of sound, and that sound, once heard, is supposed to refer back to the color/race that produced it."[18] The idea of "Black music," likewise, is shaped by this conflation of the audible and the visible. As Ronald Radano and Philip Bohlman point out in *Music and the Racial Imagination,* "Race lives on in the house of music because music is saturated with racial stuff. [. . .] As a key signifier of difference, music for America [. . .] historically conjures racial meaning."[19]

Though Radano and Bohlman are speaking broadly of American music, this statement applies particularly well to music in film, which continues to "conjure" racial meaning using well-worn stereotypical signifiers. For example, source music is often used to signify ethnic groups: from fiddle jigs and penny whistles accompanying images of Irish immigrants to pentatonicism and reverberating gongs accompanying orientalist imagery. Source jazz was used in classical Hollywood cinema—especially film noir—to represent "alcoholics, junkies, prostitutes, criminals,"[20] and a host of other unsavory characters consistently affiliated with the milieu of the urban jazz nightclub. Indeed music made by Black musicians often continues to be tied to spaces and bodies visibly marked as "Black": the synesthesia outlined by Maurice.

It is the ongoing pathologization, the representational racism, accompanying this synesthesia that Rebellion filmmakers tried to counter in their own treatment of music. *Passing Through*—a film whose protagonist, Eddie Womack, urges his fellow musicians to break away from their corrupt record label to start one of their own—is a particularly striking example of an attempt to depathologize jazz. First , though the film does present the club as a space plagued by addiction (musicians are paid in drugs), it consistently stresses the institutional dimensions of

addiction by tracing the flow of drugs back to the corrupt record executives. Second, though it does present jazz as an irrevocably embodied musical form, through multiple scenes depicting musicians practicing— together or alone—it also pushes against the essentialist assumption that jazz is an unstudied, inherent talent specific to Black bodies.

Passing Through is based loosely on the life and activities of Los Angeles pianist and bandleader Horace Tapscott (on whose hands the camera focuses during the opening sequence and who appears briefly in a few other scenes), the subject of Barbara McCullough's documentary *Horace Tapscott: Musical Griot.* As with *Passing Through, Musical Griot* focuses on the positive function of the musician as a builder of community and an agent for change, distancing Tapscott from the stereotypes he himself outlines during an interview: "He's [the jazz musician is] a junkie or a wino, or he's not too intelligent, or he's just arrogant." Instead, the documentary focuses on his capacities as a local teacher and a leader. Unlike many of his contemporaries, Tapscott stayed in Los Angeles for most of his life, remaining "obscure almost everywhere beyond the local community in which he worked and lived."[21] Within that community, though, he took up a prominent position in the overlapping networks of music education and performance, founding institutions such as the Underground Musicians Association and ensembles such as the Pan Afrikan People's Arkestra.[22]

In this way, *Passing Through, Musical Griot,* and *Trumpetistically, Clora Bryant* (Dir. Zeinabu irene Davis, 1989) are part of a depathologizing project of preservation: collecting stories of influential musical community members who, because of their lack of mainstream commercial success, could otherwise be forgotten. This project is especially important in Los Angeles, where Black musicians were historically excluded from equal participation in the city's recording industries by the segregationist politics of the musicians' unions and effaced from mainstream "West Coast" jazz narratives.

Illusions is also a part of this project, though Julie Dash is more concerned with exploring the racial dynamics of World War II–era Hollywood and creating fictional stand-ins for the many Black performers whose contributions have been relegated to the shadows. The short film is concerned with Mignon Dupree, a light-skinned African American woman passing as white as she works as an assistant to a studio executive. She befriends Esther, a young African American singer whose voice is used to dub over filmed musical numbers featuring white performers. Dash uses recordings of Ella Fitzgerald performing "Sing Me a Swing

TRUMPETISTICALLY

CLORA BRYANT

FIGURE 5.5. Promo card for *Trumpetistically, Clora Bryant* (Dir. Zeinabu irene Davis, 1989). Collection of Zeinabu irene Davis.

Song, and Let Me Dance" and "The Starlit Hour"[23] as Esther's singing voice during the dubbing scenes to imagine the process by which a Black voice was made acceptable through suture to a white body.

Dubbing singing voices during musical numbers was a common practice at the time, but the circumstances surrounding the dubbing of a Black singer's voice over a white actor's body, or a white singer's voice over a Black actor's body, indicate the place of music and voice within the dynamics of racial representation, including what sounds can acceptably emanate from which kinds of bodies. For example, a Black voice could be acceptable—even preferred—if the phenotype of the

FIGURE 5.6. *Illusions* (Dir. Julie Dash, 1982).

singer was obscured. But in other cases a white voice was dubbed over a Black performer, for example over the leading trio—Dorothy Dandridge, Joe Adams, and Harry Belafonte—in *Carmen Jones* (Dir. Otto Preminger, 1954). As Jeff Smith states, an assumption of the musical incompetence of the actors as a reason for dubbing fails in this case, since at least both Belafonte and Dandridge were very capable musicians. This, for Smith, raises the question, "were Dandridge and Belafonte 'too black' to sing opera?"[24]

The question of race and genre leads me to the final point about how the L.A. Rebellion filmmakers sought to bring nuance to the understanding of musics grouped under the heading of "Black music," that is, in concerted efforts to expand understandings of what music created by Black people could sound like. *Killer of Sheep* is particularly noteworthy in this regard, its diverse soundtrack ranging from Dinah Washington and Earth Wind & Fire to Faye Adams, William Grant Still, and Paul Robeson. Charles Burnett has stated on multiple occasions that the film was meant to serve as a "history lesson" in African American music,[25] one that simultaneously contributed to the realistic depiction of the South Los Angeles neighborhood in which the action unfolded.

EDUCATION AND CONSCIOUSNESS RAISING

Burnett's goal of expanding notions of what Black music could sound like pivots into my next discussion: music's educational functions. Many filmmakers across media and genres within the L.A. Rebellion provide music intended, as with *Killer of Sheep,* to expand the notion of what Black music can sound like and to introduce audiences to music and musicians perhaps otherwise unknown to them. While in the previous section I traced the importance of these two goals in attempts to depathologize Black music and add nuance to understandings about Black music, here I am concerned with the pedagogical functions that the selection and placement of music serve. For example, *Passing Through* opens with a dedication: "To Herbert Baker, and other black musicians, both known and unknown." The film then proceeds to populate its soundtrack with a mixture of preexisting recordings by well-known musicians—John Coltrane, Charlie Parker, Sun Ra, Sonny Fortune, and Grant Green, among others—and music performed and recorded by Tapscott and the Pan Afrikan People's Arkestra. As with *Killer of Sheep,* the sheer volume and variety of music in *Passing Through*'s soundtrack makes it difficult to separate source and score, diegetic and nondiegetic, which in turn makes it difficult to differentiate between the preexisting "known" elements and the "unknown" ones recorded expressly for the film. This mixing of professional and community musics in the soundtrack had precedent in Tapscott's career with the Pan Afrikan People's Arkestra. As Widener outlines, "While trained instrumentalists made up the bulk of the Arkestra . . . band members ranged in age from seven to seventy, and one of the band's first records featured several compositions written by Herbert Baker, a student at nearby Dorsey High School."[26] The film, then, is dedicated to one of the youngest early members of the Arkestra, an "unknown," a dedication that highlights the important effects of Tapscott's institutions and networks while simultaneously reminding viewers that "known" musicians are only a small part of the picture.

"Known" musicians, though, remain an important feature of the L.A. Rebellion films, with a particular preference shown for politicized musicians such as John Coltrane, Paul Robeson, Archie Shepp, and Nina Simone. As I illustrated in this essay's introduction, songs by Nina Simone functioned as a scaffolding on which a story of raised consciousness and liberation could be constructed and also as a musical manifestation of those revolutionary goals. Works such as *Daydream Therapy*

FIGURE 5.7. Production photograph of Horace Tapscott in *Passing Through* (Dir. Larry Clark, 1977). Collection of Larry Clark.

and *Passing Through* present music as a potential liberatory methodology, whether enacted through listening or playing. In other cases, however—such as *Killer of Sheep* and *Bless Their Little Hearts*—the presence of this politicized music highlights the difficulties around the attainment of these goals and the institutional frameworks that might make their attainment impossible. In *Killer of Sheep,* for example, Paul Robeson's iconic rendition of "The House I Live In"—a Popular Front social justice anthem whose "dream of racial inclusion has been abandoned, nearly obliterated"—accompanies neorealist shots of Black children playing in a decimated, postindustrial Los Angeles landscape,

"us[ing] black music, the linking of the African American past to the Watts present, as a way of ironically commenting on the action."[27]

Music functions in a similarly linking, if slightly less ironic, way in *Bless Their Little Hearts,* in which Billy Woodberry uses the 1980 recording *Trouble in Mind* (Archie Shepp and Horace Parlan) and various songs sung by Little Esther Phillips to underscore his domestic drama, also unfolding in Watts. This is a very different Archie Shepp from the radical free jazz used in Nicolas's shorts *Daydream Therapy* and *Gidget Meets Hondo* (1980), as *Trouble in Mind* featured mellow instrumental versions of early blues by artists such as Bessie Smith, Earl Hines, Leroy Carr, and Richard M. Jones, for whom the album is named, as well as a number of traditional blues compositions. Shepp and Parlan's renditions of these songs connect Charlie's alienated "Watts present" in *Bless Their Little Hearts* to the past: creating continuity through the musical mediation of history.

Melvonna Ballenger's short *Rain/(Nyesha),* is another example of a work that meditates on potential connections between music and politics through a compilation soundtrack, very densely packed, though this one focuses predominantly on contemporary music. In the film, the protagonist, disheartened by the rainy weather when she wakes up, turns on the radio. She quickly scans through several stations, each of which is playing a song about rain.[28] After showering, she ventures outside and meets a Black Panther handing out pamphlets. Slowly, the voice-over narration draws connections between rain and personal/political change ("Changing yourself is like waiting for the rain. [. . .] Rain always provokes a change"), a connection we have been hearing drawn in the music from the very first moments of the short. Here, as in *Killer of Sheep* and *Bless Their Little Hearts,* music is used to immerse the audience in the historical and contemporary context of African American negotiations with social change through music.

Another approach to providing a music history lesson via film can be found in the work of Jamaa Fanaka, whose films draw in part on the cinematic language of the Blaxploitation genre. In his short *A Day in the Life of Willie Faust,* for example, Fanaka uses the music of Isaac Hayes and Curtis Mayfield,[29] whose contributions to the genre through multiple soundtracks—such as for *Shaft* (Dir. Gordon Parks, 1971) and *Super Fly* (Dir. Gordon Parks Jr., 1972)—represent widely divergent scoring styles. Where Hayes's music supported the representation of Shaft as a cool and competent detective, Mayfield's undercut the actions of the film, providing critical commentary on the drug culture depicted

on-screen. Unlike the films to which *A Day in the Life of Willie Faust* refers, though, Fanaka's short, as well as his later feature-length films such as *Penitentiary* (1979) and *Welcome Home, Brother Charles*, rapidly shifts musical gears, moving from the funk and soul mode inspired by Blaxploitation, to a more minimalist, avant-garde mode inspired by other low-brow genres such as horror, to more experimental modes of jazz. While *Illusions* is concerned with reconstructing a lost history of Black music making in Hollywood, Fanaka's films reconstruct a history of Black music making in exploitation film, simultaneously providing new entries into that marginal cinematic sphere through musical collaborations with William Anderson, Andre Douglass and The Gliders, the Little Willie Peters Band, and Frankie Gaye.

While the music education of the audience was important to these works, many L.A. Rebellion filmmakers, "recognizing in their music an invaluable precedent of cultural liberation,"[30] used music and the representation or documentation of music making and musicians in a more expressly political way: as a blueprint for political processes—such as consciousness raising, community building, and liberation or self-determination—or as an important component of the representation of those processes. *Passing Through* offers many musical embodiments of revolutionary goals. First and foremost, it equates the corrupt and oppressive music industry with America, allegorized in Womack's urging of his fellow musicians to break away and start their own label, where they would be able to control and preserve their music, making sure it continued to grow and develop. It also depicts music making as personal and political narration, with Womack's saxophone performance scenes serving as entry points into elaborate sepia-toned or black-and-white flashbacks combining archival footage of civil rights–era protests and anticolonial struggles mixed with events from Womack's own past. And finally, it valorizes musical mentorship in the relationship between Womack and Poppa Harris, as do the two documentaries I mentioned earlier by Zeinabu irene Davis and Barbara McCullough. Though *Passing Through* ultimately pushes its revolutionary focus past the politics of community building and self-determination and into the territory— more frequently the province of Blaxploitation—of violent retribution, the ending of the film returns to an allegorization of Black political struggle through music. In this final sequence, Womack is shown playing his saxophone in solitary profile against a red background—a shot that actually begins the film, when Womack is searching for Poppa Harris, uncertain of his own ability to take responsibility for his own music

FIGURE 5.8. *Passing Through* (Dir. Larry Clark, 1977).

making. This time, though, when Womack plays, his music does not simply echo back at him as in the earlier sequence; it rests atop a brass texture distinct from it. This new music boils unassumingly below him until a steady high whine of another saxophone responds. Instead of his own music echoing back at him, the music we hear at the end of the film follows its own logic. The message is clear: Womack has internalized Poppa's strength and knowledge through music, and having come into his own as a leader, the space and people around him will respond with strength and independence.

Films may use music as an allegory for revolutionary change of varying kinds, but they may also use music in the depiction of those changes, outside of a musical context or narrative, as with the work of Haile Gerima. In *Bush Mama* and *Ashes & Embers,* Gerima uses music at key points in the narrative to reinforce the coming to consciousness of his protagonists, Dorothy and Nay Charles. Music also functions as a part of Gerima's overall sonic strategy to destabilize audiovisual hierarchies in film, to encourage a more active engagement with the audience, itself a pedagogical goal. I will consider this first feature—the use of songs with clear, declarative lyrics—before moving on to my concluding dis-

cussion of how musical practice in L.A. Rebellion films is central to an overall goal: the repair and redress of decades of systematic denial of interiority to Black cinematic subjects.

Bush Mama and *Ashes & Embers,* though made years apart, present strikingly similar narratives: the former, the coming to consciousness of a woman whose lover, T. C., has been incarcerated, leaving her to contend on her own with the forces of state surveillance (the welfare office) and law enforcement (the police); the latter, the coming to consciousness of a Vietnam veteran who is able to connect his actions as part of the U.S. military abroad with the violent neocolonial projects at home. Both narratives present a kind of "how-to" guide for consciousness raising, letting the audience listen to the various community members the protagonists encounter, each of whom helps the protagonists reformulate their thoughts. Given such a didactic approach, it is unsurprising that these films rely on songs with clear narrative lyrics that refer to the situation of the characters, sometimes addressing them directly, as in the phrases "well sister" and "hey bush mama!" from Onaje Kareem Kenyatta's song from *Bush Mama.*

This mode of direct address corresponds with the film's style of cinematography, in which characters often speak directly into the camera, as if they are speaking to Dorothy. *Bush Mama* is structured in part as a dialogue between Dorothy and the incarcerated T. C., so it is not surprising when the song seems to take his point of view. For example, the song initially accompanies T. C. being led to his cell, and when singing about the welfare worker, Kenyatta intones, "Asking questions about the father and where's he? Never caring to hell that I'm in jail, not guilty, not free." This connection between the politically critical lyrics and T. C. deepens throughout the film, as he sends Dorothy letters that track his growing consciousness of the racist structures that have landed him in prison.

Though the song that plays during the title credits of *Ashes & Embers*—"American Fruit," a track from of the self-titled debut album of R&B singer Zulema—does not speak directly to the protagonist, Nay Charles, it still clearly speaks to the the narrative, urging African Americans to unite and free themselves from America's institutionalized oppression.

As with the song from *Bush Mama,* "American Fruit" both describes the situation of the characters and calls for action. The message of these songs could not be any clearer, indicating that music is a part of the political project of consciousness raising in the film and one of its most powerful articulators.

FIGURE 5.9. *Ashes & Embers* (Dir. Haile Gerima, 1982).

Part of the power of these songs derives from the position they occupy within Gerima's soundscapes, accentuated in the wide range of sounds—verbal and vocal, natural and industrial, layered on top of one another—that populate the films. From its start, *Bush Mama* immerses the audience in a disorienting bath of sounds: the constant whirring of helicopter blades, sirens, the mechanized loop of a social worker asking prying questions. *Ashes & Embers* presents a similarly busy soundscape, though this one shifts from the noisiness of the country (birds, crickets, the wind in the grass and trees) to the noisiness of the city (sirens and car horns) to the noisiness of Vietnam (helicopters and gunfire).

Crafting multiple sonic layers—as in the opening sequence of *Bush Mama*, as well as the scene in the abortion clinic—Gerima creates depth in the soundscape, attempting to re-create some kind of truth about the character's experience, asking the audience to leaf through each sonic layer while they consider the experiences he is presenting on the screen. I now turn to exploring this creation of complex sonic environments as a manifestation of the final goal of L.A. Rebellion films that I have identified: the restoration of interiority to Black cinematic subjects.

RESTORATION OF INTERIORITY

In the style sheet for his doctoral degree, philosopher Charles Johnson provides a textured description of an experience of cultural imperialism he calls, along with Frantz Fanon, "epidermalization."[31] An immaterial process of dehumanization, epidermalization enacts on the Black subject, through the gaze of a white Other, a complete voiding of subjectivity, what Johnson describes as being "turned inside out like a shirtcuff." Vivian Sobchack says of this reflection on epidermalization that Johnson "evokes the lived sense of what it means when consciousness is eviscerated and evicted from its home body [. . .] when, through a look, it is thrown outside itself."[32] Omah Diegu's (Ijeoma Iloputaife) short *African Woman, USA* presents the audience with an instance of this "one-sidely seeing" when the protagonist, a Nigerian woman studying dance at an American university, gives a performance to an almost entirely white audience: a dance choreographed to "Bibile," by Congolese singer Abeti Masikini. The protagonist confides in her friend after the performance that she almost did not want to dance that night when she saw the audience, and she mentions a mistake she made while performing. Her friend says it does not matter: "White people don't care, all they can talk about is our rhythm." This reduction of the Black subject to fit within the parameters of preconceived notions continues as the protagonist attempts to find a job. Interviewers ask inane questions and are unable to correctly remember her country of origin.

After the violence that follows this moment of being "so one-sidely seen,"[33] Johnson suggests that there are three options available to him at the level of consciousness: he can accept this this hypervisualization of the outside and effacement of the inside and deploy a "useful opacity [. . .] cynically play with their frozen intentions, presuppositions, and stereotypes";[34] he can try to prove the existence of an inside; or he can try to reverse the negative meanings that have been grafted onto his skin. In *African Woman, USA,* the protagonist expresses a desire to subvert the expectations of her white audiences—those at the performance but also her interviewer—perhaps falling into the second category of responses described by Johnson.

But these options all respond to the visuality of epidermalization in kind, not unlike the predominantly visual strategies outlined by Solanas and Getino that began this essay. I wonder, though, along with Clyde Taylor, how music can be utilized in a response to cinematic

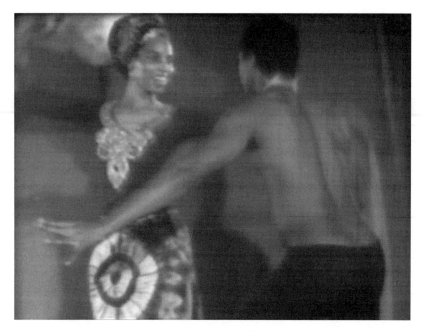

FIGURE 5.10. *African Woman, USA* (Dir. Omah Diegu [Ijeoma Iloputaife], 1980).

epidermalization. Clearly many of the strategies explored in this essay can be understood as musical responses, sound-based responses, to a visual process, with implications that exceed the realm of the visual; but I would like to conclude by discussing some moments in L.A. Rebellion films that are particularly rich in their methods for restoring interiority.[35] These moments involve the depiction of violence and change—institutional, corporeal, psychic—and the differing musical strategies that attend these depictions: a pair of moments that contend with the psychological effects of institutional interference on the bodies of Black women in *African Woman, USA* and *Hidden Memories*; and the fracturing of time during moments of trauma and elation in *Ashes & Embers*. I hope, in these examples, to summarize some of the above discussion while pointing to potential future inquiries into the many functions of music in these films, in their focus on "the internal aspects of domination."[36]

I started this section with a discussion of *African Woman, USA* because it comprises several instances of epidermalization—the denial of interiority—and the representation of a woman reacting to violence: in this case, the rape of her daughter. Responding to the casual way in

which sexual violence is treated in the mainstream media, several films of the L.A. Rebellion depict the rape of children, notably *Bush Mama*. While *African Woman, USA* does not depict the rape itself as *Bush Mama* does, it uses music in a similar way to underscore the closing scene—in which the protagonist flees the crime scene, screaming "Again!" The frenzied saxophone in the background—John and Alice Coltrane's "Reverend King"—both fits the action and offers commentary on the brutality of the crime through its invocation of Dr. Martin Luther King Jr. and his advocacy of nonviolent action. The exclamation "Again!" though, suggests that this is not the first time the protagonist has dealt with rape. The sonic layering here, as in *Bush Mama*, serves to complicate the subjective experience of the protagonist.

Another somatic experience represented vis-à-vis sonic layering is abortion. In *Bush Mama*, for example, the first suite of Handel's *Water Music* is used to represent the European roots of the institutions that police Black women's bodies and sexuality (Dorothy has been told she must have an abortion if she wishes to continue receiving monetary assistance); meanwhile the crying of babies, slowly added to the mix in increasing volume, indexes the protagonist's growing anxiety with the situation. Gunshots are layered in as well, connecting the forced abortion to the police murder that a neighborhood girl had been protesting earlier in the film. Putting the two events together as the Handel continues to build, Dorothy flees the abortion clinic.

Hidden Memories, on the other hand, represents a woman who does go through with an abortion, depicting not so much the institutional forces but the choice the protagonist must make regarding her future: she gets the results of the pregnancy test ("positive," echoing over and over again) around the same time as she gets accepted into a journalism program. While the abortion itself is represented as very painful—heightened by the sudden addition of a synthesizer to the soundtrack—the project of the film focuses more on unearthing, as the title suggests, events that are submerged through time but continue to exert force. This theme is also communicated through the selection of Diana Ross's "Reflections" in the soundtrack, casting the mind as a mirror pointed toward the past. The cold, painful memory of the protagonist's past abortion is shown as existing within her happy present, again adding depth and a sense of interiority.

To conclude, I turn to a sequence from *Ashes & Embers* that can be read as a didactic ballad similar to "American Fruit," though it is, in

FIGURE 5.11. *Hidden Memories* (Dir. Jacqueline Frazier, 1977).

reality, a monologue accompanied by nondiegetic music, a voice emerging from the chaotic soundscape to impart knowledge to the protagonist Nay Charles. After berating Nay Charles for his escapist behavior ("Go on! Run! Escape! Go back to the movies!"), Jim tells him that he (Jim) has been watching and listening to "the man" and that Nay Charles should also listen, because "if you're listening like you say you are, you're learning!" Jim goes on to tell him that he should think of Paul Robeson who "fought the whole government by himself." The people "heard his beautiful, booming voice. It rang like a freedom bell." In this moment we have a churning convergence of politics, action, and music, all in the person of Paul Robeson, whom we will remember from Burnett's soundtrack for *Killer of Sheep*. Jim says, "When you have your trials, your tribulations, your troubles, think about him. It has been my strength, let him be yours, too." Again, music is presented as something to nourish and connect across great temporal and spatial distances.

Immediately, the music—"On the Nile" by the Charles Tolliver Big Band—that has been quietly supporting Jim's monologue, his oral transmission of knowledge to Nay Charles, snaps into focus in the foreground,

a blazing high note sounded on the trumpet, drawing implicit connections to the Pan-African struggles that consistently concerned Gerima. What follows is the most sonically ebullient sequence in the entire film; no longer a shattered and chaotic layering of urban and human sounds and music, the soundtrack takes on a kind of singular musical focus the audience has not yet experienced in *Ashes & Embers*. The piano actively traverses the entire keyboard, moving in strong and fluid patterns, while a full brass section triumphantly and steadily proclaims the simple four-note melody, supported by an equally full accompanying texture. This sound carries over into the next scene, in which Nay Charles attempts to get his roommate to think politically, implying that the mood associated with this epiphanic moment has now spilled over into other spaces in the narrative, an indication that Nay Charles is learning.

In these peak moments—depicting coming to consciousness, or the events that precipitate that coming to consciousness—music contributes to the revolutionary project of "capturing the truth" outlined by Solanas and Getino; it is an indispensible component. I hope this essay has demonstrated some of the ways in which filmmakers across genres in the L.A. Rebellion have used music in their films as part of this revolutionary project: the depathologization of Black music, the expansion of understandings of that category, the use of music and the lives of musicians in educational projects, and the use of music to redress the decades-long denial of cinematic subjectivity.

NOTES

1. Fernando Solanas and Octavio Getino, "Towards a Third Cinema: Notes and Experiences for the Development of a Cinema of Liberation in the Third World," in *New Latin American Cinema*, vol. 1, *Theory, Practices, and Transcontinental Articulations,* ed. Michael T. Martin (Detroit: Wayne State University Press, 1997), 45–46 (emphasis added).

2. Ibid., 45.

3. Ibid., 49.

4. See Tammy L. Kernodle, "'I Wish I Knew How It Would Feel to Be Free': Nina Simone and the Redefining of the Freedom Song of the 1960s," *Journal of the Society for American Music* 2, no. 3 (2008): 295–317.

5. Jonathan Sterne, ed., *The Sound Studies Reader* (New York: Routledge, 2012), 9.

6. Solanas and Getino, "Towards a Third Cinema," 46.

7. Sterne, *Sound Studies Reader,* 9.

8. Known variously as underscore, background music, and incidental music.

9. Julie Hubbert, "'Whatever Happened to Great Movie Music?': *Cinéma Vérité* and Hollywood Film Music of the Early 1970s," *American Music* 21, no. 2 (2003): 188.

10. "Film-Makers Have a Great Responsibility to Our People: An Interview with Ousmane Sembene," *Cinéaste* 6, no. 1 (1973): 29.

11. Hubbert, "'Whatever Happened to Great Movie Music?,'" 189.

12. Clyde Taylor, "New U.S. Black Cinema," *Jump Cut* 28 (April 1983): 46, www.ejumpcut.org/archive/onlinessays/JC28folder/NewBlackCinema.html.

13. For a full discussion of the history of "Black music" as a concept, see Ronald Radano, *Lying Up a Nation: Race and Black Music* (Chicago: University of Chicago Press, 2003).

14. Solanas and Getino, "Towards a Third Cinema," 45–46.

15. Benchley, quoted in Alice Maurice, "'Cinema at Its Source': Synchronizing Race and Sound in the Early Talkies," *Camera Obscura* 17, no. 49 (2002): 33.

16. Maurice, "'Cinema at Its Source,'" 32.

17. Ibid.

18. Ibid., 33.

19. Ronald Radano and Philip V. Bohlman, eds., *Music and the Racial Imagination* (Chicago: University of Chicago Press, 2000), 1.

20. Charles Merrell Berg, "Cinema Sings the Blues," *Cinema Journal* 17, no. 2 (1978): 7–8.

21. Daniel Widener, *Black Arts West: Culture and Struggle in Postwar Los Angeles* (Durham, NC: Duke University Press, 2010), 118.

22. For more on this, see Widener, "The Arms of Criticism: The Cultural Politics of Urban Insurgency," in *Black Arts West,* 187–220.

23. Hits from 1936 and 1940, respectively.

24. Jeff Smith, "Black Faces, White Voices: The Politics of Dubbing in *Carmen Jones,*" *Velvet Light Trap* 51 (Spring 2003): 31.

25. Kenneth Turan, "*Killer of Sheep* Is a Timeless Wonder: Three Decades after It Was Finished, the Drama Still Has the Power to Touch the Heart," *Los Angeles Times,* April 6, 2007.

26. Widener, *Black Arts West,* 119.

27. Cynthia Ann Young, *Soul Power: Culture, Radicalism, and the Making of a U.S. Third World Left* (Durham, NC: Duke University Press, 2006), 241.

28. "Stormy Weather" (Billie Holiday), "Don't Rain on My Parade" (Nancy Wilson), "In the Rain" (the Dramatics), "Everything Must Change" (Quincy Jones), "Rainy Days and Mondays" (Johnny Hartman), "Yesterday I Heard the Rain" (Dionne Warwick).

29. "One Big Unhappy Family" and "Café Regio's" (Isaac Hayes) and "Pusherman" and "Super Fly" (Curtis Mayfield).

30. Taylor, "New U.S. Black Cinema," 46.

31. Charles Johnson, *I Call Myself an Artist: Writings by and about Charles Johnson,* ed. Rudolph P. Byrd (Bloomington: Indiana University Press, 1999), 115.

32. Vivian Sobchack, *Carnal Thoughts: Embodiment and Moving Image Culture* (Berkeley: University of California Press, 2010), 198.

33. Johnson, *I Call Myself an Artist*, 117.
34. Ibid., 118.
35. See Samantha Sheppard's essay in this volume for a more in-depth discussion of interiority in these films.
36. Young, *Soul Power*, 214.

Struggles for the *Sign* in the Black Atlantic

Los Angeles Collective of Black Filmmakers

MICHAEL T. MARTIN

I am concerned with the reality of black people and our situation. Because not only does the black population not have its reality reflected in media—because we are not empowered to give expression to what we know and feel—but the larger audience and the larger public in this country are also not aware.

—Billy Woodberry

We think with words. To be able to think together, we have to first agree on the terms we use. . . . The importance of the word is determined by the space in which it is uttered and by the reason why it is uttered.

—Joseph Gaï Ramaka

I. ON THE FORMATION OF A CINEMATIC PRACTICE AND TRADITION

Forty years have elapsed since Black independent filmmakers in Los Angeles came to prominence, time enough to engage anew with hindsight and study the oeuvre of a distinctive association of filmmakers-in-training, raconteurs whose vision, reflexivity, and contributions to a second Black creative renaissance are remarkable—indeed legendary. My project for this essay is to perform a clearing exercise that parses this cinematic formation and illumines the *habitas* of its practice and enduring legacy to this day among veterans of the group. Revisiting the earliest works by three of

the group's best-known members—Charles Burnett, Julie Dash, and Haile Gerima—I seek to discern the depth and social relevance of their extraordinary work in real time and futurity and within the framework of what David C. Wall and I call *cine-memory*.[1] By *cine-memory*, we mean a conception of history as an active and dynamic process that speaks to the past and present as it mobilizes for and gestures Black futures.

However you consider this Los Angeles assemblage of nascent film-makers, you will find in the historiography of its formation and the evolution of Black independent cinema—if nothing else—material evidence of the filmmakers' enduring presence and, perhaps more important, an undeterred claim of agential authority. Collecting utterances, creative work, and the documentary record is to conceive an archive; constituting such a body of work, however, as Stuart Hall remarks, "represents a significant moment, on which we need to reflect with care. It occurs at that moment when a relatively random collection of work, whose movement appears simply to be propelled from one creative production to the next, is at the point of becoming something more ordered and considered: an object of reflection and debate."[2] For Hall, the embodiment of the archive marks closure of "a kind of creative innocence" and the start of self-awareness of an artistic movement in which "the whole apparatus of 'a history'—periods, key figures and works, tendencies, shifts, breaks, ruptures—slips silently into place."[3] And thanks to the interlocutors of this intellectually groundbreaking project and the intervention of the UCLA Film & Television Archive, what was once a collection of "dead works" is now a living archive-in-progress.

In its "heterogeneity," Hall further explains, "the multiplicity of discourses, not only of practice but of criticism, history and theory, of personal story, anecdote and biography, are the 'texts' which make the archive live."[4] Consider that one strand among such discourses concerns the branding of the group. What's in a name, self-referential or otherwise? The title of this essay—"Struggles for the *Sign* in the Black Atlantic: Los Angeles Collective of Black Filmmakers"—makes claim to a historical, transnational, and cultural activity less the reference, admittedly compelling, although ambiguous and contentious, to "L.A. Rebellion." As the editors of the volume discuss in their introduction, the designation is not unproblematic and, indeed, is consequential for conceptualizing the group and situating them in correspondence to parallel, yet distinctive, cultural and artistic movements of the period whose practices embodied shared ideological and political convictions. I prefer Ntongela Masilela's term, *L.A. School,* and in this essay use the less

precise *L.A. Collective* or *Collective.*[5] These designations point to a *tradition,* no less compelling and transformational than *rebellion* is revolutionary. By tradition, I mean an (artistic) heritage marked by particular thematic concerns, points of view, and stylistic sensibilities. Did the L.A. Collective constitute a movement, as *rebellion* suggests?[6] Arguably yes, absent programmatic enunciations or a declaration or two of a vision and mission notwithstanding. Yet, the term *collective* better suggests the ways in which the filmmakers are linked by organizing principles of a working practice, artistic sensibility, and politics tied to other and preceding Black and Third World oppositional practices and a corpus of creative work that activates cine-memory to recuperate the past and imagine Black futures.

. . .

The L.A. Collective responded to a long history of screen racism crystallized in American cinema in D. W. Griffith's epic of antebellum strife, *The Birth of a Nation* (1915). Griffith's genius was to elevate white supremacy to existential cause—immutable, insoluble, and permanent—and, in the drama of the historical epic that is *Birth,* to affirm patriarchy and white reign in the planter aristocracy and nascent industrial bourgeoisie. In a recent essay, Wall and I describe this national project in which Griffith was so invested as involving the creation of a racist regime of historical memory:

> *Birth,* notwithstanding its claims to reality and truth, is an egregious distortion of history whose purpose is not to offer an objective view of the South during the Civil War and Reconstruction but to socially, culturally, ideologically, and historically legitimize and valorize a racial hierarchy rooted in the presumption of white superiority. [. . .] *Birth* is fundamentally a film about memory. Indeed it relies upon the nature and function of memory to perform its emotive and seductive work. [. . .] It lays claim to a kind of racial memory intended to provide a shared, yet wholly personal experience of whiteness, one that would be immediately and intimately familiar and recognizable to its intended audience. In its strategic employment of character, narrative, and plot . . . the film labors to provide a collective memory, rooted not in nationality or region but in race.[7]

Griffith then, does two devilish things that signify the ideological project of *Birth:* First, he parses race, precipitated by the crisis of the Civil War and its aftermath, to fashion a Black social class, unlike that for whites and traces of which endure to this day in the cinematic and historical world. Second, he pivots the nation's renewal on the preservation of

white supremacy and patriarchy, despite disagreement between family members, because for Griffith the personal is inseparable from the familial, which is to say, the nation.

Against *Birth*, we find the long history of struggle to (re)inscribe Black Americans in the nation as subject peoples in the struggle for the *sign*—and a Black futurity. For the record, the L.A. Collective's lineage can be traced to the fraught "stillbirth" of *The Birth of a Race* (Dir. John W. Noble, 1918), a commercially and aesthetically failed attempt to answer Griffith's racist drama with redeeming representations of Black personages across history to the present. For film historian Marc Ferro, *The Birth of a Race* marks the "first historical *counter-film* in American cinema in which African Americans incarnate a new vision of history."[8] Consider, too, that from 1909 to 1948 more than 150 independent companies made, distributed, and exhibited "race movies," that distinctive aggregate of films with all-Black casts shown largely in segregated theaters. In the first half of the twentieth century, such films constituted by all manner of genre and to varying degree counterhistorical readings of the American experience—racinated. Moreover, comprised of a range of visual and narrative styles and artisanal practices, they anticipated—as they bore traces of—a Black American cinematic tradition.[9]

. . .

Where in this struggle is the L.A. Collective? Situating it is necessarily historical and invokes two parallel traditions. First, the Black radical tradition posits racism as a systemic practice that engenders inequality while legitimizing white privilege in virtually all sectors of American society: economy, culture, judiciary, education, and so on. That tradition's roots and iterations of resistance trace to slavery and colonialism, the Civil War and Reconstruction, the rise of the United States as imperial power at the close of the nineteenth century and during the aftermath of World War II, Jim Crow, and the emergence of transnational corporations under "late" capitalism. Within this tradition, variants of Pan-Africanism—Marxist and otherwise—cohere with Black internationalism and identify with similar formations in the African diaspora, as it gestures solidarity with decolonizing and postcolonial struggles in the global South.[10]

The other tradition is cinematic and features two formations, distinct yet imbricating ideologically informed practices. In the United States, after the "race movie" period described above, Black independent

cinema was comprised of at least two wings in the 1960s: the seminal documentary work by East Coast filmmakers, among them William Greaves, Madeline Anderson, and St. Clair Bourne; and, discovered in the Harvard Film Archive, the collaborative filmmaking initiatives between Larry Neal—a key figure in the Black Arts movement—and Amiri Baraka, Edward Spriggs, and James Hinton.[11] Both groups adhered to, if not enunciated, a defining ethos and cinematic practice affirming these imperatives: that "film must have utility and social purpose; it must endeavor to give voice to protagonists who otherwise are marginalized and silenced; and must resist and debunk the received notion that Black people are unable to manage their own affairs."[12] What registers here is not stylistic or aesthetic sensibility, but rather the social advocacy function and deployment of film on behalf of Black self-empowerment.

Such tenets resonate and broadly correspond with Third Cinema—that theorized and counterhistorical reading of hegemony and underdevelopment that evolved during the 1960s and early 1970s and that privileged the documentary as the cultural form and genre for struggle preferred by adherents, in contrast with the L.A. Collective's emphasis on narrative fiction. What can be said of this militant approach to cinema and filmmaking? In counterpoint to dominant paradigms of Hollywood and European "art" cinemas of a kind, Third Cinema labors to resist and challenge the ancien régime in its twentieth- and now twenty-first-century incarnations, along with the inequality and poverty they sustain. The early programmatic texts upon which Third Cinema is premised, and which some L.A. members read and endeavored to adhere to, are largely derived from Latin American theorist-filmmakers, who, Robert Stam has observed, searched "for production methods and a style appropriate to the economic conditions and political circumstances of the Third World."[13] For Julianne Burton, these texts were "written by filmmakers whose theoretical propositions derive from the concrete practice of attempting to make specific films under specific historical conditions," as—and it is important to emphasize—members of the L.A. Collective themselves tried to do.[14] And it is also important to specify and elaborate the key texts of this movement for, in no small measure, they were espoused and adopted, selectively, by members of the Collective.

Influenced by the Caribbean theorist Frantz Fanon, the foundational declarations of Third Cinema include Argentines Fernando Solanas and Octavio Getino's "Towards a Third Cinema" (1969), which calls for a

clandestine, subversive, "guerrilla," and "unfinished" cinema that radically counteracts the hegemony of Hollywood and European production and distribution practices. They conceive of cinema, especially in the documentary mode, as an instrument of social analysis, political action, and social transformation.[15] In *An Esthetic of Hunger* (1965), Glauber Rocha, a founder of the Cinema Novo movement in Brazil, inverts the social reality of underdevelopment and dependency into a signifier of resistance and transformation rendered by the oppressed through violence as authentic and empowering. Bolivian Jorge Sanjinés delineates in *Problems of Form and Content in Revolutionary Cinema* (1978) the thematics of recovery of identity, culture, and history in peasant communities and struggles. And the fourth major polemic of this movement engages with postrevolutionary concerns ten years into the Cuban revolution. Authored by Julio García Espinosa, *For an Imperfect Cinema* (1969) rejects the technical perfection of Hollywood and calls for "an authentically revolutionary artistic culture" where filmmaker and (active) spectator are co-authors engaging with the problems and struggles of ordinary people.[16]

Together, these claims, cast as polemical declarations, foreground an "active cinema for an active spectator" and constitute the social and ideological foundations of the New Latin American Cinema.[17] They also advance a conception of cinema as a transformational social practice that reflexively "incorporates in itself a discourse on its social and material conditions of production"[18] and what Tomás Gutiérrez Alea asserts is "genuinely and integrally revolutionary, active, stimulating, mobilizing, and—consequently—popular."[19] Eloquently summarized by Kim Dodge, the aesthetic and political project of Third Cinema is, above all, to interrogate "structures of power, particularly colonialism and its legacies"; contribute, at the cultural level, to the "liberation of the oppressed, whether this oppression is based on gender, class, race, religion, or ethnicity"; engage "questions of identity and community within nations and diaspora populations"; "dialogue with history to challenge previously held conceptions of the past, to demonstrate their legacies on the present, and to reveal the 'hidden' struggles of women, impoverished classes, indigenous groups, and minorities"; "challenge viewers to reflect on by the experience of poverty and subordination by showing how it is lived, not how it is imagined"; "facilitate interaction among intellectuals and the masses by using film for education and dialogue"; and "strive to recover and rearticulate the nation, using politics of inclusion and the ideas of the people to imagine new models and new possibilities."[20]

While Ana M. López cautions that these writings "signaled a naive belief in the camera's ability to record 'truths,'" members of the L.A. Collective were cognizant of and inspired by them and the transformational practice they implied.[21] Indeed, elements of this radical conception of cinema are demonstrably evident in the Collective's work, perhaps most notably in Haile Gerima's enduring, influential, and affecting films made during and after the UCLA period.

. . .

The L.A. Collective's gestation as a distinct formation occurred during the tumultuous decade of the 1960s, a period of political ferment in postwar America during which integrationist struggles for civil rights and nationalist strategies for self-determination gave rise to corresponding oppositional gestures of artistic practice and innovation for cultural renewal. As Masilela says, the intellectual and cultural commitments of the first "wave" or first cohort of the Collective were "inseparable from the political and social struggles and convulsions of the 1960s."[22] Their thematics and practice were shaped by the Black radical and Third Cinema traditions outlined above.

The L.A. Collective's cinematic corpus clusters along and is differentiated by several overlapping motifs. Together, both films and motifs intersect in unexpected and remarkably salient ways to reconstitute the Black subject. This includes (1) women's lived experiences, subjectivities, and agential authority;[23] (2) family and community histories;[24] (3) social consciousness, activism, and protest gestures;[25] (4) the project of recuperating the past;[26] and (5) personages and celebratory evocations of diasporic spirituality and folklore.[27]

To explore these themes, the Collective developed a radical stance concerning what their film education should entail. With economy and aplomb, Toni Cade Bambara distills the Collective's position toward their filmmaking practice, with important attention to issues of cultural history and memory.

Their views differed markedly with the school's [UCLA's] orientation:

- accountability to the community takes precedence over training for an industry that maligns and exploits, trivializes and invisibilizes Black people;
- the community, not the classroom, is the appropriate training grounds for producing relevant work;
- it is the destiny of our people(s) that concerns us, not self-indulgent assignments about neurotic preoccupations;

- our task is to reconstruct cultural memory not slavishly imitate white models;
- our task leads us to our own suppressed bodies of literature, lore, and history, not to the "classics" promoted by Eurocentric academia;
- students should have access to world film culture—African, Asian, and Latin America cinema—in addition to Hitchcock, Ford, and Renoir.[28]

These principles, stated by those who testified on the Collective's behalf, constituted the raison d'être of the Collective's mission and responsibility. Though derived from different sources and enunciated with different inflections by members of the group, such principles were constitutive of a shared oppositional practice evidenced and substantiated in the Collective's creative work, which I illustrate through close-ups on Charles Burnett, Julie Dash, and Haile Gerima in part 2 of this essay.

. . .

In contradistinction to Hollywood, and however varied the motifs, *all* filmmakers in the L.A. Collective deployed *cine-memory* to foreground and memorialize thematic concerns. Constituting a "form of repository or archive, memory recuperates, documents, and parses experience. It comprises images, sounds, meanings, gestures, and aural utterances" in order to illumine and critique the present in the past.[29] In this sense, the project of cine-memory is to parse lived experience and to interrogate domination, in order to imagine a futurity. Cine-memory comprises three classes of sign and corresponds to the Latin American programmatic texts of Third Cinema noted earlier, as well as Teshome H. Gabriel's three-stage model of cultural decolonization— "unqualified assimilation," "return to the source," and the "fighting or combative" phases, derived from Frantz Fanon's seminal account of the master/slave dialectic.[30]

Class 1 cine-memory, evidenced by a film like *The Birth of a Nation,* affirms received notions and discourses and the ideological assumptions of the audience, valorizing their beliefs and expectations. It portrays the hegemonic order as natural rather than as part of culture and economy. By rendering the past, it masks ideology that normalizes the "reality" it expresses. Events appear fixed, simplistically framed, and analytically wanting. Hollywood has pioneered this form of historical reconstruction by dehistoricizing events in both past and present. Trajectories of race, class, and gender are particularly elided by personalized depictions that distance, in fact remove, audiences from the processes and dynam-

ics of history. *Birth,* for example, naturalizes Black inferiority and the inevitability of Black subjugation under white rule.

Classes 2 and 3 of cine-memory, in contrast, are evident in the L.A. Collective's filmmaking. Class 2 cine-memory works to recuperate the past and in the service of renewal, identity, culture, and nation and infers comparisons between historical struggles. (As discussed below, Gerima best exemplifies this trajectory.) It labors to reconstitute the narratives of such struggles and transform how history and the present are read by audiences. Films of this ilk of cine-memory serve, as Tomás Gutiérrez Alea claimed before his death, "to deepen the understanding of our past and re-vindicate the best traditions of struggle."[31]

Class 3 cine-memory is the more complex of the three classes. Its purpose is to inspire activism in real time in the actual world. As such, memories foreground the future as indeterminate and work in a film's narration to transform consciousness and, in the tradition of Third Cinema, enable audiences to imagine outcomes of historical struggles in the project of world making.[32]

While the three classes of cine-memory are a feature of narration, classes 2 and 3 are essential to a radical-militant film practice because they destabilize and challenge normative readings of history and the social order. And, in varying ways, *all* L.A. Collective members have deployed such cine-memory in their work, among them the three filmmakers of the close-ups that follow.

II. CLOSE-UPS

In this part, I address key themes and how they were engaged in narrative terms by the L.A. Collective, as well as the political-theoretical assumptions that—particularly in the first cohort ("wave")—influenced and shaped the filmmakers' understanding of and relationship to Black and other communities of color in the United States and internationally. Recall the period of the Collective's formation during the late 1960s and early 1970s: a moment of political and cultural upheaval and indeterminacy in the United States and world affairs and, correspondingly, of artistic renewal and invention. Inspired by these transformations, the strategic deployment of cine-memory by some of these filmmakers was the means to recuperate the past, mobilize in the present, and gesture futurity.

To illustrate these concerns, what follows are "close-ups" of three members of the Collective—Charles Burnett, Julie Dash, and Haile Gerima. Burnett and Gerima are associated with the first cohort; Dash,

the second.[33] While distinctions—aesthetic, stylistic, and otherwise—merit consideration for understanding each cohort's evolution and differences, this is not a subject for elaboration here. However, between the two cohorts, several differences stand out: arguably, in the first, urban settings and working-class family dramas, and in the more schematic films, the relationship between systemic domination and insurgency, are apparent (consider Gerima's *Bush Mama* [1975], *Ashes & Embers* [1982], and Larry Clark's *As Above, So Below* [1973]); while in the second, films appear less didactic and confrontational. I choose these three filmmakers because during their training period, their work was influential, illustrating the defining themes that preoccupied members of the Collective and shaped the tradition associated with this grouping of filmmakers. The source films I discuss are their first student works, the Project One and Two (if extant) by each filmmaker and in particular their thesis projects. I ask two questions: Who is the protagonist and for whom does she/he speak? And what is the setting for and circumstance of the story? Personage/group and setting/circumstance constitute the factors in play. By *personage/group*, I mean the central characters in the narrative and for whom they signify at the group level (by gender, race, nationality, etc.). *Setting* suggests the physical space the characters inhabit (cityscape, pastoral environment) that evokes place in the story, while *circumstance* connotes the situation that drives the story. Through these factors protagonists are constituted, emblematic, and located in time and space, while calling attention to the filmmaker's concerns and politics. Considering these factors also renders discernable similarities between the films and filmmakers, flagging the traditions they elaborated and the cultural memory they mobilized in the service of reconstituting the Black subject.

Close-Up: Charles Burnett

As one of the pioneer members of the group, Charles Burnett's cinematographic formation crystalized and was honed, his style and aesthetic evolved, and his political convictions matured.[34]

Burnett's Project One film is untitled and not extant. In Allyson Nadia Field's overview of the Project One films of the Collective in this volume, she describes Burnett's offering this way: Shot on "a Bolex with a Switar lens, borrowed from his TA, using regular 8mm Kodak color film," the film's subtext is "interracial sex" and features the artist Michael Cummings, who, cast as a Black artist, "chokes his white nude

model after making love to her." Importantly, Field goes on to say that, along with *69 Pickup* (1969) by Thomas Penick—also a member of the Collective—both films "challenge white patriarchal norms, [yet] their acts of resistance actually serve to reinforce those same norms through a form of racialized misogyny."[35] To Burnett's credit, intelligence, and self-awareness, this backward position, articulated in writings by Eldridge Cleaver and others as revolutionary, was not repeated in films that followed, although a young white woman—as an object and measure of status between Black men—appears in Burnett's next film, *Several Friends* (1969).[36] We can see how in subsequent works he develops more nuanced strategies for reframing the kind of compliant construction of the past associated with class 1 cine-memory. That is, rather than employ such a seemingly crude rejection of interracial sexual taboos (in contrast to Griffith's version of Black-on-white rape), Burnett's next works ponder more deliberately and methodically how Black people have come to the stultifying stasis that marks their lives.

His first 16mm student film, *Several Friends* chronicles the quotidian experience of Black urban life in two movements; in each, the car stands as metaphor for both stasis and mobility. In the first movement, the opening scene depicts an unspoken and powerfully realized counterpoint, along a decrepit street, between a Black child and a Black inebriated soldier. One reading of this scene imagines the child's future in the soldier's hapless and vulnerable condition. The scene also alludes, by the child's seemingly unmoving affect, that such encounters are not uncommon in the neighborhood. Next follows a verbal exchange, replete with racial epithets, as four Black adults in a parked car muster coins to purchase wine from the liquor store down the street. The site of both scenes is presumably South Central Los Angeles, damning the Black community in a testimony of the physical and moral state of decay there. A fight breaks out between two drunken Black men before the liquor store. Observing, the woman in the car calmly says, "Hey, what they doing down there, fighting going on . . . I mean it's possible that something can done about it, you know . . . Yet and still I mean, if anything can be avoided, why not avoid it?" Consider what purchase the Black woman's proposed intervention immediately calls to mind: Why does she propose to intercede and not the Black men in the car?

The second movement transitions to a house in the neighborhood. A Black man sleeping on a couch is awakened by the arrival of the mother, also Black, of his two children, who walk off and out of the frame. The point made—he has family. The couple argues, as the music in the back-

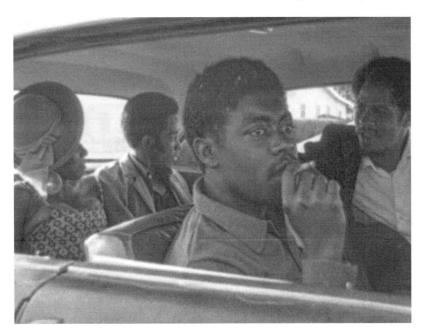

FIGURE 6.1. *Several Friends* (Dir. Charles Burnett, 1969).

ground attests to his affection for her. Cut to the preparation of chicken at the local butcher shop—a scene Burnett later refashions for the slaughterhouse in *Killer of Sheep* (1977). Cut back to the house, where the men converse as they repair a car propped on wooden crates in lieu of wheels and the woman is hanging clothes to dry. Another couple arrive—an interracial couple. The youthful white woman asks for and goes to the bathroom, while two men praise her companion's good fortune and new status. Cut to their departure, back to repairing the car, relocating the washing machine and other chores, and the arrival of another Black man and friend who urges them to prepare for that evening's tryst with other women. Together the film's two movements signify the impossibility of escape from the blight of the neighborhood and community. The car—mode of mobility—requires repair (endless repairs, and that is the point made clear by Burnett); and it is absent an essential part—the wheels—while in the house the banality of the everyday occurs, the characters transition to the fixed and ever-demanding maintenance work that signifies the stasis of their existence.

Burnett describes his Project Two film, *The Horse* (1973), as a "kind of allegory of the South."[37] The film is marked by counterpoint, as in

FIGURE 6.2. *Several Friends* (Dir. Charles Burnett, 1969).

Several Friends; a Black child caresses an old horse whose utility has passed, fated to be shot later in the day by the child's father, as four white men await his arrival in order to witness the execution. In a distinctive style, unlike the gritty realism of *Several Friends,* Burnett deploys camera, color film stock, voice, and the occasional punctuation of music in a pastoral setting to quietly, unobtrusively, and sparingly reveal the boy's agony, and the indifference of the men. This powerful, understated, and understudied, if at all critically studied, film merits a close reading—further still, an essay of its own.

Consider the opening scene, one Burnett would later refashion for *Namibia: The Struggle for Liberation* (2007), of a rural expanse, a boy (Will) beside a horse, an abandoned house in the background, each framed like a still yet moving photograph of three protagonists: boy, horse, setting. Cut to the arrival of the men. They exit the car in the heat, calmly reconnoiter the house, and claim space on what remains of the porch. Cut to the man prostrate on that porch, who tests his luck in a close-up when the descending pocketknife barely escapes his face; cut back to the horse and boy walking off in the direction of the windmill in the background, horse absorbing life from the trough, perhaps sens-

ing it will be his last gulp before death. Later the boy's father arrives. They embrace affectionately, affirming paternal ties unlike in *Several Friends*, which registers no notice of them. Cut to the gun, animated as it is taken from its sheath of paper and loaded by one of the men, not by the boy's father, which alludes to his complicity and maybe necessity but not choice in this matter. In the final scene, witness the boy close his eyes and cover his ears, awaiting the gun's discharge and the horse's death. In this profoundly haunting account, horse and father equate to a simple fact: their utility and service on behalf of whites, which Burnett alludes will be the boy's lot in manhood. In one reading suggested by the interface between the white men and Black father, mediated by the horse's pending death and death itself, Burnett points to the lesson that *all* Black youth must learn and endure—that life, like the story, is circumstantial and at best tentative.

These initial efforts to constitute a film style grounded in "home truths," and the community Burnett knows all too well by experience as unforgiving, are poignantly and sparingly realized in his thesis project and neorealist masterwork *Killer of Sheep*. A deeply meditative and haunting work of fiction, as it is haunted by the subject of its address— filmed in Watts, though the setting could be any urban space in America—the film testifies on behalf of a Black laboring class and lumpenproletariat who, displaced, hover in isolation and a debilitated community. *Killer* can be characterized as the Black American's encounter with collective trauma and "social death." And where intimacy and desire are negated, reduced to elemental forms of emotional and material subsistence, Stan and family endure without prospect. Burnett's frame is itself contained by the very material and spatial limitations exacted upon the lives of his characters. This he purposefully and dramatically revisits with damning effect through compelling scenes of children adrift in what passes for their playgrounds—alleys, abandoned and gutted buildings, a treeless savanna bounded by concrete. His approach is eminently neorealist and economical, like the lives of the characters he depicts, and is distinguished by a nonlinear narrative punctuated by surreality to underscore the alienation of the workplace. *Killer*'s realism is uncompromising. Indeed, the scopic regime of Burnett's intrusive and unforgiving camera captures starkly contrasting hues of Black and white, perfectly expressing the everyday lives of ordinary people in a setting not unlike that of a cityscape after the apocalypse, where the survivors have little other than themselves and their own ingenuity to rely on.

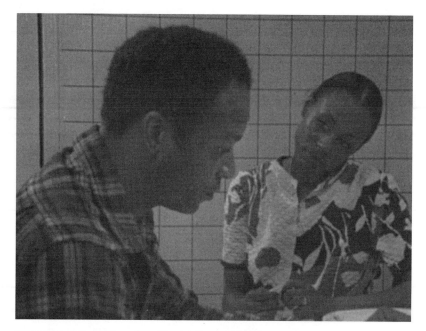

FIGURE 6.3. *Killer of Sheep* (Dir. Charles Burnett, 1977).

Stan is emblematic of Burnett's central concern: the Black working class who have been left to fend for themselves in a decayed and decaying postindustrial wasteland. As in real life, Stan, with whatever dignity he can still muster, parses the circumstance of near subsistence, along with his wife and children. Burnett then renders the Black family with his full consideration and without condescension as he displays the underbelly of urban America and all it portends for the Black laboring underclass: cement, debris, the alienating workplace of the production line in the slaughterhouse, the banality of each day, and the longing for something better that escapes them and will always and inevitably remain unattainable. In this regard, Burnett deploys class 2 cine-memory in a neorealist style to foreground the actuality and banality of community life and labor; to render visible and immediate, by gestures, spoken utterances, and the camera's intrusiveness, the disfigurement of Black urban life.

Close-Up: Julie Dash

Julie Dash, like other L.A. Collective members, consciously resisted the visual and narrative culture of Hollywood and, as Clyde Taylor puts it,

FIGURE 6.4. *Four Women* (Dir. Julie Dash, 1975).

portrayed Black women as having "an existence for themselves."[38] Unlike Burnett, she drew on her stock of class 2 cine-memory to recuperate Black women's pasts, enabling them to act on their own behalf while, not unlike Gerima, she also constituted such women as a spiritual and life-rendering force for renewal.

Dash's first three films made before and during the UCLA period illustrate this claim and are foundational to her sustained interrogation of Black women's lives and subjectivities. Beginning with *Four Women* (1975), set to jazz singer and composer Nina Simone's commanding evocation of slavery's legacy on Black women in the song of the same title, Dash renders and subverts as she signifies Black female archetypes. Casting the choreographer and dancer, Linda Young, who, like a chameleon, enacts each stereotype of Aunt Sarah, Safronia, Sweet Thing, and Peaches in cadence with the song's lament, Dash, like Simone, foregrounds the resilience, rape, miscegenation—and because of it, sexual commodification—and resolve, and bitterness that are Black women's, for want of a better word, bequeathal. The sound of flailing whips and the moans of a dispossessed people off-camera render in Young's

dance—at once poetic and haunting, beautifully choreographed and powerfully performed—the immorality, hypocrisy, and brutality of Western civilization. *Four Women* also stylistically foregrounds Dash's experiment with the aesthetic registers of movement, sound, and camera that she would later deploy with poetic and dramatic effect in her masterwork, *Daughters of the Dust* (1991), which without pause or conditions situates Black women at the epicenter of all manner of things past, present, and future.

For her Project One film, *The Diary of an African Nun* (1977), Dash set the story in Uganda, depicting the crisis of a nun whose declining fidelity to Christ is occasioned by solitude, cultural displacement, and disbelief. *Diary* is adapted from a short story by Alice Walker, and Dash's reasons for making the film are complex and revealing of the subtexts that inform the film. Among several motivations, Field notes that Dash was inspired by "the striking image of the nun's habit and a photograph [. . .] of several white women nuns surrounded by a group of Black children."[39] The "inner turmoil" of Walker's protagonist echoes that of other Black women figures in Dash's work, who are conflicted about serving white interests and how they lock the women into white-defined historical roles of servitude and invisibility.

For example, in Dash's thesis project, *Illusions* (1982), set during World War II in Hollywood, the protagonists, Mignon Dupree, a film executive passing for white, and Ester Jeeter, a Black singer dubbing for a white Hollywood star, render circumstance and reason for Dash's critique of white patriarchy in the Hollywood studio system. Engaging with the polemic of "passing" while affirming Black women's solidarity, *Illusions* foregrounds the centrality of women—Black women—in the narrative and visual frame, endowing them with agential authority from subject positions that the women can identify with and the rest of us believe in. Indeed, the film is an instructive refutation and counterpoint to Hollywood Black representations of both sexes over the preceding decade in Blaxploitation films.[40]

Close-Up: Haile Gerima

Unlike other veterans of the L.A. Collective who were unable to make many films, Haile Gerima's oeuvre is substantial for an independent Black African filmmaker. It is also deeply compelling, committed, and theorized and, in its address, consistently interrogative of Black peoples' dispossession and location in the world political economy. Born in

FIGURE 6.5. Production photograph of Lonette McKee as Mignon Dupree, *Illusions* (Dir. Julie Dash, 1982). Collection of Julie Dash.

Gondar, Ethiopia, Gerima has chronicled struggles in the Black Atlantic by time, location, and notably, gender. From his earliest films of the UCLA period to his most recent award-winning *Teza* (2008), as a "Third Worldist" Gerima debunks and lays waste to local and global narratives of domination. His project, unashamedly instructive, is without pretense the denunciation of all manner of inequality and the systemic causes of violence, racism, and patriarchy that beset African peoples on a world scale; Gerima calls for Black and other colored

communities to stand fast and resist. In this way, his films exemplify the transformative feature of class 3 cine-memory by calling for activism in real time. In my view, no other filmmaker in the Collective has emphasized and sustained the critique of domination as rigorously and without pause as Gerima, for which his reputation and standing among cineastes of political cinema are assured.[41]

Gerima's Project One film, *Hour Glass* (1971), sets forth the trajectory and purpose of his work to this day. *Hour Glass* posits a simple truth that the counterpart to college basketball in antiquity was manifest in Roman stadiums where men endured mortal combat for the pleasure and profit of others. Certainly, Gerima's analogy is not without precedent. "Bread and circus," as a strategy of domination and appropriation, takes many forms throughout history, and with this framing device and the revolutionary texts by Frantz Fanon and others, Gerima weaves a montage to raise a young Black male college basketball player's consciousness. The intersectionality of sports and the commodification of Black youth as raw material and cannon fodder are rendered immediate and compelling, as the player's deepening social awareness, suggested by the film's title, evokes the idea that social change follows in historical time.

Child of Resistance (1972), Gerima's Project Two film, is still more adamant and denunciatory than *Hour Glass*.[42] Experimental in its temporal and narrative registers and disjunctive editing, *Child* works, in the character of a Black woman imprisoned for her political convictions and activism, to condemn the "white man's world," asserts Alex James.[43] The film is set for the most part in a jail cell—and what can be more emblematic of Black dispossession?—with the audience "looking down on her as the camera pans back and forth from an uncomfortable distance; her eyes follow the camera's movement [. . .] with a chilling look of pure disdain. This feeling of disdain and anger is the mood that drives the entire film."[44] At the close of *Child,* the protagonist, speaking from deep within her person, implicates as she admonishes, "Wake up Black men. Wake up!" Here, too, Gerima's call is to Black men, but unlike in *Hour,* this project is a work of agitprop ostensibly to shame Black men to activism, and the means to do that is Black women, who themselves are at the vanguard of struggle.

Gerima's thesis project film, *Bush Mama* (1975), is no less an indictment of state policy and American racism than Burnett's take on the Black working class—anatomized and without prospect—or Dash's on Hollywood hegemony, Dupree's passing, and Jeeter's artistic appropri-

ation. Gerima theorizes a self-empowering alternative to the community's malaise by locating the community within global and colonizing formations. Gerima does not cast the individual as the protagonist of historical activity; rather it is in the circumstance of the individual that systemic levers of domination are revealed as signifiers for collective action. By situating Black Americans and other communities of color in correspondence to and in conversation with international historical struggles, Gerima renders these struggles within a larger global and civilizational frame. In *Bush Mama,* he evokes the U.S. war and occupation of Vietnam and the Angolan peoples' war of independence against Portuguese rule; he also references the Cuban revolution, which for many in the L.A. Collective was a source of inspiration, example, and solidarity.

In *Bush Mama,* Gerima's Black community is not a discrete site of poverty and decay. Rather it constitutes a distinctive formation—an internal colony—within the matrix of late twentieth-century global capitalism. And, too, the political status of inhabitants are more or less similar to other colonized peoples under corresponding conditions of dependency and underdevelopment in the global South. By gesturing a Third Worldist approach to and schema of underdevelopment and oppression, Gerima conjoins Marxist and Pan-African concepts that resonated with Black audiences at the time of *Bush Mama*'s release. In the character of Dorothy, we find the counterpart to Stan's wife in *Killer of Sheep* as well as a variant articulation of the historical subject of Burnett's and Gerima's mutual address—the Black working class and lumpenproletariat. Along with Gerima's theorizing of racial and class oppression, the practical in women's agency is manifested as both reproductive (biological) and political imperatives. This is evinced in the poster image of the Angolan mother/soldier who bears arms against the "Portuguese masters." The association between motherhood and nation personified by this iconic image at once affirms women's agency in historical struggles while it arguably feminizes the nation—the Black nation—a concern that I have raised elsewhere about *Sankofa* (1993).[45]

Moreover, unlike Burnett and Billy Woodberry (*Bless Their Little Hearts,* 1984), for whom the political evocation of women is less apparent, in the character of Dorothy, Gerima without condescension or whiff of patriarchy invites women of color to partake as equals in the strategically important task of formulating a collective way forward. And Dorothy's character suggests a nascent self-conscious militancy whose end game is the realization of personal and collective self-determination. In

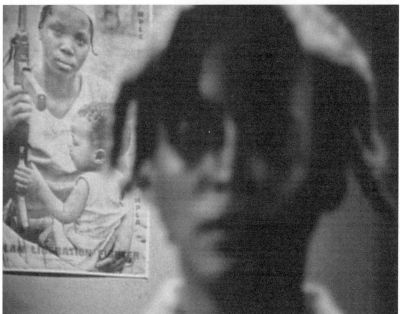

FIGURES 6.6. & 6.7. *Bush Mama* (Dir. Haile Gerima, 1975).

Bush Mama, then, Gerima's stance is without equivocation: women are at once mothers, lover-companions, and freedom fighters in the struggles ahead.

By positing America's ghettoes as internal colonies while challenging audiences to contemplate women's essential role in nation building, *Bush Mama* performs agitprop, as *Child of Resistance* does. By design, *Bush Mama*'s denunciations and claims work to reconstitute the Black subject, renew solidarity with other anticolonial formations in the African diaspora and global South, and engage with the project of world making in the United States. And as Gerima himself declared in 1983 at the Third Eye Symposium—On Third World Cinema, "This cinema must initiate the dialogue of change."[46]

. . .

Comparisons between Burnett, Dash, and Gerima are suggested by shared thematics evident between films. For example, one comparison concerns the encounter of Black Americans with modernity in urban sites, a modernity we wrongly associate with cosmopolitanism. In *Illusions,* the misrepresentation of history and the psychic toll on Black women "passing," as it were, to be heard in a white and paternal Hollywood studio system are central. Nearly a decade later in *Daughters of the Dust* (1991), Dash reframes the setting of Dupree's encounter with modernity by the crossing of the Peazant family from the Sea Islands to the mainland. This crossing is fraught with dangers that will test the fortunes and fate of the family in sites not unlike those in *Killer of Sheep* and *Bush Mama,* where predations await to rob them of their identities, along with their spirituality and folklore traditions, not to speak of their savings as well.

Class correspondences also appear in these films. Jeeter, the singer in *Illusions* who dubs for the white star, Leila Grant, is cast as a woman of modest education and means like the women characters in *Killer of Sheep* and *Bush Mama.* Dash's Dupree in *Illusions* is an exception, however; she is less constrained by the determinations of class and locale, though the gravitas of her life and circumstance is as compelling as the women's in *Killer of Sheep* and *Bush Mama.* And while their sexualities appear heterosexual (less so in *Illusions*), the women "act" in their self-interest and refute regressive discourses about Black women's identities and agency as these concepts were articulated in, say, Black Power discourses. In the arc of these portrayals, especially for Dash and Gerima and unlike for Burnett, Black women are the

purveyors of memory in whose agency the nexus, solidarity, and source for the reproduction of community are possible.

In the films discussed here, class 2 and 3 cine-memory work to refute held beliefs; substantiate and redress historical claims; "vindicate," as Gutiérrez Alea asserted, "the best traditions of struggle"; and invite audiences, in the tradition of Third Cinema, to conjure and narrate their own outcomes for historical struggles. Class 3 cine-memory is the project of world making and is most apparent among the three filmmakers in Gerima's work.

Burnett, Dash, and Gerima are among the L.A. Collective's most prominent and influential members. Their Project One, Two, and thesis films provide a means by which to understand the Collective's originary orientations, motivations, aesthetic concerns, and practice. Their films also express the core themes and trajectories of a self-conscious and evolving cinema that challenges hegemonic discourses and cinematic readings of Black subjectivity and life in America. Dash's "Afrofemcentric" orientation traces to *Four Women* and *The Diary of an African Nun* and, validating Black women and their representation in the narrative and visual frames, continues to drive and sustain her work to this day. For Burnett and Gerima, their address is engaged broadly through the trope of the Black family—for Gerima, the global African family—constituted by laboring peoples and community. Following *Killer of Sheep,* Burnett continued to mine the Black family and community in *My Brother's Wedding* (1983) and *To Sleep with Anger* (1990); more recently he has turned to the historical in world affairs with *Namibia: The Struggle for Liberation* (2007) and his in-development biopic on Algerian Abd El Kader.[47] More schematic than the others, Gerima deploys a transnational frame, associating, as noted earlier, the plight and underdevelopment of Black Americans with that of other diasporic and colonized people. Returning to his native land in his most recent film, Gerima engages with the themes of exile and displacement in the seemingly self-referential drama *Teza* (2008).[48]

. . .

What to say then of the L.A. Collective? The group was an iteration of Black independent filmmaking evolving parallel to and in real time with the East Coast, especially Boston and New York documentary formations (i.e., *Say Brother* [1968–82], *Inside Bedford-Stuyvesant* [1968–71], *Black Journal* [1968–70]) and Black Arts movement film initiatives.[49] Its members were inspired by Black pioneers of the "race movies"

era and partial to the project of Third Cinema while being ever mindful and expressive of the Black radical tradition. They were no less denunciatory of American complicity in all manner of racism and global capitalism than Third Worldist theorist-filmmakers were and are of the colonial and neocolonial project and continuing North/South antinomy. Absent a manifesto of their own, yet determined to resist Hollywood's conventions, its promotion of Blaxploitation and its popular appeal,[50] as well as its commanding cultural dominance internationally, the L.A. Collective contested representations, especially of Black masculinity and Black women's agency, along with (but less so) those of Black sexuality pervasive in popular culture.[51] As such, these filmmakers challenged ensconced and widely held accounts of Black identity and normativity.

And not to forget, albeit largely unremarked, they conversed (perhaps unknowingly?) with exilic and diasporic cinema, that emerging trajectory and international movement of filmmaking engaged with transnational migration, postcolonial and "minoritarian" subjectivities, and the émigré experience constituted and refracted in gendered and racialized narratives—what Hamid Naficy refers to in his seminal study of such films as "accented cinema."[52] Certainly Gerima's *Teza* fits the bill and, to a lesser extent, so does *Sankofa*, with its focus on identities defaced in the New World by slavery, Western modernity, and the imperatives of modern capitalism. A case, too, can be made for Dash's *Daughters of the Dust*, where the specter of the city awaits the descendants of slaves embarking en mass to the mainland. In this sense, the migration and circulation of peoples, cultures, and traditions, displaced and displacing—all that distinguishes a people from their host societies, in which faces signify difference and serve as passports—are the stuff of the Black Atlantic, past, present, and becoming.

In sum, was the L.A. group a collective, or movement, or rebellion, or motley assemblage of would-be filmmakers? With certainty, in our time and epoch, the L.A. Collective constituted one such artistic and compelling substantiation of a defining cultural struggle for the *sign* in the Black Atlantic and to whom we are—in historical terms—indebted.

NOTES

A shorter version of this essay was presented at the symposium "L.A. Rebellion: Creating a New Black Cinema," UCLA Film & Television Archive, Billy Wilder Theater, Los Angeles, November 12, 2011. I am indebted to Allyson Nadia

Field and Jacqueline Stewart for convening this timely and long overdue engagement with this collective of filmmakers and further to Stewart for useful suggestions in preparation of earlier drafts of this essay. The epigraphs are from Billy Woodberry, "Billy Woodberry: At a Certain Point, I Wanted to Make Films. To Try," interview, *Black Film Review* 1, no. 4 (1985): 14; and Michael T. Martin, "Joseph Gaï Ramaka: 'I Am Not a Filmmaker *Engagé*. I Am an Ordinary Citizen *Engagé*,'" *Research in African Literatures* 40, no. 3 (2009): 213.

1. This futurity is now witnessed in the present of the "Black Radical Imagination"—a collection of contemporary media works that CCH Pounder describes as "a carefully selected body of work inquiring and responding to what it means to be black in the 21st century." Sergio Mims, "Black Radical Imagination Screening Series Comes to REDCAT in L.A. Next Month, 10/7," *Shadow and Act,* September 13, 2013, http://blogs.indiewire.com/shadowandact/black-radical-imagination-screening-series-comes-to-redcat-in-la-next-month-10-7.

2. Stuart Hall, "Constituting an Archive," *Third Text* 15, no. 54 (2001): 89.

3. Ibid., 89.

4. Ibid., 92.

5. See Ntongela Masilela, "The Los Angeles School of Black Filmmakers," in *Black American Cinema,* ed. Manthia Diawara (New York: Routledge, 1993), 109. Kara Keeling notes, "There is disagreement among the LA Rebellion filmmakers themselves and among the scholars engaged with their work, about the aims, strategies, purview, and even the name of the movement, and there are those who question whether this diverse group actually constitutes a movement per se." See her "School of Life," *Artforum International* 50, no. 2 (October 2011): 294. The L.A. Rebellion moniker was first coined by Clyde Taylor for historical and aesthetic concerns (see his "L.A. Rebellion: New Spirit in American Film," *Black Film Review* 2, no. 2 [1986]: 11, 29), but what matters is whether the group constituted a movement. If so, what kind of movement and in relation to what other formations of cultural production and protest?

6. Collectives, including artistic ones, do not necessarily cohere along a particular mission or objective. They also work as loosely knit associations of shared interests, friendships, and motivations—common and individual—as Allyson Nadia Field suggests for the L.A. group. See her "Rebellious Unlearning: UCLA Project One Films (1967–1978)" in this volume.

7. Michael T. Martin and David C. Wall, "The Politics of Cine-Memory: Signifying Slavery in the History Film," in *A Companion to the Historical Film,* ed. Robert A. Rosenstone and Constantin Parvulescu (Malden, MA: Wiley-Blackwell, 2013), 446–47.

8. Marc Ferro, *Cinema and History* (Detroit: Wayne State University Press, 1988), 152. For the backstory to the film, see Thomas Cripps, *Slow Fade to Black* (New York: Oxford University Press, 1993), 70–76 (emphasis added).

9. Pioneers Oscar Micheaux (Micheaux Picture Corporation) and George and Noble Johnson (Lincoln Motion Picture Company), among others, are in this tradition.

10. For an overview, see Cynthia A. Young, *Soul Power: Culture, Radicalism, and the Making of a U.S. Third World Left* (Durham, NC: Duke University

Press, 2006); Cedric J. Robinson, *Black Marxism: The Making of the Black Radical Tradition* (1983; Chapel Hill: University of North Carolina Press, 2000); Penny M. Von Eschen, *Race against Empire: Black Americans and Anticolonialism, 1937–1957* (Ithaca, NY: Cornell University Press, 1997); Thomas Borstelmann, *The Cold War and the Color Line* (Cambridge, MA: Harvard University Press, 2001); Michael C. Dawson, *Black Visions: The Roots of Contemporary African-American Political Ideologies* (Chicago: University of Chicago Press, 2001); Harry Haywood, *Negro Liberation* (New York: International Publishers, 1948); Anthony Dawahare, *Nationalism, Marxism, and African American Literature between the Wars* (Jackson: University of Mississippi Press, 2003); and Michael C. Dawson, *Blacks in and out of the Left* (Cambridge, MA: Harvard University Press, 2013).

11. See Lars Lierow, "The 'Black Man's Vision of the World': Rediscovering Black Arts Filmmaking and the Struggle for a Black Cinematic Aesthetic," *Black Camera* 4, no. 2 (2013): 3–21. While some members of the L.A. Collective and Black Arts movement were aware of each other's existence and perhaps production, I am unable to discern the extent of such awareness or the influence each movement had on the other, if any.

12. While I am referring to Madeline Anderson in the specific, these tenets were shared by the other filmmakers. See Michael T. Martin, "Madeline Anderson in Conversation: Pioneering an African American Documentary Tradition," *Black Camera* 5, no. 1 (2013): 73–74.

13. Robert Stam, "College Course File: Third World Cinema," *Journal of Film and Video* 36, no. 4 (Fall 1984): 50–61.

14. Julianne Burton, "Marginal Cinemas and Mainstream Critical Theory," *Screen* 26, nos. 3/4 (1985): 4.

15. Consider Peter Rist's essay, "The Documentary Impulse and Third Cinema Theory in Latin America: An Introduction," *CineAction* 18 (1989): 60–61.

16. Michael T. Martin, ed., *New Latin American Cinema*, vol. 1, *Theory, Practices, and Transcontinental Articulations* (Detroit: Wayne State University Press, 1997), 76.

17. See my two-volume collection, Michael T. Martin, ed., *New Latin American Cinema*, vol. 1, *Theory, Practices, and Transcontinental Articulations*, and vol. 2, *Studies of National Cinemas* (Detroit: Wayne State University Press, 1997). For debates about Third Cinema, see Jim Pines and Paul Willemen, eds., *Questions of Third Cinema* (London: British Film Institute, 1989); Mike Wayne, *Political Film: The Dialects of Third Cinema* (London: Pluto Press, 2001); Anthony R. Guneratne and Wimal Dissanayake, eds., *Rethinking Third Cinema* (London: Routledge, 2003); Michael Wayne, "The Critical Practice and Dialectics of Third Cinema," *Third Text* 14, no. 52 (2000): 53–66; and Nicola Marzano, "Third Cinema Today," *Offscreen* 13, no. 6 (2009): 1–18.

18. Rist, "Documentary Impulse," 61.

19. Tomás Gutiérrez Alea, *The Viewer's Dialectic* (Havana: Jose Marti Publishing House, 1988), 18.

20. Kim Dodge, "What Is Third Cinema?," 2007, http://thirdcinema.blueskylimit.com/thirdcinema.html.

21. Ana M. López, "At the Limits of Documentary: Hypertextual Transformation and the New Latin American Cinema," in *The Social Documentary in Latin America*, ed. Julianne Burton (Pittsburgh: University of Pittsburgh Press, 1990), 407.

22. Masilela, "Los Angeles School of Black Filmmakers," 107.

23. Consider Zeinabu irene Davis's *Cycles* (1989), *A Period Piece* (1991), and *Compensation* (1999); Alile Sharon Larkin's *The Kitchen* (1975) and *A Different Image* (1982); Barbara McCullough's *Water Ritual #1: An Urban Rite of Purification* (1979); O.Funmilayo Makarah's *Define* (1988); Julie Dash's early projects, *Four Women* (1975) and *The Diary of an African Nun* (1977), and her thesis film, *Illusions* (1982), followed post-UCLA by her masterwork, *Daughters of the Dust* (1991), and *The Rosa Parks Story* (2002); Haile Gerima's, *Child of Resistance* (1972); and Bernard Nicolas's *Daydream Therapy* (1977).

24. Charles Burnett's first student project, *Several Friends* (1969), also *The Horse* (1973), his landmark thesis project, *Killer of Sheep* (1977), and *When It Rains* (1995), *My Brother's Wedding* (1983), and *To Sleep with Anger* (1990); Haile Gerima's no less compelling thesis project, *Bush Mama* (1975); Billy Woodberry's second film, *The Pocketbook* (1980), and *Bless Their Little Hearts* (1984), examples of Black realism at its best. Others include Jamaa Fanaka's *Emma Mae* (1976) and *Penitentiary* (1979), the latter a prison metaphor for Black life and community; Alile Sharon Larkin's *Your Children Come Back to You* (1979); Carroll Parrott Blue's *The Dawn at My Back: Memoir of a Black Texas Upbringing* (2003); Jacqueline Frazier's *Shipley Street* (1981); S. Torriano Berry's *Rich* (1982); Shirikiana Aina's *Brick by Brick* (1982); and Larry Clark's western and second feature, *Cutting Horse* (2002).

25. Haile Gerima's Project One, *Hour Glass* (1971); *Child of Resistance* (1972); thesis project, *Bush Mama* (1975); and in the post-UCLA period, his first feature, *Harvest: 3,000 Years* (1976); and *Ashes & Embers* (1982). Also Larry Clark's *Tamu* (1970) and *As Above, So Below* (1973); Gay Abel-Bey's *Fragrance* (1991); Shirikiana Aina's *Brick by Brick* (1982); Melvonna Ballenger's *Rain (Nyesha)* (1978); Bernard Nicolas's *Gidget Meets Hondo* (1980); and O.Funmilayo Makarah's *Apple Pie* (1975).

26. Dash's *Illusions* (1982), which resonates with Iverson White's *Dark Exodus* (1985), a meditation on racial violence and migration in America, and *The Rosa Parks Story* (2002); Haile Gerima's *Sankofa* (1993), a powerful albeit flawed indictment of slavery and reconstitution of the black subject; and Charles Burnett's *Selma, Lord, Selma* (1999).

27. Among them, Haile Gerima's *After Winter: Sterling Brown* (1985); Ben Caldwell's *Babylon Is Falling* (1983) and *I & I: An African Allegory* (1979); Don Amis's *Festival of Mask* (1982); Larry Clark's *Passing Through* (1977); Carroll Parrott Blue's *Varnette's World: A Study of a Young Artist* (1979); Zeinabu irene Davis's *Trumpetistically, Clora Bryant* (1989); O.Funmilayo Makarah's *Creating a Different Image: Portrait of Alile Sharon Larkin* (1989); Barbara McCullough's *Shopping Bag Spirits and Freeway Fetishes* (1981); Elyseo J. Taylor's, *Black Art, Black Artists* (1971); and Charles Burnett's *To Sleep with Anger* (1990).

28. See Toni Cade Bambara's delineation of the group's orientation in "Reading the Signs, Empowering the Eye: *Daughters of the Dust* and the Black Independent Cinema Movement," in *Black American Cinema,* ed. Manthia Diawara (New York: Routledge, 1993), 119.

29. Martin and Wall, "Politics of Cine-Memory," 450.

30. See Frantz Fanon, "Racism and Culture," *Presénce Africaine,* nos. 8/9/10 (1956): 15–18; and Teshome H. Gabriel, *Third Cinema in the Third World: The Aesthetics of Liberation* (Ann Arbor, MI: UMI Research Press, 1982), 7.

31. Gerardo Chijona, "Gutiérrez Alea: An Interview," *Framework* (England) 10 (1979): 29.

32. For elaboration, see Martin and Wall, "Politics of Cine-Memory," 445–67.

33. Although Dash is associated with the second cohort, recall that she completed two films before her thesis project, *Illusions* (1982): *Four Women* (1975) and *The Diary of an African Nun* (1977).

34. For an overview of Burnett's formation, aesthetics, and practice, see Charles Burnett, "Interview: Charles Burnett—Consummate Cinéaste," by Michael T. Martin and Eileen Julien, *Black Camera* 1, no. 1 (Winter 2009): 143–70.

35. Field describes *69 Pickup* as a story "about two Black men who pick up a white woman and then rob, sexually assault, and beat her." See Field's "Rebellious Unlearning" in this volume.

36. See Eldridge Cleaver, *Soul on Ice* (New York: Dell, 1968).

37. Allyson Nadia Field, Jan-Christopher Horak, Shannon Kelley, and Jacqueline Stewart, *L.A. Rebellion: Creating a New Black Cinema* (Los Angeles: UCLA Film & Television Archive, 2011), 29.

38. Taylor, "L.A. Rebellion," 29.

39. See Field's "Rebellious Unlearning" in this volume.

40. *Illusions* achieved acclaim, including awards from the Black American Cinema Society in 1985 and the jury prize for best film from the Black Filmmakers Foundation in 1989.

41. I am not uncritical of Gerima's work. See Michael T. Martin, "Podium for the Truth? Reading Slavery and the Neocolonial Project in the Historical Film: *Queimada! (Burn!)* and *Sankofa* in Counterpoint," *Third Text* 23, no. 6 (2009): 717–31.

42. In her essay in this volume, "Rebellious Unlearning," Field notes that *Child of Resistance* was inspired by Gerima's dream after witnessing Angela Davis handcuffed on television. See also this volume's oral history section and Haile Gerima, oral history interview by Jacqueline Stewart, Allyson Field, Jan-Christopher Horak, and Zeinabu irene Davis, September 13, 2010, LAROH.

43. Alex James, "LA Rebellion ATL Tour Review: Haile Gerima's *Child of Resistance,*" *Shadow and Action,* December 5, 2013, http://blogs.indiewire.com/shadowandact/la-rebellion-atl-tour-review-haile-gerimas-child-of-resistance.

44. Ibid.

45. See Martin, "Podium for the Truth?," 724.

46. See Haile Gerima, "Afro-American Cinema," in *Third Eye: Struggle for Black and Third World Cinema,* ed. Greater London Council Race Equality Unit (London: GLC Race Equality Unit, 1986), 22.

47. See Tambay A. Obenson, "Charles Burnett Heading to Algeria to Direct Biopic on Algeria's Greatest Hero, Abd El Kader," *Shadow and Action,* September 9, 2013, http://blogs.indiewire.com/shadowandact/charles-burnett-is-heading-to-algeria-to-direct-biopic-on-algerias-greatest-hero-abd-el-kader.

48. See the recent close-up on *Teza,* guest edited by Greg Thomas, *Black Camera* 4, no. 2 (2013): 38–162; see page 48 for Gerima's identification with the character Anberber as displaced immigrant.

49. See Devorah Heitner's study of Black public-affairs television, *Black Power TV* (Durham, NC: Duke University Press, 2013), and my interview with Madeline Anderson about *Black Journal,* Martin, "Madeline Anderson in Conversation," 82–86.

50. An exception, asserts Field in her essay in this volume, was Jamaa Fanaka, criticized for "embracing aspects of exploitation cinema that put him at odds with many of his classmates."

51. For comparisons, consider Matthew Henry's take on recycled iterations of black masculinity in the "hood" films of the 1990s. See his "He Is a 'Bad Mother*S%@!#': *Shaft* and Contemporary Black Masculinity," *Journal of Popular Film and Television* 30, no. 2 (2002): 114–19.

52. Hamid Naficy, *An Accented Cinema: Exilic and Diasporic Filmmaking* (Princeton, NJ: Princeton University Press, 2001).

Bruising Moments

Affect and the L.A. Rebellion

SAMANTHA N. SHEPPARD

Discussing L.A. Rebellion filmmaker Julie Dash's film, writer Greg Tate explains, "I've seen *Daughters of the Dust* [1991] eleven times, fought back tears at every screening, and lost the fight each time. What makes me weep are not plot points or the travails of individual characters, but *those bruising moments* that brush up against the black historical tragedy."[1] The "bruising moments" that Tate describes are those emotionally charged scenes that reflect cultural memories and narratives specific to African American lived experiences. For example, Tate recalls the scene where a pleading Nana Peazant (Cora Lee Day) tells her great-grandson Eli (Adisa Anderson) that when the family crosses over to the mainland, they "ain't going to no land of milk and honey."[2] This moment conjures up the reality of the false promises of a better life for Black people who migrated north in search of more opportunity and a less racially hostile environment only to find that struggles awaited them in these new urban spaces. Tate contends that this moment, along with many others in Dash's film, is powerful because it reveals "the historical subtext behind black people's surface emotions."[3] Moreover, Tate explains,

> As it echoes through the past, *Daughters* echoes around our chilly bones. Julie Dash's film works on our emotions in ways that have less to do with what happens in the plot than with the ways the characters personalize the broader traumas, triumphs, tragedies and anxieties peculiar to the African American experience. When Yellow Mary speaks of "fixing the titty" so that

she can no longer be surrogate mother to her white infant charges, or of being sent home by the employers holding her captive like a slave, we are made to feel not just Yellow Mary's pain and anger but the psychic scars inflicted on African people since the slave trade began.[4]

Tate's description demonstrates, as Sara Ahmed explains, that "emotions do things," meaning they "mediate the relationship between the psychic and the social, and between the individual and the collective."[5] Dash's film "works on our emotions" in that we are able to *feel* Yellow Mary's (Barbara O. Jones) individualized, emotional pain as attached to and exceeding the diegesis, transforming it from her own embodied experience to that of a shared sociopsychic Black experience. Furthermore, Tate's example of this bruising moment highlights how emotions circulate from the screen to the spectator through the politics of representation—individual characters personalizing broader narratives specific to Black people's experiences—as a way to bind people, specifically Black communities, together through a sense of shared sociocultural history.

Toni Cade Bambara calls *Daughters of the Dust* "the maturation of the L.A. Rebellion agenda," a schema that included being accountable to Black communities while working in such communities; focusing on the lives of Black people—particularly those in working-class communities—in order to reconstruct cultural memory; and the filmmakers' educating themselves in the cinematic and ideological practices of world film culture, specifically that of African, Asian, and Latin American cinemas.[6] L.A. Rebellion filmmakers' styles and influences ranged from the experimental and avant-garde (Barbara McCullough's *Water Ritual #1: An Urban Rite of Purification* [1979]; Ben Caldwell's *Medea* [1973], *I & I: An African Allegory* [1979]), to British documentary and Italian neorealism (Charles Burnett's *Killer of Sheep* [1977], Billy Woodberry's *Bless Their Little Hearts* [1984]), to Black feminism (Alile Sharon Larkin's *A Different Image* [1982]; Julie Dash's *Four Women* [1975], *Daughters of the Dust*), to Blaxploitation (Jamaa Fanaka's *Welcome Home, Brother Charles* [1975], *Penitentiary* [1979]), to jazz (Larry Clark's *Passing Through* [1977], Zeinabu irene Davis's *Trumpetistically, Clora Bryant* [1989]), and to Third Cinema politics and aesthetics typified in revolutionary Cuban documentary and Brazilian Cinema Novo (Haile Gerima's *Hour Glass* [1971], *Child of Resistance* [1972], *Bush Mama* [1975]). Though these filmmakers work in different modes, Bambara identifies an overarching thematic emphasis on family, women,

history, and folklore as a mark of L.A. Rebellion cinematic practice.[7] With *Daughters of the Dust* as a cresting example of the L.A. Rebellion agenda, and Tate's attention to the film's emotional registers, Dash's film provides a critical entry point into exploring the bruising moments—emotionally charged scenes that reflect and underscore broader narratives specific to Black communities—in other L.A. Rebellion films that share similar themes of family, women, history, or folklore.

As such, this essay explores the complex role of affect, specifically the embodiment and display of emotions and feelings in L.A. Rebellion films. Affects are abstract. They function as a type of "a non-conscious experience of intensity; [affects are] a moment of unformed and unstructured potential."[8] While the terms *emotions* and *feelings* are often used synonymously in place of *affects,* emotions represent a specific kind of affect. Emotions are the expression of affect through the projection and display of a feeling.[9] A critical focus on affects "draws attention to the body and emotions" and illuminates our "power to affect the world around us and our power to be affected by it, along with the relationship between these two powers."[10] Since emotions are social, Patricia Clough explains that affects are a way to "grasp the changes that constitute the social and to explore them as changes in ourselves, circulating through our bodies, our subjectivities, yet irreducible to the individual, the personal, or the psychological."[11] Therefore, this essay makes use of affect theory in order to understand how, in L.A. Rebellion films, emotions and feelings provide a way to analyze how characters personalize, as Tate suggests, the broader traumas, triumphs, tragedies, and anxieties peculiar to African American lived experiences.

For example, Charles Burnett's meditation on working-class Black life, *Killer of Sheep,* depicts a bruising moment in the languid dancing scene between Stan (Henry Sanders) and his wife (Kaycee Moore). The scene is scored to Dinah Washington's "This Bitter Earth," and both the song and the scene's scorching and freezing moments do not signify a vacuous intimacy between the two but an embodied dissonance of emotive reciprocity. In the scene, Stan, naked from the waist up, is hardened to his wife as the two dance in small circles. His wife grips his back passionately and, yet, he does not react. As she contours his hands around her, kissing his body, his face stares off blankly with an absent expression. Finally, when the song ends, as his wife's ardent kisses increase, Stan pushes her away and leaves. In this moment, Stan is not emotionless but disaffected toward his passionate wife's desire. As Ahmed explains, "Hardness is not the absence of emotion, but a different emotional

FIGURE 7.1. *Killer of Sheep* (Dir. Charles Burnett, 1977).

orientation towards others."[12] Therefore, with his naked back and torso exposed, Stan's outward hardness reflects his own interiority, disconnected not only from his wife but also from the world around him. As he reacts to her intensity, Stan's stoic and emotionally estranged behavior signifies his feelings of having no real, positive impact on his environment. In this sense, Stan's feeling of alienation represents a personalization of the broader economic and historical crisis in Watts during this time. As Cynthia Young describes, "Watts stands in for a larger set of effects across black America. Even after the civil rights movement, black people cannot help but recognize their alien and alienated status, must understand that their citizenship is defined by restriction rather than the freedom."[13] Stan's feelings of alienation and pessimism are represented and circulated through his hardened body and not only reflect the realities of his alienating work and home life but constitute changes in the social world for Blacks that go beyond the individual, the personal, and the psychological.

As this example demonstrates, my focus on affect explores how L.A. Rebellion filmmakers were deeply invested in representing not only the external milieu of Black communities, which Young describes as a

"depiction of urban communities as internal colonies," but also Black interiority, specifically how and why Black people feel the way they feel about the spaces and places they inhabit and navigate.[14] A focus on affect allows for critical attention to be given to study how emotion becomes embodied. Thus I suggest that, while their formal practices varied as much as their radical politics, one way in which L.A. Rebellion filmmakers' commonality in representational strategies and cinematic practices is evinced is through their shared practice of providing, as Tate describes of Dash's *Daughters of the Dust,* subtext behind the representation of Black people's surface emotions.

To illustrate this shared practice, I turn to Billy Woodberry's *Bless Their Little Hearts* (1984), Bernard Nicolas's *Daydream Therapy* (1977), and Zeinabu irene Davis's *Cycles* (1989) as case studies, using these diverse stylistic examples to examine affect through narratives of embodiment as a means to investigate the subtext behind representations of Black people's surface emotions. In these films, I locate bruising moments, those emotionally powerful scenes that reflect and underscore broader sociopsychic narratives and experiences specific to Black communities. At the end of my textual analysis, I return to Tate's description of how *Daughters of the Dust* "works on our emotions" to consider affect's relationship to spectatorship. I argue that L.A. Rebellion films' attention to emotions works to align Black audiences into what Lauren Berlant describes as an "intimate public" that is emotionally literate about each other's experiences.[15] In studying the representation of affect as well as the processes of spectatorial affect, I contend that L.A. Rebellion films are about the power to affect and be affected by the rendering of Black emotional experiences, which have been either disavowed or marginalized within dominant cinema's on-screen representations of Black people.

L.A. Rebellion films are not merely reactions to Hollywood depictions of Black people but rejections of Hollywood practices that flatten out Black characters and marginalize their experiences. As their namesake suggests, these filmmakers were rebelling against hegemonic constructions of Black male and female lives. L.A. Rebellion filmmakers sought to fill in, to borrow Ed Guerrero's phrasing, "the empty space in representation" that Hollywood had created in its construction of Black people as one-dimensional stereotypes.[16] As historian Donald Bogle explains, even during the Blaxploitation period of the 1970s, the Black-oriented films of the time "appeared to be black (in concept, in outlook in feel) and while they were feverishly promoted and advertised as such,

they actually were no such thing."[17] Despite the surge in Black representation on the screen and behind the camera, with directors such as Ossie Davis (*Cotton Comes to Harlem,* 1970), Melvin Van Peebles (*Sweet Sweetback's Baadasssss Song,* 1971), Gordon Parks Sr. (*Shaft,* 1971), and Gordon Parks Jr. (*Super Fly,* 1972) at the helm of productions, the wave of Hollywood Black-oriented product following these films exploited stereotypes of African Americans and African American life. Coming out of this context, L.A. Rebellion filmmakers expressed a "commitment to developing Black cinema beyond and opposed to commercial filmmaking content and techniques, [and they] affected a fundamental transformation in the character of black efforts to contest the visual representation of African Americans by Hollywood."[18] Julie Dash explains that they "were rebelling against being told this is how we were going to be seen in films" and, instead, "were going to redefine ourselves and we were going to have our own voices."[19] In doing so, L.A. Rebellion filmmakers expanded the representations of Black men and women through their dimensional explorations of the internal, emotional complexities and experiences contained within Black people's quotidian lives.

For example, Billy Woodberry's *Bless Their Little Hearts* constructs and deconstructs physical and perceptual landscapes of affect and labor, exploring the relationship between industrial desolation and emotional depletion. With a powerful screenplay and lingering cinematography by Charles Burnett, whose documentary and neorealist style sets the film's somber tone, Woodberry's familial drama is a navigation of Los Angeles through the lens of the Banks family home. Exposing the tenuous boundary between public and private spheres, the film establishes the wanderlust of the male protagonist and patriarch, Charlie Banks (Nate Hardman), as he searches for employment in a discordant industrial milieu against the backdrop of his family's home. While Charlie's sojourn for employment is fragmented with short-term work, making his stagnancy figurative of the systematic disenfranchisement of the urban space, the film renders both visible and invisible the alternative universe of female labor that shadows Charlie's labor experience.

The representation of the laboring body of Charlie's wife, Andais (Kaycee Moore), inside and outside the home explores how affects, specifically those tied to labor, become embodied and emoted as "tiredness" and, tragically, while senses are never fully felt—that is, understood—by her husband, whose frustration over nearly a decade of unemployment has left him feeling alienated from his family. Charlie's

inability to find continual employment affects his domestic relations and his ability to relate emotionally to his wife and children. Guerrero's reading of Charlie's "troubled and threatened manhood due to economic marginalization and idleness" expertly frames Charlie's emotionally depleted state of esteem and confidence in relationship to his family.[20] Here, I turn my attention to the emotional and embodied state of Andais to understand how womanhood, too, is also troubled and threatened due to economic crisis and—opposite Charlie's experience— overwork.

Unlike her husband's underemployed body, Andais's body is overworked. As the sole steady source of income for the family, she also is in charge of maintaining the home and keeping the family dynamic intact. In the home, Andais's laboring body visibly signifies her affective labor, the gendered form of labor known as "women's work" within the domestic sphere that includes tasks such as "cleaning and cooking, but it also involves producing affects, relationships, and forms of communication and cooperation among children, in the family, and in the community."[21] In the film, Andais completes all of these laborious tasks, often to the detriment of her own sense of sanity. She cooks, cleans, and even participates in posturing that Charlie is "the Man" (read: breadwinner) of the house, for the benefit of their kids. Addressing the labor of Andais's domesticity, Daniel Widener explains that "her ultimate responsibility for holding everything together is made clear time and again and is epitomized by her statement on entering the kitchen after a day of work, 'Lord have mercy, I would *think* somebody in this house would have hands besides me!'"[22] Invoking her bodily state, the "hands" are not only representative of her housework but also symbolic of her underappreciated employed labor that she does daily.

Andais's laboring body outside the home is rendered invisible. Only in moments of transition from home to work does the film privilege her labor reality. The film uses the interstices of transit to expose Andais's life/labor in the public sphere. Andais's body in transit, specifically on a bus, accentuates her invisible public labor but also foregrounds her physical as well as emotional state. For example, Andais is shown sitting on the bus, her hand gripping the bus seat's rail. The camera's focus on her body reveals how her physical and emotional state—one of exhaustion and tiredness—is embodied. The slow gripping and rotating of her hand on the rail expresses the tensions within her public and private labored existence. This scene of tension expresses what Ahmed describes as the "sociality of emotions," illustrating how "like a thickness in the

FIGURE 7.2. *Bless Their Little Hearts* (Dir. Billy Woodberry,1984).

air, or an atmosphere," feelings "not only *heighten tension,* they are also *in tension.*"[23] In this respect, the drama of Andais's tense bodily self is the map of not only her public and private labor but also her sociopsychic realities. On her corporeal terrain, the frustrations and effects of her labored existence produce not only a physical state of exhaustion but an emotional state of tiredness.

Andais embodies these states throughout the entire film. In fact, she is introduced in the film's beginning in bed, trying unsuccessfully to sleep, weary from being not only overworked but also overlooked by her husband, who comes home from a day of job searching and meandering through the derelict urban landscape only to leave moments after to hang out with his neighborhood friends. Eyes closed and yet awake, Andais is in a bodily state that reifies her fatigue and strain but also symbolizes Charlie's blindness to her struggles and the way that his struggles affect her. Charlie's lack of work, emotional alienation from his family, and feelings of depression over his constant unemployment underscore the broader economic crisis in the social history of Black Los Angeles. As Widener explains, "Charlie spends much of the film looking for work, reading want ads, and doing casual day jobs. [. . .]

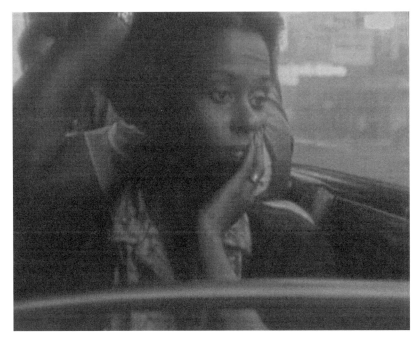

FIGURE 7.3. *Bless Their Little Hearts* (Dir. Billy Woodberry, 1984).

The sum of fruitless searches is a profound, generational moment of despair not captured elsewhere when tens of thousands of black men in Los Angeles, and millions more around the country, engaged in a futile search for steady work that could provide both individual dignity and enough money for them and their loved ones to live on."[24]

The decline of industrialization and the burden placed on both Charlie and Andais create a tense environment for everyone in the Banks family home. For example, after Charlie leaves the bathroom, Angie (Angela Burnett), his daughter, must use a wrench to loosen the sink faucet because, in a moment of tense frustration, he had turned the knobs too tight. The circulation and negotiation of affects in the domestic tension of the Banks family take up room in not just the family's psychic lives but also the place they inhabit. As Ahmed explains, "The objects of emotion take shape as effects of circulation."[25] Charlie's emotional frustration is transferred and bound up, like his wife's, in the figurative and literal home/family structure, signifying both of their emotional frustrations with their current economic state as well as the tense effect that their financial crisis is having on their family.

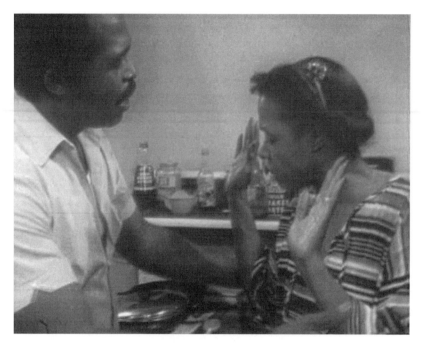

FIGURE 7.4. *Bless Their Little Hearts* (Dir. Billy Woodberry, 1984).

In a scene of both aliveness and exhaustion, Andais has an emotional release where she articulates her personal feelings on her laboring experiences that hold her family together as she breaks apart. Moments before the dramatic domestic argument between her and Charlie, Andais is shown admonishing her family for their lack of help and participation in the home, declaring that everyone sits around on their well-rested behinds while she does all the work. Tired from working and being emotionally neglected by Charlie, Andais confronts him in their kitchen. This scene functions as a bruising moment, where Andais and Charlie personalize the broader traumas and anxieties around the economic crisis that their family and other African Americans faced during this period. The scene is filmed in one continuous ten-minute shot, as Andais's body finally speaks of what goes into maintaining their home, family, and marriage. Personalizing her alienation from her husband, she tells Charlie what is wrong with her, expressing how her body and mind beg to be felt, heard, and understood. As she shifts from telling him, "I'm tired Charlie, I'm tired," to demanding his financial assistance and help with the children, Andais's bodily and mental states

become connected in her rebuke of his actions and inactions. Moreover, she exposes the hurt she feels from Charlie's betrayal of their marriage in his sleeping with a neighborhood woman.

Dispelling Charlie's attempts to make her think she's "crazy," Andais rebuts any notion of mental neurosis, explaining that she only works like a crazy person. She verbally documents how she is worked like a dog, saying, "It's just me that goes to work; it just me that sees to everything in this house; it's just me that sees to the kids." Giving all and getting very little in return, Andais labors to the point of exhaustion; all the while, the unspoken knowledge of Charlie's affair—a failed coping mechanism for Charlie who, again, is unable to perform as man/father figure for his girlfriend—is known by those in and outside the home. When Charlie claims to understand what Andais is going through, she disagrees. At one point, she tells Charlie to feel her hands, a symbol of how hard she has worked. She challenges him to *feel* her in that moment and understand that he has become disconnected and disaffected to her feelings of being overwhelmed and exhausted by the pressure of being the sole, steady breadwinner. Their emotionally charged exchange reveals that while Andais is sympathetic to Charlie's experience, she is also fed up with his trying to find a job, declaring, "Don't try, do it." Helping him dream his dreams has left her tired, old, and ugly. In many ways, the invisibility of Andais's labor outside the home marks Charlie's inability to perceive the effects that her overwork and his alienation have caused her in the home.

Woodberry's film demonstrates how characters personalized the broader anxieties specific to African American experiences in South Los Angeles at the time. In the domestic fight scene, the subtext behind Andais's and Charlie's surface emotions is rendered through the scene's dialogue, which was mostly improvised. Through improvisation, Kaycee Moore (who plays Andais) and Nate Hardman (who plays Charlie) "draw upon their own cultural repository of gestures, experiences, and memories to animate the scene."[26] Citing Clyde Taylor's designation of "'the realness dimension,'" Guerrero explains that the actors in the scene were given the social space "to play themselves and involve the spectator in issues of black reality that transcend, or decenter the illusionist narcosis so prevalent in Hollywood films."[27] In this sense, Moore and Hardman bring emotional depth beyond and through their characters by tapping into their own personal experiences, even as those experiences caused friction on the set. Woodberry explains that Hardman quit the production for nearly two months. Hardman believed that Moore had told Woodberry and Burnett private secrets about his life

that they then used in the script.[28] While the script was largely the imagination of Burnett, the themes of economic stasis and deindustrialization's effects on the domestic sphere speak to a broader social reality of the time period. Hardman's anxieties of being exposed inflect his emotional performance throughout the film, as do Moore's potential personal frustrations.

While the domestic argument scene ends with Charlie leaving to give Andais space, the moment depicts how Andais's expression of affect—her emotional outpouring—is too much for Charlie. He is unable to deal with the realities of his family's needs and so removes/alienates himself from his home environment as he has done throughout the film. However, this moment is largely contrasted by the following scene, in which Charlie cries over his daughter's injury, displaying emotion he is unable to project toward his wife. In the film's conclusion, with a temporal jump of nearly ten years, we see the Banks family in emotional and economic stasis, a state that mirrors the increased lack of job opportunities for African American men and the burden of Black women to take low-paying jobs, often of a domestic nature, in order to support their families.

The focus on affect through Black interiority, embodiment, and the personalization of a character's emotions and feelings works to a different end in Bernard Nicolas's short film *Daydream Therapy,* which depicts how within an imprisoning socioeconomic environment a Pan-African consciousness functions as mental liberation for a Black hotel worker in Los Angeles. *Daydream Therapy* visually narrativizes the lyrics of Nina Simone's rendition of "Pirate Jenny," originally from Bertolt Brecht's and Kurt Weill's epic theater production, *The Threepenny Opera* (1928). Telescoping in on the experiences of a Black female hotel worker, *Daydream Therapy* begins with the woman vacuuming the carpet of a hotel lobby. This image is juxtaposed with the nondiegetic lyrics of Simone's "Pirate Jenny." While the shot depicts the woman's cleaning, the song narrates a different tale. Disrupting the image's textual stability, the lyrics sing out: "You people can watch while I'm scrubbing these floors . . . But you'll never guess to who you're talkin'." When the lyrics tell of a Black Freighter ship, the woman stares out the window. Greeted not by the corporate high-rises of Los Angeles's cityscape but by images of the sea, the film unsettles classical narrative continuity and demonstrates a break in the character's reality that her dream later sutures.

While Nicolas explains that he chose the song based on his interest in creating visuals for Simone's version of "Pirate Jenny" and was una-

ware of its relationship to Brecht's opera, the film's visualization of Simone's version does reflect the Brechtian theater tenets the song conjures, specifically that of *Verfremdungseffekt,* or "alienation effect."[29] Alienation effect distances and "prevents the audience from losing itself passively and completely in the character created by the actor, [. . .] which consequently leads the audience to be a consciously critical observer."[30] *Daydream Therapy* reflects this tenet, leading the audience to be a critical observer by watching an alienated Black female worker come to critical consciousness through her own observations. Because of her civil rights musical tradition, Simone's rendition of "Pirate Jenny" links, at times, the disparate lyrics and visuals to the politics of equal rights and liberation, making Nicolas's film a more meaningful political work than one full of the superficial emotionality that Brecht criticized. This is not to say that emotions represented in the film's text as well as experienced in watching are wrong, but as the Brechtian tenet suggests, merely sympathizing with a character is not enough to become empowered on an intellectual level. Conversely, emotions (represented and/or watched) that mobilize agency can work toward the more meaningful political work that Nicolas's film and Brecht's theatrical style proffer. Largely, in *Daydream Therapy,* this is done through showing the female worker's own journey from alienation and harassment to consciousness and activism, particularly through an embodied emotional experience of fantastical vengeance and everyday empowerment depicted in the latter half of the film.

When the woman gets onto an elevator, she is sexually accosted by her white boss, who has been looming over her as she works. The film's bruising moment—emotionally charged scene that reflects narratives specific to African American lives—follows this first indignity. Making a bed in a hotel room, the woman is sexually solicited by her sleazy boss. The film uses the character of the Black female worker and her personalized indignities at the hands of her white boss to depict how women's service work is not only "generally feminized, given less authority, and paid less" but also exists as a place of gendered and racialized harassment for many women of color.[31] Disgusted by her boss's lechery, the woman turns away and looks out the room's glass doors as the music provides an intense affective pulse to the scene. Again, the shot cuts to reveal not a cityscape but ocean waves hitting up against rocks and a ship in the distance, as the lyrics cry out, "And you see me kinda starin' out the window, and you say, 'What's she got to stare at now?' I'll tell ya, there's a ship, the Black Freighter, turnin' around in the harbor

FIGURE 7.5. *Daydream Therapy* (Dir. Bernard Nicolas, 1977).

shootin' guns from her bow." The lyrics and the visual disruption suggest the character's internal subjectivity. Her workplace observations may seem as though she has nothing to look forward to, but the song anticipates that change is coming.

Leaving the hotel, she takes off for her lunch break, entering the busy city streets. The camera cuts to show a white lawn jockey, historically a Black minstrel figure. Then a close-up of the woman's face creates a dialectic, with the lawn jockey representing her position as ornamental and serving, alienated to the fringes of developed society. The camera then cuts to the buildings of Bank of America and E. F. Hutton, whose facades fill the entire frame. The woman is confronted by the economic infrastructure of American capitalism and class and racial imperialism. While these images loom over her as symbols of oppressive capital, the song narrates a different tale of not only how she is confronted by these symbols but also how she plans to confront them through racial and global class consciousness. Sitting alone, eating her lunch, she presumably embodies the feeling of alienation and exploitation within the matrices of individual and institutional power that she deals with daily. However, despite the isolation of the woman within the mise-en-scène,

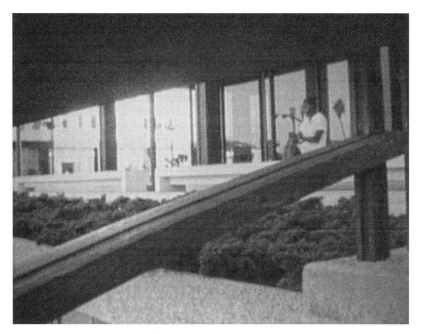

FIGURE 7.6. *Daydream Therapy* (Dir. Bernard Nicolas, 1977).

the lyrical content of "Pirate Jenny" challenges this grim representation of working life. Through its diegetic disruption into dream logic, *Daydream Therapy* breaks the isolating physical and mental state of the woman to convey an affective state of empowerment that she comes to embody through her own imagination.

As the film shifts from black-and-white cinematography to, literally, dreaming in color, the spectrum of hues initiated by the red, black, and green of the Pan-African flag connects the woman's mentally embodied state to that of global class struggles. In the dream, the woman transforms from a worker to a revolutionary member of a rebel Black community. The image of the Black Freighter ship on the sea, anticipated by the song lyrics, comes to fruition. Shot from a low angle, the hotel worker turned revolutionary is framed in a position of power, above her oppressor (played by her white boss) and in control. Holding a child, and symbolically connected to her motherland, she exercises her vengeful wrath. In the dream, the feeling of empowerment is emoted and levied against her white oppressor, evidenced in the musical crescendo to kill him "right now." Conveyed through her look, the revolutionary woman turns the song's speech act into an embodied performance. In

this new dream space, the woman is represented as empowered and her actions are tied to a communal practice of revolution that begins, first, in the mind and then becomes one's reality.

The dream's climax changes both her feelings and embodied reality. Ahmed explains that "emotion is the feeling of bodily change."[32] Cutting back to a close-up of the woman's face, as she is eating her lunch, the dream serves as the subtext behind her surface emotions. Since the woman never speaks within the diegesis, the song's narrative and the images represent her perspective. Sound and image, in this case, work together to express her evolved emotional state, further demonstrated in the film's changing soundscape. The soundtrack shifts to Archie Shepp's "Things Have Got to Change." The film ends with the woman's sojourn back to work as the camera zooms in on her legs walking. These are the literal and figurative feet of the movement, which Nicolas shows by cutting back and forth from the black-and-white images of the female worker to the color images of the revolutionary woman. Cutting between black-and-white and color images and the worker and the revolutionary, the film melds the vibrancy of the woman's revolutionary dream with the pragmatism of her daily life. Both women hold Kwame Nkrumah's book *Class Struggle in Africa,* then a poster that reads "Don't just dream, fight for what you want," then a movie camera, and finally a rifle. Through these images, the film expresses that the end of the dream is a beginning: Black Americans can be united in Pan-African struggles, and cinema is a means of revolution. Returning to the hotel, the woman's entry back into her reality is buoyed by a new physical and mental confidence and consciousness.

The intermingling of the woman's "real" and "dream" life explores how fantasy not only informs but transforms the real. In this regard, Nicolas's film is reminiscent of the "radical dreams" expressed by poet Nikki Giovanni. In "Revolutionary Dreams," Giovanni writes of how she used to "dream militant dreams":

> then i awoke and dug
> that if i dreamed natural
> dreams of being a natural
> woman doing what a woman
> does when she's natural
> i would have a revolution[33]

Giovanni's poem indicates that the average woman's transformative power comes from a natural Black female subjectivity. In the film, the

female worker dreams her own militant dream, one tied to fighting oppression; and in her awakening, she is able to mobilize her own revolutionary dream as a kind of "natural" consciousness. In this case, the woman's transformation is marked in color, literally, where she represents a return to a Black Pan-African nationalism, symbolized as more natural and authentic for the African diaspora than America's capitalist and patriarchal society. In waking up from her militant dream to this revolutionary reality, she is liberated and transformed into an activist. Nicolas's film explores the notion of personal awakening but also connects the individuated experience of one Black woman with Pan-African struggles for equality. *Daydream Therapy*'s protagonist uses her mind not only to dissociate herself from her oppressive socioenvironment but also to free-associate to her global community. The film projects this Black woman's personal feelings of empowerment in her workspace into the wider public sphere, as representative of broader narratives of Black experience throughout the world. In the end, the film's conclusion is merely a beginning, marking not only her reevaluation of her own agency and power but also women's potential to make a difference in environments that may look one way but feel another.

The embodiment and display of emotions in Zeinabu irene Davis's *Cycles,* based on a journal entry by her friend Doris Owanda Johnson, depicts affect and, specifically, its bruising moment in a slightly different way than the aforementioned films.[34] The term *bruising moment* can connote an injury or wounding as the creation of a shared experience, but it also more generally describes how emotionally charged scenes reverberate or reflect celebratory cultural memories and narratives specific to Black communities. In this sense, bruising moments are about impressions of Black history, which can be positive or negative.

Cycles is dedicated to the spirit and vision of filmmakers Kathleen Collins and Hugh A. Robertson, and its epigraph explains that the film is "for the goddess in us all."[35] A black-and-white short, *Cycles* is an experimental film that fuses a polyphonic soundtrack of voices and music—including orisha chanting, the singing of Miriam Makeba, Darryl "Munyungo" Jackson's shekere playing, and the trumpet of Clora Bryant—with the rhythms and rituals of everyday life. Davis focuses her tale of a woman waiting for her period on a series of housecleaning and personal care activities, exploring the interiority of Black female subjectivity. Despite the isolation of these activities, the film's voice-overs and dream sequence tie these rituals to a community of women and progress. The film portrays the powerful role of affect, specifically the feeling and

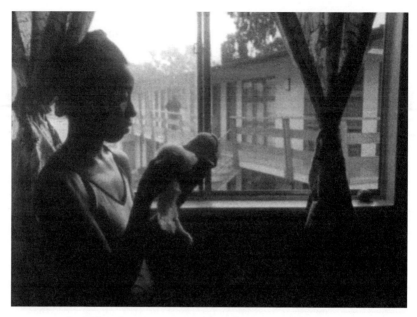

FIGURE 7.7. *Cycles* (Dir. Zeinabu irene Davis, 1989).

embodiment of animatedness, in the waiting rituals of a Black woman, gesturing toward a broader cultural and spiritual Black womanist subjectivity.[36] The protagonist, Rasheeda Allen (Stephanie Ingram), who believes she may pregnant, demonstrates how housework can be gratifying, pleasing, therapeutic, and transformative. Moreover, in a dream sequence, Rasheeda's waiting and hoping for her menstrual cycle invoke a community of women's interconnected spiritual and mental states.

Rasheeda's domestic work explores the spirit, spirituality, and spiritedness of housework. In *Cycles,* Kathleen McHugh writes, "work becomes play, labor dance, [and] housekeeping an indulgence."[37] *Cycles* creatively blends routine bodily labor with the symbolic images, sounds, and history of African ritual. However unlike the working women in *Bless Their Little Hearts* and *Daydream Therapy,* Rasheeda's bodily labor is unwaged, self-generated, and self-fulfilling. She alone makes progress in the cleaning of her home and caters to her own bodily cleaning; yet, in the dream sequence, she is connected spiritually with a community of women's play and progress. Thus, portraying housework as not just indulgent or for others but as a kind of self-care, and using dream logic, similar to Nicolas's *Daydream Therapy,* to link Rasheeda to a sisterhood of women, *Cycles* gives both divinity and normalcy to domesticity.

In the film's foregrounding of the actions of the body, we are able to see how Rasheeda's feelings of animatedness are embodied and acted out. The film's voice-over explains that Rasheeda "had no one to talk to so she indulged herself in her humble surroundings." This act of indulgence infuses women's housework with cultural significance. Carrie Noland argues that "culture is both embodied and challenged through corporeal performance."[38] Rasheeda's domestic performance reclaims "black female subjectivity through poetic (re)constructions of time, the body (particularly menstruation), and the cultural work of the African American woman."[39] Foregrounding the bodily mode, *Cycles*'s depiction of corporeal movement and gestural routines of housework—often circular, echoing the film's title—subvert the banality and isolation associated with domestic tasks. For example, the images of Rasheeda stripping her bed linens, doing laundry, vacuuming, and mopping the floor are supplemented with the reoccurring verbal motif that "progress is being made," where the repetition of movement mimics the repetition of ritual and both are used to signify fortitude and advancement.

Through experimental camera techniques, Davis produces an aesthetic of animation and, thus, a feeling of lively animatedness for Rasheeda in the film. Unlike the feelings of tiredness in the affective and physical state of Andais in *Bless Their Little Hearts,* Rasheeda's emotional and physical state shows how housework, as a kind of self-care, renders a Black woman's body energized. Using a rapid succession of photographic stills and "working with pixilation, a process of shooting film that greatly exaggerates real time," Davis animates the bodily movement of domestic chores as both mechanical and spontaneous.[40] Breathing life into the ordinary, Davis illustrates how, as Kathleen Stewart describes, "ordinary life, too, draws its charge from rhythms of flow and arrest. Still life punctuates its significance."[41] In the film, the affects of everyday chores and the cycles of life produce vibrations in the mind and body of the protagonist. When Rasheeda is cleaning her bathroom walls, the paradoxically resonant and still images of housework transition from arrest to flowing bodily movements. With Clora Bryant's trumpet layering the soundtrack, the rhythm and sensual splendor of the labor offers not only vibratory motion through the animate still images but also a way to understand the beauty of the circular, cyclical, and repetitive nature of everyday tasks. This beauty is personified when the film's housecleaning shifts to Rasheeda's personal hygiene and bodily cleaning. The narrative motif of "progress" being made in the home, on the body, and—as she takes a nap—in the mind connects all of these

notions of the working self: mind, body, and soul. *Cycles* was first conceptually conceived as an animated film, and its personalized and emotive state of animatedness highlights how Rasheeda's laboring body is affected and endowed with a physical and spiritual connection to a sisterhood of women.[42]

With Rasheeda's falling asleep, *Cycles*'s diegesis shifts to a dream sequence in which dance, direct address, and the music of drummer Munyungo Jackson layer the Haitian Veve symbol that marks the sequence's opening. Rasheeda's dream voice says, "You're doing okay and you're going to get better," emphasizing the role that repetition and movement have in cultural and historical advancement. Describing this "spiritually-charged space continuum," Gwendolyn Audrey Foster explains that Rasheeda "revels in ownership of public and private space as she is continually reinforced by voices" that "reclaim Black female spiritual space."[43] Rasheeda's expression that she is "okay" and getting "better" personalizes the notion that Black women's salvation is to be found internally. In this sense, Davis's film not only invokes but is connected to the work of Kathleen Collins, specifically her film *Losing Ground* (1982). L.H. Stallings cogently describes Collins's film about Black interiority, sexuality, and desire: it "accomplishes redemptive softness by creating a black woman character who, to save herself must feel and experience the desires of her own mind and body as opposed to solely thinking too much about external realities, expectations, and proscriptions in regard to gender or race."[44] In *Cycles*, Rasheeda's self-care and animated expressions of progress centralize the importance of Black female subjectivity for spiritual, physical, and emotional wellness.

Upon waking up and realizing she finally got what "she asked for," *Cycles*'s "period" marks not only Allen's menstrual cycle but the ritualistic theme of the entire film—an end and a beginning. The film depicts women's work as progressive, individuated, and communal. Through the dream sequence and the film's narrative "cycle," labor in the bodily mode is reproductive but not in the direct biological sense, representing "the life-affirming symbol of fluidity, cycles of power."[45] Rasheeda's waiting and working body produces cyclical moments of reflection— mental (she talks to herself), literary (she reads Toni Morrison's *Beloved*), personal (cleaning herself), and communal (in her dream she is with two of her friends). *Cycles* provides subtext to Rasheeda's affective display. Not only does Rasheeda take care of her home and herself, she taps into her own mind and body to reconnect with a world of women that affects the world around her. Beginning with the epigraph

that the film is for "the goddess within all" and concluding with women's voices discussing what they like to eat during their menstrual periods, *Cycles* represents the personal and communal feelings of Black female interiority, fusing the individual with the communal and the spiritual with the everyday.

Analyzing the work of L.A. Rebellion filmmakers through the lens of affect, specifically characters' embodiment of emotions, provides a useful way to understand how these filmmakers represented the changing and culturally specific social worlds of Black people. *Bless Their Little Hearts, Daydream Therapy,* and *Cycles* explore how "emotions shape the 'surfaces' [interior and exterior] of individual and collective bodies."[46] Moreover, as noted in the analysis of Nicolas's *Daydream Therapy,* emotions represented and embodied on-screen have potential effects on audiences. In this regard and in conclusion, it is useful to return to Tate's proclamation that Dash's *Daughters of the Dust* "works on our emotions" through characters' personalization of "the broader traumas, triumphs, tragedies and anxieties peculiar to the African American experience."[47] This leads us to look at the role of spectatorial affect in relationship to the L.A. Rebellion films discussed here and, more generally, the films of the group as a whole.

Even though reception studies comes with many methodological difficulties and limitations, African American viewing practices have been the focus of important cinema scholarship on Black spectatorship and spectatorial cultural politics, with critics such as Manthia Diawara and bell hooks analyzing the resistant and oppositional practices Black viewers have used to deal with the problems and potential of cinematic identification.[48] This body of scholarship, however, helps to characterize Black spectatorship as a process of negotiation, interpretation, and reconstitution. For example, Jacqueline Bobo's *Black Women as Cultural Readers* provides an ethnographic example of reception studies that privileges the experiences, influences, and perspectives of women of color.[49] Using Black women as audience members for specific texts, including Dash's *Daughters of the Dust,* Bobo analyzes Black female spectators as members of a physical audience who "in the process of [their] analysis of the texts and in the process of linking their statements to a broader framework of assessing black women in the totality of their lives, their history, and their social activism," become a theoretical construction.[50] In this regard, Bobo contends that Black women are "an interpretive community, which is strategically placed in relation to cultural works that either are created by black women or feature them in

FIGURE 7.8. Production photograph, *Daughters of the Dust* (Dir. Julie Dash, 1991). Collection of Julie Dash.

significant ways. Working together the women utilize representations of black women that they deem valuable, in productive and politically useful ways."[51] In addition, Jacqueline Stewart's *Migrating to the Movies: Cinema and Black Urban Modernity* explores African American urban migration, early Black film images, and Black spectatorship.[52] Describing early Black viewing practices, Stewart offers the term *reconstructive spectatorship* to "account for the range of ways in which Black viewers attempted to reconstitute and assert themselves in relation to the cinema's racist social and textual operations."[53] Bobo's and Stewart's engagements with Black spectatorial practices are important critical approaches to understanding Black social viewing experiences; these approaches go beyond apparatus theory to engage both concretely and creatively with how Black people respond/responded to on-screen depictions of themselves.

Using theories of affect, I offer another theoretical construction of Black spectatorship specific to, but also one that can be abstracted beyond, the L.A. Rebellion's cinematic practices and representational strategies. Based on Tate's description of how *Daughters of the Dust* works on our emotions through feeling a character's pain, I link the emotions of screen to the spectator through cinema's circulation of affect. Film's affective economy, in which "emotions circulate and are distributed

across a social as well as a psychic field," demonstrates that "emotions *do things*, and they align individuals with communities—or bodily space with social space—through the very intensity of their attachments."[54] This process is one of affective circulation that speaks to not only the emotions on-screen but also the intelligibility of those emotions for audiences who have a shared history.

In this sense, Tate's description underscores how affect's relationship to spectatorship involves Black public culture in the creation of an "intimate public." Lauren Berlant describes intimate publics as operating "when a market opens up to a bloc of consumers, claiming to circulate texts and things that express those people's particular core interests and desires."[55] In this type of "culture of circulation," Berlant explains that people "in the intimate public *feel* as though it expresses what is common among them, a subjective likeness that seems to emanate from their history and their ongoing attachments and actions. Their participation seems to confirm the sense that even before there was a market addressed to them, there existed a world of strangers who would be emotionally literate in each other's experience of power, intimacy, desire, and discontent."[56] Therefore, what Tate describes as *Daughters of the Dust*'s emotional power on him as an audience member signals how texts that privilege Black audiences and Black experiences help to form these audiences and experiences into a culture, a culture in turn shaped into an intimate public. Through shared historical and cultural experiences, or "bruising moments," Black spectators, like Tate, can be literally and theoretically constructed as emotionally literate figures able to understand the complexities of each other's individual—particularly when broader issues are personalized—as well as collective experiences. In this sense, L.A. Rebellion films call out and respond to Black audiences as an intimate public, creating text and subtext that confirm Black peoples' sense of themselves, their history, and their experiences.

Spectatorial affect, in the case of L.A. Rebellion film viewing, is a mode that recognizes the relationship between the representation of emotions, the subjective emotional responses of watching, and the shared and attached history of what is common among viewers. Woodberry, Nicolas, and Davis, along with their fellow L.A. Rebellion filmmakers, share the practice of providing dimensionality to Black characters through a focus on affect and Black interiority, working to bring audiences, specifically Black audiences, together. Black audiences as affective participants are able to feel connected to these texts, to each other, and to a sense of shared cultural experiences. Therefore, L.A.

Rebellion films and their audiences demonstrate how the power to affect and be affected by cinema's representation of Black people's emotional experiences provides rich and complex characters as well as an enriching and intimate viewing experience.

NOTES

1. Greg Tate, "A Word," in *"Daughters of the Dust": The Making of an African American Woman's Film,* by Julie Dash (New York: New Press, 1992), 69 (my emphasis).

2. Ibid.

3. Ibid., 70.

4. Ibid.

5. Sara Ahmed, "Affective Economies," *Social Text 79*, vol. 22, no. 2 (Summer 2004): 119.

6. Toni Cade Bambara, "Reading the Signs, Empowering the Eye: *Daughters of the Dust* and the Black Independent Cinema Movement," in *Black American Cinema,* ed. Manthia Diawara (New York: Routledge, 1993), 122, 119.

7. Ibid., 120.

8. Eric Shouse, "Feeling, Emotion, Affect," *M/C Journal* 8, no. 6 (December 2005): 5.

9. Ibid., 4.

10. Michael Hardt, "Foreword: What Affects Are Good For," in *The Affective Turn: Theorizing the Social,* ed. Patricia Clough, with Jean Halley (Durham, NC: Duke University Press, 2007), ix.

11. Patricia Clough, introduction in *The Affective Turn: Theorizing the Social,* ed. Patricia Clough, with Jean Halley (Durham, NC: Duke University Press, 2007), 3.

12. Sara Ahmed, *The Cultural Politics of Emotions* (New York: Routledge, 2004), 4.

13. Cynthia A. Young, *Soul Power: Culture, Radicalism, and the Making of a Third World Left* (Durham, NC: Duke University Press, 2006), 241.

14. Ibid., 215.

15. Lauren Berlant, *The Female Complaint: The Unfinished Business of Sentimentality in American Culture* (Durham, NC: Duke University Press, 2008), 5.

16. Ed Guerrero, "The Black Man on Our Screens and the Empty Space in Representation," in *Black Male: Representations of Masculinity in Contemporary American Art,* ed. Thelma Golden (New York: Whitney Museum of American Art, 1994), 185.

17. Donald Bogle, *Toms, Coons, Mulattoes, Mammies, and Bucks: An Interpretive History of Blacks in American Films,* 4th ed. (New York: Continuum, 2004), 241.

18. Daniel Widener, *Black Arts West: Culture and Struggle in Postwar Los Angeles* (Durham, NC: Duke University Press, 2010), 256.

19. Julie Dash, oral history interview by Allyson Field, Jan-Christopher Horak, and Jacqueline Stewart, June 8, 2010, LAROH.

20. Ed Guerrero, "Negotiations of Ideology, Manhood, and Family in Billy Woodberry's *Bless Their Little Hearts*," *Black American Literature Forum* 25, no. 2 (Summer 1991): 317.

21. Michael Hardt and Antonio Negri, *Multitude: War and Democracy in the Age of Empire* (New York: Penguin, 2004), 110.

22. Widener, *Black Arts West*, 270.

23. Ahmed, *Cultural Politics of Emotions*, 10.

24. Widener, *Black Arts West*, 269.

25. Ahmed, *Cultural Politics of Emotions*, 10.

26. Guerrero, "Negotiations of Ideology, Manhood, and Family in Billy Woodberry's *Bless Their Little Hearts*," 320.

27. Ibid.

28. Billy Woodberry, oral history interview by Jacqueline Stewart, June 24, 2010, LAROH.

29. Bernard Nicolas, oral history interview by Allyson Nadia Field, Jan-Christopher Horak, and Jacqueline Stewart, January 23, 2010, LAROH.

30. Bertolt Brecht, *Brecht on Theater*, ed. and trans. John Willett (New York: Hill and Wang, 1964), 91.

31. Hardt and Negri, *Multitude*, 111.

32. Ahmed, *Cultural Politics of Emotions*, 5.

33. Nikki Giovanni, "Revolutionary Dreams," in *The Collected Poetry of Nikki Giovanni: 1968–1998* (New York: Harper Perennial Modern Classics, 2007), 106.

34. Zeinabu irene Davis, oral history interview by Jacqueline Stewart and Allyson Nadia Field, June 24, 2010, LAROH.

35. Kathleen Collins was an African American filmmaker, playwright, and professor whose womanist film *Losing Ground* (1982) offered a groundbreaking depiction of Black women's sexuality, desire, and ecstasy. Hugh Robertson was an African American filmmaker and editor. He edited Gordon Park's *Shaft* (1971) and directed the Blaxploitation-style film *Melinda* (1972).

36. Sianne Ngai reads the affect of animatedness as a kind of racialized "ugly feeling" tied to "the disturbingly enduring representation of African Americans as at once an excessively 'lively' subject and a pliant body unusually susceptible to external control" (12). In *Cycles*, animatedness does not come from an outside force, or what Ngai explains as "the rhetorical figure of apostrophe (in which a speaker animates or 'gives life' to nonhuman objects by addressing them as subjects capable of response)" (12). Instead, Davis's film claims the embodiment of the lively emotion of animatedness as a space of self-generated and generative agency where Rasheeda controls her own body, actions, and voice. See Sianne Ngai, *Ugly Feelings* (Cambridge, MA: Harvard University Press, 2005).

37. Kathleen Anne McHugh, *American Domesticity: From How-to-Manual to Hollywood Melodrama* (New York: Oxford University Press, 1999), 188.

38. Carrie Noland, *Agency and Embodiment: Performing Gestures/Producing Culture* (Cambridge, MA: Harvard University Press, 2009), 3.

39. Gwendolyn Audrey Foster, *Women Filmmakers of the African and Asian Diaspora: Decolonizing the Gaze, Locating Subjectivity* (Carbondale: Southern Illinois University Press, 1997), 10.

40. Zeinabu irene Davis, "Woman with a Mission: Zeinabu irene Davis on Filmmaking," *Hot Wire* 7, no. 1 (January 1991): 18.

41. Kathleen Stewart, *Ordinary Affects* (Durham, NC: Duke University Press, 2007), 19.

42. Davis, oral history.

43. Foster, *Women Filmmakers of the African and Asian Diaspora*, 11.

44. L. H. Stallings, "'Redemptive Softness': Interiority, Intellect, and Black Women's Ecstasy in Kathleen Collins's *Losing Ground*," *Black Camera* 2, no. 2 (Spring 2011): 48.

45. Foster, *Women Filmmakers of the African and Asian Diaspora*, 12.

46. Ahmed, *Cultural Politics of Emotions*, 1.

47. Tate, "A Word," 69.

48. See Manthia Diawara, "Black Spectatorship: Problems of Identification and Resistance," in *Black American Cinema*, ed. Manthia Diawara (New York: Routledge, 1993): 211–20; and bell hooks, "The Oppositional Gaze," in *Black Looks: Race and Representation* (Boston: South End Press, 1992), 115–31.

49. Jacqueline Bobo, *Black Women as Cultural Readers* (New York: Columbia University Press, 1995).

50. Ibid., 24.

51. Ibid., 22.

52. Jacqueline Najuma Stewart, *Migrating to the Movies: Cinema and Black Urban Modernity* (Berkley: University of California Press, 2005).

53. Ibid., 94.

54. Ahmed, "Affective Economies," 119.

55. Berlant, *Female Complaint*, 5.

56. Ibid.

The L.A. Rebellion Plays Itself

JACQUELINE NAJUMA STEWART

L.A. Rebellion filmmakers show up in their own work, every once in a while. We see them on-screen and/or hear them on the soundtrack. They play characters in fictional narratives (S. Torriano Berry's *Rich*, 1982) or provide narration (Melvonna Ballenger's *Rain (Nyesha)*, 1978). More often they portray themselves as the makers of the films and videos we are watching (Charles Burnett's *Nat Turner: A Troublesome Property*, 2002; Haile Gerima's *Imperfect Journey*, 1994; Barbara McCullough's *Shopping Bag Spirits and Freeway Fetishes: Reflections on Ritual Space*, 1981). Self-representation is a mildly recurring device for a handful of L.A. Rebellion makers (Zeinabu irene Davis, Haile Gerima, O.Funmilayo Makarah) and cannot really be described as a hallmark of the group's body of work. But these appearances serve as illuminating moments of self-portraiture that evoke the myriad challenges that the L.A. Rebellion artists have faced in occupying the role of Black filmmaker.

The L.A. Rebellion movement grew out of efforts coordinated by UCLA professor Elyseo J. Taylor to train "minority" students to represent their own communities and perspectives, in response to the scant and superficial treatment that people of color receive in mainstream media. Taylor sought to get nascent Black, Latino, Asian American, and Native American filmmakers over the daunting hurdles of securing training, equipment, and financing. But beyond these material obstacles, this pioneering cadre of artists must also negotiate the insider/outsider position that nonwhite filmmakers occupy when they represent their

own people. That is, they share with other "indigenous" filmmakers, like the African and Latin American filmmakers many of them studied in Taylor's "Film and Social Change" course (later taught by Third Cinema theorist Teshome Gabriel), the condition of being the "Inappropriate Other." As Trinh T. Minh-ha explains, these filmmakers know, "probably as Zora Neale Hurston the insider-anthropologist knew, that she is not an outsider like the foreign [white] outsider. She knows she is different while being Him. Not quite the Same, not quite the Other, she stands in that undetermined threshold place where she constantly drifts in and out."[1]

In keeping with the ethos of affirmative action and racial self-determination that structured their film school training, L.A. Rebellion makers assert the authority of insider knowledge, their intimate relationships with their Black subject matter, which sets their work apart from white-authored representations. But as the following survey illustrates, when the L.A. Rebellion filmmakers record themselves, we also get a sense of their authorial individuality and vulnerability, of how they are situated as insiders with a difference. Whether they act in fictional roles or play themselves, whether they focus on other subjects or foreground their own biographies and performances, their self-representations demonstrate that, as Trinh T. Minh-ha puts it, the Inappropriate Other "cannot speak of them [the racial group] without speaking of herself, of history without involving her story."[2] Self-representations evince some of the ways in which the L.A. Rebellion makers negotiate the complications posed to their insider status by their training and aspirations as artists, their creative and analytical activities as writers, editors, and wielders of the camera.

As we shall see, L.A. Rebellion makers represent themselves in works spanning the formal continuum of fiction, documentary, and experimental film and video. They do not always acknowledge their insider/outsider status explicitly. And their self-presentations vary in tone, from sober to playful. But even when the makers' appearances are more self-reflective than self-reflexive, they make visible what Trinh identifies as the "cultural, sexual, political inter-realities involved in [film]making: that of the film-maker as subject; that of the subject filmed; and that of the cinematic apparatus"—the machinery of creating and presenting the work.[3] That is, when the L.A. Rebellion makers become "the subject filmed," such as when Charles Burnett includes footage of himself directing the cast and crew of Nat Turner: A Troublesome Property, these moments have the potential to expose rather than collapse the

complex relationships between Black authors, their subjects, and their chosen media. These appearances heighten our awareness of the makers' creative processes—the multiple hats they wear, the performative dimensions of their work, and the formal and stylistic decisions they make. And they highlight how gender functions as one of the key "inter-realities" that intersects with the cultural and political work the filmmakers seek to perform. In doing so, self-representations by men and women L.A. Rebellion film and video artists illustrate the range of identities they have crafted for themselves in response to their expected functions as racialized "loyal interpreters."[4]

FILMMAKERS AS SUBJECTS

We might be inclined to read the on-screen and/or on-soundtrack presence of L.A. Rebellion makers as further evidence of what Clyde Taylor describes as the "realness dimension" of their works. Their appearances apparently close the gap between screen world and real world, helping to establish in their work "only the slightest, if any, departure from the contiguous, offscreen reality."[5] Critics frequently praise the L.A. Rebellion's "neorealist" sensibility, citing its affinities with the postwar Italian cinema of the streets and struggles of working-class life. A prominent example of such praise is Thom Andersen's expansive film essay *Los Angeles Plays Itself* (2003), which concludes with an appreciation of how landmark L.A. Rebellion features by Haile Gerima (*Bush Mama*, 1975), Charles Burnett (*Killer of Sheep*, 1977), and Billy Woodberry (*Bless Their Little Hearts*, 1984) offer long overdue, materially grounded correctives to the distortions and mythologies presented in so many white-authored cinematic representations of the city, particularly those generated by Hollywood.

Andersen praises these Black independent filmmakers for their location shooting in predominantly Black areas of South Los Angeles, a strategy that spotlights "who knows the city" and the effects of its histories of racial and class discrimination: "those who walk," "those who ride the bus." Clyde Taylor's foundational scholarship on L.A. Rebellion films also describes their social critiques in terms of spatial politics, noting how for Black independent filmmakers the "contingency of on-location shooting" in Black communities manifests itself in the finished products. Their struggle to stay "mentally independent" of "the film ideology of Hollywood" within an environment that represses Black creative and political efforts becomes palpable on screen. "By Larry Clark's testimony," Taylor

writes, "the sharp-edged racial portrayals in *Passing Through* (1977) reflect his frustrations in getting his film completed against such resistances." For Taylor, the overlapping worlds of the L.A. Rebellion film/videomakers and their subjects make for a "school of adventuresome filmmaking" that "is replete with art/life ironies":[6] the very conditions of violence (including police brutality), poverty, and disempowerment in Black communities that many of the makers seek to render threaten to disrupt the production process itself. The shot of Haile Gerima and members of his film crew being accosted by LAPD officers at the start of *Bush Mama*—a fiction film about rampant police brutality in South Central Los Angeles—is an oft-discussed case in point.[7]

This shot of Gerima and scenes from Bernard Nicolas's *Gidget Meets Hondo* (1980), featuring Nicholas's narration over still photos he took at a protest against the police killing of South Central resident Eula Love, are among many powerful illustrations of how L.A. Rebellion makers have been grounded in the material worlds of the Black communities they represent. But such moments also mark the makers' entries into the realm of representation, where they are crafting their own images and voices, where their presence is an effect of audiovisual recording. Clyde Taylor observes how L.A. Rebellion films manifest on a textual level the "furious ordeal" of Black independent filmmaking. But if, as Taylor also observes, "everyone knows that the anthropologist with a camera alters the reality he/she records," then something very interesting happens when the filmmaker records her/himself.[8] These self-representations not only register the contingencies Black filmmakers face when shooting the "real" Black world as they intimately know it but also are useful reminders that the "realities" of their authorial selves are not stable things. Authorship is shaped in/by the filmmaking process, and it is performative.

L.A. Rebellion films are indeed rich with "documentary revelations" about the material environments in which they are made, as Andersen posits in *Los Angeles Plays Itself*. It is important to note that these revelations do not just pertain to the "external" social world. While these filmmakers are committed to documenting underexposed material realities of Black life, in the process their work also reveals dimensions of their own subjectivities as artists. "Documentary" speaks as much about the interests, intentions, and desires of the Black film/videomakers doing the recording as it does about the Black subjects they record. Andersen suggests as much when he cites the geographical backgrounds of Woodberry (Texas), Burnett (Mississippi), and Gerima (Ethiopia) as

influences on their representations of Los Angeles's Black residents and when he describes the personal lens Burnett applies in *Killer of Sheep,* a fiction film in which Burnett "blended together the decades of his childhood, his youth, and his adulthood, and added an idiosyncratic panorama of classic black music, from Paul Robeson to Lowell Fulson." For Andersen, the neorealism of these filmmakers is notable not only because it "describes another reality" that is alternative to the dominant (white, middle-class, Hollywood) version but also because it "posits another kind of time, a spatialized, nonchronological time of meditation and memory." In a film like Gerima's *Bush Mama,* for example, "everything is filtered through [protagonist] Dorothy's consciousness, and the film follows it as it slides freely from perception to memory." When we look carefully at how Andersen and Clyde Taylor use the terms *neorealism* and *realness,* we see that their textual analyses and their observations about the filmmakers as authors (where they come from, the stylistic strategies they use, the challenges they face) combine to acknowledge "representation as representation" in L.A. Rebellion works. Both point not to a simple reflection of a singular reality in L.A. Rebellion works but to what Trinh T. Minh-ha describes as "inter-realities" of the filmmaker, the subjects filmed and the technologies of production that inform each other in any filmmaking process.

If the L.A. Rebellion's central project is the humanizing of Black subjects, it is useful to look beyond the construction of fictional characters like Gerima's Dorothy to consider how L.A. Rebellion films evoke the complex subjectivities of the Black subjects behind the camera, how they humanize themselves as authors by evincing the challenges they face as insiders/outsiders in creating their work. Moments when the filmmakers represent themselves on-screen are particularly illuminating in this regard. In different ways, these moments signal the tensions that emerge as Black filmmakers attempt to serve as firsthand truth tellers, recorders of marginalized experiences, voices for those long ignored by mainstream media. What is more, self-representations demonstrate that these tensions are more than purely logistical (raising money, enlisting Black community support, evading police) and that they emerge even when the filmmakers are not making work in/about the "hood." The ways in which L.A. Rebellion makers record themselves trouble easy conflations of their subjectivities with those of the other Black subjects they film. Their self-representations highlight the status of their films and videos as creative constructions and raise questions about what it means to play the role of racial authority.[9]

Take, for example, the multiple roles Bernard Nicolas plays in his film *Gidget Meets Hondo*. Speaking over an opening montage of photographs he shot of a public protest/mourning of the police killing of Eula Love, Nicolas announces his shared sense of frustration with police brutality in the Black community. But the voice-over also announces the unique creative intervention Nicolas will make in the main body of the film: the staging of a fictional scenario that imagines what it would look like if police violence was directed, not at a Black woman in South Central Los Angeles, but at a white woman in the affluent seaside community of Marina del Rey. Nicolas shows up again in the fictional section of the film, in a nonspeaking role as a rather enigmatic militant who tracks the police radio call to the white woman's home and then uses the opportunity to steal the police van.

Like other L.A. Rebellion films, *Gidget Meets Hondo* takes a stand on a pressing issue facing Black people. As a longtime and well-known student activist, Nicolas is deeply committed to political issues addressed by his L.A. Rebellion classmates. But he approached this film as both a political statement and an aesthetic exercise in "the technical aspects" of the dominant commercial cinema: "I really felt that Hollywood was very successful at making films that captivated people. So what I wanted to do was learn how they do it and then reverse the message and just capture the Hollywood techniques, but then have a revolutionary message that would not be the same message as Hollywood."[10] The techniques Nicolas uses to address the major community concern of police brutality—stylized narrative, saturated colors, shooting in Marina del Rey, and studio sets on the UCLA campus—are perhaps more pronounced as cinematic mediations than the neorealist poetics of black and white, long takes and Black neighborhood shooting that characterize celebrated classics of the movement by Burnett, Gerima, and Woodberry. Given his larger aesthetic project of replicating Hollywood's captivating techniques, it makes sense that Nicolas places a white woman (blonde, scantily clad) in the central role and the Black militant he portrays in a peripheral one.

Nicolas performs in two modes in *Gidget Meets Hondo*—as sound and image—in ways that echo strategies used by other L.A. Rebellion authors. His disembodied voice-over functions in a rather conventional documentary mode, explaining over nonfiction footage his intentions as filmmaker. His silent bodily performance acts as a simulacrum for his real-life militant persona. Both performances are fragmentary. Indeed, one of the most striking things about moments of authorial self-

FIGURE 8.1. *Gidget Meets Hondo* (Dir. Bernard Nicolas, 1980).

representation in *Gidget Meets Hondo* and other L.A. Rebellion works is that they do not always clearly confirm the sense of authority and facticity that Black artists are presumed to bring to their treatment of Black subjects. Instead, we see in such moments another set of art/life ironies: when the L.A. Rebellion film/videomakers make what would seem to be the most authenticating of gestures by presenting themselves in their own work, their visual and sonic presence is frequently characterized by oblique portrayals and destabilizing gestures. Our glimpses of the makers are brief, partial, and/or unexpected; we hear but do not see them (or vice versa); they do not speak directly into the camera; they play fictional roles; they offer themselves as vehicles for telling other people's stories.

These self-representations share qualities that Michael Renov identifies in autobiographical film/videomaking since the 1980s, in which the effort to "undertake a double and mutually defining inscription—of history and the self—that refuses the categorical and totalizing" produces constructions of "subjectivity as a site of instability—flux, drift, perceptual revision—rather than coherence."[11] In L.A. Rebellion works of the

same vintage, moments of self-presentation show signs of resisting the "categorical and totalizing" treatments of Black subjects and history in at least two registers. Most obviously, they resist the broad operations of Black stereotyping so common in mainstream media. In addition, they must contend with equally "categorical and totalizing" conceptions of a singular Black reality, a formulation that has had tremendous utility for the building of a collective cultural identity and political agenda but necessarily closes off the representation of individual and nonnormative identities within the racial group.

Implicitly and explicitly, self-representations in L.A. Rebellion works embody the tensions between representing the "minority" group and the self. Nicolas may speak to Black group frustrations in his opening voice-over in *Gidget Meets Hondo,* but he also speaks as a Black artist who has the rare capacity to respond by making a film. And while *Gidget* concludes with a sense of the ongoing and collective problem of police violence (a Black officer aims his rifle at the camera), it is not clear what plan the fleeing, mysterious revolutionary portrayed by Nicolas has formulated, if any, to address the issue or if he is affiliated with others in his activities. I would argue that the highly individuated ways in which Nicolas expresses his authorial omnipresence in the film—as disembodied narrator, as mysterious on-screen observer— illustrate the limits and complexities of playing the authentic racial insider for Black filmmakers. As appealing and natural and politically necessary as this identification may seem, it cannot fully account for the many dimensions of the filmmakers' identities, their creative labors, or the aesthetic properties of the moving-image media they employ.

INSIDERS AND OUTSIDERS

It is instructive to read self-presentations by L.A. Rebellion film/video-makers through the lens of Trinh T. Minh-ha's discussion of the "both-in-one insider/outsider" identity that filmmakers of color inhabit when representing their own cultures and communities.[12] Within the L.A. Rebellion group, there is a strong tendency to embrace insider status as a way of asserting solidarity with and advocacy for the marginalized groups from which they come. But at the same time, as Trinh observes, "the moment the insider steps out from the inside" by taking up the camera, s/he "is no longer a mere insider" but "necessarily looks in from the outside while also looking out from the inside."[13] This positioning is closely related to what W. E. B. Du Bois famously described as "double-

consciousness," the Black psychic predicament of always seeing oneself through the lens of a contemptuous white society.[14] It also resonates with Gayatri Spivak's question "Can the subaltern speak?" by wondering how the voiceless can be heard when they try to speak outside of dominant channels.[15] Trinh suggests that the cinematic apparatus creates an unavoidable fissure in the consciousness of the "minority" filmmaker and a distance between the maker and her subject matter.

In a 1981 interview, Charles Burnett describes how his migration into the role of filmmaker creates the kinds of "contradictions" Trinh maps out. He faces difficulties in representing the "working class and the underclass" of his native South Central Los Angeles and in being "very attentive to their way of seeing things":

> I live in this community, I am a product of it. I went to UCLA by accident, but during my studies, I changed. I know that there is a difference between the individual I was in the beginning and what I am today. Consequently, I can't say that I speak for the community, because my perception of things is very different. They are trapped in an extremely emotional situation, stuck in the insoluble problems they're obliged to endure. They take out their frustrations in a very violent manner. They and I don't have the same ideas, and we don't have the same limits.[16]

Black artists working across time and in all media have faced similar issues. What distinguishes film and video from, say, literature or painting or even photography is the verisimilitude so strongly associated with the moving image, especially when joined by sound. When "minorities" use film to represent their own people, their efforts are often overdetermined by the medium's anthropological or journalistic capabilities. The ostensible transparency of the medium is supposed to work in tandem with the ostensible transparency of the Black filmmaker's belonging in his/her Black community. Though none of the L.A. Rebellion filmmakers have, to my knowledge, put it this way, I would argue that the ways in which their self-representations expose film image and sound as constructions constitute one of the most radical aspects of their practice. While this is not always necessarily intentional or conscious, the textual presence of the filmmakers highlights the contradictions—the limits and possibilities—of their insider/outsider status among Black community members/subjects.

When the makers appear in their own works, their textual presence can flag a "real" world but, as we see in Nicolas's *Gidget Meets Hondo,* their methods of self-representation do not always clearly conform to the widespread expectations of representativeness or authenticity in

Black-authored works. Instead, they evince Trinh's observation that "there can hardly be such a thing as an essential inside that can be homogeneously represented by all insiders; an authentic insider in here, an absolute reality out there."[17] As insiders/outsiders, the L.A. Rebellion makers do not occupy a fixed place within the "reality" of their Black subject matter, nor can they provide a direct reflection of that reality, despite the verisimilitude typically associated with Black art and with film and video technologies.

For example, we can read the shot of Gerima stopped by the LAPD during the production of *Bush Mama* as a representation of an Ethiopian-born artist endeavoring to make a film in a Black Los Angeles neighborhood, shot from a distance and played back in slow motion. We could also observe that this scene is treated differently from other scenes of police brutality presented in *Bush Mama*. It serves as a preface, and it is quite brief. The jerky movements of the camera show the operator struggling to keep all of the police officers and harassed crew members in the frame. The shot appears to have been taken from a distance and reads as a surreptitious recording, not unlike the video footage George Holliday would shoot from his apartment window of LAPD officers beating Rodney King in 1991. In all of these ways, this shot differs from *Bush Mama*'s more clearly staged scenes of police violence in which we get closer views and actors play victims and police, knowingly participating in the blocking of the shots. Additionally, this brief shot of Gerima and crew is extended temporally through the use of slow motion, so that its pace, along with its place at the start of the film, signals that this is a special case. These distinguishing features of this shot are important, since it is not clear that viewers would recognize, without the extratextual knowledge, that it shows Gerima and crew members. Given the distant framing, these figures would be hard to recognize even if viewers know what Gerima and crew look like. And it is not clear that the harassed Black people in this shot are filmmakers, as filmmaking equipment is not clearly discernable. In the absence of visible evidence that these are the makers of the film being harassed (and more specifically, that they are being harassed for making a film), it is the shot's stylistic distinctiveness that indicates that the "real" presented here is of a different order than the "real" evoked during the course of the narrative.

Moments like these show Black filmmakers like Gerima to be "not quite the Same, not quite the Other" among the Black subjects they film, both as they make their work and in the finished products.[18] Rec-

FIGURE 8.2. *Bush Mama* (Dir. Haile Gerima, 1975).

ognizing this does not blunt the social and political critiques in L.A. Rebellion works, disarming them of their "realism." By raising questions about the assignation of Black film/videomakers as insiders, representatives, and/or experts, these moments can disrupt the essentializing tendency (thoroughly critiqued by Wahneema Lubiano, Valerie Smith, and others) to value Black and other "minority" films for how faithfully they mirror or report the "realities" of the makers' native communities.[19] The shot of Gerima does more than provide evidence that police routinely accost Black people, and it goes beyond fusing Gerima's experience with the lives of his South Central subjects. It is also a compelling self-portrait of an artist, in which we can see his movements between roles as insider and outsider, as the recorder and recorded.

While other appearances by L.A. Rebellion filmmakers in fictional works may refer less directly to the filmmaking process than *Bush Mama* and *Gidget Meets Hondo* (Dir. Bernard Nicolas, 1980) do, in different ways they too reflect upon the labors and vulnerabilities involved in occupying the roles of Black film/video artists. And they do so in gendered ways. For example, in the title role in *Rich* (1982), S. Torriano

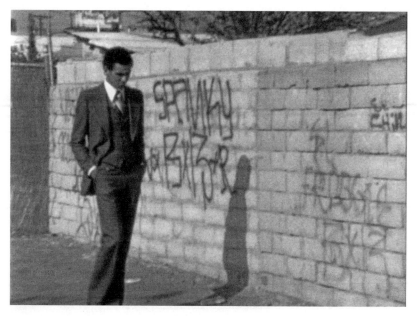

FIGURE 8.3. *Rich* (Dir. S. Torriano Berry, 1982).

Berry plays a young man struggling to pursue a college education despite the limited range of options favored by his family and peers (dead-end factory job, military, gangbanging), thereby acting out the awkward insider/outsider positioning that Charles Burnett describes in the passage quoted above, in which pursuing education potentially alienates Black subjects from their poor and working-class community members. In *A Day in the Life of Willie Faust, or Death on the Installment Plan* (1972), Jamaa Fanaka's portrayal of the lead character reaches a telling limit when he inserts shots of a real-life drug user to show a heroin overdose in graphic detail. Both films are examples of the kind of do-it-all filmmaking modeled by Melvin Van Peebles, who wrote, directed, and starred in *Sweet Sweetback's Baadasssss Song* (1971), and that foreshadow Spike Lee's early works. They show us struggling and savvy Black male filmmakers working to tell stories (one of triumph, one of tragedy) that reflect the plight of so many Black men in their communities. But as filmmakers they stand apart as those able to gain perspective through education and artistry.

We see different approaches to self-representation in fiction films by women, where their labor is rendered more subtly. In Melvonna Ballenger's *Rain* (*Nyesha*) and Zeinabu irene Davis's *Cycles* (1989), the

directors appear in what seem to be more marginal roles—as offscreen narrator and in a dream sequence, respectively—but in both cases their performances play self-reflexively with expectations of Black women's representation and authorship. In *Rain (Nyesha)*, Ballenger voices the poetic internal monologue for her protagonist (played on-screen by Evlynne Braithwaite), a Black woman typist who quits her soul-killing day job to help form a film collective but refuses the women's work of typing up the group's mission statement. In *Cycles*, Davis portrays a trusted girlfriend/orisha (a deity in the Yoruba tradition) figure whose mystical, affirming presence in a troubled Black woman's life is rendered via time-lapse cinematography. Ballenger and Davis are present in these films as part of the consciousness of their lead characters. They exist in realms of thinking and imagination, emphasized by their whimsical uses of sound and fast motion to represent themselves. In these stories of female empowerment, Ballenger and Davis evince less ego than their male counterparts. But in all of these fictional contexts, we can see how L.A. Rebellion makers present themselves in ways that do not simply confirm the realism of their fictions but point to their creative labors in constructing their fictions, their labors marking them as "not quite the Same" as their subjects but also "not quite the Other."

As we shall see in the discussion below, the L.A. Rebellion makers' insider/outsider status is also evident when they play themselves in nonfictional contexts. When the makers present themselves as themselves—performing, reflecting upon their status as artists, and/or engaging in first-person narration—they display how their work as a whole is mediated by their racial and gender identities and by their chosen media. These self-portraits document their complex balancing acts between their shared mission/expectation to express truths about Black experience in general and their efforts to express their individual subjectivities as artists.

PLAYING THEMSELVES AS PERFORMERS

Little critical attention has been paid to the small number of performance-based works made by L.A. Rebellion artists. And yet works like Alicia Dhanifu's *Bellydancing: A History & an Art* (1979), Zeinabu irene Davis's *A Period Piece* (1991), and O.Funmilayo Makarah's *Define* (1988) are extremely evocative representations of Black film/video authorship in the ways that they foreground the bodies of the women filmmakers and raise questions about racial authenticity associated with

FIGURE 8.4. *Bellydancing: A History & an Art* (Dir. Alicia Dhanifu, 1979).

these bodies. In *Bellydancing: A History & an Art,* Alicia Dhanifu offers a how-to demonstration of the basic elements of the dance as part of a history lesson that situates bellydancing within Africanist cultural traditions. Dhanifu's instructional performance is part of a larger argument (supported by archival images) about the dance's significance in Black history for an audience presumably unaware of this history.

While Dhanifu's dance lesson may function as a stand-alone attraction for some viewers, it also performs contested knowledge. That is, Dhanifu recalls that when making the film, she faced resistance from faculty advisors, caught in the cross fire of a long-standing debate about "whether or not Egypt was actually a part of Africa."[20] Dhanifu remembers being questioned by her UCLA professors "as to whether my research was accurate in saying that I was tracing the African origins of Middle Eastern dance," and she notes that she "was prohibited from actually advancing to candidacy until that decision was made." Dhanifu was a professional dancer, and when she performed in clubs in those days, "people would say to me, 'Well, I've never seen a Black belly dancer.'" Her film responds by putting a Black belly dancer on full display: Dhanifu stands at the center of the frame, pictured from head to

just below the hips, in front of an entirely black background, describing each move she performs in detail. By bellydancing as part of her cinematic history of the form, then, she gives a performance that becomes a bold and recuperative act.

In two later video works, Zeinabu irene Davis's *A Period Piece* and O.Funmilayo Makarah's *Define,* the makers also use performance in ways that challenge and broaden what is expected of Black subjects, particularly Black women. *A Period Piece* is a comic rap video performed "Super Bowl Shuffle"–style (old school phrasing, performed directly to the camera) by Davis and collaborator Quinta Seward. Superimposed in front of a variety of background images of ads for maxi pads and tampons, the two women lip-synch corny rhymes and mimic hip-hop bravado (sunglasses, B-boy stance with arms crossed), lampooning the sense of "confidence" that feminine products claim to offer women in the face of potential public embarrassment. Shots of Davis and Seward rapping are intercut with scenes of a multiracial cast of women performing classic embarrassing scenarios (getting your period at the prom, at the gym, walking down the aisle). *A Period Piece* thus speaks to or about not just Black women but all women. Rapping into tampon-microphones and splattering giant red blobs electronically on the women's bodies (via chroma-key compositing effects), Davis playfully appropriates video techniques and the masculinist posturing of hip-hop to push the boundaries of what women should talk about and how they should talk about it. Her presence in the video is in keeping with feminist video practice of the 1980s and early 1990s, in which artists such as Cheryl Dunye and Yvonne Welbon feature themselves on camera, using the inexpensive, accessible technology of video to represent their own life histories and experiences.

Makarah's *Define* also features a multiracial cast of women (Black, Asian, Latina) who, in a more meditative set of vignettes, demonstrate links between their efforts to define themselves against the oppressive labels placed upon them by the dominant society. Stylistically echoing the performances staged in the video works of Marlon Riggs, Makarah's opening voice-over and appearances with the other women (in various poses against black backgrounds) emphasize the challenges women of color face in trying to articulate themselves as artists in dismissive, hostile environments. As in Dhanifu's *Bellydancing* and Davis's *A Period Piece,* Makarah's performance emphasizes her body in ways that resist generalizing her experiences to Black subjects while tying her to other women of color. So while these performance-based works speak to issues that are relevant to Black people as a racial group, their

FIGURE 8.5. *A Period Piece* (Dir. Zeinabu irene Davis, 1991).

FIGURE 8.6. *Define* (Dir. O.Funmilayo Marakah, 1988).

concerns are also visibly and audibly connected to those of women of other backgrounds. In these works, Dhanifu, Davis, and Makarah call attention to themselves as women makers who are Black and Black makers who are women, also highlighting that these intersectional identities shape how they perform in front of and "behind" the camera.

PLAYING THEMSELVES AS ARTISTS

The issue of how the makers' complex individual identities and creative efforts relate to their racial group is central to L.A. Rebellion works in which the makers directly reflect upon their status as artists. As we see in their work in general, when the L.A. Rebellion makers portray themselves as creators of the works we are watching, they tend to emphasize their shared cultural identities with the other Black subjects they represent. But their self-representations nonetheless register the complexities of occupying the role of "Black filmmaker" and display the limits of playing the authentic racial insider, not least because of intersecting issues of gender identity. And when the L.A. Rebellion artists represent themselves as film/videomakers, they call attention to their formal and stylistic choices by framing themselves in relation to other Black artistic practices.

A number of L.A. Rebellion filmmakers represent themselves making films that profile Black artists working in other media. Janet K. Cutler has argued that making films about artistic mentors and inspirations has been a "rite of passage" for emerging Black filmmakers and that they tend to "exhibit a strong identification with their artist-subjects," particularly when "both documentarian and artist see themselves as 'storytellers' intent on illuminating previously neglected aspects of black experience."[21] As we might expect, then, appearances by L.A. Rebellion makers in films of this sort tend to be brief and to serve a framing function, foregrounding the featured artists. But just as the L.A. Rebellion makers negotiate an insider/outsider status when representing other members of their racial group, we can see points of synergy and difference between the filmmakers and the artists they profile. The filmmakers' limited on-screen presence helps us to see how their works as a whole raise questions about what film/videomaking does and does not share with other Black artistic practices formally and with regard to the question of Black artists' social and political roles.

These questions are central in the film *Black Art, Black Artists* (1971) by Elyseo Taylor, the UCLA professor who developed the film school's

Ethno-Communications Program and recruited and taught many members of the L.A. Rebellion group. The film documents an exhibition of Black art, probably the encyclopedic 1966 show "The Negro in American Art: One Hundred and Fifty Years of Afro-American Art" shown by UCLA's Dickson Center. The film's visual track displays paintings and sculptures by African American artists from the nineteenth century (the landscape paintings of Edward Mitchell Bannister) to the present (Noah Purifoy's 1966 assemblage sculpture *Sir Watts*), while the soundtrack features a conversation about the history of Black art between Elyseo Taylor and woodcut artist Van Slater. Though Taylor never appears onscreen, his vocal presence as interviewer (in cinéma-vérité style) functions in tandem with his selection of a range of Black musical forms (gospel, jazz, blues) and his varied visual approach to presenting the artwork (entire works and details, static and mobile views), both to document the work of other Black artists and to raise questions about how film relates—aesthetically and politically—to other Black artistic practices.

"The artist" Van Slater, identified in the opening credits with Compton Community College (where he presumably teaches), speaks with authority about the styles and subject matter Black artists have used across history and about the pressures they have faced, including proving their artistic capability, suiting white and middle-class Black audience tastes, and making or avoiding explicit political statements. As we watch Taylor's film document Slater's proficiency at woodcutting, along with works by dozens of other Black artists, we are invited to think about the status and functions of film as a medium for Black artistic expression. *Black Art, Black Artists* implicitly asks how Black filmmakers think about questions of style and content, of technical process and mastery, of the expectations of white and Black audiences, and of political commentary.

This last issue is particularly salient at the moment when Taylor and Slater talk, in the midst of the Black Arts movement. Slater repeatedly says that things are currently changing, that Black artists are becoming less imitative and more "honest," developing their own voices and connecting with the Black public in ways that were not happening before. But he also resists the idea that contemporary Black artists need to respond to "the revolution" in the same way. For example, Slater describes a scenario in which two Black artists see the same blighted urban conditions and respond in different ways. One artist takes an aesthetic interest and "wants to show us the beauty despite the decay";

FIGURE 8.7. *Black Art, Black Artists* (Dir. Elyseo Taylor, 1971).

he "finds delight in the rustic peeling paint, weed grown lots" and "sees a riot of color here." The other artist sees the same scene and thinks that "this is a failing of society"; in his painting, "he will more or less propagandize" by making a "social commentary." While Slater is reluctant to give one approach more merit than the other, Taylor's questioning suggests his sense that the political statement has more value because it makes "a more immediate contribution." This view is consistent with how Taylor trained his film students of color at UCLA, particularly his strong interest in documentary as an immediately useful mode of filmmaking for "minority" groups. Slater, however, is more ambivalent on this question, as he demonstrates in a sequence when he talks about the creation of his noted portrait *Eula Seated* (1964), in which a woman sits in a corner with a rather melancholy expression.[22]

We hear Slater's voice as we see close-ups of his hands shaving wood, explaining that *Eula Seated* was created out of a "kind of a vague idea": "all I knew when I started the picture was that it had to be a sense of perhaps someone being trapped." Responding in the negative to Taylor's question about whether *Eula Seated* reflects his belief that Black people are in a "hopeless" state, Slater says that it is rather a "personal expression, and it perhaps may have reflected somewhat my own state

or the state of the girl, Eula, which was my wife. She was reluctant to pose for me. But I insisted. And her reluctance to pose affected the work. But it happened to suit the mood that I wanted. [. . .] At that time that was the kind of picture I wanted to do and I can't explain it in larger sociological terms than that."

I quote Slater at some length because his comments, and the way they are rendered, powerfully illustrate the complexities of his creative process, which offer insight into creative processes more generally. Taylor's film presents Slater's words in voice-over—Slater never speaks on camera with synchronous sound. This approach (while less logistically complicated for a low-budget film such as *Black Art, Black Artists*) suggests that film can offer insights that the artwork alone cannot. The film's soundtrack can contextualize and animate the images of art with important debates and inner thoughts. Slater uses numerous qualifiers to describe the origins and development of the work ("kind of a vague idea"; "sense of perhaps"; "perhaps may have reflected somewhat"), foregrounding feeling ("mood") over intellectual or political intentions, thus destabilizing deep tendencies to read Black art in such light. He also acknowledges how the contingencies of creation—his wife's reluctance to pose—shape the work. This acknowledgment of the contingencies of the artistic process is extremely useful for thinking about filmmaking in general, and low-budget filmmaking like the L.A. Rebellion in particular, because as discussed earlier in this essay, these works are profoundly shaped by the major economic, social, and political limitations they faced. The particulars of Slater's story are also significant—his wife's "reluctance" to pose and the fact that he "insisted" she do so says much about the gender roles he and his wife play. Slater's desire for the freedom to express himself outside of the expectations of racial politics is fulfilled in part by his assertion of male dominance over his wife. Her bad "mood" generates the expression—read by Taylor as Black disaffection—that inspires one of Slater's most celebrated works.

While Slater's story evokes a rather stereotypical interaction of male artist and female model, Barbara McCullough's video *Shopping Bag Spirits and Freeway Fetishes: Reflections on Ritual Space* (1981) provides a complex picture of what it means for a woman to articulate herself as an artist. McCullough delves more deeply than Elyseo Taylor into the relationship between the film/video artist's creative process and that of Black artists working in other media. McCullough was deeply interested in exploring how film and video could be used to address aesthetic and spiritual questions that are both personal and shared.

FIGURE 8.8. *Water Ritual #1: An Urban Rite of Purification* (Dir. Barbara McCullough, 1979).

McCullough opens *Shopping Bag Spirits* with her earlier film, *Water Ritual #1: An Urban Rite of Purification* (1979), and then she appears in a close-up to explain the tape's focus on the theme of ritual. Like in Van Slater's work, there is an element of the intuitive that she cannot put into words, leading her to conversations with other artists: "Other people have asked me why it is that I am interested in ritual, and I can't really say that I understand why. I know in African societies that art and ritual are related, and that ritual objects are actually art objects. So therefore I thought what I would do is ask other artists of different media that I know why is it that they employ ritual, whether it be objects that they make, or words that they use, or actions or tones that in some way stand for symbolic action for them." *Shopping Bag Spirits* is at once a remarkable documentation of Black artists working in Los Angeles during this era (some of whom would become internationally renowned) and one of McCullough's many creative "exercises," in which she is exploring the possibilities of her film/video practice.

Throughout the tape, McCullough uses video to record the artists' creative processes and display their works and also to generate dialogue about aspects of the intuitive dimensions of artmaking that are difficult to verbalize. The tape's first featured artist, David Hammons, struggles

at first to describe how his creative process is related to ritual ("it's very hard to talk about these things"). But as we watch him arrange an improvised outdoor composition of found objects, he eventually likens his practice to those of vanguard jazz musicians. Later, poets Raspoeter Ojenke, Kenneth Severin, K. Curtis Lyle, and Kamau Daa'ood flow between describing and displaying their synergistic approaches, as does the improvisational musical trio Freedom in Expression, accompanying each other with voice and percussion. Senga Nengudi recalls feeling "possessed" while dancing in costume at the collaborative performance she staged to open her *Freeway Fets* installation at a Los Angeles freeway underpass, and we hear her cutting nylon stockings, the material she uses for her extraordinary panty-hose sculptures.[23] The analytical intimacy with which McCullough records these creative processes, and her own, reflects her insider/outsider positioning; as Trinh T. Minh-ha describes it, "Like the outsider she steps back and records what never occurs to her—the insider—as being worth or in need of recording. But unlike the outsider, she also resorts to non-explicative, non-totalizing strategies that suspend meaning and resist closure."[24]

Like an outsider, McCullough attempts to document creative processes that the artists present as natural and intuitive, dynamics that they cannot always put into the clearest of verbal terms. But at the same time, the casualness of their interactions with McCullough suggests that these artists view her as an insider, someone with whom they can share their intimate spaces of creation. While these interviews are shot in Los Angeles in, I imagine, some of the same neighborhoods in which *Bush Mama, Passing Through,* and *Killer of Sheep* were made, there is a sense of calm, safety, and productiveness in these creative zones, not just in what look to be home and studio spaces, but also in the outdoor spaces in which Hammons makes his assemblage and Nengudi installs and performs her works. And while McCullough is looking for insights from these artists, it is clear that whatever "explanations" she seeks are not intended to make their art legible to general audiences, as an outsider would. The tape is a personal ritualistic exercise that rather serves as creative and spiritual guidance for McCullough's own artistic development.

When McCullough appears a second time on-camera at the tape's conclusion, she gives further indication of how working in video situates her as insider/outsider among Black artists. She finds that video can complicate the individual and collective dimensions of artmaking in comparison with the poets, visual artists, and musicians she records/

FIGURE 8.9. *Shopping Bag Spirits and Freeway Fetishes: Reflections on Ritual Space* (Dir. Barbara McCullough, 1981).

interacts with in the tape. In a closing conversation with renowned artist Betye Saar, McCullough describes her effort to find a spiritual practice that can fill the void left by her disenchantment with Catholicism. While McCullough has chosen to work in film and video, she notes the challenges she has faced in trying to achieve the kind of spiritual expression via these media that Saar achieves in her assemblage pieces. McCullough (in her oral history) says that when she started working with the moving image, she felt that

> there should be a way that I'm able to utilize film and video to create another experience, a cathartic experience, spiritually motivated, for my audience or for my participant viewers. [. . .] I started this project by saying, OK fine, I'm going to do these rituals that I was going to create, and I would work with one camera and I would do these things. And I really felt at a loss after a while because I felt like I didn't know what I was doing, I didn't have enough background, I didn't maybe totally understand enough things to just proceed by myself in my exploration.[25]

McCullough tells Saar that her work is inspirational because of its "utilization of things, symbols [. . .] that seem to want to touch another world, that seem to tune in to another level of existence." McCullough then shyly asks, "I was wondering, um, how did you get to that point? You know? [They laugh.] How did you get to that point?" Saar responds by offering McCullough an inspiring definition of ritual: it is not just a

rite but also "what feels right," a process that builds the artist's sense of success and confidence.

When McCullough whispers "thank-you" at the end of their interview, she is expressing gratitude to Saar for helping her build her own artistic confidence. McCullough recalls in an oral history that the first time she interviewed Saar for this project, the sound recordist failed to get any audio, a snafu that left McCullough "totally demoralized" and "too embarrassed to go back and tell her I didn't have sound, till much later on."[26] *Shopping Bag Spirits* was made when video recording equipment was quite cumbersome and involved multiple crew members, factors that could exacerbate the already gendered dynamics that discouraged women from engaging in moving-image production. Gender and technology pose obstacles to McCullough, and she struggles with how to make video feel useful, natural, and "right" like the family heirlooms and African ritual objects feel in Saar's assemblages.

McCullough's performances as herself in *Shopping Bag Spirits,* with their intense focus on creative processes, are not simply explanatory bookends for the artist profiles. They also represent the interactions between her subjectivity as videomaker, that of her other subjects, and the recording apparatus that could be intimidating and alienating for artists from marginalized groups. McCullough engages in a creative practice that is as much about process as it is about finished products, frequently restaging and reworking material. She goes back to Saar for a do over of their conversation, not just to replace footage, but also to have an interaction informed by what she has learned in the interim. McCullough also includes her older project *Water Ritual #1* within *Shopping Bag Spirits,* but she updates the black-and-white film with colorful video effects. In these ways, McCullough's self-representation acknowledges her vulnerabilities in relation to other Black artists, her steep learning curve in relation to her chosen media of film and video.

This degree of authorial vulnerability that McCullough expresses as a Black woman videomaker is less readily visible in Charles Burnett's on-screen appearance in his film *Nat Turner: A Troublesome Property* (2002), though the film calls into question notions of authoritative historical or creative interpretation. Produced for PBS, the film explores the life of the leader of the legendary slave rebellion in Southampton County, Virginia. The film surveys how Nat Turner has been represented across history: from the jail cell interviews with Turner published by white Virginia lawyer Thomas R. Gray in 1831, to Harriet Beecher Stowe's Turner-like character in *Dred: A Tale of the Great Dismal*

Swamp in 1856, to Black playwright Randolph Edmonds's version of Turner presented in 1935, to William Styron's controversial Pulitzer Prize–winning 1967 novel *The Confessions of Nat Turner*. The innovative structure of Burnett's film combines interviews with esteemed historians and other commentators with dramatizations of various authors' constructions of Turner performed by different actors. Offering a comparative view in this way—Gray's Turner played by Carl Lumbly; Edmonds's Turner played by Tommy Hicks; Styron's Turner played by James Opher; and so on—Burnett emphasizes the lack of authoritative evidence about this historical figure and the ways in which this lack of specificity has enabled varied characterizations of the man as martyr, hero, monster, depending on the context. As the film's narrator, Alfre Woodard, puts it, "There certainly was a real Nat Turner who lived and died in Southampton County, Virginia, in 1831. But the man who lived and died in numerous artistic portrayals since 1831 was re-created over and over again to fit the needs of each of his creators."

Burnett appears toward the end of the film, presenting himself at the end of a long line of artists who have taken up the figure of Turner and his meanings in the history of race in America. Burnett comments in the film that "it is not that we are trying to reclaim Nat. We are just trying to present other artists' interpretations of Nat Turner and trying to do that very faithfully without interpreting their work." Though Burnett says his goal is to be as "faithful as possible" to earlier representations of Turner—he is "not trying to take any kind of license"—the footage of Burnett directing the actors and coordinating shots with the crew highlight the creative, interpretive work that he and all of these people are performing. The film's co-producer and co-writer, historian Kenneth S. Greenberg, acknowledges this work when he asks, "When you do a film about interpretation, what's the film about that interpretation? Isn't that film another interpretation?"

Though *Nat Turner: A Troublesome Property* centers on representing others' representations of Turner, the shots of Burnett in production cannot help but implicate him in the debates about what has motivated different artists in their approaches to Turner, particularly, as Burnett notes, how artists have "interpreted [Turner's uprising] a certain way on racial lines." The shots of Burnett making this film raise questions about "the cultural, sexual, political inter-realities" involved in his approach to the project as a Black male director from the South. Indeed, these behind-the-scenes shots of Burnett are preceded by shots of another contemporary Black artist, the Southampton-based painter

FIGURE 8.10. *Nat Turner: A Troublesome Property* (Dir. Charles Burnett, 2002).

James McGee, completing a large canvas depicting Tuner and his fellow rebels. Burnett and McGee state very different motivations for their representations of Turner: McGee says he paints "to illustrate what is said to me through my ancestors," while Burnett seeks to cultivate interracial dialogue about this historical event. And their conditions and methods of creation differ substantially: McGee works alone while Burnett collaborates with an interracial production team. By showing these two Black male artists in this order, the film invites us to think about how Burnett's film functions as a work of art in its own right and about the racial politics of Burnett's authorship, even if he does not raise these issues directly.

Burnett's self-representation is that of a filmmaker who is proficient and self-assured, able to helm a high-prestige project and to re-represent the works of a host of other artists. Indeed, Burnett enters the history of Turner's mythobiography using a medium that can re-represent all previous media—literature, theater, visual art. Burnett's self-portrait as a filmmaker is quite different from Barbara McCullough's more vulnerable, self-exploratory mode in *Shopping Bag Spirits and Freeway Fetishes: Reflections on Ritual Space,* and it resists the overt political commentary advocated by Elyseo Taylor in *Black Art, Black Artists.* But as meta-artistic projects, all of these works show the makers negotiating their own creative positions in relation to the aesthetic and political

issues faced by other Black artists. In the final section of this essay, I describe how members of the L.A. Rebellion group represent their identities and activities as film/videomakers when they work in autobiographical modes, in which the inter-realities of "the film-maker as subject; that of the subject filmed; and that of the cinematic apparatus" are most explicitly conveyed.

PLAYING THEMSELVES IN PERSONAL NARRATIVES

As we have seen, self-representations in L.A. Rebellion works visibly and audibly confirm Trinh T. Minh-ha's observation that the filmmaker of color "cannot speak of them [the racial group] without speaking of herself." We might say that their autobiographical works show the reverse to be true as well: the L.A. Rebellion film/videomakers cannot speak of themselves without speaking of "them," the community members they are charged to represent. Indeed, when the L.A. Rebellion makers play themselves in intensely personal and autobiographical works, they take great pains to share representational space with representatives of the community, family, and cultural histories that have shaped them. This serves as further evidence of the L.A. Rebellion artists' firm commitment to use their chosen media to illuminate Black experiences in general. But these autobiographical reflections also display and discuss the authors' differences as film/videomakers from the other Black subjects they represent. To return to Thom Andersen's praise for the L.A. Rebellion group, their works describe "another reality" that deviates from not only the dominant (white, middle-class, Hollywood) version but also versions that might be articulated by other Black subjects. The makers' autobiographical works make most explicit the ways in which their constructions of time and place, history and memory are informed by concerns for their racial group as a whole but are filtered through their individual subjectivities and creative labors.

In *Imperfect Journey* (1994), for example, Haile Gerima presents himself as an empathetic spokesman for repressed Ethiopian subjects. He returns to his home country with Polish journalist and author Ryszard Kapuściński to document the devastating effects of Mengistu Haile Mariam's military junta and to consider the country's future after Mengistu was deposed in 1991. Much of the film consists of interviews in which people describe the horrors of the Ethiopian "Red Terror" of 1977–78, the genocidal campaign Mengistu waged against alleged "counterrevolutionaries." Gerima left Ethiopia to study in the United

FIGURE 8.11. *Imperfect Journey* (Dir. Haile Gerima, 1994).

States in the late 1960s. It is, therefore, as an insider/outsider that he collects stories from people who remained there through the violence and famine of the 1970s and 1980s and from those who live with the prospect of continued political repression with the new regime.

Commissioned by the BBC, *Imperfect Journey* investigates the state of a nation. Yet it reads very much like a personal, autobiographical narrative because of Gerima's extensive references to his early family life in Ethiopia and his consistent physical and aural presence throughout the film. He is known as "Gerima's son," the offspring of a widely known playwright, and the filmmaker brings new tools to continue his father's project of educating and fortifying Ethiopian people through storytelling. Gerima appears on-screen consistently. We see him in conversation with Kapuściński as they travel around the country and conduct interviews. Gerima interviews people in Amharic, often in a call-and-response rhythm that demonstrates his intimate engagement with their stories. At highly emotional moments we see him comfort interviewees as they express their still raw grief for children and siblings they lost decades ago, at one point holding an elderly woman's hands in the foreground of the shot. Gerima also provides voice-over narration

throughout the piece, describing the making of this project frequently in terms of the access he can gain to his interviewees through his family connections.

In these ways, Gerima emphatically embraces the role of spokesperson, noting that "every time I return to Gondar, the people want to tell me about many things; they want to tell me things so I can tell the world for them." Gerima thus acts as a vessel, and his insider/outsider status is key to collecting and then disseminating the stories beyond Ethiopia's borders. Given the film's BBC sponsorship, it is not surprising that Gerima acts as a kind of interpreter, making the stories of his countrymen and -women visible and sympathetic to white Western audiences. At the same time, Gerima's representation of his filmmaking process is structured by what he cannot capture, the roadblocks that he faces. At a key moment, Gerima summarizes in voice-over a disturbing interaction he has with government officials in which they try to dictate the contents of his film. We might read this moment alongside Gerima's rendering of his run-in with police while shooting *Bush Mama* in Los Angeles two decades earlier, as another illustration of how his filmmaking faces state repression. This image of Gerima facing and defying political repression is fundamental to his self-representation as a Black filmmaker. The camera seems to place a target on his back, subjecting him to the kinds of dangers faced by the disempowered Black subjects he seeks to represent. Gerima uses this as a strategy to make his difference (as filmmaker) a sameness.

While Gerima attempts to fuse his subjectivity with those of others in his racial/cultural communities, other L.A. Rebellion artists show the tensions that inhere in their status as the same/other, insider/outsider to be less readily resolved. There is a strong sense of intraracial and interracial alienation in Omah Diegu's (Ijeoma Iloputaife's) *The Snake in My Bed* (*Die Schlange in Meinem Bett*, 1995). Produced with funds from the German government (Young German Film Committee and ZDF Television), the film shows Diegu returning to sites in her home country of Nigeria and in Germany to retrace traumatic episodes in her own life. While in Nigeria, Diegu had married and had a son with a white German businessman who later abandoned her to return to a German wife and child he had kept secret. In the film, as Diegu fights to get her son's father to acknowledge his paternity, she finds herself caught between two worlds in which she is seen as a transgressor and her son's identity is deemed illegible and illegitimate. "The position of a child that is born of a white father is insecure" in the Ibo culture, she tells us. In this patriarchal society,

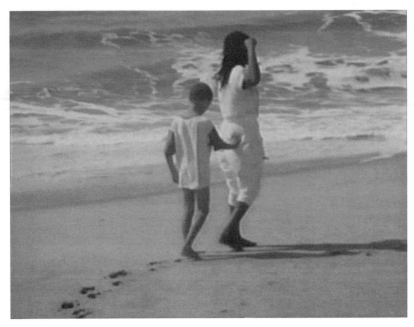

FIGURE 8.12. *The Snake in My Bed* (Dir. Omah Diegu [Ijeoma Iloputaife], 1995).

and with probable rejection from his white patriarchal line, "a boy would have to scratch up a lineage practically from the street. Such a child is therefore way out of the system."

Diegu presents herself as an insider/outsider in several ways. She stages numerous on-screen conversations between herself and relatives and friends in Nigeria and Germany about her ordeal, in which we can see the rock-and-a-hard-place position she and he son were in, with people in both locations having no experiences to draw upon to help her find resolution. She also acts as the film's narrator, speaking to her son in voice-over as if the film is a letter he can read someday when he is old enough to take in the story of his troubled origins. The visual track primarily shows locations that are central to her story, or that resonate with them—scenes from an Ibo wedding while she describes her own wedding, a baby duck floating with its family as she describes her child's birth, kids at a German playground while she talks about an encounter with another biracial child years before. The shots meditate on landscapes (ocean, foliage, roads) and activities (hair braiding, church services, gardening). Diegu appears in some but not all of these scenes, typically as an observer, while her voice-over narrates what her

experiences were like in these and similar spaces. There is thus a consistent lack of alignment between Diegu's vocal and visual performances and a temporal gap between the past she talks about and the present she shows, heightening the sense of her dislocation.

While Diegu uses her voice-over to produce a sense of interiority (as we see in *Rain* (*Nyesha*) and *Black Art, Black Artists*) and to offer explanatory information (as we see in *Gidget Meets Hondo* and *Imperfect Journey*), her voice never smooths over the disjunctures between sound and image. It works with the poetic, meditative quality of her lingering shots to heighten our sense that she is analyzing her situation, not simply recounting it. Her voice-over challenges us as viewers to analyze her situation as well, not simply to consume her images as racial melodrama. To this end, Diegu also resists exploitative readings of her light-skinned son by taking care to represent him only indirectly on-screen (his limbs; the back of his head, in silhouette). We get the first frontal shot of his face at the film's conclusion, when Diegu has secured the legal acknowledgment of her son's paternity, giving him the homeland identity he needs in order to have a place in both Ibo and German societies. While Diegu's film concludes with her son carefully following in her footsteps along a Nigerian beach, the phenotypical differences between them signal that their status as outsiders may never be resolved. The film expresses Diegu's hope that her son and her Ibo society will find compatibility, but ultimately she cannot speak for either of them.

Many members of the L.A. Rebellion group employ themes of traveling to and from home and of family legacies in their autobiographical works. Their attempts to create meaningful, affirming images require addressing historical traumas and ruptures such as the slave trade and later migrations in Black individual and collective experiences. We see this in Shirikiana Aina's *Through the Door of No Return* (1997), another film that centers on returning to Africa, but from the perspective of an African American. Aina brackets her visual presence even more than Omah Diegu does in *The Snake in My Bed*, suggesting an even greater distance Aina has to bridge between her self and her African brothers and sisters.

Born and raised in Detroit, Aina describes her project as motivated by her father who, during his older years, "surprised everybody, got his Super 8 camera, and up and went to Africa" for the Pan-African Congress in 1974. Aina's father, Edward Mack Moss, died before she could talk with him about his experiences in Africa and her generation's burgeoning interest in the continent. She announces *Through the Door of*

No Return as a project that she takes up at the age of forty, now that she is a mother herself, seeking to understand her personal, familial, and cultural relationship to Africa and its people through her father's experiences. We see her hands take a vintage Baskon 8mm camera (presumably her father's) out of a leather case. She blows off the dust, holds it up to her eye, and says in voice-over, "With a small film crew I started out to follow my father's voice, to follow my father's footsteps." The image of Aina looking through the camera is shot from the side and heavily shadowed. This silhouetted profile captures the authorial role Aina plays in the film: she is a vehicle, seeking answers that will connect the ancestral past to her own life and those of present and future generations of Black people.

Aina provides a continuous, poetic voice-over throughout the film, but she only rarely and partially appears on camera. She documents her tour of slave "castles" in Ghana, the dungeons where enslaved Africans were held before they walked through "the door of no return," to be packed into ships headed to the New World, and she interviews fellow Black tourists, primarily from the United States. Aina also interviews Black people who have repatriated from the United States and the Caribbean to make their homes in Ghana. While we occasionally hear Aina's voice ask questions in these interviews, she does not present herself speaking on camera. And in the film's powerful opening and closing sequences featuring family photographs and a visit to her father's gravesite, she shows not herself but her children interacting with these artifacts of family history. Aina's slow-moving, close-up shots of her children and her many Black interviewees in Africa capture their wide range of emotions as they engage with their histories and feelings, as varied as their brown skin tones rendered attentively in natural lighting. By staying by and large out of the frame, Aina's camera becomes her point of view, conveying a strong sense of intimacy, love, and respect for her Black subjects. It is tempting to contrast Aina's subdued presence in her film with Gerima's in *Imperfect Journey,* in which he similarly travels and interviews people but includes his speaking image, in terms of gender difference—they occupy roles as vessels in strikingly different ways. But, as discussed above, the women filmmakers McCullough (in *Shopping Bag Spirits*) and Davis (in *A Period Piece*) speak/rap on-camera. Aina's approach seems motivated both by her gender and her project: she is presenting herself as her father's daughter and a daughter of Africa, and as a mother with a responsibility to impart family history for future generations.

FIGURE 8.13. *Through the Door of No Return* (Dir. Shirikiana Aina, 1997).

By emphasizing her vocal rather than visual presence, Aina situates her storytelling in the African oral tradition of communal expression, rejecting what Teshome Gabriel describes as the "concept of 'hero'" in Western narrative traditions. Aina does not individuate herself to enlist audience identification with her alone. Rather, her presence is structured to stress the need for "collective engagement and action," so that her presence "does not make history" but "only serves history's necessities."[27] One of these necessities is to create the conditions for people in Africa and its diaspora to recognize one another in the wake of the massive rupture of the slave trade. Aina notes the "local amnesia regarding slavery" that prevents many Ghanaians from recognizing her and the history of enslavement that she represents. In one of the film's most powerful scenes, Aina's camera focuses on an elderly priestess as Aina asks her if any descendants of enslaved Africans are in the room. Aina's effort to "document one moment of attempted recognition on camera" is staged suspensefully; eventually the elder points questioningly toward the camera where Aina is positioned. By remaining off-camera even at this highly personal moment, Aina attempts to open the scene up beyond her individual experience to create a space for her Middle Passage Black

viewers to vicariously experience recognition by Africans. She attempts to use film to develop an intersubjective relation with Africans that is deeper than superficial tourism.

Just as Aina searches for her history and identity through the travels of her deceased father, Carroll Parrott Blue tells her life story through the lens of her mother's life and the complicated relationship they shared as a southern Black family. Published as an interactive DVD-ROM (as well as in book form), Blue's groundbreaking *The Dawn at My Back: Memoir of a Black Texas Upbringing* (2003) describes in vivid detail how she and her mother, Mollie Carroll Parrott (1900–1976), pursued the same goals of educating themselves and working toward the social equality of Black people.[28] Mollie Parrott pursued these goals as a community organizer in Houston, while Blue has pursued them as an artist, a beneficiary of the opportunities opened up by the civil rights movement. Blue recognizes her indebtedness to the labors of her mother and thousands of other Black women community activists who were the rank and file of Black liberation efforts but did not receive acknowledgment in official histories for their work: "My mother was more like a worker bee or a soldier ant. Historically, she is faceless."[29] Blue's memoir seeks, in part, to redress this facelessness by telling her mother's story. She shares the space of her memoir, so that it includes the events stretching far back before her own birth.

Sharing this space with her "heroine" is a complex matter, though, because Blue's mother's facelessness contributed in large measure to the deep frustrations that caused her to be an abusive parent. Mollie Parrott bristled under the profound limitations placed on her as a Black woman in the South before, during, and after the civil rights era, despite her extraordinary intelligence and ambition. Blue explains how her mother channeled much of her resentment toward her daughter, the product of an unwanted pregnancy in a troubled marriage. *The Dawn at My Back* functions in many ways as Blue's journey toward understanding her mother's position, an attempt to find peace and healing by confronting the many factors that shaped her mother's worldview and life experiences: lynching, segregation, the assimilationist aspirations of the Black middle class, sexism, media misrepresentation.

In light of the overwhelming presence of Mollie Parrott and the personal and racial histories she represents, Blue modulates her presence in this memoir. Much like Diegu's presence in *The Snake in My Bed* and Aina's in *Through the Door of No Return*, Blue's presence in the DVD-ROM is largely expressed through her narration. In the expansive audi-

ovisual archive of both the DVD-ROM and book, images of Blue are relatively few. On the book cover, she appears in a self-portrait consisting of her shadow on a Houston sidewalk, hand bent toward her head holding a camera we cannot see. Her mother's eyes are superimposed over Blue's shadow image, challenging her, and us, to come to terms with the difficult times Blue has seen. Blue's self-portrait functions very much like Shirikiana Aina's silhouette at the start of *Through the Door of No Return*, announcing her presence not simply for herself but for the representation of her parent's story, her race's story.

The synergies and differences between the lives of Blue and her mother are effectively conveyed through *The Dawn*'s interactive DVD-ROM format, which allows viewers to move through the memoir in a nonlinear fashion. We hear episodes of audio narration by Blue as we navigate a quilt-inspired interface, in which Blue offers a vast archive of visual texts that evoke various times, locations, themes. These visual texts include family photographs and letters, newspaper and magazine articles, advertisements, portraits of Hollywood stars like Lena Horne and Dorothy Dandridge, and samples of Blue's extensive work as a still photographer. The topics in the DVD-ROM and book make sweeping personal, historical, and cultural connections: reading her mother's annotations written into a book about Spanish history is connected to the "discovery" of the New World and its history of enslavement, seeing Ava Gardner in the film *The Barefoot Contessa* (Dir. Joseph L. Mankiewicz, 1954) at the age of eleven, taking her own film to a festival in Bilbao on her first trip to Europe, and the inspiration she finds in Pedro Almodóvar's film *All about My Mother* (1999).

While the events and texts Blue selects connect her to her mother within shared histories of oppression and aspiration, she charts how her own subjectivity develops beyond the limitations experienced and embodied by her mother. For example, after an outing to the movies, her mother is disgusted by the ending scene of *The Graduate* (Dir. Mike Nichols, 1967): "But to my mind, in that film my generation was clearly winning. We had barred the church doors with a cross. Her generation was locked inside, screaming silently through the windows, looking on helplessly at Dustin Hoffman and Katharine Ross as they escaped, happy and free. Looking directly into her eyes, I realized I too had won. I was no longer joined at the hip of my mother's belief system. I was free. I had finally come into my own. I was going about the business of becoming an artist."[30] The sheer act of making this claim—"of becoming an artist"—was certainly bold for a Black woman in 1967, a declaration of a

Black creative self that defies the expectations of the dominant society and, very often, those of one's own family and community.

L.A. IN MY MIND . . .

In playing themselves, the L.A. Rebellion artists visibly negotiate the challenges of their insider/outsider positions as a pioneering generation of film/videomakers. Blue, Aina, Diegu, and Gerima do so by invoking familial relations, demonstrating how they are tracing the paths of their ancestors and/or laying new ground for the next generations. Burnett, McCullough, and Taylor study the examples of other artists. Makarah, Davis, and Dhanifu use performance to signal the multiple (not just racial) identities and affiliations they claim through their creative practices. And in a range of fictional works, Davis, Ballenger, Fanaka, Berry, Gerima, and Nicolas demonstrate how the Black worlds they feature on-screen are filtered through their subjectivities and creative processes.

While the L.A. Rebellion makers present themselves as vehicles for the expression of other marginalized subjects, their textual presence makes visible how their presumed status as authentic racial insiders is complicated by their activities as stagers and recorders of the action, as framers and interpreters of Black experiences. In fiction and nonfiction works, they consistently run the risk of using their positions of representational power in ways that replicate dominant anthropological methods of "giving voice" to the marginalized, in which, as Trinh T. Minh-ha observes, "these 'given' voices never truly form the Voice of the film."[31] We tend to overlook these power relations in Black filmmaking. But when the makers play themselves we see, perhaps surprisingly, that the relationships between Black artists and their subjects are not direct or seamless. These performances illustrate how the "documentary" value of L.A. Rebellion works includes the evidence they provide of Black artistic labor. And displaying this labor has different implications for male and female members of the group.

O.Funmilayo Makarah's deceptively simple short video *L.A. in My Mind* (2006) bears this out. The film presents what appears to be straightforward "documentary" footage shot mostly from her car as she prepared to move away from the city in the summer of 1995. The images we see turn out to be a litany of Makarah's most treasured Los Angeles resources: we see the ocean, a mural for the Los Angeles County Museum of Art, the UCLA campus, the Oh! My Nappy Hair salon, and other locations, as the names of numerous additional L.A. places, peo-

FIGURE 8.14. *L.A. in My Mind* (Dir. O.Funmilayo Makarah, 2006).

ple, institutions, and features float across the screen from various angles, in different bright colors and fonts: Biddy Mason . . . Trader Joe's . . . L.A. Free Clinic . . . Visual Communications . . . fast freeways . . . Charles Burnett . . .

L.A. in My Mind reflects upon the many people and places that have provided material and spiritual support for Makarah in her life as a media artist in Los Angeles. Makarah does not provide a voice-over but allows her selection of shots and overlaid text to speak for her. When she represents herself visually, it is usually in partial view, showing close-ups of sections of her face—primarily her eyes—sometimes occupying only a portion of the frame. These strategies might seem to minimize her presence. But the recurring shots of Makarah's eyes scanning in all directions emphasize her acts of looking, consistently reminding us that the video's visual and textual references to places and people of Los Angeles are filtered through her individual Black consciousness. Makarah does not simply record these scenes, and she travels far beyond South Central Los Angeles. The video represents Makarah's processes of collecting images of the city in/for her own mind's eye, of organizing and communicating them from her creative point of view. It is a powerful

assertion of Black female looking, an act that constitutes, as bell hooks has noted, a radical assumption of an ocular power long denied; hooks quotes Julie Dash: "'I make films because I was such a spectator!'"[32] As we look at Makarah looking, we see how the L.A. Rebellion's pioneering efforts to develop new methods for representing Black people onscreen have always included the crucial and complex work of developing identities, subjectivities, and images as Black women and men film/video artists.

NOTES

1. Trinh T. Minh-ha, "Outside In Inside Out," in *Questions of Third Cinema,* ed. Jim Pines and Paul Willemen (London: British Film Institute, 1989), 145.

2. Ibid., 147.

3. Ibid., 142.

4. Ibid., 133.

5. Clyde Taylor, "New U.S. Black Cinema," *Jump Cut* 28 (April 1983): 41, 46–48, www.ejumpcut.org/archive/onlinessays/JC28folder/NewBlackCinema.html. (accessed February 3, 2012).

6. Ibid.

7. See, for example, Toni Cade Bambara, "Reading the Signs, Empowering the Eye: *Daughters of the Dust* and the Black Independent Cinema Movement," in *Black American Cinema,* ed. Manthia Diawara (New York: Routledge, 1993), 120; Paula J. Massood, *Black City Cinema: African American Urban Experiences in Film* (Philadelphia: Temple University Press, 2003), 110; and Mike Murashige, "Haile Gerima and the Political Economy of Cinematic Resistance," in *Representing Blackness: Issues in Film and Video,* ed. Valerie Smith (New Brunswick, NJ: Rutgers University Press, 1997), 187.

8. Taylor, "New U.S. Black Cinema."

9. For a postmodern theatrical reflection on the discomforts of Black authorship and self-representation (via the author showing up in the work), see Branden Jacobs-Jenkins's play *An Octoroon* (2014).

10. Bernard Nicolas, oral history interview by Allyson Nadia Field, Jan-Christopher Horak, and Jacqueline Stewart, January 23, 2010, LAROH.

11. Michael Renov, *The Subject of Documentary* (Minneapolis: University of Minnesota Press, 2004), 110.

12. Minh-ha, "Outside In Inside Out," 146.

13. Ibid., 145.

14. W.E.B. Du Bois, *The Souls of Black Folk,* reprinted in *Three Negro Classics,* ed. John Hope Franklin (1903; New York: Avon Books, 1965).

15. Gayatri Spivak, "Can the Subaltern Speak?: Speculations on Widow Sacrifice," *Wedge* 7/8 (Winter/Spring 1985): 120–30.

16. Catherine Arnaud and Yann Lardau, "An Artisan of Daily Life: Charles Burnett," in *Charles Burnett: Interviews,* ed. Robert E. Kapsis (Jackson: Univer-

sity Press of Mississippi, 2011), 7. It is important to note that this quote is from an interview that translated Burnett's comments into French for publication in *La Revue du cinema* (July/August 1981), which were then translated (back) to English for publication in Kapsis's collection, undoubtedly changing Burnett's original wording.

17. Minh-ha, "Outside In Inside Out," 146.

18. Ibid., 145.

19. See Wahneema Lubiano, "But Compared to What?: Reading Realism, Representation, and Essentialism in *School Daze, Do the Right Thing*, and the Spike Lee Discourse," *Black American Literature Forum* 25, no. 2 (Summer 1991): 253–82; and Valerie Smith, "The Documentary Impulse in Contemporary African-American Film," in *Black Popular Culture*, ed. Michele Wallace and Gina Dent (New York: Dia Center for the Arts/Bay Press, 1992), 56–64.

20. Alicia Dhanifu's quotations in this paragraph are from her oral history interview by Allyson Nadia Field, September 13, 2010, LAROH. This debate raged between classicists and Afrocentrists, coming to a head with the publication of Martin Bernal's controversial 1987 book, *Black Athena*, which traces how racist ideologies developed through European colonialism, coding Ancient Greeks as white and obscuring the Egyptian (Black) influences on the development of Western civilization. Bernal, *Black Athena: Afroasiatic Roots of Classical Civilization*, vol. 1, *The Fabrication of Ancient Greece, 1785–1985* (New Brunswick, NJ: Rutgers University Press, 1987).

21. Janet K. Cutler, "Rewritten on Film: Documenting the Artist," in *Struggles for Representation: African American Documentary Film and Video*, ed. Phyllis R. Klotman and Janet K. Cutler (Bloomington: Indiana University Press, 1999), 153–54. Other examples of documentaries on artists by L.A. Rebellion makers, to name just a few, include Alile Sharon Larkin's portrait of poet and educator *Miss Fluci Moses* (1987); Zeinabu irene Davis's *Trumpetistically, Clora Bryant* (1989) about the pioneering jazz musician; and numerous works by Carroll Parrott Blue, including *Varnette's World: A Study of a Young Artist* (1979) about painter Varnette Honeywood.

22. *Eula Seated* is reproduced in Samella Lewis, *African American Art and Artists* (Berkeley: University of California Press, 2003), 253.

23. The work of many of these artists was featured in the recent exhibition curated by Kellie Jones. See the catalog *Now Dig This! Art and Black Los Angeles, 1960–1980*, ed. Kellie Jones (Los Angeles: Hammer Museum, University of California; New York: DelMonico Books/Prestel, 2011).

24. Minh-ha, "Outside In Inside Out," 145.

25. Barbara McCullough, oral history interview by Jacqueline Stewart and Jan-Christopher Horak, June 8, 2010, LAROH.

26. Ibid.

27. Teshome Gabriel, "Towards a Critical Theory of Third World Films," in *Questions of Third Cinema*, ed. Jim Pines and Paul Willemen (London: British Film Institute, 1991), 45, 48.

28. Carroll Parrott Blue, *The Dawn at My Back: Memoir of a Black Texas Upbringing* (Austin: University of Texas Press, 2003); special edition with a DVD-ROM by Carroll Parrott Blue, Kristy H.A. Kang and the Labyrinth

Project, *The Dawn At My Back: Memoir of a Black Texas Upbringing; An Interactive Cultural History* (Los Angeles: Annenberg Center for Communication, University of Southern California, 2003).

29. Ibid., 52.

30. Ibid., 196.

31. Minh-ha, "Outside In Inside Out," 134.

32. bell hooks, "The Oppositional Gaze: Black Female Spectators," in *Black Looks: Race and Representation* (Boston: South End Press, 1992), 126.

9

Encountering the Rebellion

liquid blackness Reflects on the Expansive Possibilities of the L.A. Rebellion Films

ALESSANDRA RAENGO

There is a sense in which my generation [. . .] received most
of our understandings of the politics of identity and race as
a digital signal, as an upload, if you like, of an always-already
marked set of structured absences: Fanon, the Panthers, Black
Power and so on. So there is a sense in which the founding
regime, the narrative regime that overdetermined everything
we did, came to us as a set of digital simulacra; as traces of
moments forever fixed as virtual references, but always
deferred and always already there as a signal, a noise, a kind
of utopian possibility.

—John Akomfrah

THE L.A. REBELLION COMES TO TOWN

In late summer 2013 Matthew Bernstein, chair of the Film and Media
Studies Department at Emory University, contacted me for a possible
collaboration: bringing the "L.A. Rebellion: Creating a New Black Cin-
ema" tour to Atlanta. He told me that the thirty-six films on tour across
North America would no longer be available after the end of the year.
If we wanted them we had to act fast.

Matthew's proposition came at a most propitious time, since I had
been considering the possibility of constituting a research group focused
on issues of blackness and aesthetics that would comprise students
within and without Georgia State University, as well as interested

curators, local artists, and intellectuals. I envisioned the group as both the product of and the motor for porous forms of cross-pollination between academia and less institutionalized centers of thought and creative production—a fluid structure inspired by the conviction that artistic, curatorial, and scholarly practices are only materially, but not substantially, different ways of generating critical thought. Opening our doors to the L.A. Rebellion appeared as an ideal and provocative first project. Thus the research group *liquid blackness* was quickly constituted in order to facilitate the unfolding of the L.A. Rebellion tour.[1]

Many of us knew the value of this work, even though we had seen only a handful of the films that came through with the tour, while others trusted the determination and energy of those more familiar with the films. All approached the tour as a collective research project. Thus, even before we saw the films, we came together and were slowly giving shape to some form of "collective," where decisions are made nonhierarchically and by trusting the "genius" of the group. We now realize how much this resonates with the very conditions of formation of the L.A. Rebellion, which had successfully experimented with collaborative and community-based modes of production and therefore could help us reflect on the power of collective forms of both artistic practice and critical thinking.

To prepare for the tour we shared an essential bibliography of critical essays on the L.A. Rebellion, and those of us in teaching positions restructured our syllabi to create both a context for and an introduction to the tour; we created ad hoc assignments, offered incentives to encourage our students' participation in the screenings, and enlisted our students' help in hanging flyers and advertising the events so that they would feel part of a community-building activity. In the process of designing publicity materials for the tour, we developed a close relationship with some of the L.A. Rebellion images, mostly frame grabs that the tour's curators made available to us. For the postcard and flyer, we chose two stills from Billy Woodberry's *The Pocketbook* (1980), while the iconic image of Barbara O. Jones as Angela Davis in Haile Gerima's *Child of Resistance* (1972), reaching through the bars of her jail, became the mesmerizing large poster for the tour. This is the same image in Zeinabu irene Davis's unfinished documentary, *Spirits of Rebellion* (2011), that Clyde Taylor cites as expressing the overall attitude of the new type of filmmaking he eventually described as the L.A. Rebellion.

From a conceptual standpoint, it was immediately clear to us that we did not want to present the L.A. Rebellion as a minority cinema that

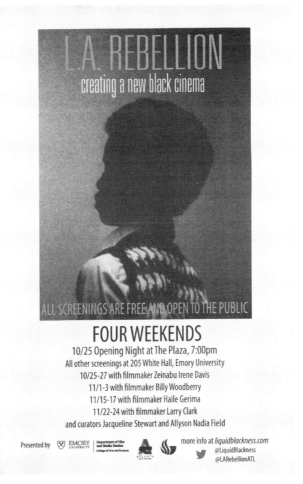

FIGURE 9.1. Atlanta poster, L.A. Rebellion tour, 2013. Joey Molina, poster designer. Image from *The Pocketbook* (Dir. Billy Woodberry, 1980).

should solely be directed to minority audiences. On the contrary, we discussed it as a body of work that expands the film history canon by demonstrating unseen possibilities of cinema as a medium and an art form to articulate experiences that have always been at odds with mainstream narrative structure and visual repertoires. Thus, we felt that the L.A. Rebellion's conditions, context, and modes of production have the potential to rejuvenate conversations about creativity in situations of oppression or neglect. A cinema of survival and endurance, the L.A.

Rebellion highlights the power of collective artistic practices in offering viable alternatives to articulate underrepresented experiences and political visions. We therefore felt that the L.A. Rebellion had to be offered as widely as possible; there was no audience or constituency that would not benefit from an encounter with this work. Hence it was our job to develop the transformative power of this encounter and make sure that the L.A. Rebellion would not leave its viewers unchanged. In fact, we sought ways to make the L.A. Rebellion *stay* and continue to resonate.

Many people in the larger scholarly community commented that it *made perfect sense* that the tour would travel to the South as its last stop in North America. Yet we quickly realized that this was not at all a self-evident proposition for our audiences and instead *sense had to be made:* audiences had to be educated as to what this material would be like, what it would be for, and why they should care for it. Further, we knew that hosting the tour would require strategies to involve nonacademic audiences, in keeping with the spirit of the L.A. Rebellion itself as well as the dynamic impulse at the heart of *liquid blackness*. In particular, I was inspired by the possibilities of collective viewing and the meaningful encounters that it might create, which these films had already mined in their previous public circulation at the time of their production. Michele Beverly, an alumna of the Moving Image Studies Program and former advisee, had experienced this firsthand when she worked with Haile Gerima and Shirikiana Aina during the distribution of *Sankofa* (1993); and Mary Feld, an advanced graduate student who was teaching a Third Cinema class at the time, told me she had been driven by an interest in the political possibilities of Third Cinema's communal viewing practices. It seemed to me that we had to attempt to create a similar experience and probe the transformative possibilities of the L.A. Rebellion cinema, given that it was made and consumed in a collective manner and for a collective good.

These considerations instigated the creation of a multifaceted and adventurous outreach program. We mapped out environments that we believed should be exposed to this type of cinema and created teach-ins to educate various Atlanta communities, bringing the filmmakers to places as diverse as the fine art gallery and the feminist bookstore, the community arts center and the corporate world.[2] We facilitated postscreening conversations to foster contacts between filmmakers and audiences and to let the works reverberate as we discussed them informally. We held the tour's opening night at the iconic Plaza Theater, made available by the Atlanta Film Festival,[3] and gathered afterward at the historic Manuel's

Tavern, a local hangout for progressive Atlanta politicians. We also congregated at the Low Museum, a gallery space run by Georgia State University undergraduate students on the first floor of their house, and at the Sound Table, a restaurant and music venue excited to host us after the screening of Larry Clark's *Passing Through* (1977). We in *liquid blackness* also reached out to scholars and curators in Atlanta to be in conversation with the films and some of the guest filmmakers.[4] The response, timid at first, continued to build over the unfolding of the film series.

Thus the process of hosting the tour became part of our own process of getting to learn the object, that is, the actual films and filmmakers. At the same time, our hosting was initiator and catalyst for the constitution of *liquid blackness* as a research group that is unavoidably already inspired by this encounter with the forms of collectivity that make up the L.A. Rebellion itself—collectivity not only in terms of collaborative modes of production (either with fellow UCLA students or more broadly with local communities of artists, sometimes specifically trained to work as film crew)[5] but also for the way that the L.A. Rebellion demands a collectivity at the point of reception. Of course, any filmmaking requires an audience to sustain itself.[6] But more specifically, as Larry Clark put it, channeling a sentiment he found expressed by Sékou Touré, art has to be demanded: the *people have to ask for it.*[7]

At the screenings, we discovered audience members who had traveled from Birmingham, Alabama, to see the films; others, such as two female activist producers from South Carolina, happened to be in town, saw our fliers announcing the tour, and came to see Zeinabu Davis's films and talk to her. I remember an Afrocentric architect, an Ethiopian restaurant owner, and various members of the business community; there were both seasoned and bourgeoning artists and curators who were swept away by the audacity of the cumulative vision of the L.A. Rebellion, as well as older and more "traditional" scholars who knew some of the Burnett, Dash, and Gerima films but came to see the less accessible works. The tour also gave us the opportunity to expose our own students to unseen material and to make sure that the young aspiring filmmakers among them would know that, though they might in the future find themselves working with compromised means, they do not have to compromise their vision. The work done for the tour eventually inspired a short publication we posted on our website, as a way to chronicle our voyage through this experience and maybe also as a form of thanksgiving for insights received that have already begun to inform our scholarly practices.[8]

WHAT WE HAVE LEARNED SO FAR

I want to emphasize "so far," since this is very much a still unfolding process and an ongoing commitment that, for instance, has brought us to undertake an in-depth study of *Passing Through,* which is still unfolding. This film in particular strongly resonates with the ideas of aesthetic liquidity we are pursuing as a group.

One of the first things we learned is that the L.A. Rebellion is a concept still in the course of definition. There is not yet a unified historiographical narrative. There is instead a vivacious plurality of voices, a polyphony of discourses, conversations, debates, and arguments about, for example, what it means to recognize this output under one historiographical umbrella, or what it means to describe it solely through Clyde Taylor's label as opposed to a broader definition of "black independent cinema."[9] Furthermore, while the L.A. Rebellion involved community-based and collaborative modes of production, the term *collective* does not strictly apply (although I feel attracted to it, if it is understood in a loose sense); nor does the term *school* apply and even less, we feel, the idea of a *movement*. Everybody we met (Zeinabu irene Davis, Billy Woodberry, Haile Gerima, Larry Clark, and two of the tour's co-curators, Jacqueline Stewart and Allyson Nadia Field) has a different version of what keeps this work together. From their accounts we piece together an attachment to, and celebration of, collaborative production practices and the awareness of making a radically different cinema that should be recognized as such, but also the impossibility, reluctance, or unwillingness to foreclose heterogeneity and individual expression by adopting a unified manifesto or poetic/aesthetic program.[10]

But then what might be the point of holding on to this (or any other) label? What might *L.A. Rebellion* ultimately designate?

The term is born from a desire to describe an aesthetic distinctiveness that emerged in clear opposition to the surrounding American cinema, thanks to the heterogeneous output of generations of nonwhite film students who were closely involved in each other's creative and production processes in the pursuit of different ways to tell their own stories or articulate their own artistic and political vision.[11] Yet, at this point in time, *L.A. Rebellion* describes more directly and unequivocally an archival project that challenges the understanding of American film history, claiming visibility for a set of aesthetic resources and production practices that, for some time, created a powerful parallel alternative to mainstream cinema.

Only now, as I am being asked to write about my own and the group's experience of the L.A. Rebellion, do I realize that in many ways I am the product and beneficiary of both of these moments. In fact, I learned of the L.A. Rebellion first from Manthia Diawara's *Black American Cinema* and Clyde Taylor's essays, as I first came in contact with NYU faculty in the early 1990s, particularly Robert Stam who, I am convinced, started it all by letting me read the page proofs of *Unthinking Eurocentrism*. Surprisingly, a year or two later, I met Clyde Taylor in Italy, at a communications conference called "Antenna Cinema," in Conegliano, a town only twenty minutes from where my parents lived. There I saw *Sankofa, A Powerful Thang* (Dir. Zeinabu irene Davis, 1991), and Barbara O. While this sequence of events still puzzles me, it also indicates how I was always predisposed to think of the L.A. Rebellion in the aggregate. Thus, I "buy" the need for some designation, because I realize that, from yet another angle, the *L.A. Rebellion* label can be seen as a way to emphasize the productivity of a specific set of circumstances: the first generation(s) of filmmakers of color to have a formal education in filmmaking; the first generation(s) of filmmakers of color to develop a specifically domestic focus/aesthetics at the same time as they were articulating a transnational film language; the first generation(s) of filmmakers of color to create urgently topical, yet timeless works; the first generation(s) of filmmakers of color to think of aesthetics as rarely, if ever, divorced from politics and to think of aesthetics from the point of view of a commitment to envisioning new ways of being in the world.

Finally, for us, the L.A. Rebellion is also inseparable from its tour, and thus it designates a specific series of events we facilitated in which various Atlanta audiences, who do not normally interact, came together in the same room to look at some (however loosely conceived) form of "collective" production and, more importantly, to consider the vivid testimony of the possibilities of an unrelenting Black imagination. The L.A. Rebellion is also what brought *liquid blackness* together, as a research group and as facilitator of conversations about the possibilities of blackness, creativity, and aesthetics. In this sense, the L.A. Rebellion is also very much a particular type of encounter. Thus, above and beyond its specific merit or shortcomings, one could regard this label and the archival program and scholarly output of which this book offers evidence as providing precisely the critical mass that, Larry Clark insisted, is necessary for any recognizable Black aesthetics.[12]

THE EXPANSIVENESS OF BLACKNESS

One of the most compelling, and possibly contagious, aspects of the L.A. Rebellion might be what Jacqueline Stewart has described as the determination to preserve the possibilities of "black imagination."[13] In this sense, the L.A. Rebellion is expansive. In fact, it is a body of work that demonstrates the *expansiveness of blackness*.

An expansive dimension of the L.A. Rebellion resides in its being fueled by a transnational sensibility, or what Teshome Gabriel described as a nomadic aesthetics.[14] This transnational sensibility is also evident at the point of reception, given the high visibility of many of these films in international film festivals, particularly in Europe and Africa. Developed through a close study of different national and transnational filmmaking traditions—most notably Third Cinema and African but also Asian cinema—the L.A. Rebellion also expresses a profoundly erudite cinema, which is radical in the very shape and modes of acquisition of this erudition: just consider the $1,000 grant that allowed Haile Gerima and other students to organize Thursday screenings of Third World Cinema, a film series eventually taken over by Teshome Gabriel.[15] Yet the L.A. Rebellion produced a cinema profoundly engaged with its local community, in other words, a cinema that finds *elsewhere* the artistic tools to articulate something very specific and tragically neglected about the *over here*. This is a cinema profoundly invested in portraying the *fine grain* of the community *here* and *now*, particularly, but not exclusively, in the case of Charles Burnett's and Billy Woodberry's films (*Several Friends* [1969], *Killer of Sheep* [1977], *My Brother's Wedding* [1983], *When It Rains* [1995] by Burnett; *The Pocketbook* [1980], *Bless Their Little Hearts* [1984] by Woodberry; but I should also mention Alile Sharon Larkin's *Your Children Come Back to You* [1979])—films that can be considered part of the L.A. Rebellion's "neorealist" thread.[16]

Many of the films pivot around various forms of Afrocentric imagination, an investment in seeking links, connections, and interpretive schema from an ancestral past and alternative forms of historical consciousness, temporality, and sense of space and place. One might read in *Water Ritual #1: A Rite of Urban Purification* (Dir. Barbara McCullough, 1979) and *I & I: An African Allegory* (Dir. Ben Caldwell, 1979), for instance, an Afrofuturistic sensibility in their exploration of forms of *being in*, but *not belonging to*, American culture. Many films share this sense that blackness comes from, and leads, elsewhere and communicates at levels that do not necessarily belong to an earthly plane.[17] They share a sense of

the possibilities of reassembling disjointed fragments of a past no longer within reach; the sense of a beauty that can be constructed from a place of debilitation; poetry that can be fashioned in the midst of endangered environments. In *Passing Through,* for example, jazz assumes a cosmological power: it seems to travel by water, across the Middle Passage—where the "Middle Passage" also manifests itself in the myriad forms of oppression in everyday life, poignantly documented through the use of archival newsreel footage of episodes of police brutality at Attica, Cleveland, and Birmingham—and yet, as the musicians' mentor Poppa Harris insists, jazz is also rooted in the earth and soil. It responds and expresses contingent experiences of disruption and alienation and yet it also communicates what he describes as the "universal tempo."

In some L.A. Rebellion films the expansiveness of blackness manifests itself as the ability to empower the body to overcome its own limitations, even when various racial and gender-specific forms of oppression coalesce around it. In Julie Dash's *Four Women* (1975), for instance, dancer Linda Martina Young acts *out* and *through* the various characters described by the Nina Simone song featured in the film's soundtrack. In the film's prologue Young's silhouette is tightly wrapped in a veil, signifying the physically and metaphysically cramped conditions of the Middle Passage. She struggles to break free, while the soundtrack carries sounds of whip lashes, water, and moaning. Then, as the Simone song begins, Young gradually develops a wider range of motion—first, as Aunt Sarah, her arms are still wrapped around her body; then, as Saphronia and Sweet Thing, she gains momentum and sensuality; and finally, as Peaches, she stretches her arms fully and kicks amply into the air, as the editing repeats this gestures at an increasingly faster pace. Her movements both mimic and overcome the limitations imposed upon the body of the different archetypal women described in the song's lyrics, while the camerawork and fast cuts layer a multiplicity of angles (including from underneath her jaw) onto her unfolding movements.

Similarly, Emma Mae, the "country cousin" arriving in L.A. from Mississippi in Jamaa Fanaka's eponymous film (1976), is surprisingly gifted with the capacity (and determination) to settle any disagreement with a fistfight. The film's editing emphasizes her power to exceed the frame, so that "not only [does she] transcend the forces that regulate her body, [but] she also initiates new possibilities that move through the bodies of those around her."[18] Alana, the protagonist of Alile Sharon Larkin's *A Different Image* (1982), insists on sitting with her legs spread open. This is comfortable to her, unattached to any intention other than the

expansive occupation of her personal space; yet the culture and people who surround her, particularly her male friend Vincent, find it difficult to accept this possibility. In Zeinabu irene Davis's *Cycles* (1989) the female body is both awesome and sublime: its physiological rhythms might at times be mysterious and unexpected, but its possibilities for beauty, harmony, and pleasure are boundless.[19]

The path for this type of exploration was already opened in Barbara McCullough's *Water Ritual #1: An Urban Rite of Purification,* in which the impact of the filmic image is tightly dependent on the expressive power of performer Yolanda Vidato's body. The climax of the film, her urination inside a dilapidated shack, constitutes a personal and social rite of purification.[20] But there is something I find even more poignant about the way this action unfolds in time. After she squats down, nude in the foreground and center frame, the film cuts to a close-up of her pensive face. After a few moments, the camera slowly moves down her body and stops at the pubic area. Only then, and only after this uninter-rupted camera movement, does she begin to urinate. The point here is that it is the cadence of her bodily expression that dictates the speed of the camera movement, not any heterodetermined dramatic logic of cin-ematic time.

The expansiveness of blackness also manifests itself in the L.A. Rebellion films in an intensive manner, especially in the "neorealist" films. For example, in the films' minute and loving commitment to the tight fabric of lived communities, the small but significant gestures of the people who live in them, made poignant and somewhat universal by the very attention the camera directs at them and by the plethora of gestural and verbal non sequiturs, which might not belong in a Holly-wood film but do belong to the subtle absurdities of real life.[21]

THE MAGNITUDE OF SMALL GESTURES

The lack of availability of many of the tour's films prompted a form of consumption that is decidedly cinephilic. Since the films were screened over four weekends between late October and late November 2013, we found ourselves holding on to gestures, moments, textures, and moods that profoundly affected us, which we tried to piece together in a short publication—"*liquid blackness* on the L.A. Rebellion"—the written reflections we issued shortly after the end of the tour. For us, therefore, the L.A. Rebellion is very much tied to our individual and collective recollection of the material we saw.

FIGURE 9.2. *My Brother's Wedding* (Dir. Charles Burnett, 1983).

In our brief writings on the tour we all focused on different details, but here are some of the gestures that immediately "stayed" with me:[22] I am compelled by Pierce's grandfather in Charles Burnett's *My Brother's Wedding,* who is stubbornly committed to keeping his shoes on, even though he is not planning to leave the house. Among other things, he reminds me of my own father. I am amused by the moment in *Fragrance* (Dir. Gay Abel-Bey, 1991) when George, who is sleeping on the couch during a visit to his family before shipping out to Vietnam, is awakened by his aunt who wants to gift him a nice new button-down shirt. George is grateful but also embarrassed, because the aunt is catching him without his pants on. Even more powerfully, I am profoundly moved by the moment in Billy Woodberry's *Bless Their Little Hearts,* in which the father is readying the children to go to church and deposits—slowly, deliberately, and painfully—a coin in each of their hands. The moment is solemn as well as terrifying, since we know he has gotten the money from his wife, standing in the hallway, encouraging (and forgiving) him behind the scene.

Many of these actions have the poignancy of a Brechtian *gestus,* amply employed, for instance, in Third Cinema and in the European New Waves but here reinterpreted in different directions: the individual

does not disappear to the advantage of a symbolic act that captures the complex intersection of sociopolitical forces but is rather protected, preserved, and elevated in her individuality, even simply because of the camera's ability to record her.[23] These gestures are particular and universal, resilient and sublime.[24] Charles Burnett's films are packed with them, especially the gestures of children, a fact that has been amply addressed in the critical literature on his work.[25] There is a moment in *When It Rains* that elicited chuckles from several audience members. The film follows a man who is trying to gather enough money from neighborhood friends to help a woman avoid eviction, a plot foil for several vignette-like encounters with various members of the community. During one of these exchanges a child is standing in the background making armpit farts as the adults discuss the woman's situation. Suddenly, the film cuts away to the child so that he is alone in the frame as he continues this important activity. There is absolutely no dramatic reason for this action, nor can it simply be described as a "reality effect."[26] Rather, it is compelling and profoundly rich in itself precisely for its dramatic uselessness. Considered in relation to Burnett's oeuvre, it is also part of a growing gestural archive of the everyday that he almost single-handedly initiated.

I find many of these moments both delightful and profound, but I am drawn a bit differently to the father's hands in *Bless Their Little Hearts*. We first see them in close-up in the opening sequence as he is painstakingly filling out an application form at the employment office: I am struck by the deliberate and laborious movement of the pencil across the page. Throughout the film, his hands are rarely employed to work, and when they are, they are almost unseen, as happens in the sequence in which he paints a garage wall, which is almost entirely shot from behind his back. Even when he is shown smoking, his hands are somehow effaced. Instead, it is his entire bodily posture that commands attention within the frame. His body is rarely still or even vertical but rather is always slightly rocking, at an angle, or slowing pivoting on itself; or else it is slouched onto a chair, a couch, seemingly unable to muster any energy beyond the effort to ask one of his children to fetch a pack of cigarettes for him. Seemingly unable to convey emotion, these hands suddenly become poignant with meaning as they tighten the faucets after a long, careful, and almost burdensome shave—a scene shot from his side and in one long take. Their grip is so strong, the struggle they are both expressing and holding back so overwhelming, that the young daughter who follows the father in the bathroom is unable to turn the faucet open with her bare strength and has to fetch a wrench to help her.

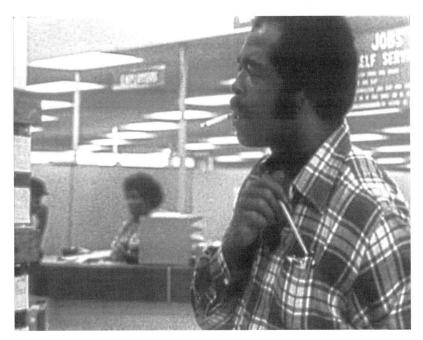

FIGURE 9.3. *Bless Their Little Hearts* (Dir. Billy Woodberry, 1984).

In these slow and drawn-out actions we get access to something that the L.A. Rebellion has described so radically and so well: the landscape of the characters' minds. The ability to render a profound, intense, and complicated interiority of the characters is, we in *liquid blackness* feel, one of the most astonishing accomplishments of the L.A. Rebellion work considered in its entirety.

LANDSCAPES OF THE MIND

Anybody who focuses on the use of locations in the L.A. Rebellion films will have to agree that they are reflective not only of the characters' living conditions but also of their psychological landscapes. One of the most vivid examples is the widely discussed opening of *Bush Mama* (1975), where the film crew is harassed by the police while interrogatory voices of social workers are layered on the soundtrack. Through this use of sound and the almost seamless transition between the footage of police harassment, the long tracking shots of store windows and pedestrians in a street of Watts, and then eventually the shots of Dorothy strolling in this street, the film establishes an ambiguous place for the

spectator, both inside and outside Dorothy's mind. Or, more provocatively, the film expands the conflict within Dorothy's mind to its entire mise-en-scène. Throughout, *Bush Mama* employs audacious editing patterns that weave together thoughts, imaginations, visions, and memories to channel Dorothy's inner landscape, the difficulty of her choices, and the psychological and systemic violence that is constantly directed at her as she begins to form a different way of looking at her reality.

The visual and material culture of the Black radical tradition that punctuates the film sets offers another powerful insight into the characters' minds. Recurring iconic images, such as the seemingly ubiquitous poster of Angela Davis, constitute the backdrop for a number of dramatic scenes,[27] also the photograph of a female African freedom fighter, holding a child with one hand and a rifle with the other. This latter is the image that ignites a shift in Dorothy's political consciousness in *Bush Mama,* when the editing orchestrates a series of intense looks between the two women across time and space; but I see it also on the nightclub's wall in *Passing Through,* when the musicians are discussing the possibility of recording independently from white music producers. Further, many of the sets display books by W.E.B. Du Bois, Frantz Fanon, Eldridge Cleaver, Aimé Césaire, and a number of African American and Third World radical thinkers, which function to externalize the characters' political mind-set.[28]

Access to the landscape of the mind does not occur through classical character identification but through a focus on characters' gestures and concrete circumstances, as in the moments from *Bless Their Little Hearts* mentioned above. The only (tentative and partial) access to Stan's mind in *Killer of Sheep* occurs in the slaughterhouse sequences, where he arguably appears most active.[29] Yet it is the status of the sheep—suspended between the literal (Stan's job), the figural (insofar as they stand in for the coerced violence that encroaches on him), and the reference to a rich film history tradition (from Sergei Eisenstein's *Strike* [1925], to Georges Franju's *Blood of the Beasts* [1949], to Djibril Diop Mambéty's *Touki Bouki* [1973])—that acts as a virtual archive of possibilities for Stan's personal and political actions.[30] The fact that Stan does not effectively act does not erase the resonance of these important references, which still press onto the image, within a film that, even though it focuses on layered forms of social, political, ideological, and psychological stagnation, is far from acquiescent.

More generally, as a technology, an apparatus, and an archival practice, "film" arguably becomes in the L.A. Rebellion a place where

repressed dreams and desires can finally be manifested. Think about the hotel maid in *Daydream Therapy* (Dir. Bernard Nicolas, 1977) and the fact that her righteous desire for retaliation is "acted out" only "on-film," so to speak, and not in her diegetic world: her impulses, reactions, and aspirations are recorded and safely guarded only this way. Or consider Dorothy's desire to hit the social worker with a bottle in *Bush Mama*. In the hands of the L.A. Rebellion filmmakers, cinema acts as an organic counterarchive for an alternative personal and political imagination.

At other times, the landscape of the mind is rendered through camera movements: for instance, in the way the camera gives in to, reproduces, and magnifies Barbara O.'s painful pacing within her suffocating prison cell in Gerima's *Child of Resistance*. The camera pivots on its axis with a restless pendulum-like movement, alternating between two perspectives: the point of view of the incarcerated—a figure inspired by Angela Davis—and the point of view of the guard. This incessant motion creates a strenuous viewing condition for the spectator as well. The sets, too, especially in Gerima's films, give access to the character's psychological landscape through their almost confrontational materiality: the makeshift (rocking) electric chair, also in *Child of Resistance*, produces a painful metallic sound, acting as an ominous and all too concrete foreboding soundtrack. Through it, the prisoner's destiny or destination is made tangible and terrifying. The chains that constrain both the Barbara O. character and the customers of the bar she visits in her imagination are conspicuously sized and obviously artisanally made, but this fact only enhances, rather then detracts from, their ability to convey their abysmal social, political, and human weight.

Halfway through the L.A. Rebellion tour I began to think about the films' ability to highlight the incongruities of American society. The very term *incongruity* is incongruously mild when used to describe the state of war in which the Black subject finds herself in these films. Yet it might still register the poignancy of some moments in which the viewer is jolted by the perception of incompatible forces being co-present in the same time, same place, and often in the same body. In other words, *incongruity* here expresses a question I believe these films pose very clearly for contemporary audiences: how can *this* and *that* be going on at the same time/in the same place? There are too many of these moments to list, but I want to reference at least *The Diary of an African Nun* (Dir. Julie Dash, 1977), where Barbara O.'s body is torn apart from competing alliances to the rigidity demanded by her religious habit and the riveting beat of the African drums she hears outside her window. Her habit was her

coveted prize and greatest childhood desire—a form of "regal" and dignified "liveness" she envied in the nuns and priests who taught at the mission school she frequented. She dreamed of wearing it, being "shrouded in whiteness like the mountains I see from my window," her voice-over explains, and earning the "right to never be without it." Yet, as the day ends, she retires to her room and that same habit now has to come off, the drums she hears carry other impulses and desires: the food, wine, and conviviality she no longer has access to, or the equally unattainable spark of a young romance. More importantly, the drums awaken the conflict between a world she is committed to but that requires such a deep mortification and the world she really belongs to.

Shot in black and white, the film emphasizes the contrast between the immaculate whiteness of the protagonist's dress and the richness of her complexion. As she disrobes to the drumbeat, she remarks, "I sing my whole chant in response to theirs." Her body becomes a battlefield, since she is forced to maintain a composure both threatened and undermined by the sounds surrounding her. Yet the film does not have to withstand the same mortification: when her voice-over describes the possibility of a young girl dancing with her lover in the middle of the circle, while "the whole crowd can see the weakening of her knees," the editing becomes furiously paced, showing repeated shots of the nun's hands coming together in prayer from a multiplicity of angles. As the tempo increases she falls on her knees to pray, as if overwhelmed by her body's desire to be the conduit of *that* type of liveness, rather than the "regal" kind she thought her habit would make accessible to her. Reminiscent of Dziga Vertov's *Man with a Movie Camera* (1929), even the window's shutters move rapidly and rhythmically to convey the emotional charge of the scene.

There are countless other examples of similar incongruities. In *Fragrance,* for example, two brothers react differently to the choice their older brother George has made to fight in Vietnam. The weight and incongruity of this decision are effectively captured the moment the youngest brother, Bobby, is made to sing "My Country 'Tis of Thee" in school, as punishment for talking in class. At the end of the film, when we know George will indeed go to Vietnam, we are left with a close shot of Bobby's face framed next to the American flag, still at school, still expected to sing, but now standing silently and refusing to do so.

Brick by Brick (Dir. Shirikiana Aina, 1982) is a documentary investigation into the incongruity and human cost of gentrification in Washington, DC. A woman who lives in an overcrowded basement apart-

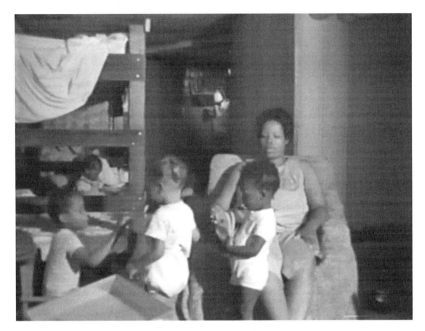

FIGURE 9.4. *Brick by Brick* (Dir. Shirikiana Aina, 1982).

ment articulates this through a painful recollection of the things she is blamed for, signaling the perpetuation of a categorical and systemic confusion between cause and effect. Her monologue is as arresting as it is eloquent:

> You're the cause why there's no grass, you're the cause why the landlord stopped coming to fix the property, you're the cause why you don't have a [health] care and why your children are fighting in school and come home with stitches in their head. You're the cause why teachers are afraid in school. [. . .] The world resents you, the government resents you because you resent them. The system resents you because you don't want to be a part of it. Your children resent you because you're trying to live a better life for them and don't give them just everything they want."[31]

At the end, how does one reconcile these incongruities? The films certainly refuse to do so, offering no facile respite, consolation, or resolution.

FORMS OF LIQUIDITY

Surprisingly, perhaps, the *liquid blackness* research group found a variety of forms of aesthetic liquidity in the films of the L.A. Rebellion.

While the concept is still evolving for us and is more specifically tied to contemporary forms of visual and sonic culture,[32] in this context it indicates the capacity to seize the malleable qualities of the film image. An example is the expressive alternation between black-and-white and color footage as a way to foster the possibility for the filmic medium to convey a double vision. The filmic image, in other words, is handled as something that can stretch in two directions: toward what it shows and the thought process of which it is part. This is very clearly the case in *Hour Glass* (1971), where Haile Gerima's use of rapid alternation between color and black-and-white footage inserts a level of critical engagement with the image that expresses the protagonist's slowly awakening political consciousness. The film begins on a basketball court. A fast-paced editing of the protagonist's moves (he is a basketball player) is matched to the rhythm of spoken word from the Last Poets featured in the soundtrack. As the film transitions to shots of white patrons in the stands, flickering between black-and-white and color, it also records the player's realization of his own exploitation. Thus this alternation is used both for its potential to transition between subjective and objective reality and as a form of Brechtian alienation effect.

In general, the audacious Project One films of the L.A. Rebellion were one of the most exciting discoveries in terms of "liquid" aesthetics. We were amazed by their uncompromising energy and commitment to creating *new* images and by the diversity of artistic and cultural traditions, film techniques, and aesthetic solution harnessed in order to do that. We found liquidity more specifically in the way that many of these projects are invested in advancing and experimenting with the possibility of cinema's engendering a different historical imagination. I am thinking, for example, about Ben Caldwell's *Medea* (1973), where the texture and pulsating movement of the clouds in the opening sequence sets the stage for a seamless transition to a foregrounding of the round shape of a pregnant body, while a woman's voice delivers a quasi-hypnotic chant punctuated by a recurring refrain: "to raise the race . . . to raise the race."[33] The chant is overlaid on a montage of still images that encompass African peoples and Black American figures, recapitulating the breadth of the diaspora in the ontogenesis of every soon-to-be-born Black child in America. The montage moves rapidly, increasingly assuming the pace of the mother's heartbeat, her breathing, and her chanting all at once. Bathed in a warm hue, the still images display an extraordinary visual consistency, possibly in keeping with Caldwell's interest in texture and in the relationship between the Black

body and its environment.[34] This is a living, breathing, and organic counterarchive that does not abide by the representational logic that rarely serves Black bodies on film but is instead propelled by bodily rhythms and breath. This "impossible" archive is finally congealed in the delicate yet poignant image that concludes the film: a small child interacting with the spherical shape of a white balloon. Evoking circularity as well as perfection, this image gestures toward the idea of a self-contained Black history, which finds within itself the resources for its fulfillment.

There is also aesthetic liquidity in Zeinabu irene Davis's film *Compensation* (1999), which follows two parallel relationships between a deaf woman and a hearing man as they unfold in the context of impending death at the beginning and the end of the twentieth century. The choice to focus on Black deaf culture gives an urgency to issues of communication, reciprocity, and mutuality that also informs the film's formal choices. The diegetically motivated use of sign language creates the opportunity for individual shots to linger on a series of poignant gestures that temporarily suspend the expected narrative pace and appear to demand fulfillment, development, and existence beyond the here and now. As one witnesses the laborious and delayed communication between the characters, one is also experiencing a sort of in-between space, an unbridgeable gap that demands but does not provide resolution. The protagonists' investment in communicating across the "hearing line" brings up important questions about (forms of) segregation as something powerfully played out at the level of the human sensorium[35]— a segregation that the film somewhat overcomes by being equally accessible to hearing and deaf audiences.

We also found liquidity in the way a number of films—I am thinking primarily but not exclusively about *I & I, Water Ritual,* and *Passing Through*—display a commitment to working with texture, understood as a flexible, elastic, and plastic property of the image. Their use of superimpositions highlights the porosity and multiple temporalities of the image, while slow motion brings attention to its grain. The transitions enabled by the films' textural emphasis are not only narrative but most importantly spatiotemporal, at times evoking forms of time travel that connect New World blacks back to their African roots. It is because of the texture of the image, created by sunlight filtering through the holes of an abandoned shack in land cleared for highway expansion in *Water Ritual,* that the film's location seems suspended in time and space, primitive and postapocalyptic at the same time. It is the crisp,

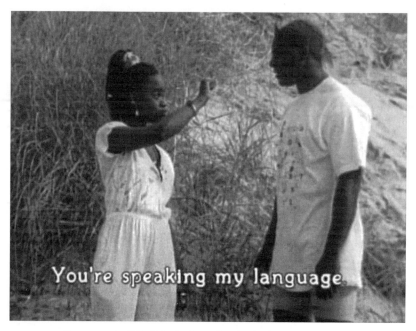

You're speaking my language

FIGURE 9.5. *Compensation* (Dir. Zeinabu irene Davis, 1999).

slow-motion cinematography that makes the specks of dust settling on Yolanda Vidato's face and hair, after she has blown it into the wind and toward the circle of found objects she has arranged in front of her spread legs, appear as particles full of potentiality, instability, and vibrancy. In Ben Caldwell's films especially, but also in *Passing Through*, superimpositions are held for a long time. Several images, it seems, have to coexist and flow together over an extended duration in order to render the multiple ways in which blackness exists in space and time and to simultaneously index rootedness and displacement, origin and alienation.

This emphasis on the textural qualities of the image may render highly disparate genres compatible within the same film: *I & I*, for example, combines elements of experimental cinema with an oral history project. The film opens on a close-up of a shore with tiny waves gently washing over it. This suggests a libation offered to the elders as well as introduces the time travel of Alefi, the Wind.[36] Played by Pamela Jones, Alefi is introduced by a pan shot sweeping first over a tree trunk slowly and at close range and then over the body of a woman sitting at the base of the tree, her face initially hiding on her lap. The camera then

focuses on her hands, which hold and slowly crack dry foliage. She stretches upward, making guttural sounds, and becomes the conduit for a primordial "om." Here, attention to the textural qualities not only functions to create haptic images but rather is meant to evoke the Middle Passage as a "corridor" connecting Africa to the American shores, in both directions: African spirituality, the film suggests, and especially the concept of the "I," can offer a foundation for reciprocity rather than the relations of prevarication introduced by the concept of the "you."[37]

In Caldwell's work cinematography is key to the philosophical depth of the image, and the inner tension between stillness and movement conveys a fluidly multilayered visual structure. In *I & I* many transitions occur through overexposed images: for example, the transposition of the mythological Alefi from a natural environment to a modern downtown space. Sunlight splashing over the sharp edge of a skyscraper shot obliquely and from an extremely low angle appears to almost reach back and wash over the last image of the previous tree sequence. Similarly, after the camera tilts toward the ground to find Alefi again, now in a long shot, framed by the hard lines of modern architecture, and follows her gliding through this space, the image dissolves into a series of close-ups of old men's faces; the shots are so close that their eyes and mouths fill the entire frame. The singing in the soundtrack has the quality of a whisper and the long-held superimpositions appear "breathful": they feel full of air, space, and wind. This, too, is an expansive quality, rendered through fluidly layered cinematographic gestures.

Even more radically, we found liquidity in the way some of the most aesthetically abstract films fluidly incorporate newsreel images "from the world." The primary example for this is *Passing Through,* which repeatedly transitions to archival footage of episodes of police violence and repression. These transitions, which are usually ushered in by changes in sound—whether the strained sound of a saxophone solo or the vibrant energy of an entire jazz ensemble—render continuous painfully incongruous aspects of human life: the seemingly unbound creativity of the musicians, on the one hand, and the worthlessness of their lives within oppressive, indeed deadly, labor conditions, on the other. Or, in a larger scope, they draw together the conditions of Los Angeles Black artists' communities with the pervasive domestic and international antiblack violence, seen in the context of the international decolonization struggles the film professes alliance to. More fundamentally, the film employs aesthetic liquidity in the fluid processes of translation

FIGURE 9.6. *The Fullness of Time* (Dir. Cauleen Smith, Videography by Alexandra Lear, 2008). Courtesy Cauleen Smith.

and transposition between sound and vision, jazz and cinema, the main character's compromised creative process and the possibility to fashion himself as a fulfilled and free individual.

Liquidity is also a way to regard how L.A. Rebellion films embrace their participation in translational artistic flows and to appreciate their reliance on aesthetic traditions developed in other countries, often in comparable political situations and conditions of production. Liquidity offers a way to describe the films' fluid relationship to time and consciousness. Many of the films—*Medea, I & I,* and *Water Ritual* can stand as examples here—create a sense of people who are *in* this culture but not *of* this culture, which, if one follows the historiographical framework that Zeinabu irene Davis establishes in *Spirits of Rebellion,* leads to the Afrofuturist sensibility permeating the work of Cauleen Smith.

Again, taken together the L.A. Rebellion films demonstrate the expansiveness of blackness: blackness as a form of historical consciousness, blackness as engendering forms of interaction between bodies, blackness as a bundle of affective forces, immersive experiences, forms of cultural memory, and so on. But also blackness as cosmic principle— "to raise the race . . . to raise the race," chants the expectant mother in *Medea*—blackness as life force and truly vibrant matter.

THE L.A. REBELLION AND US

Where are we in relation to the L.A. Rebellion? What kind of relationship can we entertain with the work, its times and conditions of production, and the filmmakers themselves? Commenting on her personal experience of seeing *Daughters of the Dust* in 1992 at the Baltimore Museum of Art, *liquid blackness* member Michele Prettyman-Beverly writes, "This singular event had united the sometimes disjointed worlds that I cared about—the worlds of spirituality, community, art, and culture—and for a few hours a stage was set for us to have a uniquely intimate experience with cinema and with each other."[38]

The other *liquid blackness* members, too, had a similar experience, even though more dispersed and historically removed. Meeting the filmmakers left a profound impact on all of us, the implications of which we are still trying to understand.[39] Yet, if our relationship to some of the filmmakers can now be understood on personal ground, what is our relationship to the conditions and the events that prompted their artistic vision? I find some help in understanding our investment in this work in John Akomfrah's articulation of his generation's relationship to the same sources and events. In his essay "Digitopia and the Specters of Diaspora," Akomfrah explains the "digitopic yearning" that the diasporic subject of his generation feels toward historical suturing moments of which he/she has not been part—"Fanon, the Panthers, Black Power." Whether it is taking place in scholarly or artistic practices, his/her work of recollection is unavoidably marked by a form of hauntology, by "that impossible gesture, a desire to seize and entrap the ghost."[40]

We are indeed objectively removed from the formative moments that gave rise to the L.A. Rebellion and even twice removed, both generationally and in terms of national context, from the conditions of the Black Audio Film Collective. At the same time, this very distance—this double ghost—affords us a space to see the work in a new light, as speaking directly to our concerns in the present. We are drawn to the digital imagery evoked in Akomfrah's writing because it suggests a "fluid" relationship with the archive and thus "pliable" ways of suturing artistic or scholarly practices onto it. In fact, this is our investment, as well as the source of our excitement: not so much to entrap the ghost but to channel its continued resonance. We have been touched by something that is both distant and intimate, raw and hopeful, confined and unbound. The L.A. Rebellion tour has opened up a space where conversations can

occur over what before was still part of the "territory of the unspoken."[41] Identity politics no longer forecloses access to this work; on the contrary, the imaginative aesthetic possibilities explored by the L.A. Rebellion appear to have opened up a space where students, artists, and scholars of all extractions can commit to, invest in, and desire a greater understanding of the experience and expansive possibilities of blackness.

NOTES

Epigraph: John Akomfrah, "Digitopia and the Specters of Diaspora," *Journal of Media Practice* 11, no. 1 (2010): 27.

1. The *liquid blackness* group now comprises about ten members: alumni and graduate students of Georgia State University's Moving Image Studies Program in the Department of Communication (Michele Prettyman-Beverly; Lauren M. Cramer; Katharine Zakos; Kristin Juarez; Dorothy Hendrix; and Cameron Kunzelman), alumni of our undergraduate program in Film, Video, and Digital Imaging (Chris Hunt, Joey Molina, and Michael Sanders), and a graduate student from the Department of Art and Design (Christina Price Washington). Several sympathizers and students also offer logistical support: Jasmine A. Tillman from the Department of African American Studies, for example, as well as people from the Atlanta artistic community who are collaborating on some of our initiatives.

2. The specific locations we selected were Arnika Dawkins Fine Art Photography Gallery, WonderRoot Community Arts Center, Charis Bookstore, and King & Spalding Law Firm.

3. Atlanta Film Festival director Chris Escobar was instrumental to this partnership.

4. We invited the following people: Ayoka Chenzira, herself a pioneer East Coast filmmaker, now director of the Digital Moving Image Salon at Spelman College, whose work has been shown at festivals together with that of the L.A. Rebellion; Cinque Hicks, interim editor of the *International Review of African American Art;* Carol Thompson, curator of African art from the High Museum; Folashadé Alao, assistant professor of English and African American studies, University of South Carolina; and Akinyele Umoja and Makungu Akinyela, respectively chair and associate professor of African American studies at Georgia State University. Several Q&A sessions were facilitated by Michele Prettyman-Beverly.

5. Larry Clark trained members of artists' communities such as the Performing Arts Society of Los Angeles (PASLA) to work on his films, and many of the L.A. Rebellion filmmakers have indicated various types of collaborations with fellow UCLA students within and across departments, across "generations" (Charles Burnett, for example, shot a number of younger students' films), and more broadly with entire neighborhoods, as it happens in Burnett's films.

6. Filmmaking requires a triangular relation that also includes the critic, as Haile Gerima outlined in an influential essay, even though, he insists, consid-

erations of audience taste and reactions should not be part of a filmmaker's creative process. See Haile Gerima, oral history interview by Jacqueline Stewart, Allyson Nadia Field, and Zeinabu irene Davis, September 13, 2010, LAROH. The classic essay is Haile Gerima, "Triangular Cinema, Breaking Toys, and Dinknesh vs Lucy," in *Questions of Third Cinema*, eds. Jim Pines and Paul Willemen (London: British Film Institute, 1995), 65–89.

7. Larry Clark, interview for "Dossier on *Passing Through*," by Alessandra Raengo, San Francisco State University, March 19, 2014, unpublished. Clark's decision to not seek theatrical distribution for *Passing Through* (1977), so that it would exist solely as an art object, clearly exemplifies this attitude.

8. Available on the *liquid blackness* website, http://liquidblackness.com /LB1_LARebellion.pdf.

9. See Haile Gerima's call to form a united distribution company in his L.A. Rebellion oral history.

10. As Billy Woodberry put it, as I was driving him to a postscreening event at the Low Museum, *"*We all worked in each other's films, but if we had to write a manifesto or give a formal structure to these collaborations, then we would not have known who was going to make coffee or do the photocopying." In her oral history, Julie Dash expresses a similar sentiment, as does Clyde Taylor, who emphasizes the "bond" and collaborative climate among the UCLA students. Julie Dash, oral history interview by Jacqueline Stewart, Allyson Nadia Field, and Jan-Christopher Horak, June 8, 2010; and Clyde Taylor, oral history interview by Zeinabu irene Davis, Allyson Nadia Field, and Jacqueline Stewart, March 22, 2011, LAROH.

11. See Clyde Taylor's retrospective characterization of this aesthetic distinctiveness as "bold," "in your face," "experimental," and "transnational" in his L.A. Rebellion oral history.

12. Larry Clark, conversation with the author, on the occasion of Clark's visit to Atlanta for the L.A. Rebellion tour, November 22–24, 2013.

13. Jacqueline Stewart, "Defending Black Imagination: The 'L.A. Rebellion' School of Black Filmmakers," in *Now Dig This! Art and Black Los Angeles, 1960–1980*, ed. Kellie Jones (Los Angeles: Hammer Museum, University of California; New York: DelMonico Books/Prestel, 2011), 41–49.

14. Teshome H. Gabriel, "Thoughts on Nomadic Aesthetics and the Black Independent Cinema: Traces of a Journey," in *Out There: Marginalization and Contemporary Cultures*, eds. Russell Ferguson, Martha Gever, Trinh T. Minh-ha, and Cornel West (New York: New Museum of Contemporary Art; Cambridge, MA: MIT Press, 1990), 395–410. To continue our reflection on diaspora identities and aesthetics in a transnational context, *liquid blackness* hosted a film and speakers series about the Black Audio Film Collective from the United Kingdom. The publication on "fluid radicalisms" that emerged from this research project is available at http://liquidblackness.com/issues/LB4essays/LB4final.pdf.

15. In his oral history interview, Haile Gerima specifically discusses this grant, but screenings of international Third World or art cinema are also mentioned by Julie Dash, Billy Woodberry (who discusses off-campus venues), and Larry Clark. See Julie Dash, oral history; Billy Woodberry, oral history interview by Jacqueline Stewart and Allyson Nadia Field, June 24 and July

6, 2010; and Larry Clark, oral history interview by Jacqueline Stewart and Christopher Horak, June 2, 2010, LAROH.

16. The very applicability of neorealism as a description of these films testifies to their transnational breadth. See, at least, Paula J. Massood, "An Aesthetic Appropriate to Conditions: *Killer of Sheep,* (Neo)Realism, and the Documentary Impulse," *Wide Angle* 21, no. 4 (1999): 20–41. See also Clyde Taylor's L.A. Rebellion oral history for a similar grouping of the films.

17. This statement is partly inspired by Barbara McCullough's interview on UCLA's cable program, *The View* (c. 1979), www.cinema.ucla.edu/la-rebellion/barbara-mccullough (accessed April 30, 2014). Clyde Taylor, too, emphasizes this aspect when he describes the role of "Africanity" in articulating a "science-fiction" aspiration: "a lot of the imagining, a lot of the dream work of possibility, had an African design to it." In the same context, he also mentions Octavia Butler. Clyde Taylor, oral history. Consider also Julie Dash's self-definition of her work as "speculative fiction."

18. Lauren M. Cramer, "Black Sister's Reality: Black Bodies and Space in *Emma Mae,*" in "*liquid blackness* on the L.A. Rebellion," *liquid blackness* 1, no. 1 (2014): 20, http://liquidblackness.com/LB1_LARebellion.pdf.

19. See Joey Molina, "Purification Rituals: Beauty and Abjection in *Cycles,*" in "*liquid blackness* on the L.A. Rebellion," *liquid blackness* 1, no. 1 (2014): 22, http://liquidblackness.com/LB1_LARebellion.pdf.

20. See, at the very least, Jacqueline Stewart's write-up on the film in the UCLA Film & Television Archive, www.cinema.ucla.edu/la-rebellion/films/water-ritual-1-urban-rite-purification (accessed April 30, 2014).

21. An example would be the frequent wrestling between father and son in Burnett's *My Brother's Wedding,* discussed in Cameron Kunzelman, "Playfighting in South Central: On the Everyday in *My Brother's Wedding,*" in "*liquid blackness* on the L.A. Rebellion," *liquid blackness* 1, no. 1 (2014): 25–27, http://liquidblackness.com/LB1_LARebellion.pdf. Given the attention granted in the literature to Charles Burnett's films, this has in great part already been acknowledged. I do want to mention, however, Cliff Thompson, "The Devil Beats His Wife: Small Moments and Big Statements in the Films of Charles Burnett," *Cinéaste* 23, no. 2 (1997): 24–27, which criticizes Burnett's later work for not maintaining the same attention to small details as his earlier work. I further discuss this *intensive* expansiveness when I focus on the presence and power of "small gestures."

22. I mention these scenes because only a handful of the films screened for the tour will become readily available in the near future, and therefore most of this material will continue to be encountered in similar circumstances. (The notable and exciting exception is the induction of Billy Woodberry's *Bless Their Little Hearts* into the National Film Registry, which we hope will speed up its transition to DVD.)

23. On Third Cinema and the European New Waves, see Robert Stam, *Reflexivity in Film and Literature: From Don Quixote: to Jean-Luc Godard* (Ann Arbor, MI: UMI Research Press, 1985).

24. For a reflection on the black cinema sublime, see Terri Simone Francis, "Flickers of the Spirit: 'Black Independent Film,' Reflexive Reception, and a Blues Cinema Sublime," *Black Camera* 1, no. 2 (2010): 7–24.

25. See, at least, Nathan Grant, "Innocence and Ambiguity in the Films of Charles Burnett," in *Representing Blackness: Issues in Film and Video,* ed. Valerie Smith (New Brunswick, NJ: Rutgers University Press, 2003), 135–55.

26. Roland Barthes, "The Reality Effect," in *The Rustle of Language* (New York: Hill and Wang, 1986).

27. In Gay Abel-Bey's *Fragrance,* for example, as well as in Haile Gerima's *Ashes & Embers,* from which the tour's cover image was taken.

28. Haile Gerima's *Hour Glass* (1971) is a great example of the use of iconic elements from the visual and material culture of the Black radical tradition. Not only are the key moments of the protagonist's awakening political consciousness punctuated by his engagement with radical books and iconic images, but at times the film also stages the intersection between visual and material culture: for instance, in the recurring scenes of a naked child covered only with a sheet alternatively featuring images of Malcolm X, Martin Luther King Jr., and Angela Davis. Repeatedly, a white woman enters the frame and pulls the sheet away, leaving the child naked in bed.

29. Massood, "An Aesthetic Appropriate to Conditions." See also Amy Ongiri's reflection on Burnett's choice to abstain from on-screen violence in Amy Abugo Ongiri, "Charles Burnett: A Reconsideration of Third Cinema," *Nka: Journal of Contemporary African Art* 21, no. 1 (2007): 82–89.

30. *Touki Bouki* opens with shots of zebus being conducted to the abattoir. See Heather Snell, "Toward 'A Giving and a Receiving': Teaching Djibril Diop Mambéty's *Touki Bouki,*" *Journal of African Cultural Studies* 26, no. 2 (2013): 127–39. More broadly, see Sharon Holland's reading of the presence of animals in Burnett's films. She reflects on the precarious status of black "humanity" and love once blackness is recognized as "on par with the animal and paired with it, taxonomically speaking." Sharon Patricia Holland, "(Black) (Queer) Love," *Callaloo* 36, no. 3 (Summer 2013): 666.

31. For a longer discussion of the film, see Dorothy Hendricks, "Children of the Revolution: Images of Youth in *Killer of Sheep* and *Brick by Brick,*" in "*liquid blackness* on the L.A. Rebellion," *liquid blackness* 1, no. 1 (2014): 16–18, http://liquidblackness.com/LB1_LARebellion.pdf.

32. Alessandra Raengo, "Blackness, Aesthetics, Liquidity," *liquid blackness* 1, no. 2 (2014): 4–18, http://liquidblackness.com/LB2.pdf.

33. The chant comes from Amiri Baraka's poem "Part of the Doctrine." See Allyson Nadia Field, "Rebellious Unlearning: UCLA Project One Films (1967–1978)," in this volume.

34. I am referring to the "Awakening" photographic series that Caldwell used for his application to UCLA. Some of the photographs were hand painted and a good number were pictures of "Black women in the desert because I thought there was an interesting similarity between our skin, the brownness and the bushes, like our hair, and how it shows itself." Ben Caldwell, oral history interview by Allyson Field and Jacqueline Stewart, June 14, 2010, LAROH.

35. See Mark M. Smith, *How Race Is Made: Slavery, Segregation, and the Senses* (Chapel Hill: University of North Carolina Press, 2006).

36. These reflections about *I & I* are Caldwell's own, from his oral history.

37. Ibid.

38. Michele Prettyman-Beverly, "Daughter of the Rebellion," in *"liquid blackness* on the L.A. Rebellion," *liquid blackness* 1, no. 1 (2014): 12–15, http://liquidblackness.com/LB1_LARebellion.pdf.

39. First came Zeinabu (Davis), who showed us her work in progress, *Spirits of Rebellion,* and tirelessly fielded all our questions about the L.A. Rebellion group, its history, and the friendships that still unite so many of the filmmakers. Then came Billy (Woodberry). His first task was to talk a bit about Jamaa Fanaka, and he made us all feel a bit of Fanaka's energy, joviality, and charm. On the second evening, Billy talked about his own work, and he did so in his characteristic eloquent and yet humble and self-effacing way, emphasizing over and over again how it had been Charlie (Burnett) who had given him the script for *Bless Their Little Hearts,* had shot it, and had let him (Billy) figure out how to direct it and make his own mistakes in the process—this about a film that has now been made part of the National Film Registry. With tour co-curator Allyson Field, Billy came with us to the WonderRoot Community Arts Center, where he fielded questions about the general artistic context of the L.A. Rebellion and the reasons this group of people chose to make art as a way to affect something in their environment. Billy also came with us to a postscreening conversation at the Low Museum and interacted with talented young filmmakers, graduates of Georgia State University's Film, Video, and Digital Imaging Program, well into the night. Haile Gerima was our guest on the third weekend. He was generous, witty, vivacious, and uncompromising. Unsurprisingly, he was hard-hitting on political issues, encouraging and visionary on artistic issues, and soft and tender in his interactions with everybody, particularly with my own ten-year-old daughter, Margot, who came to lunches and dinners with us and attended the screening of *Bush Mama.* I covered her eyes on a few occasions, obviously, but I am happy she was in the same room as *this* film and *this* filmmaker. This, too, might be counted as an L.A. Rebellion encounter. Finally, on the last weekend we welcomed Larry Clark. Karl Injex, one of the owners of the Sound Table, already knew about the "legendary" *Passing Through* and was delighted that Larry would be hanging out at his restaurant. Larry, too, was immensely gracious with us; he discussed his creative process, explained his aesthetic choices, and just hung out with graduate and undergraduate students so that eventually a strong enough relationship formed among us, which is now the basis for the research *liquid blackness* has undertaken on his film and on the arts and politics of the jazz ensemble.

40. Akomfrah, "Digitopia and the Specters of Diaspora," 27. On hauntology, see Jacques Derrida, *Specters of Marx: The State of Debt, the Work of Mourning, and the New International,* trans. Peggy Kamuf (1994; New York and London: Routledge, 2006).

41. I want to thank Michele Prettyman-Beverly for helping me articulate this thought.

L.A. Rebellion Oral Histories

10

L.A. Rebellion Oral Histories

Since June 2010, the editors have conducted interviews with more than two dozen individuals associated with the L.A. Rebellion. These interviews reveal the great diversity of backgrounds and interests of this group of Black filmmakers, as well as the concerns and experiences they shared while at UCLA and beyond. Covering both personal and professional topics, these interviews have served as key sources of information for the contributors to this volume, providing material quoted in several chapters. This information has also been crucial for the many facets of the L.A. Rebellion Preservation Project at the UCLA Film & Television Archive, including the website.

While the interviews took different directions depending on the responses of the interviewees, the same core questions were posed to each subject. These topics are reflected in the sections below: "Early Life," "Matriculation and Experiences at UCLA," "Student Filmmaking at UCLA," "Production Challenges," "Festival Travel and Exhibition," "Careers after UCLA," and "Reflections on the Term *L.A. Rebellion.*" Material from the interviews has been excerpted and combined in an effort to include as many voices as possible in the space available and to foster comparative consideration of the stories and perspectives shared in the interviews. Suspension points in the excerpts represent pauses in speech; bracketed ellipses indicate omitted text. Full transcripts of the interviews are available at UCLA Library, Special Collections and at the Getty Research Institute as part of the Pacific Standard Time initiative.

EARLY LIFE

Zeinabu irene Davis: My dad was a big theater fan and I have very vivid memories of holding his hand jumping over sidewalk cracks in Philly, Northwest Philly is where I'm from, just singing Beatles songs but going to go see *Zooman and the Sign* or some other forum, 'cause Freedom Theater was in Philadelphia, so that was a very important cultural place for African Americans at the time. So we would walk to the bus and then take the subway to Freedom Theater, see all kinds of plays, and I saw all different types of plays, not just African American . . . I was like [my dad's] date, you know, he would make it a point of taking me to see these cultural events or to do culturally related things with me. It just instilled in me this very strong need to recuperate stories or lost cultural memories— or to tell stories that weren't being told, that were still in the community.

Haile Gerima: My father was—I would say—a historian and a playwright and especially as I got to be eight or nine, I used to be in some of his plays as an extra. He did these traditional plays that had come up out of our historical processes in Ethiopia; very epic musical plays, et cetera. And I would bring the points that I think are related to storytelling. My grandmother—at the time I grew up, there was no electricity, it was the fireplace and around the fire my grandmother told stories, my mother told stories and so storytelling is very, very traditional in Ethiopia. This is how you shaped the kids philosophically, sociologically, and then, I even know now its psychological benefit, et cetera. So, I was growing up in a very, very interesting time in Ethiopia. On weekends we went into the outskirts of Gondar to eat wild fruits and this is also very important to my storytelling life: the films I'm—the scripts I'm writing, the film I just finished, all this has to do with a lot of this folkloric legacy that I was inheriting on a very subconscious level because it was not a conscious transaction, but it's just the landscape of the culture.

Julie Dash: It was very much of like coming up in a community of people; all kinds of people and being exposed to different languages and customs and all kinds of things. And that's one of the wonderful things about growing up in New York.

Billy Woodberry: My great aunt, who told me stories she shouldn't have told me because I used to be left with her, until she told me so

many frightening stories that I couldn't sleep, told me things that I couldn't process, you know? . . . Family lore and other things, but she told me some good things . . . She was a carrier of the ethic . . . One thing I am grateful for is my great-grandmother made sure that I knew my people, you know?

Alile Sharon Larkin: I come from a large family. My father was very creative; he was an artist and they always said that I was creative like my dad—that I could draw like my father. But—I mean, that was acknowledged, but it wasn't encouraged . . . So as a little child artist, film saved my life, because that's where I was able to channel my creativity. I was a little kid film buff. You know, I didn't realize until I got to film school that the reason it was so healing is because all the arts were in those movies, and I could watch the same movie over and over and over and over again.

Jacqueline Frazier: I'm from San Francisco, born in San Francisco. [. . .] Both my parents are from the South. My mother was actually raised in Chicago, but my father was raised in Monroe, Louisiana. And when he was confronted by these people that were police, when he and his friends were talking on a corner somewhere, he said, "That's it. I'm going to California" . . . And he came to California on four or five trains. He had to do train stops all on his own and he ended up in San Francisco . . . And then my mother was in Chicago, and her people moved to San Francisco because of the shipyard. And everybody was working at the shipyard at that time during World War II. So that's how they got there.

Jamaa Fanaka: [The move from Mississippi to California] was a real culture shock. [. . .] People at the time, they looked down on people that were from the South. You know what I mean? You know, "You farmers, you farmers coming up here. Get on back down there to Mississippi." They also thought we were cowards for allowing the white man to do us like that down in Mississippi, et cetera.

Charles Burnett: Everyone in my neighborhood basically was from the South, and really people born in California, but everyone was from the South—Mississippi, Arkansas, whatever is was and so forth, so you had this southern environment there, you know? And L.A. at the time was very much like the South in many ways, you know, because you couldn't go across certain areas, you know, and so it was very segregated from the very beginning.

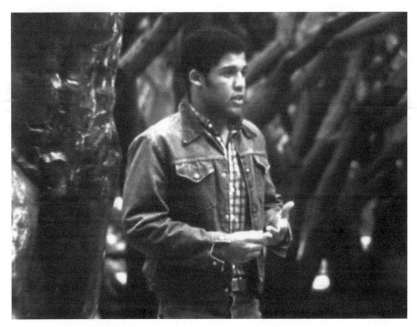

FIGURE 10.1. *A Little Off Mark* (Dir. Robert Wheaton, 1986).

Robert Wheaton: Like a lot of people, we were southern transplants. I was born in Meridian, Mississippi. I came out to California with my family when I was two. [. . .] My father was a doctor and my mother was a school teacher; I grew up around a lot of professional people . . . I got exposed to a lot of different types of films, theater, and different types of experiences like that.

Robert Nakamura: I was in Manzanar, and I was in the camps when I was six years old and I came out when I was nine. [. . .] After Pearl Harbor, we were—for me, it was my classmates, my teachers, all of a sudden I was—I had the face of the enemy. [. . .] That experience of being rounded up, and then the third experience is coming back, which was a real hostile environment. L.A. was awful.

Julie Dash: That's when everyone was migrating around that time and they came to New York. But [. . .] they still maintained [. . .] the Geechee culture. Like, what we ate at home was very different from what the other kids or some of my friends ate, and that was something when I was growing up I didn't want people to know.

Bernard Nicolas: San Pedro is a very multicultural kind of city because there's a lot of immigrants from lots of different places, eastern Europe, Filipinos. [. . .] So our impression of the United States was this box that would come from Sears and then a catalog that would come from Sears . . . Realizing what the reality of the United States was [. . .] shocking.

Stormé Bright Sweet: I was born in Glendale, Ohio, which is a historic area of Cincinnati, Ohio. I grew up in a very integrated neighborhood and stayed there until I left for college. My father's family is from the South; Nashville, Tennessee . . . I went to school with people of all races, creeds, and religions. When I left Glendale I went south, because my father begged me to go to school in the South to a traditional Black college, which is not what I wanted to do, but because he had family who were educators at Fisk, I went to Fisk.

Barbara McCullough: I lived in New Orleans in segregated times . . . Regardless of the fact that it was . . . this whole thing with segregation [. . .] when you walked down the street, whomever you saw, you expected to say hello, good evening, good morning, whatever, you know? So there was that thing that was really sorely missed when I moved to L.A.

Jamaa Fanaka: To this day my father and I are very close. Matter of fact, my whole family and we consider my father the, the salt of the earth. You know? So, I had a great upbringing. [. . .] I never felt that my family could even get along without me. You know what I mean? I was such, I felt that I was such an integral part of the unit that the whole unit would collapse if I wasn't there.

Charles Burnett: I didn't have too much family, no . . . Just my brother and myself . . . grandmother, and everyone else is in Mississippi actually, stayed in Mississippi, and that's the thing. But when we got older, and we got cars and things like that . . . And then we went everywhere.

Zeinabu irene Davis: I did have some tensions with my mother because my mother was biracial and from Canada and racism doesn't exist in Canada, in case you didn't know. I would be having arguments with my mother, I as a teenager, about how the man was keeping us down and my mother was looking at me like, "What the hell are you talking about?" I think I even said, "I hate all white people," and she's like, "Do you hate your grandmother?" and I say, "Well, everyone except nana."

Ben Caldwell: My life was charted to do films because my grandfather was a projectionist. [. . .] My grandpa used to babysit me, so I was four years old when I first kinda remember the first arc and projection booth and I would help him change reels.

Julie Dash: It was very random how I got involved with film. [. . .] My girlfriend . . . said, "Let's go over to the Studio Museum of Harlem because there's this free still photography workshop and maybe we could get a camera." Because we couldn't afford a camera, and I was like, "Yeah, I want to shoot some still photography." Being a still photographer was cool, you know.

Larry Clark: So that was the first thing that I did, I took this old photograph of my mother and photographed it. And then after I got really involved in photography, I sort of dropped photography for a while, and then I went to college and got involved in photography again. So the type of stuff that I did was more social commentary. Basically I would walk through the toughest part of Cleveland, Coughlin, take photographs. You know, find little alleys and stoops and I'd take photographs of people. There was this real militant group in Cleveland, they were called—there were two groups, Republic of New Africa and Afro Set, these guys were so tough, they wouldn't allow the Panthers to come into Cleveland, that's how tough they were. So I took, I knew them all, so I took photographs of them. A lot of social commentary; in fact, those photographs are what got me into UCLA.

Charles Burnett: I wanted to take still photography, but for some reason never gravitated over to that area where that department was. But I always wanted to do that. And they really didn't have any counselors, over there [at L.A. Community College], any guidance at all. You were just on your own, basically.

Carroll Parrott Blue: I was really into films because my father would take us, would take me to see films at least once or twice a week. In that way I got to see practically everything that came out of Hollywood . . . I got to see *No Way Out, Pinky, Gentleman's Agreement,* all of the serious films that they say now were the problem films of the late 1940s, in which Jewish filmmakers talk about race and class, and so I got to see all of those films with [my mother]. She would go to those and take me with her. She was also familiar with all the Black films that were coming out, so I saw *Porgy and Bess, Carmen Jones.*

Jamaa Fanaka: My parents gave me an eight millimeter camera and that's how I really fell in love with film . . . You learn a lot just by fiddling with the camera. But I still didn't think I was going to be a filmmaker. I didn't know what a film director was.

Julie Dash: There was a flyer that I picked up at the Studio Museum of Harlem and on that flyer it talked about these Black filmmakers at UCLA: Larry Clark, Haile Gerima, and, I believe, Charles Burnett's name was mentioned. They may even have had a picture. And the flyer was talking about these guys making these dramatic films, narrative films. And I wanted to learn how to make a dramatic film, because the documentary tradition was prevalent in New York for a long, long time; documentary and experimental, and I wanted the freedom of working in the experimental realm because everyone around me was making these hard-core political films and newsreels and everything.

Ben Caldwell: I saw plenty of movies, and I think how it impressed my life as a filmmaker was it made me an experimental filmmaker because I had gotten to see the films over and over again. The whole idea of the talking heads really didn't engage me, so the whole idea of dealing with film as a picture medium and having it be worth a thousand words, each picture, to me really engaged me once I was able to be a filmmaker. I found the root there, really, strangely because my first camera was in the military. I bought a still camera while I was in Vietnam because I felt that it was like no other army movie that I'd ever seen. So, I thought that really gave me the impetus really to first document the process that I was going through as a soldier.

Carroll Parrott Blue: I was in San Francisco to get to that place of making film . . . But in the Bay Area in 1968 or '69 to 1970, I photographed the entire Black Panther antiwar movement at the height of Haight-Ashbury—everything that was going on in those streets, I was there photographing it and it was a wonderful experience for me.

Larry Clark: Oh yeah, [I was] very active politically, very much so. When I was doing the darkroom work, then I realized—what happened was right across campus, from my university, there was a college called Western College for Women. And it was all one school, and Ohio is very conservative, but the girls that went to that school, they were mostly from the East Coast, or they were

daughters of diplomats, they were very progressive. And I used to go over there all the time, and I remember one day I was over there, and they had a movie playing and I looked in and it was *Seven Samurai*, it was the final battle in *Seven Samurai*, that battle in the rain. And I'm watching this, and that's when I really started thinking about film, I just saw that one scene in *Seven Samurai* and I really started thinking about film.

MATRICULATION AND EXPERIENCES AT UCLA

Alile Sharon Larkin: I was told that if you want to work, you go to USC . . . Now, when I went to film school, I wasn't thinking about working, I just loved film and, "Oh, you can go study that?" So I just want to go do that, so I didn't care about working, about getting a job . . . The other thing that I always said was that my undergraduate, you know, going to college, was my mom's dream for me, for all of her daughters, so that was for mama, and this was for me. Film school was for me. I was going to do what I wanted to do, and so it was about that.

Jamaa Fanaka: So, I'm on Rosecrans Boulevard and Compton, waiting for Chunky to come back from Num Num's house . . . Num Num had a father who drank a lot who had a gun and he never would notice when the gun was missing. So I was waiting for Chunky to come back from Num Num's house with the gun and . . . I see a sign across the street in a storefront in yellow and gold, UCLA colors. It said, "UCLA! You're Welcome!" Or something to that effect, and I'm intrigued by that. So, this is Rosecrans Boulevard, which is a real busy thoroughfare in Compton. So I make it over across the street to the storefront, almost getting hit by cars, and go in and [am] met by this pretty receptionist. She gave me a cup of coffee and a couple of doughnuts—they were really good doughnuts too . . . And [she] asked me if I wanted to go to UCLA. I said, "Sure, I want to go to the moon too but my chances of getting there are pretty miniscule" . . . So, when Chunky comes back, I'm all really UCLA stars in my eyes now. I'm not about to mess up a good chance by pulling off some stupid robbery. And Chunky was really disappointed in me . . . And I was so happy when I was accepted into UCLA. I wanted to write; that's what I wanted to learn, how to write.

Zeinabu irene Davis: And the way I get to UCLA is, I'm on the East Coast, I'm at Brown, and I gotta become a filmmaker, so I start to do research. I start to go down to New York, and I get in touch with people, part of the Black Filmmaker Foundation . . . They tell me about Haile Gerima . . . And I basically develop a relationship with Haile as a mentee . . . He said, "You'd have more equipment [at UCLA], we don't have that much equipment at Howard, you're going to get frustrated. You'll find your way through UCLA to be able to do the kinds of stuff that you want to do. . . ." And so, you know, he put me in touch with Teshome [Gabriel]. [. . .] So, that Saturday I was over in Powell Library in the basement with Teshome for the African Film Festival, and I'm the only girl there at the time, by the way, which was kind of strange, but that's the way it was . . . He takes [Marc Chery and Pierre Désir] aside and he says to them, "Gentlemen, you must take care of this young lady, you must take care of my sister. You must treat her with respect and make sure that she gets everything that she needs here." And they listen, 'cause I ended up marrying Marc Chery and we've been together for more than twenty-five years. And Pierre Désir is our good friend, and he shot, Pierre as a cinematographer, shot two of my films. He shot *Cycles,* which was my thesis film here at UCLA, as well as *Compensation,* which was my feature film and the last narrative film that I completed.

Robert Nakamura: [The department was] approaching ethnocommunications from ethnographic film, which we hated, a lot us. Some of us didn't know what ethnographic film was, but once we began to see some of the films, we totally kind of rejected it. So there was a little friction there, I think. [. . .] The idea was for us to document and present our own communities, and not going into somebody else's community and portraying them through our own lenses.

Richard Hawkins: We had an ethnographic film workshop, which could be a year-long thing if students were interested, in which they did shorter films and projects locally, and [. . .] when they could submit a project for thesis, or for special project. Then we had equipment that we could assign to them, and they could take it overseas or wherever and film. We originally thought we would team up anthropologists and filmmakers and have them work together as a team, but that didn't work very well. There was a struggle, [about] who was actually in charge, and apparently each side sort of resented the other.

Barbara McCullough: The only place I ever wanted to come to school was UCLA. Because when I was a senior in high school, I got the opportunity to come and get a campus tour and go to an orientation, and it was like, this is where I want to go.

Bernard Nicolas: What happened is, UCLA, in its formation and its conception in some ways, afforded this [ability to make films] because it's the place that Hollywood didn't take seriously, because it was never a conveyor belt. It had to take its . . . obligation and its presence and this research, academic context seriously, you had to have a curriculum . . . you had to take classes. It wasn't a shop school. It pioneered . . . ethnographic filmmaking, right? And it said . . . you own your film. You own it, you pay for it, you run, you make it. You make it here, but it belongs to you. You make what you want, okay? As long as you satisfy your requirements of this school and our standards. [. . .] That's pretty open, you know?

Abdosh Abdulhafiz: There were a few instructors who believed that this school must be [an] experimental kind of school, compared to USC. They said we are not connected to Hollywood, this is completely—you have to be independent, you have to be creative.

Stormé Bright Sweet: At UCLA, I felt like I was in a battle from the day I stepped onto campus, and it was such a culture shock . . . I got here and I just felt like, oh, my goodness. And it was not a battle like a skirmish; it was a free-for-all! Thank God I knew how to defend my position and I knew how to research things. I would speak up; I was always taught to speak up. Thank God I was like that, because who knows what could have happened here if it didn't already happen. I found UCLA very, very tough.

Don Amis: I was really having a lot of fun in that first year. And I was trying to figure out where I fit and what suited me well. And I got through the first year and I was into the second year and I really hadn't found my niche, you know. And I was sitting—it was called the gypsy wagon—I was sitting out by the gypsy wagon one afternoon, looking at the campus catalog of classes, and I saw a cinematography class. I said I'll try that, you know, and actually you had to be in the department to take the class. Well, I went over to the department and I don't remember the teacher's name, but he was cool and he said, "Yeah, come on in." So, I took a cinematography class and . . . after I got that first print of what I had shot on that Super 8 camera then I knew that that's where I belonged . . .

I think it was something real simple like trying to capture a texture like of a nail file. You know, get the texture right. You know, get the lighting of this, get the lighting of that. So it was exercises and as we're doing them I just knew that that was where I fit. And then I applied to get into the school and I was accepted.

Haile Gerima: When I came to UCLA, I had decided to fight everybody, even when I'm wrong. I don't have to be right because I'm threatened; my whole identity's threatened, I'm devaluated, I was not going to accept.

Barbara McCullough: Things at UCLA at that time were really very, very political, you know? I mean, you had Jamaa on one hand, back in the classroom yelling at the instructor, you got Haile in the hallways being the professor that he actually became and, basically, they were saying some stuff that was probably really true and things that needed to be said, but it was a highly politically charged environment, you know?

Shirikiana Aina: Toni Cade Bambara says for example, "The role of an artist"—I'll say artist, I think she said writer—"is to make revolution irresistible." And the artists of that period took on that challenge. Whether they called it revolution—whatever they called it, they were striking out at something. They were trying to carve something. And when you carve something, you're destroying something at the same time that you are creating something new. It wasn't just hitting a rock and destroying it. But destroying that rock by turning it into something that is useful to us, that will be there for your children, that will inspire the next generation. So, I think that's what happened with this initial group of people, blacks, and Latinos, and other people of color that went to UCLA in the '60s and '70s. Whether or not they knew it, they were angry, and how do you address that anger? You take a tool that you are becoming familiar with and make it something that helps you to address that anger. That's—that moment in time influenced me a great deal.

Julie Dash: Alile Sharon Larkin, Carroll Blue, Billy Woodberry was my TA, teaching assistant, Barbara McCullough was there. Larry was just leaving. Charles was leaving. And Haile was leaving at the time, the year I came in. And so there was a lot of activity and it was like being in heaven. Because people are sleeping on the editing-room floors and just working around the clock. Everyone's complaining, miserable. It was great.

Charles Burnett: It was just a fun place to be, it was a great place to be. You know we stayed there almost twenty-four hours . . . And what was really rough was at the end of the quarter we tried to mix a film, and you could stay up for days. I'd sleep on the couch and stuff like that.

Bernard Nicolas: It was just kind of understood that you supported each other, because you would run into people at three o'clock in the morning in the upstairs part of Melnitz, and there was an intimacy about it without having to be conscious about it. It was like we are all family. But then the Third World students, and the Black students in particular, we ended up having meetings together, we were trying to form organizations and then we worked on each other's films.

Barbara McCullough: So it wound up being a very interesting experience because Alile Sharon Larkin was already here, O.Funmilayo was already here . . . Gay Abel-Bey and Anita Addison and then Stormé Bright, and a couple other people, Jackie Frazier and Vel Frances Young, so it was interesting because there was this influx of women with this exodus of men, of African American men. And that was so interesting, because I'm like, hmmm . . . double minority. Double minority, that's what we were.

Jamaa Fanaka: I love UCLA. I love what UCLA did for me and what I gave back to UCLA, and this is a great institution of higher learning and it will always have my love, respect, and all the other good things that go with loving your university.

STUDENT FILMMAKING AT UCLA

Ben Caldwell: I ended up on that road of really seeing my film work as a way of emancipating the image. So that's the reason I got involved with the first frame. With each frame I wonder, how does it look? How was it operated? And we as humans see each frame. It changes your view, and so how are they related to each other almost like poems? Each was created within the poem, there is no word stronger than the word before it or the word that it is about to follow—it's the same thing with pictures.

Shirikiana Aina: There was very little [critique of *Brick by Brick*]—the students and teachers didn't have the ability to understand the material. And that's a pretty heavy thing to say in a film school,

FIGURE 10.2. Alile Sharon Larkin on the set of *A Different Image* (Dir. Alile Sharon Larkin, 1982). Collection of Alile Sharon Larkin.

because they're looking at materials from around the world. But they didn't understand it and didn't appreciate it. So, I had to take my material and find my own source of feedback off the campus. I found Black people whose opinion that I trusted.

Alile Sharon Larkin: We had to raise money to do our films. So that's why it took that long. 'Cause we're working full-time jobs whenever we can, and taking your whole check to the film lab. That was kind of a lot of money in those days—like, it really makes you think differently about money—but we were so passionate about it. And

I remember taking my whole check to the lab, and the young lady who worked at the lab saying, "That's my rent." It was probably my rent, too, you know?

Charles Burnett: [With] *Several Friends* I wanted to do a film about my neighborhood again, people I knew and the situations they always find themselves in. A lot of it's very humorous and so I just wanted to capture that slice of life.

Jamaa Fanaka: Well, I wanted people to see how they could take a little lie, you know, and if it hangs around long enough it's going to grow. It's going to grow to the point where people accept it as truth and almost becomes the truth. You know what I mean? If enough people believe in it, it becomes a sort of truth. So I felt a filmmaker has a lot of power because he's got a number of people in a darkened room. Okay? That's attention focused directly on the screen . . . And so, you got this power to say something. You know? To influence people's thoughts and minds, reactions to images and stuff. So I wanted to use that to make a serious statement about this ridiculous myth that was generated by the white slave owner because they were scared that the white women would want to have surreptitious sex with the slave. And it backfired on them. Instead of scaring them, it intrigued them. You know what I mean? And so, that was my first film, *Welcome Home, Brother Charles.*

Haile Gerima: Child of Resistance was a dream. It came out of a dream. Now *Bush Mama,* I'll tell you, for example, *Bush Mama* has a lot to do with my having seen a Black woman in Chicago evicted in winter. And I never knew how a person could be thrown out, and so I came up with the idea *Bush Mama;* this African mother in the snow. So *Bush Mama* just evolved over time to be what it became.

Bernard Nicolas: My first film [*Fifteen Years*] was about my family because I wanted to understand why [my father] was the way he was. He was such a proud person. He was the chief of police of Haiti's second-largest city, and then he came to the United States and work[ed] in a warehouse and he hated his job, every moment of it.

Barbara McCullough: In terms of influences, I had heard about Maya Deren for years, by way of *Film Culture Reader* and Jonas Mekas, and all those people, basically, and I had seen photographs from *Meshes in the Afternoon* before I'd ever actually seen the film. And

FIGURE 10.3. Jamaa Fanaka on the set of *Welcome Home, Brother Charles* (Dir. Jamaa Fanaka, 1975). Ben R. Caldwell Artist Photo.

that image was so striking to me that I said oh, that is so—there's just something about the richness of that photograph that I saw that really, really motivated me to want to do a project that in some way showed a female in a different way.

Billy Woodberry: [In *Bless Their Little Hearts*] there's one source of music . . . It's a recording by Archie Shepp and Horace Parlan called "Trouble in Mind," and there's another one called "Goin' Home," and one is classic blues, and the other is spirituals, slave songs . . . But that's pure, classical American music and Black music . . . It's foundational, right? . . . It's the thing the characters sort of [were] speaking about, sacred and profane . . . sort of pleasure and duty, material and spiritual kinda thing, right? And so that's central to human experience and the Black experience is often implied in that—that music, you know?

Julie Dash: In fact, when I shot *Illusions* [. . .] I had Ahmed El Maanouni come over and shoot it. We met him in Cannes. He is a Moroccan filmmaker, and we shot *Illusions* on black-and-white reversal and I was going for that 1940s film noir, very rich, rich

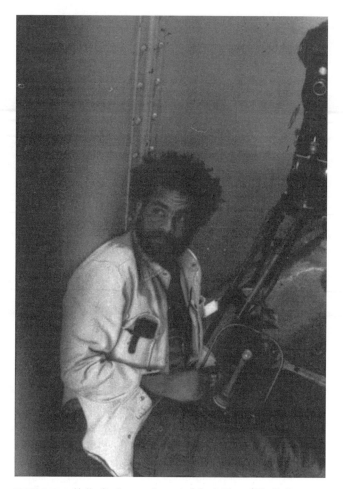

FIGURE 10.4. Haile Gerima on the set of *Bush Mama* (Dir. Haile Gerima, 1975). Ben R. Caldwell Artist Photo.

velvety Black look, so we used reversal stock. And when I brought it to the labs here, they said, "Oh, this is, this is underexposed." It was like, "No it's not. It just, it's film noir."

Haile Gerima: I come to Paris. I'm on a subway on Sunday. A Black woman comes in, a model Black woman comes in only wearing a jacket and all these Africans early in the morning like in the slave boat, the train going like this [illustrating with his body]. The sister came [to] start modeling. A white guy comes in from behind [and starts] taking her picture. That's Mona. I said, "Where's this Mona

FIGURE 10.5. *Sankofa* (Dir. Haile Gerima, 1993).

come [from] . . . she's disfranchised. Where's her genetic scramble come from?" Shola.

Barbara McCullough: And also I have to talk about the fact that I was understanding who I was as a female person, as a creative person, even a mother. Even as a mother, even as a lover. And also understanding my body and feeling comfortable with my body. I think all of that is part of [what] *Water Ritual* was about. So it had a meaning in a sociopolitical way, in terms of okay, fine, I'm a part of a culture that I don't have—that I'm mentally informed about. So I'm gravitating toward something that I can't totally verbalize.

Haile Gerima: So in *Ashes & Embers* I was really looking for when does one change? When is one right? Is it at, like, do you get born at seven thirty? No, it's a circle of confusion. No one can put their finger [on] the minute, the second you were born. They just give you the general. So, it's the same thing, change. When does a person change? When do you become a feminist suddenly? What are the quantitative things that lead to you becoming? So, I'm saying, when does one become revolutionary? When do we become socially relevant? When do you notice something about yourself? But it's a gradual thing that has been going on, and the artist and the filmmaker have to find all the things that led up to this rupture. That is more important to be committed to than three-act anything.

Larry Clark: When I went to UCLA, initially I wanted to be a camera-
man. That was the idea, I was going to shoot films, because I came
from a photography background. And on that first film we shot at
PASLA [Performing Arts Society of Los Angeles], I was the camera-
man on this film that's called *Blackbird.* It was never edited, so don't
try to find it [laughs]. And then I started getting interested in writing
and directing because I wanted to say something. I think Project One
is what did it. Because that first Project One—I'm tired of these
negative stereotypes coming out from Hollywood, and I wanted to
do something positive, so I go out and I shoot my Project One and
I edit it, and it's one of these "Aha! Eureka!" moments. I am editing
the film and I get a rough cut and I say, "Jesus Christ," and I saw
this film is just as negative and stereotypical as anything coming out
of Hollywood. And that's when I really realized how deep this stuff
[is]—people say, "Oh, I'm not influenced by Hollywood," but even
if you are a person of color you pick up on these same negative
things. So then you realize "I have some work to do"; you can't just
say, "I'm going to do something that's not negative." Those are
good intentions, but how do you get there? And you have to unlearn
a lot of stuff. So that was an important moment for me, to look at
that and to realize that. So I had to go back and recut the whole
thing in a way to kind of salvage it.

Charles Burnett: You look for good locations that become characters,
in a sense, in the film itself. 'Cause, I mean, it's all the visual—you
look at . . . how film's supposed to look. And it adds a lot of value
to it visually . . . and we were very conscious of that always.

Jamaa Fanaka: Like I say, if you start off with an idea and wound up
at the end of your effort with a completed film, you've already won.
Regardless if nobody comes to see it, you've already won because
you have completed the project. And that in itself gives you encour-
agement, gives you knowledge, gives you more resilience, gives you
confidence.

Robert Wheaton: It was definitely a very collaborative thing . . .
I worked on Torriano's films. He was very prolific at UCLA. He's
probably one of the most prolific filmmakers at UCLA . . . I think
the first film I ever worked on at UCLA was a documentary on
Horace Tapscott that was directed by Barbara McCullough. It
didn't take that long for me to jump in. I would just start getting
involved in other people's films.

PRODUCTION CHALLENGES

Haile Gerima: Just the idea of [what] the insurance buys—in our time, it [bought] five roll[s] of film. So, we were illegal. We didn't care about insurance. We shot. We put a tripod [up], police come—in *Bush Mama,* you see in the beginning, police were apprehending us with our camera, everything. They almost killed me by mistake. And so it's really an improvisation. It's not a plan. It's an improvisation and the discovery becomes knowledge and you become more coherent.

Carroll Parrott Blue: I remember we were trying to shoot her [in *Varnette's World*] and I didn't even have a pole for the sound. And so we took a broomstick, we put the little mic and taped it onto this little broomstick, and I'm standing there with the broomstick and the mic over her. It was a trip; it was something else. It was pitiful.

Charles Burnett: If a thing could go wrong, it went wrong. We had some problems with some of the actors that were just incredible. My main actor wanted more money and he sort of held out and more money, more money, and he disappeared and I had to find him, and he was somewhere in the South and we had to pay for him to come back. He said [that] he got ordained as a preacher, and so he stepped off the airplane with this cape and a Bible in his hand. Literally.

Carroll Parrott Blue: I was working with James Cleveland, you know. And we went to his church; we were setting up, and we had our little blue jeans on and getting everything ready for lighting and getting ready for the thing. And so, then the church starts, right, and so Cleveland says, "You can't come in." And we're like, "We were just—what do you mean?" "Women wearing pants, not in my church." And so we had to run home and I had all these African skirts that you wrap around, so all the women had their pants on and had their little African skirts.

Bernard Nicolas: [During the *Daydream Therapy* shoot] it was a misty morning; I just remember it being overcast. And of course you couldn't bother with permits or asking anyone's permission, because later I tried to do that . . . So I had this bizarre assemblage of maybe about twelve, fifteen Black people, one white guy, very strange costumes, a rifle, a sword . . . and we're shooting at the top of the park. We're in the middle of shooting a scene and this

sheriff's car just pulls up into the scene. "What going on here?!" They were ready to arrest all of us. It turns out that this [former] child actor who was on the ground with ketchup on his head had gone to school with the sheriff.

Pamela Jones: I just saw what had to happen and I made it happen [during the production of *One*] . . . The choreographer was the woman who plays in Larry's film [*Passing Through*] . . . She's an awesome dancer, but what happened was she was supposed to bring a whole company that day and we were filming them, but only three people came, or they came late, or something. It was a lesson in ingenuity, because we had to film them as if there was a whole company on the stage.

Julie Dash: With *Daughters* [*of the Dust*] our [choice of] film stock was very, very, very conscious. We did a lot of testing and we decided to go with Agfa-Gevaert film because Agfa-Gevaert—it was a negative stock that we used and it had a lot of orangey tones in it and we wanted to use that, because to warm up the Black skin tones, because we knew that we were going to be shooting a lot of sea and island people, a lot of very dark-skinned African Americans, and we wanted to warm them up. Also, the cinematographer Arthur Jafa created these little hand-held reflectors that he would hold or have the grips hold close to the faces of some of the actors, to highlight and to reflect the sun, and all of these things because . . . we couldn't use lights. We couldn't use lights because we were on this ecoprotected sand dune area that was a mile hike . . . from where the parking was, from where base camp was into the location. It was a mile inland before you reached—you would have to go inland through the woods before you reached the beach on Hunting Island. And there could be no vehicles used on that path or on the beach, and so therefore we could not bring in lights. So everything was a reflection, natural light, or scrimming.

Jamaa Fanaka: I worked on Ben's film, you know, I worked on Charles's film and Charles worked on my film. Ben worked on my film. All the Black students worked on my film at one time or another, you know. If one couldn't come—you know, like [*Welcome Home*] *Brother Charles* was made completely on weekends. Because I could get the equipment for those two days, Saturday and Sunday, and I'd have the equipment back Monday. And the community was with me. That scene I shot in a courtroom

FIGURE 10.6. Julie Dash on the set of *Daughters of the Dust* (Dir. Julie Dash, 1991). Collection of Julie Dash.

really was a courtroom. On *Brother Charles* there was not one set in the film, although there were free sets available at UCLA. I felt, first of all it costs money and time to build sets. There were sets made here—the interior of Emma Mae's house, the interior of Big Daddy's house—but most of the stuff was shot on location. The house party was shot in my aunt's back den. I would just go to the location that suited my needs.

FESTIVAL TRAVEL AND EXHIBITION

Carroll Parrott Blue: Then I took the film to Chicago, to the film festival, and that was funny. I think I told you the story where I didn't hear [about] the film. I sent the film in, nothing. No comments, nothing. Did they get the film? So, I called up and I said, "Excuse me, I have a film in the film festival, did you get it? . . . So the guy says, "What's the name of the film?" *Varnette's World: A Study of a Young Artist.* So he said, "I'll look for it." I'm waiting. So he comes back kind of sheepish and says, "Your film got the Gold Hugo." "Oh, you mean it won." He says, "It won the top award." For some reason nobody had told me, so I am trying to

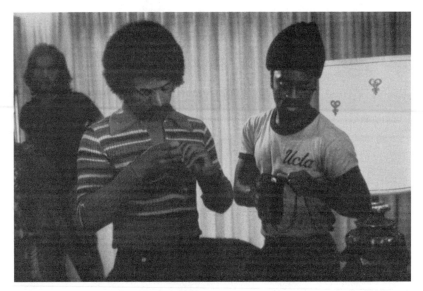

FIGURE 10.7. Charles Burnett (right) on the set of *Welcome Home, Brother Charles* (Dir. Jamaa Fanaka, 1975). Ben R. Caldwell Artist Photo.

find out where am I going to get the money to go to Chicago to see the film festival and everything.

Julie Dash: We didn't even know that you needed to . . . have foreign freight for all of this. We just had a full suitcase full of short films. We went through customs, and people, they would stop and look at the film can[s] . . . going through. We were so lucky because they could have held them in customs.

Barbara McCullough: And so [Julie Dash] was familiar with the terrain of how Cannes worked. And also she had a very close friend, Ahmed El Maanouni who was a filmmaker, and he had been at Cannes the previous year when Julie was there, so she knew the whole landscape of how to really work it. So we took, I think we took Billy's film, we took Charles's film, the short one [called *The Horse*]. I think we took Carroll Blue's film . . . And then we had our own films . . . So that's when I got to see *Penitentiary*, at Cannes. And it was a small screening room and it was packed with people.

Ben Caldwell: I showed *I & I* in Paris. And so in Paris, when we had our screenings there, there were the Africans that were there; that was in [the Fnac department store]. And then we showed it at

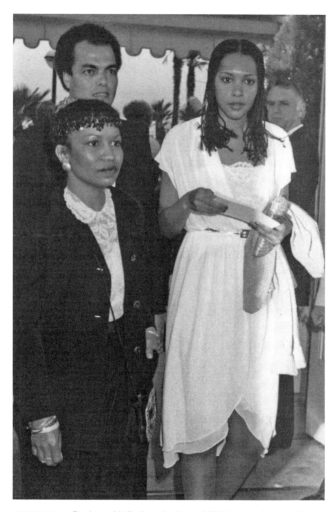

FIGURE 10.8. Barbara McCullough, Ahmed El Maanouni, and Julie Dash at Cannes. Collection of Julie Dash.

UNESCO and I showed at the Black Theatre, and we showed at several cultural centers and around Paris. For five weeks—I was there for five weeks—we were on a natural high.

Jamaa Fanaka: I would just go up on Sunset Boulevard. The last buildings right before you hit the residential areas of Beverly Hills, all those buildings. I would go in those buildings and I would go from the bottom floor all the way up to the top floor looking for distribution companies. And I would walk in there with my film

under my arm. As a matter of fact, Mark Tenser, who runs Crown International Features . . . was so intrigued by when his secretary came in and told him that a Black guy is here in the foyer with a film under his arm, and he wanted a distributor. That just was not how it was done.

Robert Nakamura: We screened at community centers, in church basements, a lot of classroom screening—it was very hectic and kind of exciting. We [would] fly to San Francisco with our projector and reels because we didn't trust anyone else's projectors, because invariably they don't work or they scratched the films. So we went all over, we've had audiences of maybe sixty or a hundred and we've had audiences of maybe two. I think that [was], at least for myself, the payoff—to see the reaction of the audience.

Barbara McCullough: I showed my Project One and . . . I was so terrified by the experience of showing something that I had done, that after I screened it I went to my car and cried. I cried and cried. And before I got in my car . . . I can't tell you the panic that I felt sitting there, because I think I had started to cry after my film had shown . . . I was absolutely panic-struck from the experience of sitting in there showing something that I did . . . It was personal. It was personal, but anyway, so I lived through that experience.

Haile Gerima: When I screened *Child of Resistance,* students came from the art [and] other departments to kick my ass because this was that loud guy, that loud guy who talks so much shit about films, his film is showing. It was packed, and then my turn came to show . . . *Child of Resistance.* [When] the film ended . . . it was like [they] just applauded left and right. The film was applauded I guess for its energy . . . When I showed [the film] in Oakland . . . a Black woman in the back says, "I feel like that woman in that prison." That was to me saying, "Oh. You're a filmmaker." I wanted that, the feedback, but it was not at the cost of giving them what is traditional.

Ben Caldwell: We didn't get shown that much here in Los Angeles. It was mostly around the country, and here in Los Angeles it was mostly in the university, and then *I & I* also was shown as a part of the Brockman Gallery's festivals, which was the Pan-African film festival of that time period. So, I showed *I & I* during that era there, and I got pretty much positive reactions from all the communities here, and we showed our films as a series, we showed a group

of films. Where I think our films don't do well is like in places where I'm from, like New Mexico types of places, it doesn't do too well. Mainly because they're expecting to see Hollywood films, and that was the first thing they asked me when I was showing my film, years ago, because I showed it there. All my friends were like, "Ben, how come you can't do a *Sanford and Son* or something funny, you know, do an *Amos 'n' Andy,* do something." So that was the reaction I got from the kids I was raised with. I was like, well, that shows why I'm not here, because you guys want me to do those kinds of films. I don't even know how to do a *Sanford and Son,* but if I was given the job I think I could do it pretty well and make it funny. But I still don't think that you necessarily have to be . . . that's not all who we are. So that's the problem, but it would be cool if we had more stories, if we could tell more of our stories, but you can't do that within someone who's captured you and conquered you.

Bernard Nicolas: I knew that my films were kind of different. I remember when *Gidget Meets Hondo* played at the Black Film-maker Foundation, the reaction was like . . . people didn't know what to make of it. And of course there was this desire to be supportive; people wouldn't denounce your film, but they would be kind of quiet. Because the stuff I was doing didn't fit into any specific trendy category that people wanted to talk about. And that was okay with me; I was just sort of used to being different.

Julie Dash: I had a stack of the DVDs of different films that I had done and . . . it was in [a] conference kind of setting, with a group of people around a conference table—mixed race and male, female. And a man said to me, "You mean, you're telling me you actually directed all of these?" And I didn't quite know how to respond to him. "You're actually," he said, "You're actually saying," like he was confronting me for this impossible declaration or like, "Am I supposed to believe this?" Even though my name was right on the DVD . . . he could not comprehend it. So . . . that kind of bias is still there.

Larry Clark: So the first international, the first place out of the country was Locarno [Switzerland]. I was so broke at the time I couldn't go, and I didn't know that they are supposed to invite the directors . . . And then *Passing Through* showed at Moscow—it showed at Deauville, then it showed at Edinburgh in Scotland, and it showed

at a number of other places. And it took on a life of its own, [because] I never pushed it or sent out any promotional material, and it just had a bigger life, it floated around this country a lot. It showed at churches, and during the apartheid movement it was used a lot in terms of raising money, and they would show it and talk about the antiapartheid movement, and a lot of art museums. It showed a lot going from hand to hand, and that was part of the plan . . . I was never looking for distributing in the theaters, it was supposed to be noncommercial. That was the idea. You know, money was a dirty word.

CAREERS AFTER UCLA

Bernard Nicolas: Well, the only thing that made sense to me as I was about to finish, or being pushed out, was that I needed to get away from this country. I'll go anywhere, but I'm not staying here . . . so I developed a plan to sell everything—my furniture, everything I owned—and set off for Zimbabwe.

Charles Burnett: Well, I was working at this agency . . . so I was doing that and knew I had to stop and save up some money. Just stop and do something with film. So I was trying to save some money and just do that. Because you couldn't do both, you had to make a decision, to just spend a year trying to make a film, put a film together, so that is what I tried to do.

Julie Dash: I still feel that I've just only scratched the surface of the things I want to do. It takes so long to do things, and in-between, and so. Oh, there's so much more work to be done and that's what I'm looking forward to. The work to be done.

Barbara McCullough: I was working at Digital Domain at the time . . . They were like, you're going to Italy? This is so funny, because in my whole career in the film industry, no one's ever known about my own personal work . . . Maybe it's also me, because there's this certain underground filmmaking [that] has not really been discussed in the community of people I work with professionally.

Zeinabu irene Davis: I can't handle a freelancer's life. It's too hard for me. You work six weeks and then you don't work again for another six months. That's very, very hard and I just can't take it. So that's kind of why I transitioned into, first into teaching on the

high school level, and then teaching on the college/university level. Because I found that I liked teaching and I could give back to the community in that way.

Haile Gerima: I think all of us [had the] human power to constitute a credible distribution company that would have really changed [the] course for our life now as filmmakers. I'm one, for example, in distribution with my wife Shirikiana. We were one, but we would have been so powerful with twenty, ten, fifteen. We would have put our package together, our films together, output our DVDs together. Shirikiana and me, we do our DVDs, we do our distribution. Sometimes there's a good deal that comes to us, but this franchise is our own way of avoiding exploitation to benefit somebody else. And so, the energy and the power from coming together was destroyed by our own weakness. Maybe we never believed a lot of what we bragged. I don't know. But we would have fared better than what we look like now had we been united, taken it to the second level of beyond student friendship and collective to professional collective. I know some attempts happened, but it disintegrated because of our own individual insecurities and the system's formidableness. The system don't play. And so, we're scattered . . . I don't see it as success, because I know our capacity to write. Like a whole screenplay over in two weeks, three weeks, our capacity to shoot in a very, very, unbelievable speed. I mean our skill, I mean it's helping me to film co-productions I enter in Europe. What I learned from my friends at UCLA is my—I mean, I'm an amazing producer.

Jamaa Fanaka: I refused to fail, like I refuse to fail on this project. I refuse to fail on my memoir. I'm writing two scripts now, *Penitentiary 4*, which is a futuristic type of prison film that is set in today's world, and a film that is called *I Learned to Respect the Power of Love* . . . It's about a veteran Black police officer, where she solves the crime of a drive-by shooting where a little girl gets killed [and] she comes to grips with her own demons of her youth.

Charles Burnett: Some of us kept in contact. Ben's around the corner. Haile is always calling. You know, back and forth we had. You know, Teshome I would see . . . and Billy and stuff like that. I mean . . . we didn't see each other every day, like at school, but it was—yeah, we have always kept in contact.

REFLECTIONS ON THE TERM *L.A. REBELLION*

Clyde Taylor: So, I scratched out several names of titles, and one of them was "The L.A. Rebellion," and John Hanhardt [the Whitney Museum's film and video curator] said, "That's it—the L.A. Rebellion!" And I said, "Oh, what have I done?" I wanted to backtrack from that immediately because it sounded so catchy, it sounded so zingy . . . And of course that's part of the dilemma of presenting anything. You do want to catch an audience's eye. You want people to notice.

Julie Dash: I remember [Clyde Taylor] always writing stuff and calling us the L.A. Rebellion, and at the time we were just thinking it was like some joke. You know, it's like it's some nickname he was calling us . . . But, I guess it stuck, huh?

Robert Nakamura: I'm sorry, I never heard [of] the L.A. Rebellion. And I think rebellion might be a little strong . . . Well, I guess in one way, speaking of attitude toward media, [it] could be a rebellion . . . We reject Hollywood and the arts and we're going our own way. But rebellion is like, a really strong word . . . I don't know if I would call it a rebellion, except in the broad sense of rejecting the traditional filmmaking arts and Hollywood.

Jamaa Fanaka: I love that term, I love that term. And there was a rebellion here. We all felt that we were going to make our mark on the history of cinema. In our own way. The way we wanted to do it individually, but we wanted to support each other . . . And that's the way, you're going to get a lot more accomplished, if you stick together than if you isolate. Yeah, I love that—the slave rebellion and the L.A. Rebellion. The juxtaposition of those two things.

O.Funmilayo Makarah: Well, the interesting thing is when I hear the term *L.A. Rebellion,* I think of what happened to Mr. Rodney King. And I've also done work and videos on that, so that's the first thing that happens. When I hear it in connection with the UCLA students, it makes a lot of sense, because I think we did change what was happening at UCLA, and what was happening in film. We'd see a film or talk about somebody's film or somebody's script and we'd argue back and forth about it and then go out to breakfast. Because it was all done out of love. And so that term to me does mean a lot and I do think it's accurate.

Don Amis: I think I asked you what that term meant when I first talked to you . . . It's catchy is what I think about it. I don't know how much rebelling the filmmakers were doing, because as I said a lot of them were trying to express themselves. I think there was a lot of different expression going on by minority filmmakers, which was new, on that scale. Nobody had quite seen [it]. I think rebellion in the sense that guys were getting stuff off their chests, through their films, in a lot of esoteric ways. But the rebellion that was going on in society at that time, I don't think was very well reflected in these films. I don't think that's the case. People were approaching it from a lot of different directions . . . and you really don't see too many good—too many films that were showing what was happening. And there was a lot of stuff happening, all the time. You could just walk out your door and people were protesting this and protesting that and marching here and marching there. Cops sweeping through the streets, it was wild. But nobody was dealing with that stuff that I know of. So the term *rebellion,* coming from my background, means a whole different thing. So it's a catchy phrase and all that, and it might fit for academic reasons. But, see, I'm not an academic. I'm really more of a practical, down-to-earth kind of guy. Rebellion to me is struggle. Struggle for change. And no film that I can recall made during that time dealt with those issues. None of them were really struggling—pushing change.

Clyde Taylor: I had resistance because . . . I wasn't sure that the filmmakers would like being portrayed that way, because there is a way in which being militant can be almost cartoonish in American life. It's easy to be made a caricature . . . I was concerned that I might have been giving too much attention to the Los Angeles filmmakers and not enough to the many filmmakers in New York and other places who were making important films.

Haile Gerima: It was not a monopoly of Blacks only. This is why . . . I'm not crazy about the L.A. Rebellion a lot, because to me it had Chicanos . . . I mean, I'm sure revolt is there, but it's not a copywritten thing of Black people—it's unfair to Chicanos, it's unfair to Asians, even some white students; gutsy white students who were there—left wing white students. And so, for me . . . I don't like it personally. I don't mind people using it, but for me it excludes, strictly becomes a Black thing and excludes the Chicanos, [. . .] the Asians, there were even Iranian students that were part of that.

Clyde Taylor: But that's what was needed for these filmmakers, you know? That was what was needed to describe them, yeah? They were strong.

Ben Caldwell: Yeah, I like that better than "Blaxploitation" films, which is part of what people would have categorized us as, but I ended up looking up the word *rebellion,* and the first thing that came up was slave rebellion.

Julie Dash: Let's see. Every time I think of the word *rebellion,* I always think of something from the Civil War, because it's an old term, so it's like, "Yes! We shall strike when the iron's hot!" . . . "We shall come up there with our lanterns and we shall, we shall overturn these tea baggers or whatever" . . . But, yes, we were [rebelling]. We were rebelling against being told this is how we were going to be seen in films and this is how the films were going to define us. We were going to redefine ourselves and we were going to have our own voices. So, yes, we were very much in the midst of rebelling against Hollywood and working in the so-called belly of the beast, because this is where these images came out and that defined the whole world and controlled the world and the whole manifest destiny. So yes, we were rebelling against that.

Ben Caldwell: We were all under one banner and we wanted to tell stories about our people that we hadn't seen before. So everybody I think appreciated the differences . . . all of that difference was really kind of engaging, even though that same difference made it impossible for us to organize a name for the organization. But, like, I think part of it had a lot to do with [the fact that] the reason we were together was to be different.

Julie Dash: We were doing the film festival circuit in other countries and that was going on everywhere. Everyone kind of had a flag, a moniker, and it was like they were doing their films and so why not us? Well . . . it would all go well, and we'd be sitting in someone's living room for hours talking about all of the great things that we were going to do, and then it would come down to naming the group and everything would just go downhill.

Pamela Jones: Some people think that success would be to be in a twenty-five-million-dollar picture and [having] an agent, and some people define that as success. Others felt that success was getting the film that they wanted made and maybe getting it distributed. And some people just want to make a film to show in church . . .

I think at that point in time and space there were enough of us to say, "We have the skills, the talent, the ability to make film. You will not allow us to participate in this industry. And as we look at it more critically, we don't even want to be over there in that industry, because you don't get us and we want to get us. We want to put what we got on film, okay?" It really wasn't "us" as opposed to "them" straight down the line. It was us even though they don't see us. It was more that.

Barbara McCullough: If you look at how it's been defined, how I think Clyde has defined it, it's like wanting to bring another image . . . having us tell our own story, you know? Having another image out there, and not Blaxploitation . . . all these things in a way are kind of funny because they are a part of the reality of our life at the time. And so whatever you want to call it, it was an opposition to something that had been before it, or something that didn't exist that needed to have a place.

Billy Woodberry: It turned out to be a useful concept, not only for [Clyde Taylor], but it was at least a way that what happened was recorded or acknowledged in some way.

Zeinabu irene Davis: We didn't walk around calling ourselves the L.A. Rebellion. That's not what people who are in the middle of something are doing . . . Look at the work. It's there . . . The spirit is in the work. And you look at Ben's work, you look at Barbara's work, you look at my work, you look at Cauleen Smith's work . . . there's a through line.

Robert Wheaton: I think the filmmakers that came in the late '60s and the '70s—what they did was a little different than what we did. I think when we came in—in the early '80s—I wouldn't even consider us rebels, in a sense. I think we were more geared toward Hollywood, and then when we got to UCLA, we started to get exposed to other things and it broadened our horizons. It made us look at film in a slightly different way . . . The beauty of UCLA is that there was room for different types of filmmakers. There was room for different voices.

Bernard Nicolas: It's appropriate to call it the L.A. Rebellion because we certainly were rebellious and we did have an attitude that the last thing we wanted to do was break into Hollywood. We didn't know what we were doing, but whatever it was, it was the opposite of breaking into Hollywood. So the fact that this is

FIGURE 10.9. Zeinabu irene Davis and Pierre Désir on the set of *Compensation* (Dir. Zeinabu irene Davis, 1999). Collection of Zeinabu irene Davis.

FIGURE 10.10. Larry Clark on the set of *As Above, So Below* (Dir. Larry Clark, 1973). Collection of Larry Clark.

being documented, I'm excited about it and it gives me . . . there's an existential thrill to being able to be a part of this because it's like, okay, a huge chunk of my life, the biggest chunk perhaps, is gonna be written down somewhere.

Larry Clark: Even when we were in college, in university, we never thought of it like that. We were making films. And I think that it was important that Clyde Taylor coined it something, because then you can refer to it, not just some people at UCLA who one day made some films. You can put it in a category. We never put it in a category ourselves, just like I don't think the neorealist filmmakers put themselves in a category, though they probably should have. We were making films and it just happened to be a good group of students there, not just African American students, Asian students, Chicano students, just a good group of people that were there all at the same time. That's part of it. If you're there just by yourself, it is harder to get stuff done. But if you get the right group of people together, it is very different, and that is something, just being in the right place at the right time. So I have always been very thankful that I was at the right place at the right time.

Filmography

The following filmography lists L.A. Rebellion works by director. We have listed all filmmakers affiliated with the L.A. Rebellion with which we are familiar as of this book's printing, but it is nevertheless not a complete list. The UCLA Film & Television Archive online catalog (search "L.A. Rebellion" under "Topic or genre/form") and the archive's website devoted to the L.A. Rebellion continue to be updated as we uncover more information.

A director's films from the same year are listed alphabetically. Cast and crew information for most works is listed where available and illuminating. For the sake of space, this filmography does not list all specific crew positions or all available credits for every title. It does attempt to reflect the extent to which L.A. Rebellion filmmakers collaborated on each other's projects and the network of artists with which they have been in dialogue (including writers and musicians). Where known, we list the original formats in which the works were produced.

Information for extant works is gleaned primarily from direct viewing of credits and from external labeling of films and videos (film cans, video cases). We have silently corrected misspelled names. Sources for additional information for extant and nonextant works are listed at the end of the filmography, including primary sources and, in some cases, secondary sources such as previously published filmographies. We are deeply grateful to the filmmakers for providing and/or confirming much of the information included here.

Where available, this filmography offers information about the availability of works for viewing (in the original or other formats), either in archival collections (primarily the UCLA Film & Television Archive—consult the Archive's catalog for formats) or, more rarely, in commercial or educational distribution. While some of the distribution sources are no longer current (e.g., VHS tapes or DVDs now out of print), we provide them to assist readers seeking to trace copies and/or distribution histories.

GAY ABEL-BEY

Tommy 1978 (Super 8mm, color, 12 min)

DIRECTOR Gay Abel-Bey
OTHER CREDITS Scarlett Sa[?], Ivy C. Sharpe
CAST Luke Finley, Winona Easley
ARCHIVES / DISTRIBUTORS UCLA Film & Television Archive

Happy Valentine's Day 1980 (Video, color, 21 min)

PRODUCER / PRODUCTION CO. Gay Abel-Bey
DIRECTOR Gay Abel-Bey
SCRIPT Gay Abel-Bey
CAMERA Tunde Ogunley, Steven S. Poitras, Jon O'Brien
EDITOR Gay Abel-Bey
OTHER CREDITS Gay Abel-Bey Charlotte O'Brien
CAST Martha Elcan, Beth Baird, Irene Schonwit, Christine McKee
ARCHIVES / DISTRIBUTORS UCLA Film & Television Archive

Fragrance 1985 (16mm, b&w, 38 min)

PRODUCER / PRODUCTION CO. Gay Abel-Bey / Adriana Productions
DIRECTOR Gay Abel-Bey
SCRIPT Gay Abel-Bey
CAMERA Steven S. Poitras
EDITOR Gay Abel-Bey and S. Torriano Berry
OTHER CREDITS Chemín, Bernard Nicholas, Chris Painter, Victoria Thomas,
 Melvonna Ballenger, Anthony Cummings, Prudence C. Faxon
CAST Tony Ginn, Roy Fegan, Fumilayo, Leslie Rainey, Raymond Dunmore,
 Minnie S. Lindsey, Sy Richardson, Alfreda Dean Masters, Drew Wilson,
 Sibyl Motley, Michelle Banks, Jean Hubbard Boone
ARCHIVES / DISTRIBUTORS UCLA Film & Television Archive

ANITA W. ADDISON

Eva's Man 1976 (Super 8mm, color, 11 min)

PRODUCER / PRODUCTION CO. Anita W. Addison
DIRECTOR Anita W. Addison
SCRIPT Anita W. Addison, based on novel by Gayl Jones

Savannah 1984 (No other information available.)

There Are No Children Here 1993 (Color, 120 min)

PRODUCER / PRODUCTION CO. John Duffy / Do We Inc. / Harpo Productions / LOMO Productions; aired on ABC TV Network

DIRECTOR Anita W. Addison
SCRIPT Bobby Smith Jr., based on book by Alex Kotlowitz
CAMERA Mike Fash
EDITOR John Duffy
CAST Oprah Winfrey, Keith David, Mark Lane, Norman D. Golden II, Maya Angelou

Deep in My Heart 1999 (Color, 89 min)

PRODUCER / PRODUCTION CO. Frank Konigsberg, Christine Sacani; aired on CBS TV Network
DIRECTOR Anita W. Addison
SCRIPT Ronni Kern
CAMERA Alar Kivilo
EDITOR Charles Bornstein
CAST Anne Bancroft, Lynn Whitfield, Alice Krige, Cara Buono, Gloria Reuben, Jesse L. Martin

PBS Hollywood Presents: Copshop (TV episodes) 2004 (Color, 45 min per episode)

PRODUCER / PRODUCTION CO. Marry Mazur Anita W. Addison, Joe Cacaci, Richard Dreyfuss; aired on PBS Television
DIRECTOR Anita W. Addison, Joe Cacaci
SCRIPT David Black, Robin Shamburg

SHIRIKIANA AINA

Brick by Brick 1982 (16mm, color, 33 min)

PRODUCER / PRODUCTION CO. Shirikiana Aina / Mypheduh Films
DIRECTOR Shirikiana Aina
SCRIPT Shirikiana Aina
CAMERA Norma Blalock, Ellen Sumter
EDITOR Shirikiana Aina
CAST Lester Wakefield
ARCHIVES / DISTRIBUTORS UCLA Film & Television Archive

Through the Door of No Return 1997 (16mm, color, 80 min)

PRODUCER / PRODUCTION CO. Haile Gerima, Shirikiana Aina, Selome Gerima / Negod Gwad Productions and Elimu Films
DIRECTOR Shirikiana Aina
SCRIPT Shirikiana Aina
CAMERA Rick Butler
EDITOR Haile Gerima
OTHER CREDITS David White
ARCHIVES / DISTRIBUTORS Mypheduh Films, Sankofa Distribution (DVD)

DON AMIS

Ujamii Uhuru Schule Community Freedom School 1974 (Super 8mm, color, 8 min, 50 sec)

PRODUCER / PRODUCTION CO. Don Amis
DIRECTOR Don Amis
CAMERA Don Amis
EDITOR Don Amis
ARCHIVES / DISTRIBUTORS UCLA Film & Television Archive

Festival of Mask 1982 (16mm, color, 25 min)

PRODUCER / PRODUCTION CO. Don Amis
DIRECTOR Don Amis
SCRIPT Jennifer Amis, Don Amis
CAMERA Ben Caldwell, Don Cropper, Jeff Fazio, Daniel Riesenfeld
EDITOR Don Amis
OTHER CREDITS Carroll Parrott Blue, Dennis Beamer Brown, Jennifer Brundage, Bernard Nicholas, Dean Curtis, Mildred Richards, Melvonna Ballenger, Gay Abel-Bey, Munyungo Jackson, Jumma Santos; Musicians: Munyungo Jackson, Jumma Santos, Tony Cummins, Joy Reneher, Richard Portman, Jennifer Brundage, David Valenti
CAST Carmen Stetson, Kwasi Badu, May Mori
ARCHIVES / DISTRIBUTORS UCLA Film & Television Archive

MELVONNA BALLENGER

Rain/(Nyesha) 1978 (16mm, b&w, 16 min)

PRODUCER / PRODUCTION CO. Melvonna Ballenger
DIRECTOR Melvonna Ballenger
SCRIPT Melvonna Ballenger
OTHER CREDITS Music: "After the Rain" by John Coltrane
CAST Evlynne Braithwaite, Bernard Nicholas, Ijeoma Iloputaife, Michael Friend, Keith Williams
ARCHIVES / DISTRIBUTORS UCLA Film & Television Archive

Nappy-Headed Lady 1985 (unfinished) (16mm, b&w, 8 min)

DIRECTOR Melvonna Ballenger
ARCHIVES / DISTRIBUTORS UCLA Film & Television Archive

DENISE BEAN

Blossoms of Black Seed 1976 (3/4-inch video, b&w, 19 min)

PRODUCER / PRODUCTION CO. Bonnie Teklin, Claudia Queen, Denise Bean
DIRECTOR Denise Bean
EDITOR Ben Allin

OTHER CREDITS Ron Powell

CAST Razi Baghuei, Marianne Braubach, Stormé Bright Sweet, Gary Campbell, Sarajo Frieden, Karen Greene, Marney Horton, Violet Hubbs, Rod Johnston, Paula Kane, Margaret Logan, Mimi Mardula, Stan Mindel, Rivi Oppenheim, Jeff Palmer, Rod Scott, Amy Shorr, Martti Tarkela, Mohammad Tat

ARCHIVES / DISTRIBUTORS UCLA Film & Television Archive

Something Special 1977 (3/4-inch video, color, 20 min, 25 sec)

PRODUCER / PRODUCTION CO. Denise Bean, Ralph Ferguson

DIRECTOR Denise Bean

CAMERA Ben Caldwell

EDITOR Denise Bean, Ben Allin

OTHER CREDITS Robert Takagi, O.Funmilayo Makarah, Yazid Asim-Ali, Sheree Brown, Ron Powell

ARCHIVES / DISTRIBUTORS UCLA Film & Television Archive

RUBY BELL-GAM

My Child, Their Child 1982 (Super 8mm, color, 10 min)

PRODUCER / PRODUCTION CO. Ruby Bell-Gam

DIRECTOR Ruby Bell-Gam

SCRIPT Ruby Bell-Gam

CAMERA Ruby Bell-Gam

EDITOR Ruby Bell-Gam

S. TORRIANO BERRY

Rich 1982 (16mm, b&w, 22 min)

PRODUCER / PRODUCTION CO. S. Torriano Berry

DIRECTOR S. Torriano Berry

SCRIPT S. Torriano Berry

CAMERA Iverson White

EDITOR S. Torriano Berry

OTHER CREDITS Alicia Rodriguez, Sandy Butler, Robert Wheaton, Nancy Jones, Bill Oliver, Nietzchka Keene; All original music by S. Torriano Berry

CAST S. Torriano Berry, Susann Akers, Haskell V. Anderson III, Krystoffer Fields, Joey Murray, Alero Mack, Dwayne Nunley, Rita Crafts, Rosanne Katon, Lee Bailey

ARCHIVES / DISTRIBUTORS UCLA Film & Television Archive / AIMS Media Inc., Southern University Library (VHS), Miami Dade Public Library System (16mm)

In the Hole 1984 (3/4-inch video, 8 min)

PRODUCER / PRODUCTION CO. Torriano Film Productions

DIRECTOR S. Torriano Berry

SCRIPT S. Torriano Berry, Robert Wheaton
EDITOR S. Torriano Berry

Stardom 1984 (16mm, color, 4 min)

PRODUCER / PRODUCTION CO. Torriano Film Productions
DIRECTOR S. Torriano Berry
SCRIPT S. Torriano Berry
EDITOR S. Torriano Berry

The Connection 1985 (3/4-inch video, color, 7 min)

PRODUCER / PRODUCTION CO. Torriano Film Productions
DIRECTOR S. Torriano Berry
SCRIPT S. Torriano Berry
EDITOR S. Torriano Berry
ARCHIVES / DISTRIBUTORS Black Film Center / Archive (DVD)

Deathly Realities 1985 (3/4-inch video, 15 min)

PRODUCER / PRODUCTION CO. Torriano Film Productions
DIRECTOR S. Torriano Berry
SCRIPT S. Torriano Berry
CAMERA S. Torriano Berry
EDITOR S. Torriano Berry
OTHER CREDITS Gay Abel-Bey, Robert Wheaton
ARCHIVES / DISTRIBUTORS Black Film Center / Archive (DVD)

The Coming of the Saturnites 1986 (Video, color, 27 min)

PRODUCER / PRODUCTION CO. Torriano Film Productions
DIRECTOR S. Torriano Berry
SCRIPT S. Torriano Berry
CAMERA S. Torriano Berry, Robert Wheaton
EDITOR S. Torriano Berry
ARCHIVES / DISTRIBUTORS Black Film Center / Archive (Betacam SP)

The Day of the Crow's Call 1986 (3/4-inch video, color, 5 min)

PRODUCER / PRODUCTION CO. Torriano Film Productions
DIRECTOR S. Torriano Berry
SCRIPT S. Torriano Berry and Joel Fluellen
CAMERA S. Torriano Berry
EDITOR S. Torriano Berry
ARCHIVES / DISTRIBUTORS Black Film Center / Archive (VHS)

The Light 1988 (3/4-inch video, color, 24 min, 25 sec)

PRODUCER / PRODUCTION CO. S. Torriano Berry, Robert D. Lott, Roy Oliver, and the Minority Advisory Board of WPVI-TV 6
DIRECTOR S. Torriano Berry
SCRIPT Jeannette Berry, S. Torriano Berry, Venise T. Berry
EDITOR S. Torriano Berry
ARCHIVES / DISTRIBUTORS Black Film Center / Archive (Betacam SP)

When It's Your Turn 1988 (3/4-inch video, color, 24 min)

PRODUCER / PRODUCTION CO. S. Torriano Berry and the Minority Advisory Board of WPVI-TV 6
DIRECTOR S. Torriano Berry
SCRIPT S. Torriano Berry
EDITOR S. Torriano Berry

Berger & Fry's (TV Pilot) 1989 (3/4-inch video, color, 28 min)

PRODUCER / PRODUCTION CO. Torriano Film Productions
DIRECTOR S. Torriano Berry
SCRIPT S. Torriano Berry
ARCHIVES / DISTRIBUTORS Black Film Center/Archive (VHS)

Euphrates Awakening 1992 (16mm, b&w, 2 min, 30 sec)

PRODUCER / PRODUCTION CO. Torriano Film Productions
DIRECTOR S. Torriano Berry
SCRIPT S. Torriano Berry
CAMERA S. Torriano Berry
EDITOR S. Torriano Berry
ARCHIVES / DISTRIBUTORS Black Film Center/Archive (Betacam SP)

Money'll Eat You Up 1992 (3/4-inch video, color, 24 min, 30 sec)

PRODUCER / PRODUCTION CO. Torriano Film Productions
DIRECTOR S. Torriano Berry
SCRIPT S. Torriano Berry
CAMERA S. Torriano Berry
EDITOR S. Torriano Berry
ARCHIVES / DISTRIBUTORS Lee County Library System (VHS), Black Film Center / Archive (Betacam SP)

The Embalmer 1996 (16mm, color, 86 min)

PRODUCER / PRODUCTION CO. Torriano Film Productions
DIRECTOR S. Torriano Berry

SCRIPT S. Torriano Berry
CAMERA S. Torriano Berry
EDITOR S. Torriano Berry
OTHER CREDITS S. Torriano Berry
CAST Kenneth E. Mullen, Jennifer T. Kelly
ARCHIVES / DISTRIBUTORS Black Film Center/Archive (DVD), Spectrum Entertainment (DVD)

Euphrates Sun: An Experiment in Subtext 1996 (16mm, 5 min)

PRODUCER / PRODUCTION CO. Torriano Film Productions
DIRECTOR S. Torriano Berry
SCRIPT S. Torriano Berry
CAMERA S. Torriano Berry
EDITOR S. Torriano Berry
ARCHIVES / DISTRIBUTORS Black Film Center/Archive (Betacam SP)

This Is My Beloved: A Photo Essay on Man's Inhumanity to Man 2003 (Mini-DV, 2 min, 45 sec)

PRODUCER / PRODUCTION CO. Torriano Film Productions
DIRECTOR S. Torriano Berry
ARCHIVES / DISTRIBUTORS Black Film Center/Archive (VHS, DVD, Betacam SP)

Noh Matta Wat! (TV Series) 2005–2010 (Mini-DV)

PRODUCER / PRODUCTION CO. Denvor Fairweather / 13 Productions; aired on Great Belize Television
DIRECTOR S. Torriano Berry
SCRIPT Kimberly Vasquez
CAMERA S. Torriano Berry
EDITOR S. Torriano Berry
ARCHIVES / DISTRIBUTORS Black Film Center/Archive (DVD)

CARROLL PARROTT BLUE
Low Rider 1975 (Super 8mm, 3 min)

PRODUCER / PRODUCTION CO. Carroll Parrott Blue
DIRECTOR Carroll Parrott Blue
SCRIPT Carroll Parrott Blue
CAMERA Carroll Parrott Blue
EDITOR Carroll Parrott Blue

Two Women 1977 (Super 8mm, 10 min)

PRODUCER / PRODUCTION CO. Carroll Parrott Blue

DIRECTOR Carroll Parrott Blue
SCRIPT Carroll Parrott Blue
CAMERA John Simmons
EDITOR Carroll Parrott Blue

Varnette's World: A Study of a Young Artist 1979 (16mm, color, 25 min, 46 sec)

PRODUCER / PRODUCTION CO. Carroll Parrott Blue, D. Loxton
DIRECTOR Carroll Parrott Blue
SCRIPT Carroll Parrott Blue
CAMERA Daniel Riesenfeld
EDITOR Linda Dove, Carroll Parrott Blue
OTHER CREDITS Jerry Weissman, Becca Wilson, Charlene Greenhouse, Edwina White, Karina Friend, Janice Tanaka, Alan Kondo, Jerry Weissman; Soundtrack by Benny Yee
CAST Varnette Honeywood, James Cleveland
ARCHIVES / DISTRIBUTORS UCLA Film & Television Archive / Third World Newsreel

Conversations with Roy DeCarava 1983 (16mm, color, 28 min)

PRODUCER / PRODUCTION CO. Carroll Parrott Blue and David Loxton (Television Lab for WNET/Thirteen)
DIRECTOR Carroll Parrott Blue
SCRIPT Carroll Parrott Blue
CAMERA Emiko Omori
EDITOR David Schwartz
CAST Roy DeCarava
ARCHIVES / DISTRIBUTORS Black Film Center/Archive (VHS), Icarus Films (DVD)

Nigerian Art: Kindred Spirits 1990 (16mm, color, 60 min)

PRODUCER / PRODUCTION CO. Adrian Malone / *Smithsonian World;* aired on PBS Television
DIRECTOR Carroll Parrott Blue
SCRIPT Carroll Parrott Blue
CAMERA Norris Brock
ARCHIVES / DISTRIBUTORS Black Film Center/Archive (VHS)

Nova: "Mystery of the Senses: Vision" (TV episode) 1995 (16mm, color, 60 min)

PRODUCER / PRODUCTION CO. Carroll Parrott Blue, Paula Apsell / *Nova;* aired on PBS Television
DIRECTOR Carroll Parrott Blue
SCRIPT Carroll Parrott Blue

The Fern Street Circus 1996 (Video, 5 min)

PRODUCER / PRODUCTION CO. Carroll Parrott Blue
DIRECTOR Carroll Parrott Blue
CAMERA Norris Brock

Journeys through the Bloodline 1998 (Video, 15 min)

PRODUCER / PRODUCTION CO. Carroll Parrott Blue
DIRECTOR Carroll Parrott Blue
SCRIPT Carroll Parrott Blue

The Dawn at My Back: Memoir of a Black Texas Upbringing 2003 (DVD-ROM, color, 9 hr)

PRODUCER / PRODUCTION CO. Marsha Kinder, The Labyrinth Project, USC
 Annenberg Center for Communication
DIRECTOR Carroll Parrott Blue, Kristy H. A. Kang
SCRIPT Carroll Parrott Blue
CAST Carroll Parrott Blue, Debbie Allen, Ossie Davis, Ruby Dee

Dubai 2005 (Digital video, color, 5 min)

PRODUCER / PRODUCTION CO. Carroll Parrott Blue
DIRECTOR Carroll Parrott Blue
SCRIPT Carroll Parrott Blue
CAMERA Carroll Parrott Blue
EDITOR Carroll Parrot Blue

Thelma Scott Bryant and Third Ward: An Urban Redevelopment Story 2006
(Digital video, 6 min)

PRODUCER / PRODUCTION CO. Carroll Parrott Blue
DIRECTOR Carroll Parrott Blue
SCRIPT Carroll Parrott Blue
CAMERA Carroll Parrott Blue
EDITOR Carroll Parrot Blue

Third Ward Storymapping Project 2007 (Web video)

PRODUCER / PRODUCTION CO. Carroll Parrott Blue
DIRECTOR Carroll Parrott Blue
SCRIPT Carroll Parrott Blue
CAMERA Carroll Parrott Blue
EDITOR Carroll Parrot Blue

EVLYNNE BRAITHWAITE
If You Don't (15 min)

CHARLES BURNETT

Several Friends 1969 (16mm, b&w, 22 min)

PRODUCER / PRODUCTION CO. Charles Burnett
DIRECTOR Charles Burnett
SCRIPT Charles Burnett
CAMERA Jim Watkins
EDITOR Charles Burnett
OTHER CREDITS Rodolfo Restifo, Mano Da Silva, Tom Penick
CAST Andy Burnett, Gene Cherry, Charles Bracy, Cassandra Wright, Donna Deitch, Deloras Robinson, James Miles, L.E. McGraw, Ernest Cox, E.R. Canan, Arthur Boot, Allen Jurgins
ARCHIVES / DISTRIBUTORS UCLA Film & Television Archive / Milestone Films (DVD)

The Horse 1973 (16mm, color, 14 min)

PRODUCER / PRODUCTION CO. Charles Burnett
DIRECTOR Charles Burnett
SCRIPT Charles Burnett
CAMERA Ian Conner
EDITOR Charles Burnett
OTHER CREDITS Larry Clark, Charles Morrison, Tom Penick, Rodolfo Restifo; Music: excerpts from Samuel Barber's "Knoxville, Summer 1915"
CAST Gordon Houston, Maury Wright, Gary Morrin, Roger Collins, George Williams, Larry Clark
ARCHIVES / DISTRIBUTORS UCLA Film & Television Archive / Milestone Films (DVD)

Killer of Sheep 1977 (16mm, b&w, 81 min)

PRODUCER / PRODUCTION CO. Charles Burnett
DIRECTOR Charles Burnett
SCRIPT Charles Burnett
CAMERA Charles Burnett
EDITOR Charles Burnett
OTHER CREDITS Charles Bracy, Willie Bell, Larry Clark, Christine Penick, Andy Burnett
CAST Henry Gayle Sanders, Kaycee Moore, Charles Bracy, Angela Burnett, Eugene Cherry
ARCHIVES / DISTRIBUTORS UCLA Film & Television Archive / Milestone Films (35mm, DVD), BFI (DVD)

My Brother's Wedding 1983 (35mm, color, 118 min); 2007 Director's cut (81 min)

PRODUCER / PRODUCTION CO. Charles Burnett, Gaye Shannon-Burnett
DIRECTOR Charles Burnett
SCRIPT Charles Burnett

CAMERA Charles Burnett

EDITOR Thomas Penick

OTHER CREDITS Thomas M. Penick, Lance C. Davidson, Ruth E. Cassius, Garnett Hargrave, Julie Dash Fielder, Ronald Hairston, Camelia Frieberg, Omar El Aide, A. J. Fielder, Lynn Smith, Veda Campbell, Arthur J. Lopez

CAST Everette Silas, Jessie Holmes, Gaye Shannon Burnett, Dennis Kemper, Ronald E. Bell

ARCHIVES / DISTRIBUTORS UCLA Film & Television Archive / Milestone Films (35mm, DVD), BFI (DVD)

To Sleep with Anger 1990 (35mm, color, 102 min)

PRODUCER / PRODUCTION CO. Caldecot Chubb, Thomas S. Byrnes, Darin Scott

DIRECTOR Charles Burnett

SCRIPT Charles Burnett

CAMERA Walter Lloyd

EDITOR Nancy Richardson

CAST Danny Glover, Paul Butler, DeVaughn Nixon, Vonetta McGee, Sheryl Lee Ralph, Carl Lumbly

ARCHIVES / DISTRIBUTORS Sony Pictures Entertainment, BFI (DVD)

America Becoming 1991 (35mm, color, 90 min)

PRODUCER / PRODUCTION CO. Dai Sil Kim-Gibson; aired on PBS Television

DIRECTOR Charles Burnett, Dai Sil Kim-Gibson

CAMERA Charles Burnett

EDITOR Baylis Glascock, Judy Reidel

OTHER CREDITS Meredith Vieira

The Glass Shield 1994 (35mm, color, 115 min)

PRODUCER / PRODUCTION CO. Thomas Byrnes, Carolyn Schroeder

DIRECTOR Charles Burnett

SCRIPT Charles Burnett, based on a story by Ned Walsh

CAMERA Elliot Davis

EDITOR Curtiss Clayton

OTHER CREDITS Monica Swann, Stephen James Taylor, Gaye Shannon-Burnett, Patrick Peach, Paul Childs, Veda Campbell, John Oh, Bufort McClerkins Jr., Penny Barrett, Joel Carter, Lisa Boutillier, John Hartigan, Kim Davis, Felicia Linsky

CAST Erich Anderson, Richard Anderson, Michael Boatman, Bernie Casey, Wanda De Jesús, Victoria Dillard, Elliott Gould, Don Harvey, Tommy Hicks, Ice Cube, Michael Ironside, Natalija Nogulich, Lori Petty, Sy Richardson, M. Emmet Walsh, Gary Wood

ARCHIVES / DISTRIBUTORS UCLA Film & Television Archive / Miramax Films, Echo Bridge Home Entertainment (DVD)

When It Rains 1995 (16mm, color, 13 min, 14 sec)

PRODUCER / PRODUCTION CO. Chantal Bernheim / Leapfrog Production; aired on Sept-ARTE

DIRECTOR Charles Burnett

SCRIPT Charles Burnett

CAMERA Charles Burnett

EDITOR Charles Burnett

OTHER CREDITS Stephen James Taylor, Rich Raposa, Jon Oh

CAST Ayuko Babu, Kenny Merritt, Charles Bracy, Soul, R. Ray Barness, Barbara Bayless, Steven Burnett, Billy Woodberry

ARCHIVES / DISTRIBUTORS UCLA Film & Television Archive / Milestone Films (DVD)

Nightjohn 1996 (35mm, color, 96 min)

PRODUCER / PRODUCTION CO. Dennis Stuart Murphy / Hallmark Entertainment, Sarabande Productions, Disney Channel, Signboard Hill Productions Inc.; aired on Disney Channel

DIRECTOR Charles Burnett

SCRIPT Bill Cain

CAMERA Elliot Davis

EDITOR Dorian Harris

OTHER CREDITS Stephen James Taylor, Sharen Davis, Naomi Shohan, Jim Hill, Evette Siegel

CAST Beau Bridges, Carl Lumbly, Lorraine Toussaint, Bill Cobbs, Kathleen York, Gabriel Casseus, Tom Nowicki, Joel Thomas Traywick, Allison Jones

ARCHIVES / DISTRIBUTORS UCLA Film & Television Archive/ Disney Channel, Echo Bridge Home Entertainment (DVD)

The Final Insult 1997 (Video, color, 55 min)

PRODUCER / PRODUCTION CO. Charles Burnett, ZDF; screened at Documenta X (Kassel, Germany)

DIRECTOR Charles Burnett

SCRIPT Charles Burnett

CAMERA Charles Burnett

EDITOR Charles Burnett

OTHER CREDITS Music: Stephen James Taylor

CAST Ayuko Babu, Charles Bracy

ARCHIVES / DISTRIBUTORS Absolute Medien (Berlin, distributed as *Am Ende*) (VHS)

Dr. Endesha Ida Mae Holland 1998 (16mm, 16 min)

PRODUCER / PRODUCTION CO.

DIRECTOR Charles Burnett

The Wedding 1998 (35mm, color, 135 min)

PRODUCER / PRODUCTION CO. Doro Bachrach / Harpo Films; aired on ABC TV Network

DIRECTOR Charles Burnett

SCRIPT Lisa Jones, based on the novel by Dorothy West

CAMERA Fred Elmes

EDITOR Dorian Harris

OTHER CREDITS Music: Stephen James Taylor, Lawrence C. Paull

CAST Halle Berry, Eric Thal, Lynn Whitfield, Carl Lumbly, Michael Warren, Marianne Jean-Baptiste, Cynda Williams, Charlayne Woodard

ARCHIVES / DISTRIBUTORS UCLA Film & Television Archive / Harpo Films, ABC (original broadcaster), D'Vision (Paris) (DVD)

The Annihilation of Fish 1999 (35mm, color, 102 min)

PRODUCER / PRODUCTION CO. Paul Heller, William L. Fabrizio, John Remark, Eric Mitchell / American Sterling Productions

DIRECTOR Charles Burnett

SCRIPT Anthony C. Winkler

CAMERA John Ndiaga Demps

EDITOR Nancy Richardson

OTHER CREDITS Christine Peters, Laura Karpman, Nina Ruscio

CAST Lynn Redgrave, James Earl Jones, Margot Kidder

ARCHIVES / DISTRIBUTORS UCLA Film & Television Archive

Selma, Lord, Selma 1999 (35mm, color, 94 min)

PRODUCER / PRODUCTION CO. Christopher Seitz / Esparza/Katz Productions, Walt Disney Television; aired on ABC TV Network

DIRECTOR Charles Burnett

SCRIPT Cynthia Whitcomb; based on the book by Sheyann Webb and Rachel West Nelson, as told to Frank Sikora

CAMERA Johnny Simmons

EDITOR Nancy Richardson

OTHER CREDITS Naomi Shohan, Ousan Elam, Lonnie Smith, Greg Elam, Kofi Elam, Katherine Elam, Cal Johnson, Mike Norris, Jean Higgins, Kris Krengel, Michael Moore

CAST Mackenzie Astin, Jurnee Smollett, Clifton Powell, Ella Joyce, Yolanda King

ARCHIVES / DISTRIBUTORS UCLA Film & Television Archive / ABC (original broadcaster), Buena Vista International Inc. (DVD)

Finding Buck McHenry 2000 (35mm, color, 94 min)

PRODUCER / PRODUCTION CO. Lin Oliver, Bobby Heller, Robert Halmi; aired on Showtime Network

DIRECTOR Charles Burnett

SCRIPT Alfred Slote, David Field

CAMERA John Demps

EDITOR Dorian Harris

OTHER CREDITS Stephen James Taylor, Kathleen Climie, Jamie Jones, Anthony Chrystosum, Stephen J. Turnbull, Tamara Winston, Marilyn Kiewiet, Erica Milo, Michael LaCroix, Andrew DeCristofaro, Mark Lanza, Rebecca Hanck, Nancy Nugent, Marysue Heron, George Aywaz, Susan Pilcher

CAST Ossie Davis, Ruby Dee, Ernie Banks

ARCHIVES / DISTRIBUTORS UCLA Film & Television Archive / Showtime Entertainment (VHS, DVD)

Olivia's Story 2000 (16mm, color, 14 min)

PRODUCER / PRODUCTION CO. Dai Sil Kim-Gibson

DIRECTOR Charles Burnett

CAMERA Steve Schecter

EDITOR Charles Burnett

ARCHIVES / DISTRIBUTORS University of Maryland Libraries (VHS)

American Family: Journey of Dreams (TV series) 2002–2004 (Video, color, 45 min per episode)

PRODUCER / PRODUCTION CO. Gregory Nava, Barbara Martinez Jitner; aired on PBS Television

DIRECTOR Charles Burnett

EDITOR Larry Bock

OTHER CREDITS Scott Cobb, Francisco Hernandez

CAST Edward James Olmos, Constance Marie, Esai Morales

Nat Turner: A Troublesome Property 2002 (35mm, color, 58 min)

PRODUCER / PRODUCTION CO. Frank Christopher, Kenneth S. Greenberg/Subpix, ITVS, KQED Public Television; aired on PBS Television

DIRECTOR Charles Burnett

SCRIPT Charles Burnett, Frank Christopher, Kenneth S. Greenberg

CAMERA John L. Demps Jr.

EDITOR Frank Christopher, Michael Colin

ARCHIVES / DISTRIBUTORS California Newsreel (DVD)

The Blues: "Warming by the Devil's Fire" (TV episode) 2003 (Video, color, 106 min)

PRODUCER / PRODUCTION CO. Richard Hutton, Wesley Jones

DIRECTOR Charles Burnett

SCRIPT Charles Burnett

CAMERA John L. Demps Jr., Richard Pearce

EDITOR Ed Santiago

ARCHIVES / DISTRIBUTORS Sony Music Entertainment (DVD)

For Reel? 2003 (Video)

PRODUCER / PRODUCTION CO. Charles Burnett, Skye Dent / PBS
DIRECTOR Charles Burnett
SCRIPT Charles Burnett, Skye Dent, Bill Plympton
EDITOR John L. Demps Jr.

Namibia: The Struggle for Liberation 2007 (35mm, color, 161 min)

PRODUCER / PRODUCTION CO. Abius Akwaake, Steve Gukas/Namibian
Film Commission
DIRECTOR Charles Burnett
SCRIPT Charles Burnett
CAMERA John L. Demps Jr.
EDITOR Ed Santiago
CAST Carl Lumbly, Danny Glover
ARCHIVES / DISTRIBUTORS Great Movies GmbH (Germany) (Blu-ray), Best
Entertainment (DVD)

Quiet as Kept 2007 (Digital video, color, 5 min, 23 sec)

PRODUCER / PRODUCTION CO. Jon Oh, Charles Burnett
DIRECTOR Charles Burnett
SCRIPT Charles Burnett
CAMERA Charles Burnett
EDITOR Charles Burnett
OTHER CREDITS Jon Oh; "Up the Mountain performed by Carmen Twillie,
composed by Stephen James Taylor
ARCHIVES / DISTRIBUTORS UCLA Film & Television Archive / Milestone
Films (DVD)

Relative Stranger 2009 (35mm, color, 88 min)

PRODUCER / PRODUCTION CO. Brian Martinez, Erik Olson, Randy Pope,
Michael Moran/Larry Levinson Productions; aired on Hallmark Channel
DIRECTOR Charles Burnett
SCRIPT Eric Haywood
CAMERA Todd Barron
EDITOR Craig Bassett
OTHER CREDITS Art director: Steven Joseph St. John
CAST Eriq La Salle, Cicely Tyson, Michael Michele
ARCHIVES / DISTRIBUTORS Genius Entertainment (DVD)

BEN CALDWELL
Medea 1973 (16 mm, color, 6 min, 36 sec)

PRODUCER / PRODUCTION CO. Ben Caldwell
DIRECTOR Ben Caldwell

SCRIPT Ben Caldwell, adapted from "Part of the Doctrine" by Amiri Baraka
CAMERA Ben Caldwell
EDITOR Ben Caldwell
ARCHIVES / DISTRIBUTORS UCLA Film & Television Archive

For Whose Entertainment 1979 (16mm, 90 min)

PRODUCER / PRODUCTION CO. Ben Caldwell
DIRECTOR Ben Caldwell
SCRIPT Ben Caldwell, Artie Ivie

I & I: An African Allegory 1979 (16mm, color, 32 min)

PRODUCER / PRODUCTION CO. Ben Caldwell
DIRECTOR Ben Caldwell
SCRIPT Ben Caldwell
CAMERA Ben Caldwell
EDITOR Ben Caldwell
OTHER CREDITS Paul Stallworth, Beneva, Jamaa Fanaka, Ben Caldwell, Gary Gaston, Don Amis, Majid Mahdi, John Brown, Pat Bohannon, Ken Merritt, Phil Sisson, Leslie Sisson, Thomas Lord Duckett, Glen Dixon, John Rier, Tamara Nalls, Ron Hairston, Curtis Jenkins, O.Funmilayo Makarah, Richard and Mike Caldwell; Advisors: Richard Hawkins, Ed Brokaw, Dan McLaughlin, Elyseo Taylor
CAST Pamela B. Jones, Al Cowart, Marcia Bullock, Pearl Collins, Byron Simmons, Tamara Nalls, Stephanie Bell, Deborah Cotton, Larry Clark, Jamaa Fanaka, Haile Gerima, Pam Caldwell, Dara Caldwell
ARCHIVES / DISTRIBUTORS UCLA Film & Television Archive

The Nubian 1980 (16mm, color, 20 min)

PRODUCER / PRODUCTION CO. Ben Caldwell
DIRECTOR Ben Caldwell
SCRIPT Ben Caldwell
CAMERA Ben Caldwell
EDITOR Ben Caldwell

Babylon Is Falling 1983 (16mm, 35mm and video animation, 60 min)

PRODUCER / PRODUCTION CO. Ben Caldwell
DIRECTOR Ben Caldwell
SCRIPT Ben Caldwell
CAMERA Ben Caldwell
EDITOR Ben Caldwell

I Fresh 1984 (16mm, color, 16 min)

PRODUCER / PRODUCTION CO. Ben Caldwell

DIRECTOR Ben Caldwell
SCRIPT Ben Caldwell, Charles Burnett
CAMERA Ben Caldwell, Charles Burnett, Roderick Young
EDITOR Ben Caldwell

HollyWatts Productions ("United States of Emergency," "March of Progress," etc.) (Multimedia performances, 60 min per episode) 1984–1991
PRODUCER / PRODUCTION CO. Ben Caldwell, Roger Guenveur Smith
DIRECTOR Ben Caldwell
SCRIPT Roger Guenveur Smith
CAMERA Ben Caldwell, Michael Wesley Groves

Frederick Douglass Now 1990 (Video, color, 60 min)
PRODUCER / PRODUCTION CO. Ben Caldwell, Roger Guenveur Smith, Michael Wesley Groves
DIRECTOR Ben Caldwell
SCRIPT Roger Guenveur Smith
CAMERA Ben Caldwell
EDITOR Ben Caldwell

LARRY CLARK
Tamu 1970 (16mm, color, 12 min)
DIRECTOR Larry Clark
CAST Alistair Allen, Estell Roberts, Curt West
ARCHIVES / DISTRIBUTORS UCLA Film & Television Archive

As Above, So Below 1973 (16mm, color, 52 min)
PRODUCER / PRODUCTION CO. Larry Clark, Performing Arts Society of Los Angeles Film Workshop
DIRECTOR Larry Clark
SCRIPT Larry Clark
CAMERA Larry Clark
EDITOR Larry Clark
OTHER CREDITS Music: Horace Tapscott, Roderick R. Young, Thomas Washington, Lucian Smith, Richard Wells, Ricky Mention, Bob Allen, Richard Wells, Roderick Young, Bob Allen, Kwan Chung Yen, Michael Clark, Eddy Wong, Ricky Mention, Cheryl Thompson
CAST Nathaniel Taylor, Lyvonne Walder, Billy Middleton, Gail Peters, Kodjo
ARCHIVES / DISTRIBUTORS UCLA Film & Television Archive

Passing Through 1977 (35mm, color, 111 min)
PRODUCER / PRODUCTION CO. Larry Clark

DIRECTOR Larry Clark

SCRIPT Larry Clark, Ted Lange

CAMERA Roderick Young, George Geddis, Myko Clark, Bob Allen, Charles Burnett

EDITOR Larry Clark

OTHER CREDITS Penny Bannerman, Carol Yasunaga, Julie Dash; Live music performed by the Pan African Peoples Arkestra, arranged and conducted by Horace Tapscott; Compositions by Herbert Baker, Horace Tapscott, Lester Robinson, Jesse Sharps, Adele Sebastian, Ernest Roberts

CAST Nathaniel Taylor, Clarence Muse, Pamela Jones, Johnny Weathers, Della Thomas, Horace Tapscott

ARCHIVES / DISTRIBUTORS UCLA Film & Television Archive / NFSA Canberra (16mm), Xavier University of Louisiana (16mm), Rockville (CT) Public Library (16mm)

Cutting Horse 2002 (35mm, color, 124 min)

PRODUCER / PRODUCTION CO. Larry Clark

DIRECTOR Larry Clark

SCRIPT David Hentz, Larry Clark

CAMERA Alexandra Cantin, Ruben O'Malley

EDITOR Larry Clark

CAST Albert Harris, Cesar E. Flores, Robert Earl Crudup, Melissa Cellura, Rufus Norris

ARCHIVES / DISTRIBUTORS Image Entertainment (DVD)

JULIE DASH

Working Models of Success 1973 (16mm, 50 min)

DIRECTOR Julie Dash

Four Women 1975 (16mm, color, 7 min)

PRODUCER / PRODUCTION CO. Winfred Tennison

DIRECTOR Julie Dash

SCRIPT Julie Dash, based on song by Nina Simone

CAMERA Robert Maxwell

EDITOR Julie Dash

OTHER CREDITS Linda Martina Young, Jim Bagdonas, John Murphy, Steve St. John

CAST Linda Martina Young

ARCHIVES / DISTRIBUTORS UCLA Film & Television Archive / Third World Newsreel (VHS, DVD)

The Diary of an African Nun 1977 (16mm, b&w, 15 min)

PRODUCER / PRODUCTION CO. Julie Dash

DIRECTOR Julie Dash
SCRIPT From a story by Alice Walker
CAMERA Orin Mitchell
EDITOR Julie Dash
OTHER CREDITS Ron Flagge, Mshinda Price
CAST Barbara O. Jones, Barbara Young, Makimi Price, Ron Flagge, Renee Carraway
ARCHIVES / DISTRIBUTORS UCLA Film & Television Archive / Women Make Movies

Illusions 1982 (16mm, b&w, 36 min)

PRODUCER / PRODUCTION CO. Julie Dash
DIRECTOR Julie Dash
SCRIPT Julie Dash
CAMERA Ahmed El Maanouni
EDITOR Julie Dash, Charles Burnett
OTHER CREDITS Brenda Y. Shockley, Omar El Aïdi, Charles Burnett, Orin Mitchel, Ben Caldwell, Bernard Nicolas, Tom Cole, Jennifer Smith-Ashley, Plus One Hair Studio, Mikey Ueno, Norio Shinzawa, Takashi Enokido, Barbara Jackson, Richard Cervantes, Patrick Movroud, Abdul Hafiz, Karen Guyol, Melvonna Ballenger, Amy C. Halpern, Stephen Flood, Salinda Perera, Billy Woodberry, David Milchowsky, Jonathan Curtisy, Oliver Woodall, Michael Anderson; Music: Chick Webb and His Orchestra, vocals by Ella Fitzgerald
CAST Lonette McKee, Rosanne Katon, Ned Bellamy, Jack Radar, Fernando Lundi Faust
ARCHIVES / DISTRIBUTORS UCLA Film & Television Archive / Women Make Movies, University of Chicago Film Studies Center (16mm)

Daughters of the Dust 1991 (35mm, color, 112 min)

PRODUCER / PRODUCTION CO. Julie Dash, Lindsay Law, Arthur Jafa, Steven Jones/Geechee Girls, American Playhouse
DIRECTOR Julie Dash
SCRIPT Julie Dash
CAMERA A. Jaffa Fielder
EDITOR Amy Carey, Joseph Burton
OTHER CREDITS Len Hunt, Arline Burks, John Barnes, Kerry Marshall, C.C. Barnes, Nandi Bowe, Ronald Daise, Margaret Washington-Creel, Pamela Ferrel of Cornrows and Company, Steven Jones
CAST Cora Lee Day, Alva Rogers, Barbara-O (Barbara O. Jones), Adisa Anderson, Kaycee Moore, Cheryl Lynn Bruce, Tommy Hicks
ARCHIVES / DISTRIBUTORS UCLA Film & Television Archive / Kino Video (DVD)

Praise House 1991 (16mm, color, 25 min)

PRODUCER / PRODUCTION CO. Alyce Dissette / Alive TV; KTCA Twin Cities
 Public Television
DIRECTOR Julie Dash
EDITOR Amy Carey
OTHER CREDITS Jawole Willa Jo Zollar, Urban Bush Women
ARCHIVES / DISTRIBUTORS Women Make Movies, Third World Newsreel
 (DVD)

Relatives 1991 (Super 8mm)

DIRECTOR Julie Dash

SUBWAY Stories: Tales from the Underground (Segment: *Sax Cantor Riff*) 1997
(Super 16mm, color, 80 min)

PRODUCER / PRODUCTION CO. Richard Guay, Valerie Thomas; aired on
 HBO Network
DIRECTOR Julie Dash
SCRIPT Julie Dash
CAMERA Ken Kelsch
EDITOR Elizabeth Kling
ARCHIVES / DISTRIBUTORS HBO Home Video (DVD)

Women: Stories of Passion "Grip Till It Hurts" (TV episode) 1997 (Color, 26 min)

PRODUCER / PRODUCTION CO. Maricel Pagulayan; aired on Showtime Net-
 work
DIRECTOR Julie Dash
SCRIPT Julie Dash
CAMERA Matthew Libatique
EDITOR Amy Carey
OTHER CREDITS Jason Volenec

Funny Valentines 1999 (35mm, color, 108 min)

PRODUCER / PRODUCTION CO. Scott White; aired on BET Movies / Starz!3
DIRECTOR Julie Dash
SCRIPT Ron Stacker Thompson, Ashley Tyler, Amy Schor Ferris, based on
 story by J. California Cooper
CAMERA Karl Hermann
EDITOR Hibah Sherif Frisina
OTHER CREDITS Pam Warner, Dean Mumford, Scott White, Sandra Hernan-
 dez, Nancy Bridger-Arnold, Jennifer Murphy, Mike Schorr, Carrie Angland,
 Sterfon Demmings, Betty Lou Skinner, Peter Drake Austin, Stuart Grusin
CAST Alfre Woodard, Loretta Devine, CCH Pounder
ARCHIVES / DISTRIBUTORS UCLA Film & Television Archive

Incognito 1999 (Color, 95 min)

PRODUCER / PRODUCTION CO. Directors' Circle Filmworks; aired on BET Network
DIRECTOR Julie Dash
SCRIPT Shirley Pierce
CAMERA David E. West
EDITOR Hibah Frisina
CAST Allison Dean, Richard T. Jones, Phil Morris
ARCHIVES / DISTRIBUTORS Urban Works (DVD)

Love Song 2000 (Color, 90 min)

PRODUCER / PRODUCTION CO. Claudio Castravelli, Kimberly Ogletree; aired on MTV Network
DIRECTOR Julie Dash
SCRIPT Josslyn Luckett
CAMERA David Claessen
EDITOR Pamela Malouf
CAST Monica Arnold, Christian Kane, Essence Atkins

The Rosa Parks Story 2002 (Color, 95 min)

PRODUCER / PRODUCTION CO. Pearl Devers, Elaine Eason Steele, Christine Sacani / Chotzen-Jenner Productions and Come Sunday Inc., Jaffe-Braunstein; aired on CBS Television
DIRECTOR Julie Dash
SCRIPT Paris Qualles
CAMERA David Claessen
EDITOR Wendy Hallam-Martin
OTHER CREDITS Music composed by Joseph Conlon; Mayling Cheng, Susan V. McConnell
CAST Angela Bassett, Peter Francis James, Tonea Stewart, Von Coulter, Dexter Scott King, Afemo Omilami, Sonny Shroyer, Mike Pniewski, Chardé Manzy, Cicely Tyson
ARCHIVES / DISTRIBUTORS UCLA Film & Television / Jaffe-Braunstein Films Ltd., Xenon Pictures (DVD)

Brothers of the Borderland 2004 (Color, 20 min)

PRODUCER / PRODUCTION CO. Theresa Anne Matthews, Zo Wesson; commissioned for the National Underground Railroad Freedom Center (Cincinnati, OH)
DIRECTOR Julie Dash
SCRIPT Ronald Taylor
CAMERA David Claessen
EDITOR Terry Lukemire
CAST Oprah Winfrey, Christopher Dressler, Giselle Jones

ZEINABU IRENE DAVIS

Filmstatement 1982 (16mm, b&w, 13 min)

DIRECTOR Zeinabu irene Davis

Re-creating Black Women's Media Image 1983 (Video, color, 28 min)

DIRECTOR Zeinabu irene Davis

Crocodile Conspiracy 1986 (16mm, color, 13 min)

PRODUCER / PRODUCTION CO. Workshop One Productions

DIRECTOR Zeinabu irene Davis

SCRIPT Zeinabu irene Davis

CAMERA Charles Burnett

EDITOR Zeinabu irene Davis

OTHER CREDITS Pamela Tom, Mark Chery, Weitsy Wang, Julie Dash, Gary Phillips, Nancy Kenney

CAST Renee Triniana, John Jelks, Sandra Sealy, Natalie White, Jerome Williams, Betsy Burian

ARCHIVES / DISTRIBUTORS UCLA Film & Television Archive / Third World Newsreel (DVD)

Sweet Bird of Youth 1987 (Video, color, 5 min)

DIRECTOR Zeinabu irene Davis

Cycles 1989 (16mm, b&w, 17 min)

PRODUCER / PRODUCTION CO. Zeinabu irene Davis / Wimmin with a Mission Productions

DIRECTOR Zeinabu irene Davis

SCRIPT Zeinabu irene Davis, Doris-Owanda Johnson

CAMERA Pierre Désir

EDITOR Zeinabu irene Davis

OTHER CREDITS Zeinabu Davis, Doris-Owanda Johnson, Pierre Désir, Marc Chery, Quinta Seward, Nietzcha Keene, Ihoyiya and Mosadi Ku Rima, Miriam Makeba

CAST Stephanie Ingram, Darryl Munyungo Jackson, Marc Arthur Chéry, Doris-Owanda Johnson, Zeinabu irene Davis

ARCHIVES / DISTRIBUTORS UCLA Film & Television Archive / Women Make Movies

Trumpetistically, Clora Bryant 1989, Cable TV version (16mm and video, color, 5 min); 2006 (16mm and video, color, 54 min)

PRODUCER / PRODUCTION CO. Zeinabu irene Davis, Marc Arthur Chéry

DIRECTOR Zeinabu irene Davis

SCRIPT Zeinabu irene Davis, Lillian E. Benson
CAMERA Katherine Engstrom, Willie Dawkins, Charles Burnett, S. Torriano Berry, Yasu Tsuji, Biya Ababulga, Pierre Désir
EDITOR Lillian E. Benson, Katherine Engstrom
CAST Clora Bryant, Dizzy Gillespie, James Newton, Helen Cole, Teddy Edwards
ARCHIVES / DISTRIBUTORS Wimmin with a Mission Productions / Getty Research Institute (U-Matic, 3/4-inch)

Kneegrays in Russia 1990 (Video, color, 5 min)

PRODUCER / PRODUCTION CO. Wimmin with a Mission Productions
DIRECTOR Zeinabu irene Davis
CAMERA Willie E. Dawkins

A Period Piece 1991 (3/4-inch video, color, 4 min)

PRODUCER / PRODUCTION CO. Zeinabu irene Davis
DIRECTOR Zeinabu irene Davis
SCRIPT Zeinabu irene Davis, Casi Pacilio
CAMERA Zeinabu irene Davis
EDITOR Zeinabu irene Davis, Casi Pacilio
OTHER CREDITS Creative consultant: Max Almy; Storyboard: Pierre Désir; Original music and music recording: Bill Beck; Lyrics: Zeinabu Davis, Quinta Seward
CAST Judy Hoy, Lisa Pomer, Sandra Sealy, Quinta Seward, Zeinabu irene Davis
ARCHIVES / DISTRIBUTORS UCLA Film & Television Archive / Black Film Center / Archive (VHS)

A Powerful Thang 1991 (16mm, color, 57 min)

PRODUCER / PRODUCTION CO. Zeinabu irene Davis
DIRECTOR Zeinabu irene Davis
SCRIPT Marc Arthur Chéry
CAMERA S. Torriano Berry
EDITOR Casi Pacilio
OTHER CREDITS Willie E. Dawkins
ARCHIVES / DISTRIBUTORS Women Make Movies, Black Film Center / Archive (VHS)

Mother of the River 1995 (16mm, b&w, 30 min)

PRODUCER / PRODUCTION CO. Zeinabu irene Davis
DIRECTOR Zeinabu irene Davis
SCRIPT Marc Arthur Chéry
CAMERA Mark Petersen

EDITOR Cyndi Moran

OTHER CREDITS Dana Briscoe, Yvonne Welbon, Peter Wentworth

CAST Adrienne M. Coleman, Joy Vandervort, Michael L. Nesbitt, Kevin Nesmith, Minerva T. King, Jenny Strassburg, Jennie Sine, Bo Parham, Linda Gibson

ARCHIVES / DISTRIBUTORS UCLA Film & Television Archive / Third World Newsreel (DVD), Women Make Movies, Black Film Center / Archive (VHS)

Compensation 1999 (16mm, b&w, 92 min)

PRODUCER / PRODUCTION CO. Zeinabu irene Davis / Wimmin with a Mission Productions

DIRECTOR Zeinabu irene Davis

SCRIPT Marc Arthur Chéry

CAMERA Pierre Désir

EDITOR Zeinabu irene Davis, Dana Briscoe

OTHER CREDITS Score: Reginald R. Robinson; Original African instrumental score: Atiba Y. Jali, Maestro-Matic, Janina Edwards, Cathy C. Cook, Liz Sheets, Bridget A. Camden, Chéy Greene, Paula Timm, Pierre Désir

CAST John Earl Jelks, Michelle A. Banks, Nirvana Cobb, Kevin L. Davis, Christopher Smith

ARCHIVES / DISTRIBUTORS UCLA Film & Television Archive / Women Make Movies

Passengers 2009 (Video, color, 5 min)

PRODUCER / PRODUCTION CO. Zeinabu irene Davis

DIRECTOR Zeinabu irene Davis

CAMERA Andy Rice

EDITOR Lillian E. Benson

Co-motion: Tales of Breastfeeding Women 2010 (Video, color, 23 min)

PRODUCER / PRODUCTION CO. Zeinabu irene Davis

DIRECTOR Zeinabu irene Davis

SCRIPT Zeinabu irene Davis, Lillian E. Benson

CAMERA Andy Rice, Katherine Engstrom-Lehr, Stefani Foster, Anne Kaneko, Yasu Tsuji, Ge Jin (Jingle), Lauren Berliner

EDITOR Lillian E. Benson, Andy Rice, Katherine Engstrom-Lehr

OTHER CREDITS Bobby McFerrin, Paula Sonhando, Arnaldo Antunes, Sweet Honey in the Rock, Charles Gregory Washington, George Winston, Todd Lehr, Kenny Charles

CAST Tiffany Taliferro, Charles Taliferro, Liah Taliferro, Michelle Banks, Sa'man Banks, Shawn Thomas, Ricardo Guthrie, Maya Thomas Guthrie, Asia Simpson, Amaya Furticamper, Zeinabu irene Davis, Maazi Chéry, Desta Chéry, Delle Chatman, Ramona Chatman Morris, Arlette Simon, Sophia Simon, Alex Simon

ARCHIVES / DISTRIBUTORS UCLA Film & Television Archive

Momentum: A Conversation with Black Women on Achieving Advanced Degrees
2010 (Video, color, 19 min)

PRODUCER / PRODUCTION CO. Zeinabu irene Davis
DIRECTOR Zeinabu irene Davis
SCRIPT Zeinabu irene Davis, Lillian Benson
CAMERA Andy Rice, Zeinabu irene Davis
EDITOR Lillian E. Benson
OTHER CREDITS Andy Rice, Imani Winds, Naomi Robinson, Reginald R.
Robinson, Che Cafe, Mario Torero
ARCHIVES / DISTRIBUTORS UCLA Film & Television Archive

Spirits of Rebellion: Black Cinema from UCLA 2015 (Digital video, color, 97 min)

PRODUCER / PRODUCTION CO. Zeinabu irene Davis, Andy Rice
DIRECTOR Zeinabu irene Davis
CAMERA Andy Rice
EDITOR Andy Rice

WILLIE E. DAWKINS

Across the River 2001 (14 min)

PRODUCER / PRODUCTION CO. Arun K. Vir
DIRECTOR Willie E. Dawkins
SCRIPT Willie E. Dawkins
CAMERA Stephen McGehee
EDITOR Willie E. Dawkins

MARY DELL

Shattered Image 1983 (16mm, 30 min)

DIRECTOR Mary Dell
SCRIPT Mary Dell

ALICIA DHANIFU

Summer Affair 1971 (35mm, color, 83 min, 20 sec)

PRODUCER / PRODUCTION CO. Nicholas Pomilia, Johnny Minervini
DIRECTOR George S. Casorati; Additional scenes written, choreographed, and
directed by Alicia J. Dhanifu
SCRIPT George S. Casorati
CAMERA Sergio D'Offizi
EDITOR Giuseppe Baghdighian
OTHER CREDITS Original music by Gianni Marchetti; Costume design by
Francesca Panicali

CAST Les Rannow, Ornella Muti, Abraham Gordon, Vicki Izay, Chris Avram, Marcy Marks, Louis Pistilli, Holly Gagnier, Gregory Labaqui, Stylistic Dancers

ARCHIVES / DISTRIBUTORS UCLA Film & Television Archive / Transvue Pictures Corp., Telavista (DVD)

Bellydancing: A History & an Art 1979 (16mm, color, 22 min)

PRODUCER / PRODUCTION CO. Alicia Dhanifu

DIRECTOR Alicia Dhanifu

SCRIPT Alicia Dhanifu

CAMERA Gary Gaston

EDITOR Jerry Weissman

OTHER CREDITS Director of photography: Gary Gaston; Sound: Arthur Joe Lopez; Production manager: Barbara McCullough; Costume designer: Iola Kelly; Make-up: Kathy Jackson; Graphics, animation, and title design: Christine Shaw

CAST Dancers: Alicia J. Dhanifu, Linda Grant, Yasmeen la Roche, Diana Lopez, Ruth Manzo, Nadia Simone; Musicians: Mohammed Ali, Joe Carson, Abram Hourany, Norman Johnson, Mohammed Maquri; Narrated by Alicia J. Dhanifu

ARCHIVES / DISTRIBUTORS UCLA Film & Television Archive

OMAH DIEGU (IJEOMA ILOPUTAIFE)

African Woman, USA 1980 (16mm, color, 19 min)

PRODUCER / PRODUCTION CO. Omah Diegu

DIRECTOR Omah Diegu

SCRIPT Omah Diegu

CAMERA Ben Caldwell

OTHER CREDITS Don Amis, Bernard Nicolas, Melvonna Ballenger; Music: John Coltrane

ARCHIVES / DISTRIBUTORS UCLA Film & Television Archive

Obaledo 1980 (8mm, 15 min)

DIRECTOR Omah Diegu

SCRIPT Omah Diegu

Atilogivu: The Story of a Wrestling Match 1982 (3/4-inch video, b&w)

PRODUCER / PRODUCTION CO. Omah Diegu

DIRECTOR Omah Diegu

SCRIPT Omah Diegu

ARCHIVES / DISTRIBUTORS UCLA Film & Television Archive

The Snake in My Bed 1995 (16mm, color, 90 min)

PRODUCER / PRODUCTION CO. Omah Diegu / Omafe Productions

DIRECTOR Omah Diegu

SCRIPT Omah Diegu

CAMERA Omah Diegu, Berthold Schweiz, Petra Buda

EDITOR Omah Diegu

OTHER CREDITS Nicola Heidemann, Michael Mieke, Ben Caldwell, Segun Ouomorokun, Marie Lang, Peter Notz, Tschangis Chahrokh, Bert Egerti, David Heineman

CAST Petra Gudrat-Kuckherz, Ezekwesili Iloputaife, Chinedum JajaNwachuku, Ozim Ott

ARCHIVES / DISTRIBUTORS UCLA Film & Television Archive

JAMAA FANAKA

A Day in the Life of Willie Faust, or Death on the Installment Plan 1972 (8 mm, color, 20 min)

PRODUCER / PRODUCTION CO. Jamaa Fanaka (as Walt Gordon)

DIRECTOR Jamaa Fanaka

SCRIPT Jamaa Fanaka

CAMERA Gary, Glenn, and Boots

EDITOR Jamaa Fanaka

CAST Baby Katina, Walt, Lynn, Carmen, Boots, Snooks, Gary

ARCHIVES / DISTRIBUTORS UCLA Film & Television Archive

Welcome Home, Brother Charles 1975 (35mm, color, 91 min)

PRODUCER / PRODUCTION CO. Jamaa Fanaka / Bob-Bea Productions

DIRECTOR Jamaa Fanaka

SCRIPT Jamaa Fanaka

CAMERA James Babij, George Geddis, Charles Burnett

EDITOR Jamaa Fanaka

OTHER CREDITS Theme music by Jamaa Fanaka; Music composed and produced by William Anderson; Ben Caldwell, Thomas Wright, David Silvan, Dan Warner, Jack Wheaton, Glenn Dixon, Rodney Smith

CAST Marlo Monte, Reatha Grey, Stan Kamber, Tiffany Peters

ARCHIVES / DISTRIBUTORS UCLA Film & Television Archive / Crown International Pictures, UC Berkeley Libraries (35mm), Xenon Pictures (as *Soul Vengeance*) (DVD)

Emma Mae 1976 (35mm, color, 100 min)

PRODUCER / PRODUCTION CO. Jamaa Fanaka / Bob-Bea Productions

DIRECTOR Jamaa Fanaka

SCRIPT Jamaa Fanaka

CAMERA Stephen Posey

EDITOR Robert A. Fitzgerald

OTHER CREDITS Geraldine Gerson, Music: H.B. Barnum, Adel Mazen, Marva Farmer, Don Sanders, Linda Dove, Dwaine Fobbs, Marva Farmer

CAST Jerri Hayes, Ernest Williams II, Charles D. Brooks III, Leopoldo Mandeville, Malik Carter

ARCHIVES / DISTRIBUTORS UCLA Film & Television Archive / Xenon Pictures (as *Black Sister's Revenge*) (DVD)

Penitentiary 1979 (35mm, color, 99 min)

PRODUCER / PRODUCTION CO. Jamaa Fanaka

DIRECTOR Jamaa Fanaka

SCRIPT Jamaa Fanaka

CAMERA Marty Ollstein

EDITOR Betsy Blankett

OTHER CREDITS Adel Mazen, Gregory Lewis, Jovon Gillohm, Yance Hamlett, Sergio Mims, Imelda Richard Billings, Ben Caldwell

CAST Leon Isaac Kennedy, Thommy Pollard, Gloria Delaney, Donovan Womack, Hazel Spear

ARCHIVES / DISTRIBUTORS Black Film Center/Archive (VHS) / Xenon Pictures (DVD)

Penitentiary II 1982 (35mm, color, 103 min)

PRODUCER / PRODUCTION CO. Jamaa Fanaka / Bob-Bea Productions, Ideal Films

DIRECTOR Jamaa Fanaka

SCRIPT Jamaa Fanaka

CAMERA Stephen Posey

EDITOR James E. Nownes

OTHER CREDITS Original music score composed and conducted by Jack W. Wheaton; Additional music by Gordon Banks; James E. Nownes

CAST Leon Isaac Kennedy, Glynn Turman, Ernie Hudson, Mr. "T.", Eugenia Wright, Ebony Wright, Donovan Womack

ARCHIVES / DISTRIBUTORS UCLA Film & Television Archive / Xenon Entertainment Group (DVD), Black Film Center/Archive (VHS)

Penitentiary III 1987 (35mm, color, 91 min)

PRODUCER / PRODUCTION CO. Jamaa Fanaka, Leon Isaac Kennedy

DIRECTOR Jamaa Fanaka

SCRIPT Jamaa Fanaka

CAMERA Marty Ollstein

EDITOR Alain Jakubowicz

OTHER CREDITS Craig Freitag, Robert Wheaton

ARCHIVES / DISTRIBUTORS UCLA Film & Television Archive / Cannon Films (VHS)

Street Wars 1992 (35mm, color, 92 min)

PRODUCER / PRODUCTION CO. Jamaa Fanaka, Bert Caldwell, Beatrice Gordon, Robert L. Gordon Jr.
DIRECTOR Jamaa Fanaka
SCRIPT Jamaa Fanaka
CAMERA John L. Demps Jr.
EDITOR Alain Jakubowicz, Taesung Yim
CAST Alan Joseph, Cliff Shegog, Bryan O'Dell, Deniese Payne
ARCHIVES / DISTRIBUTORS Image Entertainment (DVD)

JACQUELINE FRAZIER

Hidden Memories 1977 (8mm, b&w and color, 10 min)

PRODUCER / PRODUCTION CO. Jacqueline Frazier
DIRECTOR Jacqueline Frazier
SCRIPT Jacqueline Frazier
CAMERA Jacqueline Frazier
EDITOR Jacqueline Frazier
OTHER CREDITS Charles Burnett, Velfrancis Young, Dennis Brown; Music (live): Michael "Imani" Holmes
CAST Don Maharry, Mike Nixon, Adimbola Adetoye, Dr. Osborne Jr., Rita Dimeglio, Mrs. Johnson; With students of Compton High: Jamal Fenial, Linda Fenial
ARCHIVES / DISTRIBUTORS UCLA Film & Television Archive

Black Radio Exclusive 1980 (16mm, 20 min)

PRODUCER / PRODUCTION CO. Jacqueline Frazier
DIRECTOR Jacqueline Frazier

Curly Locks & the Three Brothers c. 1980s (3/4-inch video, color, 10 min)

DIRECTOR Jacqueline Frazier
ARCHIVES / DISTRIBUTORS UCLA Film & Television Archive

Shipley Street 1981 (16mm, color, 25 min)

PRODUCER / PRODUCTION CO. Jacqueline Frazier
DIRECTOR Jacqueline Frazier
SCRIPT Jacqueline Frazier
CAMERA Robert Holguin, Joseph Callaway, James Babig, James Jeffery, Dan Riesenfeld
EDITOR Porsche Stewart, Janice Cook, Jacqueline Frazier
OTHER CREDITS William McKinney, Raymond Bell, Don Maharry, John P. Garry

CAST Leslie Smith, Don Maharry, Sandra Sprouling Jacques, Dwana Willis, Miles Taylor, Roshard Liston

ARCHIVES / DISTRIBUTORS UCLA Film & Television Archive

TESHOME GABRIEL

Analogy 1972 (8mm, color, 5 min)

PRODUCER / PRODUCTION CO. Teshome Gabriel
DIRECTOR Teshome Gabriel
ARCHIVES / DISTRIBUTORS UCLA Film & Television Archive

HAILE GERIMA

Hour Glass 1971 (8mm, color and b&w, 13 min)

PRODUCER / PRODUCTION CO. Haile Gerima
DIRECTOR Haile Gerima
SCRIPT Haile Gerima
CAMERA Larry Clark, Haile Gerima
EDITOR Haile Gerima
CAST Mel Rosier
ARCHIVES / DISTRIBUTORS UCLA Film & Television Archive / Mypheduh Films (DVD)

Child of Resistance 1972 (16mm, color and b&w, 36 min)

PRODUCER / PRODUCTION CO. Haile Gerima
DIRECTOR Haile Gerima
SCRIPT Haile Gerima
CAMERA Reed Hutchinson
EDITOR Haile Gerima
CAST James Dougall, Barbara O. Jones
ARCHIVES / DISTRIBUTORS UCLA Film & Television Archive / Mypheduh Films (DVD)

Bush Mama 1975 (16mm, b&w, 97 min)

PRODUCER / PRODUCTION CO. Haile Gerima
DIRECTOR Haile Gerima
SCRIPT Haile Gerima
CAMERA Charles Burnett, Roderick Young
EDITOR Haile Gerima
CAST Barbara O. Jones, Johnny Weathers, Susan Williams, Cora Lee Day
ARCHIVES / DISTRIBUTORS UCLA Film & Television Archive / Mypheduh Films (DVD)

Harvest: 3,000 Years 1976 (16mm, b&w, 138 min)

PRODUCER / PRODUCTION CO. Haile Gerima / Mypheduh Films
DIRECTOR Haile Gerima
SCRIPT Haile Gerima
CAMERA Elliot Davis
EDITOR Haile Gerima
OTHER CREDITS Elliot Davis, Philip Kuretski, Michael Moore, Bob Roth, Ron Saks, Roy Barge; Original music: Tesfaye Lema
CAST Kasu Asfaw, Gebru Kasa, Worke Kasa, Melaku Makonen, Adane Melaku, Harege-Weyn Tafere
ARCHIVES / DISTRIBUTORS UCLA Film & Television Archive / Mypheduh Films (VHS)

Wilmington 10—U.S.A. 10,000 1979 (16mm, color, 97 min)

PRODUCER / PRODUCTION CO. Haile Gerima
DIRECTOR Haile Gerima
CAMERA Skip Norman
EDITOR Haile Gerima

Ashes & Embers 1982 (16mm, color, 129 min)

PRODUCER / PRODUCTION CO. Haile Gerima / Mypheduh Films
DIRECTOR Haile Gerima
SCRIPT Haile Gerima
CAMERA Agustin E. Cubano
EDITOR Haile Gerima
OTHER CREDITS Agustin E. Cubano, Shirikiana Aina, Lary Moten, Lenora Vernon, Ellen Sumter, Tim Lewis, Joy Shannon, Tony Regusters, Felicia E. Howell, Norma Jean Blalock, Elliot Davis, Charles Burnett, Abdul Hafiz, Bernard Nicolas, Abiyi R. Ford; Music: Brother Ah and the Sounds of Awareness
CAST Evelyn A. Blackwell, John Anderson, Norman Blalock, Kathy Flewellen, Uwezo Flewellen, Barry Wiggins
ARCHIVES / DISTRIBUTORS UCLA Film & Television Archive / Mypheduh Films (VHS)

After Winter: Sterling Brown 1985 (16mm, color, 60 min)

PRODUCER / PRODUCTION CO. Haile Gerima
DIRECTOR Haile Gerima
EDITOR Haile Gerima
CAST Sterling Brown
ARCHIVES / DISTRIBUTORS Mypheduh Films

Sankofa 1993 (35mm, color, 124 min)

PRODUCER / PRODUCTION CO. Haile Gerima / Negod-Gwad Productions Inc., Ghana National Commission on Culture, Diproci of Burkina Faso, NDR-WDR Television, Channel 4

DIRECTOR Haile Gerima

SCRIPT Haile Gerima

CAMERA Agustin E. Cubano

EDITOR Haile Gerima

OTHER CREDITS Music: David J. White, Andrew Millington, Charles Butler Knuckles, Shirikiana Aina, Kerry Marshall, Tracey White, Henry Brown

CAST Kofi Ghanaba, Oyafunmike Ogunlano, Alexandra Duah, Nick Medley, Mutabaruka, Afemo Omilami

ARCHIVES / DISTRIBUTORS UCLA Film & Television Archive / Mypheduh Films (DVD)

An Imperfect Journey 1994 (Super 16mm, color, 88 min)

PRODUCER / PRODUCTION CO. Fiona Morris, Andrew Coggins / Low Flying Pictures / BBC

DIRECTOR Haile Gerima

CAMERA Nick Gifford, Roger di Vito

EDITORS Nick Anderson, Yemane I. Demissie

OTHER CREDITS Albert Bailey, Alemayeuh Yifru

CAST Haile Gerima, Ryszard Kapuścinski

ARCHIVES / DISTRIBUTORS First Run, Icarus Films (VHS)

Adwa 1999 (35mm, color, 90 min)

PRODUCER / PRODUCTION CO. Haile Gerima / Mypheduh Films / ZDF / ARTE

DIRECTOR Haile Gerima

SCRIPT Haile Gerima

CAMERA Augustin Cubano

EDITOR Haile Gerima

ARCHIVES / DISTRIBUTORS Mypheduh Films (DVD)

Teza 2008 (Super 16mm, color, 140 min)

PRODUCER / PRODUCTION CO. Haile Gerima, Phillipe Avril, Karl Baumgartner, Marie-Michelegravele Cattelain / Negod-Gwad Productions, Pandora Film Produktion, WDR

DIRECTOR Haile Gerima

SCRIPT Haile Gerima

CAMERA Mario Masini

EDITOR Haile Gorima, Loren Hankin

CAST Aaron Arefe, Takelech Beyene

ARCHIVES / DISTRIBUTORS Ripley's Home Video (Italy) (DVD), Filmfreak
Distributie (Holland) (DVD)

KAREN GUYOT
Untitled 1980 (Super 8mm, 15 sec)
DIRECTOR Karen Guyot
SCRIPT Karen Guyot

PAS SI BÔ 1982 (16mm, 3 min, 3 sec)
DIRECTOR Karen Guyot
SCRIPT Karen Guyot

PAMELA JONES (REVALYN GOLD)
Forward Ever 1978 (16mm)
PRODUCER / PRODUCTION CO. Pamela Jones
DIRECTOR Pamela Jones
SCRIPT Pamela Jones

One 1980 (Super 8mm, 10 min)
PRODUCER / PRODUCTION CO. Pamela Jones
DIRECTOR Pamela Jones
SCRIPT Pamela Jones
EDITOR Pamela Jones

ALILE SHARON LARKIN
The Kitchen 1975 (8mm, b&w, 7 min)
PRODUCER / PRODUCTION CO. Alile Sharon Larkin
DIRECTOR Alile Sharon Larkin
SCRIPT Alile Sharon Larkin
EDITOR Alile Sharon Larkin
ARCHIVES / DISTRIBUTORS UCLA Film & Television Archive

Your Children Come Back to You 1979 (16mm, b&w, 29 min, 43 sec)
PRODUCER / PRODUCTION CO. Alile Sharon Larkin
DIRECTOR Alile Sharon Larkin
SCRIPT Alile Sharon Larkin
CAMERA Charles Burnett
EDITOR Alile Sharon Larkin, Charles Burnett
OTHER CREDITS Arthur Lopez; Music: Sabu Zawadi

CAST Angela Burnett, Patricia Bentley King, Sumi Nelson, Sabu Zawadi

ARCHIVES / DISTRIBUTORS UCLA Film & Television Archive / Women Make Movies

A Different Image 1982 (16mm, color, 51 min)

PRODUCER / PRODUCTION CO. Dankwa Khan, Claudine Mitchell

DIRECTOR Alile Sharon Larkin

SCRIPT Alile Sharon Larkin

CAMERA Charles Burnett

EDITOR Alile Sharon Larkin

OTHER CREDITS Don Amis, Abdul Hafiz, Bernard Nicolas, Reco Richardson, Jennifer Ashley-Smith, Julie Dash, Tony Cummings

CAST Margot Saxton-Federella, Adisa Anderson

ARCHIVES / DISTRIBUTORS UCLA Film & Television Archive / Women Make Movies

Miss Fluci Moses 1987 (Video, color, 22 min)

PRODUCER / PRODUCTION CO. Alile Sharon Larkin

DIRECTOR Alile Sharon Larkin

SCRIPT Alile Sharon Larkin

CAMERA Lynn Smith

EDITOR Alile Sharon Larkin, Veronica Rowe

ARCHIVES / DISTRIBUTORS Getty Research Institute (U-Matic, 3/4-inch)

Dreadlocks and the Three Bears 1991 (3/4-inch video, color, 12 min)

PRODUCER / PRODUCTION CO. Alile Sharon Larkin

DIRECTOR Alile Sharon Larkin, Armandilo Cousin

SCRIPT Alile Sharon Larkin

CAMERA Melvonna Ballenger

EDITOR Alile Sharon Larkin

OTHER CREDITS Music, Dave Larkin Jr.

CAST Alile Sharon Larkin

ARCHIVES / DISTRIBUTORS UCLA Film & Television Archive / Black Film Center / Archive (VHS)

Mz Medusa 1998 (Video, color, 28 min)

PRODUCER / PRODUCTION CO. Alile Sharon Larkin

DIRECTOR Alile Sharon Larkin

SCRIPT Alile Sharon Larkin

CAMERA Kwaku-Roderick Young (as Roderick Young)

EDITOR Bernard Nicolas

ARCHIVES / DISTRIBUTORS Black Film Center / Archive (VHS)

Video in the Classroom c. 2005–present (9 episodes in a series)
(Video, 10 min per episode)

PRODUCER / PRODUCTION CO. Alile Sharon Larkin / KCLS-TV
DIRECTOR Alile Sharon Larkin
SCRIPT Alile Sharon Larkin
CAMERA Alile Sharon Larkin
EDITOR Alile Sharon Larkin

O.FUNMILAYO MAKARAH

Apple Pie 1975 (Super 8mm, color, 20 min)

PRODUCER / PRODUCTION CO. O.Funmilayo Makarah
DIRECTOR O.Funmilayo Makarah
SCRIPT O.Funmilayo Makarah
CAMERA O.Funmilayo Makarah
EDITOR O.Funmilayo Makarah

As Time Goes By 1974 (Super 8mm, color, 5 min)

PRODUCER / PRODUCTION CO. O.Funmilayo Makarah
DIRECTOR O.Funmilayo Makarah

Grandma Willey 1977 (3/4-inch video color, 20 min)

PRODUCER / PRODUCTION CO. O.Funmilayo Makarah
DIRECTOR O.Funmilayo Makarah
SCRIPT O.Funmilayo Makarah
CAMERA O.Funmilayo Makarah
EDITOR O.Funmilayo Makarah

Survival: The Black South African Theatre '77 Project 1977 (1/2-inch
Video Portapak, b&w, 30 min)

PRODUCER / PRODUCTION CO. O.Funmilayo Makarah
DIRECTOR O.Funmilayo Makarah
SCRIPT O.Funmilayo Makarah
EDITOR O.Funmilayo Makarah

Ritual for Third World Women Artists 1978 (1/2-inch video, b&w, 30 min)

PRODUCER / PRODUCTION CO. O.Funmilayo Makarah
DIRECTOR O.Funmilayo Makarah
SCRIPT O.Funmilayo Makarah
CAMERA O.Funmilayo Makarah
EDITOR O.Funmilayo Makarah

Rummage Sale 1978 (3/4-inch video, color, 60 min)

PRODUCER / PRODUCTION CO. O.Funmilayo Makarah

DIRECTOR O.Funmilayo Makarah
SCRIPT O.Funmilayo Makarah
CAMERA O.Funmilayo Makarah
EDITOR O.Funmilayo Makarah

Define 1988 (3/4-inch video, color, 5 min)
PRODUCER / PRODUCTION CO. O.Funmilayo Makarah
DIRECTOR O.Funmilayo Makarah
SCRIPT O.Funmilayo Makarah
CAMERA Quinta Seward, Hiroko Yamazaki
EDITOR O.Funmilayo Makarah
OTHER CREDITS Zeinabu irene Davis
CAST O.Funmilayo Makarah, Yreina D. Cervantez, Kelly A. Hashimoto

. . . Just Names . . . Just Names . . . 1988 (Video 8, color, 20 min)
PRODUCER / PRODUCTION CO. O.Funmilayo Makarah
DIRECTOR O.Funmilayo Makarah
SCRIPT O.Funmilayo Makarah
CAMERA O.Funmilayo Makarah
EDITOR O.Funmilayo Makarah

Creating a Different Image: Portrait of Alile Sharon Larkin 1989
(3/4-inch video, color, 5 min)
PRODUCER / PRODUCTION CO. O.Funmilayo Makarah
DIRECTOR O.Funmilayo Makarah
CAMERA Marie Angela Kellier, Hiroko Yamazaki
EDITOR O.Funmilayo Makarah
OTHER CREDITS David Larkin, Melanie Dubose, Apryl Isaacs, Melanie
 Dubose, Apryl Isaacs, O.Funmilayo Makarah, Marlene Hatcher, Laini Dakar,
 Quinta Seward, Maria Raquel Rozzi, Diane Frederick, Lynne Kirste, Max
 Almy, Zeinabu Davis, Russell Leong, Barbara McCullough, Terry Sanders
ARCHIVES / DISTRIBUTORS UCLA Film & Television Archive

Diversity 1989 (3/4-inch video, color, 12 min)
PRODUCER / PRODUCTION CO. O.Funmilayo Makarah
DIRECTOR O.Funmilayo Makarah
SCRIPT O.Funmilayo Makarah
CAMERA O.Funmilayo Makarah, Quinta R. Seward, Cindy Wong
OTHER CREDITS Russell LeongAnna Chi, Pierre Désir, Christina Ku, Michael
 Lichter, Karen Umemoto, Anna Chi, Hiroko Yamazaki, O.Funmilayo
 Makarah, Zeinabu irene Davis, Abe Ferrer, Teshome Gabriel, Russell Leong,
 Terry Sanders, Emilio J. Virata Jr., Robert Wheaton, Karen Umemoto
ARCHIVES / DISTRIBUTORS UCLA Film & Television Archive

Together 1990 (16mm, color, 3 min)
PRODUCER / PRODUCTION CO. O.Funmilayo Makarah
DIRECTOR O.Funmilayo Makarah
SCRIPT O.Funmilayo Makarah
CAMERA O.Funmilayo Makarah
EDITOR O.Funmilayo Makarah

Voices from the Neighborhood 1992 (Hi-8 video, color, 20 min)
PRODUCER / PRODUCTION CO. O.Funmilayo Makarah
DIRECTOR O.Funmilayo Makarah
SCRIPT O.Funmilayo Makarah
CAMERA O.Funmilayo Makarah
EDITOR O.Funmilayo Makarah

Traditions: The Black Experience at Smith 1993 (SVHS, VHS, Hi-8 and 3/4-inch video, color, 58 min)
PRODUCER / PRODUCTION CO. O.Funmilayo Makarah
DIRECTOR O.Funmilayo Makarah
SCRIPT O.Funmilayo Makarah
CAMERA O.Funmilayo Makarah
EDITOR O.Funmilayo Makarah

She Must Be Dreaming 1994 (16mm, color, 7 min)
PRODUCER / PRODUCTION CO. O.Funmilayo Makarah
DIRECTOR O.Funmilayo Makarah
SCRIPT O.Funmilayo Makarah
CAMERA Hiroko Yamazaki
EDITOR O.Funmilayo Makarah

Fired-Up or How I Turned My Rage into Art 2006 (Hi-8 and video 8, color, 57 min)
PRODUCER / PRODUCTION CO. O.Funmilayo Makarah
DIRECTOR O.Funmilayo Makarah
CAST Margarita de la Vega-Hurtado, Zeinabu irene Davis
ARCHIVES / DISTRIBUTORS UCLA Film & Television Archive

L.A. in My Mind 2006 (Digital video, color, 4 min)
PRODUCER / PRODUCTION CO. O.Funmilayo Makarah
DIRECTOR O.Funmilayo Makarah
SCRIPT O.Funmilayo Makarah
CAMERA O.Funmilayo Makarah
EDITOR O.Funmilayo Makarah
ARCHIVES / DISTRIBUTORS UCLA Film & Television Archive

Dreams, Memories, Amnesia, and Déjà Vu (work in progress) (3/4-inch video, color)

PRODUCER / PRODUCTION CO. O.Funmilayo Makarah
DIRECTOR O.Funmilayo Makarah
SCRIPT O.Funmilayo Makarah
CAMERA O.Funmilayo Makarah
EDITOR O.Funmilayo Makarah

BARBARA MCCULLOUGH

Water Ritual #1: An Urban Rite of Purification 1979 (16mm, b&w, 6 min)

PRODUCER / PRODUCTION CO. Barbara McCullough
DIRECTOR Barbara McCullough
SCRIPT Barbara McCullough
CAMERA Peter Blue, Ben Caldwell, Roho
EDITOR Barbara McCullough
ARCHIVES / DISTRIBUTORS UCLA Film & Television Archive / Black Film Center / Archive (VHS), Third World Newsreel (DVD)

Fragments 1980 (3/4-inch video, color, 10 min)

PRODUCER / PRODUCTION CO. Barbara McCullough
DIRECTOR Barbara McCullough
SCRIPT Barbara McCullough
CAMERA Barbara McCullough, David Hamlin
EDITOR Barbara McCullough
ARCHIVES / DISTRIBUTORS Black Film Center / Archive (VHS), Third World Newsreel (DVD)

The World Saxophone Quartet 1980 (3/4-inch video, color, 5 min)

PRODUCER / PRODUCTION CO. Barbara McCullough
DIRECTOR Barbara McCullough
SCRIPT Barbara McCullough
CAMERA Barbara McCullough
EDITOR Barbara McCullough
ARCHIVES / DISTRIBUTORS Black Film Center / Archive (VHS), Third World Newsreel (VHS)

Shopping Bag Spirits and Freeway Fetishes: Reflections on Ritual Space 1981 (Video, color, 60 min)

PRODUCER / PRODUCTION CO. Barbara McCullough
DIRECTOR Barbara McCullough
SCRIPT Barbara McCullough
CAMERA Barbara McCullough
EDITOR Barbara McCullough

OTHER CREDITS Barbara McCullough, Bernard Nicolas, John Simmons, Roderick Young Nicolas, John Simmons, Roderick Young

CAST David Hammons, Raspoeter Ojenke, Kenneth Severin, K. Curtis Lyle, Kamau Daa'ood, Kinshasha Cornwill, Houston Cornwill, Senga Nengudi, Betye Saar

ARCHIVES / DISTRIBUTORS UCLA Film & Television Archive / Third World Newsreel (VHS)

ORIN MITCHELL
Poverty Struck 1980 (Super 8mm, 4 min)

PRODUCER / PRODUCTION CO. Orin Mitchell
DIRECTOR Orin Mitchell
SCRIPT Orin Mitchell

JAMES MUNDY
Untitled 1980 (8mm, 1 min)

PRODUCER / PRODUCTION CO. James Mundy
DIRECTOR James Mundy
SCRIPT James Mundy

BERNARD NICOLAS
Daydream Therapy 1977 (16mm, color and b&w, 8 min)

PRODUCER / PRODUCTION CO. Bernard Nicolas
DIRECTOR Bernard Nicolas
SCRIPT Bernard Nicolas
CAMERA Bernard Nicolas
EDITOR Bernard Nicolas
OTHER CREDITS Music by Nina Simone and Archie Shepp
CAST Gay Abel-Bey, Marva Anderson, Larry Bell, Jeff Cox, Keith Taylor
ARCHIVES / DISTRIBUTORS UCLA Film & Television Archive

Gidget Meets Hondo 1980 (16mm, color, 8 min)

PRODUCER / PRODUCTION CO. Bernard Nicolas
DIRECTOR Bernard Nicolas
SCRIPT Bernard Nicolas
CAMERA Don Amis, Ben Caldwell
EDITOR Bernard Nicolas
OTHER CREDITS Frances España, Ivy Sharpe, Anita Addison, Geoff Gilmore, Billy Woodberry, Gay Abel-Bay, John Esaki, Melvonna Ballenger, Justin Chart; Music: Archie Shepp
CAST Peggy Skomal, Reginald Bruce, John Daspachel, Marie Contin, Michael Friend, Bernard Nicolas
ARCHIVES / DISTRIBUTORS UCLA Film & Television Archive

Boat People 1982 (16mm, color, 9 min)

PRODUCER / PRODUCTION CO. Bernard Nicolas
DIRECTOR Bernard Nicolas
CAMERA Patrick Melly
OTHER CREDITS Kathleen Forrest, Abdul Hafiz, Mel Ballenger, Todd Darling, Julie Dash, John Esaki, Brigitte Kelly, Alfie Muronda, Alex Salazar, Dan Valentine, Jerry Weissman, Pete Wilson
CAST Richard Penn, John Lawrence, Janet Rotblatt, Karen Guyot, Trevor Mitchell, Jonathan Wacks, Marc Chéry, Sherri Hurdle, Frank Kelly
ARCHIVES / DISTRIBUTORS UCLA Film & Television Archive

AKINTUNDE OGUNLEYE
A Victim or Crook 1980 (Super 8mm, 15 min)

PRODUCER / PRODUCTION CO. Akintunde Ogunleye
DIRECTOR Akintunde Ogunleye
SCRIPT Akintunde Ogunleye

THOMAS PENICK
69 Pickup 1969 (8mm, b&w, 2 min, 30 sec)

PRODUCER / PRODUCTION CO. Thomas Penick
DIRECTOR Thomas Penick
SCRIPT Thomas Penick
CAMERA Charles Burnett
CAST Charles Bracy, Peggi Chute, Cliff Penick
ARCHIVES / DISTRIBUTORS UCLA Film & Television Archive

ROOSEVELT RICHARDS
Triad Reflections 1980 (Super 8mm, 12 min)

PRODUCER / PRODUCTION CO. Roosevelt Richards
DIRECTOR Roosevelt Richards
SCRIPT Roosevelt Richards

LEROY RICHARDSON
Heavy Is 1980 (Super 8mm, 40 min)

PRODUCER / PRODUCTION CO. Leroy Richardson
DIRECTOR Leroy Richardson
SCRIPT Leroy Richardson

JOHN RIER
Black Images from the Screen 1978 (16mm, color and b&w, 60 min)

PRODUCER / PRODUCTION CO. John Rier

DIRECTOR John Rier
CAST Narrator: Barbara O; Bodacious Buggerrilla
ARCHIVES / DISTRIBUTORS Black Filmmaker Foundation (16mm)

IVY SHARPE
So You Want to Be an Actress 1980 (Super 8mm, color, 12 min)

PRODUCER / PRODUCTION CO. Ivy Sharpe
DIRECTOR Ivy Sharpe
SCRIPT Ivy Sharpe

IMELDA SHEEN (MILDRED RICHARD)
Forbidden Joy/Plaisar Defundus 1975 (8mm, color and b&w, 10 min)

PRODUCER / PRODUCTION CO. Mildred Richard
DIRECTOR Mildred Richard
SCRIPT Mildred Richard
ARCHIVES / DISTRIBUTORS UCLA Film & Television Archive

Been Here Before 1976 (16mm, color, 12 min)

PRODUCER / PRODUCTION CO. Mildred Richard
DIRECTOR Mildred Richard
SCRIPT Mildred Richard
ARCHIVES / DISTRIBUTORS UCLA Film & Television Archive

Faux Pas 1976 (16mm, b&w)

PRODUCER / PRODUCTION CO. Mildred Richard
DIRECTOR Mildred Richard
SCRIPT Mildred Richard
ARCHIVES / DISTRIBUTORS UCLA Film & Television Archive

Vampira Marapasa 1978 (unfinished) (16mm)

PRODUCER / PRODUCTION CO. Mildred Richard
DIRECTOR Mildred Richard
SCRIPT Mildred Richard
ARCHIVES / DISTRIBUTORS UCLA Film & Television Archive

Zivia 1980 (16mm)

PRODUCER / PRODUCTION CO. Mildred Richard
DIRECTOR Mildred Richard
SCRIPT Mildred Richard
ARCHIVES / DISTRIBUTORS UCLA Film & Television Archive

STORMÉ BRIGHT SWEET

Prisms: Life Flights of Minds and Souls c. 1976 (3/4-inch video, color and b&w, 33 min)

DIRECTOR Stormé Bright Sweet
ARCHIVES / DISTRIBUTORS UCLA Film & Television Archive

Locker Room Rites 1978 (3/4-inch video, 20 min)

PRODUCER / PRODUCTION CO. Stormé Bright Sweet
DIRECTOR Stormé Bright Sweet
EDITOR Stormé Bright Sweet

The Single Parent: Images in Black c. 1978 (3/4-inch video, color, 21 min, 15 sec)

PRODUCER / PRODUCTION CO. Stormé Bright Sweet
CAMERA Alile Sharon Larkin, Craig Roberts, Jay Abramowitz, Stormé Bright Sweet
ARCHIVES / DISTRIBUTORS UCLA Film & Television Archive

That's Love: Celebrity Tennis Tournament 1978 (3/4-inch video, color, 21 min)

PRODUCER / PRODUCTION CO. Stormé Bright Sweet
DIRECTOR Stormé Bright Sweet

Whose Child? 1979 (3/4-inch video, 15 min)

PRODUCER / PRODUCTION CO. Stormé Bright Sweet
DIRECTOR Stormé Bright Sweet

When I Grow Up I Want to Marry an African Prince 1984 (3/4-inch video)

PRODUCER / PRODUCTION CO. Black Film Collective
DIRECTOR Stormé Bright Sweet, Julie Dash, Alile Sharon Larkin

ELYSEO TAYLOR

Black Art, Black Artists 1971 (16mm, color, 16 min)

PRODUCER / PRODUCTION CO. UCLA University Extension
DIRECTOR Elyseo J. Taylor
CAMERA Mohammed Sadrzadeh, Tony Gorsline
CAST Van Slater
ARCHIVES / DISTRIBUTORS UCLA Film & Television Archive

To Promote the General Welfare 1972 (16mm, color, 70 min)
DIRECTOR Elyseo J. Taylor
ARCHIVES / DISTRIBUTORS UCLA Film & Television Archive

BETHELEHEM TESHAYU
A Journey 1980 (8mm, 10 min)
PRODUCER / PRODUCTION CO. Bethelehem Teshayu
DIRECTOR Bethelehem Teshayu
SCRIPT Bethelehem Teshayu

MONONA WALI
Evening Still 1978 (Super 8mm, color, 12 min)
PRODUCER / PRODUCTION CO. Monona Wali
DIRECTOR Monona Wali
CAST Kate Skinner
ARCHIVES / DISTRIBUTORS UCLA Film & Television Archive

Grey Area 1982 (16mm, b&w, 38 min)
PRODUCER / PRODUCTION CO. Monona Wali
DIRECTOR Monona Wali
SCRIPT Thomas Gandolfo Musca, Monona Wali
CAMERA Amy C. Halpern
EDITOR Monona Wali
OTHER CREDITS Joy Cohen, Peter McCarthy, Joy Cohen, Rachel Rosenthal, Shaun Madigan, John Sharaf, Steve Nelson, Don Amis, Patrick Moyrold, Ian Valentine, Jean-Pierre Renaud, Anthony Cummings; special thanks, Kameshwar and Kashi Wali, UCLA technical staff, Jorge Preloran
CAST Eve Holloway, Haskell V. Anderson, Lance Nichols, Andre Waters, Sy Richardson
ARCHIVES / DISTRIBUTORS UCLA Film & Television Archive / New York Public Library (16mm)

Maria's Story 1990 (16mm, color, 53 min)
PRODUCER / PRODUCTION CO. Monona Wali, Catherine Ryan
DIRECTOR Monona Wali, Pamela Cohen
CAMERA John Knoop
EDITOR Anita Clearfield
ARCHIVES / DISTRIBUTORS PM Press (DVD)

KALICHE WARNI
Dear Chi Chi 1980 (Super 8mm, 10 min)
PRODUCER / PRODUCTION CO. Kaliche Warni

DIRECTOR Kaliche Warni
SCRIPT Kaliche Warni

ROBERT WHEATON
A Little Off Mark 1986 (16mm, b&w, 9 min)

PRODUCER / PRODUCTION CO. Robert Wheaton
DIRECTOR Robert Wheaton
SCRIPT Robert Wheaton
CAMERA S. Torriano Berry
EDITOR Robert Wheaton
OTHER CREDITS Assistant director: Joseph Brown; Technical assistants: Paul B. Stephens, Ade Olatunji, James D. Wheaton
CAST Peter Parros, Lee Daniels, Carol Porter, Robin R. Robinson, Debi Tinsley
ARCHIVES / DISTRIBUTORS UCLA Film & Television Archive / Mosaic Films

At the Bus Stop 1991 (16mm)

PRODUCER / PRODUCTION CO. Robert Wheaton
DIRECTOR Robert Wheaton
SCRIPT Robert Wheaton
EDITOR Robert Wheaton

The Making of "Green Dragon" 2002 (Video, color, 15 min)

PRODUCER / PRODUCTION CO. Robert Wheaton, Daniel Ferguson / Spirit Dance Entertainment
DIRECTOR Robert Wheaton
SCRIPT Robert Wheaton
EDITOR Daniel Ferguson, Fred Smith

IVERSON WHITE
Self-Determination 1982 (Super 8mm, b&w, 10 min)

PRODUCER / PRODUCTION CO. Iverson White
DIRECTOR Iverson White
SCRIPT Iverson White
CAMERA Iverson White
EDITOR Iverson White

Dark Exodus 1985 (16mm, color and b&w, 28 min)

PRODUCER / PRODUCTION CO. Iverson White / Oracy Productions
DIRECTOR Iverson White
SCRIPT Iverson White
CAMERA Lindy Laub
EDITOR Iverson White

OTHER CREDITS Music: Kamau Kenyatta; Musicians: Ralph Jones, Charles Moore, Kamau Kenyatta; Vocals: Una Van Duvall, Ferdinand "Jelly Roll" Morton; Una Van Duvall, Zeinabu irene Davis

CAST Clarence Tennille, Jon Jelks, Harold House, Jeffery Dixon, Geraldine Dunston, Starletta Dupois

ARCHIVES / DISTRIBUTORS UCLA Film & Television Archive / Winona State University (VHS), Harvard University (VHS), University of Wisconsin–River Falls (VHS)

Magic Love 1992 (16mm, color, 97 min)

PRODUCER / PRODUCTION CO. Iverson White
DIRECTOR Iverson White
SCRIPT Iverson White
EDITOR Iverson White

The Johnson Girls 1995 (16mm, color, 28 min)

PRODUCER / PRODUCTION CO. Iverson White
DIRECTOR Iverson White
SCRIPT Iverson White, based on story by Toni Cade Bambara
EDITOR Iverson White

It's Always Something 2001 (Video, color, 47 min)

PRODUCER / PRODUCTION CO. Iverson White
DIRECTOR Iverson White
SCRIPT Iverson White
EDITOR Iverson White

Self-Determination 2006 (16mm, color, 11 min)

PRODUCER / PRODUCTION CO. Carlo Besasie, Joe Spang / Oracy Productions
DIRECTOR Iverson White
SCRIPT Iverson White
CAMERA Carlo Besasie
EDITOR Iverson White

The Funeral 2009 (Video, color, 13 min)

PRODUCER / PRODUCTION CO. Joe Spang / Flexible Films
DIRECTOR Iverson White
SCRIPT Iverson White
CAMERA Carlo Besasie
EDITOR Iverson White
OTHER CREDITS Kara Mulrooney

GRAYLING WILLIAMS

Bob Marley (Bob Marley and the Wailers interviewed by UCLA students at UCLA Pauley Pavilion locker room, November 23, 1979) 1979 (3/4-inch video, color, 44 min)

PRODUCER / PRODUCTION CO. Grayling Williams, Crystal Maddox Williams
CAMERA Bernard Nicolas
OTHER CREDITS Barbara McCullough, Roderick "Kwan Lynn" Young, Crystal Maddox Williams
CAST Bob Marley and the Wailers
ARCHIVES / DISTRIBUTORS UCLA Film & Television Archive

Kinky Babylon 1979 (3/4-inch video, b&w, 19 min, 43 sec)

DIRECTOR Grayling Williams
OTHER CREDITS Music: Bob Marley and the Wailers, Sudwestfunk Orchestra conducted by Ernest Bour; Passage from *Steppenwolf* by Hermann Hesse
CAST Mike James, Ingrid Johnyne, Josh Kean, Val Ibarra, David S. Rodes, Amenta Dymally, J. Sommerville
ARCHIVES / DISTRIBUTORS UCLA Film & Television Archive

BILLY WOODBERRY

The Pocketbook 1980 (16mm, b&w, 13 min)

PRODUCER / PRODUCTION CO. Billy Woodberry
DIRECTOR Billy Woodberry
SCRIPT Billy Woodberry, based on story "Thank You, M'am" by Langston Hughes
CAMERA Mario DeSilva, Gary Gaston, Charles Burnett
EDITOR Billy Woodberry
CAST Ella "Simi" Nelson, Ray Cherry, David Jenkins, Al Williams, Christopher Thompson, Phillip Weatherspoon
ARCHIVES / DISTRIBUTORS Black Film Center / Archive (16mm)

Bless Their Little Hearts 1984 (16mm, b&w, 84 min)

PRODUCER / PRODUCTION CO. Billy Woodberry / Black Independent Features
DIRECTOR Billy Woodberry
SCRIPT Charles Burnett
CAMERA Charles Burnett
EDITOR Billy Woodberry, in consultation with Alan Kondo, Tom Penick
OTHER CREDITS Patrick Melly, Richard Cervantes, Music: Little Esther Phillips, Archie Shepp
CAST Nate Hardman, Kaycee Moore, Angela Burnett, Ronald Burnett, Kimberly Burnett, Eugene Cherry, Lawrence Pierott, Ernest Knight, Ellis Griffin
ARCHIVES / DISTRIBUTORS UCLA Film & Television Archive / New York Public Library (16mm), Miami Dade Public Library System (16mm),

University of Wisconsin–Milwaukee (VHS), University of Virginia Library (VHS), California Institute of the Arts (VHS)

The Architect, the Ants, and the Bees 2004 (Video installation, color, 120 min)
DIRECTOR Billy Woodberry
CAMERA Billy Woodberry

VELFRANCES YOUNG
Patrice Rusten 1980 (8mm, 20 min)

PRODUCER / PRODUCTION CO. VelFrances Young
DIRECTOR VelFrances Young
SCRIPT VelFrances Young

WORKS CONSULTED

Black Film Center/Archive. "Collections, Films." Web. 3 May 2015.
Bobo, Jacqueline, ed. *Black Women Film and Video Artists*. New York: Routledge, 1998.
Denker, Susan and Maya Freelon. *African American Visual Artists Database*. Web. 10 May 2015.
Kapsis, Robert E. *Charles Burnett Interviews*. Jackson: University Press of Mississippi, 2011.
Kelley, Shannon, ed. and Allyson Nadia Field, Jan-Christopher Horak and Jacqueline Stewart, co-eds. *L.A. Rebellion: Creating a New Black Cinema* (exhibition catalog). Los Angeles: UCLA Film & Television Archive, 2011.
Klotman, Phyllis R. and Gloria J. Gibson. *Frame by Frame: A Filmography of the African American Image, 1978–1994*. Bloomington: Indiana University Press, 1997.
Taylor, Elyseo Jose. "Mass Media and the Social Dialogue, One Experience." The Role of the Mass Media in Enlisting Public Support for Marginal Groups. The European Centre for Social Welfare Training and Research. Sponsored by the United Nations. The Rockefeller Foundation Study and Conference Center, Bellagio, Italy. 20 September 1976. Revised draft 3 May 1977.
Third World Newsreel. "Catalog." Web. 1 May 2015.
UCLA Library. "Film and Television Archive Catalog." Web. 8 May 2015.
Women Make Movies. "Film Catalog." Web. 6 May 2015.

Selected Bibliography

BOOKS, JOURNALS, AND FILM INDUSTRY PRESS

Aldama, Frederick Luis. *Postethnic Narrative Criticism: Magicorealism in Oscar "Zeta" Acosta, Ana Castillo, Julie Dash, Hanif Kureishi, and Salman Rushdie.* Austin: University of Texas Press, 2003.

Alexander, George. *Why We Make Movies: Black Filmmakers Talk about the Magic of Cinema.* New York: Harlem Moon, 2003.

Alexander, Karen. *"Daughters of the Dust." Sight and Sound* 3, no. 9 (September 1993): 20–22.

Amine, Laila. "Julie Dash's Aesthetic Vision." *Black Camera* 19, no. 2 (Fall/Winter 2004): 3–4.

Anderson, Lisa M. *Mammies No More: The Changing Image of Black Women on Stage and Screen.* Lanham, MD: Rowman and Littlefield, 1997.

Arthur, Paul. *"Killer of Sheep." Film Comment* (January/February 2008): 38.

Backstein, Karen. "The Cinematic Jazz of Julie Dash." *Cinéaste* 19, no. 4 (1993): 88.

Bambara, Toni Cade. "Reading the Signs, Empowering the Eye: *Daughters of the Dust* and the Black Independent Cinema Movement." In *Black American Cinema*, edited by Manthia Diawara, 118–44. New York: Routledge, 1993.

Bell-Scott, Patricia, ed. *Life Notes: Personal Writings by Contemporary Black Women.* New York: W. W. Norton, 1994.

Benton, Jacquelyn. "Grace Nichols' *I Is a Long Memoried Woman* and Julie Dash's *Daughters of the Dust:* Reversing the Middle Passage." In *Black Women Writers across Cultures: An Analysis of Their Contributions*, edited by Valentine Udoh James, James S. Etim, Melanie Marshall James, and Ambe J. Njoh, 221–32. Lanham, MD: International Scholars Publications, 2000.

Biccum, April. "Third Cinema in the 'First' World: *Eve's Bayou* and *Daughters of the Dust." CineAction* 49 (1999): 60–65.

Blue, Carroll Parrott. *The Dawn at My Back: Memoir of a Black Texas Upbringing.* Austin: University of Texas Press, 2003. Special edition with a DVD-ROM by Carroll Parrott Blue, Kristy H. A. Kang and the Labyrinth Project, *The Dawn at My Back: Memoir of a Black Texas Upbringing; An Interactive Cultural History.* Los Angeles: Annenberg Center for Communication, University of Southern California, 2003.

————. "Pacific Picturesque: The Hawaii International Film Festival." *Independent* 10, no. 4 (May 1987): 24–25.

————. "Sometimes a Poem Is Twenty Years of Memory: 1967–1987." *Sage: A Scholarly Journal on Black Women* 4, no. 1 (1987): 37–38.

Bobo, Jacqueline. *Black Women as Cultural Readers.* New York: Columbia University Press, 1995.

————, ed. *Black Women Film and Video Artists.* New York: Routledge, 1998.

Bogle, Donald. *Toms, Coons, Mulattoes, Mammies, and Bucks: An Interpretive History of Blacks in American Films.* 4th ed. New York: Continuum, 2001.

Bowser, Pearl, Jane Gaines, and Charles Musser, eds. *Oscar Micheaux and His Circle: African-American Filmmaking and Race Cinema of the Silent Era.* Bloomington: Indiana University Press, 2001.

Boyd, Valerie. "Conjuring the Restless Spirits: *Daughters of the Dust.*" *Eight-Rock* 1 (Summer 1990): 9–13.

Breen, Jennifer. Review of *Medusa Redux. Black Camera* 14, no. 1 (Spring/Summer 1999): 5.

Brill, Lesley. *Crowds, Power, and Transformation in Cinema.* Detroit: Wayne State University Press, 2006.

Brøndum, Lene. "'The Persistence of Tradition:' The Retelling of Sea Islands Culture in Works by Julie Dash, Gloria Naylor, and Paule Marshall." In *Black Imagination and the Middle Passage,* edited by Maria Diedrich, Henry Louis Gates Jr., and Carl Pedersen, 153–63. New York: Oxford University Press, 1999.

Brouwer, Joel R. "Repositioning: Center and Margin in Julie Dash's *Daughters of the Dust.*" *African American Review* 29, no. 1 (Spring 1995): 5–16.

Brown, Caroline. "The Representation of the Indigenous Other in *Daughters of the Dust* and *The Piano.*" *NWSA Journal* 15, no. 1 (Spring 2003): 1–19.

Burnett, Charles. "Film as a Force for Social Change." *Black Film Review* 2, no. 4 (1986): 12–14.

————. "The House I Live In: An Interview with Charles Burnett." By Aida A. Hozic. *Callaloo* 17, no. 2 (Spring 1994): 471–87.

————. "Inner City Blues." In *Questions of Third Cinema,* edited by Jim Pines and Paul Willemen, 223–26. London: British Film Institute, 1989.

————. "Interview: Charles Burnett." By Saundra Sharp. *Black Film Review* 6, no. 1 (1991): 4–7.

————. "Interview: Charles Burnett—Consummate Cinéaste." By Michael T. Martin and Eileen Julien. *Black Camera* 1, no. 1 (Winter 2009): 143–70.

————. "An Interview with Charles Burnett." By Bérénice Reynaud. *Black American Literature Forum* 25, no. 2 (1991): 323–34.

————. "Writing and Directing *To Sleep with Anger.*" Interview by Tod Lippy. *Scenario: The Magazine of Screenwriting Art* 2, no. 1 (1996): 96–99.

Burnett, Charles, and Charles Lane. "Charles Burnett and Charles Lane." *American Film* 16, no. 8 (1991): 40–43.

Byrge, Duane. Review of *Daughters of the Dust. Hollywood Reporter,* January 22, 1991.

Caldwell, Ben. "KAOS at Ground Zero: Video, Teleconferencing and Community Networks." *Leonardo.* 26, no. 5 (1993): 421–22.

Cham, Mbye Baboucar. "Art and Ideology in the Work of Sembène Ousmane and Hailé Gerima." *Présence Africaine* 129 (1984): 79–91.

———. "Artistic and Ideological Convergence: Ousmane Sembene and Haile Gerima." *Ufahamu* 11, no. 2 (1982): 140–52.

Cham, Mbye Baboucar, and Claire Andrade-Watkins, eds. *Blackframes: Critical Perspectives on Black Independent Cinema.* Cambridge, MA: MIT Press, 1988.

Chan, Vera. "The *Dust* of history." *Mother Jones* 15, no. 7 (November/December 1990): 60.

Chandler, Karen. "Folk Culture and Masculine Identity in Charles Burnett's *To Sleep with Anger.*" *African American Review* 33, no. 2 (Summer 1999): 299–311.

"Charles Burnett." *Current Biography* 46, no. 9 (1995): 9–12.

"Charles Burnett." In *Contemporary Black Biography: Profiles from the International Black Community,* vol. 115, edited by Shirelle Phelps. Farmington Hills, MI: Gale, Cengage Learning, 2014.

Clytus, Radiclani. "The Pedagogy of Slavery: Understanding Literacy in Charles Burnett's *Nightjohn.*" *Black Camera* 12, no. 2 (Winter 1997–98): 3.

Coplan, David B., and Bridget Thomson. "The Internal Dialogue of an African Filmmaker." In *Transgressing Boundaries: New Directions in the Study of Culture in Africa,* edited by Brenda Cooper and Andrew Steyn, 141–52. Athens: Ohio University Press, 1996.

Covey, William B. "Reckoning Day: Race, Representation, and Redress in Women's Literature and Film." *Modern Fiction Studies* 52, no. 3 (2006): 705–13.

Cox, Alex, and Armond White. "Slaughter House Blues." *Sight and Sound* 12, no. 7 (July 2002): 28–30.

Cramer, Lauren M. "Black Sister's Reality: Black Bodies and Space in *Emma Mae.*" In *"liquid blackness* on the L.A. Rebellion,*" liquid blackness* 1, no. 1 (2014): 19–21. http://liquidblackness.com/LB1_LARebellion.pdf.

Cucinella, Catherine, and Renee R. Curry. "Exiled at Home: *Daughters of the Dust* and the Many Post-Colonial Conditions." *MELUS* 26, no. 4 (Winter 2001): 197–222.

Curry, Renee R. "*Daughters of the Dust,* the White Woman Viewer, and the Unborn Child." In *Teaching What You're Not: Identity Politics in Higher Education,* edited by Katherine J. Mayberry, 335–56. New York: New York University Press, 1996.

Dash, Julie. "Daughters of the Diaspora: An Interview with Filmmaker Julie Dash." By Rahdi Taylor. *Third Force* 1, no. 5 (December 1993): 12–16.

———. "*Daughters of the Dust:* A New Screenplay." *Catalyst* (Summer 1987): 25–34.

———. *Daughters of the Dust: A Novel.* New York: Plume, 1999.

———. "*Daughters of the Dust:* Interview with Julie Dash." By Zeinabu irene Davis. *Black Film Review* 6, no. 1 (1991): 12–17, 20–21.

———. "*Daughters of the Dust*": *The Making of an African American Woman's Film.* New York: New Press, 1992.

———. "Geechee Girl Goes Home: Julie Dash on *Daughters of the Dust.*" Interview by Deborah Thomas and Catherine Saalfield. *Independent* 14, no. 6 (July 1991): 25–27.

———. "'I Do Exist': From 'Black Insurgent' to Negotiating the Hollywood Divide—A Conversation with Julie Dash." Interview by Michael T. Martin. *Cinema Journal* 49, no. 2 (Winter 2010): 1–16.

———. "Interview with Julie Dash." By Yvonne Welbon. *Black Screenwriter* 1, no. 1 (September/October 1991): 4–5.

———. "An Interview with Julie Dash." By Zeinabu irene Davis. *Wide Angle* 13, nos. 3/4 (1991): 110–18.

———. "Making Movies That Matter: A Conversation with Julie Dash." Interview by Michael T. Martin. *Black Camera* 22, no. 1 (Spring/Summer 2007): 4–12.

———. "Not without My *Daughters:* A Conversation with Julie Dash and Houston A. Baker, Jr." Interview by Houston A. Baker Jr. *Transition* 57 (1992): 150–66.

Dash, Julie, and Alile Sharon Larkin. "New Images: An Interview with Julie Dash and Alile Sharon Larkin." By Kwasi Harris. *Independent* 9 (December 1986): 16–20.

Daulatzai, Sohail. *Black Star, Crescent Moon: The Muslim International and Black Freedom beyond America.* Minneapolis: University of Minnesota Press, 2012.

Davies, Jude. "Tensioned and Interlocking Identities in *Daughters of the Dust.*" In *Gender, Ethnicity and Sexuality in Contemporary American Film,* edited by Jude Davies and Carol R. Smith, 82–90. Edinburgh: Keele University Press, 1997.

Davis, Thulani. "Julie Dash's *Daughters of the Dust.*" *YSB* (February 1992): 36–38.

Davis, Zeinabu irene. "'Beautiful-Ugly' Blackface: An Esthetic Appreciation of *Bamboozled.*" *Cinéaste* 26, no. 2 (2001): 16–17.

———. "Black Independent or Hollywood Iconoclast?" *Cinéaste* 17, no. 4 (1990): 36–37.

———. "Daunting Inferno." *Afterimage* 21 (Summer 1993): 20.

———. "The Future of Black Film: The Debate Continues." *Black Film Review* 5, no. 4 (1989): 6, 8, 26, 28.

———. "Pushing beyond the Stereotypes and Fostering Collaboration: One Sistuh's Approach to Teaching Media Production." In *Women Faculty of Color in the White Classroom: Narratives on the Pedagogical Implications of Teacher Diversity,* edited by Lucila Vargas, 201–18. New York: P. Lang, 2002.

———. "Woman with a Mission: Zeinabu irene Davis on Filmmaking." *Hot Wire* 7, no. 1 (January 1991): 18–19, 56.

Dean, Sharon, and Frances Stubbs-Palmer. "Film Festival/Workshop Brings Together, Artists, Audience, and Issues." *Black Camera* 1, no. 2 (Winter 1985): 1–2.

Dennis, Raoul. "Selling *Sankofa*." *YSB* 4, no. 5 (1995): 94–97.

Diawara, Manthia, ed. *Black American Cinema*. New York: Routledge, 1993.

———. "The 9th Pan-African Film Festival." *Black Camera* 1, no. 1 (1985): n.p.

Dittmar, Linda. "All That Hollywood Allows: Film and the Working Class." *Radical Teacher* 46 (April 30, 1995): 38.

Donalson, Melvin. *Black Directors in Hollywood*. Austin: University of Texas Press, 2003.

Ebrahim, Haseenah. "Africanity and Orality in the Films/Videos of Women Filmmakers of the African Diaspora." *Deep Focus* 8, nos. 3/4 (1998): 99–105.

Ebron, Paulla A. "Enchanted Memories of Regional Difference in African American Culture." *American Anthropologist* 100, no. 1 (March 1998): 94–105.

Edwards, Tonia M. "From Boyz to the Banlieue: Race, Nation, and Mediated Resistance." PhD diss., Indiana University, 2008.

Ellison, Mary. "Echoes of Africa in *Too Sleep with Anger* and *Eve's Bayou*." *African American Review* 39, nos. 1/2 (2005): 213–29.

Enwezor, Okwui. "Between Localism and Worldliness." *Art Journal* 57, no. 4 (Winter 1998): 32–36.

Erhart, Julia. "Picturing *What If*: Julie Dash's Speculative Fiction." *Camera Obscura* 38 (May 1996): 116–31.

Filemyr, Ann. "Zeinabu Irene Davis: Filmmaker, Teacher with a Powerful Mission." *Angles* 1, no. 2 (1992): 6–9.

Foster, Gwendolyn Audrey. *Women Filmmakers of the African and Asian Diaspora: Decolonizing the Gaze, Locating the Subjectivity*. Carbondale: Southern Illinois University Press, 1997.

Francis, Terri. "Cinema on the Lower Frequencies: Black Independent Filmmaking." *Black Camera* 22, no. 1 (Spring/Sumer 2007): 19–21.

———. "Contemporary Independent Filmmakers." In *African Americans and Popular Culture*, edited by Todd Boyd, 117–40. Westport, CT: Praeger, 2008.

Francke, Lizzie. "*Daughters of the Dust*." *Sight and Sound* 3, no. 9 (1993): 43–44.

Fregoso, Rosa Linda. "Born in East L.A. and the Politics of Representation." *Cultural Studies* 4, no. 3 (1990): 264–80.

Gabriel, Teshome. "Cinema Novo and Beyond . . . A Discussion with Nelson Pereira dos Santos." *Emergences* 2 (1990): 49–82.

———. "Images of Black People in Cinema: A Historical Over-View." *Ufahamu: A Journal of African Studies* 6, no. 2 (1976): 133–67.

———. *Third Cinema in the Third World: The Aesthetics of Liberation*. Ann Arbor, MI: UMI Research Press, 1982.

———. "Thoughts on Nomadic Aesthetics and the Black Independent Cinema: Traces of a Journey." In *Out There: Marginalization and Contemporary Cultures,* edited by Russell Ferguson, Martha Gever, Trinh T. Minh-ha, and Cornel West, 395–410. New York: New Museum of Contemporary Art; Cambridge, MA: MIT Press, 1990.

———. "Towards a Critical Theory of Third World Films." In *Questions of Third Cinema,* edited by Jim Pines and Paul Willemen. London: British Film Institute, 1991.

Gaither, Laura. "Close-Up and Slow Motion in Julie Dash's *Daughters of the Dust.*" *Howard Journal of Communication* 7, no. 2 (April/June 1996): 103–12.

———. "'We Have Seen We': Reifying the Visual in Julie Dash's *Daughters of the Dust.*" In *Process: A Graduate Student Journal of African-American and African Diasporan Literature and Culture* 1 (Fall 1996): 112–23.

George, Nelson. *Blackface: Reflections on African-Americans and the Movies.* New York: HarperCollins, 1994.

Gerima, Haile. "Afro-American Cinema." In *Third Eye: Struggle for Black and Third World Cinema,* edited by Greater London Council Race Equality Unit, 22. London: GLC Race Equality Unit, 1986.

———. "Black Independent Film: An Interview with Haile Gerima." By Inez Hedges. *Socialism and Democracy* 10, no. 6 (1996): 119–27.

———. "Cinema, an Important Tool for a Better Understanding." *Cine and Media* 2 (1999): 7–8.

———. "Decolonizing the Filmic Mind: An Interview with Haile Gerima." By John L. Jackson Jr. *Callaloo* 33, no. 1 (2010): 25–36.

———. "Filming Slavery: A Conversation with Haile Gerima." Interview by Pamela Woolford. *Transition* 64 (1994): 90–104.

———. "The Filmmaker as Storyteller: An Interview with Haile Gerima." By Kathy Elaine Anderson. *Black Film Review* 2, no. 1 (Winter 1985): 6–7, 19.

———. "'Fireplace-Cinema' (Gathering, Warming, Sharing)." *Filmfaust* 39 (May/June 1984): 44–55.

———. "Haile Gerima: Cultural Warrior." Interview by Audrey T. McCluskey. *Black Camera* 15, no. 1 (Spring/Summer 2000): 1–3.

———. "Haile Gerima: In Search of an Africana Cinema." Interview by Diane D. Turner and Muata Kamdibe. *Journal of Black Studies* 38, no. 6 (2008): 986–91.

———. "Haile Gerima: Radical Departures to a New Black Cinema." Interview by Tony Safford and William Triplett. *Journal of the University Film and Video Association* 35, no. 2 (Spring 1983): 59–65.

———. "Storyteller of Struggles: An Interview with Haile Gerima." By Rob Edelman. *Independent* 8, no. 11 (1985): 16–19.

———. "Thoughts and Concepts: The Making of Ashes and Embers." *Black American Literature Forum* 25, no. 2 (Summer 1991): 335–50.

———. "Triangular Cinema, Breaking Toys, and Dinkesh vs Lucy." In *Questions of Third Cinema,* edited by Jim Pines and Paul Willemen, 65–89. London: British Film Institute, 1989.

———. "Visions of Resistance." *Sight and Sound* 5, no. 9 (1995): 32–33.

Gibbs, James Lowell, Jr. Review of *Daughters of the Dust. African Arts* 26, no. 1(1993): 81–83.

Gibson, Gloria. "In Focus: 'There Are Many Stories to Be Told and Many Battles to Begin.'" *Black Camera* 1, no. 2 (Winter 1985): 3.

Gibson-Hudson, Gloria J. "African American Literary Criticism as a Model for the Analysis of Films by African-American Women." *Wide Angle* 13, nos. 3/4 (July/October 1991): 44–54.

———. "Aspects of Black Feminist Cultural Ideology in Films by Black Women Independent Artist." In *Multiple Voices in Feminist Film Criticism,* edited by Diane Carson, Linda Dittmar, and Janice R. Welsh, 365–79. Minneapolis: University of Minnesota Press, 1994.

———. "A Different Image: Integrating Films by African American Women into the Classroom." In *Shared Differences: Multicultural Media and Practical Pedagogy,* edited by Diane Carson and Lester D. Friedman, 127–48. Urbana-Champaign: University of Illinois Press, 1995.

Gourdine, Angeletta K.M. "Fashioning the Body [as] Politic in Julie Dash's *Daughters of the Dust.*" *African American Review* 38, no. 3 (Autumn 2004): 499–511.

Grant, Nathan. "Innocence and Ambiguity in the Films of Charles Burnett." In *Representing Blackness: Issues in Film and Video,* edited by Valerie Smith, 135–55. New Brunswick, NJ: Rutgers University Press, 1997.

Grayson, Sandra M. *Symbolizing the Past: Reading "Sankofa," "Daughters of the Dust," and "Eve's Bayou" as Histories.* Lanham, MD: University Press of America, 2000.

Guerrero, Ed. "Black Film: Mo' Better in the '90s." *Black Camera* 6, no. 1 (Spring/Summer, 1991): 2–3.

———. "The Black Man on Our Screens and the Empty Space in Representation." In *Black Male: Representations of Masculinity in Contemporary American Art,* edited by Thelma Golden. New York: Whitney Museum of American Art, 1994.

———. "The Black Man on Our Screens and the Empty Space in Representation." *Callaloo* 18, no. 2 (Spring 1995): 395–400.

———. *Framing Blackness: The African American Image.* Philadelphia: Temple University Press, 1993.

———. "Negotiations of Ideology, Manhood, and Family in Billy Woodberry's *Bless Their Little Hearts.*" *Black American Literature Forum* 25, no. 2 (Summer 1991): 315–22.

Hall, Aimee. "Julie Dash: Filmmaking within a Culture of Women." *Black Camera* 11, no. 2 (Winter/Spring 1996–97): 2–4.

Hamilton-Wray, Tama Lynne. "The Cinema of Haile Gerima: Black film as a Liberating Cinema." PhD diss., Michigan State University, 2010.

Hankin, Kelly. "And Introducing . . . The Female Director: Documentaries about Women Filmmakers as Feminist Activism." *NWSA Journal* 19, no. 1 (Spring 2007): 59–88.

Harris, Erich Leon. *African-American Screenwriters Now: Conversations with Hollywood's Black Pack.* Los Angeles: Silmen-James, 1996.

Hartman, S. V., and Farah Jasmine Griffin. "Are You as Colored as That Negro? The Politics of Being Seen in Julie Dash's *Illusions.*" *Black American Literature Forum* 25, no. 2 (Summer 1991): 361–73.

Hedges, Inez. "Signifyin' and Intertextuality: *Killer of Sheep* and Black Independent Film." *Socialism and Democracy* 21, no. 2 (2007): 133–43.

Hendricks, Dorothy. "Children of the Revolution: Images of Youth in *Killer of Sheep* and *Brick by Brick.*" In *"liquid blackness* on the L.A. Rebellion," *liquid blackness* 1, no. 1 (2014): 16–18. http://liquidblackness.com/LB1_LARebellion.pdf.

Henry, Annette. "The Politics of Unpredictability in a Reading/Writing/Discussion Group with Girls from the Caribbean." *Theory into Practice* 40, no. 3 (Summer 2001): 184–89.

Hess, John, Chuck Kleinhans, and Julia Lesage. "After Cosby / after the L.A. Rebellion: The Politics of Transnational Culture in the Post Cold War Era." *Jump Cut* 37 (1992): 2–4.

Heyde, Paul. "Black Women Filmmakers Forum: An Alternative Aesthetic and Vision." *Black Camera* 21, no. 1 (Spring/Summer 2006): 15.

Hobson, Janell. "Viewing in the Dark: Toward a Black Feminist Approach to Film." *Women's Studies Quarterly* 30, nos. 1/2 (Spring/Summer 2002): 45–59.

Hodgkins, John. "The Drift: Rethinking the Affective Dynamics of Adaptation." PhD diss., University of Rhode Island, 2010.

Hoelscher, Jean. Filmex Review of *Passing Through. Hollywood Reporter,* March 22, 1977.

Holland, Sharon Patricia. "(Black) (Queer) Love." *Callaloo* 36, no. 3 (Summer 2013): 658–68.

Hollywood Reporter. "*Emma Mae* Goes before the Cameras June 20." June 18, 1976.

———. "Fanaka Seeks to Tap Black Market with *Penitentiary.*" July 27, 1978.

———. "Indie Distribs Hard-Pressed but *Penitentiary* Paying Off." April 1, 1980.

Holmlund, Chris, and Justin Wyatt. *Contemporary American Independent Film: From the Margins to the Mainstream.* London: Routledge, 2005.

hooks, bell. "Black Women Filmmakers Break the Silence." *Black Film Review* 2, no. 3 (1986): 14–15.

———. *Reel to Reel: Race, Class and Sex at the Movies.* New York: Routledge, 1996.

Howard, Steve. "A Cinema of Transformation: The Films of Haile Gerima." *Cinéaste* 14, no. 1 (1985): 28–29, 39.

Huang, Vivian, and Bérénice Reynaud. "Charles Burnett: *Killer of Sheep.*" *Motion Picture* 3, nos. 3/4 (1990): 5–6.

———. "Julie Dash: *Illusions.*" *Motion Picture* 3, nos. 3/4 (1990): 6–7.

Humm, Maggie. "Black Film Theory, Black Feminisms: *Daughters of the Dust.*" In *Feminism and Film,* 113–41. Bloomington: Indiana University Press, 1997.

Hunter, Patricia-Khlotele V. *Subversive Delights Flourished in Julie Dash's Daughters of the Dust.* University Heights, OH: John Carroll University, 2009.

Hutchinson, Sharon, and Bruce Wiegand. "Gerima's *Imperfect Journey:* No End in Sight." Review of *Imperfect Journey. American Anthropologist* 100, no. 1 (March 1998): 169–71.

Jackson, Elizabeth. "Contemporary Black Film, Television and Video Makers: A Survey Analysis of Producers." PhD diss., Northwestern University, 1989.

Jackson, Lynne, and Karen Jaehne. "Eavesdropping on Female Voices: A Who's Who of Contemporary Women Filmmakers." *Cinéaste* 16, nos. 1/2 (1987): 38–43.

James, David E. *Allegories of Cinema: American Film in the Sixties.* Princeton, NJ: Princeton University Press, 1989.

———. "Lens on Los Angeles." *Artforum International* 50, no. 2 (October 2011): 287–93, 340.

———. *The Most Typical Avant-Garde: History and Geography of Minor Cinemas in Los Angeles.* Berkeley: University of California Press, 2005.

———. "Towards a Geo-Cinematic Hermeneutics: Representation of Los Angeles in Non-Industrial Cinema—*Killer of Sheep* and *Water and Power.*" *Wide Angle* 20, no. 3 (1998): 23–53.

Johnson, Albert. "Moods Indigo: A Long View." *Film Quarterly* 44, no. 2 (Winter 1990–91): 13–27.

———. "Moods Indigo: A Long View, Part 2." *Film Quarterly* 44, no. 3 (Spring 1991): 15–29.

Jones, David. "Afrocentric Ideologies and Gendered Resistance in *Daughters of the Dust* and *Malcolm X:* Setting, Scene, and Spectatorship." *Ethnic Studies Review* 21 (April 20, 1998): 71.

Jones, Jacquie. "The Black South in Contemporary Film." *African American Review* 27, no. 1 (1993): 19–24.

Kandé, Sylvie. "Look Homeward, Angel: Maroons and Mulattos in Haile Gerima's *Sankofa.*" Translated by Joe Karaganis. *Research in African Literatures* 29, no. 2 (1998): 128–46.

Kaplan, Sara Clarke. "Souls at the Crossroads, Africans on the Water: The Politics of Diasporic Melancholia." *Callaloo* 30, no. 2 (Spring 2007): 511–26.

Kapsis, Robert E, ed. *Charles Burnett: Interviews.* Jackson: University Press of Mississippi, 2011.

Keeling, Kara. "School of Life." *Artforum International* 50, no. 2 (October 2011): 294, 296–97.

———. *The Witch's Flight: The Cinematic, the Black Femme, and the Image of Black Common Sense.* Durham, NC: Duke University Press, 2007.

Kim, Sojin, and R. Mark Livengood. "Talking with Charles Burnett." Review of *To Sleep with Anger.* Includes interview excerpts with Charles Burnett. *Journal of American Folklore* 111, no. 439 (Winter 1998): 69–73.

Kleinhans, Chuck. "Charles Burnett." In *Fifty Contemporary Filmmakers,* 2nd ed., edited by Yvonne Tasker, 60–69. London: Routledge, 2010.

———. "Realist Melodrama and the African-American Family: Billy Woodberry's *Bless Their Little Hearts.*" In *Melodrama: Stage, Picture, Screen,* edited by Jacky Bratton, Jim Cook, and Christine Gledhill, 157–67. London: British Film Institute, 1994.

Klotman, Phyllis Rauch, ed. *Screenplays of the African American Experience.* Bloomington: Indiana University Press, 1991.

Klotman, Phyllis Rauch, and Janet K. Cutler, eds. *Struggles for Representation: African American Documentary Film and Video.* Bloomington: Indiana University Press, 1999.

Knight, Arthur. Review of *Emma Mae. Hollywood Reporter.* December 27, 1976.

———. *"Penitentiary." Hollywood Reporter,* December 21, 1979.

Kunzelman, Cameron. "Playfighting in South Central: On the Everyday in *My Brother's Wedding.*" In *"liquid blackness* on the L.A. Rebellion," *liquid blackness* 1, no. 1 (2014): 25–27. http://liquidblackness.com/LB1_LARebellion.pdf.

Larkin, Alile Sharon. "Black Women Filmmakers Defining Ourselves: Feminism in Our Own Voice." In *Female Spectators: Looking at Film and Television,* edited by E. Deidre Pribram, 157–73. London: Verso, 1988.

———. "Cinematic Genocide." *Black Camera* 18, no. 1 (Spring/Summer 2003): 3–4, 15.

Lev, Peter. "From Blaxploitation to African American Film." In *American Films of the '70s: Conflicting Visions,* 127–41. Austin: University of Texas Press, 2000.

Lierow, Lars. "The 'Black Man's Vision of the World': Rediscovering Black Arts Filmmaking and the Struggle for a Black Cinematic Aesthetic." *Black Camera* 4, no. 2 (2013): 3–21.

Lohani-Chase, Rama. "Redirecting the Gaze: Gender, Theory, and Cinema in the Third World." *Women's Studies Quarterly* 30, nos. 1/2 (Spring 2002): 324–27.

MacDonald, Scott. *A Critical Cinema: Interviews with Independent Filmmakers.* Berkley: University of California Press, 1988.

Machiorlatti, Jennifer A. "Revisiting Julie Dash's *Daughters of the Dust:* Black Feminist Narrative and Diasporic Recollection." *South Atlantic Review* 70, no. 1 (Winter 2005): 97–116.

Mack. Review of *Emma Mae. Variety,* December 23, 1976.

Madison, D. Soyini. "Rhythm as Modality and Discourse in *Daughters of the Dust.*" In *This Is How We Flow: Rhythm in Black Cultures,* edited by Angela M. S. Nelson, 87–97. Columbia: University of South Carolina Press, 1999. 87–97.

Maio, Kathi. "A Screen of One's Own." Review of *Daughters of the Dust: The Making of an African American Woman's Film,* by Julie Dash. *Women's Review of Books* 10, no. 5 (1993): 10.

Makrah, O. Funmilayo. "Fired-Up!" In *Black Women Film and Video Artists,* edited by Jacqueline Bobo, 125–38. New York: Routledge, 1998.

Maloney, Lane. *"Penitentiary* Taking Shot at Crossover Audiences." *Variety,* February 22, 1980.

Martin, Michael T., ed. *Cinemas of the Black Diaspora: Diversity, Dependence, and Oppositionality.* Detroit: Wayne State University Press, 1995.

———. "Podium for the Truth? Reading Slavery and the Neocolonial Project in the Historical Film: *Queimada! (Burn!)* and *Sankofa* in Counterpoint." *Third Text* 23, no. 6 (2009): 717–31.

Martschukat, Jürgen. "'You Be a Man If You Can, Stan': Family Life and Fatherhood in Charles Burnett's *Killer of Sheep* (1977)." In *Inventing the Modern American Family: Family Values and Social Change in 20th Century United States,* edited by Isabel Heinemann, 223–43. Frankfurt: Campus Verlag, 2012.

Masilela, Ntongela. "Interconnections: The African and Afro-American Cinemas." *Independent* 11, no. 1 (January/February 1988): 14–17.

———. "The Los Angeles School." *IJELE: Art eJournal of the African World* 5 (2002). www.africaknowledgeproject.org/index.php/ijele/article/view/784.

———. "The Los Angeles School of Black Filmmakers." In *Black American Cinema,* edited by Manthia Diawara, 107–17. New York: Routledge, 1993.

———. "Women Directors of the Los Angeles School." In *Black Women Film and Video Artists,* edited by Jacqueline Bobo, 21–41. New York: Routledge, 1998.

Massood, Paula J. "An Aesthetic Appropriate to Conditions: *Killer of Sheep,* (Neo)Realism, and the Documentary Impulse." *Wide Angle* 21, no. 4 (1999): 20–41.

———. *Black City Cinema: African American Urban Experiences in Film.* Philadelphia: Temple University Press, 2003.

———. "Movies and a Nation in Transformation." *American Cinema of the 1970s: Themes and Variations,* edited by Lester D. Friedman, 182–204. New Brunswick, NJ: Rutgers University Press, 2007.

Mayne, Judith. "Screening Lesbians." In *The New Lesbian Studies: Into the Twenty-First Century,* edited by Bonnie Zimmerman and Toni A.H. McNaron, 165–71. New York: Feminist Press at the City University of New York, 1996.

McBride, Joseph. "Birth of a Black Director: Jamaa Fanaka Completes at 26; Master's Degree from UCLA." *Variety,* September 8, 1976.

———. "Jamaa Fanaka Working on 2nd Feature as Master's Thesis." *Variety,* August 19, 1976.

McClure, Michelle L. "*Sankofa:* 'One Must Return to the Past in Order to Move Forward.'" Review of *Sankofa. Black Camera* 15, no. 1 (Spring /Summer 2000): 9.

McCluskey, Audrey T. "A Black Camera Interview: Audrey T. McCluskey." By Michael T. Martin. *Black Camera* 21, no. 2 (Fall/Winter 2006): 25–27.

McCullough, Barbara. "Barbara McCullough, Independent Filmmaker, 'Know How to Do Something Different.'" Interview by Elizabeth Jackson. *Jump Cut* 36 (1991): 94–97.

———. "Interview with Barbara McCullough." By Elizabeth Jackson. *Black Film Review* 7, no. 2 (1992): 4–6, 30.

McHugh, Kathleen Anne. *American Domesticity: From How-To Manual to Hollywood Melodrama.* New York: Oxford University Press, 1999.

McKoy, Sheila Smith. "The Limbo Contest: Diaspora Temporality and Its Reflection in *Praisesong for the Widow* and *Daughters of the Dust.*" *Callaloo* 22, no. 1 (Winter 1999): 208–22.

Meisel, Myron. "Burnett's *To Sleep with Anger:* His Ticket to Indie Mainstream." *Film Journal* 93 (1990): 14, 84.

Mellencamp, Patricia. "Haunted History: Tracey Moffatt and Julie Dash." *Discourse* 16, no. 2 (Winter 1993–1994): 127–63.

———. "Making History: Julie Dash." *Frontiers: A Journal of Women Studies* 15, no. 1 (1994): 76–101.

Mercer, Kobena. "Third Cinema at Edinburgh: Reflections on a Pioneering Event." *Screen* 27, no. 6 (November/December 1986): 95–102.

Merritt, Bishetta D. "Charles Burnett: Creator of African American Culture on Film." *Journal of Black Studies* 39, no. 1 (2008): 109–28.

Michel, Anthony J. "Visual Rhetorics and Classroom Practices: Negotiating 'Contact Zones' in Julie Dash's *Daughters of the Dust*." In *Alternative Rhetorics: Challenges to the Rhetorical Tradition,* edited by Laura Gray-Rosendale and Sibylle Gruber, 167–83. Albany: State University of New York Press, 2001.

Mims, Sergio Alejandro. "A New Life: Independent Black Filmmaking during the 1980's." *Black Camera* 5, no. 1 (Spring 1990): 3–4.

Mitchell, Monica. "Maker of Films: Charles Burnett." *Director's Guild of America Magazine* 23, no. 2 (1998): 89–91.

Molina, Joey. "Purification Rituals: Beauty and Abjection in *Cycles*." In *"liquid blackness* on the L.A. Rebellion," *liquid blackness* 1, no. 1 (2014): 22–24. http://liquidblackness.com/LB1_LARebellion.pdf.

Moon, Spencer. *Reel Black Talk: A Sourcebook of 50 American Filmmakers.* Westport, CT: Greenwood Press, 1997.

Moore, Darrell. "A Mosaic of Black Women Directors." *Afterimage* 19, no. 9 (April 1992): 4–5.

Moskowitz, Gene. "Passing Through." *Variety,* August 31, 1977.

Murashige, Mike. "Haile Gerima and the Political Economy of Cinematic Resistance." In *Representing Blackness: Issues in Film and Video,* edited by Valerie Smith, 183–203. New Brunswick, NJ: Rutgers University Press, 1997.

Muse, Zain A. (Omisola Alleyne). "Revolutionary Brilliance: The Afrofemcentric Aesthetic." In *Arms Akimbo: Africana Women in Contemporary Literature,* edited by Janice Lee Liddell and Yakini Belinda Kemp, 239–54. Gainesville: University Press of Florida, 1999.

Nicholson, David. "Which Way the Black Film Movement?" *Black Film Review* 5, no. 2 (1989): 4–5, 16–17.

Noel, Vera. *"Killer of Sleep* (Q&A Charles Burnett Is Perhaps the Least Known Great American Director)." *BusinessWorld,* July 7, 2000.

Norton, Chris. "Black Independent Filmmaking and Influence of Neo-Realism: Futility, Struggle and Hope in the Face of Reality." *Images: A Journal of Popular Culture* 5 (December 1997). http://www.imagesjournal.com /issue05/features/black.htm.

O'Brien, Ellen L. "Charles Burnett's *To Sleep with Anger:* An Anthropological Perspective." *Journal of Popular Culture* 35, no. 4 (Spring 2002): 113–26.

O'Grady, Lorraine. "The Cave: On Black Women Directors." *Artforum* 30, no. 5 (January 1992): 22–24.

Ogunleye, Foluke. "Transcending the 'Dust': African American Filmmakers Preserving the 'Glimpse of the Eternal.'" *College Literature* 34, no. 1 (2007): 156–73.

Oloruntoba, Bunmi John. "Constructing a Postcolonial-Surrealist Framework for West African Cinema: The Cinemas of Jean Rouch and Djibril Diop Mambety." PhD diss., University of California, Los Angeles, 2008.

Ongiri, Amy Abugo. "Charles Burnett: A Reconsideration of Third Cinema." *Nka: Journal of Contemporary African Art* 21, no. 1 (2007): 82–89.

Opoku-Agyemang, Naana, Paul E. Lovejoy, and David V. Trotman, eds. Africa and Trans-Atlantic Memories: Literary and Aesthetic Manifestations of Diaspora and History. Trenton, NJ: Africa World Press, 2008.

Orwin, Anne. "Women's Stories, Women's Films: Integrating Women's Studies and Film Production." *Women's Studies Quarterly* 30, nos. 1/2 (Spring 2002): 271–84.

Petty, Shelia J. *Contact Zones: Memory, Origin, and Discourses in Black Diasporic Cinema.* Detroit: Wayne State University Press, 2008.

Pfaff, Françoise, ed. *Focus on African Films.* Bloomington: Indiana University Press, 2004.

———. *Twenty-Five Black African Filmmakers: A Critical Study With Filmography and Bio-Bibliography.* Westport, CT: Greenwood Press, 1988.

Prettyman-Beverly, Michele. "Daughter of the Rebellion." In *"liquid blackness on the L.A. Rebellion," liquid blackness* 1, no. 1 (2014): 12–15. http://liquidblackness.com/LB1_LARebellion.pdf.

Prince, Stephen. *A New Pot of Gold: Hollywood Under the Electronic Rainbow, 1980–1989.* New York: Charles Scribner's Sons, 2000.

Rachleff, Peter. "The Reel Watts." Review of *Killer of Sheep. New Labor Forum* 17, no. 2 (2008): 130–34.

Raengo, Alessandra. "The L.A. Rebellion Comes to Town." In *"liquid blackness on the L.A. Rebellion," liquid blackness* 1, no. 1 (2014): 1–11. http://liquidblackness.com/LB1_LARebellion.pdf.

Rainer, Peter. "*Penitentiary* Not Too Sweet." *L.A. Herald Examiner,* February 29, 1980.

———. Review of *To Sleep with Anger.* *American Film* 16, no. 6 (June 1991): 58.

Ramanathan, Geetha. *Feminist Auteurs: Reading Women's Film.* London: Wallflower, 2006.

Raphael-Hernandez, Heike. *The Utopian Aesthetics of Three African American Women (Toni Morrison, Gloria Naylor, Julie Dash): The Principle of Hope.* Lewiston, NY: Edwin Mellen Press, 2008.

Redding, Judith M., and Victoria A. Brownworth. *Film Fatales: Independent Women Directors.* Seattle: Seal Press, 1997.

Reid, Mark A. *Black Lenses, Black Voices: African American Film Now.* Lanham, MD: Rowman and Littlefield, 2005.

———. "Dialogic Modes of Representing Africa(s): Womanist Film." *Black American Literature Forum* 25, no. 2 (Summer 1991): 375–88.

———. "Haile Gerima: 'Sacred Shield of Culture.'" In *Contemporary American Independent Film: From the Margins to the Mainstream,* edited by Chris Holmlund and Justin Wyatt, 141–53. London: Routledge, 2005.

———. "Rebirth of a Nation: Three Recent Films Resist the Southern Stereotypes of D.W. Griffith, Depicting a Technicolor Region of Black, Brown, and G(r)ay." *Southern Exposure* 20, no. 4 (Winter 1992): 26–28.

————. *Redefining Black Film.* Berkeley: University of California Press, 1993.

Reynaud, Bérénice. "Charles Burnett." *Cahiers du Cinéma* 433 (1990): 58–59.

Rhines, Jesse Algeron. *Black Film/White Money.* New Brunswick, NJ: Rutgers University Press, 1996.

Roberts, Jerry, and Steven Gaydos. *Movie Talk from the Front Lines: Filmmakers Discuss Their Works with the Los Angeles Film Critics Association.* Jefferson, NC: McFarland, 1995.

Robinson, Cedric J. "The Black Middle Class and the Mulatto Motion Picture." *Race and Class* 47, no. 1 (2005): 14–34.

Rocchio, Vincent F. *Reel Racism: Confronting Hollywood's Construction of Afro-American Culture.* Boulder, CO: Westview Press, 2000.

Rootz Africa. "Meeting Haile Gerima: Filmmaking Strategies." *Rootz Africa: Jazz and Culture* 20 (2006): 20, 22.

Ryan, Judylyn S. "Outing the Black Feminist Filmmaker in Julie Dash's *Illusions.*" *Signs* 30, no. 1 (Autumn 2004): 1319–44.

————. *Spirituality as Ideology in Black Women's Film and Literature.* Charlottesville: University of Virginia Press, 2005.

Scheiber, Andrew. "Healing and the Blues: Charles Burnett's 'To Sleep With Anger.'" *Connecticut Review* 26, no. 2 (Fall 2004): 131–41.

Shiel, Mark. *Hollywood Cinema and the Real Los Angeles.* London: Reaktion, 2012.

Shohat, Ella, and Robert Stam. *Unthinking Eurocentrism: Multiculturalism and the Media.* London: Routledge, 1994.

Sklar, Robert. *Movie-Made America.* Revised and updated. New York: Vintage, 1994.

Smith, Valerie. "Black Masculinity, Labor, and Social Change." In *Black Male: Representations of Masculinity in Contemporary Art,* edited by Thelma Golden, 119–26. New York: Whitney Museum of American Art, 1994.

————. "Julie Dash: Filmmaker." In *Artist and Influence Volume 9,* edited by James Hatch and Leo Hamalian, 27–35. New York: Hatch-Billops Collection, 1990.

————. *Not Just Race, Not Just Gender: Black Feminist Readings.* New York: Routledge, 1998).

————. "Reading the Intersection of Race and Gender in Narratives of Passing." *Diacritics* 24, nos. 2/3 (1994): 43–57.

————. "Reconstituting the Image: The Emergent Black Woman Director." *Callaloo* 37 (Autumn 1988): 709–19.

Snead, James A. "Images of Blacks in Black Independent Films: A Brief Survey." In *Blackframes: Critical Perspectives on Black Independent Cinemas,* edited by Mbye D. Cham and Claire Andrade-Watkins, 16–25. Cambridge, MA: MIT Press, 1988.

Speciale, Alessandra. "Haile Gerima: Adua, lorsque nous étion des voyageurs actifs de l'histoire" [Haile Gerima: Adowa, when we were active travelers in history]. *Ecrans D'Afrique* [African screen] 24 (1998): 74–83.

Springer, Christina. "Waiting and Dreaming, Praying and Cleaning." *Sojourner: The Women's Forum* 15, no. 8 (April 2009): 1–3.

Springer, Claudia. "Black Women Filmmakers." *Jump Cut* 29 (February 1984): 34–37. www.ejumpcut.org/archive/onlinessays/JC29folder/BlackWomen Filmkrs.html

Stewart, Jacqueline Najuma. "Defending Black Imagination: The 'L.A. Rebellion' School of Black Filmmakers." In *Now Dig This! Art and Black Los Angeles, 1960–1980*, edited by Kellie Jones, 41–49. Los Angeles: Hammer Museum, University of California; New York: DelMonico Books/Prestel, 2011.

———. "L.A. Rebellion." *Focus: The Journal of the Documentary Film Group* 2, no. 2 (Spring 1997): 4–5.

———. *Migrating to the Movies: Cinema and Black Urban Modernity*. Berkley: University of California Press, 2005.

Streeter, Caroline Anne. "Ambiguous Bodies, Ambivalent Desires: The Morphing Mullata Body in United States Culture, 1965–1999." PhD diss., University of California, Berkeley, 2000.

———. "Was Your Mama Mulatto? Notes toward a Theory of Racialized Sexuality in Gayl Jones's *Corregidora* and Julie Dash's *Daughters of the Dust*." *Callaloo* 27, no. 3 (Summer 2004): 768–87.

Taylor, Clyde. "Black Cinema in the Post-Aesthetic Era." In *Questions of Third Cinema*, edited by Jim Pines and Paul Willemen, 90–110. London: British Film Institute, 1989.

———. "Decolonizing the Image: New U.S. Black Cinema." In *Jump Cut, Hollywood, Politics and Counter-Cinema*, edited by Peter Steven, 166–78. Toronto: Between the Lines, 1985.

———. "The Future of Black Film: The Debate Continues." *Black Film Review* 5, no. 4 (1989): 7, 9, 27–28.

———. "The L.A. Rebellion: New Spirit in American Film." *Black Film Review* 2, no. 2 (1986): 11, 29.

———. *The Mask of Art: Breaking the Aesthetic Contract—Film and Literature*. Bloomington: Indiana University Press, 1998.

———. "New U.S. Black Cinema." *Jump Cut* 28 (April 1983): 41, 46–48. www.ejumpcut.org/archive/onlinessays/JC28folder/NewBlackCinema.html.

———. "The Next Wave: Women Film Artists at UCLA." *Black Collegian* (1980): 12.

———. "The Paradox of Black Independent Cinema." *Black Film Review* 4, no. 4 (1988): 2–3, 17–19.

———. "*Passing Through*. An Underground Film About Black Music Underground." *Black Collegian* (February/March 1980): 20–22.

———. "We Don't Need Another Hero: Anti-Theses on Aesthetics." In *Blackframes: Critical Perspectives on Black Independent Cinema*, edited by Mbye D. Chan and Claire Andrade-Watkins, 80–85. Cambridge, MA: MIT Press, 1988.

Thompson, Clifford. "The Devil Beats His Wife: Small Moments and Big Statements in the Films of Charles Burnett." *Cinéaste* 23, no. 2 (1997): 24–27.

———. "Good Moments in a Tough World: The Films of Charles Burnett." Review of *Killer of Sheep: The Charles Burnett Collection*. *Cinéaste* 33, no. 2 (2008): 32–34.

Tobias, James. *Sync: Stylistics of Hieroglyphic Time*. Philadelphia: Temple University Press, 2010.

Ukadike, Nwachukwu Frank. *Questioning African Cinema: Conversations with Filmmakers*. Minneapolis: University of Minnesota Press, 2002.

Variety. "Fanaka Regains Enthusiasm with Third 'Penitentiary' Installment." August 26, 1987.

Vaughn, Christopher. "Daughters Not Stopping in L.A." *Hollywood Reporter*, March 6, 1992.

Wali, Monona. "L.A. Black Filmmakers Thrive Despite Hollywood's Monopoly." *Black Film Review* 2, no. 2 (1986): 10, 27.

———. "Life Drawings: Charles Burnett's Realism." *Independent* 11, no. 8 (1988): 16–22.

Walker, David, Andrew J. Rausch, and Chris Watson. *Reflections on Blaxploitation: Actors and Directors Speak*. Lanham, MD: Scarecrow Press, 2009.

Wambu, Onye. "Decolonizing Film." *Black Film Bulletin* 3, nos. 2/3 (1995): 14–17.

Weisenfeld, Judith. "'My Story Begins Before I Was Born': Myth, History, and Power in Julie Dash's *Daughters of the Dust*." In *Representing Religion in World Cinema: Filmmaking, Mythmaking, Culture Making*, edited by. S. Brent Plate, 46–66. New York: Palgrave Macmillan, 2003.

Welbon, Yvonne. "Calling the Shots: Black Women Directors Take the Helm." *Independent* 15, no. 2 (March 1992): 18–22.

———. "The Marketing, Distribution and Exhibition of *Daughters of the Dust*: A Case Study." Thesis, Northwestern University, 1993.

———. "Sisters in Cinema: Case Studies of Three First-Time Achievements Made by African American Women Feature Film Directors in the 1990s." PhD diss., Northwestern University, 2001.

White, Armond. "Sticking to the Soul: Charles Burnett." *Film Comment* 33, no. 1 (1997): 38–41.

Widener, Daniel. *Black Arts West: Culture and Struggle in Postwar Los Angeles*. Durham, NC: Duke University Press. 2010.

———. "Writing Watts: Budd Schulberg, Black Poetry, and the Cultural War on Poverty." *Journal of Urban History* 34, no. 4 (2008): 665–87.

Wilderson, Frank B., III. *Red, White, and Black: Cinema and the Structure of U.S. Antagonisms*. Durham, NC: Duke University Press, 2010.

Williams, John. "Black Filmmaking in the 1990s: A Pioneering Event." *Independent* 11 (December 1988): 16–19.

———. "Re-creating Their Media Image: Two Generations of Black Women Filmmakers." *Cinéaste* 20, no. 3 (1994): 38–41.

Wood, Winifred J. "Bunnies for Pets or Meat: The Slaughterhouse as Cinematic Metaphor." *JAC: A Journal of Rhetoric, Culture and Politics* 31, nos. 1/2 (2011): 11–44.

Woodberry, Billy. "Billy Woodberry: At a Certain Point, I Wanted to Make Films. To Try." Interview. *Black Film Review* 1, no. 4 (1985): 3, 14–15.

Wright, Nancy E. "Property Rights and Possession in *Daughters of the Dust*." *MELUS* 33, no. 3 (Fall 2008): 11–25.

Yearwood, Gladstone L., ed. *Black Cinema Aesthetics: Issues in Independent Black Filmmaking*. Athens: Ohio University Press, 1982.

————. *Black Film as a Signifying Practice: Cinema, Narration and the African-American Aesthetic Tradition.* Trenton, NJ: Africa World Press, 2000.

Young, Cynthia A. *Soul Power: Culture, Radicalism, and the Making of a U.S. Third World Left.* Durham, NC: Duke University Press, 2006.

NEWSPAPERS AND POPULAR MAGAZINES

Adams, Sam. "Me and the Devil Blues: Charles Burnett on Bringing the Blues (and The Blues) to Life." *City Paper* (Philadelphia), October 2, 2003.

Allegra, Donna. "Sisters on Screen: Julie Dash's *Daughters of the Dust* Draws Pictures that Are Ripe with Meaning for African-Americans." Review of *Daughters of the Dust. Gay Community News* (Boston), March 8, 1992.

Allen, Tom. Review of *Penitentiary. Village Voice,* April 21, 1980.

Ansen, David. "A Visit from a Trickster." Review of *To Sleep with Anger. Newsweek,* October 22, 1990, 75–77.

Armes, Roy. "Haile Gerima: From *Harvest* to *Embers.*" *London Magazine,* April/May 1984, 114–18.

Atkinson, Michael. "The Old New Black Cinema: MOMI Celebrates a Movement." *Village Voice,* February 13, 2013.

Auerbach, Michael. "Gerima Beats around the Bush in *Mama.*" *UCLA Daily Bruin,* April 6, 1978.

Bennett, Allegra. "*Daughters of the Dust* Emerges after 15 Years." *Washington Times,* February 27, 1992.

Benson, Shelia. "A Magical, Mystical Tour of South-Central Los Angeles." Review of *To Sleep with Anger. Los Angeles Times,* November 2, 1990.

Bentley, Rosalind. "Tinseltown Doesn't Shine for the Sisters." *Star Tribune,* June 18, 1993.

Bournea, Chris. "Charles Burnett's Landmark Film *Killer of Sheep* to Play Wexner." *Call and Post* (Cincinnati), September 19, 2007.

Branch, Shelly. "Cinema Scope: A Geechee Girl Gets Ready for the Big Time." *Emerge,* October 1990, 92.

Brooks, Brandon I. "Penitentiary 20 Years After." *Sentinel* (Los Angeles), March 20, 2008.

Brown, Georgia. "How We Grew." Review of *Daughters of the Dust. Village Voice,* January 21, 1992.

Burnett, Charles. "Burnett Looks Back." Interview by Amy Taubin. *Village Voice,* January 10, 1995.

Calloway, Earl. "*Daughters of the Dust,* Compelling with Dramatic Urgency." Review of *Daughters of the Dust. Chicago Defender,* January 8, 1992.

Canby, Vincent. "In *Penitentiary II,* Too Sweet Gordon Gets Out." Review of *Penitentiary II. New York Times,* April 2, 1982.

————. Review of *Penitentiary. New York Times,* April 4, 1980.

————. "Scene: Black Middle-Class Home. Enter a Comic, Lost Demon." Review of *To Sleep with Anger. New York Times,* October 5, 1990.

Carmichael, Rodney. "L.A. Rebellion Revisits Black Cinema." Contains interview with Allyson Nadia Field. *Creative Loafing* (Atlanta), November 14, 2013.

Cerone, Daniel. "Awakening to the Realities of Black Life." *Los Angeles Times,* August 12, 1989.

Charles, Harold E. "*Sankofa:* A Must-See Film." Review of *Sankofa. Chicago Defender,* September 3, 1994.

Cheshire, Godfrey. Review of *Daughters of the Dust.*" *New York Press,* January 15, 1992.

Cook, Shantrell A. Review of *Namibia: The Struggle for Liberation. Gambit Weekly* (New Orleans), August 5, 2008.

Corliss, Richard. "Blood Bonds." Review of *To Sleep with Anger. Time,* October 22, 1990, 63.

Cross, Linda. "*Bush Mama*: A Trip to Awareness." *Los Angles Times,* April 7, 1978, 20.

Daniel, Lincia. "Cutting through the Hype." *Black Briton,* November 22, 1991.

Dargis, Manohla. "Whereabouts in Watts? Where Poetry Meets Chaos." Review of *Killer of Sheep. New York Times,* March 30, 2007.

Darling, Lynn. Review of *Daughters of the Dust. New York Newsday,* January 13, 1992.

Dash, Julie. "Daughter of the Diaspora: An Interview with Filmmaker Julie Dash." By Rahdi Taylor. *Third Force* (Oakland), December 31, 1993.

———. "A Splash of Julie Dash: The *Sisters in Cinema.*" Interview by Kam Williams. *Afro-American, 5 Star Edition* (Baltimore), February 13, 2004.

———. "Waiting to Excel." Interview by Greg Tate. *Vibe,* September 1996, 73.

———. "'We're Still Trying to Get Our Projects Made': Questions and Answers." Interview. *National Post* (Don Mills, Ontario), January 25, 2013.

Day, Barbara. "Black Woman Makes 'The Kind of Film I've Always Wanted to See.'" *Guardian* (London), January 22, 1992.

Dollar, Steve. "*Daughters of the Dust* Dances with the Dialect of Women's Tales." *Atlanta Journal-Constitution,* October 6, 1991.

———. "Repertory Film: Rebellion from around the World." *Wall Street Journal,* January 31, 2013.

Dymally, Donna Fitzsimmons. "Ben Caldwell's Kaos Network: A Cutting Edge Multimedia Arts Facility in Historical Leimert Park." *Sentinel* (Los Angeles), August 17, 2006.

Easton, Nina J. "The Invisible Women in Hollywood's Rush to Embrace Black Filmmakers, Women Directors are Being Left Out, but Some Expect That Picture to Change." *Los Angeles Times,* September 29, 1991.

Fanaka, Jamaa. "Director Fights to Redeem Hollywood's Dirty Little Secret." *Sentinel* (Los Angeles), July 2, 1998.

———. "Hollywood 'Black List,' Same Crime, New Time." *Sentinel* (Los Angeles), November 27, 1997.

———. "Hollywood Blocks Door for Minorities." *Los Angeles Times,* July 12, 1993.

———. "Hollywood's 'Black' Out Continues to Exclude Minority Filmmakers." *Sentinel* (Los Angeles), June 17, 1998.

Farley, Christopher John. "Roots Inspire Filmmaker Dash." *USA Today,* January 24, 1991.

Fraser, Gerald C. "Black Women's Outlook in Whitney Film Series." *New York Times,* December 28, 1986.

———. "Group Celebrates a Decade of Distributing Black Films." *New York Times,* June 7, 1989.

Greeves, Natasha. "*LA Rebellion: Creating a New Black Cinema* Film Tour Comes to Atlanta." *Indiewire,* October 25, 2013. http://blogs.indiewire.com/shadowandact/la-rebellion-creating-a-new-black-cinema-film-tour-comes-to-atlanta-10–25–11–24–2013.

Greggs, LaTicia D. "Turning the Camera on Black Women Directors." *Chicago Defender,* March 7, 1992.

Harper, Hilliard. "Helping Hand for *Figaro*." *Los Angeles Times,* January 29, 1986.

Heffley, Lynne. "Bowl's 'Open House' Offers Multiethnic Program." *Los Angeles Times,* June 27, 1992.

Hera (Binghamton, NY). Review of *Daughters of the Dust.* March 31, 1995.

Hillis, Aaron. Review of *My Brother's Wedding." Village Voice,* September 4, 2007.

Hoberman, J. "Independents." Review of *Bush Mama. Village Voice,* December 24, 1979.

Holden, Stephen. "*Daughters of the Dust:* The Demise of a Tradition." Review of *Daughters of the Dust. New York Times,* January 16, 1992.

Hruska, Bronwen, and Graham Rayman. "On the Outside, Looking In: When It Comes to Directing Hollywood Movies, Black Women Speak Loudly but Form a Small Club." *New York Times,* February 21, 1993.

Irish Times (Dublin). "The Film that Hollywood Would Never Have Made." July 28, 2008.

James, Alex. "LA Rebellion ATL Tour Review: Haile Gerima's *Child of Resistance.*" *Shadow and Action,* December 5, 2013, http://blogs.indiewire.com/shadowandact/la-rebellion-atl-tour-review-haile-gerimas-child-of-resistance.

Johnson, Brian D. Review of *To Sleep with Anger. Maclean's* (Toronto), November 19, 1990.

Jones, J. R. "The Black and the Green." *Chicago Reader,* March 28, 2013

Kauffmann, Stanley. "Two Women." Review of *Daughters of the Dust. New Republic* February 10, 1992.

Kempley, Rita. "*Daughters of the Dust:* Spirit of a Time Past." Review of *Daughters of the Dust. Washington Post,* February 28, 1992.

Kennedy, Shawn. "Making It as a Mainstream Director." *New York Times,* August 15, 1993.

Kim, Nelson. "Charles Burnett." *Senses of Cinema,* May 2003. http://sensesofcinema.com/2003/great-directors/burnett/#1.

King, Susan. "Classic Hollywood: Black Experience; A Festival Focuses on African Americans Who, Influenced by a Socially Charged Era, Created a New Culture of Film." *Los Angeles Times,* October 3, 2011.

———. "The *L.A. Rebellion* Returns." *Los Angeles Times,* October 3, 2011. http://articles.latimes.com/2011/oct/03/entertainment/la-et-classic-hollywood-20111003.

Klawans, Stuart. Review of *To Sleep with Anger. Nation,* November 5, 1990.

Lee, Felicia R. "In the Old Neighborhood with Julie Dash: Home Is Where the Imagination Took Root." *New York Times,* December 3, 1997.

Lee, Nathan. "Killer Debut." *Village Voice,* March 7, 2007.

Lopate, Phillip. Review of *To Sleep with Anger. Esquire,* November, 1990.

Los Angeles Times. "Black Film-Makers Fest to Open Sunday." April 26, 1974.

———. "UCLA Students Will Film Aspects of Ghetto Life as Means to Dialog." January 4, 1970.

Magnani, Peter. "*Passing Through* A Lasting Experience." Review of *Passing Through. Sun Reporter* (San Francisco), June 9, 1977.

Marriott, Michel. "Remembrance of Slave Ancestors Lost to the Sea." *New York Times,* June 19, 1994.

Maslin, Janet. "*Bush Mama* Tells Story of a Coast Ghetto." Review of *Bush Mama. New York Times,* September 25, 1979.

———. Review of *Ashes and Embers. New York Times,* November 17, 1982.

McKenna, Kristine. "*Sankofa:* A Saga of Slavery Reaches the Big Screen." *Los Angeles Times,* May 29, 1995.

Mills, David. "A Dash of Difference: The Filmmaker's New Take on Tradition." *Washington Post,* February 28, 1992.

Mudede, Charles. "The Brainy Rebellion." *Stranger* (Seattle), March 6, 2013.

New York Amsterdam News. "MoMA Retrospective *Charles Burnett: The Power to Endure.*" April 28, 2011.

Nichols, Peter. Review of *The Glass Shield. New York Times,* June 25, 1995.

Obenson, Tamba A. "Charles Burnett Heading to Algeria to Direct Biopic on Algeria's Greatest Hero, Abd El Kader." *Shadow and Action,* September 9, 2013. http://blogs.indiewire.com/shadowandact/charles-burnett-is-heading-to-algeria-to-direct-biopic-on-algerias-greatest-hero-abd-el-kader.

O'Driscoll, Bill. Review of *Killer of Sheep. Pittsburgh City Paper,* June 20, 2007.

Opuiyo, Alafaka. "*Killer of Sheep* Offers Glimpses into Despair of Ghetto Life." *Afro-American Red Star* (Washington DC). Review of *Killer of Sheep.* June 16, 2007.

Palmer, J. Jioni. "Jamaa Fanaka and the DGA: Round 1." *Sentinel* (Angeles), October 7, 1998.

Parker, Emanuel. "Black Movie Directors File Suit." *Sentinel* (Los Angeles), May 28, 1997.

Patterson, John. "*L.A. Rebellion: Creating a New Black Cinema*" *LA Weekly.* October 6, 2011. www.laweekly.com/2011-10-06/film-tv/l-a-rebellion-creating-a-new-black-cinema.

———. "Untold Stories of the LA Rebellion: While Hollywood Rejoiced in Blaxploitation, an Underground Generation of Black Film-Makers Came out of Los Angeles in the 60s and 70s to Forge a Series of Forgotten Masterpieces." *Guardian* (London), June 6, 2008.

Pincusm, Elizabeth. "Beyond the Catfight: Visions of Women's Communities in the Bleak *Red Lantern* and the Lush, Inspiring *Daughters of the Dust.*" *San Francisco Weekly,* April 1, 1992.

Perez, Mary Anne. "Symbols of Unrest." *Los Angeles Times,* November 15, 1992.

Raeshaun, Iris. "*Daughters of the Dusk* [sic] Explores Life of Determined Women." Review of *Daughters of the Dust*. *Chicago Defender*, August 7, 1991.

Rafferty, Terrence. Review of *To Sleep with Anger*. *New Yorker*, November 5, 1990.

Reader (Chicago). "Myron Meisel Makes *Penitentiary* Critics Choice." February 29, 1980.

Reaves, Michele. "Filmmaker Wins Fight for *Adwa*." *Ethiopian Review*, February 28, 2000.

Robertson, Nan. "*New Directors/New Films* Looks at the World Family." *New York Times*, March 30, 1984.

Rohter, Larry. "An All-Black Film (Except the Audience): *To Sleep with Anger* Wins High Praise but Misses Its Target." *New York Times*, November 20, 1990.

Romney, Jonathan. "A View from the Beach." Review of *Daughters of the Dust*. *New Statesman and Society* (London), September 17, 1993.

Rosenbaum, Jonathan. "LA Existential: Thom Andersen Crams Architectural History, Film Criticism, Political Analysis, and More into a Rhapsodic Paean to His Hometown." Review of *Los Angeles Plays Itself*. *Chicago Reader*, October 1, 2004.

Rosenberg, Howard. "*Maria's Story* Untold . . . So Far." *Los Angeles Times*, July 28, 1989.

Rule, Sheila. "Director Defies Odds with First Feature, *Daughters of the Dust*." *New York Times*, February 12, 1992.

Ryan, Caitlin. "Black Independent Cinema Focus of *L.A. Rebellion* Film Series." *Emory Report*, November 13, 2013. http://news.emory.edu/stories/2013/11/er_la_rebellion_film_series/campus.html.

Saltz, Rachel. "Finding Voices, Sharing Visions." *New York Times*, February 3, 2013.

Sandhu, Sukhdev. "'We Thought that Film Could Help to Change the World' *Killer of Sheep*, a Seventies Black Cinema Classic, Is Finally Coming Out of Copyright Limbo. Sukhdev Sandhi Talks to Its Director, Charles Burnett." *Daily Telegraph* (London), June 20, 2008.

Schenker, Andrew. Review of *Teza*. *Village Voice*, March 31, 2010.

Schwartz, Todd David. "Hard Time." *Los Angeles Times*, September 6, 1987.

Sentinel (Los Angeles). "Black Filmmaker Wins in Court." January 26, 2000.

———. "*A Day in the Life of Black LA*." December 10, 1992.

———. "Filmmaker Charles Burnett Gets Under the Skin of Interracial Marriage in Mulatto Play." August 12, 2010.

Shepard, Richard F. "Going Out Guide; Black Films at the Whitney." *New York Times*, Dec 30, 1986.

Sims, Tammy. "Struggles of Black Filmmaker Jamaa Fanaka." *Los Angeles Times*, July 28, 1988.

Skanner (Portland). "*Daughters of the Dust* a Great Debut for Filmmaker." Review of *Daughters of the Dust*. October 29, 1997.

Smith, Patricia. "A Daughter's Tale: Julie Dash Finally Gets to Tell Her Story of Gullah Life." *Boston Globe*, March 15, 1992.

Smith, Russell. *"Daughters of the Dust." Dallas Morning News,* April 3, 1992.

Snowden, Don. "Ben Caldwell's *Fresh* Approach to Filmmaking." *Los Angeles Times,* January 8, 1988.

———. "Tapscott Video in Limbo: Barbara McCullough's Frustrating Interlude." *Los Angeles Times,* October 20, 1987.

———. "Video Festival Takes to the Freewaves." *Los Angeles Times,* November 18, 1989.

Sragow, Michael. "An Explorer of the Black Mind Looks Back, but Not in Anger." *New York Times,* January 1, 1995.

Stewart, Jacqueline Najuma. "Interview with Jacqueline Stewart, Co-curator of *L.A. Rebellion: Creating a New Black Cinema.*" By Felicia Mings. *Conversations at the Edge* (School of the Art Institute of Chicago), May 17, 2013. http://blogs.saic.edu/cate/interview-with-jacqueline-stewart-co-curator-of-l-a-rebellion-creating-a-new-black-cinema.

Tate, Greg. "Cinematic Sisterhood." *Village Voice,* June 4, 1991.

———. "Favorite Daughters: Julie Dash Films Gullah Country." *Village Voice,* April 12, 1988.

———. "Of Homegirl Goddesses and Geechee Women: The Africentric Cinema of Julie Dash." *Village Voice,* June 4, 1991.

Terry, Clifford. "Gold *Dust:* Julie Dash Evokes Gullah Culture." *Chicago Tribune,* January 3, 1992.

Thomas, Kevin. "*Compensation* Rewards: Hollywood Black Film Festival's World Premiere of a Poem-Inspired Film Uses the Historic Tools of Cinema's Trade to Tell a Powerful Story." *Los Angeles Times,* February 24, 2000.

———. "Filmmaker's Unique View of the Black Experience: Julie Dash's *Daughters of the Dust* Evokes Her African Heritage 'With a Freshness about What We Already Know.'" *Los Angeles Times,* March 20, 1992.

———. "*Hearts* a Rough-Hewn Look at a Man Out in the Cold." Review of *Bless Their Little Hearts. Los Angeles Times,* June 14, 1991.

———. "Helping to Heal the Wounds of Slavery." Review of *The Healing Passage: Voices from the Water. Los Angeles Times,* August 12, 2004.

———. "Memory and Love in the South." *Los Angeles Times,* February 10, 2005.

———. "*Penitentiary* Freshens Myth." *Los Angeles Times,* February 29, 1979.

Travers, Peter. Review of *To Sleep with Anger. Rolling Stone,* November 11, 1990.

Turan, Kenneth. "*Killer of Sheep* Is a Timeless Wonder: Three Decades after It Was Finished, the Drama Still Has the Power to Touch the Heart." *Los Angeles Times,* April 6, 2007.

Valentine, Victoria. "*Sankofa* Explores the Present Through the Prism of History." *Emerge,* March 1994, 57.

Van Peebles, Mario, and Melvin Van Peebles. "Movies in Their Blood." Interview by Julie Dash. *Interview,* May 1993, 108–13.

Vance, Kelly. "Angel Dust: What's the True Screen Image of Los Angeles? How Much Time Have You Got?" *Express* (Emeryville, CA), June 2, 2004.

Wall, James M. Review of *To Sleep with Anger. Christian Century* (Chicago), January 16, 1991.

Weinraub, Bernard. "A Director Who Collects Honors, Not Millions." *New York Times*, January 30, 1997.

Whittaker, Kamille D. "Black Hollywood? The Making of Atlanta's Film Industry." *Atlanta Tribune*, June 2011, 25–29.

FESTIVAL CATALOGS AND EXHIBITIONS

Field, Allyson Nadia, Jan-Christopher Horak, Shannon Kelley, and Jacqueline Stewart. *L.A. Rebellion: Creating a New Black Cinema.* Los Angeles: UCLA Film & Television Archive, 2011.

Jones, Kellie, ed. *Now Dig This! Art and Black Los Angeles, 1960–1980.* Los Angeles: Hammer Museum, University of California; New York: DelMonico Books/Prestel, 2011.

Makrah, O.Funmilayo. "Is There a Reason a Black Woman is in the Kitchen? Or, Black Women Re-Claiming Black Women's Image." In *Scratching the Belly of the Beast: Cutting-Edge Media in Los Angeles, 1922–94*, edited by Holly Willis, 40–41. Los Angeles: Filmforum, 1994.

Mungen, Donna. "The Black Experience from L.A. Auteurs." In *Scratching the Belly of the Beast: Cutting-Edge Media in Los Angeles, 1922–94*, edited by Holly Willis, 40–41. Los Angeles: Filmforum, 1994.

Ruell, Catherine. "Larry Clark: On My Way, the Movie." In *Catalogue Festival de cinéma noir Racines Noires*, 43–47. Paris: Festival Racines Noires, 2000.

Smith, Valerie. "The Black Woman Independent: Representing Race and Gender." In *Whitney Museum of American Art: The New American Filmmakers Series 34.* New York: Whitney Museum of Art, 1986.

Snead, James A. "Recoding Blackness: The Visual Rhetoric of Black Independent Film." In *Whitney Museum of American Art: The New American Filmmakers Series 23*, 1–2. New York: Whitney Museum of Art, 1985.

Tanifeany, William. "Julie Dash: Independents and Future." In *Catalogue Festival de cinéma noir Racines Noires*, 48–51. Paris: Festival Racines Noires, 2000.

Taylor, Clyde. "The L.A. Rebellion: A Turning Point in Black Cinema." In *Whitney Museum of American Art: The New American Filmmakers Series 26*, 1–2. New York: Whitney Museum of Art, 1986.

Contributors

ALLYSON NADIA FIELD is associate professor of cinema and media studies at UCLA, where she serves on the faculty of African American studies and moving image archive studies. She is the author of *Uplift Cinema: The Emergence of African American Film and the Possibility of Black Modernity* (Duke University Press, 2015). Her essays have appeared in *Cinema Journal, Framework*, and the *Journal of Popular Film and Television*. Field is co-curator of the UCLA Film & Television Archive film series and tour, "L.A. Rebellion: Creating a New Black Cinema."

JAN-CHRISTOPHER HORAK is director of the UCLA Film & Television Archive and professor of cinema and media studies. Formerly, Horak served as director of archives and collections, Universal Studios; director, Munich Filmmuseum; senior curator, George Eastman House; professor, University of Rochester; professor, Hochschule für Film und Fernsehen, Munich; professor, University of Salzburg. His publications include *Making Images Move: Photographers and Avant-Garde Cinema* (Smithsonian Press, 1997), *Lovers of Cinema: The First American Film Avant-Garde, 1919–1945* (University of Wisconsin Press, 1995), *The Dream Merchants: Making and Selling Films in Hollywood's Golden Age* (George Eastman House, 1989), and *Saul Bass: Anatomy of Film Design* (University Press of Kentucky, 2014). He has published more than 250 articles and reviews in English, German, French, Italian, Dutch, Spanish, Hungarian, Czech, Swedish, and Hebrew. He initiated and co-curated the UCLA Film & Television Archive film series and tour, "L.A. Rebellion: Creating a New Black Cinema."

DAVID E. JAMES is professor of critical studies at the University of Southern California's School of Cinematic Arts. James's *The Most Typical Avant-Garde: History and Geography of Minor Cinemas in Los Angeles* (University of California Press, 2005) contains histories of independent filmmaking by ethnic and other minorities that emerged parallel with the L.A. Rebellion. Since that

publication he has co-edited *Optic Antics: The Cinema of Ken Jacobs* (Oxford University Press, 2011) and *Alternative Projections: Experimental Film in Los Angeles, 1945–1980* (Indiana University Press, 2015). His *Rock 'n' Film: Cinema's Dance with Popular Music* is forthcoming from Oxford University Press.

CHUCK KLEINHANS is co-editor of *Jump Cut: A Review of Contemporary Media* and has published articles on Charles Burnett, Billy Woodberry's *Bless Their Little Hearts,* and Marlon Riggs's *Ethnic Notions* and *Tongues Untied.* His most recent critical studies include Lydia Lunch's *The Right Side of My Brain,* "Marxism and Media Studies" in *Oxford Bibliographies,* Ed Bland's 1959 film *The Cry of Jazz,* and a major reconsideration of the landmark *Cahiers du Cinéma* analysis of John Ford's *Young Mr. Lincoln.*

MICHAEL T. MARTIN is director of the Black Film Center/Archive and professor of communication and culture at Indiana University, Bloomington. He is the editor/co-editor of five books, including *Redress for Historical Injustices in the United States: Slavery, Jim Crow, and Their Legacies* (Duke University Press, 2007) and, forthcoming with David Wall, *Nothing but a Man* (Indiana University Press). His articles and interviews appear in *Film Quarterly, Journal of Latin American Cultural Studies, Third World Quarterly,* and *Framework.* More recent publications include an essay on Gillo Pontecorvo and Haile Gerima in *Third Text* (23:6) and interviews with filmmakers Julie Dash, *Cinema Journal* (49:2); Joseph Gaï Ramaka, *Research in African Literatures* (40:3); Charles Burnett, *Black Camera* (1:1); Yoruba Richen, *Quarterly Review of Film and Video* (28:2); Amy Serrano, *Camera Obscura* (25:2); and most recently Ava DuVernay, *Black Camera* (6:1). He also directed and co-produced the award-winning feature documentary on Nicaragua, *In the Absence of Peace* (1988).

ALESSANDRA RAENGO is associate professor of moving image studies in the Department of Communication at Georgia State University where she works on blackness in the visual and aesthetic fields and is coordinator of *liquid blackness,* a research project on blackness and aesthetics. She is the author of *On the Sleeve of the Visual: Race as Face Value* (Dartmouth College Press, 2013) and is currently working on a book titled *Critical Race Theory and Bamboozled,* for Bloomsbury Press. She has co-edited several volumes, including two anthologies on adaptation studies, *Literature and Film: A Guide to the Theory and Practice of Film Adaptation* and *A Companion to Literature and Film* (Blackwell, 2005 and 2004), with Robert Stam.

SAMANTHA N. SHEPPARD is assistant professor of cinema and media studies in the Department of Performing and Media Arts at Cornell University. She is currently working on a book titled *Sporting Blackness: Embodiment and Performance in Sports Films.* Her work has appeared in *Cinema Journal* and she is co-editor of a forthcoming collection on Tyler Perry.

JACQUELINE NAJUMA STEWART is professor in the Department of Cinema and Media Studies at the University of Chicago. She is the author of *Migrating to the Movies: Cinema and Black Urban Modernity* (University of California Press, 2005), and her essays have appeared in *Critical Inquiry, Film Quarterly, Film History,* and *The Moving Image.* She is currently completing a study of the

African American actor/writer/director Spencer Williams. In addition to her role as co-curator of the UCLA Film & Television Archive film series and tour, "L.A. Rebellion: Creating a New Black Cinema," her work in moving image archiving and preservation includes founding the South Side Home Movie Project and serving as an appointee to the National Film Preservation Board.

CLYDE TAYLOR was associate professor-in-residence in the English Department at UCLA from 1969 to 1972. In 1975 he founded the African Film Society in the Bay Area while he was a lecturer in ethnic studies at UC Berkeley. He has received several awards for his writings on literature and film, including the Oakland Pen/Josephine Miles Literary Award for *The Mask of Art,* and in 1999 he was inducted into the National Hall of Fame for Writers of African Descent at the Gwendolyn Brooks Cultural Center, Chicago.

MORGAN WOOLSEY is a doctoral candidate in the Department of Musicology at UCLA. Her work focuses on sound and music in marginal film cultures and genres, as well as the politics of representation in film sound and music.

Index

440 | Index

film critics, xvi
Filmex (film festival), 30, 142
film festivals, 30, 341–46. *See also names of
individual festivals*
filmmakers. *See* L.A. Rebellion filmmakers;
names of individual filmmakers
Film News Now Foundation, 32
filmography, 355–406
film(s): affective economy of, 246–47; Black
independent, as a movement, xv;
ethnographic films, 329–30; exhibition
and distribution of, 29–37; film noir,
source jazz in, 178; film viewing, nature
of, 59; meaning of, 66; professional vs.
commercial, ix; race movies, ix, 4, 199,
218–19; subjects and strategies of,
19–29; transformative language of,
27–29; underground film, 158, 160–63,
346. *See also* cinema; L.A. Rebellion;
Project One films; Third Cinema; *titles
of individual films*
film stock, 96, 340
Film & Television Archive, UCLA, 4–5,
37–42, 115
The Final Comedown (Williams), 121
financing: of Black films, 152n7; for *Bush
Mama*, 137; for *Emma Mae*, 131–32; of
L.A. Rebellion films, 38; of *Passing
Through*, 142, 157
First Cinema, 78n5
First Run Features (distributor), 34
Fitzgerald, Ella, 179–80
"fluid radicalisms" *(liquid blackness)*, 315n14
Fnac Forum, 30, 32
For an Imperfect Cinema (García Espinosa),
201
form, experimentation with, 28. *See also*
nonlinear structures
formal strategies, in Project One films, 87
Fortune, Sonny, 182
For Whose Entertainment (Caldwell), 30
Foster, Gwendolyn Audrey, 244
Four Women (Dash): Afrofemcentric
orientation, 218; black expansiveness in,
299; key themes of, 211–12; mentions
of, 109; photographs from, 211*fig.*;
showings of, 30; song basis for, 170n17;
style of, 226
Foxy Brown (Hill), 137
Fragrance (Abel-Bey): incongruities in, 306;
music in, 165; photographs from,
166*fig.*; preservation of, 42; remembered
gestures from, 301; subjects of, 20, 21;
222n25, 301, 317n27

*Framing Blackness: The African American
Image* (Guerrero), 36
Franju, Georges, 304
Frank, Robert, 160
Franklin, Carl, 65
Frazier, Jacqueline: background, 18;
distribution of films by, 33; on early life,
323; *Hidden Memories*, 21, 86, 106–8,
177, 190–91; mentioned, 332;
preservation of materials from, 42;
Project One film, 106–8
Freedom in Expression (musical trio), 272
Freedom Theater (Philadelphia), 322
Free Jazz, 157, 158, 161, 168, 169n2
freelancing, Davis on, 346–47
Freeway Fets (Nengudi), 272
French New Wave, 3
Frick, Caroline, 37
Friedan, Betty, 160
From These Roots (Greaves), 31
The Fullness of Time, 312*fig.*
full preservation, definition of, 40
Fulson, Lowell, 255
funding. *See* financing
Funkadelic, 164

Gabriel, Teshome H.: *Analogy*, 14*fig.*;
Burton and, 67; cultural decolonization,
model of, 203; Davis and, 329; Gerima
and, 15; on hero, concept of, 283;
"Images of Black People in Cinema," ix;
importance, 114; interview with, 62; on
nomadic aesthetics, 298; Taylor and,
xiv; teaching by, 252; on Third Cinema,
23, 24, 27, 28; Third Cinema and, 60;
Third World Cinema and, 298; at
UCLA, 13–14, 48; Watts Rebellion and,
76; on women at UCLA, 117n30
gang violence, 134–35, 136
Ganja & Hess (Gunn), 31, 121
García Espinosa, Julio, 201
Garner, Margaret, 101
Gaye, Frankie, 185
gays and lesbians. *See* LGBT issues
gender: assertive nationalism and, 85;
gender equality, struggle for, 159–60; as
inter-reality, 253
gender roles: Black Panthers and, 99; in
Black revolution, 93; male filmmakers'
use of patriarchal, 90; movie production
and, 274; in *Rain*, 113; of Slater and
wife, 270. *See also* Black men; Black
women; men; women
Genet, Jean, xvi

as locale for L.A. Rebellion films, 181,
235, 253; welfare system, 138
Los Angeles Collective. *See* L.A. Rebellion
Los Angeles Newsreel, 167, 169
Los Angeles Plays Itself (Andersen), 253,
254
Los Angeles Police Department (LAPD), 26,
140, 167
Los Angeles School (of Black Filmmakers).
See L.A. Rebellion
"The Los Angeles School of Black
Filmmakers" (Masilela), xv
Los Angeles Times: on Blaxploitation films,
122; on *Bush Mama*, 137; *Emma Mae*
review, 136; on MUC Program, 10
Losing Ground (Collins), xx, 244, 249n35
Louie B. Mayer Foundation grants, 157,
158
Love, Eula, 26, 52n48, 88, 254, 256
Low Museum (Atlanta), 295
Luann *(Bush Mama)*, 138
Lubiano, Wahneema, 261
Lumbly, Carl, 275
lumpenproletariat, 209, 215
Lyle, K. Curtis, 272

Maanouni, Ahmed El, 19, 335–36, 342,
343*fig.*
The Mack (Campus), 122
Madea (Tyler Perry character), 117n51
Madhubuti, Haki R. (Don L. Lee), 159
Mafundi Institute, 6
Maggot Brain (Hazel), 164
Makarah, O.Funmilayo: *Apple Pie*, 86, 100;
background, 17–18; *Define*, 42, 263–64,
265–66; *L.A. in My Mind*, 20, 286–88;
on L.A. Rebellion as term, 348;
mentioned, 332; self-representation,
251, 265, 267, 286–88; as teacher, 49
Makeba, Miriam, 241
male filmmakers, 88–90. *See also names of
individual filmmakers*
Mambéty, Djibril Diop, 304
"the Man," critiques of, 130–31
Mannas, Jimmy, xiv
Man with a Movie Camera (Vertov), 306
Manzanar War Relocation Center, 324
Martin, Michael T., 2, 42, 46, 196
Martinez, Francisco, 19, 51n13, 90
Masikini, Abeti, 189
Masilela, Ntongela, xv, 2, 85, 147, 202
Maslin, Janet, 137
Mason, B. J., 122

Massiah, Louis, xv
Massood, Paula J., 36
Matthews, Edsel, viii
Maurice, Alice, 177–78
Maurice, Richard, 31
Maya *(Passing Through)*, 141, 143, 146
Mayfield, Curtis, 94, 125, 184–85
Mays, Peter, 161
McBride, Joseph, 132
McCullough, Barbara: background, 18; at
Cannes, 343*fig.*; on career after UCLA,
346; *Chephren-Khafra: Two Years of a
Dynasty*, 86, 108–9; on early life, 325;
on festival travel and exhibition, 342,
344; *Horace Tapscott: Musical Griot*,
175, 179; on L.A. Rebellion as term,
351; on L.A. Rebellion purpose, 3;
mentioned, 331; as program curator, 32;
program mention of, 33*fig.*; Project One
film, 108–9; self-representation, 251,
270–74, 282, 286; *Shopping Bag Spirits*,
30–31, 251, 270–74, 276; Taylor on,
xii; on UCLA, 330, 331, 332, 334–35,
337; as university faculty member, 49.
See also *Water Ritual #1*
McGee, James, 276
McGee, Vonetta, 121, 134
McHugh, Kathleen, 242
McKee, Lonette, 213*fig.*
McMahon, Kevin, 52n48
Medea (Caldwell): aesthetic liquidity in,
308–9, 312; description of, 100–102;
impact of social disconnects on, 88;
pregnant belly in, 101*fig.*; style of, 226;
subjects of, 21, 86
Media Urban Crisis Committee (MUCC,
"Mother Muccers"), 7, 84–85
Media Urban Crisis (MUC) Program, 8–10,
51n13
Mekas, Jonas, 161, 334
Melinda (Robertson), 121
memory, racial, 198
men: hypermasculinity, 128–30; male
filmmakers, 88–90. *See also* Black men
Menace II Society (Hughes brothers), 65–66
Mengistu Haile Mariam, 277
menstrual cycles, 241, 244–45, 265
mental health, as subject of Project One
films, 86
Meshes of the Afternoon (Deren and
Hammid), 112, 162, 334–35
"Message to the Grass Roots" (Malcolm
X), 92
Micheaux, Oscar, ix, 4, 31